To Editha
and to our sons, David, Robert, Eric, and Mark

CONTENTS

Colorplates 1–16 appear between pp. 200 and 201
Colorplates 17–32 appear between pp. 648 and 649

Art is surely nothing less than one of many manifestations of culture, which in turn consists essentially of patterns of human behavior developed in response to environmental conditions and demands. But culture is a fluctuating process in which the continuity of behavioral patterns and their products—utilitarian things, institutions, ideas, and the objects or concepts we may call works of art—are constantly modifying the environmental conditions themselves, for once these things are created they alter their surroundings by their very presence.

art reflects culture & culture reflects works of art.

Throughout history, art has undergone a complicated evolution. Far from being a simple linear and cumulative development, this evolution has been an expanding, sloughing, subdividing process, like the delta of a river where some waters are constantly being absorbed into the earth and where currents branch and rejoin, receiving new waters to branch again. If there appears to be a pattern of increasing range and variety in the imagery of art down through the centuries, it is the natural result of the increasing specializations that have developed in human society, the steady growth of population and potential range of audience, the refinements of technology and communications, and the accumulation and exploration of image-making techniques. One of the purposes of this volume is to present the story of mankind's artistic experience as it participates in these developments, providing a glimpse into the marvelous variety in man's relationship to his world, the restlessness of the human mind and spirit embodied in images.

art has changed — not in a uniform manner) changes are patterned analogous to complexities of the mind.

The images man creates may celebrate the joy of life, praise deity, humanity, or the world of nature. They can record a living presence or commemorate an event, preserve a memory or give substance to a fantasy. Images may become magical counterparts, by design or interpretation, as when a religious image is experienced as a divine immanence or when a voodoo image or an effigy substitutes for an actual being as a focus for some occult ritual or as a substitute receptor for the emotions of frustration or revenge. It is characteristic of images that they transcend their material

images man creates has many different purposes & meanings

Art is active + has a def. purpose in life.

substance. The ancestral portrait, the pictures in the family album, and the photograph carried in the wallet or locket hold private meanings for their possessors that lie well beyond the mere record of likeness.

Art, therefore, serves mankind, celebrates the experience of being human, and is both repository and agent of human values. It would be a distortion, however, to relegate it to mere passive service, for art can be an active force, a rebel, even an anarchist in the midst of a present order. It can challenge, synthesize, or enhance the accepted values of the moment. In the tenacious continuity of art lies the mute evidence of its vital purpose. In its capacity to adapt to new conditions lies the secret of its longevity.

The nature of art is such that its true character can be revealed only by patiently exploring the complexities of visual relationships and strands of meanings within a context of time and place. Tidy definitions of "art" tend to coalesce rather than expand, and thus they inhibit the aureole of sensation and meaning that radiates from any work of art. All the trappings of civilization that have added grace, comfort, power, and sometimes agony to human existence—systems of religion, social and political institutions, the concepts of science, the inventions of technology, rituals of sound and movement—may impinge on the image-making process. It is absolutely meaningless to ask of works of art the question, "Is this relevant?" They cannot escape relevancy, for they are distillations from the very substance of human existence. To study art is to study nothing less than mankind itself—a conviction that underlies every portion of this volume.

This is a book for the student and general reader who desire an acquaintance with the history, forms, and ideas of art. It should provide a sound and flexible basis for further exploration of the visual arts, whatever path that exploration takes. Through a pattern of overlapping sequences, this book traces certain themes and traditions from early to late manifestations. It does not, therefore, survey art in the usual sense, unfolding cultures, movements, and artists in strict chronological order. Nor does it approach art from the

standpoint of formal principles, each diagrammed and ex-
plicated by appropriate examples from the world's art. In-
stead, it combines the best features of both by concentrating
on the development of series of ideas and forms in their
cultural contexts. Thus, although the book does not follow
a strict chronological framework, there is a recurrent pattern
of chronological sequences throughout as each series is ob-
served from its beginnings to its most current manifesta-
tions. The book has been organized with an eye toward
providing the reader with the flexibility necessary to under-
stand great works of art in relation both to their own time
and to the major themes and traditions of which they form
a part.

Part 1 deals first with the identity of the artist in terms of
his cultural milieu and his training from ancient times to the
present and then proceeds, in the second chapter, to an
explanation of the idea of continuity and renewal which
forms the conceptual basis for the book. Central to this
chapter is the matter of stylistic inertia and change and their
relationship to cultural factors, the orientation of individual
artists, and the influence of style itself as a phenomenon
affecting the creative choices made by the artist.

Style, as Meyer Schapiro has defined it,* is a system of forms
whose characteristics can reveal the broad outlook of a group
or the outlook, even the personality, of an individual artist.
It is manifest in constant motifs and patterns (the elements
of form), in relationships between these elements, and in
various specific or general qualities that might be called
"expression." For the art historian, style is of primary impor-
tance for its own sake as well as for its usefulness in placing
works of art in their proper context of time, place of origin,
and authorship. Style can serve this diagnostic function be-
cause it has inherent features and qualities that affect a work
of art in its parts and as a whole. In this second chapter the
discussions of developments are aimed, in part, at demon-
strating some essential aspects of style as a preparation for

*Meyer Schapiro, "Style," in A. L. Kroeber, ed., *Anthropology Today*
(Chicago: University of Chicago Press, 1953).

material in subsequent chapters. Iconography, or the study of the meanings attached to images by tradition (but often modified by new contexts or the inventions of individual artists), is also briefly discussed here, since it, too, will play an important role in what is to follow. Chapters 1 and 2 therefore establish a framework of ideas that will be explored in greater detail throughout the rest of the book.

The third chapter is a discussion of the beginnings of art in three regions of the prehistoric and ancient worlds. The attention of the reader is focused upon the broad interrelationships between the general physical and cultural settings and the style and content of the art produced in each. Apart from information specific to each of these areas of early art, the reader will acquire from this chapter a good grasp of the cultural significance of art and an increased familiarity with the methods of dealing with matters of style and content.

Chapter 4 narrows the focus somewhat but expands the geographical range to include ancient Greece, Hindu India, and the Far East. It concentrates on the ways in which art has expressed mankind's relationship to the natural world and to the supernatural powers that may be conceived as immanent in it. In the Far East this has received particular emphasis in landscape art, a genre whose development in the Western world is surveyed in chapter 5. Here the isolation of a specific type of art and an examination of its development over several centuries will not only give the reader a deeper appreciation of art as a carrier of values related to attitudes toward the natural world, but also bring him to a greater awareness of the interplay of continuity and renewal as they bear on a single genre over the centuries.

The next three chapters pick up more directly the relationship between the natural and the supernatural by dealing explicitly with the themes of divinity and the quasi-religious aura that has often been attributed to heroes and royalty, some hints of which appear in earlier chapters. In general, this section of the book aims at a balance between iconography and form while presenting, as it were, a catalog of types. Another important aspect of this section is its emphasis on the changes that occur within each of the three categories as effects of cultural and stylistic influences. Of particular

interest is the series of transformations that affect the images of Buddha and Christ over time and across cultural lines.

Part 4 is devoted to a single chapter, "The Classical Tradition in Western Art," which explores a persistent ideal embodied in classical prototypes that has survived for centuries, undergoing a series of modifications as the immediate context has changed. Since it treats the tradition as a historical continuity, the chapter serves as a survey of Western art by tracing the fortunes of a single but variable set of ideas from the Greco-Roman world to the modern era. Although there is no comparable chapter on another significant current in Western art—the Christian tradition—it will be apparent that a considerable portion of chapter 6 is devoted to it, that it intersects with the classical tradition at many points, and that it is a pervasive presence in other chapters.

Underlying chapters 10 and 11 is the force of cultural conditioning in images when the artist leaves his familiar world to depict far-off places and societies ethnographically different from his own. This section of the book, more specialized than previous chapters, should demonstrate to the reader the strong grip that tradition and cultural prejudice exert on the artist and therefore has implications that reach far beyond the art discussed here—and beyond the subject of art itself.

The next three chapters return to a series of themes that deal with man's relationship to the world around him—art is seen as a vehicle for expressing attitudes toward the commonplaces of everyday life, for dealing with the realities that accompany the problems and crises of human society, and for giving form to the fancies that emerge from the artistic imagination as it serves a variety of functions.

The last section of the text is devoted to the art of the twentieth century, its immediate predecessors, and its scope for the future. It develops as a brief survey of twentieth-century art and bears a symmetrical relationship to the chronological development in the chapters on the ancient beginnings, landscape in the West, and the classical tradition. Given the difficulties frequently encountered by those

who confront the bewildering variety of modern art for the first time, the art of the twentieth century seems to demand the special emphasis it is accorded here. While the section does not always point overtly to themes presented earlier, traces of them will be noted throughout, since older ideas and interests continue to be explored—and modified—in the light of new conditions. The reader will also note that the number of color reproductions is weighted in favor of recent art. This was a deliberate choice, since color per se plays a proportionately greater role in this art, sometimes to the extent that a picture is almost meaningless without it.

As additional aids to the reader, synoptic tables give a concise chronological survey of civilization and the major developments in the arts, organized to present a cross section of simultaneous developments around the world; a glossary provides definitions of terms found in the text as well as a selection of others commonly encountered in the vocabulary of art; and a bibliography includes not only works consulted by the author but also additional readings that might prove of interest to the reader, arranged according to chapter.

It is hoped that the discursive approach selected for this text will prove to be a distinct advantage by leading the reader along several different routes, by a variety of conveyances, to a recognition of the marvelous complexity of image making and a fuller understanding of the degree to which art is woven as a vital component into the fabric of human experience and purposes.

ACKNOWLEDGMENTS

The debt I owe to others in the formation of the ideas presented in this book I can never adequately convey. Nor, for the most part, can I always sort out from what has become an organic part of my personal convictions and attitudes the contributions I have received from my own teachers, *de facto* and *ex libris*, and from my students in their quests for understanding. Ultimately, of course, the works of art themselves are the primary sources on which I have depended during some years of meditation on their qualities and meanings. The years have brought all these together in a slow process of accumulation, cross-fertilization, and selection. Sometimes the roots are hard to find.

I am especially grateful to Charles Scribner, Jr., for his encouragement and to my editor, Elsie Kearns, for her patience and expert guidance; to manuscript editor Barbara Wood; to Jane Anneken and Beatrice Close who relentlessly tracked down the illustrations; to designer Emilio Squeglio; and to the production supervisor, Janet Hornberger. To those who read the manuscript and offered much helpful criticism, my sincere thanks: Van Deren Coke, Baruch Kirschenbaum, John Rupert Martin, Thomas Ford Reese, Charles Scribner III, Mildred Walker, and Jerrold Ziff. My gratitude is theirs, but any errors or distortions I claim for myself. To my colleague Stephen Wilkinson I owe a special debt of gratitude for his advice on a portion of the manuscript, and my thanks are also extended to other colleagues —artists and scholars alike—from whose insights I continually enrich my own. Numerous other individuals and organizations have rendered valuable services: Randal Arabie; Asia House Gallery; Columbia University libraries; Moyuyama & Co. Ltd., Tokyo; The New York Public Library; Claire Sotnick; and Emoretta Yang of Cornell University. Thanks

also to Eric Spencer for his work on the diagrams and to Elizabeth Glanz and Eleanor Kuhar for their expert typing of nearly illegible drafts.

Finally, I want to express my appreciation to the family for its moral support and to my wife, Editha, whose intelligent discourse and sensitivity to both the visual image and the written word are constant factors in my own work. To Editha and to our sons, David, Robert, Eric, and Mark, I should like to dedicate this book.

Harold Spencer
University of Connecticut

_____THE IMAGE MAKER

THE
IMAGE MAKER

We shall never know when man first became a maker of images, but it must have been very early in his evolution. Nor can we know with certainty what kind of image first emerged as that dawn-creature moved slowly into self-awareness. It is difficult to conceive of the human mind in a completely preimage state. Consciousness itself seems to demand some image in the mind, something for awareness to fix upon, some "likeness," whether it be of the prey sought by the hunter or a fellow creature recognized as a being like oneself in form and capacities. From these primeval levels imaging must have grown.

How long shadowy configurations glided through the mind of primitive man without ever being fixed in some concrete form, scratched on a stone or modeled in clay, is a matter about which we can only speculate. It is an essential function of the human mind to project on its secret screen a multitude of images: traces of memories, daydreams, and fantasies, as well as direct perceptions of the visible world. These shadows become images, in the physical sense of works of art, only when awareness of the identity and continuity of humanness becomes strong enough for man to attach some significance to the images of the mind as the signals of a vital process.

It may not be far from the mark to assume that the first generative images in the mind were something like one's reflection in a pool, a narcissistic attraction that gradually became a fixed image of the self. Out of the desire to perpetuate that identity—at a level above raw instinct for survival—grew the panoply of human extensions that comprise society and its institutions as well as the concept of continuity beyond death.

The social, political, and religious institutions that man has created over the centuries are also organisms of a sort, and they have, in turn, formed their own self-images. These institutional identities, like those of individuals, are inseparable from the roles they assume they play, have in fact played, or aspire to play. (Needless to say, these self-images are not always what other individuals or institutions may perceive them to be.) The celebration and propagandization of these images—individual or institutional—constitute processes in which the artist as image maker has always been purposively engaged. In these extensions of human identity lie the seedbeds that have nourished art.

Works of art are tangible things, forms fashioned out of substances as durable as marble or as transient as sound; the skill to manipulate some medium into a form unique, or imitative, or repeatable is necessary before imagings can emerge as works of art. Perhaps it all began when the first hand tool was shaped, consciously, with a view to its ultimate purpose. At any rate, melding the imaging capacity with the image-making skill was surely the first chapter in the genesis of art.

Man is a compulsive imager whether he is an artist or not. Indeed, his very identity depends upon the particular image he has of himself. Each of us, as a concrete biological unit, exists in a reasonably well-defined dimension of time and space. We are conceived and born at precise moments, at determinable locations in space, and we live through a limited span of time. Throughout our lives, however, there is a dimension we bear with us that cannot be viewed under a microscope, in an X ray, through a telescope, or with the naked eye; yet we always carry it, and we live in it during a considerable portion of our existence. Let us call it, for convenience, the realm of the mind: the sum and interaction of our attitudes, fears, aspirations, dreams, and self-projections. An individual can truly experience only his own private version of this realm. He can but glimpse, now and then, some of the symptoms of it in others.

Man habitually extends himself beyond mere consciousness of his own physicality and his simplest creature needs to the

intangible areas of spiritual, aesthetic, and playful satisfaction. This extension of human consciousness readily accommodates free movement back and forth throughout one's memory of his past, or into a fictional past "that might have been," into anticipations of the future and into hybrid situations that are without a definite focus in time and often lie in some limbo of unreality. Thus it is that man's daydreams may place him atop a mountain he has never scaled or in a life role he will never play. Some individuals may even construct in the mind's eye extreme configurations we call "fantasies," since they lack to a remarkable degree any real counterpart in the world that our five senses can experience and are pieced together by their imaginations out of fragments of experience. There are things in this world, of course, that we sometimes find fantastic merely because they happen to have qualities that depart so much from what is familiar or comfortable that we find them almost unbelievable.

All the arts of mankind, nourished by cultural roots, are concrete manifestations of this fluctuant, marvelously malleable dimension of the mind. It is in the processes that operate within the dimension of the mind and back and forth between it and the raw experience of day-to-day environment that we must find and understand man as a maker of images, images that are ultimately and collectively the tangible projections of man's total existence as a private being and a functioning element in human society.

PART

ONE

ARTIST AND IMAGE

THE ARTIST AND HIS MILIEU

The artist's status in his society has varied throughout the course of history, although in some instances information is so scanty that the facts are difficult, if not impossible, to determine with any degree of accuracy. There is often no record of the artist's presence beyond the work that has come from his hands. There is very little one can discover, for example, about the status of the painter, carver, or modeler in prehistoric times. We can assume that some members of ancient hunting and gathering societies were more skillful at image making than others; but were they set apart as a special caste with special powers, as medicine men or shamans, as a prehistoric priesthood? These are questions for which conjecture, however reinforced by the study of contemporary primitive societies, is really our final refuge. Some evidence of the artist's role has been preserved from later periods of the ancient world, but it is still fragmentary information. For example, Egyptian paintings depicting artists at work (fig. 1) and the discovery of actual workshops of Egyptian sculptors, or the representations in Greek vase painting of potters or weavers at work (fig. 2) and signatory inscriptions on the vases, reveal something about the circumstances of artists' activities. Occasionally the scope of our knowledge is enlarged by useful fragments of literary evidence, like the Greek sources (Xenocrates of Sikyon, Duris of Samos, and others) from which the Roman writer Pliny the Elder (ca. A.D. 23–79) derived the important commentaries on Greek artists that appear in his monumental *Historia naturalis.*

Monastery and cathedral records, contracts, and handbooks on materials and techniques, like *Il libro dell' arte* (which appeared in 1437, during the Renaissance, but reflected

1

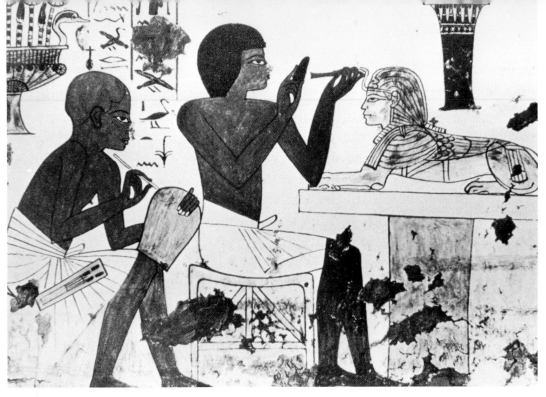

1. **Craftsmen at Work**, *detail of a wall painting from a tomb of two sculptors in Thebes. Egyptian, late Eighteenth Dynasty, ca. 1400 B.C.*

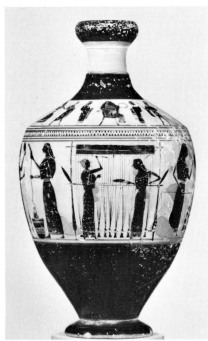

medieval practices), by Cennino Cennini (ca. 1370–1440), provide useful information for reconstructing the artists' milieu during the medieval era in the Western world. During the Renaissance in Italy, commencing in the fifteenth century (the quattrocento), there emerges a fairly complete picture of the artist as an individual and a functioning member of his society. In addition to various records like contracts for works to be executed and tax lists, information comes from more personalized sources: artists wrote treatises on art and the biography of the artist became a feature of the age, commencing with the anonymous biography of the architect and sculptor Filippo Brunelleschi (1377–1446). In 1436 Leon Battista Alberti (1404–72) published his Italian

2. **Women Working Wool on Loom**, *black-figured lekythos. Athenian, ca. 560 B.C. Height 6¾″. The Metropolitan Museum of Art, New York (Fletcher Fund, 1931)*

treatise *Della pittura* ("On painting"), which followed its parent Latin version, *De pictura*, of the previous year, and by mid-century he had published treatises on architecture *(De re aedificatoria)* and sculpture *(De statua)*. The sculptor Lorenzo Ghiberti (ca. 1378–1455) wrote his *Commentarii* sometime during the last decade of his life. Besides comments on artists of antiquity derived from earlier sources, the *Commentarii* included discussions of recent artists, among them an autobiographical account, and theoretical material, including a discussion of optics. The painter Piero della Francesca (ca. 1420–92) wrote treatises on perspective (*De prospectiva pingendi*, 1480–90) and geometry. The most renowned work underscoring the Renaissance concept of the artist as an individual genius was published in the sixteenth century (the cinquecento): *Lives of the Most Eminent Painters, Sculptors, and Architects* by Giorgio Vasari (1511–74), the first edition in 1550 and the second in 1568. Vasari, himself an artist, knew personally some of the artists about whom he wrote, and by distinguishing three major periods of recent art—the fourteenth, fifteenth, and sixteenth centuries—and giving them some characterization as historical periods, he added a new dimension to artists' biographies. The notebooks of Leonardo da Vinci and the poetry of Michelangelo further emphasize the enlarged scope of the artist in the Renaissance. The closer to our own era, the clearer the picture, and we become more certain at least of the ground on which we can base our conclusions about the place of the artist in society, his artistic personality, and ideas concerning his creative role.

In ancient Egypt the structure of a hieratic social system with a god-king at its head did not admit painters or sculptors to a level much higher than that of menial workers, even though their services were important to the loftiness and continuity of the kingship. The images they created both preserved the royal-divine milieu in the eternal afterlife celebrated in the darkness of the tombs and embellished the temples of the gods along the Nile.

The temple and palace workshops of ancient Egypt must have been well-organized systems of apprenticeship and pro-

duction to have spawned the amount and controlled quality of the sculptures, paintings, and other objects in the service of the kingship, the royal court, and the gods that have been recovered thus far by archaeologists, whose work is far from finished. The continuity of a relatively consistent Egyptian style over many centuries bespeaks the firm hand of tradition that flourishes under such conditions. The artist was essentially a specially trained servant to the priesthood, the court, and the god-king. The names of some Egyptian artists have been preserved, and there is evidence that the status of the artist may have risen in the New Kingdom between 1580 and 1085 B.C.; but his role probably never reached very far above the level of mere subservience, however much his skills were appreciated.

That good artists were apparently sought in the ancient Near East is affirmed by the request of the Hittite king Hattusilis III (ca. 1275–1250 B.C.) that the king of Babylon lend him a sculptor; but the social status of the artist in the Tigris-Euphrates region was probably no greater than in Egypt. He humbly served higher powers, sacred and secular.

The artist first emerged from millennia of virtual anonymity in ancient Greece. Here artists signed their works on more than an occasional basis, thus linking their personal identities to the work of their hands. Their signatures were the guarantees of their reputations. There also seems to have been recognition of the artist as a personage worthy of fame for his artistry. Indeed, one might claim for ancient Greece the first recording of artistic personality, as legends, however fragmentary, grew about the renowned skills and eccentricities of some Greek artists. One instance of individual pride of craft is evidenced in an amusing way by the inscription the Greek potter and vase painter Euthymides affixed to one of his vases. He was the contemporary—and competitor—of another artist, Euphronios, who was renowned for his skill, and in this instance Euthymides was so pleased with the results of his own craft that he inscribed on his vase, "Euphronios never did anything like it."

The paradigmatic demonstration of the Greek artist's pride in his skill is a story told of an exchange between the re-

nowned painter Apelles and Protogenes of Rhodes. Apelles
sailed to Rhodes to visit the latter, whose work he admired,
and, finding him absent from his workshop, left a curious
calling card. He had found an old woman keeping watch
over the studio, and when she asked who he was, Apelles
picked up a brush and drew a line of exceptional delicacy
across a panel, informing the old woman that this would be
sufficient identification, and left. Protogenes returned and
decided that his visitor must have been Apelles, since the
line was so precise. Picking up a brush charged with another
color, Protogenes drew an even finer line through the center
of the one drawn by Apelles, splitting it neatly along its
length. He told the old woman to show this to the visitor
should he return and to inform the visitor that the author
of the second line was the man Apelles was seeking. Apelles
returned later and, finding the second line, drew yet another,
splitting this second line so finely that it was impossible to
add another. After Apelles departed a second time, Protog-
enes returned and, beaten at the game of skill, hurried to the
harbor to greet his visitor. Even if fictitious, anecdotes such
as this are facts of a sort: they are manifestations of individ-
ual pride and imply a cultural ambience in which the artist
is free to display his pride as a fitting accompaniment to his
professional skills.

Other anecdotes about Apelles seemed to be aimed at pro-
moting the idea that figures of importance in the Greek
world held artists of his caliber in high personal esteem.
Alexander the Great was supposedly a frequent visitor to
Apelles' workshop and is said to have forbidden anyone else
to paint his portrait. It is reported that on these visits he
would discourse at length on subjects about which he knew
nothing, whereupon Apelles would remind him that even
the assistants who ground the colors were laughing at him.
Alexander apparently took no offense. These and the other
tales told of Greek artists give the modern reader some sense
of the presence of an artistic personality, and thus artists like
Apelles become more than just names associated with long-
lost works.

The evidence from the ancient world is, however, ambiva-
lent. The image of the artist that one finds in Plato's writ-

ings, for example, is clearly that of a menial worker who does not invent but merely imitates. This point of view, which supports the paradox of despising the artist while admiring his handiwork, effectively separates the personality of the artist from his creations. In all probability, Plato's attitude reflects an older aristocratic view of the artist's lot as that of one who works ignobly with his hands, like a slave. But the presence of signatures on Greek vases and sculptures and the tales of artists that had developed by the time of Alexander the Great indicate a changing order from which the artist gained new social status.

Rome inherited much from the Greek world, including a residue of the old aristocratic notion that working with one's hands was demeaning, particularly if for gain. Mingled with this attitude, however, was appreciation of the genius of the great Greek masters, as evidenced in the writings of Pliny the Elder. Seneca, on the other hand, wrote that even while offering prayers and making sacrifices before the statues of the gods "we despise the sculptors who make them." Whether Roman art was created by Romans (a designation not easy to be precise about in a spreading geographical expanse like the Roman state) or by Greeks and eastern Mediterranean artists and workshops employed by Roman patrons and whether many of these artists were actually slaves are still open questions. There is, moreover, no body of literature like that brought together by Pliny the Elder about Greek art to give us accounts of Roman artists. The presence of occasional signatures offers little assistance. The Roman artist remains a shadowy image. We do know that poets were held in greater esteem and that this generally remained true even in the Augustan Age, when the arts gained considerable prestige. Poetry seemed a more intellectual pursuit and thus more becoming to a gentleman. Yet, amateurism in the visual arts became fairly widespread in the Roman Empire, and even emperors were known to have engaged politely in the art of painting; but this was not painting for a livelihood, a practice beneath the Roman highborn.

Nowhere was the cultivation of painting as a polite occupation more fully developed than in China, probably as early

as the first centuries of our era. The status of the Chinese painter was established by his position in the scholar caste, which fostered the arts of calligraphy and painting within the civil administration. The literacy of the artist was the key to his enviable social position, and his status compared with that of his counterpart in the Western world remained relatively stable. These conditions probably established distinct limits to the classes of people who became artists. In some respects the Chinese master might be compared to the amateur: his livelihood came not through his artistic life but through his bureaucratic function, which left him relatively free to create for his own pleasure. Although the Chinese painter's bureaucratic connection with the court secured his social and economic position, he was also firmly committed to tradition. The common practice of copying earlier masters perpetuated a tenacious bond with the styles of the past (see pp. 138–41).

In the Western world during early Christian times, the artists who served the growing new religion were humble artisans of limited skill, not a truly professional class. They derived many of their visual devices from the more accomplished illusionistic paintings of antiquity (Pompeiian art, for example), but at a sketchy, simplified, austere level, showing features that resulted from uninformed repetition of a distant stylistic model. But this art carried a new burden of symbolic meaning appropriate to the message of salvation that permeated the new faith, and the new content was a force that eventually helped to transform the modest art of the early Christians into new forms during the Middle Ages. In this gradual transformation from late antique to medieval styles, the artist does not emerge as an individual, but only as a statistic. The focus is not on the uniqueness of the artist's personal invention but on the prescribed tradition in the service of a religion that had become the true successor of the old Roman state.

Symptomatic of this shift in emphasis is the philosophy of Plotinus (ca. A.D. 205–70), who was an Egyptian by birth and was possibly influenced by Indian thought. Settling in Rome, Plotinus developed ideas that became known as Neoplatonism, a metaphysical system involving emanations

from a divine source that became increasingly bereft of the divine element as they reached into the material world. Residing in this material realm, the human soul has yet some degree of the divine in it, and by a disciplined process of disengagement from material concerns (and, therefore, from individual identity) the soul can achieve reunion with the divine realm from which it was descended. Within this frame of reference, the creative act of the artist, imposing a beautiful form upon formless material—a piece of marble, for instance —was a transformation that engaged the divine, that turned back toward it as the true source of beauty. The artist, as a divinely inspired agent, did not gain personal identity in the process; he was like a reed bending in the wind, not an originator comparable at the mortal level to a divine creator. (That idea had to await the Renaissance.) Instead, it was the divine, spiritual factor in the created work itself—or, to put it another way, what it symbolized—that acquired value.

In the world of medieval art, dedicated to the glory of God, the individual artist (whose personal identity, if pressed too far, would smack of the cardinal sin of vanity) stood once more in the shadow of anonymity. This does not mean that he was a completely anonymous creature, even in the earlier centuries. The names of thousands of medieval artists and architects or master builders have been recorded, but these names are unconnected with personalities until the late Middle Ages. We should, however, be cautious in declaring the anonymity of the medieval artist (and others about whom we have few records), for the possibility always exists in largely illiterate societies that information concerning contemporary reputations and personalities was embedded in an oral tradition now irretrievably lost to history.

The medieval artist was not "expressing himself" (which has been so important in more recent concepts of the artist's role) except as he endeavored to execute his work to the full range of his capacities. He was, rather, absorbed into a larger identity, the sacred or secular institution and function that his completed work was to serve and celebrate. His role was in some respects akin to that of the Egyptian artist of ancient times. This was true both in the Byzantine East, where ecclesiastical and secular power were concentrated in the

person of the emperor, who was archpriest as well as head of state; and in the West, the province of the Roman Catholic church, where ecclesiastical and secular power were separate and eventually, in the later Middle Ages, openly competitive. Although many works of art produced during the medieval era were clearly the creations of individual artists, not collective enterprises (as would be the case, for example, with an extensive mosaic decoration, requiring many workmen skilled in the art, albeit not without some supervising presence), the individual artistic personality was secondary to the general purpose the art was intended to serve: the adornment—ritualistic, oblatory, didactic—of the house of God or the visible manifestation of secular power and glory residing in some prince. Recent history has conditioned us to think of the artist almost exclusively in individualistic terms, to emphasize the loneliness of the creative act; but for long periods of history the artist functioned more as a part of a collective effort than as an individual creator, however much his particular skills and insights were his own.

This collectivism has been of three general kinds: the workshops identified with a specific temple, palace, or monastery; the medieval masons' lodges; and the guilds. The workshop was essentially an organized group of master artists (or artist), assistants, and apprentices (fig. 3). The masons' lodge was also a workshop (under the supervision of masters who had charge of supplying materials and labor and of planning, organizing, and executing the work), but a characteristic of the lodges was their mobility, as they followed opportunities for employment from building project to building project during the era of medieval cathedral construction. It should be noted, however, that even in monastery workshops some art was produced by itinerant journeyman artists and craftsmen. Although workshop organization, with masters and apprentices, was an ancient institution and a feature of the guild system, the guild contributed something new. It was essentially an association of individual masters and their shops that established in an urban situation what was, in effect, a monopoly in a particular area of production, shared among the member workshops. It assured the distribution of available work, but it was also an effective deterrent to outside competition.

3. The Duchess Flagentine Superintending the Building of the "Judgment Tombs" ac-cording to Nascien's Instructions, *from* Roman de Saint-Graal. *Early fourteenth century. Manuscript illumination. By courtesy of the Trustees of The British Museum, London*

The medieval workshop featured considerable specialization; among the manuscript artists, for example, there were clear distinctions among painters of miniatures, calligraphers, and painters of initials. Most artistic training took place in the monastic workshops, so the traditions established there would have been perpetuated even among the journeymen and artists employed in the secular courts. As urbanization evolved at an accelerated pace in the later Middle Ages, this collectivism and specialization became concentrated in the workshops of the guild system in the towns of western Europe. A similar system also seems to have functioned in India from a very early period as part of the caste structure. Associations of merchants and craftsmen are known to have existed in ancient Greek times, and in the late Roman Empire various organizations were made responsible for a variety of municipal affairs. Classes were bound to their professions and a corporate existence was clearly established within the various professions. During

the later Middle Ages, this corporate structure was manifested in the guilds, which regulated their respective professions as distinct economic entities. The apprenticeship system assured the continuity of the class.

Among the major guilds in Florence, for example, were those of the wool merchants, bankers, silk weavers, and physicians and apothecaries. Early in the fourteenth century, painters were admitted to the guild of physicians and apothecaries, with some logic in the alignment. Physicians acquired their medicines and painters their pigments from the apothecary shops, and since St. Luke had supposedly been both physician and artist he became the patron saint of both. The entry of the artists into the guild system was an indication of their enhanced status within the town; but during the course of the Renaissance, artists came to view the guild as a restrictive rather than a protective system.

The medieval guild governed the training of the artist through the apprenticeship system of the workshop *(bottega)*. Indeed, the very right to practice one's art depended upon the sanction of the guild, which was a "closed shop" system in which membership was limited and supply thereby adjusted somewhat to demand. The artist worked solely on commission from a patron and did not accumulate works in the *bottega* for future sale. The training process developed the thorough craftsmanship the guild demanded in its products. A young man who wished to follow a career in art was obliged to enter a period of apprenticeship and then to serve several years as a journeyman before he could become a master and a full-fledged member of his guild. Limiting the number of masters within the guild was another control which eventually created tensions that contributed to the demise of the system. The masters were able to form large shops full of apprentices and journeymen, thus assuring themselves a larger profit. Eventually it became difficult for a journeyman to advance to the status of a master without some familial or marital tie to an established master. Early efforts of journeymen to organize separately were ineffective because of the towns' support of the guilds. So the guilds, which at first gave the artist a recognized

status within the economic system, became restraints on the artist once he began to assert his identity, first as a member of a subclass of the system, later as an individual. The break finally came with the development of new centers of power through which the artist might find sufficient patronage and support independent of the guilds. These centers were the Renaissance courts, secular and ecclesiastical, with which another organization, the art academy, eventually became associated.

The papacy played an important part in this development. Influenced by Michelangelo, who was opposed to the collaborative nature of work in the traditional *bottega*, Pope Paul III released the sculptors in Rome from the authority of the guilds by a decree in 1539. This release marks the attrition of the old system through pressures exerted by a new breed of artists who, like Michelangelo, were jealous of their personal stature and reputations and reluctant to submit completely to the regulations of the guilds. A similar freedom for painters in Rome came later, in 1577, under the papacy of Gregory XIII. In 1571 Florentine painters were freed by decree from the old ties to the guild of physicians and apothecaries, and sculptors achieved exemption from the minor builders' guild. In Venice, the movement developed much later. Painters severed ties with the guild system and formed their own Collegio dei Pittori in 1682; sculptors did not gain their independence until 1723.

In the early Renaissance, when the artist was still functioning under conditions quite similar to the medieval workshop milieu (fig. 4), his status, generally speaking, was no more than that of a highly skilled craftsman. But the Renaissance artist differed markedly from his medieval predecessor in one very important particular: he effectively eliminated the separation between the intellectual and the practitioner, between mental pursuits and the hand skills of the artist. He made art a scientific vehicle of sorts by joining the rendering of natural appearances to a theoretical basis—namely, perspective (fig. 5). This union was symptomatic of a general condition of the moment, for science had begun to consider the use of empirical observation and experiment in its study

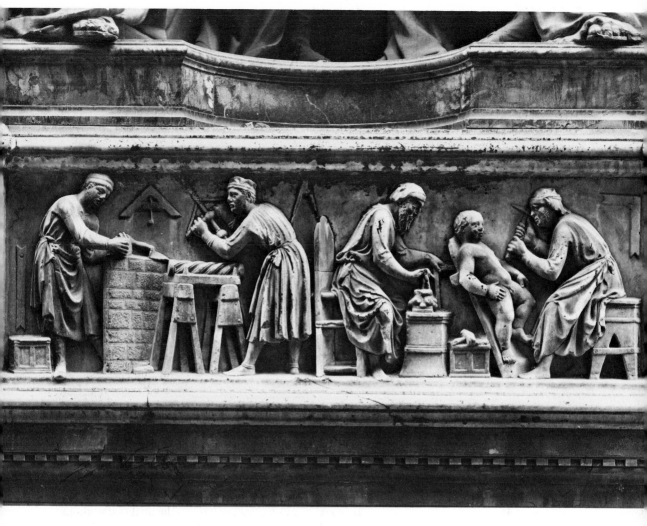

1408–14. Marble. Or San Michele, Florence (Alinari-Art Reference Bureau)

of the natural world. The interweaving of these interests brought art and science into a common field and contributed to the enhanced status of the artist. Such a climate could foster a multifaceted career like that of the High Renaissance artist Leonardo da Vinci, who developed a scientific basis for the study of anatomy and whose activities reached far beyond painting, sculpture, architecture, and artistic theory into hydraulics, aerodynamics, internal

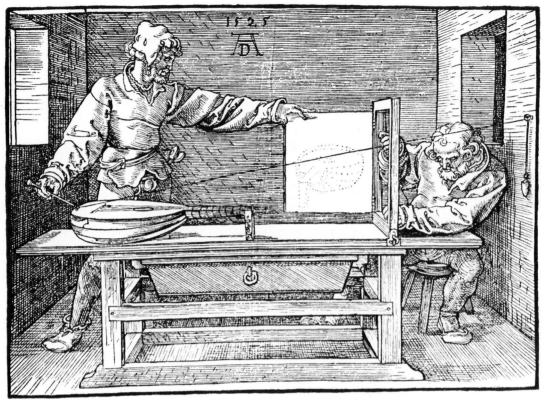

5. ALBRECHT DÜRER. Draftsman Drawing a Lute, *from the artist's treatise* Instruction in Proportion. *1525.*
Woodcut. ca. 5 ⅛″ × 7 ⅛″. Prints Division, The New York Public Library (Astor, Lenox and Tilden Foundations)

anatomy, geology, botany, and other scientific and techno-logical areas. Although the breadth of Leonardo's explora-tory accomplishments outstrips all other artists of the Re-naissance, it should be remembered that it was the common, open ground of art and science that made a phenomenon like him possible—and this ground was already prepared by the general thrust of fifteenth-century art.

Perhaps, with respect to the artist's status, the High Renais-sance was well named, for it was then, in the era of Leo-nardo, Michelangelo, Raphael, and Titian, that the superla-tive artists gained superlative social positions. They were on intimate terms with princes of church and state, with the intellectually privileged of the ecclesiastical and secular courts; they were proclaimed as men of genius, their powers

of creation exalted as never before, far beyond the praise for
Apelles' skill of hand. The Renaissance concept of the artist
as a genius was appropriate to an age obsessed with the
potential of man and the style of talented personality. At
this point the history of the "modern" artist begins.

The cult of genius has had curious side effects. One of these
is the sense of estrangement from the mainstream of society
that subsequently infiltrated the psychology of the artist.
When the Renaissance centers of power courted the artist
to enhance their own glory by the reflected brilliance of his
creative resources, the old role of the artist as a servant to
his sources of patronage was completely turned around.
Moreover, the high value placed on the artist's creative
powers gave these mysterious qualities a degree of prece-
dence that competed with the artist's work itself. It is surely
a long leap, and clearly a *reductio ad absurdum,* for the artist
then to assume that his every gesture or clever conceit is a
legitimate artistic statement.

The late Renaissance art world was not without its own
collective institution, the art academy. The academy dif-
fered from the guild in several respects: it elevated the
artistic profession because it was usually associated with a
secular or ecclesiastic court, and it offered a program of
theoretical study as well as practical instruction. In time the
academy acquired other functions.

Much of the practical instruction sponsored by the acade-
mies took place in various artists' workshops, so the drift
away from the old workshop tradition and toward the studio
classroom was only gradual. The academies also retained
some aspects of the old guilds. The Accademia di San Lucca,
founded in Rome in 1588, had rules reminiscent of those in
effect under the guild system, especially the regulations
bearing on professional ethics and price structure. There
were, for example, fines for price cutting and for luring
students away from other academies.

Although it had shadowy forerunners in the schools oper-
ated by artists in several courts, the Accademia del Disegno
has been cited as the first real academy of art in the Western

world. Promoted by Giorgio Vasari, it was formed in Florence in 1563 under the sponsorship of Grand Duke Cosimo I de' Medici. Vasari had intended that the Accademia del Disegno, modeled after literary academies, should advance the prestige of the profession, but the institution also placed considerable emphasis on teaching. There were classes in geometry and anatomy as well as practical instruction and criticism from visiting teachers. A new element, which had not been a feature of the guild system, was the eventual attraction to the art academies of dilettantes and art lovers —the amateur wing. Amateurism in the arts was not unknown in the ancient world, as pointed out earlier, but it was now to flourish as never before. This social mixture of professionals and dilettantes did much to give the art academy a central role in matters of taste and to ensure a sympathetic and influential audience for its art. The stubborn grip of academy precepts on official art for the next few centuries was largely the consequence of this union of the artists of the academy with amateurs whose ranks included both the intellectuals and the affluent. Academies became the adjudicators in questions of artistic policy: the curriculum in which the artist was trained, the principles official art was to follow, the criteria for awards to artists, and the organization of exhibitions when these finally became regular features of the artist's world. Theories of art and criticism radiated from academy circles, and by the middle of the seventeenth century the term "academic art" had acquired a precise meaning.

One of the most influential of the early academies was the private school formed in Bologna around 1582 by the Carracci family of artists (Ludovico and his two nephews, Agostino, the theoretician, and Annibale, the most accomplished artist of the three). Initially called Accademia delli Desiderosi (*desiderosi* signifying those who aspired to learning and fame), its name was changed to Accademia degli Incamminati (*incamminati* suggesting, as one scholar phrases it, "those who are making it") around 1590, when it seems to have acquired some pretensions. Eventually the academy became the cultural center of Bologna. Although there was theoretical instruction at the academy through

lectures and discussions, it is doubtful that there was a thoroughly systematic curriculum. The Carracci workshop and the academy worked closely together. The paraphernalia of the academy included anatomical casts and casts of famous sculptures, so that drawing from the plaster cast (fig. 6) soon became a major feature of academic discipline (continuing in art schools into the present century). The emphasis placed on the development of a style that took the art of classical antiquity as one of its major models helped to set a classical timbre to the history of academic art. While considerable emphasis in the academic tradition was placed on nature through drawing from life—nature, therefore, being somewhat of a guide—it was a nature, more often than not, tempered by the blank beauty of the antique.

6. C. N. **COCHIN THE YOUNGER. The Program of Art Instruction in France**, *plate 1 from Denis Diderot and Jean Le Rond d'Alembert*, Encyclopédie. *1763. Engraving.*

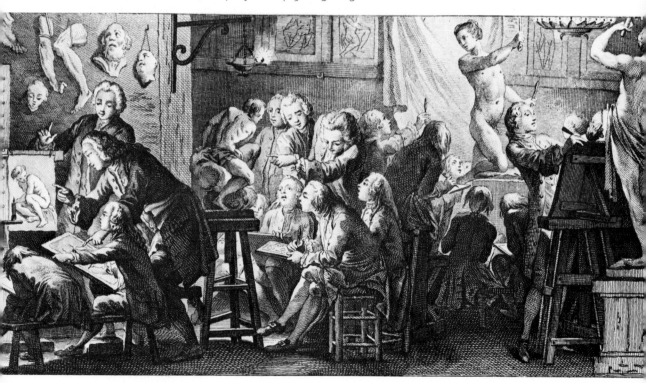

In the seventeenth century the academy was firmly established as a major force in Western art, and its most doctrinaire manifestation was embodied in the Académie Royale de Peinture et de Sculpture founded in France in 1648, during the early years of the reign of Louis XIV. The autocratic French regime found in its academy an effective device for imposing official taste on French art; through the widespread emulation of the court of Louis XIV, its influence spread throughout Europe. Through the academy and its precepts a classical tone was imposed on all branches of the arts, and with the king's sanction the institution became a virtual art dictatorship. With the founding in 1666 of a branch in Rome, where prize students were sent to study the art of antiquity firsthand, the influence of classicism was further reinforced.

In 1768 the Royal Academy of Arts was founded in London, and in the same year an Academy of Fine Arts, formed in St. Petersburg, sent students to Paris and reflected the strong French influence that had been growing in Russia since Peter the Great's trip to western Europe in 1697–98. The English academy, as set forth in a document addressed to George III in November of 1768 and signed by several British artists, aimed at "establishing a well-regulated School or Academy of Design, for the use of students in the Arts, and an Annual Exhibition, open to all artists of distinguished merit, where they may offer their performances to public inspection, and acquire that degree of reputation and encouragement which they shall be deemed to deserve." Its primary purpose, then, was to benefit the profession of the English artist, and its program, as it developed under the presidency of Sir Joshua Reynolds (1723–92), held as its model a grand style derived from the example of selective monuments from the sculpture of classical antiquity, French academic precepts (infused with classicism), and the art of the Italian High Renaissance.

The life cycle of the art academy, as both a professional organization and a school for aspiring artists, seems to have followed a rhythm similar to that of its predecessor, the guild system. Implicit in its self-image was the notion that its

program and precepts would ensure a high level of quality in the art it helped to generate. Yet the concept of service to the profession consistently evolved into a doctrine or policies that subsequent generations of artists would find restrictive and even antagonistic to their creative impulses. The academy became a static institution, a fortress of conservative or reactive attitudes in the midst of an inevitably evolving art scene that was responsive to new configurations in human society and eager to explore new directions of creative activity. The revolt of artists against the strictures of the guilds was to have its counterpart in revolts of artists against academy positions, first demonstrated in the "Poussiniste-Rubéniste" controversy during the latter part of the reign of Louis XIV (see pp. 426–29). This antagonistic relationship developed into a seesaw of movements during the nineteenth century and has accelerated at an unprecedented rate in the course of this century. The underlying reality of all this is the fact that art has never been a static phenomenon, although at times it has been subject to strong authority. Organically bound to patterns of change in human society, its vitality depends on its capacity for change. The security provided by such institutions as the guild and the academy could be no more than a temporary sanctuary or a phase of consolidation around an artistic concept. Movements in art, however strong at their crests, do not sustain themselves indefinitely; they have a way of expending their vitality and lapsing into a phase of "followers" that makes them "academic" (movements frozen, as it were, into fixed aesthetic positions) and likely targets for dissident factions of artists.

In the United States, the independent art school, sometimes affiliated with a museum of art, has been a prominent feature in the professional training of the artist. During the last half of the nineteenth century, several of these schools were established in the United States: Cooper Union (New York) in 1859, Massachusetts School of Art (Boston) in 1873, Art Students League (New York) in 1875, Art Institute of Chicago in 1879, Cleveland Institute of Art in 1882, and in 1887 the Art Academy of Cincinnati and Pratt Institute (Brooklyn, N.Y.).

The college or university art department or school of art has had a particularly pervasive influence in American art and has acquired features of a complete patronage system well beyond the simple fact of employing artists as teachers. Its growth was little short of phenomenal in the period following the Great Depression of the 1930s and particularly after the Second World War. During the depression official federal patronage of the arts (occurring for the first time in this country with anything approaching a large-scale commitment) was an important part of the Works Progress Administration program, which, through the extensive Federal Arts Projects, provided a livelihood for some of the best artists and a period of self-testing for some younger artists who were later to advance to the foreground of American art. In the wake of recovery from the depression and in partial consequence of the flight from Europe of accomplished artists escaping the threat of Nazism, the arts in America became increasingly conspicuous. Colleges and universities began to develop departments and schools of art emphasizing studio training as a part of their programs, whereas previously studies in architecture and the history of art, dominated by old-line institutions chiefly in the East, had been the primary concern at that level of education.

After the Second World War, the vast resources for developing studio programs at state-supported colleges and universities threatened the independent art school, which attempted, in many instances, to meet the competition by offering degree programs in emulation of the pattern in colleges and universities. With a few outstanding exceptions, however, the field was dominated by college and university departments offering artist-teachers economic security. This unprecedented growth of training programs for artists fostered a subculture of artistic activity in which artists emerging from university and college departments or schools were settling back into the same system. Herein lies the kernel of a complete training-patronage system, in which the artist is supported by his teaching function (as the Chinese artist was supported by his bureaucratic duties) and is relatively free—insofar as time permits—to engage in creative work according to his own lights. Although this circular system of training artists to teach artists to teach

artists (as well as students with no intentions of becoming artists) was able to sustain itself adequately for a time, the present period of saturation was inevitable. What its outcome will be is uncertain. Despite the criticism that has been leveled at the pattern, the existence of this economic subculture for the artist is a social fact that is unlikely to disappear.

One development, spurred by technological growth in this century, has augmented the artist's role in society: the commercialization of art through the expansion of entertainment, communications, and indoctrination media. This has brought with it new media for the artist and activities somewhat different from the traditional ones. Photographic techniques in advertising, film, and television alone have opened many new channels that have had a pronounced influence on the profession and on styles in art.

When the role of the artist was embedded in services to institutions such as priesthoods, kingships, and deities or in corporate organizations like the guilds, there was no significant need for public exposure of his work in order to attract buyers. As the patterns of his working situation changed and he became increasingly an independent professional seeking a market for his art in competition with other artists, some device for self-advertisement became necessary. Although there was undoubtedly some degree of public exposure of art in earlier times—workshops were sometimes located just off the streets—it was probably not until the sixteenth century in the Western world that anything like a public display of art began to appear, in contradistinction to the common display of utilitarian crafts in the marketplaces of the towns and cities. By then artists were finding the markets and fairs suitable for displays, and occasionally painters' guilds would show examples of their work in public places. Early in the century, the Pantheon in Rome was the site of exhibitions, and by the seventeenth century whole collections of art were occasionally exhibited publicly.

The first regular exhibition of art seems to have been the Salon des Artistes Français, begun in 1673 under royal sponsorship and held every two years in Paris, later annually.

Originally the exclusive prerogative of members of the Académie Royale, it opened to all artists, subject to selection by jury, in 1791. The exhibition grew into an event of crucial significance; by the nineteenth century the exhibition of an artist's work in the Paris salon and the prizes awarded there had become marks of recognition, and rejection by the jury often a point of controversy between the rising generations of artists and the "old guard." Like academies of art, the exhibitions were often reflective of the more conservative wing of the artistic spectrum of the times, and by the late 1850s the Paris salon was clearly dominated by the Académie des Beaux-Arts, since 1816 the successor to the old Académie Royale, which had been dissolved in 1793 during the French Revolution. Opposition to the tone of orthodoxy that permeated the salon through the academy's instructional arm, the École des Beaux-Arts, had its first important expression in 1855, when Gustave Courbet, two of whose most important works were rejected by the jury at the Paris Exposition Universelle, set up his Pavilion of Realism. In 1863, the famous Salon des Refusés was established for works rejected by the jury of the official salon. The well-known *Déjeuner sur l'Herbe* (1863, The Louvre, Paris) by Édouard Manet (1832–83) was the storm center among the rejected works.

By the 1880s independent exhibitions were being held that were of great importance for developments in art, and the influence of the old salon declined. In the spring of 1874, the first impressionist exhibition was held, and the event continued in eight group shows until 1886. The year 1884 saw the inauguration of the Salon des Indépendants, a radical departure from the traditional salon since there was no jury and no prizes were awarded. The institution of the exhibition had been completely democratized. In 1903 the Salons d'Automne began, and the third of these, in 1905, launched an early twentieth-century movement whose proponents were called *Fauves* ("wild beasts") after a remark by an antagonistic critic (see pp. 604–6). By the early twentieth century numerous exhibitions were held all over western Europe to advance the cause of modern movements, and retrospective exhibitions of important modern masters were becoming frequent enough to indicate a growing recognition of the

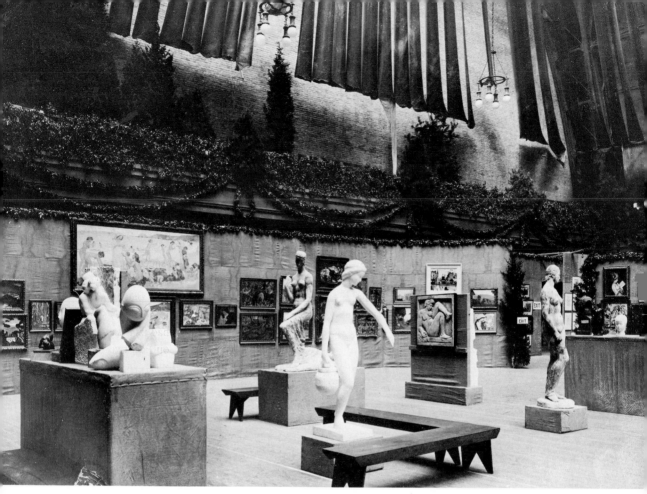

7. View of the International Exhibition of Modern Art, *69th Regiment Armory, New York. 1913. Photo: Courtesy of The Museum of Modern Art, New York*

pioneers of new modes of image making. On occasion, an exhibition might attract so much attention that it would become a major influence on developments in art. The first impressionist exhibition, the Salon d'Automne of 1905, and the New York Armory Show of 1913, which introduced the American public and some artists to modern European art (fig. 7), belong to this class. The public exhibition had by this time become an established institution with a range of types that represented the full spectrum of artistic idioms; and artists, supported by sympathetic critics, dealers in art, and influential collectors, were freeing themselves from the monopolistic tendencies of official exhibitions—or, perhaps, exchanging one kind of institution for another.

From this proliferating sequence of exhibitions grew yet another aspect of the twentieth-century art world: the association of various dealers' galleries with new movements in art and the eventual spread of this kind of sponsorship to museums of art through special exhibitions. Many museums have begun to view their function as extending beyond that of repository of past art to that of active—and thereby taste-making—supporter of current trends. Museum directors and museum curators of contemporary art are beginning to join the dealers and critics in the intricacies of the art market game and by their dicta are going beyond support to the actual setting of new directions in art.

CHAPTER

2 CONTINUITY AND RENEWAL: TRADITION AND INVENTION IN ART

The history of art is an endlessly reciprocal process of continuity and renewal. There is, on one hand, the inertia of tradition, a "handing over" of knowledge, customs, beliefs, and practices from generation to generation. The style of a society as well as its art have a tendency to retain certain features at a fairly constant level over a period of time. Tradition, therefore, is fundamentally a conservative force. On the other hand, it is subject to, and in the long run responsive to, reorientations that shifts in man's physical, social, and psychological environment foster and force upon it. These transformations at times can be drastic enough to reshape the old configurations so completely that new traditions are born. The vitality of the entire process is secured by this interlacement of continuity and renewal. The continuity of tradition, linking each present with its past, and the forces that alter and renew, acting upon the resistant grip of tradition, define an evolutionary process that maintains the vigor of the arts and gives each segment of their history its special identity.

The process of renewal and change has never been constant in the arts, since its rate, direction, and degree are so dependent upon the concert of forces that happen to be currently at work within the larger social context of which the creative arts are an integral part. In ancient Egypt, for example, a remarkably stable culture, thriving in a predictable physical environment steadied by the perennial cycle of the Nile, produced a style of art that, although hardly static, for centuries changed relatively little (figs. 8 and 9); whereas in ancient Greece a culture sharply divided by local loyalties, engaged in developing varied forms of government, and

Renewal isn't constant .

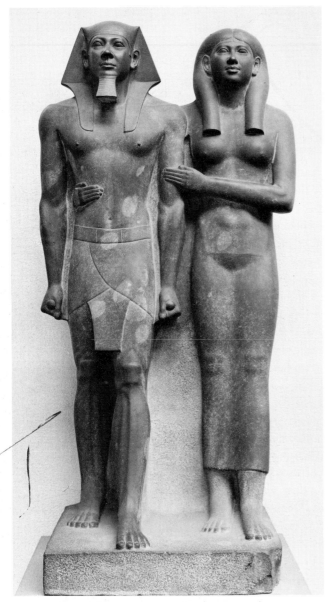

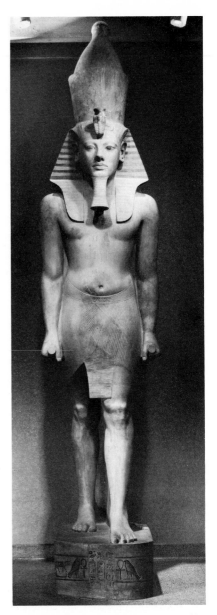

8. Mycerinus (Men-kau-Re) and His Queen Kha-Merer-Nebty II, *from Giza. Egyptian, Fourth Dynasty, 2599–2571* B.C. *Slate schist. Height 54½″. Courtesy, Museum of Fine Arts, Boston (Harvard-Boston Expedition)*

9. Colossal Statue of King Tut-ankh-Amen, *from the mortuary temple of Eye and Har-em-hab (arms, legs, base, and part of the crown restored). Egyptian, Eighteenth Dynasty, ca. 1360–1351* B.C. *Red quartzite. Height with base 17′3″. Courtesy of the Oriental Institute, University of Chicago*

challenged by the invitations of the sea produced an art that underwent, in the course of but a few centuries, a relatively active sequence of stylistic developments (see figs. 20, 22, 23, 87, and 16, pp. 33, 34, 35, 121, and 30, in that order). In Egypt, then, conditions would appear to have favored the inertia of those traditions established early in the history of the valley civilization. In Greece, conditions favored a restless process of renewal and change, a situation that led to the invention of several new species of images.

It would be a serious error, however, to assert that invention was not a feature of Egyptian art or that tradition was not an important factor in the Greek styles. The establishment of a peculiarly Egyptian schema for representation of the human form in painting and relief sculpture was an invention of considerable consequence for Egyptian art and for the art of other civilizations as well, not excepting the Greeks, as their Archaic sculpture and painting affirm (cf. figs. 8 and 22, pp. 26 and 34). This Egyptian invention transformed the irregular concepts of Neolithic modes of representation into something constant and consistent and fostered a long-lived tradition.

The Egyptian figural schema was invented about the time when the delta region and the upper Nile were united under a common kingship around 3100 B.C. (see fig. 69, p. 94, and pp. 90–91). The formula was remarkable for its simplicity and clarity. As applied to drawing or painting or relief (which in Egypt was extremely shallow, approaching the condition of a linear technique), the formula was a method of projecting on a plane surface an elementary diagram of the human figure, selecting those views of each major anatomical section that would satisfactorily indicate its general character (fig. 10). Thus, the head was generally rendered in profile, defining the features and the direction, right or left, in which the figure was intended to face along the plane of the relief or painted wall. The torso was a mixture of frontal and profile features, while arms, hips, and legs were in profile. Within such a formula, the repertory of gestures was limited and body movement inhibited; but for essential clarity it was an efficient image.

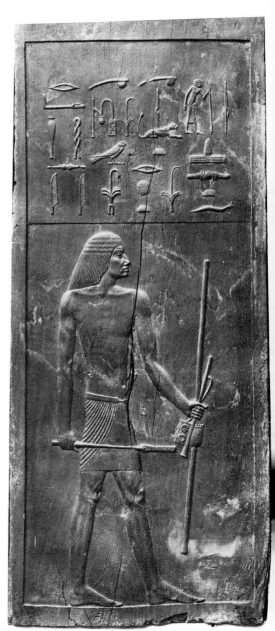

10. **Portrait Panel of Hesi-Re**, *from Saqqara. Egyptian, Third Dynasty, ca. 2650 B.C. Wood. Height 45". Egyptian Museum, Cairo*

In accord with this diagrammatic approach to image making, conditioned to convey the essential aspect of the human form rather than its transitory manifestations, the Egyptian sculptor also distinguished between frontal and profile views in his sculpture-in-the-round. Archaeological evidence from sculptors' workshops confirms this practice of marking off separate frontal and profile views on the sides of the rectangular blocks of stone from which statues were to be carved. The basic form of the figure was then systematically cut away. Working in from the sides, the sculptor retained, even in the final state, the original cubic character of the stone block (fig. 11). Such an approach precluded the suggestion of movement even if it had been sought. It was not a question of how the Egyptian artist literally "saw" the human form, but a matter of method in execution according to an artistic convention.

It is doubtful that the limitations of this approach were ever considered real limitations, for it was, after all, a timeless rather than a momentary image that the Egyptian sculptor was charged to make. The practice of providing the tomb with a likeness of the deceased did not require—or, perhaps, even allow—the illusion of movement. The image fashioned need only be a receptacle for the spirit of the deceased, apart from the requirements of an approximate likeness. Accordingly, the immobility of the Egyptian funerary statue was appropriate to its function: to provide a durable, unchanging image of the deceased throughout the eternity of life beyond death. This particular method of carving in the round was passed from generation to generation, since nothing changed in the functional role of the sculpture to alter the practice. A royal statue not intended for a tomb and the statues of gods were equally exempt from such ephemeral things as casual physical action. The tradition had been fixed —ideologically, through the Egyptian concentration on manifestations of eternity, and practically, through the methods of projecting the human image on a plane surface or in the round.

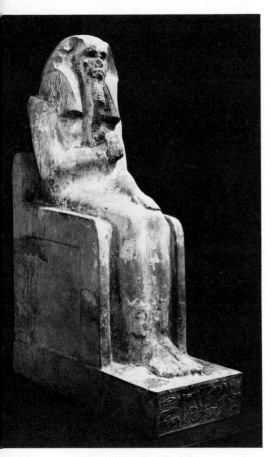

11. **Zoser**. *Egyptian, Third Dynasty, ca. 2750 B.C. Limestone with traces of color. Height 55″. Egyptian Museum, Cairo*

The application of this severe canon to Egyptian figural art was by no means uniform. It was most strictly adhered to

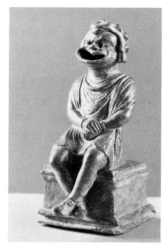

12. **Athlete from Benevento.** *Greek, ca. 410 B.C. Bronze. Height 13″. The Louvre, Paris*

13. **Comic Actor Seated on Altar.** *Hellenistic, second to first century B.C. Bronze. Height ca. 7 9/16″. The Art Museum, Princeton University*

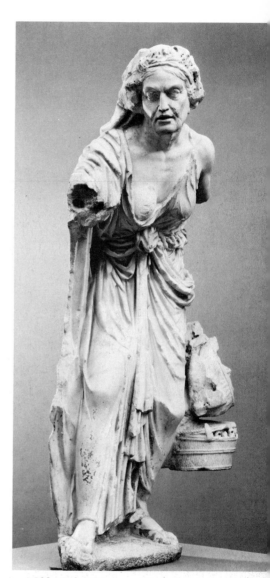

14. **Old Market Woman.** *Greek, found in Rome, second century B.C. Pentelic marble. Height 49½″. The Metropolitan Museum of Art, New York (Rogers Fund, 1909)*

at the upper levels of society, in representations of the pharaoh, royalty, and officialdom; but it was relaxed in representations of the activities of the lower classes, where surprisingly radical departures from the figural formula can be found (see fig. 398, p. 523).

As for Greek art, for all the variety it developed, there is no denying the insistence throughout its history of an idealizing tendency in the artists' pursuit of the images of man and the gods, however much that search seems to have dwelt increasingly, as time went by, upon realistic representation and indications of specific human emotions registered on faces and supported by gestures (see figs. 26 and 208, pp. 37 and 298). This continuity of idealizing tendencies, arriving at a moment of equilibrium between perfected human beauty and tactile reality in the fifth century B.C. (fig. 12), was the traditional force in Greek art. There were exceptions, to be sure, in works that exploited the comic and the grotesque (fig. 13) or confronted the pathetically real (fig. 14). The Greek image of man, as it developed from the Archaic to the Hellenistic eras, was an invention of major

importance, for it explored for the first time in the history of art the full range of human significance.

In a grave stele for a young Athenian of the mid-fourth century B.C., a father looks sadly on the image of his dead son (fig. 15). It is a touching evocation of the entire galaxy of human emotions and threads of lives, yet the physical perfection of the young man reminds us of the tenacious current of idealization in Greek art. In the image of the Terme *Boxer* (fig. 16), we see a physicality quite different from the splendid youth on the stele. The boxer is older, a veteran of many hours in the arena, a tough-bodied professional athlete. His battered face and open wounds, the broken nose, the scar tissue above his eyes, the cauliflower ears, send a message of humanity brutalized. Yet the artistry with which the pose is adjusted to that listening, uncomprehending gesture of the boxer's head makes the image so real and immediate that the viewer is touched; his response turns from revulsion to compassion. A comparison with the heroic *Poseidon* (see fig. 85, p. 117), a bronze of some four

15. Stele of Ilissos, *grave stele. Attic, ca. 340–330 B.C. Pentelic marble. ca. 66⅜" × 43⅜". National Museum, Athens (TAP Service, Athens)*

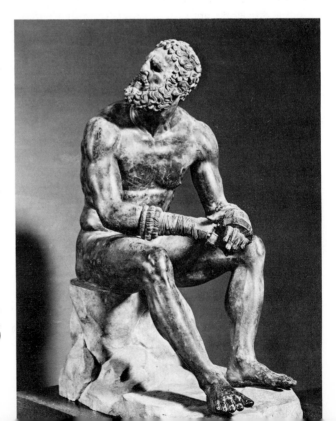

16. APOLLONIUS. Boxer. *ca. 50 B.C. Bronze. Height 50⅜". National Museum, Terme, Rome (Alinari-Art Reference Bureau)*

hundred years earlier, suggests not only the range of Greek inventiveness in utilizing the human form as a vehicle for ideas, but also the changing fortunes of the ideal tradition in Greek art, particularly evident when one surveys a chronological sequence of other images of the male nude (see figs. 21, 23, 86, 265, and 87, pp. 33, 35, 119, 367, and 121).

The continuity provided by traditions, whether of a practical or an ideological nature, is always linked to inventiveness, the seminal force that creates what becomes worthy of conserving and the energy that constantly renews the continuum, building new traditions or modifying old ones. This process functioned in Greek art through a tradition of idealization continually modified and given new dimensions by the Greek fascination with humanity as it was.

It has been said that although the ancient Greeks had inventive capacities, they were generally content to perfect the old rather than invent the new, a view that gives precedence to tradition in Greek art. To argue which was the stronger force—tradition or invention—may be a meaningless exercise, for one might argue with as much justification that Greek art was a constant exploration of the new, tempered only by the restraining force of tradition; the balance is that close. It is quite sufficient at this point to concentrate on the interplay between these two reciprocating forces as revealed in an evolving image of man in Greek sculpture.

Toward the close of the obscure period following the dissolution of the Mycenaean civilization, the human image in Greek art began to emerge from the matrix of geometric decoration on pottery (fig. 17) and to make its appearance in small bronzes, many of which are very close in style to the dark silhouettes of human figures on the pottery of the period, but less geometrically severe.

The little Geometric *Warrior* (fig. 18) of the eighth century B.C. is a generalized image with minimal anatomic detail, its arms growing like small, bent branches out of the softened triangularity of the torso. The head and facial features are large—in contrast to the pea-headed figures on Geometric

17. Amphora. *Attic, late Geometric style, eighth century B.C. Height ca. 59". National Museum, Athens (Alinari-Art Reference Bureau)*

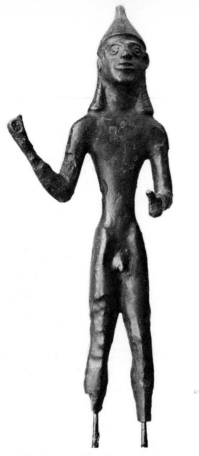

vases—but schematically rendered, with large, staring eyes. There is only a rudimentary hint of action in the bent arms of the figure (which once held a spear and a shield). More complex in pose, only slightly fuller in modeling, and, although still highly generalized, a more naturalistic image is the little *Armorer Working on a Helmet* (fig. 19) of the same century. Both bronzes, for all their simplicity, recognize the human form as a growing, moving thing; they possess an organic vitality. A fragmentary bronze (fig. 20) from early in the next century represents another approach to the human image. Here the figure is not conceived as a configuration of lean masses with continuously flowing contours, like the other two bronzes, but as a deliberately articulated assemblage of carefully defined parts, each asserting its independent character (cf. fig. 10, p. 27). It is a thoroughly formalized conception that nevertheless displays considerable interest in anatomic details; but these details have submitted to a rigorous geometricizing scheme.

In these three small bronzes we see in elementary form two currents that continue in Greek art as mingling opposites. The first is the tendency to seek an organic image replicating the natural appearance of the human body, leading eventually to convincing anatomy, draperies, and whatever implied movement or expression would enhance its naturalism in accord with its purposes—a tendency supported by the practice of painting statues with natural colors and filling the eye sockets of bronzes with "eyes" realistically inlaid with colored paste. The other tendency was to construct the human image on the basis of a conceptual scheme, either patently geometric or subtly idealized by elimination of irregularities and adherence to a preordained type.

Turning from small bronzes to marbles, we can see in the *Kouros from Sounion* (fig. 21) an early example of a type of statue popular in the Archaic period of Greek art: a nude male figure standing in a frontal pose, left foot slightly forward and arms, occasionally bent at the elbows, held close to the sides. In general appearance—frontally posed, with broad shoulders, narrow waist, advanced foot, arms at its sides—it is an echo of a debt to Egyptian traditions; but its

18. Warrior, *from the Acropolis. Athenian, Geometric period, late eighth century B.C. Bronze. Height ca. 8". National Museum, Athens (Marburg-Art Reference Bureau)*

19. Armorer Working on a Helmet. *Greek, Geometric period, eighth century B.C. Bronze. Height 2". The Metropolitan Museum of Art, New York (Fletcher Fund, 1942)*

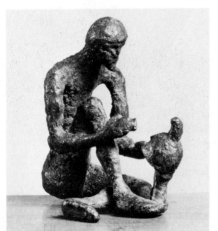

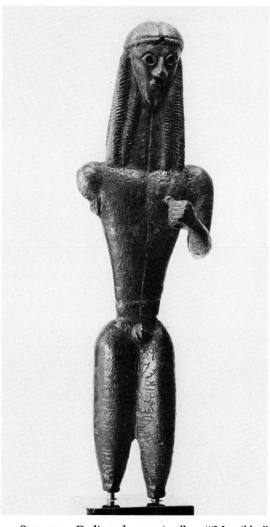

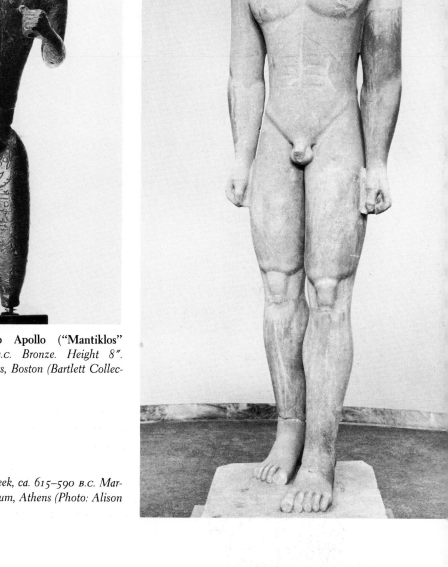

20. Statuette Dedicated to Apollo ("Mantiklos" Apollo). *Greek, 700–675 B.C. Bronze. Height 8″. Courtesy, Museum of Fine Arts, Boston (Bartlett Collection)*

21. Kouros from Sounion. *Greek, ca. 615–590 B.C. Marble. Height 11′. National Museum, Athens (Photo: Alison Frantz)*

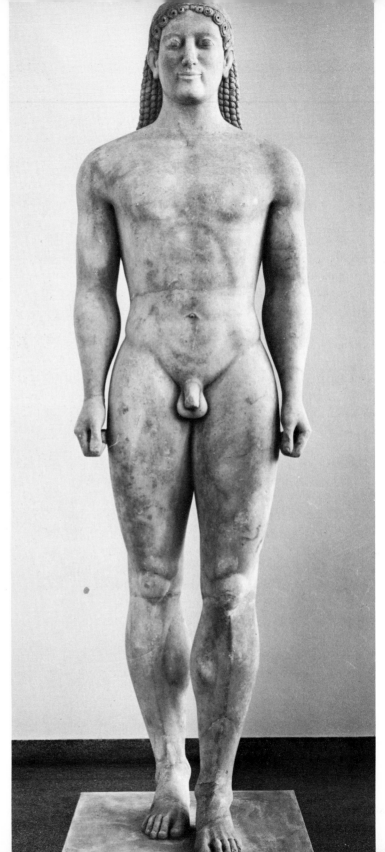

22. Kroisos (Kouros from Anavysos). *Greek, ca. 525 B.C. Marble. Height 76". National Museum, Athens (Photo: Alison Frantz)*

complete nudity and its freestanding character are decidedly Greek: an Egyptian statue would have featured a loincloth and the back of the stone slab would not have been cut away (cf. fig. 8, p. 26). The *Kouros from Sounion*, from between 615 and 590 B.C., about one hundred years later than the three bronzes, reflects an increasing interest in surface anatomy and the body's bulk; but it still shows traces of the old triangular torso, and patterns of musculature are treated as rigid relief more formalized than organic. Although the head has begun to acquire its natural bulk by this time and the sculptor has begun to sense the transitions in the curvature of cheek and chin, the features are formalized, the eyes seem abnormally large—almost like sunglasses—and the ears resemble architectural volutes. The conceptual scheme is dominant. Only here and there does something like the naïve fascination with the knee areas and the toes reveal the ongoing pursuit of the natural.

Around one hundred years later, the same basic scheme, by now an established tradition in figural art, still governs the *Kroisos (Kouros from Anavysos)* (fig. 22), but the quest for a more natural appearance has advanced. Within the rigid confines of the *kouros* type, the surface anatomy is now handled with greater knowledge and with skillful modeling and transitions that link muscle systems much more organically than before. The head remains strongly formalized, an impression reinforced by the pattern of tight curls and braids in the hair, the Archaic pucker of the lips, and the large eyes—not as enormous as in the *Kouros from Sounion*, to be sure, but not yet held naturally in the eye sockets. Yet the modeling of the larger masses of the face makes concessions to the skull underneath, and the ear has become more believable. These hints of increasing naturalism in the features seem less significant when we realize that, for the most part, the head is still an Archaic stereotype with protruding, wide-open eyes, apple cheeks, artificial smile, pointed chin —the basic configuration of the heads of many a *kouros*.

By the early fifth century B.C., the rigid type is broken and the Archaic formula is sloughed off. *"The Kritios Boy"* (fig. 23) is a credible image of a supple body standing at ease but

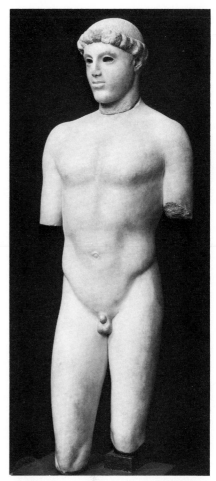

23. Standing Youth ("The Kritios Boy"). *Greek, ca. 480 B.C. Marble. Height 34". Acropolis Museum, Athens (Alinari-Art Reference Bureau)*

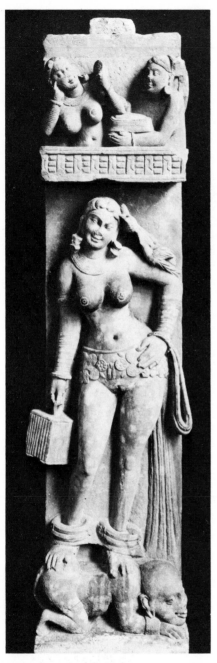

capable of smooth, flowing action; it represents an inventive moment in the history of Greek sculpture. The youth's head, more subtly modeled than the earlier examples, has a sober look. The most striking aspect of all is the departure from the tense frontality of the traditional *kouros:* the figure stands with the body's weight concentrated on the straight thrust of the left leg, while the right leg is relaxed, knee slightly bent, drawing the right hip lower than the left; the head turns slightly—very slightly—to the figure's right. The almost imperceptible curve and twist of the axis of the figure marks the beginning of the *contrapposto* stance that established its own continuity in Western art from Greek times onward (see figs. 216, 261, 200, and 224, pp. 307, 363, 291, and 314, in that order) and even, with considerable modification, reached as far as the Orient (fig. 24).

Around this time the human figure in Greek sculpture and vase painting exhibits a wide variety of active postures convincingly rendered. The new freedom of this implied movement extends to draperies as well, no longer as in early Archaic times cocoonlike sheaths or delicate, almost linear, low reliefs. By the mid-fifth century B.C., they cling in natural folds to the body's form and respond to its movements, as in the pedimental sculptures of the Parthenon (fig. 25). Toward the end of the century, in the *Nike of Paionios* (ca. 420 B.C., Museum, Olympia), and much later, in the *Nike*

24. Yakshi, *railing pillar from Bhutesar, Mathura. Indian, Kushan period, second century. Red sandstone. Height 55″. Indian Museum, Calcutta*

25. Three Fates, *from east pediment of the Parthenon. Greek, ca. 438–432 B.C. Pentelic marble. Height 59 ⅝″. By courtesy of the Trustees of The British Museum, London*

of *Samothrace* (see fig. 90, p. 125), the draperies, blown by some imagined wind, acquire life of their own.

As if the Greek capacity for artistic invention were reaching for some new dimension in the human form, after having exploited fully the range of surface appearances, the sculptors of the Hellenistic age (from around 330 B.C. to the first century B.C.) began to explore within, to ephemeral mental states that could be exposed by expression or gesture. Thus, the dazed interval between life and death is dramatized in the *Dying Gaul* (see fig. 208, p. 298) and heroic agony in *The Laocoön Group* (fig. 26). By the Hellenistic age the individualization of the human face also began to assert itself against the traditional generalizations (figs. 27 and 28).

The image of man that emerged at various times in the history of Greek art was therefore an equation in which

27. Coin of Antimachus of Bactria. *ca. 185 B.C. Silver. Diameter 1 ¼ ". By courtesy of the Trustees of The British Museum, London*

28. Statuette of Hermarchos(?), *standing on an Ionic column. Greek, third century B.C. Bronze. Height 13 ⅝ ". The Metropolitan Museum of Art, New York (Rogers Fund, 1910)*

26. AGESANDER, ATHENODORUS, and POLYDORUS OF RHODES. The Laocoön Group *(present state, former restorations removed). Hellenistic, late second century B.C. Marble. Height 95 ¼ ". The Vatican Museums, Rome (Fototeca Unione, Rome)*

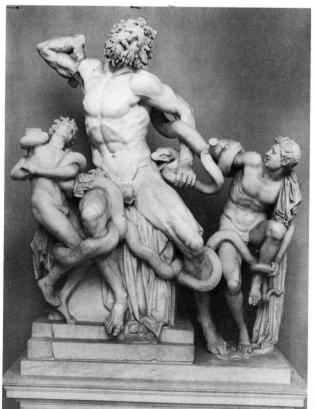

idealism and naturalism were ever-present but variable factors. Until the most extreme examples of Hellenistic naturalism began to appear by the latter half of the third century B.C., Greek sculpture was never without its element of idealism, that tendency to construct the human image not on visual appearance alone or on knowledge of the bone and muscle mechanisms of the body, but on preordained principles—geometric, proportional, typal, even technical—that would set the image apart from immediate, ordinary reality. Nor was this ideality expressed in the same way throughout the history of Greek art; it underwent its own evolution.

In the Geometric period it was expressed primitively in the simple schematic combinations that gave form to the figures on the vases and to the lean, small bronzes. In the Archaic period it was embodied in the concept of the stereotyped image to which the *kouroi* generally conformed. As this traditional type gradually weakened under the increasing overlay of natural surfaces, as organically interlocking musculature began to replace the formalized patterns characteristic of the earlier *kouroi*, a new ideality grew out of this more natural image of man. But the naturalism therein was only relative, for, although surfaces in this new classical sculpture of the fifth century B.C. might replicate natural appearances, the refined proportions of the figures and the regularity of their features—effecting a sober, superior calm —purged the statuary of a fair measure of its naturalistic content. This new type of perfected naturalism constituted the ideality of classicism, the "blank beauty of the antique" that was to form the basis of the long classical tradition in Western art.

In any society the carriers of tradition in the arts are so numerous and interwoven in their effects as not to be readily detached from the total context. Some carriers do stand out distinctly, however, being exclusively identified with production and conservation of art. These, as we have seen, are the institutions that train the artist—workshops, academies, schools—and those that collect and preserve works of art— the museums and libraries where the evidence of art's history is displayed or stored. Whether workshop, studio,

academy, or school, the institutions of training and apprenticeship have generally been prime carriers of tradition. Of course, many of the practices and ideas pursued there were not necessarily their exclusive product. Frequently these were prescribed by other institutions, sacred or secular, whose prescriptions were accepted and preserved in the training of the artists.

As religious and secular institutions take shape in a society, they develop self-images based on their organization and rituals. These may foster, in turn, a body of imagery to serve institutional purposes in a variety of ways: symbolic, didactic, propagandistic. Thus, for example, over the centuries during which the Egyptian civilization flourished along the Nile, an image gradually emerged from ritual and symbolic paraphernalia that became the ideotype for the god-king. Certain attributes became the exclusive hallmarks of the image, so that it is possible for even a casually informed viewer to identify with little hesitancy the type of image that represents the Egyptian pharaoh. Identifying features of an image of this kind might include a particular headdress or garment, an object designating the office, or a prescribed repertoire of gestures. In some instances, as in the Christian art of the Middle Ages, the realm of symbolic attributes might grow into an elaborate body of iconography (the meaning of an image in its context), in this case—and also in Buddhist art—a "sacred language." Ecclesiastically defined church doctrine was the carrier of the Christian iconographical tradition in the Middle Ages, but the artists' workshops had at least partial custody, as knowledge of these attributes was passed from master to apprentice.

In some instances a tradition may not be identified with a single institution but be carried along through several channels affecting the arts on a wide front. One such continuum has been of far-reaching consequence for the Western world: the so-called classical tradition. It is a complicated phenomenon, stubborn in its survival as an identifiable spirit, flexible in its adaptation to a variety of institutional and individual demands and to the distinctive orientations of successive eras in Western history. It evolved from the

prestige acquired by the art of the ancient Greeks, affecting the styles of neighboring and successor civilizations directly through examples of its art and indirectly through literary channels that kept alive for future "revivals" the idea of Greek perfection. This tradition was in no way the creation of the Greeks themselves; it was an accumulative tribute that successive eras paid to a moment in history that seemed to have achieved perfect equilibrium. It was an idea kept alive by adulation and emulation (see chapter 9).

Continuities in art do not invariably indicate identifiable traditions that are linked to a particular society, to institutions within it, or to a cohesive body of ideas (like the classical tradition) passed along from era to era. There are continuities that hop and skip through time as a series of apparently disconnected resemblances. It is necessary to say "apparently," for we may lack still undiscovered evidence that might link such a series or part of it into a cohesive sequence. There are motifs that have had a remarkably long history of this sort and a correspondingly wide geographic range, such as the image of a predatory beast or bird attacking another creature and the motif of a human form between two beasts.

We are fortunate to have one object on which both these motifs appear: a gold and enamel purse cover (fig. 29) from the grave of an East Anglian king of the seventh century A.D. The motif of man and beasts can be found in the same century in Scandinavia and on fabrics from the Byzantine area of about the same period when northern seamen were sailing far beyond the waters of their homeland. Although the basic motif is similar, the styles vary from place to place, reflecting local traditions, and the animals change—bears in Scandinavia and lions in the East. The old homeland of this image seems to have been the ancient Near East and Egypt, for it can be found quite frequently on Sumerian cylinder seals of the third millennium B.C. (fig. 30) and even earlier in a wall painting from Hierakonpolis in predynastic Egypt (fig. 31). Between these ancient beginnings and the examples from the early Middle Ages lie widely scattered examples of the motif, rendered in local styles and in a variety of media.

29. **Purse Cover,** *from the Sutton Hoo ship burial. Before 655. Gold, garnets, glass, and enamel. Length 7½". By courtesy of the Trustees of The British Museum, London*

30. **Cylinder Seal Impression.** *Sumerian, early Second Dynasty, ca. 2800 B.C. Ashmolean Museum, Oxford*

31. **Men, Boats, and Animals,** *wall painting in a sepulchral chamber, from Hierakonpolis. Predynastic Egyptian, ca. 3200 B.C.*

32. Staff Finial, *from Chin-ts'un. Chinese,
Warring States period, ca. 481–221 B.C.
Bronze inlaid with gold and silver. Height
5 5/16". The Cleveland Museum of Art (Pur-
chase from the J. H. Wade Fund)*

For examples of the predatory attack (represented on the
Sutton Hoo purse lid by the double image of the eagle or
falcon attacking a duck) we can go as far afield as China
during the late Chou dynasty, nearly a thousand years before
the English example was made, and find a bronze finial
inlaid with gold and silver and formed of a bird standing on
the jaws of a dragon and biting the dragon's snout (fig. 32).
A more common variant of this motif, a lion attacking a
ruminant animal, appears much earlier on slate palettes
from predynastic Egypt as well as on several Near Eastern
cylinder seals; on bronzes from Luristan (fig. 33)—a region
lying to the east of the Tigris-Euphrates river system—
where the motif is drastically ornamentalized; on "animal
style" ornaments from the Asiatic steppes (fig. 34); and in
vase paintings from ancient Greece and adjacent islands.
Again the time-distance-style disjunctions pervade the scat-
tered sequence.

Such motifs may, in some instances, be bunched closely
enough in period, style, and geography to make more posi-
tive connections possible, as in the ribbonlike biting ani-
mal interlacement that appears in the upper center of the
Sutton Hoo purse lid, in Irish manuscripts of the same
century (see fig. 441, p. 578), and in Scandinavian wood
carving somewhat later (fig. 35). In such instances the rela-
tionships are clearer against the background of cultural in-
terchange around the British Isles and the lands bordering
the North Sea during this era of history.

A single motif repeated again and again over a period of time
may also undergo gradual but extensive transformations as
each successive instance departs slightly from its immediate
predecessor. One such transformation was the octopus motif
on pottery in the Aegean world during the Bronze Age. It
first appeared on pottery from Crete in a lively naturalistic
form and then, through a series of repetitions and simplifica-
tions, emerged at the other end of the process with its
octopoid personality somewhat diminished.

One of the most significant variables in the continuity of an
image involves its meaning in each successive context in

33. Pole Top Ornament, *from Luristan. Ninth to seventh century*
B.C. Bronze. Height 7 ½". By courtesy of the Trustees of The British
Museum, London

34. Plaque, *Hsiung-nu, Mongolia. Second*
century B.C. Bronze. 3 ⅛" × 4 ⅝". By
courtesy of the Trustees of The British Mu-
seum, London

35. North Doorway of Urnes Church, *Urnes, Norway. ca.*
1050–70. Wood. Historisk Museum, Bergen, Norway

which it appears. Images may change their meanings when they are taken over by different societies or institutions or when, in time, their former meanings become obscure and they acquire new connotations.

A particularly rich field for such transferrals was Christian art, which derived much of its symbology from images common to pagan antiquity, a process that has been likened to a mass baptism of pagan motifs. Figures derived from pagan art were sometimes invested with new Christian meanings through standardization of their gestures or other attributes. For example, one of the most common images in the catacombs is that of the *orans,* a standing figure, Roman in character, with arms upraised—a personification of the idea of prayer. Indeed, early Christian art was predominantly an extended metaphor for prayers of deliverance. In catacomb paintings, many of the early prayers ("as Thou didst hearken to Daniel in the den of lions . . ." or "as Thou didst deliver the children from the furnace . . .") are evoked in representations of Old Testament episodes that employ the *orans* figure to depict those who were delivered from danger.

Early Christian artists adopted several pagan motifs as symbols of the next world—*putti,* Tritons and Nereids on sarcophagi, and allegorical subjects like the Seasons—in catacomb wall paintings. Some pagan subjects acquired distinctly new meanings in the Christian context: the peacock, once an attribute of Juno, became an image of immortality since its flesh was supposedly incorruptible; pagan scenes of grape gathering and wine making (see fig. 169, p. 246) became related to the labors of the faithful in the vineyard of the Lord and to the Eucharist as symbolic of the Blood of Christ. Early representations of Christ were modeled after images of Apollo, Helios (the sun god), or various youthful heroes from the myths and legends of antiquity. Even Judeo-Christian themes like Daniel in the lions' den were represented by the ancient motif of the man between two lions. The halo, or aura of light behind the head of a personage, an ancient attribute of divinity, can be traced from its association with the pagan sun god, thence to the Roman emperor as he acquired the glory of divine status,

and finally, once Christianity had been recognized as the state religion of the Roman Empire, to Christ, the Virgin Mary, and ultimately the saints. It appears behind the head of the Byzantine emperor Justinian at San Vitale, Ravenna (see fig. 248, p. 342), where it signifies the archpriesthood of the imperial office, and also behind the head of his empress, Theodora (colorplate 2), who—if we can believe the Byzantine historian Procopius—was somewhat shy of saintliness.

An earlier example of this transferral of prerogatives may be observed in ancient Egypt where the pyramid, originally the sole prerogative of the god-kings, lost both its exclusiveness and its property of standing more or less independently as a mortuary monument to become, first, the funerary marker for nobles and, later, a mere finishing piece atop the mortuary temple of Mentuhotep at the beginning of the Middle Kingdom of Egypt. As a mortuary monument in ancient Rome, it was merely a foreign type. The Egyptian obelisk, once sacred to the sun god Re, was either reduced to decorating parks, piazzas, and fountains or transformed into public memorials (Washington Monument, Washington, D.C.) and private memorials in the form of grave markers in our cemeteries.

Few architectural forms have had a longer continuity of variations than the basilica, derived from pagan Roman prototypes, adapted to the functions of the early Christian church, and carried on in church architecture through successive variations of its form into the modern era (fig. 36). The persistence of the basilica is one of the most emphatic demonstrations of the force of tradition in the Western world.

The continuity of a form and its repeated variations may also be a prominent factor in the work of individual artists, where the symbiotic relationship between continuity and change is the most concentrated and, in the modern era, the most dramatic. An artist's work, considered in its entirety from the beginning of a career to its end, is a continuity of a very special kind, because to an exceptional degree it feeds upon

36. The Survival of the Basilica. a. *An early Christian type of basilica, shown here with its atrium or forecourt. The plan of the basilica itself featured, characteristically, a central nave (1) with flanking aisle or aisles (2) and an apse (3). A transept located between the end of the nave and the apse and extending out beyond the lateral walls was not always present. The basilica form also underlies b, c, and d.*
b. *A French Romanesque church, Abbay-aux-Dames, in Caen, Normandy*
c. *A French Gothic cathedral, Amiens*
d. *A French church, Notre Dame du Raincy, built in 1922 (Drawings by Eric Spencer)*

itself. Visual ideas continually resurface as manifestations of the artist's identity, orientation, and style—in short, his artistic biography. These recurrent elements—a type of composition, a preferred range of colors, a way of handling the paint, an idiosyncrasy in proportioning figures, and so on through infinite possibilities—are the visible traces of the artist's compulsions, preferences, and conditioning. At times these elements may swerve somewhat from the accustomed path and provide the stimulus for new directions; or a series of features stretching out over a period of time may merge at some point in a synthesis that marks an inventive moment of real consequence. The interplay of continuity

and change within an artist's work often functions as a conceptual movement in which certain specific forms or ideas undergo a gradual evolution. At any point in an artist's development, regardless of the immediate extrinsic forces at work at that particular time, he is the sum of what he has been before, and each new inventive leap of his artistic imagination is taken from the base he has already built. Not infrequently, as we examine the outcome of such a leap, its uniqueness is revealed in fuller perspective when we see how much the artist's past work, in particulars as well as generalities, has fed the inventive thrust. It is, in effect, a microcosm that has as its transcendent analogue the broader waves of

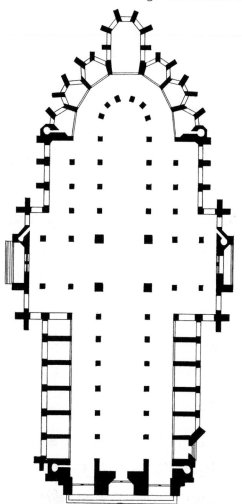

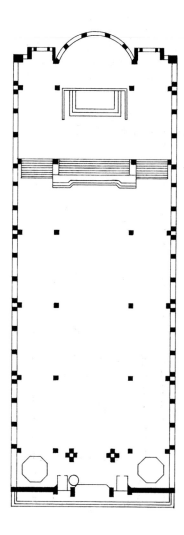

37. **ROBERT BASSLER. Anatome R V.**
1965. Wood construction. 37″ × 29″. Collection of Mr. and Mrs. Robert Brown, California

38. **ROBERT BASSLER. Anatome Variation II.** *1966. Cast bronze. Height 20″. Collection of Dr. and Mrs. Seymour Bird, California*

continuity in the history of art, and it reminds us of how much mankind's pursuit of image making has been a sequence of themes and their variations.

This process is clearly demonstrated in a series of sculptures by Robert Bassler (b. 1935) representing a compact period of time from 1965 to 1970. *Anatome R V* (fig. 37) is a relief that stresses bilateral symmetry, sensuous ovoid forms and rhythms, and the appeal of variations in the wood's natural color and grain. It is contained, deliberately and frankly, by a frame. *Anatome Variation II* (fig. 38), from a year later, moves away from the relief concept toward a freestanding form—but not entirely. Although the enframement has now been expanded into a shaftlike container for the abstract figure motif, the figural element is a sunken relief. The ovoid elements persist in the artist's vocabulary, both in the figure and in the hollow that shelters it. A new factor, however, is introduced: the sides of the shaft seem to push outward as if from some internal pressure. *Anatome S III* (fig. 39), completed soon thereafter, stands partially free of its enframement, but without abandoning the space-defining geometricity of the block, now open on sides and top. Evocations of the human form remain as a more sensuous echo of the previous work. The pressure sensed on the sides of the *Anatome Variation II* is still expressed in *Anatome S III* through lateral expansion of the swelling central image, still symmetrical, still showing a tendency to ovoid forms, but with a more supple play to their interlockings. Turning to the translucencies of polyester resin in *Total Enclosure III* (fig. 40), Bassler has now expanded the central mass to fill the enframement, which is reduced to a metallic linear boundary. The translucent form it contains swells in places beyond the rectilinear enclosure of the sides, recalling the lateral pressure suggested in *Anatome Variation II*. In the reflections and refractions of the translucent medium the ovoids persist, but now in a more active relationship to the sculptural mass, as each shift of the viewer's position, or each variation in lighting, brings new patterns into play. Finally, *Three Piece Enclosure* (fig. 41) has been freed of an enframing container, but it retains the sculptor's predilection for the blend of rectilinear and ovoid forms that

40. **ROBERT BASSLER. Total Enclosure III.** *1968–69. Cast polyester resin. Height 24″. Collection of Dr. and Mrs. Frank Byers, Florida*

39. **ROBERT BASSLER. Anatome S III.** *1966–67. Steel, wood, plaster, plexiglass, and epoxy. 96″ × 48″. Collection of the artist*

41. **ROBERT BASSLER. Three Piece Enclosure.** *1970. Cast polyester resin. Height 24″. Collection of the artist*

marked his earlier pieces. The translucent medium is exploited more fully than in the previous work, so that the patterns formed by its interplay with light achieve greater variety. Elements of symmetry remain, but the medium's response to light has considerably modified them.

This sequence of creative choices on the part of the artist defines, like a linked series of coordinates on a graph, an evolutionary process of developing forms, each image seeming to contain, as it were, some latent force leading to a subsequent stage as art renews itself from art.

There are images in art that have had a long history but little coherent stylistic or iconographic continuity. One such image is that of the bull. At one level—as the image of a particular kind of animal—its identity is constant; but at other levels, depending on its cultural context, the artist's intentions, and other factors, the image acquires a variety of meanings that lie well beyond its biological identity. A cave painting of a bull (see fig. 49, p. 64) or another grazing animal essential to the life of the hunting society may originally have held a meaning analogous to that of a sacred image or icon (an image of a sanctified personage that "stands for" that being), since there seems to have been a conviction in prehistoric times that a magic relationship existed between a creature itself and its painted image (see pp. 67–71).

Many centuries later, in predynastic Egypt, through a natural translation of the physical prowess of the bull into the grander power implied by the idea of a divine kingship, the bull image was transformed into a symbol of the power of the king and a surrogate image for the king himself (fig. 42). Although the bull is depicted as battering down the walls of a town and trampling the figure of an enemy, the stance of the beast is static, its feet shackled by the rigid ground line. The physical energy of the bull is as thoroughly symbolic as the image itself is symbolic of the king's power. It has become a kind of hieroglyph or form of picture writing, a visual metaphor.

42. **Palette of King Narmer** *(detail), from Hierakonpolis. Egyptian, First Dynasty, ca. 3100 B.C. Slate. Height 25" (entire). Egyptian Museum, Cairo (Hirmer Fotoarchiv, Munich)*

43. PAUL POTTER. The Young Bull. *1647. Oil. 7′8¾″ × 11′1½″. Mauritshuis, The Hague (Bruckmann-Art Reference Bureau)*

44. FRANCISCO GOYA. The Picador Falls under the Bull, *plate 26 from* **Tauromaquia.** *1816. Etching. ca. 9 4/5" × 13 ¾". The Metropolitan Museum of Art, New York (Harris Brisbane Dick Fund, 1916)*

The young bovine in a seventeenth-century picture (fig. 43) by Paul Potter (1625–54) is a complete visual description of the beast. The viewer can gather from it a detailed inventory of physical features—the texture of the hairy body, the look of the eye, the formation of the nostrils—and the painting has, to boot, an explicit setting containing several other creatures and a Dutch peasant. It might be argued that there is something iconic about this image, too, as an epiphany of realism. The artist was clearly intent upon recording natural appearances; in fact, he was to some extent celebrating "likeness" as an end of art. But although Potter's painting may have had some added significance for its seventeenth-century Dutch burgher audience as a manifestation of a practical, materialistic national spirit, the image it projects on twentieth-century consciousness is generally a rather prosaic one. It seems a mere replication of a fragment of the

natural world, as matter-of-fact as a habitat group in a museum of natural history.

The bull appears in a different light, as a protagonist in a ritual drama, in a plate from the *Tauromaquia* series (fig. 44) by Francisco Goya (1746–1828). Here the artist registers the powerful thrust of the bull's body within a centripetal massing of forms that dramatizes the loneliness of a struggle between man and beast in the terrible space of the arena. The ceremonial content of the image that emerges from the scene in the bullring evokes visions of some ancient ritual of sacrifice. *Tauromaquia*, in its literal sense, records episodes of the national spectacle of Spain as it was performed in Goya's time; but through his imagery—the isolation of the compacted energy of the men and beasts in the light-bleached emptiness of the arena and the peripheral cluster-

45. PABLO PICASSO. Bull's Head. *1943. Bronze cast of parts of a bicycle. Height ca. 16⅛". Galerie Louise Leiris, Paris*

ing of agitated spectators—the artist draws the viewer into the psychology of the event.

A delightfully inventive variation occurs in a work by Pablo Picasso (1881–1973) that evokes an image of the head of a long-horned bull (fig. 45)—"evokes" because the constituent elements that form the image cannot by their very nature actually "represent" and because no effort has been made to disguise their original identities. It is only because the bicycle handlebars correspond roughly to the curvature of a bull's horns and the seat, in a vertical position, resembles a bull's head that the combined objects evoke the intended image. Here the meaning of the image involves the delight the viewer may derive from his recognition of the whimsical metaphor. Some portion of the attraction the work holds for the viewer depends upon the alternating visual shifts from bull's head to assembled bicycle parts which persist in the process of viewing it. Cast in bronze, it is once removed from the objects from which it is compounded and several times removed (by what sequences of associations we may never know) from the creature it evokes. This sculpture appeals to the observer's sense of humor and, at the same time, is a reminder of the power of association in our mental processes. In this instance, a simple combination of two manufactured parts out of context and out of their normal relationship to each other, by virtue of their faint and chance resemblance to a bull's head, project a figuration of the real thing. Only when we compare Picasso's sculpture with a fairly literal image of the same subject do we realize the distance spanned by the power of association in validating this visual metaphor.

As these scattered examples from the history of the bull image indicate, an image can serve as a carrier for a variety of ideas determined by its moment in history and by the values, private or institutional, it conveyed in the past. But any work of art, if preserved beyond its own era, has a peculiar life of its own, a continuity that passes from its original function into that of a fragment of history as works of art recovered and preserved from the past are protected *in situ* or gathered in public, institutional, and private col-

lections. They may also be reproduced and circulated to a wide audience via substitute images in newspapers, magazines, books, postcards, color reproductions, photographs, slides, and films, with the vast accumulation of these substitute images constituting a highly mobile "museum without walls." While this provides an expanding public, it also tends to foster an image of the work of art in terms of its reproduction, generally reduced in scale, removed from its original context, and—given the limitation of reproductive processes—often shorn of a good measure of its intrinsic qualities. The work of art is, therefore, transformed by its reproduction.

One of the paradoxes of image making is the curious fact that an image, once created and preserved, never ceases to be re-created. Each viewer plays his part in this ongoing re-creative process. Of course, the total experience of the creative act as the artist himself lived it can never again be precisely duplicated, and each subsequent viewer of the work proceeds to "see" it in his own way. Beyond differences in basic visual capacity (sharpness of vision, ability to perceive nuances of color), each individual has a separate history to bring to the experience. Many generations of viewers can be involved in experiencing the same work of art over a long period of time, each apprehending the work from a general point of view, or taste, determined to some extent by factors peculiar to his moment in history. Representatives of different cultures may simultaneously view a single work of art and receive from it distinctly different experiences, determined largely by their cultural conditioning. Furthermore, each person who views a particular work does so from a different personal background that governs to some extent what is given particular emphasis, accepted or rejected, even noticed, in his visual experience. Finally, the work of art itself undergoes changes: colors may darken or fade, panels crack, the paint film flake, the marble erode in the elements and the air's pollution. The physical object that we designate a work of art is not a stable thing in time. The paradox, therefore, is that the two constants in the experience of a work of art are variability and relativity.

Thus, an altarpiece painted for an Italian church in the fifteenth century embodied the circumstances of the artist's livelihood, the donor's desire for earthly prestige and heavenly reward, and the celebration of the Christian faith. This was its compound active role; if it were to remain in its original setting, embellishing the ritual of the Mass century after century down to the present, some portion of its original role would cling to it even though its wider context outside the sanctuary would have altered appreciably.

But suppose this altarpiece finds its way into a museum. What then? Taken out of its original context, it assumes another kind of existence: it becomes, apart from its identity as an object of beauty, an explicit memento of the past, to be viewed as an example of an artist's skill, a historical style, and a key to values once current. The viewer can reconstruct its original role, of course, but only as an intellectual projection, not as a living function in its former sense. It becomes an object of contemplation in quite a different way from whatever contemplation was accorded it when it served its original purpose. Yet, it may still move an observer who is receptive to its aesthetic qualities—its beauty, its colors, and its forms—or who is attuned to the religious or philosophical values it expresses. Therefore, it goes on "living" in a new world as a part of the ongoing historical record and a stimulus to aesthetic response—the latter function sometimes being a ritual of sorts as visitors to the museum "pay their respects." As an individual work of art, carefully preserved and restored from time to time, it continues to enhance human experience whenever it catches a sympathetic and responsive eye. In short, it participates in a secondary level of artistic continuity, unpredictable and discursive: the inevitable evolution of an object's significance.

Continuity and renewal in the arts do not constitute a true antithesis but are mutually reinforcing ingredients. They become estranged from each other only when one condition prevails: when the configuration born of artistic invention becomes an end in itself, when the artist surrenders to its outward form and skillful repetition follows. At that point the inventive moment becomes enshrined in its own

dogma and the ensuing continuity loses touch with life and the creative impulse. It is within the interwoven matrix of continuity and change as it bears upon mankind's compulsion for imaging and image making that the substance and variety of the visual arts is sought in the chapters that follow.

PART

TWO

IMAGES OF MAN AND NATURE

3

THE ANCIENT BEGINNINGS

Mankind's oldest art has been properly identified and generally accepted only within the last century or so; serious study has occurred largely within the last seventy-five years. In 1879 a nobleman-archaeologist, Don Marcelino de Sautuola, was examining the clay floor of the cavern of Altamira (Santillana, Santander, Spain) for artifacts. He was accompanied that day by his five-year-old daughter, Maria. Not entertained by such mundane things as dirt floors and flints, she chanced to look up to the ceiling and saw there, to her delight, the splendid red-and-black bisons (fig. 46) that have since become so famous. When her father announced the discovery as works of very great antiquity, he met with scorn from specialists who considered them to be either forgeries or the crude sketches of some passing cowherd of recent times. But the case for a prehistoric art was gradually building during the twenty years before Altamira was finally recognized for what it was: an impressive gallery of prehistoric art.

Some prehistoric sites had been known for a long time. Niaux (Ariège, France), for example, had been visited for centuries, but it was not until 1906 that it was finally recognized as a Paleolithic site. Rouffignac (Fleurac, Dordogne, France), first declared to be a Paleolithic site in 1956, although apparently known from at least the sixteenth century, was the subject of considerable controversy over its authenticity even in the mid-twentieth century. Paleolithic artifacts of stone and bone, decorated with the forms of animals, seem to have been more readily accepted, but even they had their problems. By the mid-1830s objects later to be recognized as Paleolithic in origin were turning up and were often attributed to Celtic peoples.

Paleolithic Art (Old Stone Age)

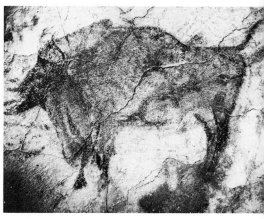

46. **Bison,** *cave painting from Altamira, Spain. Paleolithic, ca. 15,000–10,000 B.C. Length 8'6". (Photo: Romain Robert)*

61

By the beginning of the twentieth century the art of prehistory was fully recognized, and the first half of this century saw the publication of a vast literature on the subject as more and more sites were discovered and explored scientifically. Before the techniques of color photography had been perfected to a degree that made it possible to record quickly and accurately on the spot the appearance of the cave paintings, much of the knowledge about the character of these images was derived from the extensive renderings and publications of Abbé Henri Breuil, who studied the sites, made detailed colored drawings of the paintings, and patiently recorded the outlines of the engravings on the walls. Indeed, for many initiates to the forms and qualities of Paleolithic art, the images constituting their "gallery" have been, until very recently, not the original works (admittedly rather difficult of access) but the drawings of Breuil. The dispassionate objectivity possible with the camera lens provides today a more accurate record of much of this work, but it must be admitted that decades of exposure have wrought some changes in the condition of many of the paintings so they no longer appear as Breuil first saw them. The sensitive record he made remains a valuable index. Nevertheless, his drawings did involve interpretation of vague or confusing portions of the original images. The identity of some of the more enigmatic of these still remains uncertain despite his attempts at clarification. This problem of the intervention of an interpretive hand between an original work and a reproduction of it will be a subject for exploration in a later chapter (see pp. 475–81).

Prehistoric art is not without stylistic development. From animal and genital forms engraved as crude outlines on irregular flat slabs of stone ranging in size from about one to two feet in diameter and tentatively dated between 30,000 and 27,000 B.C., Paleolithic art developed into the large paintings of animals in the great galleries of Lascaux where the ensemble achieves a polychromatic effect and into the expressive outlines and hatched textures at Niaux, the latter dating from around 12,000 B.C.

Roughly between 25,000 and 18,000 B.C., in an area stretching from Spain to Russia, the repertoire of images increased,

although the finds are as yet not numerous: tools decorated with the figures of animals, incised or carved in relief; statuettes of animals and humans, including the famous Willendorf (fig. 47) and Lespugue "Venuses"; and the first cave decorations that can be reliably dated. Although the engravings of animals in the caves generally display details that clearly indicate the species, they are sketchy in appearance. Their necks and backs are generally strongly defined by line, but the lower extremities are often loosely suggested or missing (fig. 48).

From this point to around 13,000 B.C., cave art underwent considerable development. Cave paintings of animals were richly rendered with ochers that permitted a wide range of yellows, reds, and browns, while manganese and charcoal provided the blacks. Engravings on the walls appeared frequently as did reliefs. The images of the animals from this phase are more completely rendered than before, the legs generally well defined though shorter than was actually the case. The colors in these paintings were applied by a variety of means. In some instances chunks of pigment were appar-

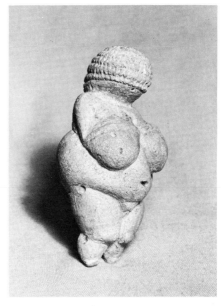

47. Venus of Willendorf. *Paleolithic, ca. 18,000 B.C. Stone. Height 4 ⅜". Museum of Natural History, Vienna*

48. Engraved Horses, *from Pair-non-Pair cave, Gironde, France. Paleolithic, ca. 18,000 B.C. Length of horse on right 29½".*

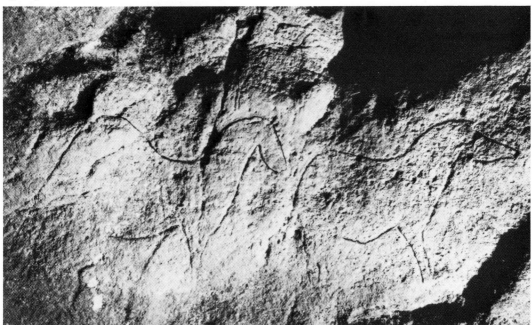

ently used very much like pastels or crayons. Elsewhere the pigment might be ground with some kind of sticky substance into a paste or thick paint and applied with fingers, frayed sticks, or crude brushes, perhaps made of feathers. A primitive "airbrush" technique was also used, with paint being sprayed on the wall by mouth (as among the Australian aborigines) or possibly through hollow bones or reeds. From this period come fine works at Lascaux (fig. 49), El Castillo, and portions of Altamira, with the great bisons there belonging to the next phase, perhaps around 12,000 B.C.

To the period from around 13,000 to roughly 10,000 B.C. belongs the largest body of known Paleolithic art. The animal forms from this era have richly differentiated outlines and the articulation of limbs is carefully studied. Details such as eyes, nostrils, manes, and the long hair of the mammoths are defined with remarkable care. In the Salon Noir at Niaux (fig. 50) the forms of bisons and horses display a

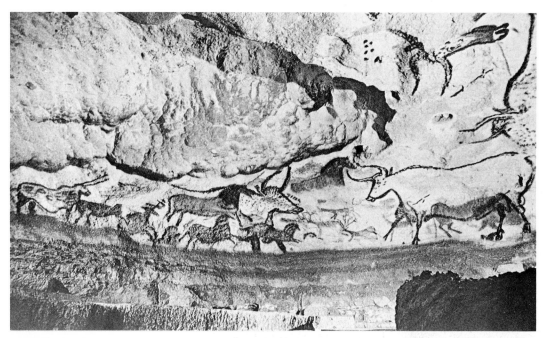

49. Hall of Bulls, *rotunda from Lascaux cave, Dordogne, France. Paleolithic, ca. 15,000–10,000 B.C. Length of largest bull 18'.*

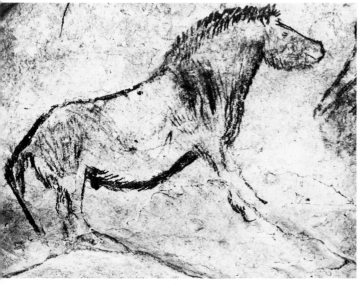

50. Horse, *cave painting from Niaux cave, Ariège, France. Paleo-
lithic, ca. 15,000–10,000 B.C. Hatched technique. Length 27″.
(Photo: Romain Robert)*

technique of hatched lines that elaborate the textures of
their coats. But there are also examples of extremely sketchy
renderings that capture the essence of their subject, as in the
engraved image of a bison scratched in clay at Niaux (fig.
51). Its cursive vigor spans time to the bulls and minotaurs
of Pablo Picasso.

51. Bison, *from Niaux cave, Ariège, France.
Paleolithic, ca. 15,000–10,000 B.C. Scratched
in clay. Length 22 ¾″. (Photo: Romain Ro-
bert)*

Scattered throughout Paleolithic art from its early figurative phases to its latest manifestations can be found various "abstract" signs as yet of uncertain identity: dots, strokes, and rectilinear shapes of varying degrees of complexity. It has been suggested that some of these may be calendrical markings. Other signs have the appearance of conventionalized genitalia. Human images, where they appear, are generally less well defined than the animal forms contemporary with them. Whether the possible magic content of prehistoric art discouraged a more realistic portrayal of one's own kind or whether the greater complexity of the human form and its movements made fashioning such images too difficult remains a question. Some images are clearly hybrid, combining human posture with the attributes of other creatures like the bison or the deer. Whether these represent hunters in stalking disguise, ceremonial dancers, or sorcerers is a matter of speculation. One conviction clearly emerges from a study of prehistoric art: complementary visual languages—abstract, conventionalized forms and realistically oriented depictions of living creatures—coexisted from very early times.

One curious feature, by no means frequent in Paleolithic art, invites comparison with graffiti left in many sites by modern visitors. This is the "negative" imprint of a hand formed by daubing, blowing, or spattering red or black pigment around a hand (usually the left) pressed against the cave wall—the signature, as it were, of an individual human presence. These, some of which appear to be either deformed or deliberately altered by retouching, are found in several French and Spanish sites. What they signify may never be known.

It is difficult to speak of "composition"—that is, of an ordered arrangement of images—when dealing with Paleolithic art. In the case of the decoration of objects like spear throwers (shafts with notched seats for the butts of spears, for increased leverage in the throw), which frequently incorporate animal forms, the very shape of the instrument forces some accommodation of the figural image to the shape it embellishes; but cave walls and ceilings constitute a different field. These large, undulating, irregular surfaces afford no such mold for an image. Despite some statistical studies that suggest recurrent groupings of certain species of animals in conjunction with other species (ox with horse, bison with

horse, mammoth with bison), the immediate impression
conveyed by the cave paintings is one of chaotic masses of
creatures, scattered, jostling, overlapping one another. In
some instances the overlappings seem to represent later ad-
ditions and thus to form a kind of archaeological stratigra-
phy; but this may not be the case when the overlapping
figures belong to the same style, although even here consid-
erable time may have elapsed between the drawings of two
superimposed forms. Uncertainties abound in our interpre-
tations of this art, but it may be that the renewal of these
images from time to time was part of their ritual signifi-
cance.

Whatever else one may say about the figural groupings on
the walls and ceilings of the caves, they do evoke an impres-
sion of disarray, like the chance effects of an aimless natural
growth. They fit perfectly the meandering surfaces of their
subterranean settings. Furthermore, since they are located
in the deep recesses of the caves and thus had to be created
by the light of crude torches or lamps, it is doubtful that
Paleolithic viewers would normally have seen them as a
complete ensemble. More likely, in the halo of a passing
torch, they would emerge magically, one image after an-
other, from the utter darkness of the cave.

We can only speculate about the nature of prehistoric man's
concept of the natural world around him, but judging from
the images he created he must have defined it largely in terms
of the creatures that inhabited it. The grazing animals upon
which he chiefly depended for his own sustenance were the
dominant forms. The natural world—as a setting distinct
from its faunas—scarcely found its way into the imagery of
prehistoric art. One could say that it is there only by implica-
tion: for example, engraved on a shaft of bone (fig. 52), stags
appear to be crossing a salmon-filled stream (during one of
the seasonal salmon runs?), which is merely implied by the
presence of the salmon in the space around the stags. Two
other forms behind one of the stags, who is turning his head
back toward them, serve as a reminder of the difficulties
attending the interpretation of Paleolithic art, for these
forms—lozenges, each split by a short, vertical dividing mark
in the center—are not identifiable with any certainty.

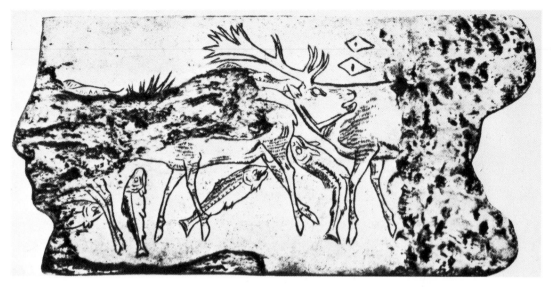

52. Reindeer and Salmonid, *from Lorthet, Hautes-Pyrénées, France. Paleolithic, ca. 15,000–10,000 B.C. Engraving on bone. Length 9⅔". Musée des Antiquités Nationales, Saint-Germain-en-Laye*

Difficulties also attend the interpretation of the numerous friezes of animals on the walls of caves. Are processions of horses or mammoths to be viewed as moving through space, or are they simply there, in quantity and kind, for some symbolic purpose for which we have yet to find the proper key? Beyond various hypotheses anthropologists might suggest, all we can say with any assurance is that the art of the Old Stone Age was inhabited by the creatures that man hunted to sustain his life. There can be no question that they were of vital, absolutely fundamental importance to him, and that they should be chief among the images in his art is only natural.

What strikes us as being so unusual about these images is the degree of skill with which the artists selected and rendered the characteristic features of the various animals. Proportionally few are ambiguous enough to raise serious questions about their species, and most reveal the artist's intimate knowledge of their structure and movements. We can be sure that there lies behind these Paleolithic images an entire development of art that may forever elude us, that

may, in fact, having been made of or on perishable materials, be entirely lost.

Without being able to reach sure conclusions regarding the precise functional role these images played in the life of a primeval hunting society, we can be reasonably certain that they were connected in some way with ritual. Their vital, life-evoking properties and their impressive organic groupings, flowing with the undulations of the cavern walls, urge us to attach to them some cosmic significance in the life of early man.

What do these images signify beyond their obvious concern for representing a clearly recognizable creature? Perhaps they should be read as imitative magic, the belief that by imitating a desired object or event one can actually bring it into being. Accordingly, the act of image making itself, it has been assumed, would promote, in its Paleolithic context, success in the hunt when the beast's image was shaped and the power over it thus fixed. It is possible that some kind of killing ritual may have taken place in conjunction with the image making. It is apparent, for example, that some such ceremony must have occurred in one of the galleries of the Montespan cave (Commune de Montespan, Haute-Garonne, France) where clay figures of animals were found with marks on them indicating that they had been ritually wounded. In some instances Paleolithic paintings of animals are accompanied by shaft forms, frequently barbed, that have been interpreted as spears or darts, and some of these animals are also depicted with marks on their bodies that may represent wounds. It has been suggested, however, that these "spear" shapes and "wound" marks may have yet another significance, correlated with male and female genitalia, respectively. Only a fraction of the animal representations are so accompanied, so the question of what precise function these devices served as a class is still open.

It is also possible that another but related kind of imitative magic lies behind these images of the animals: the belief that the creation of them was in effect a fertility act ensuring the increase of the herds as well as acquisition of power

over them. In this connection much has been made of the pregnant appearance of some of the animals, but that observation is by no means a certainty.

Some researchers have claimed that these images, through their groupings in number and kind and through their possible equivalence with male and female principles, hypothesized on the basis of associated signs interpreted as sexual, represent the fundamental complement of sexes in the natural order, a cosmic assemblage symbolizing for prehistoric man the inexorable cycle of life and death. Viewed in such a light, these images acquire a kind of liturgical order. They then would appear to be nearly religious in nature and the caverns themselves to be the first "cathedrals" of mankind. As to the nature of the rituals that might accompany such a concept, one can only surmise. The numerous footprints of children fortuitously preserved on the floors of some of the caves suggest initiatory rites, but this, like most interpretations of Paleolithic art, is ultimately conjecture.

However we choose to interpret these works within the scope of our imperfect knowledge, a further note of caution seems appropriate. It may be risky to rely too heavily on analogies drawn from studies of surviving primitive societies like the Eskimos or Australian aborigines. Such analogies are still the basis for many of our suppositions about the nature of prehistoric man. There are parallels, to be sure, but each of the primitive cultures around the world that has survived to become the subject of anthropological studies has its own unique history, and the conditions under which each developed its characteristic forms were not precisely those of the Paleolithic hunter of the caves of Europe. Such studies can contribute to our knowledge of the possibilities that must have existed for the painters of the caves, but it is also important to consider how these very studies should caution us against analogical traps. Nor should we assume that the great antiquity of the Paleolithic images implies a supremely uncomplicated life for these image makers. There is always the chance that we are inclined to be too smug about the complexities with which we must cope in our modern world. Who can say what complications fostered by the unknown

—and then unknowable—terrors in the natural world lay upon the daylight consciousness and haunted the nights of prehistoric man?

While hunters were still stalking the last reindeer herds around the old Paleolithic centers in France, eastward across the Mediterranean the Neolithic planting and grazing prelude to the great valley civilizations was being formed. The ancient native habitat of wild wheat and barley, which were essential to the development of agriculture and must have been gathered seasonally before they were deliberately cultivated as domesticated grains, seems to have been in Asia Minor, with spurs reaching southward into the Levant and far to the east, well beyond the southern shore of the Caspian Sea. Roughly coextensive with this area, but of wider range, was the native habitat of those species ancestral to the domesticated sheep and goats that formed another essential sector of an evolving agricultural economy. By around 9000 B.C., an agricultural way of life had appeared in the Levant and Iraq, and by 7000 B.C., a village culture dependent on emmer wheat and barley, goats and sheep, was flourishing in the Near East.

Whereas Paleolithic man had depended almost entirely on the caprices of nature for his livelihood, hunting and gathering wherever he could, Neolithic man was somewhat more independent of nature's whims in that he could exercise some control over his welfare through planting and harvesting his grains and pasturing, milking, and butchering his flocks. But in another sense his life was more circumscribed. He was almost literally in bondage to the soil and to a settled way of life. The order of the seasons—the times of plowing, planting grains, husbanding spring lambs, and harvesting—was both a security and a burden. Nature was then, as now, no subservient force. Drought, unseasonable rains, destructive floods, plagues, or locusts could upset the settled order of life. There was also, perhaps as never before, a threat from man himself, from wild marauders who preyed upon the villages and their stores of goods, from other communities disputing territorial rights, or from incursions of migratory peoples seeking new lands. So we find at Neolithic

Neolithic Art
(New Stone Age)

levels in Jericho, to the northeast of Jerusalem, rude walls and towers protecting the town from that most dangerous of predators, man himself. Not surprisingly, therefore, the image of man and his activities gains importance in works of art.

From the same period at Jericho, around 7000 to 6000 B.C., come two kinds of images that have some significance for the history of art. The first of these is a group of human skulls (fig. 53) that have been transformed into sculpture by the addition of tinted plaster over the bony substructure of the features, like the layers of flesh once there. Seashells set in the eye sockets add to the eerie impression that the viewer is here confronted by a surrogate life. Like the leathery compression of features on Egyptian mummies that have been unwrapped, the plaster flesh supported by the skulls is remarkably evocative of an individual human presence, but

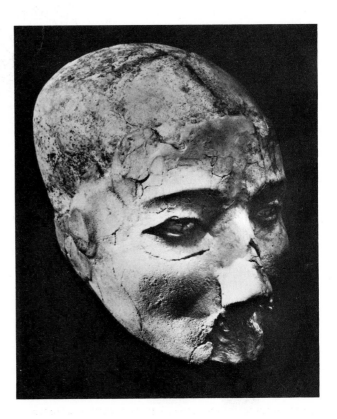

53. Human Skull, *from Jericho. Neolithic, ca. 7000–6000 B.C. Features molded in tinted plaster with seashell eyes. Life-size. Jericho Excavation Fund*

a presence so elusive as to be wraithlike. The archaeological evidence surrounding these images reinforces what their appearance implies: that they served a cult of ancestor veneration.

For our purposes this phenomenon can be viewed more as a symptom of an abiding concern for continuity, for the ongoing linkages between generations, dead, living, and yet unborn, than for what it represents initially: one manifestation of a belief in an afterlife. This sense of continuity must have come very early to mankind, even before the advent of *Homo sapiens,* for there is evidence of a cult of skulls as far back as Peking man in the cave at Choukoutien (China) around five hundred thousand years ago and later in Europe among Neanderthal men. Evidence from later Paleolithic levels seems to confirm the continuity of the cult, and examples from primitive societies like those in the Sepik River area of New Guinea, which are remarkably close in concept to the Jericho works, bring the tradition into modern times.

The plastered skulls of Jericho convey yet another meaning to us. As remembrances of individual beings they fall into a special category of art that has had elaborate development throughout history: the tradition of portraiture. Composed of a part of the actual being, the Jericho images are more than mere replicas. Their closest counterpart in the ancient world is to be found in the Egyptian practice of mummification, where the idea incipient in the plaster reconstitution of the flesh is extended to the actual preservation of the body, accompanied in its tomb by enduring portraits in stone. The entire tradition of portraiture stems from this sense of individual continuity, from this curious magic belief in the possibility of participation in life when life is gone. The idea was never more poignantly expressed than in these ancient times when the seashell eyes of ancestors watched the living and the images of Egyptian dead looked on the manifestations of life carved or painted on the walls of their tombs.

A second class of objects from Neolithic Jericho consists of a group of fragmentary human figures of almost natural size

(fig. 54). They are made of unbaked clay and, like the skulls, have seashells for eyes, with the clay laid over the edges of the shells to form simple eyelids. The figures are rather flatly modeled and one of the best-preserved heads, that of a man, is so shallow when viewed from the side that the general appearance of its form is like that of a thick paddle. The expression that emerges is curious—at once puckish and sad. Hair and beard are indicated by a series of nearly parallel strokes of reddish brown paint.

Together these two Neolithic examples point out, however imperfectly, divergent tendencies in image making: on one hand, the attempt to achieve a replica of the original model, an image almost interchangeable with it; and on the other,

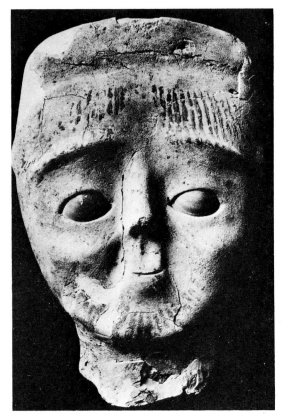
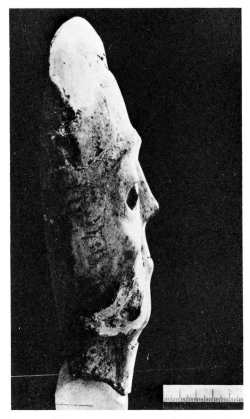

54. Head, *from Jericho. Neolithic, ca. 7000–6000 B.C. Clay with seashell eyes. About life-size. School of Archaeology and Oriental Studies, University of Liverpool*

the fashioning of an image which is derived from a specific kind of object but which, rather than depicting the precise likeness of the model, is almost totally submissive to a conceptual schema. The former approach aims at uniqueness, the latter at generality. The two modes of image making, foretold in these Neolithic examples, have a long subsequent history.

One other point bears mentioning in conjunction with Neolithic art. The shift from a mobile hunting life to a settled existence in villages resulted in the development of an extensive utensil culture. These ceramic utensils are an extremely useful item from the archaeologist's point of view. Made in great quantities, widespread throughout the world, evolving a variety of specialized shapes and decorations reflecting local styles, this pottery—or more usually its fragments, potsherds scattered about sites—constitutes a valuable index to stylistic change, to shifts in populations, and in general provides a sequential calendar that in cross-reference with other evidence establishes at the very least the relative dating of sites and occupation levels.

Generally speaking, pottery tends to exert a special kind of influence upon the decoration that graces it. The shape of the vessel itself seems to dictate that its decoration follow certain rhythms, concentrate on certain areas, or shift its character to fit particular portions of that shape, since foot, body, shoulder, neck, or handles may present distinctly different surface dynamics.

Decoration, in the strict sense of the term, implies the embellishment of a surface with patterns or textures aimed at enhancing its appeal to the senses. The decorative ensemble, if it is to perform effectively its function of visual or tactile enrichment, must incorporate at least two properties: first, an organic or logical relationship to the surface or form with which it is associated; and second, an intrinsic visual or tactile order. Decoration that lacks the first property separates itself from the form or surface it was intended to enhance and asserts a separate identity. Its decorative function is thus impaired if not completely obliterated. Decora-

tion that lacks internal logic—which may consist of such devices as repetition or variations on a basic theme—is reduced to aimless muddling of the surface or breaks down into a conglomerate of separate units having very little relationship to one another apart from the accidents of proximity. These separate elements compete with each other for attention, and in the resulting clamor the sense of decorative unity is lost. Decoration, then, is a mode of enhancement that involves considerable discipline among its constituent parts and in its relationship to the larger entity it serves. Its basic principles seem to have been defined already in prehistoric pottery.

Two examples will serve to illustrate the range of prehistoric pottery decoration within the context outlined here. One of these is a vessel from predynastic Egypt (fig. 55); the rim is set off by parallel bands of sketchy zigzag or wavy lines, and the bosses on the shoulder are enhanced by similar lines rippling out to form half-oval patches that appear to hang from the lines about the rim. Here the vessel itself seems to dictate the arrangement of the decorative motifs. But the body of the vessel is viewed by the artist as simply a large, swelling surface upon which to paint, in more or less random fashion, human and animal forms, all reduced to schematic simplicity. On a vessel from prehistoric Susa (fig. 56), the decoration is subjected to a more demanding scheme, both in its relation to the surface dynamics of the vessel and in relation to the schematizing of animal forms. A solid band painted around the rim of this beaker and a wider band around the base frame the decoration, which consists of three friezes running horizontally around the vessel, set off from one another by a variety of wide and narrow painted bands. The topmost frieze reads initially as a running cadence of accented vertical lines that bear some resemblance to musical notation but on closer inspection are revealed as drastically schematized long-necked birds. The middle frieze consists of schematically simplified dogs running (?) around the vase in the opposite direction to the procession of birds. The last and widest of the friezes is broken up into panels in which a goat or ibex has been boldly reshaped into a form that for all its abstract character retains the cocky

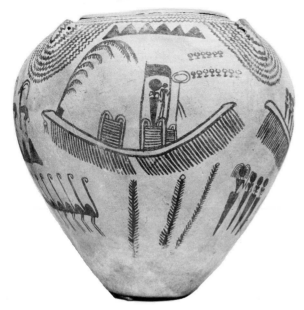

55. Jar. *Predynastic Egyptian, before 3200 B.C. Height 12". The Metropolitan Museum of Art, New York (Rogers Fund, 1920)*

vitality of the creature. The aggressive horns enframe a circular device of unknown significance.

What strikes one immediately about these two vessels is the degree to which the Susa beaker emerges from the comparison as a disciplined form, consistent throughout. The animals represented in the decoration are inseparable from their participation in the decorative pattern itself; the Egyptian vessel, by comparison, seems to be more chaotic than orderly. This comparison should not be understood as a demonstration of fundamental differences between Egyptian and Mesopotamian art, however, for there are predynastic Egyptian pots with applied patterns entirely decorative in character, orderly in composition, and abstract with respect to animal forms. It is also in Egypt, sometime around 3100 B.C., that a schematic basis for its figural art was established that imposed on it a strict discipline for nearly three thousand years (see pp. 90–96).

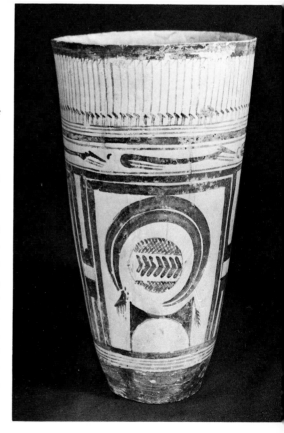

56. Beaker, *from Susa. ca. 5000–4000 B.C. Painted terra-cotta. Height 11¼". The Louvre, Paris (Bulloz-Art Reference Bureau)*

Mesopotamia and Egypt

The idea of continuity is the stable center of civilization. Since the life-style of Neolithic man centered on the village and its contiguous fields and pastures, continuity acquired new significance as territorial identity became linked with it. One's land became ancestral land and a place for posterity as well. The seed planted here was that which grew into the larger entities we recognize as civilizations; but its first real flowering was to be a transplant in other soils—in the river basins of Mesopotamia and Egypt.

Sometime around 5000 B.C. the agricultural way of life spread to the floodplains of the Nile and the Tigris-Euphrates river system. There, with the development of irrigation to extend the planting areas, large populations could eventually be supported. By around 3300 B.C. in Mesopotamia, and shortly thereafter in Egypt, there developed distinct and unprecedented patterns of life. On the plains of Mesopotamia, in the lower Tigris-Euphrates valley, scattered villages became cities and cities became city-states, conceived as estates of the gods managed by human overseers. The center of early Mesopotamian civilization lay in the regions known, from south to north, as Sumer, Babylon, and Akkad. Sumer lay at the mouths of the Tigris and Euphrates, which in ancient times did not join as they do today before emptying into the Persian Gulf. The latter then extended northward beyond its present shores almost to the ancient city of Ur. In Egypt, where a more compact village system was strung out along the narrow river plain, events brought the entire valley under the rule of a single divine kingship. Although these two centers were in contact throughout their history, they developed and maintained distinctly different patterns of culture. It is difficult to avoid the conclusion that a crucial factor was the difference in nature itself between these two regions.

Ancient Mesopotamian descriptions have embedded in them clues to the forces of nature experienced along the Tigris and Euphrates, where storms and floods came suddenly and destructively, drowning "the harvest in its time of ripeness." Nature was not—as it was in Egypt—a generally benign and predictable presence. In Mesopotamia, the

temple of the city god was the visual focus of each community, since it was built atop a terraced brick structure, or ziggurat (fig. 57), rising above the plains like a miniature mountain. Indeed, the names given these structures—like "House of the Mountain"—indicate that they were actually intended to be mountains, proper settings for the manifestation of divine power. This was a natural metaphor, since the streams and the storms came out of the highlands that lay along the northeastern flank of Mesopotamia. It was therefore appropriate that the supernal powers of nature wielded by the gods of the Mesopotamian cosmic state should be concentrated in the image of the mountain built on the plains. The violence of nature in Mesopotamia was reflected in its myth of creation, which involved a cosmic battle between gods led by the god-hero Enlil or Marduk, armed with the winds, and the powers of chaos, led by Tiamat, a primeval watery force. The natural world was storm born. It

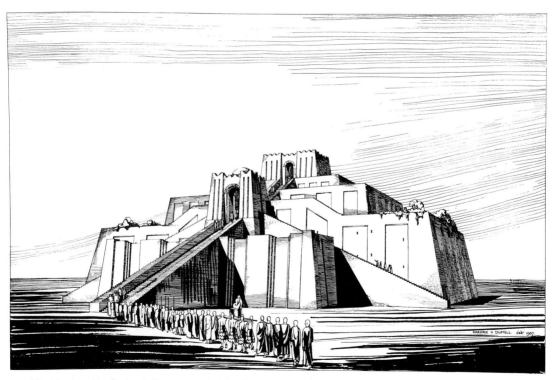

57. Ziggurat, *at Ur, drawing of a reconstruction. ca. 2100 B.C. The University Museum, University of Pennsylvania, Philadelphia*

humbled man and forced upon him a sense of his own frailty. He was an ephemeral thing as insubstantial as the wind. Something of the anonymity of his position touched Mesopotamian art; no tradition of portraiture developed there comparable to that in Egypt. It has been remarked that were a man from that time and place to return and see the great stepped ziggurats he had raised to his gods now eroded away to shapeless mounds, he would not be disturbed; the sight would merely confirm his assessment of man's estate.

Egypt was a different world. It seemed to be rooted in order and regularity. The Nile flowing northward to the Mediterranean was flanked on either side by cliffs rising to arid tablelands over which the sun daily rose and set defining a counteraxis to the river—a fundamental symmetry of topography and movement. The cycle of the Nile's seasons was unfailing and predictable. During the spring the level of the waters fell as if the river were dying, but during the summer months it swelled back to life, inundating the lowlands and depositing rich alluvial soil. With irrigation canals and deep wells the waters could be held to feed the outlying fields and dispensed to extend the growing season for harvesting two or three crops a year. Egypt, as Herodotus observed, was the gift of the Nile; but it was the steady rhythm of labor in the fields and the irrigation systems that secured the river's bounty.

As in Mesopotamia, the character of the land was incorporated into the myths of creation, in which a primeval hill (the first land) emerged from the waters just as the receding Nile, after the inundation, left behind the rich earth for sowing the crops. The art that emerged from this predictable environment would reflect both its order and its security through a form that was individual, durable, and patiently crafted.

Man and Nature in Mesopotamian Art

There is an almost baffling variety to the art of the ancient Near East. From the early Sumerian era through the As-

syrian and Persian empires, it presents a constantly changing pattern of styles. Even within a given culture there may be a variety of visual modes. In Mesopotamian art, for example, there is a distinct polarity. Throughout its history the art of this region shows a strong decorative inclination, a love of ornament even for its own sake (see fig. 77, p. 104), and there is an equally strong taste for depicting physical reality (see fig. 82, p. 110). These diametric approaches occasionally combine in a delicate equilibrium that produces a consummate work of art (see fig. 62, p. 85). To some degree this variety— as compared with the relatively homogeneous character of Egyptian art—can be attributed to the historical fact that Mesopotamia and the highlands to the north in Asia Minor and to the east in Iran witnessed a continual rise and fall of dynasties and civilizations. More vulnerable to invaders than Egypt and more fragmented by its pattern of localized city-states, the Mesopotamian region lacked the concentrated cultural continuity that characterized Egypt. Nevertheless, certain basic forms survived stubbornly through all these cultural fluctuations, attesting to the generative role of early Sumerian and Akkadian art.

The Mesopotamian city-state was bureaucratically organized in the practical pursuits of daily life and ceremonially organized in its theocratic nature. The clay tablets on which the Sumerian invention of cuneiform writing preserved so much detail confirm the dedication with which these servants of the gods applied themselves to keeping good accounts. Inventories abound. There is something ritualistic in these practices, but the ritual at another level of Mesopotamian life is of greater consequence to art.

From a sanctuary at Tell Asmar, on the northern edge of the lower Tigris-Euphrates region, comes a group of figures (fig. 58) that may represent a communal act of religious dedication involving both mankind and the gods. These figures— the largest, almost thirty inches high, representing Abu, a god of vegetation, and the next largest, a mother goddess— are an odd mixture of abstraction and concrete reality. There are few distinctions among the figures that would

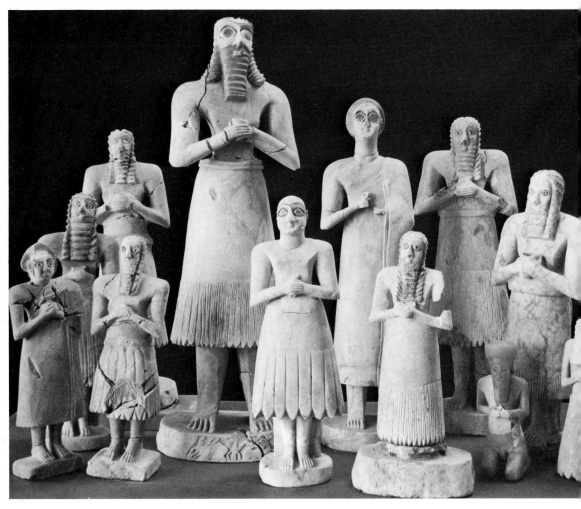

58. **Worshiper Statues,** *from Abu Temple, Tell Asmar. Sumerian, early Second Dynasty, ca. 2800–2775* B.C. *Gypsum. Height of tallest figure 28 ⅜". Courtesy of the Oriental Institute, University of Chicago*

identify them as either deities or mortals: they are all geometrical in form, their bodies suggestive of cylindrical substructure. Their hands are clasped piously to their chests or hold there small objects of offering. Although there are individual differences from figure to figure, there is a strain of anonymity in the group that variations in size, costume, and sex cannot obliterate. Despite their uniformly geometric substructure, these images from Tell Asmar do project considerable presence as beings. Their enormous eyes fascinate

one—not as glances, however, for they do not really look out at the world but rather are intently fixed, trancelike, on some vision of indefinite locus. It is a communal imagery appropriate to an emphasis on the ritual in which they are obviously intended to participate as surrogate beings. It has been suggested that this group, placed in the sanctuary, may have represented the participants in the ceremonies attending the Mesopotamian New Year, when the primeval battle against the forces of chaos was liturgically reenacted to bring order to the seasons.

Although the human image in early Mesopotamian art stays close to the schematic formula exemplified in the Tell Asmar statuettes, there are instances in which individuality of a sort seems about to break through the strictness of the style, as in the benign little priest's head from Khafaje (fig. 59). But even here, despite a fleshy softening of the modeling, the formula is so persistent that one is inclined to view the animation of his features as simply a formula of a face about to smile.

The formalism so prevalent in Mesopotamian art is completely absent, however, from another image of a slightly earlier period: a figurine of a monster (fig. 60) carved from

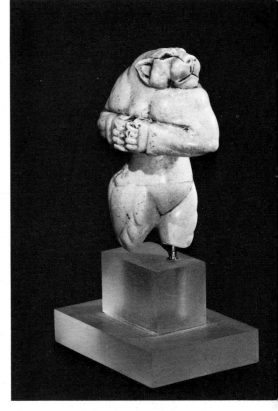

60. **Leonine Figurine.** *Proto-Elamite, ca. 3000 B.C. Indurated limestone. Height 3 5/16". Courtesy of the Brooklyn Museum (Lent by Mr. Robin B. Martin)*

59. **Priest's Head,** *from Temple Oval II, Khafaje. Sumerian, early Third Dynasty, ca. 3000–2340 B.C. Limestone, eyeballs of shell, one pupil of lapis lazuli. Height 2 ¼". Courtesy of the Oriental Institute, University of Chicago*

crystalline limestone. It is a demonic image, half-human and half-lioness. The violent tension of its form, with hips twisted at right angles to the plane of its upper torso and head turned sharply to its left, is rendered organic by the swelling strength of its musculature. The potentially explosive energy projected by this tiny image, at once savage and magnificent, is truly monumental. In it the artist has concentrated a wild power that welds man and beast together as a single irrational force. Compared with such an image as this, its Egyptian counterpart of a later period, the goddess Sekhmet (fig. 61), has the appearance of a serene three-dimensional pictograph, an emphatically symbolic and formalistic image.

From around 2340 to 2180 B.C., the Mesopotamian city-states were united under the rule of non-Sumerian kings, Sargon of Akkad and his successors. The Akkadians of the north were unrelated to the Sumerians, but they adopted much of the Sumerian culture as their own. While Sumerian forms in art still retained their influence, the Akkadian overlordship did bring with it some new emphases. There is a distinct stress on corporeality in Akkadian images, as evidenced in the bronze head of an Akkadian ruler (fig. 62) found at Kuyunjik, the site of ancient Nineveh, in the upper Tigris region. Although somewhat damaged—the inlaid eyes, probably of some precious material, have been gouged out and the nose is battered—it is still a commanding image. Its features approach anatomical accuracy but are nonetheless elegantly schematized. The eyebrow line departs from the regular arch of Sumerian prototypes by acquiring an eccentric curve, but the paired eyebrows form a strictly symmetrical arrangement and their feathered texture is as regular as it is precise. The lips, while sensuously modeled, are quite symmetrical and a firm, metallic outer edge encases them. The hair and beard are remarkably detailed, as if each individual hair were carefully registered; but the curls of the beard and the plaited, basketrylike coiffure with its chignon marshal each strand into a severe pattern. The schematic tyranny is much in evidence. Paradoxically, it is this that lends so much character to the head. Formalism has been harmonically reconciled with physical reality. It is not a

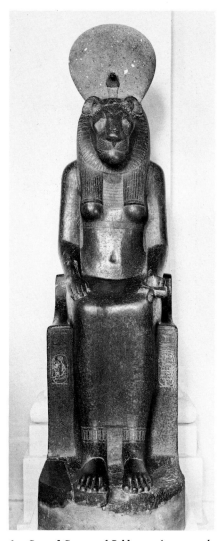

61. Seated Statue of Sekhmet, *from temple of goddess Mut, Karnak. Egyptian, Eighteenth Dynasty, ca. 1405–1370 B.C. Black granite. Height 90½". The Louvre, Paris (Marburg-Art Reference Bureau)*

62. Head of an Akkadian Ruler, *from Nineveh (Kuyunjik). Akkadian, ca. 2300–2200 B.C. Bronze. Height 12". The Iraq Museum, Baghdad (Scala)*

63. Victory Stele of Naram-Sin. *Akkadian, ca. 2300–2200 B.C. Pink sandstone. Height 78". The Louvre, Paris (Bulloz-Art Reference Bureau)*

projection of an individual personality but a masterful distillation of the idea of impersonal kingly authority.

The image of royal power reaches new dimensions in the victory stele of Naram-Sin (fig. 63). This stele, or stone marker, commemorates a victory of an Akkadian king, Naram-Sin, over his enemies, who have fled to a mountaintop. The setting is clearly defined by rolling, wooded slopes rising to the conical peak. The king's troops follow him up the mountain where he stands, larger than all the rest, with enemies felled or begging for mercy. Over the conical peak at the broken top of the stele are astral symbols of the gods. In an earlier Sumerian stele of similar subject matter (figs. 64a and 64b), the ruler leads his troops; but it is the god Ningirsu who has defeated the enemy and holds them in his net, and it is the god who is so much larger than the rest

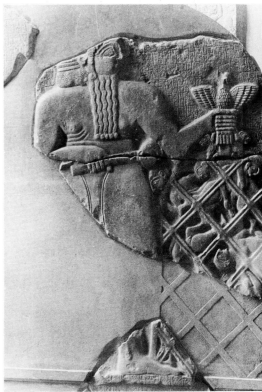

64b. Stele of the Vultures, *from Telloh. Sumerian, ca. 3000–2500 B.C. Limestone. Total height 74″. The Louvre, Paris (Marburg-Art Reference Bureau)*

64a. Ningirsu with Captives (Stele of the Vultures), *from Telloh. Sumerian, ca. 3000–2500 B.C. Limestone. Total height 74″. The Louvre, Paris (Alinari-Art Reference Bureau)*

of the figures. Naram-Sin now enjoys this superior position and even wears the horned headdress that was once the prerogative of the gods. It is clear that here is a new genre: a historic event glorifying a hero-king and depicted in a specified natural setting.

The confident image of Naram-Sin has little in common with the statues of Gudea, the *ensi* (city ruler or overseer) of Lagash, a community that seems to have enjoyed some freedom in a period when other cities of the region were subject to the rule of invaders. Although Gudea was proud of his reputation as a builder of temples and his self-esteem was undoubtedly responsible for his "portrait" statues, his image (fig. 65) is remarkably self-effacing. His hands are

65. **Seated Gudea.** *Sumerian, ca. 3000–2000 B.C. Diorite. Height 17½". The Louvre, Paris (Giraudon)*

clasped in a pious gesture and his features have the appearance of a benign formula conventionally humanized. For all the swelling roundness of the forms, the figure seems to shrink within its suppliant attitude; it is almost as anonymous as the figurines from Tell Asmar. Here, in the image of Gudea, the ancient Mesopotamian concept of man as a creature whose days are numbered and who is as ephemeral as the wind seems perfectly embodied.

Man and Nature in Egyptian Art

The civilization of ancient Egypt was to an uncommon degree shaped by its geography and particularly by the Nile itself. Perhaps no other single geographic factor has ever exerted as much influence on an entire society as this one river rising out of the heartland of Africa. The abruptness with which the green fields of the valley break down at the edge of the desert on either hand is even today a startling phenomenon; to the ancients it must have seemed a miracle. The Egyptian was oriented in terms of the river. Not only did his life depend upon the fertility of the fields, dependent in turn upon the annual inundations of the river, but his language and thought reflected this essential relationship, and the very basis of the divine kingship that united the valley—and Egypt was the valley—was linked in form and substance to the Nile.

The divine kingship of Egypt seems to have been identified from its beginning with Horus, a sky god of Upper Egypt represented in the form of a falcon. The kingship was also linked to a god of uncertain origin, Osiris. He originally may have been a mythical king who, having died, was supposed to have become a ruler of the dead; or he may have been a god of the earth which receives the dead or a Nile god who died and came to life again, like the cycle of the river. But, whatever his origin, he was by dynastic times the king of the dead and also manifest in the renewal of vegetation following the life-giving inundations of the Nile. The Egyptian pharaoh, as a reigning god-king, was Horus, the son of Osiris, born of Isis, sister and wife of Osiris. Upon his death the pharaoh became identified with Osiris as king of the

dead, and the successor to the throne became the reigning Horus. Thus the continuing cycle of divine kingship was maintained, and the annual "death" and "rebirth" of the river and the equivalent cycle of vegetation were brought into phase with it. Accordingly, the forces of nature as they bore on the seasons of the valley were manifest in the kingship itself.

There were two Egypts in ancient times, identified with two aspects of the Nile: the long upper valley and the broad delta region bordering the Mediterranean. When these two lands were brought together as one, Egypt was born as a historic entity and the dynastic basis of Egyptian chronology began. But even then the distinction was preserved in the two crowns of the pharaoh: the tall white crown of Upper Egypt and the red crown of Lower Egypt around the delta. With the establishment of the unified kingship, Egyptian art adopted the form that would become the standard basis of its images for centuries, with relatively few departures from its precepts (see pp. 27–29).

There was, however, a decided ambivalence in predynastic Egyptian art with respect to the ordering of figural images in relation to one another and to the space they occupied. We have already noted how, on some predynastic pottery, images were scattered about in a rather chaotic fashion. But even there, in contiguous groupings of figures (note the ibises in fig. 55, p. 77), in instances where images confront one another in such a way as to imply a mutual relationship, and in the occasional use of a ground line linking figures of humans or animals, there is evidence of a deliberate order.

On a fragmentary predynastic palette (a ceremonial tablet on which cosmetics were ground for ritual adornment) there is the barest suggestion of spatial dimension as lines of hunters enclose their quarry (fig. 66). It could be argued that it is the shape of the palette itself that has determined the appearance of orderly design in the lines of hunters, but elsewhere there is a more casual disposition of images and the tip of the palette has merely afforded a convenient field for the representation of a lion pierced by arrows. As a

66. **Hunters Palette,** *from Hierakonpolis. Predynastic Egyptian. Slate. Height 25 ⅞″. By courtesy of the Trustees of The British Museum, London*

whole, the arrangement of human and animal forms is a mixed affair, with some images—like the double-headed bull —having the appearance of isolated pictographs.

The relief representations on the predynastic mace head of King Scorpion (fig. 67) are an important benchmark in the development of Egyptian art, for they foretell its subsequent strict manner and, at the same time, provide a rare example of something generally absent later on: an attempt to represent the irregular topographic features of the natural world. The king, who is depicted wearing the crown of Upper Egypt, stands on what appears to represent, by the wavy pattern of its surface, the junction of two channels of water; in the area to the right of this junction are figures of workers, some kind of enclosure, and a tree. The king is apparently officiating at a ceremony relating to the irrigation of the fields. Event and setting are clearly registered, and spatial extension is presented like a map.

There are some later examples of topographical definition of space in Egyptian art, but for the most part a rigid ground line defines the surface on which men and beasts walk, and

67. **King Scorpion Mace Head,** *from Hierakonpolis. Predynastic Egyptian, ca. 3250 B.C. Limestone. Height 9 ½". Ashmolean Museum, Oxford*

a horizontal band textured with zigzag lines represents water, on the top edge of which—as if on another ground line —boats may sail. Within such bands fish, crocodiles, and hippopotamuses may swim and the legs of wading cattle may extend; but this watery element rarely meanders as it does on the mace head of King Scorpion to chart a space for human action.

Apart from a few scattered instances, Egyptian art did not attempt to represent spatial depth in a manner that would have led to an illusionistic art. A rare scene found at Tell el 'Amarna (ca. 1372–1354 B.C.) includes two diagonal paths that converge slightly as they lead from a river bank through a garden to a palace. Most Egyptian art consistently eschews perspectives of this kind in favor of a diagrammatic plan,

emphasizing what is known to be there rather than how it is actually seen from a particular point of view. Thus, the depiction of gardens or courtyards will often be laid out like a map (fig. 68), with trees, people, animals, or buildings in these contexts shown in profile or elevation. Sometimes buildings incorporate plan views of sections of them where such devices would clarify the layout of interior spaces. Simple overlappings are the general rule in Egyptian art for

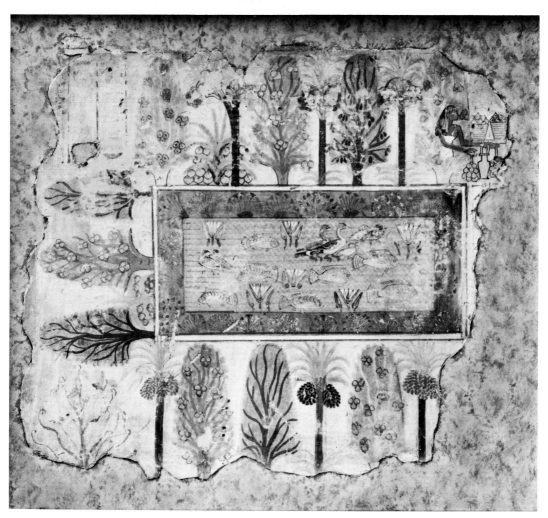

68. Garden with Fish Pond, *wall painting from a tomb at Thebes. Egyptian, Eighteenth Dynasty, ca. 1400 B.C. 24 ¼″ × 28 ⅜″. By courtesy of the Trustees of The British Museum, London*

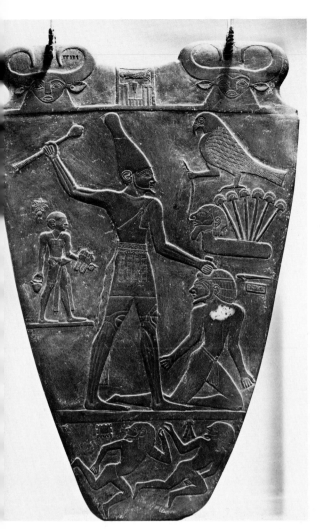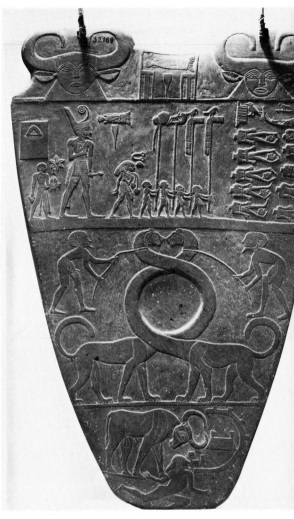

69. Palette of King Narmer, *from Hierakonpolis. Egyptian, First Dynasty, ca. 3100 B.C. Slate. Height 25″. Egyptian Museum, Cairo (Hirmer Fotoarchiv, Munich)*

suggesting the spatial depth in groups of animals or humans. Otherwise images are strung out, distinctly and separately, along their ground lines. In short, the conventions of Egyptian art seem calculated to impart information clearly and simply, as a pictorial inventory.

The high level of clarity reached by this approach can be seen in the ceremonial Narmer palette (fig. 69), which commemorates the union of the two Egypts and displays as well the characteristic Egyptian style fully formed. On one face of this palette, the king stands barefoot on a ground line that marks the bottom of the major register. His figure is rendered in the composite frontal-profile view. He wears the crown of Upper Egypt and brandishes a mace in his right hand, while his left holds the hair of a kneeling Lower Egyptian. There is a ritualistic character to this representation, for despite the gestures there is no real movement in the king's figure. His stance is simply registered as a graphic equivalent for absolute power, while the servant on the subsidiary ground line behind him carries his sandals, emphasizing the ceremonial—even sacred—nature of the king's "action." Above his victim, a falcon, the form of the god Horus who was identified with the reigning king, perches atop a pictograph representing the defeated delta. A further reference to the event is made in the lowest register, where two of the defeated enemy are either fleeing or slain. Unattached to ground lines, they float freely in their allotted space.

70. **Cylinder Seal Impression.** *Mesopotamian, ca. 3000 B.C. Height 1 ¾". The Louvre, Paris*

On the other face of the palette, the king, whose importance is signified in part by his larger size, now appears wearing the crown of Lower Egypt. With his servant behind him and standard bearers in front, he views two vertical rows of decapitated figures who lie in the space over the ground line as if viewed from above. The decorative middle register contains in its center the depression in which cosmetic pigment would be ground. Entwined about it are the abnormally long necks of beasts similar to creatures depicted on Mesopotamian cylinder seals (fig. 70). That they are captives seems to be indicated by the cords around their necks. In the lowest register a bull—metaphor of the king (see p. 50)—tramples a fallen enemy while his horns batter down a wall shown in plan view.

The formulary representation of the figures of the king, the ground lines and hieroglyphic labels, and the pictographic clarity of the imagery on the Narmer palette are characteristic of the classic Egyptian style in relief sculpture and painting (which shares its principles). The Narmer palette is evidence that the style had already arrived at its basic form during the very period when the two Egypts were joined.

After the establishment of a single divine kingship, Egypt soon developed its sculpture, painting, and architecture on a scale commensurate with the idea of a living god as ruler. Unlike Mesopotamia, Egypt was well endowed with excellent stone for carving and building, which ensured the durability of both these arts. Indeed, durability is the quality that may best identify the character of the Egyptian civilization; but it was not absolutely unchanging, for had it been inflexible it could not have survived for as long as it did. It was responsive to changing conditions and unforeseen events, and these are registered in the art like transient expressions flickering over the same face; but it did maintain to a remarkable degree the artistic tradition established early in its history as a pervasive formal spirit in all its art. If continuity seems dominant over change, it is merely a measure of the strength of a tradition founded on principles in complete harmony with the enduring aspects of the culture itself. The steady cycle of nature along the Nile promoted a sense of continuity, and carving and building for eternity were its

natural consequences. But living things died, so the continu-
ity could achieve its full dimension where human life was
concerned only in a life of the dead. In Egypt the idea of
this life beyond life was elaborated into a complex of mortu-
ary literature, ritual, and art. In fact, most of what we know
about Egyptian life until very late in its history is gleaned
from the arts that served the dead—but not all the dead.
These elaborations of the afterlife seem to have been at first
the prerogatives of the pharaoh, gradually extending to
those in high places about the court, and even here may have
begun only as an emanation from the god-king himself.

Since the human body was ephemeral, its life form was
preserved after death, to the extent that it was possible, by
the art of embalming. To assure further the continuity of
this afterlife, portrait statues of the deceased were made.
The comfort of this world of the tomb was secured by
including prized possessions and furniture among the mor-
tuary objects and by decorating the mortuary chapels with
scenes from daily life and ritual. The spirit, or *ka*, of the
deceased looked on a familiar world. The Egyptian obsession
was not with death, as some have maintained, but with life.

The fundamental distinction between the appearance of life
and the appearance of death was resolved by the form of the
Egyptian portrait statue. The life that was peculiar to each
being and manifest in his individual appearance was caught
in the portrait likeness, which in such works as the bust of
Vizier Ankh-Haf (fig. 71) seems to be invested with every
distinguishing feature. Not all Egyptian portraits have this
uncompromising reality; some degree of generalization,
through simplifying details, and even some idealization of
features, by imparting to their expression a transcendent
serenity or nobility, are very much in evidence (fig. 72; see
also fig. 8, p. 26). Yet, as eloquent as these works are in
projecting the individuality of their subjects, they remain
aloof from participation in life. They are immobile, and no
spontaneous gesture seems to have been allowed them. They
sit or stand or kneel in a limited repertoire of poses, and they
do so as if each position were assumed for eternity.

Egyptian sculpture reconciles opposites at yet another level:

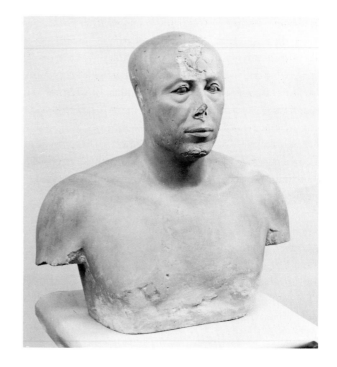

71. Bust of the Vizier Ankh-Haf, *from Giza. Egyptian, Fourth Dynasty, ca. 2652–2600 B.C. Painted limestone with thin plaster coating. Height 21″. Courtesy, Museum of Fine Arts, Boston (Harvard-Boston Expedition)*

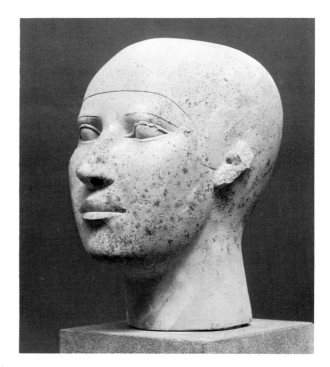

72. Reserve Head of a Prince, *from Giza. Egyptian, Fourth Dynasty, ca. 2600 B.C. Limestone. Height ca. 10 7/16″. Courtesy, Museum of Fine Arts, Boston (Harvard-Boston Expedition)*

in the unexpected harmony achieved between the individu-
alized human face and the generalized form of the body.
Within the category of gender, the bodies of Egyptian stat-
ues are nearly interchangeable. There are relatively few de-
partures from this conceptual mold, and its persistence is
one of the factors that misleads casual observers into accept-
ing the notion of an absolutely unchanging art.

The most dramatic shift in Egyptian art came with the
pharaoh Amenhotep IV, who ruled from around 1372 to
around 1354 B.C. Soon after assuming the kingship, he left
the old capital at Thebes, changed his name to Akhenaten,
and set up a new court and a new religious cult at Tell el
'Amarna, which he named Akhetaten ("Horizon of Aten")
after Aten, the sun disk. In the relief shown here (fig. 73),

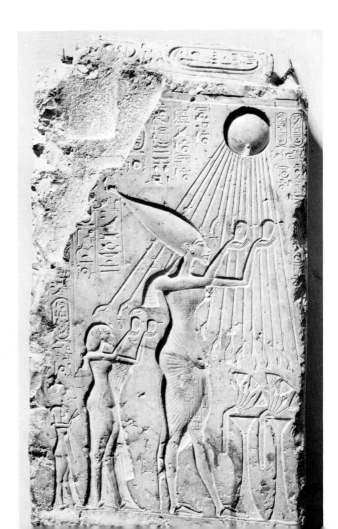

**73. Akhenaten and Family Sacrificing to
Aten,** *relief from Aten Temple at Tell el
'Amarna. Egyptian, Eighteenth Dynasty,
ca. 1372–1354 B.C. Limestone. Height
41". Egyptian Museum, Cairo (Photo:
Courtesy of The Metropolitan Museum of
Art, New York)*

Aten, the presumably monotheistic center of this new religion, is shown extending its rays to grace the royal family. Although the figures adhere in a general way to the old conventions for representing the human form, there is a mannered elegance in the contours that breaks sharply with the earlier style. The refined beauty that was already tempering New Kingdom art is here pushed almost to the point of graceful caricature as exaggerations of the human form invest the figures with pronounced hermaphroditic aspects. A new sensuousness also pervades much of this Amarna style and reaches a level of remarkable explicitness in a torso of one of the royal princesses (fig. 74). After the death of Akhenaten, his successors abandoned the heretical capital and this phase of Egyptian art came to an end; but the expressive grace of the Amarna style was echoed now and then in subsequent New Kingdom art. One of the most familiar works in this aristocratic Amarna manner is surely the lovely head of Akhenaten's queen, Nefertiti (fig. 75).

The Narrative Art of Assyria

The heartland of Assyria was in the hilly upper Tigris region that produced a vigorous stock of people, tempered by the intermittent warfare that accompanied the rise and fall of various dynasties during the course of the second millennium B.C. Once a part of the territory controlled by Indo-European invaders from the east, the Mitannians, Assyria finally gained its independence in the mid-1300s B.C., when war between the Indo-European Hittites of Anatolia and the Mitannians resulted in a Mitannian defeat. Between around 1000 and 612 B.C., when they were defeated by a coalition of Medes and Scythians, the Assyrians built an empire reaching southward into the lower Tigris-Euphrates, westward to the Mediterranean, and penetrating, in the seventh century B.C., even into Lower Egypt as far upriver as Memphis and Thebes. The Assyrian military machine was well developed and well disciplined, a truly professional striking force. In an empire maintained by warfare, Assyrian art, deliberately propagandistic, celebrated a passion for conquest.

The stylistic origins of Assyrian art are obscure. There may be connections with Hittite work, particularly in monumen-

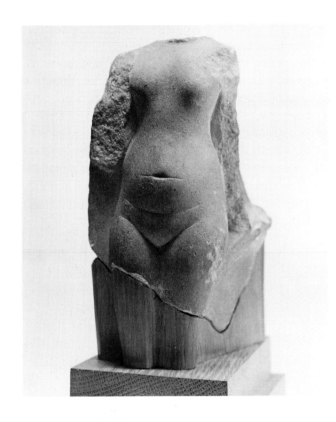

74. **Torso of a Princess,** *from Tell el
'Amarna. Egyptian, Eighteenth Dynasty, ca.
1372–1354 B.C. Quartzite. Height 5 ⅞". De-
partment of Egyptology, University College,
London (Petrie Collection)*

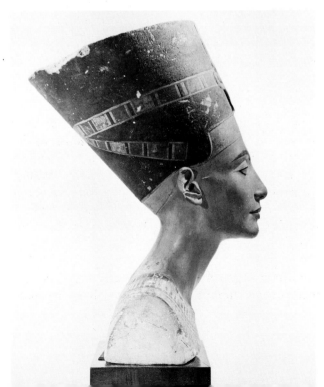

75. **Queen Nefertiti,** *from Tell el 'Amarna.
Egyptian, Eighteenth Dynasty, ca. 1360 B.C.
Limestone. Height ca. 20". State Museum,
Berlin (Marburg-Art Reference Bureau)*

tal sculpture, but there are more affinities with the art of
Babylonia to the south, where the older Sumerian and Ak-
kadian traditions were preserved. During the troubled sec-
ond millennium B.C., Babylon had replaced Sumer and Ak-
kad as the center of Mesopotamian civilization and under
Hammurabi (ca. 1792–1750 B.C.) had achieved a position of
cultural importance that survived for centuries after its polit-
ical significance had subsided. Although Babylonian art was
no doubt admired by the Assyrians, Assyrian art contains so
many characteristics peculiar to its own culture that it must
be reckoned a distinct tradition and one that made original
contributions to the history of art.

The most striking achievements of Assyrian art are to be
found among the decorations of the palaces of the kings.
Mural art, both painting and relief sculpture, reached a high
level of development concurrently with the Assyrian con-
quests and perhaps as the natural companion of this out-
reach of power. Assyrian art was, to a degree unusual at the
time, a secularized art of the state. The numerous alabaster
reliefs that have been preserved from Assyrian palaces com-
memorate the military victories and hunting prowess of
Assyrian kings, and yet, for all the detailed accounting of
their separate exploits, the images of these kings are remark-
ably indistinguishable from one another, as if they were
merely the impersonal agents of a power that resided in the
larger entity of empire.

Assyria was well situated for the development of sculptural
art. The upper Tigris was rich in resources of stone, particu-
larly an alabaster that was readily quarried and easily carved.
Undoubtedly the ease in working the surface of the stone
encouraged the development of an art of relief that was
more completely pictorial than anything yet produced in the
ancient Near East and more episodically integrated than
anything before such Roman reliefs as those on the Column
of Trajan. These Assyrian reliefs depict military campaigns
and hunts with such vividness and dramatic detail that one
is inclined to view them as the visual counterparts of a lively
tradition of storytelling.

One can distinguish two major modes of Assyrian art. There is a formal side that emphasizes decorative principles of symmetry and ornamental detail. It is almost exclusively magical, ceremonial, or religious in content, consisting chiefly of the *lamassu* (fig. 76), strange composite creatures who guard the gates and throne rooms, and the winged genies who accompany representations of the king in ceremonials or stand in heraldic confrontation on either side of fantastic, and obviously sacred, trees or vines, tending

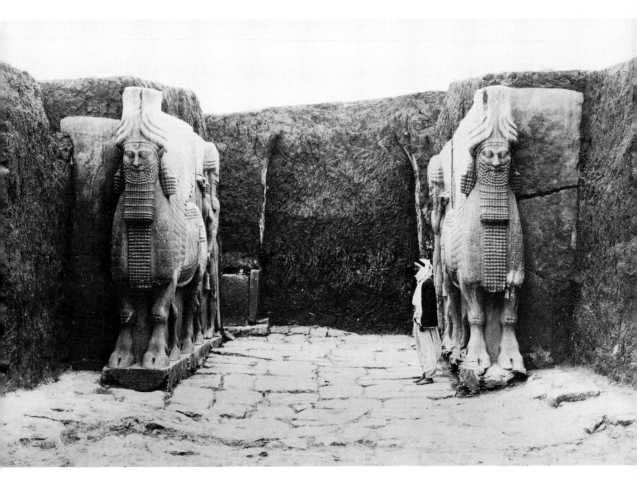

76. Outer Portal of Gate A of the Citadel of Sargon II, *Khorsabad. Assyrian, ca. 721–705 B.C. Gypseous alabaster. Height 12′1 ⅝″ (each figure). Courtesy of the Oriental Institute, University of Chicago*

them (fig. 77). Deity seems extremely remote from man in Assyria, and this remoteness is accented by the severe formality of the art that deals with images of supernatural forces and rituals relating to the worship or appeasement of the gods. A second mode, the narrative, is more in evidence. Although narrative reliefs have their allotment of decorative embellishments, the dominant thrust is toward a realistic portrayal of events, even though certain conventions may be involved in the representation of figures and settings. Some of them appear to be exploring, somewhat tentatively, the illusion of receding space. The natural world of plains and mountains, marshes and rivers (fig. 78), trees and gardens, is depicted with an eye to its varied textures, and wild and domestic beasts—horses, hunting dogs, lions, wild asses, and gazelles—are rendered with an awareness of their animal vitality that recalls the images of Paleolithic art.

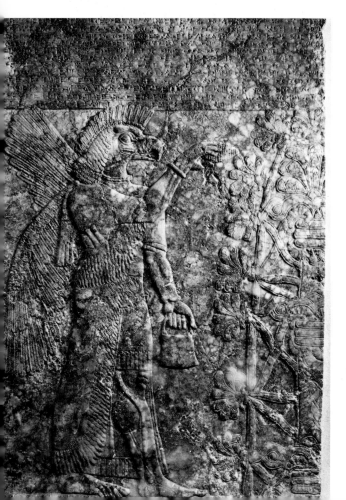

77. Heraldic Genie and Sacred Tree, *relief from Palace of Ashurnasirpal, Nimrud. Assyrian, ninth century B.C. Gypseous alabaster. By courtesy of the Trustees of The British Museum, London*

78. **Warfare in the Marshes,** *relief from Palace of Sennacherib, Nineveh (Kuyunjik). Assyrian, seventh century* B.C. *Gypseous alabaster. Height 60". By courtesy of the Trustees of The British Museum, London*

The blending of a love for decoration with a native penchant for realism is exemplified in a relief from Khorsabad (fig. 79) that shows King Sargon II carrying an ibex to a sacrifice. The image of the king is rendered with the formalism characteristic of ritual reliefs. His muscular arms and leg receive careful attention, but the carved surfaces undulate so slightly above the plane of the stone in defining the swell and pull of the muscles and the indications of bony substructure that only raking angles of light bring out fully the illusion of three-dimensional bulk; even the tiny ibex, which emerges as a convincingly real creature, follows the same pattern of shallow modeling. But it is also apparent from this example that the Assyrian sculptor understood the possibilities of evoking substantiality within these limitations and could flatten forms so sensitively that physicality is relatively

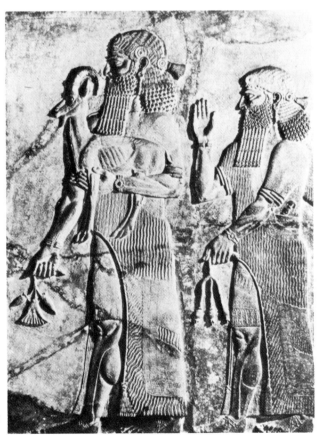

79. Sargon II with Ibex, Followed by Attendant, *relief from Khorsabad. Assyrian, ca. 721–705 B.C. Gypseous alabaster. Height 8′9½″. The Louvre, Paris*

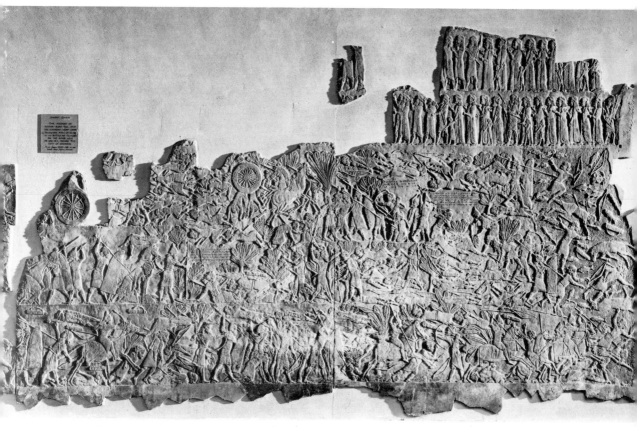

8o. Defeat of the Elamites at the Ulai River, *relief from Palace of Sennacherib, Nineveh (Kuyunjik). Assyrian, ca. 650 B.C. Gypseous alabaster. 48″ × 59″. By courtesy of the Trustees of The British Museum, London*

unimpaired. The lean agility of the ibex is nicely evoked in the springy tension of its legs and the alert arch of its neck. There has been no tradition in art in any time or place that has caught with greater empathy the particularity of animals and their capacity for wild, free motion. Assyrian imagery presents us with the paradox of a remarkable sympathy for spirited creatures coexisting with the deliberate cruelty of the Assyrian arts of hunting and war.

A relief from Nineveh depicting the defeat of the Elamites (fig. 8o) is an exhaustive catalog of battlefield carnage. The victims of the Assyrians are slain among the trees; driven

into a river teeming with dead or dying men and horses, discarded weapons, and a few resident fish; or marched away in captive procession. This relief combines several devices for representing the action. There is considerable use of the simple ground line to define the surface along which men and horses move and to which they fall. The lower part of the relief is developed in this manner with figures of combatants overlapping each other and the trees that grow from the ground line. Sometimes, however, denying the logic of this scheme, figures of dead soldiers or discarded weapons lie superimposed on the foliage above the main conflict in this register, as if some *horror vacui* compelled the sculptor to fill every conceivable gap in the fighting with evidence of Assyrian superiority. In the area above this lower portion of the relief, ground lines sometimes fade out and the figures are represented in profile or bird's-eye view on an open field scattered with trees and occasional inscriptions. The river, full of floating figures, is represented in bird's-eye view at the right of the battle scene. If the devices for establishing a relationship between the figures and the place of action are mixed and suggest an unresolved pictorial problem, the general effect is nonetheless a visual equivalent for the confusion of battle.

In some instances Assyrian reliefs display a cohesiveness that explores at an elementary level the problem of spatial recession that found one solution, centuries later, in the development of linear perspective. In a scene representing the sack of a city (fig. 81), one can postulate a simple guiding principle: higher up equals farther away. So, beyond the foreground slope rise the city walls, and the plane of the stone surface around them can be read as sky or simply empty space. On the slope itself is a grove of trees and a curving path leading to the city gate. Coming down this path, but utilizing the left-hand edge of it as a ground line, is a procession of men bearing loot from the city, herded by a soldier at their rear. They are represented in profile view, but the diagonal curve of the path converging slightly toward the gate lends them some degree of movement in depth, made all the more convincing by the slightly smaller scale of the men atop the walls of the burning city. While the

possibility exists that these are merely chance occurrences, there is evidence enough in other Assyrian reliefs to make a case for Assyrian art taking the initial steps toward a representation of pictorial depth, toward visualizing the spatial dimensions of the natural world as extending back beyond the plane of the relief. It is only a beginning, but it should be credited as a significant phase in the evolution of the artist's visual means. It is worth noting here that only when the artist's purpose was to record an event simply in terms of human action—without overtones of cosmic forces manifest in them or divine powers acting through them— could there be the kind of emphasis on the material presence of the objective world that would finally lead to a naturalism that embraced the entire range of nature's phenomena, from the physicality of creatures to the replication of their natural or man-made surroundings. Assyrian art may have taken the first step in that direction.

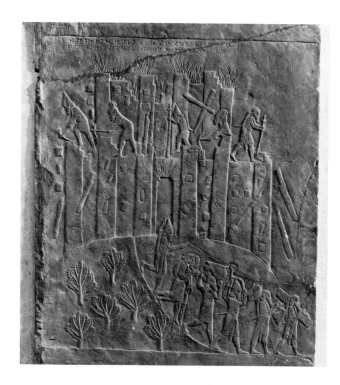

81. Sack of the City of Hamanu in Elam, *relief from Nineveh (Kuyunjik). Assyrian, ca. 650 B.C. Gypseous alabaster. 36″ × 25″. By courtesy of the Trustees of The British Museum, London*

In another example (fig. 82) one is confronted with a tricky problem often haunting our interpretations in the history of art: the question of whether the visual evidence is clearly a manifestation of artistic intention or an interpretation deriving from subsequent developments and the conditioning of the modern viewer to read the voids around realistically rendered objects as illusionistic space. In this relief of a herd of gazelles, the beasts are spread out in scattered formation on the plane of the stone, but the cadence of their strides sets up a movement from right to left. A male at the rear turns his head back toward danger and appears to be about to leap forward. The vertical plane of the stone out of which the forms of the gazelles have been carved functions—to modern eyes, at least—as a level plain receding toward the top of the relief. It is a striking image that charges the spaces around the gazelles with real significance, and one can only admire the observant skill of a sculptor who, whatever his intentions with respect to space, has caught at the very least that moment before unexpected danger suddenly becomes terrifyingly real and immediate.

One other area of Assyrian relief sculpture bears special mention in terms of the relationship between man and beast. Opinion seems divided, or at least uncertain, as to the proper interpretation of the hunting scenes in Assyrian art.

82. Herd of Gazelles, *relief from Nineveh (Kuyunjik). Assyrian, 668–626* B.C. *Gypseous alabaster. Height 20 ¾". By courtesy of the Trustees of The British Museum, London*

Perhaps they are to be viewed generally as the aristocratic sport that hunting becomes when it is no longer necessary for survival. It can then become a dangerous game—when the quarry is a lion, for instance—that tests the courage and skill of the hunter against the courage, strength, and cunning native to the creature he hunts. It can even become a kind of art with its own peculiar aesthetic, as in bullfighting. In the Assyrian context, it has been suggested, the hunts were devices that between campaigns kept the killing instinct sharp for war. Others have seen one hunt in particular —the slaying of lions by the king—as a ritual descended from the ancient role of a shepherd leader protecting the flocks. There may be justification for all of these views, for they are not mutually exclusive, but the internal evidence in the reliefs themselves makes a good case for some element of ritual sacrifice involved in the king's lion hunting. Depictions of lions being released from cages in these hunting reliefs confirm that they were trapped for deliberate slaying, clearly a sacrificial implication when taken in the context of the other scenes. In the sequence illustrated here (figs. 83 and 84), the formalism of ceremonial art is blended with realism as ritual joins narrative.

The killing ritual itself is shown in a relief from the palace of Ashurbanipal at Nineveh (fig. 83), where a lion lunges at the king on his horse and a second, though already pierced with arrows, leaps from behind. The sculptor has effectively captured the force of the wounded lion's leap. In another section of Ashurbanipal's reliefs, the body of a lion is borne like a dead hero by the king's attendants; adjacent to this scene a row of dead lions has been laid before an altar, while the king, holding his bow and arrows in his left hand, pours a libation on their heads with his right (fig. 84). The killing ritual is completed. We can only guess at the precise meaning it had for the Assyrian kingship, but the dangerous game must have been played to reflect in some way on the glory or renewed power of the king.

Viewed as a unit, these depictions of the king hunting and performing rituals over the kill constitute a continuous nar-

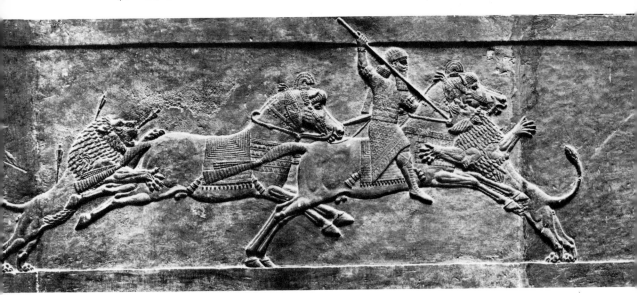

83. The Lion Hunt: King Ashurbanipal Spearing a Lion from the Saddle, *relief from Nineveh (Kuyunjik).*
Assyrian, 668–626 B.C. Gypseous alabaster. Height 43 ¼". By courtesy of the Trustees of The British Museum,
London

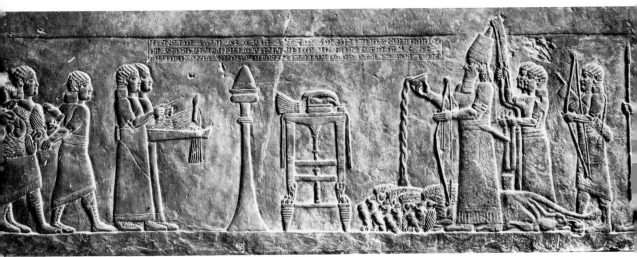

84. Ashurbanipal Pouring a Libation over Dead Lions, *relief from Nineveh (Kuyunjik). Assyrian, 668–626 B.C.*
Gypseous alabaster. Height 22". By courtesy of the Trustees of The British Museum, London

rative that seems to define an official role, just as the reliefs recounting Assyrian victories in war appear to be both historical records and propaganda for royal power. The narrative approach was a direct means of preserving and communicating the official image of the Assyrian state.

4 IMAGES OF MAN, NATURE, AND DIVINITY: WEST AND EAST

Few ideas about the ancient Greeks have been more persistent than the notion that theirs was a culture in which man was the measure of all things. But the ancient Greek did not regard the world as a realm fashioned by deity for man's pleasure and exploitation; this would presume an apartheid of man and nature that he did not acknowledge. He did sense an analogue between human nature—its capacities, moods, and inscrutabilities—and the manifold energies in nature, but his relationship to those natural forces transcended figurative imagery. He did not merely parcel out the world of nature and its mysterious energies among a series of appropriate human metaphors—beings human in form but immortal and gifted with suprahuman powers and beauty—to form his panicle of high gods and to make the inscrutable understandable, but he developed his Olympian deities by refining and systematizing the cosmic forces and primitive gods of earlier myths.

The gods were already anthropomorphic images early in Greek history, appearing as such by the ninth century B.C. in the epics of Homer. In the following century, at a time when a Greek civilization was emerging from the dark era following the collapse of the old Mycenaean culture whose glories and horrors were sung by Homer some three hundred years after the events, the anthropomorphism of the gods continued in the *Theogony* of Hesiod. But anthropomorphic gods were not mere literary fictions the Greeks imposed on the natural world, for the images had already been evolving gradually out of the more ancient and universal concept of the Earth Mother. According to Greek mythology, after the primeval void of Chaos came Gaea, the earth goddess, who from her union with the sky became the

Ancient Greece: Nature and Images of Gods and Man

mother of the Titans. From the Titan pair Rhea and Kronos (Saturn) came Zeus and the first generation of the Olympian gods who, in turn, overthrew the rule of the Titans and established their own supremacy under the leadership of Zeus. The overthrow of the Titans may be symbolic of a shift in the Greek religion from the older comprehensive divinity of earth powers to the anthropomorphic individualizations of the Olympians. Yet there was no dramatic change, for both generations of deities were of nature and the old survived in the shadows of the new and as part of their hybrid character. At popular levels, among country folk, the older forms undoubtedly remained for a long time, with local variations, just as today one can find fragments of the old pagan ambience in the folk beliefs of rural Greece.

It is significant, in this connection, that the sanctuaries of the Olympian gods were always situated in close relationship to features of their natural surroundings and not set apart as formal, self-contained entities, architectural hollows that shut off the outside world. There were, moreover, no Greek temples in unsanctified places; the sites were already sacred before the temples were built, and deity was embodied in the site itself as much as in the temple or in the image of deity housed within it. Thus, the gods of Greece were nature gods in the fullest sense: they were of and in the land, the sea, and the sky, manifest in nature's phenomena, shaped in human form, and mirrored in the inward nature of man. Nor were these gods transcendent beings working from some outside realm—although high Olympus was certainly a step in that direction; they were, instead, immanent in the natural flux of nature and the fortunes of mankind. They acted impartially through natural phenomena and selectively through the deeds of men, as in those moments when human powers seemed dramatically enlarged in the course of active life. Thus, the inanimate and animate worlds were joined in a common energy. However imperfectly the ancient Greek may have understood the forces of nature from a purely scientific standpoint, in psychological terms he comprehended them very well indeed—and that was as adequate for his own reconciliation with them as it was essential to his art.

By the early fifth century B.C., Greek art had developed the perfect vehicle for conveying the idea of Olympian deity: the perfected, organic human image. It was an image that achieved harmonic balance between the appearance of the natural form of the human body and a concept of that form raised to a level of exceptional beauty and majesty. So effective was this image that it has survived for centuries as the epitome of the godlike. Paradoxically, even as its general form linked man to the gods, the very ideality of the image conveyed a sense of remoteness that set a distance between it and the ordinary world of human action and purposes. Yet it was not an image that would strike the beholder with fear or move him to feel the presence of a deity in whose compassion and mission lay the redemption of mankind. It was, in a sense, as if humanity were reflected in a mirror that aggrandized its image but whose surface was—mirrorlike—immediate, vivid, but, after all, impenetrable.

The bronze statue (fig. 85), probably of Poseidon, brother of Zeus, is an impressive artistic manifestation of this con-

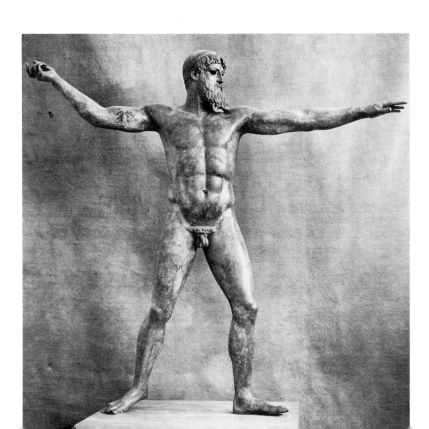

85. Poseidon (Zeus?). Greek, ca. 460–450 B.C. Bronze. Height 82″. National Museum, Athens (Photo: Alison Frantz)

cept of deity. One of the finest pieces of original Greek sculpture, it was found in the sea off Cape Artemision where the vessel carrying it to some unknown destination had sunk. It is a superbly conditioned human body, yet the commanding gesture of preparing to hurl—if he is indeed Poseidon—the trident (three-pronged spear) he may once have held, the majestic head with its fine profile and intricately patterned hair and beard, the latter thrusting forward aggressively like breaking sea waves, all convey an impression of suprahuman power. The poise and vitality of the image are appropriate for Poseidon, a god of movement manifest in the sea and sea winds, in the earthquake and the running horse, a god who drives his chariot through the waves and is patron of both sailors and horsemen. Poseidon may represent an older concept than Zeus, whose own image incorporates some attributes that seem once to have been Poseidon's, like the storm and the thunderbolt; the birth of Zeus in a cave on Crete seems more appropriate to the sea god.

In contrast to the active physicality of the *Poseidon* is the *Apollo* from the west pediment of the Temple of Zeus at Olympia (fig. 86), where the marble statue stood in the midst of a battle between Lapiths (a human clan) and centaurs (hybrid creatures half-human, half-horse, symbolic of wild, untamed nature). Apollo stands almost motionless, the main axis of his body stiff and frontal, as the vertical center of the temple's gable where the statue was originally displayed. While essentially unmoving, he nevertheless controls the outcome of the conflict, not by active participation but by turning his head and stretching out his right arm, through which his power flows to the Lapiths' cause. It is a lofty, dignified image whose frontality must have gathered and reflected the full afternoon sun on the pediment of the temple—appropriately, for as Phoebus Apollo he was the god of pure, life-giving light, a solar divinity without actually being the sun itself (until a very late tendency to identify him with it). The image here precisely duplicates the image of the god built up in the *Iliad* when, challenged to a duel by Poseidon as the gods took sides in the Trojan War, he calmly rejected the fight as unworthy of a god; when he stopped the impetuous Diomedes (bent on slaying Aeneas

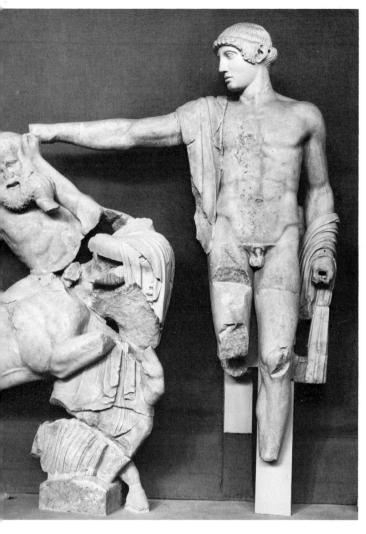

86. **Apollo,** *from the west pediment of the Temple of Zeus at Olympia. Greek, ca. 460 B.C. Parian marble. Height 10′3″. (Photo: Alison Frantz)*

even as the latter was being protected by Aphrodite, whom Diomedes had wounded) by reminding the Greek hero of the distance that lay between mortals and the gods, a distance man trespassed only at great risk; and when, near the close of the epic, Apollo came before the other gods to charge Achilles with breaking the laws of nature and lacking the self-restraint appropriate to nobility of character in abusing the corpse of Hector, "dishonoring the dumb earth." The sculptor of the Olympian pediments must have based his image of Apollo on the Homeric god.

"Mantiklos dedicated me to the Far-darter of the silver bow, as part of his tithe; do thou, Phoebus, grant him gracious recompense." Thus reads the inscription on an early Greek bronze (see fig. 20, p. 33) dedicated as an offering to Apollo. The reference to the darts and bow of Apollo relates to another aspect of the god, who may have been in pre-Homeric times an Asiatic deity who dealt death with his arrows. The attribute lingered and was reconciled with the god of light, since the Greek summer full of the sun's light was also the time of plagues. According to Greek mythology, the bow was one of Apollo's attributes from the beginning, as he dispatched the monster Python with his archer's skill almost from the cradle. But, as we see in the Olympian marble and in the famous *Apollo Belvedere* (fig. 87), it is the harmonic side of Apollo that prevails: he is a god of order, of music and song, leader of the Muses; a god of healing, purification, and atonement, not out of compassion for mankind but from his identification with the idea of order in nature. This harmonic identity of Apollo is well expressed by the sculptor of the *Apollo Belvedere* in the graceful bearing of the god and in the ease with which he has released the string of the bow he once held, strummed as he might strike his lyre.

If the image of Poseidon was expressive of active forces in nature, the image of Apollo is more abstract—one might say more intellectual—preeminently the image of the moderation and order that the Greek mind opposed to the passion and wildness in another quarter close to the raw violence in nature: Dionysos and his followers. Ivy-crowned Dionysos, a son of Zeus and apparently of minor significance in Homeric times but an important deity by the fourth century B.C., was a god close to the earth whose power in early times seems to have stemmed from the sap of vegetation and whose special province became the cultivation of the grape. A sensual god, he was associated with fertility and the intoxicating powers of wine and wild music. Accompanied by his boisterous band, he was generally immanent in forest and mountain places, and rituals related to his worship were frequently orgiastic. If Apollo can be viewed as representative of controlled rationality, then Dionysos and his train are from the opposite face of the coin—ecstatic passion. Yet the

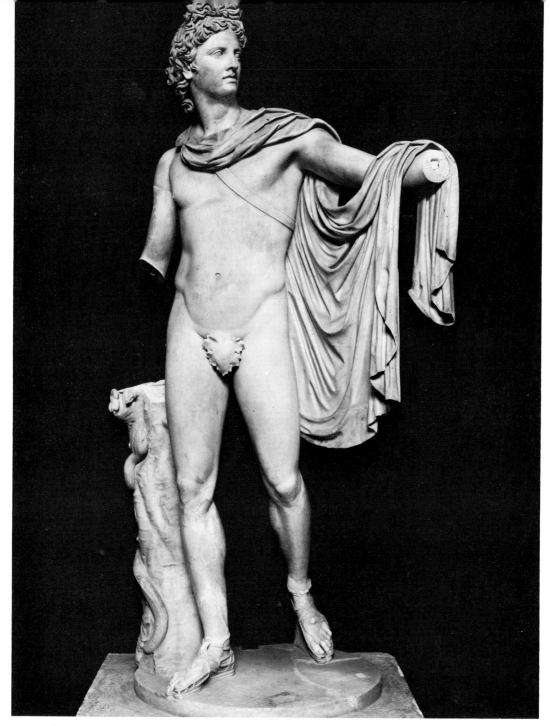

87. Apollo Belvedere. *Roman copy of a Greek original of late fourth or first century* B.C. *Marble. Height 88¼″. The Vatican Museums, Rome (Alinari-Art Reference Bureau)*

god himself, more often than not, is depicted in Greek art as the calm center of his stormy troupe composed of satyrs (woodland and mountain spirits with goatlike ears and short tails) and maenads (female followers of Dionysos who are depicted as playing music or dancing and who often carry the *thyrsos*, a staff with a pine cone as a finial). Opposite as Dionysos is to Apollo, the two gods sometimes shared the same sanctuaries. Both were associated with divination, music, and poetry, and the development of Greek drama is traditionally linked to the rituals of Dionysos. In the red-figured vase painting illustrated here (fig. 88), Dionysos, only

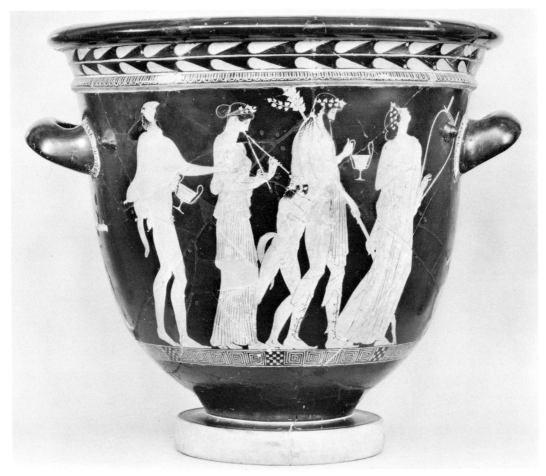

88. THE METHYSE PAINTER *(attributed).* **Dionysos, Satyrs, and Maenads,** *red-figured bell krater. Athenian, fifth century* B.C. *Height 19½". The Metropolitan Museum of Art, New York (Rogers Fund, 1907)*

slightly tipsy and supported by a small satyr, retains his dignity in the midst of his typical entourage. He holds a *kantharos*, a type of drinking cup, and carries the *thyrsos*. We see him here in only one of his many forms; at other times he appears as an infant or as a somewhat indolent youth.

The variety of images of Dionysos reflects the richness of the stories about him, from the unusual circumstances of his birth, his boyhood among the nymphs, and the later tales of his Asiatic journey (derived from the conquests of Alexander the Great). There are many complexities and contradictions in the genealogy of all the Greek gods; their powers and attributes sometimes overlap, and they acquire a variety of roles, reflecting an evolution that went on for centuries with local variations and mixtures. But, by and large, their ancient origins in the forces of nature dominate, however much they may have been refined and specialized over centuries of paying them homage in a variety of circumstances and locales.

As a god of the vine Dionysos was subject to a recurrent cycle associated with the death of vegetation and the new life of spring—a pattern not inharmonious with his double birth, taken as he was from the womb of his mother, Semele, who had been destroyed by the fire of Zeus, to be reborn from the latter's thigh. This cycle of the seasons, understandably significant in an ancient society in which agriculture played an important role, was to be found in the configuration of other deities as well: in Apollo, the god of light supposed to retire to far places in the winter; in Kore (Persephone) who spends part of the year, the winter, in the netherworld as the bride of Hades, its king; and even in Aphrodite, whose season of sorrow is marked by the fading of her flowers, linked with the death of her beloved Adonis, a symbol of beauty slain in its prime. The forces of nature are never far from the splendid images of the Greek gods.

At times an image from nature is translated into a human form as an obvious visual metaphor, like the statue of the river god, probably representing the stream Kladeos, from

89. Kladeos, *from the east pediment of the Temple of Zeus at Olympia. Greek, ca. 476–456 B.C. Marble. Height ca. 32 ½". (Photo: Alison Frantz)*

the east pediment of the Temple of Zeus at Olympia (fig. 89). The reclining pose, appropriate to his identity and equally proper as a figure to fill one of the two small angles of the pediment, literally flows along in a twisting rhythm that evokes both liquidity and the meandering course of that particular stream near the site of the temple.

Some images are more like personifications of ideas or feelings in response to transient events than embodiments of forces in nature at large. The *Nike of Samothrace* (fig. 90), representing the goddess of victory, is such a configuration. Her poised, hovering presence is the perfect translation into stone of the soaring spirits that attend a victory. She both announces and celebrates an event.

If the *Nike of Samothrace* symbolizes a transient experience,

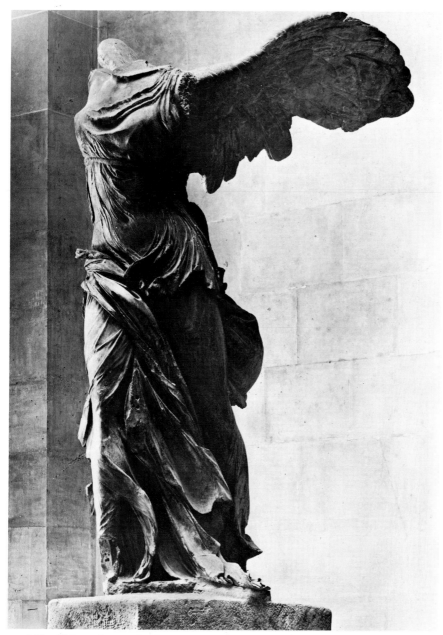

90. **Nike of Samothrace.** *Greek, ca. 200–190 B.C. Marble. Height 96". The Louvre, Paris
(Marburg-Art Reference Bureau)*

the battered statue of the earth goddess Demeter (fig. 91), disregarding the head which belongs to some other statue, is the embodiment of stability, a matronly image as elemental and enduring as the earth in which her powers are manifest. Her draperies cling firmly to the ample core of marble, enhancing the simple monumentality of the form. She is a presence that does not act, but is. On the threshold of the Hellenistic era, when the Greek sculptors were increasingly engaged in exploring human dimensions from the sublime to the trivial, the image of Demeter calls us back to the earth-born beginnings of the Greek gods and the primal forces they represented. One is reminded of Prometheus in agony, chained on the mountain for stealing fire from Olympus to give to mankind and enduring the torture of an eagle tearing at his liver, crying out to the winds, the waves, the rivers, and the earth, the mother of all.

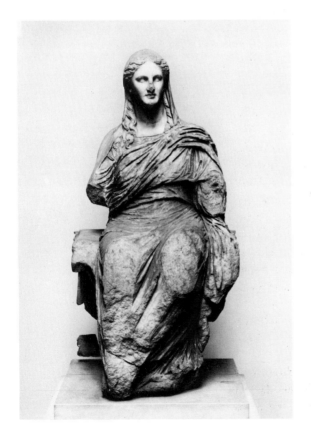

91. **Demeter,** *from Cnidus. Greek, ca. 340–330* B.C. *Marble. Height 60". By courtesy of the Trustees of The British Museum, London*

Hinduism, which has probably exercised greater influence on Indian life than any other tradition, was without a personal founder, differing in this respect from faiths like Buddhism, Christianity, and Islam. As a tradition it was a developing process rather than a fixed doctrine, a characteristic that explains in part its flexibility. It has been tolerant of many gods who have advanced and retired throughout its long history. This ongoing evolution of Hinduism has its analogue in the Hindu notion of creation as a continuous process of birth, death, and rebirth. Nature, the concrete substance of this creative process and the expression of divinity, is itself a force that through its attractions and entrapments inhibits man from escaping the endless rounds of time and change to reach the desired goal of union with the spiritual realm. Paradoxically, however, the very forms of the material world—the imagery of art, a ritual, or a spoken formula, even a particular creature or thing—become channels through which divinity can be reached. Thus, even the sexual acrobatics in the sculptural decoration of some north Indian temples can be interpreted as symbols of the idea of union as a principle rather than as mere eroticisms.

In Hindu art, then, considerable emphasis appears to be placed on the world of the senses and emotions, conveyed to the beholder through images rooted in the natural world; but neither images nor their emotional content are primary, for, in the Hindu context, true reality resides in an ineffable realm *(Brahman)* outside the material world of time and change *(Maya)*. According to this view, all aspects of the material world derive from a common ancestry—a cosmic life—in the spiritual realm. Nature, for all its concreteness, is but the immediate symbol of a higher, pure, and infinite reality. Thus, in a sense, there can be no strict separation of the sacred from the secular. Everything has its measure of sacred content and so no aspect of life or art can, in theory at least, be savored for itself alone.

The art of India begins in the valley of the Indus, one of India's two great river systems, where a civilization known to us only since the earliest excavations there in the 1930s

Nature in Indian Art: Sensuousness and Spirituality

flourished in the third millennium B.C. and ended, destroyed by Aryan invaders, sometime between 2000 and 1500 B.C. Excavations have revealed a well-developed urbanization with street patterns laid out axially and served by sewage systems. It was then apparently an irrigated region rich in agriculture and pasturage, but even by the time of Alexander the Great it had become the arid place it is today.

From these Indus valley sites come human images that seem already to possess a quality that characterizes later Indian art: naturalism tempered by sensuousness. Two fragmentary statuettes from Harappa exemplify these qualities. In the first of these (fig. 92), the nude torso is fully modeled with

92. **Nude Male Torso,** *from Harappa. Indus culture, third to second millennium B.C. Red sandstone. Height 3 ¾". National Museum, New Delhi*

a soft fleshiness that reminds one of the Indian ideal that the human form appear inflated—filled with breath, which was regarded as a fundamental principle in all animate things. This, through the discipline of controlled breathing, was a part of the practice of yoga, and there is evidence from the Indus valley civilization that the practice may have had its beginnings at that early date. The curious drill marks at the shoulders of this statuette have been the subject of considerable speculation. Perhaps they were intended as sockets for attaching a movable pair of extra arms (anticipating the many-armed images of a later date?), or they may represent some symbolic mark or serve as places for attaching an emblem. The second of these small stone figures (fig. 93) twists on its axis, perhaps in dance. The soft, swelling form is present here, too, but the dominant emphasis is on its organic movement. A small copper figure (fig. 94) from Mohenjo-Daro, although different in style, is, like the other

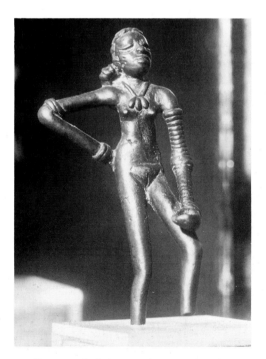

93. Nude Torso, *from Harappa. Indus culture, ca. 2400–2000 B.C. Gray limestone. Height 3 ⅞″. National Museum, New Delhi (Frederico Borromeo-Scala)*

94. Dancing Girl, *from Mohenjo-Daro. Indus culture, ca. 3000 B.C. Copper. Height 4 ¼″. National Museum, New Delhi (Frederico Borromeo-Scala)*

two works, basically a naturalistic image, a lean form that projects a remarkable natural vitality reinforced by particularized features and expression. Its negroid character suggests a relationship to a negroid strain found today in south India where these people probably migrated under pressure from Aryan invaders in the northwest. These three works collectively express two aspects of Indian figural art: the inner animation of the body mass and the outer manifestations of movement, altogether a counterpart of the energy that was presumed to flow through the animate natural world.

The aspects of Indian figural art reflect an old view of nature that emphasizes its procreative vitality, effectively symbolized in two human forms: the *yaksha*, a male nature spirit associated with trees and the wealth of things from the earth; and the *yakshi*, his female counterpart embodying the fertility of vegetation. These spirits were worshiped as powers promoting the procreation of children and flocks. In a *yakshi* from the East Gate of the Great Stupa at Sanchi (fig. 95), the distinctive aspects of the earlier Indus valley statuettes seem to have been preserved and joined in an image symbolizing the eternal unity of all life through the conjunction of sensuous human form and lush vegetation. The *yakshi* and the tree are separate entities, yet the trunk and the branches of the tree and the limbs of the female spirit are similarly formed, as of the same substance, and the *yakshi* herself forms a branching rhythm like the tree to which she clings in symbolic sensual interlacement. One form echoes the other, and the two entities become one.

The *yakshi's* body proclaims its lovemaking and life-bearing capacities, hearkening back to more ancient fertility images, just as representations of the female figure in subsequent Indian art echoed the *yakshi's* voluptuous form. Some one thousand years later, in the figure of a celestial beauty (fig. 96), the spirit of the *yakshi* image is still evoked, but in a style that has refined the rhythms of the older form into a supple, spiraling movement of the body and a delicate linear treatment of the dress and ornament. The sculptor understood well the erotic effect of a device like the rippling draperies that cross the girl's elegant back. Viewing such

96. *(below)* **Celestial Beauty,** *from Parshvanatha Temple. Indian, ca. 1000. Sandstone. Height ca. 48″. Khajuraho, India*

95. *(above)* **Yakshi,** *from the East Gate of the Great Stupa, Sanchi. Indian, early Andhra period, first century* B.C. *Sandstone. Height ca. 60″. Eliot Elisofon, Time-Life Picture Agency,* © *Time Inc.*

works as these, one can appreciate the charming Indian tradition that has certain trees flowering at a young woman's embrace, at the touch of her foot, at the sound of her music or dancing, even at her glance.

Nature spirits like the *yakshi* are common in the imagery of Hinduism, as are zoomorphic deities like the elephant-headed Ganesha and Hanuman, the monkey-god. These divinities seem to have their origins in the pre-Aryan Dravidian culture of India, whose deities mingled with the gods from the Veda scriptures and later sacred writings of the Aryan conquerors to form the body of Hindu polytheism. The veneration of animals—still surviving in the sacredness of cattle—and phallic worship were apparently features of the old Indus valley civilization. The erotic strain in Indian art may have its roots there. At any rate, the sensuous strain persisted and the fertility theme was so strong that even the absolute spirituality of Buddhism could not put aside the voluptuous *yakshi*—even the Great Stupa complex at Sanchi, the location of the *yakshi* in fig. 95, is a Buddhist site. It is typical of the imagery of Indian art that the pantheons of gods in the three main religious systems of India—Hinduism, Buddhism, and Jainism—intermingle freely.

In contrast to the earthy fertility cults rooted in Dravidian agricultural society, the Vedic strain in Hinduism brought gods appropriate to the nomadic, chariot-borne Aryan bowmen who poured into India from the steppes: among them, Indra, a warrior-god of the sky and storms; Surya, a solar god who drove his chariot across the heavens; and Agni, a god of fire. As Hinduism developed, many of the old Vedic gods remained, but as lesser figures. Although they were more dramatic personifications than the Dravidian fertility spirits, these Vedic gods were nevertheless manifestations of natural phenomena, too, and the idea of cosmic forces at work eventually became embodied in the Great Hindu Trinity: Brahma the Creator (who later lost his importance), Vishnu the Preserver, and Shiva the Destroyer (fig. 97).

Shiva is a god of contrasts who derives his identity from both

97. Shiva Nataraja (Lord of the Dance). *South Indian, Chola period, eleventh century. Copper. 43 ⅞″ ×
40″. The Cleveland Museum of Art (Purchase from the J. H. Wade Fund)*

Aryan and non-Aryan sources: from the Vedic deity Rudra, a god of destruction, and from aspects of a pre-Aryan divinity who appears on Indus valley seals and who seems to have been both a lord of beasts and an ascetic. Shiva is associated with the asceticism of yogic meditation, but he is also a fertility god whose phallic symbol, the *lingam* pillar, is a common feature in his worship. He is represented here in his role as Nataraja, the Lord of the Dance. Framed by the sun's orb, whose serpentine rim is punctuated by a running pattern of flames that gesture like the god's hands, he dances the cosmic dance, the movements of which represent the eternal round of creation and destruction in the universe. In his outermost right hand he holds a drum, symbolizing creation by evoking the very first vibration of sound in the universe; in his outermost left hand he holds a flame, the symbol of destruction. The other right hand gestures in reassurance that there need be no fear of existence, while the left hand points to the raised foot, a symbol of release from the endless cycle of existence, the ultimate goal. It is as if an entire cosmology arising from the forces of nature were summed up in this one symbolic image.

Sometimes the image of Shiva absorbs the entire Great Trinity into his own identity, as in his threefold appearance as Mahesha, in which each of his three countenances represents a different aspect of the Great Trinity: a fierce destroyer, a serene preserver, and a feminine aspect—fertility and creation.

The manifold energy of the universe, embodied in the concept of the Great Trinity of Hinduism and symbolically defined in the image of the dancing Shiva and in his Mahesha form, is present everywhere in Hindu art. The temples (fig. 98) are richly endowed with manifestations of it, for there is something that savors strongly of the earth in the pronounced stratigraphy of their mountainous clusters. The temples' sides, layered like the record of millennia of geologic time, are heavily encrusted with statuary, reliefs, and architectural ornament as if the procreative energies of all nature were concentrated there, spinning out life in successive generations.

98. **Kandarya Mahadeva Temple,** *Khajuraho, Bundelkhand. Indian, ca. 1000. (Federico Borromeo-Scala)*

99. **Descent of the Ganges,** *from Mahamallapuram. Indian, Pallava period, ca. 625–74. Granite. ca. 28′ ×
84′. Eliot Elisofon, Time-Life Picture Agency,* © *Time Inc.*

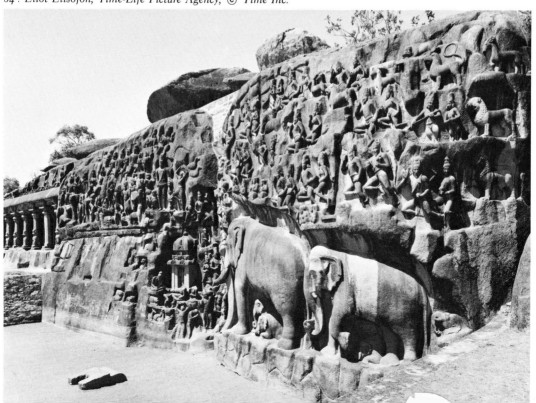

This relationship to the earth seems to be stressed over and over in Indian art; so many of its sculptural and architectural monuments are carved from the living rock. At a former great pilgrimage site on the Indian Ocean, Mahamallapuram, one of the world's most impressive sculptures (fig. 99) is carved out of a granite outcropping over twenty feet high. It represents the *Descent of the Ganges,* and during the rainy season, when waters collect in a pool at the top and then overflow, they stream over a dammed-up cleft in the rock and cascade down a central passage in the sculpture—an activated manifestation of the Ganges itself. The face of the stone is alive with what could be described as a microcosm of the Hindu world—river spirits, elephants and other creatures, gods, and men—all congregated at the sacred river. The huge relief is not composed, in the Western sense, but seems to derive its patterns from the natural surfaces of the rock; with but a nudge of the imagination, one can envision the entire throng as growing right out of the stone, a spontaneous expression of the procreative powers of nature, a tangible image signifying the inexpressible but omnipresent energy of that divine spiritual realm where, for the Hindu, true reality exists.

Chinese Painting: Man in Nature

One feature of the "new" China that often strikes observers from the Western world with disturbing force is the degree to which the Chinese people seem to have submitted willingly, even happily, to the overriding presence and purposes of the state. The homogeneous honor guard for visiting dignitaries at the Peking airport marching in precise formation, no one taller than his neighbor; the squads of young people sweeping and scraping a thin snowfall from the streets; the markings on the great square in Peking for neatly assembling the masses of people at public events; the uniformity of costume—these are all highly visible reminders of the reach and depth of a way of life about which Americans, at least, have had only vague and half-believed notions. Yet, viewed in the perspective of China's long cultural heritage, is this "new" order a pattern unique to the China of our time only? To answer question with question, was there not in China from very ancient times, evidenced in its philosophy and social codes and mirrored in its art, a spirit of attunement to—even submergence in—a larger entity than the self? Is it not worth noting, too, that from very ancient times the Chinese people have lived close to the land as an agricultural peasantry submissive to the all-enveloping cycles of life and the seasons? The larger entity seems to have been there from early times: in the way of Tao that accepted nature, its order and chaos alike, and a life in harmony with its ebb and flow; and in another system, Confucianism, likewise concerned with man's relation to the scheme of things in the world around him, but more in terms of the world of human affairs, emphasizing harmony in human society, achieved by orderliness and authority, for which obedience was the guiding principle. This submergence of the individual in a larger entity therefore transcends sociopolitical configuration, for it is something deeply entrenched in Chinese tradition. From the present entity of the state, it hearkens back to the older entity of the family, and—in a realm quite apart from that, in Taoism—to a belief in a universal unity underlying all the variety and transience of the physical world. The way of Tao was a path of spiritual detachment from materiality, moving passively in the stream of existence, bringing its adherent into spiritual communion with the fundamental rhythm of nature. In the old

Chinese context, man did not have dominion over nature—seeking, as in the Western world for centuries and in a China now moving into the nuclear age, to subordinate nature to human will—but instead sought harmony with it out of reverence for its sacred order.

In such a relationship between man and nature, ritual played an important role in bringing the patterns of human life into consonance with the natural order of things. Since the art of landscape painting developed in China as a manifestation of this relationship, it was in itself a ritual of sorts. It involved preparation. The Chinese painter did not work directly from nature like the French impressionists but, through contemplation of nature, gathered to his inner consciousness a refined archetypal image of the natural world which he drew upon when he painted. It was incumbent upon him that he travel through nature and contemplate its spirit and general character, the changing seasons and times of day, thus comprehending both its fleeting and its eternal aspects. Then he was prepared to work.

It is clear from the literature that landscape art in China began in pre-Han times, and from the evidence on tile decorations it must have been well advanced during the Han dynasty, which lasted from the end of the third century B.C. until the early third century A.D. The character of now-lost landscapes from the Six Dynasties period (around the sixth century A.D.) may be reflected in a finely carved sarcophagus (fig. 100) believed by some to belong to this era. It contains many landscape elements incised in the stone—several varieties of trees, fantastic rock formations, clouds—but these do not constitute an independent landscape, for they are subordinated to scenes representing examples of filial piety, Confucian in origin. Although the landscape moves around the scenes carrying the pious messages, its continuity is interrupted by the vertical barriers of the trees and the architectural forms. It is by no means a primitive work but implies a long development with some features traceable to Han and even late Chou times.

The growth of painting from Han times on was probably stimulated by the flowering of calligraphy at the end of the

Han era that produced a freer form than before, a cursive script, boldly stroked (fig. 101). Calligraphy is closely linked to Chinese painting not only because the painter belonged to the class of scholars who were, in effect, the custodians of the complicated system of writing, but, more importantly,

100. **Sarcophagus Engraved with Stories of Filial Piety,** side. *Chinese, Six Dynasties period, ca. 525. Engraved gray stone. 24 ½" × 88". Nelson Gallery, Atkins Museum, Kansas City, Missouri*

101. **HAN YÜ. Song of the Stone Drums,** *cursive script, part of a hand scroll. Chinese, Yüan dynasty, ca. 1300. Ink on paper. 40 ¾" × 81 ¼" (entire). Collection of John M. Crawford, Jr., New York*

because brushwork was a fundamental aspect of the painting art, and the brush that wrote was also the brush that painted. Thus, the personal style of the artist became, quite literally, his "handwriting."

During the T'ang dynasty, from the seventh to the tenth century, painting developed to a point that Chinese historians consider a golden age of the art; by the time of the Sung dynasty, beginning around 960 and lasting until 1279, landscape painting, which provides us with the best evidence of the Chinese experience of nature, had become an art of primary importance.

The Chinese master of the early fifth century who is credited with saying that landscape painting is a significant art because landscapes have material existence and yet touch the realm of the spirit was observing a truth that could even apply to some aspects of landscape art in the Western world. But the realm of the spirit has special significance in the landscape painting of China.

The first of Hsieh Ho's *Six Canons of Painting* (ca. 500), an important document in the history of Chinese art, has been variously transcribed as "spirit resonance" or "spirit harmony" and can be understood as something akin to empathy ("in-feeling"), a sympathetic enmeshment of the artist with the vitality of the natural world around him so that his own spirit is infused with it and absorbed into it. This mutual absorption of the artist's vitality with the energy of nature is his real mission. The work of art itself is but the record of the experience and a vehicle through which others can partake of the artist's inspiration within the enveloping presence of nature. The Chinese landscape, then, as it had developed by Sung times, presents an image of the visible world tempered by the inspired harmony attained when the artist's spirit is fully attuned to the cosmic spirit. For the Chinese sensibility this was a transcendent truth. It has been said that what the Chinese landscapist painted was not, strictly speaking, a scene, but a state of awareness; yet the essential character of various kinds of

trees, rocks, mists, the flow of water, and the grasp of roots was not denied in the process.

Hsieh Ho's *Six Canons of Painting* affirmed, as a second principle, a structural method in painting that was based on the use of the brush; the third and fourth principles clearly endorsed a degree of naturalism by emphasizing fidelity to the object being depicted and conformity to kind in the application of colors; the fifth principle, like the Western concept of pictorial composition, stressed proper planning in the placement of elements within the picture; and the sixth principle advocated the practice of copying the masters of the past, a part of the discipline of mastering one's own art (a practice frequently encountered in the Western world) and a means of preserving continuity with the past.

Hsieh Ho's sixth canon points to a troublesome issue in the history of Chinese painting: the question of whether one is dealing with an original, a contemporary copy, or a copy of a later date. It has a rough parallel in the Roman practice of copying Greek originals, now lost and known to us only in the Roman versions. Likewise, many renowned Chinese masters of the earlier periods are known only through copies, which may be so close to the originals in date or presumed style and of such good quality as to raise complicated aesthetic issues. It will suffice here to note that the notion of originality as a factor in determining the quality of a work of art did not carry, in Chinese tradition, the weight it has borne in recent Western art. What counted was that the painting represented the artist's realization of the harmony in nature through a consonant image of it in his work, not his personal view, even though the individual painter's brushwork came to be appreciated.

An important painter of the Northern Sung dynasty, Kuo Hsi (1020–ca. 1090), noted in his essay "Advice on Landscape Painting" that the natural world is large and therefore properly contemplated only from some distance, an observation in keeping with representations of great expanses in Sung landscapes of the time. Spatiality in Chinese landscapes was achieved chiefly through a series of overlapping

land forms—strips of land, patches of trees, hills, mountains —piled up and back in space and through the gradual fading and diminution of objects as they lie farther away. In the hand scroll, another aspect of spatiality is encountered in the pronounced horizontal extension of space along the length of the scroll. The hand scroll, like a motion picture, must be experienced in the dimension of extended time, for the picture, sometimes several feet in length, is unrolled from right to left a small section at a time. The viewers—hardly more than two or three, conveniently—"travel" through the landscape as it unfolds before them.

Kuo Hsi spoke of landscapes fit to walk through and to contemplate, and those fit to ramble in and to live in, in that ascending order of excellence. The landscape, then, was not something to be contemplated solely from the illusory distance imposed upon it by the artist, but a thing to be figuratively entered and experienced in detail as well.

Kuo Hsi defined three general types of spatiality in Chinese landscapes. The first, *kao yüan* or "high distance" (see fig. 104, p. 146), is that which stresses the height of mountains, as if one were looking up at them, a type particularly suited to the hanging scroll which is displayed vertically, the entire composition revealed at once, unlike the experience of the hand scroll. In this *kao yüan* type, the long plunge of a waterfall may emphasize the mountain height by creating a rising-falling counterpoint. The second type of spatiality, *shên yüan* or "deep distance" (fig. 102), is a progression from foreground to background, weaving through successive mountain ranges toward a high, far distance. Since the repetition of the planes of the mountains stepping farther and farther back into space is the essential element in establishing depth, the practice of depicting clouds or mists floating between the mountains suggests the possibility of even greater distances simply by their effect of making the intervals ambiguous. The third type, *p'ing yüan* or "flat (level) distance" (fig. 103), is one in which the view is from a nearby elevation, looking across low, flat hills and stretches of water. If mists are employed in the composition, they are properly low, horizontal layers to emphasize the level ex-

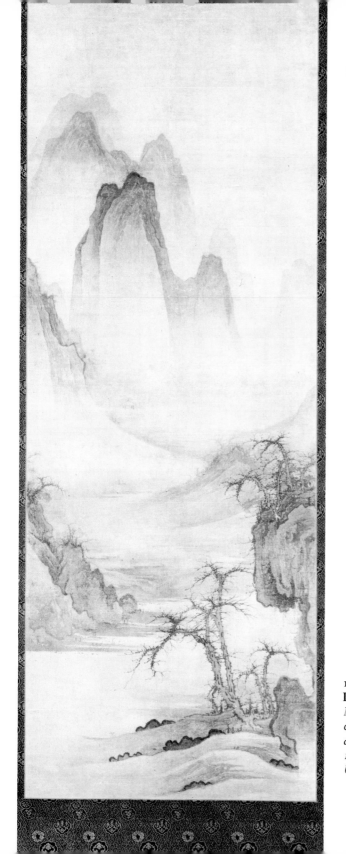

102. **LI KUNG-NIEN** *(attributed).* **Landscape,** *hanging scroll. Late Northern or early Southern Sung dynasty, early twelfth century. Ink and slight color on silk. ca. 51″ × 19″. The Art Museum, Princeton University*

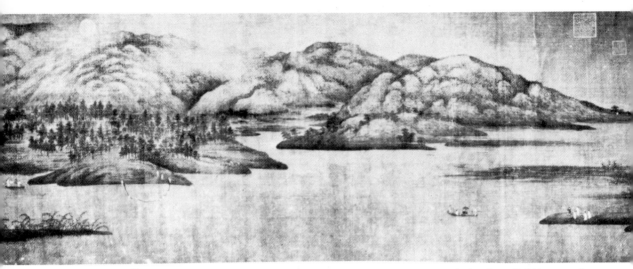

103. TUNG YÜAN (attributed). **Scenery along the Hsiao and Hsiang Rivers,** *part of a hand scroll. Chinese, early Sung dynasty, late tenth century. Ink and slight color on silk. Shanghai Museum*

panses of distance. Additions to Kuo Hsi's triad of concepts were made in the twelfth century, defining landscapes in which there are foreground shores, expanses of water, and distant mountains and those landscapes in which mists and fogs assume more and more importance to the point that they practically dissolve the landscape image. These elaborations seem to be of such a specialized character, however, that they could conveniently fall into the earlier, more general categories. Furthermore, as one surveys the deployment of spatial devices throughout Chinese landscape painting, it becomes apparent that although some paintings may represent with remarkable consistency one of these types of distance, not all are so exclusively conceived. Combinations abound, for these categories were in no sense doctrinaire. There is a problem lurking, too, in our tendency to seek too many parallels in Western art in order to place Chinese landscape within a familiar conceptual framework, a tendency compounded by difficulties in rendering translations of the old Chinese writings on art.

Kuo Hsi opened his essay by noting how virtuous men (in the Confucian sense of being dutiful in meeting their responsibilities to society and the state) loved landscape. Caught up in their duties, they could not wander freely in the mountains and along the streams, submitting to nature's spell—except through an intermediary, the artist. It is as if viewing the picture were a kind of ritual through which the viewer gained sanctuary from the world of busy affairs. There are no bustling courts and cities in Chinese landscapes—only half-hidden pavilions, tiny mountain villages, fishing boats, secluded places. But this communion with nature that was so desirable was more than mere escapism; it had deep spiritual roots and purpose.

These landscapes were, quite literally, "mountain-water" pictures. Mountains were sacred to the Chinese from very ancient times, for in them the powerful forces of nature were deemed manifest. An anthropomorphic image was sometimes evoked by the mountain, with its rocks as the bones, its streams as the veins and arteries of its blood, the trees and grasses as its hair, and the clouds and mists gathering around its heights as its breath. Kuo Hsi spoke of mountains in terms that gave them human bearing of one kind or another, arrogant or dignified, looking around or bowing, or seated with legs spread. These anthropomorphic images, however, should not be construed as indications that the Chinese were literally anthropomorphizing nature, conceiving it in the image of man. Rather, this was a figurative device whose true content lay in the recognition that man was himself a part of nature. The metaphor served to dramatize the vitality in nature shared by man.

In a painting, *Travelers among Mountains and Streams* (fig. 104), by Fan K'uan (fl. ca. 990–1030), the mountain towers over the near distance beyond the foreground mass of rocks and dominates the landscape. It looms up from the mists of the valley, forcing the viewer to scan up its sides, eyes led by the crescendo of layered rocks. In a nicely scaled countermovement, an elegantly defined cataract falls into the mists beyond the roofs of a small village. The angle of vision shifts when looking down to the foreground and near distance,

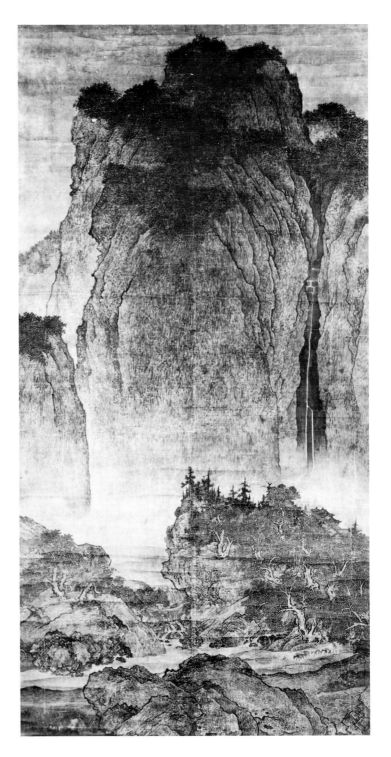

104. **FAN K'UAN. Travelers among Mountains and Streams,** *hanging scroll. Northern Sung dynasty, early eleventh century. Ink on silk. Height 81 ¼". Collection of the National Palace Museum, Taipei, Taiwan, Republic of China*

spotting the small caravan moving in from the right along the bank of the stream. In his imagination the viewer has here world enough to live in, as did Fan K'uan himself; he was apparently a shy man who avoided public life and lived in the mountains close to the natural forces epitomized in his work.

In *Travelers among Mountains and Streams,* Fan K'uan has made use of a pictorial device that was to have a long history of variations in Chinese landscapes: the separation of the successive planes of distance by soft-edged bands of mist formed by the gradual fading out of brush strokes. The ink medium used in such paintings was very flexible, permitting a range of values from a deep, lustrous black to a mere whisper of a tone scarcely distinguishable from the untouched paper or silk. The ink was made from soot and glue mixed into a paste that was then dried into sticks or cakes and ground into ink with water on a slab of metal, fired clay, or stone. The artist could achieve the precise value he required for any passage by skillful adjustment of the amounts of ground ink and water. The entire process, from laying out materials and brushes in preparation for painting, through the ink preparation, to the strokes of the brush, was a ritualized activity. In his essay, Kuo Hsi suggested more than this when he spoke of the preparation: the artist seated peacefully by a bright window before a clean table, incense burning to dispel anxiety. Only when the circumstances were ripe and the heart and hand responsive would his strokes be true.

Kuo Hsi's *Early Spring* (fig. 105) is a remarkable work, mingling attributes of strength and delicacy, simplification and elaboration, the real and the grotesque. The range of values is wide and the brushwork, while asserting its variety, is never forced beyond what is appropriate to its function of delineating specific features of the landscape and defining the general character of this animated image of nature. Compared with the simple monumentality of Fan K'uan's image, with its tripartite division of foreground, near distance, and mountain background expanding upward, *Early Spring* is rhythmically much more complicated and spatially freer. The rocky formations move in a connected series of

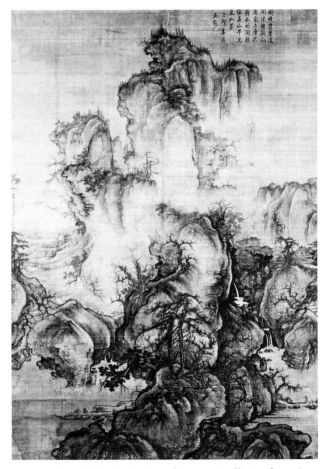

105. KUO HSI. Early Spring, *hanging scroll. Northern Sung dynasty, 1072. Ink and slight color on silk. Height 62 ¼". Collection of the National Palace Museum, Taipei, Taiwan, Republic of China*

jostling masses back to the near distance at the right where a high, misty valley shelters a village, finely drawn, and swing leftward, partially framing a vista where plains spread back to distant mountains. Towering over this writhing spatial embrace, shoulder after shoulder of mountain masses pile up above the path of mist that meanders diagonally across the vertical and horizontal axes of the painting's substructure. The entire landscape is animated in keeping with the imagery in Kuo Hsi's essay. It is not a literal image, nor was it intended to be. It is, rather, the materialization of an experience of mountains and water and space, opening out,

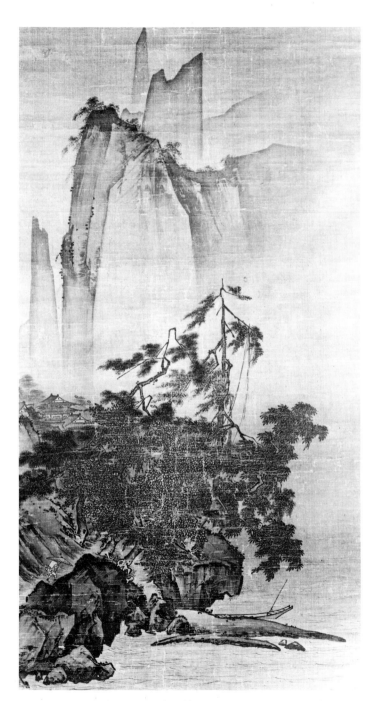

106. MA YÜAN *(attributed).*
Landscape in Wind and Rain,
*hanging scroll. Southern Sung
dynasty, 1127–1279. Ink on silk.
Height 43 ¾". Seika-dō Founda-
tion, Tokyo*

closing in, moving always as one moves in the country, clambering over rocks, seeking footholds and handholds. The fluid expanding and contracting rhythms of the space infuse the image with life, as if it were a breathing thing.

When the Sung dynasty in the north was overthrown by Tatars in 1127, the remnants of the court fled south of the Yangtze, beginning the final, southern phase of the Sung dynasty. During this period a lyrical, atmospheric style developed in which landscape forms seem to emerge from a great void. Its emphases on brushwork, acute angles, and dramatic contrasts of light and dark, as in a landscape (fig. 106) attributed to Ma Yüan (fl. ca. 1190–ca. 1224), were influential in later Chinese painting that emphasized the brush technique over the image. Ma Yüan was one of the principle Southern Sung masters of this lyric style. Called by Chinese writers "one-corner Ma" for his habit of asymmetrical composition, his style is elegant, as in the blade-shaped mountains depicted in *Landscape in Wind and Rain*. Although differing in its marked asymmetry, this painting recalls the structure of the monumental composition of Fan

107. **HSIA KUEI. Pure and Remote View of Stream and Hills,** *part of a hand scroll. Southern Sung dynasty, 1127–1279. Ink on silk. 18 ¼″ × 34′ (entire). Collection of the National Palace Museum, Taipei, Taiwan, Republic of China*

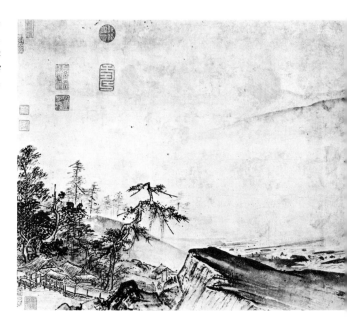

K'uan (see fig. 104, p. 146), but the two lower bands of distance are more compressed, the mountains less solid and massive.

A second Southern Sung lyricist was Hsia Kuei (1180–ca. 1230), whose frequent emphasis on boldly defined forms in the foreground and on floating, misty shores and mountains in the distances imparts to his best works a rhythm suggestive of almost limitless space, as in the example here (fig. 107). The landscape is airy, crisp—a quality reinforced by the spontaneous brushwork—and extensive, for the scroll is some thirty-four feet in length; only a section is shown.

The calligraphic briskness and suggestiveness of the lyric style were factors affecting the Ch'an Buddhist (Zen in Japan) artists who worked in the vicinity of the Southern Sung court, but apart from it. This sect, repudiating such Buddhist formalities as the old texts, rituals, and charms, turned to an intuitive, individual path to enlightenment, with the mind freed of intellectualism but fond of enigma. Truth would be revealed suddenly, unexpectedly. In such an

108. SESSHU. Haboku Landscape, *hanging scroll. Japanese, Ashikaga period, fifteenth century. Ink on paper. 28 5/16″ × 10½″. The Cleveland Museum of Art (Gift of the Norweb Foundation)*

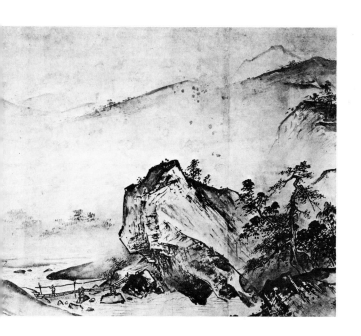

atmosphere, a highly spontaneous style developed, associated with the Ch'an monasteries from which it was exported to Japan, where its influence was strong by the early fifteenth century (fig. 108).

Between the dense tangibility of Fan K'uan's forms and the open passages of Hsia Kuei—an interval of some two hundred years—the Sung art of landscape underwent a series of transformations in which the virtuosity of brush handling assumed greater and greater importance. In the process the vitality of nature, expressed earlier in images that implied an intense contemplation of natural forms, became a vitality expressed through spirited brushwork. The material presence of the natural world began to fade into suggestive notations—disciplined, knowledgeable, but, all in all, manneristic.

5

THE EVOLUTION OF LANDSCAPE ART IN THE WEST

Long before landscape art developed as a distinct genre in the Western world, man was sensitive to the attractions of nature. The art of ancient Egypt and the Near East abounds in visual reminders of his powers of observation and his capacity to record these observations in striking images. But his attention in the visual arts was focused primarily, where the natural world was concerned, on the active creatures rather than on the slow, silent life of plants, the ephemeral dramas of the skies, or the inanimate topography of the earth. Nevertheless, the floras around him and the phenomena that affected their growth had vital meaning for his existence. He recognized this in his rituals and his gods. The grain, the vineyard, the life-giving waters, the sun, and the storm were all, in one way or another and at one time or another, recognized as significant aspects of his environment, sometimes to the extent that they were accorded the status of deity or, at least, were considered manifestations of it. Trees, flowers, and vines also appear in ancient art as decoration (where they may also carry some measure of symbolic content) on architecture, furniture, pottery, and various ornaments; and as indications of locale for figural representations—helpmates to narrative—when depicted in conjunction with streams, hills, and other landscape features.

Landscape art, in its fully developed form, has been as much a matter of spatial extension as a representation of tangible features like trees and rocks and water; and this spatial factor was very long in developing. Man's awareness of the possibilities of organized space antedated his attempts to create the illusion of it on the plane surface of a wall or panel. He used space architecturally (as enclosures, as extended ave-

nues of approach to buildings, or as a factor in site selection) before he acquired the means to create an illusion of space through various modes of projection onto a plane surface. Landscape evolved from simple devices suggesting that one object lay in front of another into more complex formulas involving the diminution in the size of objects, as their distance from the viewer increased, and variations in the clarity and local color of objects as the light falling on them varied in intensity, hue, and direction. To trace this development in detail would overextend this chapter, but some attention must be given here to spatiality in the history of art, since it has played such an important part in the development of landscape painting.

A simple overlapping of objects in reliefs or mosaics (as in figs. 203 and 248, pp. 294 and 342) is one very old means by which spatial extension was at least implied. Another means, already mentioned in the section on the narrative art of Assyria (pp. 108–9), is the device of laying out the spatial field of action like a map, or bird's-eye view, which often effects an illusion of the ground being tipped up toward the viewer when images of men, beasts, trees, or other forms are depicted on it. In such situations images at the bottom of the scene are normally read as being closer to the viewer and as increasing their distance from the viewer the closer they come to the top of the scene. "Higher up" is thus "farther

109. Renaissance Linear Perspective according to the System Devised by Alberti *(after Hartt). A represents the picture area (wall, panel, paper) on which the artist first established a unit for the height of a man, which would determine the position of a horizon line (1). Then the base line (2) was divided into units corresponding to one-third of this height and orthogonals (6) were drawn between these and a vanishing point (4). Then, outside the picture area or on another part of the wall, a "little space" (B) was established with a base line extended from that of the picture and with a vertical (5) equal to the height fixed for the horizon line (1). The base line of this "little space" was then divided into segments equal to those of the base line of the picture space and orthogonals were drawn as indicated. The viewer's distance from the picture was established by the placement of the transversals (3), which were formed by drawing, at any point in the "little space" the artist wished, another vertical (7), intersecting the orthogonals. From these intersections the transversals were drawn parallel to the base line. By this system the entire field of the picture space could be constructed. (Drawing by Eric Spencer)*

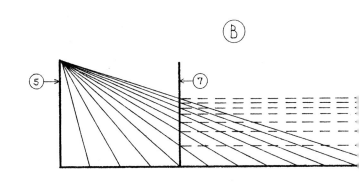

away." These early images of the natural world, however, for all their references to topography and plant life, serve primarily as grounds on which the actions of gods, men, or beasts are depicted. The role of the purely landscape elements is strictly supportive, like a label that identifies the action as taking place out-of-doors.

Two developments were necessary before landscape could evolve much beyond this supporting role or its features beyond mere surface decoration. The first of these was finding a means of spatial projection (fig. 109) that would establish on a plane surface an equivalent for the sensation of *looking through space* at objects disposed throughout it (thus *perspective*, from the Latin word *perspectus*, "see through"). The second was the development of attitudes toward the natural world that would elevate its importance

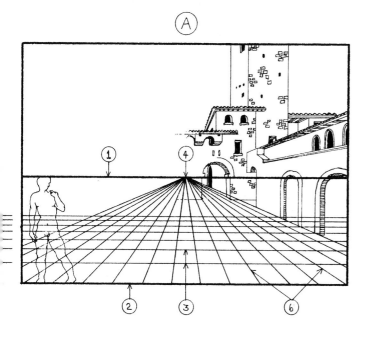

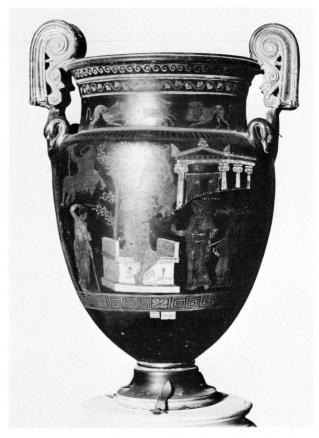

110. **Orestes, Iphigenia, and Pilade,** *red-figured Apulian krater.
Greek, fourth century B.C. Height ca. 24 13/16". National Museum, Naples (Alinari-Art Reference Bureau)*

to the status of a subject in and of itself worthy of replication in serious works of art. Both these developments took some time to mature, and an expansion of the functions of art as well as changing patterns in the practice and patronage of the artist encouraged the process.

In the absence of a surviving body of Greek mural art, it is the vase paintings of the Greeks that give us some indication of the degree to which their artists were concerned with representing the space-occupying properties of objects. There are numerous examples from Greek vase paintings of

such essentially cubic objects as stelae, altars, temples, chairs, and couches whose sides are depicted as receding diagonally. Such devices clearly seek to create an illusion of space-filling bulk; when foreshortening (the extension or projection of objects toward the viewer or away from him) in representations of human figures and horses is added to the other visual evidence from the vases, it seems likely that the Greek vase painter was expanding his purpose of decorating the surface of the pottery to considerations of spatiality and the depiction of what is seen as well as what is known. From literary references to Greek mural and easel painting, it has been assumed that the evidence from the vases reflects practices established in the other areas of painting.

But there is as yet no firm evidence of systematic perspective in ancient Greece like that developed centuries later in the Renaissance. Occasionally there does seem to be some recognition of normal angles of vision, in a general sense, as in the decoration of an Apulian krater in Naples: the altar on which the figure of Orestes is seated (fig. 110; the receding sides of the altar are differentiated from the front by overpainting the front with white, a further enhancement of the object's bulk) is rendered as seen from above, as one normally views a relatively low-lying form, while the temple in the "background" is rendered as seen from below, the normal view of one standing on the ground from which the structure rises. The elementary logic of this juxtaposition of views, however, is not carried out consistently in Greek vase painting. Representations of chairs and couches, for example, are sometimes rendered as if seen from slightly below or from the level of the seat rather than from above, and it would seem that the decorative borders or ground lines on which they stand determine the way in which the bulk of the object is depicted: the legs generally spring from that line. There seems to have been no system based on a fixed point of view.

Topography in these vase paintings is suggested in the most rudimentary fashion: no more than meandering lines (in the Apulian krater, marked by dots) to indicate a rise of ground

or an irregular surface, with the addition of an occasional plant or tree. The basic ingredients of a landscape are there, but in so austere a form that they assume a subsidiary role, barely supportive of the human action that constitutes the real theme of the representation. Nevertheless, all this is a significant development. The Greek painter was clearly cognizant of the possibility of representing bulk and space on the surface of the vessels he was decorating; there are few instances more revealing than this of the problems that were posed by such explorations. This probing of depth led the artist away from concentration on the graceful ordering of forms on the surfaces of the vessels, with the result that many of these decorations seem disjointed and awkward when compared with the earlier black-figured style (see fig. 2, p. 2) that generally went no further than simple overlappings with only occasional attempts at foreshortening.

Landscape features in ancient Egyptian and Near Eastern art and minimal indications of landscapes in Cretan and Greek art hardly constitute an independent genre. Images of the out-of-doors were still subservient to figural representation. Perhaps it was the growing urbanization within Hellenistic and Roman civilizations and the increase in leisure among the upper classes that finally drew attention to the consoling invitations of a nonurban world of meadows, groves, rocky headlands, and open sea. At any rate, there is reason to believe that the development of a landscape art in the ancient Mediterranean world may have been the pictorial counterpart of the romantic responses to nature repeatedly expressed in the Hellenistic verses of Theocritus which celebrate the charms of the pastoral life or in the bucolic poetry of Augustan Rome. Apart from numerous examples of Roman landscape that have come to light in Rome and elsewhere since the first excavations were undertaken at Pompeii and Herculaneum, we have the observations of Pliny the Elder, who remarked the variety of landscape painting produced by one Studius of the Augustan period. This artist decorated the walls of houses with scenes of villas, harbors, landscaped gardens, woods, and hills, introduced figures into these scenes, and developed a taste for depicting seaside towns on the walls of open galleries.

111. **Landscape Vistas Framed by Painted Architecture,** *mural from the cubiculum of a villa at Boscoreale near Pompeii. Roman, ca. 40 B.C. The Metropolitan Museum of Art, New York (Rogers Fund, 1903)*

112a. Destruction of the Fleet of Ulysses, *from the* **Odyssey Landscapes,** *mural from a house on the Esquiline. Roman, ca. 50 B.C., after an original of mid-second century B.C. The Vatican Museums, Rome (Alinari-Art Reference Bureau)*

From the visual evidence presented by Roman wall painting and the literary evidence in Vitruvius's *De architectura* (ca. 25–23 B.C.), in Euclid's *Optics* (ca. 300 B.C.), and in other ancient writings, it is tempting to conclude that sometime between the fifth century B.C. and the Hellenistic era artists in the Greek world had established a rudimentary sort of perspective by which they could construct on a plane surface images of the physical world of solids and voids that was comparable to, but not as systematic as, that which the Renaissance artists later developed. But it must be admitted that this procedure involves considerable interpolation and some speculation, for the visual evidence does not vigorously

support the hypothesis. To be sure, illusions of three-dimensionality and spatial void are strikingly conceived in Roman wall painting (fig. 111), but they lack the internal consistency of a fixed point of view that was central to the Renaissance theories and practices of space projection. It seems more likely that observations of such phenomena as the apparent convergence of parallel lines as they recede into the distance led to rule-of-thumb practices that approximated a system not thoroughly worked out until conditions spawned it in the Renaissance. There are still too many inconsistencies in the spatial construction of Roman wall paintings, as effective as it may be in isolated sections, to establish the existence of a perfectly consistent system at some as yet unknown moment in the ancient world. Admittedly, the possibility is there; but it has yet to be proved beyond doubt.

112b. Odysseus among the Laestrygonians, *from the* **Odyssey Landscapes,** *mural from a house on the Esquiline. Roman, ca. 50 B.C., after an original of mid-second century B.C. The Vatican Museums, Rome (Alinari-Art Reference Bureau)*

What is of significance for the development of landscape painting is the indisputable fact that Roman wall painting shows evidence of an already well-established tradition of representing the physical world as seen through space and utilizing the effect of light falling upon and reflecting from solid objects to enhance their tangibility. There is also evidence that this tradition recognized the possibilities for increasing the illusion of distance through the blurring and fading of solid forms as they recede into the picture's space. This stage of development was a necessary prerequisite for the depiction of landscape, and it is assumed that this may have been an accomplishment of the Hellenistic era.

Whereas the inconsistencies in Roman spatial projection are readily grasped when the firm angularities of architectural forms are the subjects of paintings, they are not so obvious when the artist deals with the looser formations of landscape settings. This is borne out particularly well in the case of the *Odyssey Landscapes* (figs. 112a and 112b). These scenes—eight of them, separated from one another by a framework of simulated pilasters—have the appearance of a continuous landscape viewed as from an open gallery overlooking it. There is a convincing illusion of atmosphere; foreshortenings are numerous, as a figure moves diagonally in space or a ship turns at an angle to the picture plane; and the surface of the sea is clearly defined as a horizontal plane sweeping back toward a distant horizon. The illusion of space is enhanced by the cool, luminous light that creates a soft atmosphere, poetic and dreamlike. This atmospheric ambience can be found in other Roman landscapes, like the wall painting in the Villa Albani, Rome (fig. 113); but here it assumes a special character, as a misty element from which there emerge at intervals and with variable clarity bits of poetic descriptions, like floating islands, fragments of conventional images from bucolic poetry, a passage isolated here, another there, the entire landscape an assemblage of literary vignettes. This art of landscape, which apparently enjoyed some popularity in Roman painting and stucco reliefs, declined with the empire. With the triumph of Christianity in the Roman world, and with Christianity's emphasis on an enduring, unchanging, divine order instead of the transient

113. Landscape, *mural from Villa Albani. Roman, first century. (Alinari-Art Reference Bureau)*

world of physical life and matter, on the vulnerable soul of
man instead of the pleasures of human existence, the soil
from which a true landscape art could grow lay fallow for
centuries. One is reminded of St. John's admonition that
mankind should not love the world or worldly things, those
being at odds with the love of God. Only with the changes
in man's attitudes toward nature that came about by the end

of the Middle Ages did a landscape art reemerge in the Western world.

During the Middle Ages there were, to be sure, representations of aspects of nature, but these were more like emblems of the natural world's presence than replications of its visual relationships, and they were certainly in no way representations of nature for its own sake. Such an attitude would require centuries to develop after the decline of Rome and the subsequent overshadowing of a pagan poetry that had celebrated the beauties of the Italian countryside and the sensuous pleasures of life. Landscape elements in medieval art generally served only to indicate some natural feature essential to complete a sacred image, and such features were only schematically indicated, "coded," as it were. Not until very late in the Middle Ages were landscape features organized as spatially defined stages for action.

Minimal indications of landscape features appear in early Christian times in several religious images, like the dome mosaic in the Orthodox Baptistery at Ravenna, Italy (fig. 114). Here the representation of the baptism of Christ by John the Baptist shows John standing on the rocky bank of a stream whose waters flow in variegated striations over the lower portion of the Savior's body. An old pagan device— a river god—emerges from the waters with an inscription over his head signifying that this is the Jordan. A somewhat earlier mosaic, also in Ravenna, in the Mausoleum of Galla Placidia (fig. 115), depicts Christ in his role of Good Shepherd sitting in the midst of his flock with a more extensive landscape setting around him, a shallow ledge of rocks and plants. Clefts at the edge of the ledge, a few overlappings, and some indications of cast shadows tentatively imply spatiality, but the decorative bias underlying the character of mosaic persists to the extent that the landscape features seem more to fill the areas between figural representations than to define a distinct space.

In a much later work, the manuscript known as the *Utrecht Psalter*, landscape features become an important part of the illuminations of the Psalms, but still in a subsidiary way. It

114. The Baptism of Christ. *Mid-fifth century. Mosaic, inner surface of dome. Orthodox Baptistery, Ravenna (Anderson-Art Reference Bureau)*

115. The Good Shepherd. *425–50. Mosaic. Mausoleum of Galla Placidia, San Vitale, Ravenna (Alinari-Art Reference Bureau)*

is an ingenious use of landscape for what might be termed a nonlandscape function, since the landscape serves merely as an arbitrary means of linking together a series of images, or figures of speech, that emerge from the language of the Psalms. The example shown here (fig. 116) illustrates Psalm 104 (the numbering differs in the psalter). The psalmist addresses the Lord, "who walketh upon the wings of the wind" and is depicted accordingly—standing on the four winds, clustered like a small cloud. The stream flowing out of the hills at the left gives "drink to every beast of the field: the wild asses quench their thirst." And so two braying asses appear by the tree, which in turn represents "the cedars of Lebanon . . . where the birds make their nests." "The high hills are a refuge for the wild goats," one of whom rears up to nibble on a branch at the right. Below, "young lions roar after their prey," and at the left, by the curve of the stream, "man goeth forth unto his work"—a plowman with his oxen. The cursive strokes that define the rocky landscape seem charged with energy, as if the emotion of the psalmist were transmitted directly to the artist's hand (cf. fig. 268, p. 375). The undulating, tree-capped rocks recall Roman landscapes and stucco reliefs from which these illuminations probably derive through the intermediary of some late fourth- or early fifth-century manuscript prototype. The landscapes of the *Utrecht Psalter* thus represent one of those survivals of the classical tradition that emerged persistently throughout the Middle Ages. Even the tiny figures, although nonclassical in their impetuosity, have been compared to the diminutive figures that inhabit the *Odyssey Landscapes* (see figs. 112a and 112b, pp. 160–61). Drawn in pen with bister (a brown pigment extracted from wood soot), these illustrations have the appearance of an agitated calligraphy reflective of a highly personal style.

For the most part, landscape features in medieval painting until the fourteenth century are minimal and merely symbolic—the walls of a town, a rolling ground line, a tree or two, will suffice. In the *Souvigny Bible* (fig. 117) of the late twelfth century, the illuminations depicting the life of David, mixtures of Romanesque and Byzantine elements, contain in their compacted compositions a few decorative allu-

116. Illustration to Psalm 104, *from the* Utrecht Psalter. *ca. 820–32. Manuscript illumination. ca. 10 4/5″ ×
9 4/5″ (entire page). University Library, Utrecht*

117. Scenes from the Life of David, *from the* Souvigny Bible.
*Late twelfth century. Manuscript illumination. ca. 22″ × 15 ⅜″
(entire page). Bibliothèque Municipale, Moulins (Giraudon)*

118a. AMBROGIO LORENZETTI. Good Government *(first part). 1338–40. Fresco. Palazzo Pubblico, Siena* *(Anderson-Art Reference Bureau)*

sions to landscape filling the interstices between figural representations but suggesting, in the scenes of David killing the lion and David battling Goliath, a latent sense of the function of landscape as a field for human action.

It would require a renewal of the old Roman sensibility to the presence of nature and the gentle St. Francis of Assisi's (1182?–1226) awareness of it to turn European eyes again toward the natural world as something to be savored for its own innate charms. The poets and philosophers of an ascendant humanism were to play an important role in this transformation.

118b. AMBROGIO LORENZETTI. Good Government *(second part). 1338–40. Fresco. Palazzo Pubblico,
Siena (Anderson-Art Reference Bureau)*

The Italian poet Petrarch, probably more than any other
figure from the late Middle Ages, symbolizes the loving
contemplation of nature that is one of the prerequisites for
the rise of landscape art. From his youth he cultivated a love
of country places that found expression in his poetry as he
matured. His ascent of Mont Ventoux, when he was in his
early thirties, has sometimes been cited as evidence of a shift
in values toward an appreciation of nature for its own sake
and the initial phase of a modern view of the natural world;
but that adventure, alas, seems to have been inspired not by
nature itself but by his reading in Livy that Philip of Mace-
don had once climbed a mountain for the view. Petrarch's
own account of the ascent of Mont Ventoux is laced with
reflections on his sins, climaxed by reading on the summit

a passage from St. Augustine's *Confessions,* which he happened to have with him and which made him angry with himself—he tells us—for admiring the things of this world. More to the point as evidence of Petrarch's genuine love for the attractions of the physical world, and reminiscent, too, of Roman lyrics, is a poem *(Canzone L)* he wrote a few years later in the village of Capranica on his way to Rome, a poem full of sensitive responses to the Italian landscape, even though it was then a troubled, dangerous countryside full of human violence. That he was receptive to the attractions of nature, although a nature that had long felt the hand of man as tiller of the soil and keeper of flocks, and wove his perceptions publicly into his verse is one bit of evidence that the climate for the development of a visual art focused on the natural world was at least beginning to form. Indeed, it was already bearing fruit in Siena, although an appreciation of a true wilderness landscape had to wait for much later generations.

A fresco by the Sienese artist Ambrogio Lorenzetti (d. 1348), *Good Government* (figs. 118a and 118b), is an important landmark in the history of landscape painting. It is a daring composition for its time, an encyclopedic image of Siena and its countryside that invites the viewer to explore the streets of the town and wander through fields and groves outside the walls. It is remarkably specific in its representation of the town and countryside, which is very much like that still to be seen along the small roads that wind among the hills in the vicinity of Siena; and the sense of space is vividly, if unsystematically, conveyed to the viewer. Both the town and the countryside are rendered as environments for human action, and the countryside is plotted like a three-dimensional map. The fresco's allegorical message is clear: peace and prosperity are the twin fruits of good government. The figure of Securitas, airborne over the city gate and bearing an explanatory scroll, while almost superfluous considering the obvious message in the sister fresco representing the consequences of bad government, is a reminder, nonetheless, of the secondary role landscape features had traditionally played in medieval art. But pride in the town and love for its environs are here primary ingredients in the

image, which takes the viewer a step beyond allegorical content to a contemplation of the surroundings for the felicity they project in and of themselves. The neat internal logic of Renaissance perspective lies a century in the future, but the sense of place—indeed, a fascination with it—and the spaciousness of the landscape are compellingly presented in this fresco. In many respects this painting can be viewed as a reemergence of features found in Roman painting: the schematic piling up of architectural forms and the high angle of vision characteristic of many Roman landscapes.

For the most part, however, the landscape of the late Middle Ages is still subordinate to human action, as in the work of both Duccio di Buoninsegna (fl. 1278–1318) and Giotto di Bondone (ca. 1267–1337). Duccio, like Lorenzetti a Sienese artist, shares the latter's love of landscape detail (fig. 119), but never to the extent of detracting from the action for which it is the stage. Giotto's landscape (fig. 120) is more austere and summary in execution, closer to earlier medieval practice in this respect but otherwise advanced in the authority with which it creates a convincing, if narrow, stage for action, viewed from the level of the participants in the drama depicted and relatively close to them. Thus, the figural representations gain emphasis at the expense of the setting. There is a more even-handed balance between figures and setting in Duccio's work.

At this point it is worth mentioning the presence of fully developed landscape painting in Islamic art during the same century (fig. 121). There is evidence that Muslim writers were acquainted with Chinese painting and that, even before the rise of Islam, Arab traders had made contact with the Far East. With the Mongol invasions of the thirteenth century, the Far Eastern influence was more keenly felt, and Persian illuminated manuscripts of the fourteenth century, like the example illustrated here, show clearly the impact of Chinese landscape painting, which, as we have already seen (pp. 141–52), was a remarkably accomplished art during the Sung dynasty (960–1279). Whether knowledge of these Eastern traditions had reached medieval Europe during the

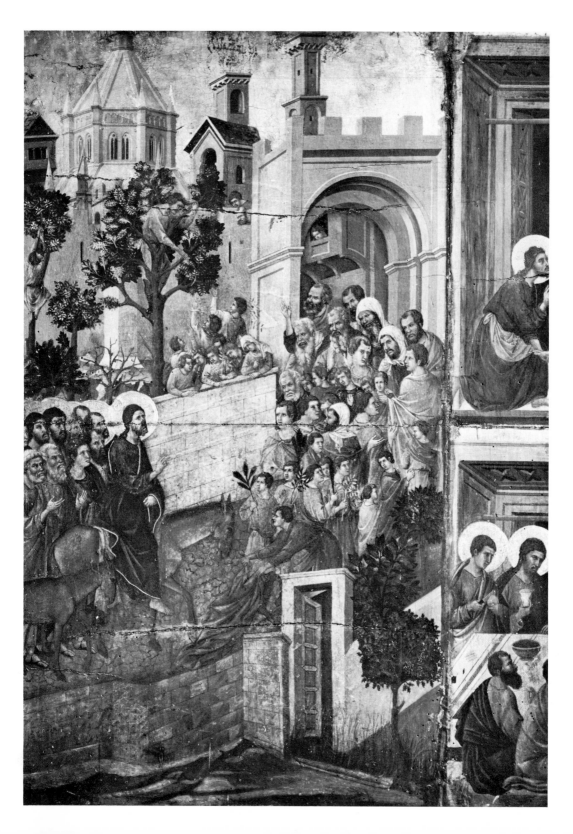

120. *(left)* GIOTTO DI BONDONE. The Flight into Egypt. *1505–6. Fresco. Arena Chapel, Padua (Alinari-Art Reference Bureau)*

121. *(right)* Summer Landscape, *from* Album of the Conqueror *(Sultan Mohammed II). Mongol, mid-fourteenth century. Topkapi Saray Museum, Istanbul*

119. *(opposite)* DUCCIO DI BUONINSEGNA. Christ Entering Jerusalem, *from the back of the* Maestà Altarpiece. *1308–11. Tempera on wood panel. 40⅛" × 21⅛". Duomo Museum, Siena (Alinari-Art Reference Bureau)*

era of the Crusades and contributed to the development of landscape painting in the West is an open question.

The depiction of landscape developed rapidly in Italy and the north during the fifteenth century, but still as a setting or background for figural representations. In the illuminated manuscript *Les Très Riches Heures du Duc de Berry* (fig. 122), executed by the Limbourg brothers for the duc de Berry between 1413 and 1416, landscape plays a prominent supporting role of this kind while simultaneously asserting its presence as a well-defined environment. The content remains essentially medieval: its connection with the activities of the seasons links it to Gothic allegorical reliefs depicting the cycle of labors associated with the months of the year, from plowing and planting to harvest (see fig. 400, p. 525, and colorplate 7). But the landscape portions of these illuminations are developed beyond mere emblematic purpose and approach the character of true landscapes. Visually the work seems to belong to a new era of painting in which the natural world is enthusiastically observed and recorded.

The paintings of early Netherlandish artists contain many landscape passages rich in minute details, like the view through the arcade in *Madonna with Chancellor Rolin* (colorplate 6) by Jan van Eyck (ca. 1390–1441). The skill with which van Eyck renders the crystalline hardness of gems or the sheen of embroidered draperies is extended to the delineation of the material aspects of the commonplace world, even though the content of the paintings may be religious, proclaiming an otherworldly reality. The landscape portions of such works imply a new vision that looks outward to the world and begins to appreciate the uniqueness of places, as Konrad Witz (ca. 1400–1447) of Basel did when he painted an altarpiece for the cathedral at Geneva in which *The Miraculous Draught of Fishes* (fig. 123) is depicted as taking place along the shores of Lake Geneva.

While the visual evidence from the art of the fifteenth century indicates an increasing response to the presence of the natural world and the desire to render its features convincingly, other factors also made their contributions to the

122. THE LIMBOURG BROTHERS. October, *from* Les Très Riches Heures du Duc de Berry. *1413–16. Manuscript illumination. 11 7/16″ × 8 ¼″ (entire page). Musée Condé, Chantilly, France (Bulloz-Art Reference Bureau)*

development of landscape painting. During the fifteenth and sixteenth centuries, landscape gradually became disengaged from its subservient role as an embellishment to religious, mythological, allegorical, and portrait subjects. That is not to say that it gained absolute independence as a specialized genre, for it continued to serve in its traditional capacity. But, degree by degree, it began to acquire an independence that led eventually to paintings that would be

123. KONRAD WITZ. The Miraculous Draught of Fishes. *1444. Tempera on wood panel. 51″ × 61″. Museum of Art and History, Geneva (Marburg-Art Reference Bureau)*

"pure" landscapes freed of their bondage to older themes. In the process, it has been suggested by some scholars, numerous influences played important roles.

In the late medieval workshops, there was often a division of labor, some artists concentrating on the figure, others on the backgrounds, still others on still life details, draperies, and so on. After the breakup of the medieval workshop

tradition and the concomitant widening of patronage, the market opened to specialists in the various categories once subsumed by the old workshop arrangement. This process seems to have been most pronounced in the Low Countries and Germany between the fifteenth and seventeenth centuries, where it coincided with the growth of a rich merchant class with materialistic interests—thus the frequently cited relationship between landscape painting and middle-class taste. But it has been pointed out that Italy, too, was important in the development of landscape painting, there being a good market south of the Alps for northern landscapes—leading Giorgio Vasari to remark in 1548, in a letter to Benedetto Varchi, that there was not a cobbler's house without a German landscape. How advanced pure landscape had become in the north as early as the last decade of the fifteenth century can be seen in a work (fig. 124) by Albrecht

124. ALBRECHT DÜRER. Mills on a River Bank. *1495–97. Watercolor and gouache on paper. ca. 9⅞″* × *14 7/16″. Bibliothèque Nationale, Paris*

Dürer (1471–1528), one of many fine landscapes from his hand in addition to those that appear in the backgrounds of his paintings and graphic works.

A popular notion that landscape painting in Europe was born in the Low Countries—one eminent writer remarking that landscape is a romantic art (a reasonable assertion within limits) invented by a lowland people who had no landscape of their own—ignores the Roman tradition, its lingering echoes during the Middle Ages, and the positive contributions of Italian and German artists. The allegation that Netherlanders had no landscape of their own is surely denied by what Dutch artists made of their own expanses of fields and skies in their landscapes of the seventeenth century.

The Italian contribution was both direct and indirect—direct, in that landscape features, particularly in Venetian painting, soon asserted their presence to the extent that one could speak of any number of paintings as being essentially "landscapes with figures" (see fig. 127, p. 182, and colorplate 7); indirect, in that the Italian invention and application of perspective systems was of considerable consequence for mastery of the illusion of spatiality in painting, one of the essential contributions to the development of landscapes.

Italian developments in rendering landscapes can be briefly sketched by citing a series of works ranging in time from the mid-fifteenth to the early seventeenth century. The Florentine artist Benozzo Gozzoli (1420–97), in his frescoes for a chapel in the Medici-Riccardi Palace in Florence (fig. 125), depicts a *Procession of the Magi* in which some of the figures are undeniably portraits and may represent members of the Medici family and one, possibly the Byzantine emperor John Paleologus (who is not in the section shown). They process on foot and horseback, with asses and camels bearing loads of gifts, through a tapestrylike landscape assembled from conventionalized trees and rock formations, piled up, layer after layer, to distant mountains. It is an idealized landscape—a garden world—and for all the fragments of reality that surface here and there, it is essentially unreal. Only in the gap of space beyond the spur of the high

125. BENOZZO GOZZOLI. Procession of the Magi. *ca. 1459–63. Fresco. Medici-Riccardi Palace, Florence (Alinari-Art Reference Bureau)*

land at the right does the landscape abandon its vertical layering and stretch out horizontally into space.

Toward the end of the fifteenth century, the Venetian painter Giovanni Bellini (ca. 1430–1516) painted his *St. Francis in Ecstasy* (colorplate 7), in which the saint, in front of an arbored cave entrance, looks up at an olive tree that bends toward him. The landscape stretches back to the hills; everything is rendered with remarkable clarity of detail, almost Netherlandish in its attention to the minutiae of the natural world and the architecture on the far slopes. It is a constructed landscape like that in Benozzo's painting, but the details are rendered so naturalistically that the resultant ensemble acquires a particularity absent in the earlier Florentine work. Although the space recedes by a series of overlapping sequences not unlike Benozzo's composition, the horizontal penetration into space is quite pronounced. The underlying geometry of Italian Renaissance perspective is explicit in the arrangement of the arbor and in the structure of the desk and implicit in every mass of rock and in the various ground levels. The remarkable visual appeal of this work lies in the artist's control of space and love of surface, balanced evenly against each other.

At about the same time Giovanni Bellini was painting his *St. Francis in Ecstasy*, Leonardo da Vinci (1452–1519) was at work on the Louvre version of *The Virgin of the Rocks* (fig. 126) which joins to its design a landscape of quite another order—a fantastic geology that blends the mysterious shadows of grottoes with an equally mysterious luminosity falling on the sacred triangle of figures in the foreground and shining out through the openings in the rocks from some indeterminate distance. However much these rock formations prefigure Leonardo's scientific interest in geology and may reflect his observations of Italian stone quarries, they persist in our consciousness as the creations of a fanciful imagination and would not seem foreign to the romantic era some three centuries in the future.

No painting of the Italian Renaissance is more redolent of

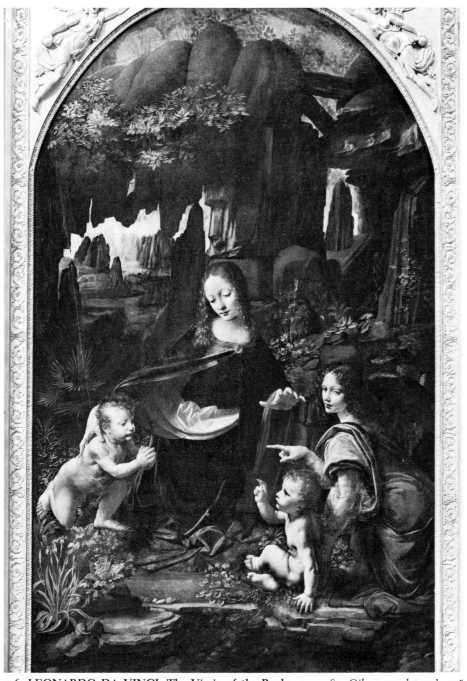

126. LEONARDO DA VINCI. The Virgin of the Rocks. *ca. 1485. Oil on wood panel. 75″ × 43 ½″. The Louvre, Paris (Alinari-Art Reference Bureau)*

moody nature, more romantic in tone, than a relatively small Venetian canvas of the early sixteenth century, *The Tempest* (fig. 127) by Giorgione da Castelfranco (ca. 1475–1510). The curious arrangement of foreground figures who frame the intimate landscape vista—a soldier looking across a dark stream toward a nude woman nursing an infant—has elicited numerous attempts, none conclusive, to decode the meaning of the scene. X-ray photographs show that Giorgione originally painted a nude woman bathing where the soldier now stands, a fact that only lends further confusion to the iconography. The figures may have no precise meaning; they may be simply "there," adding their human presence to this portrayal of one of nature's moods. There is a pervasive atmosphere, heavy with the unearthly light one often observes just before a summer storm breaks. The buildings beyond the little bridge gleam with a subtle phosphorescence echoed intensely in the flash of lightning from a rolling cloud. Light from a still unobscured sun somewhere off to the left of the picture's space catches the leaves of trees against the darkening sky of the storm front. Whatever the figures in the foreground may or may not signify, the dominant sensation is nature's own. The poetic mood the painting projects is not entirely a fiction, for it is a sensitive record of a natural phenomenon.

127. GIORGIONE DA CASTEL-FRANCO. **The Tempest.** *ca. 1505. Oil on canvas. 31 ¼" × 28 ¼". Galleria dell' Accademia, Venice (Alinari-Art Reference Bureau)*

Another facet of the Venetian contribution to landscape painting can be seen in the landscape portion of *Venus and the Lute Player* (fig. 128), which Titian (1487–1576) arbitrarily set off from the rest of the picture space. Distance here is achieved not so much as a factor of perspective construction as by modulations of color and light and increasing indistinctness of forms as space deepens, an approach of special significance for later landscape painting down to the impressionists of the nineteenth century. The

128. **TITIAN. Venus and the Lute Player.** *ca. 1560–65. Oil on canvas. 65″ × 82 ½″. The Metropolitan Museum of Art, New York (Munsey Fund, 1936)*

129. **ANNIBALE CARRACCI. The Flight into Egypt.** *ca. 1603. Oil on canvas. 48″ × 90 ½″. Doria Gallery, Rome (Alinari-Art Reference Bureau)*

landscape is freely brushed in the manner of the aging Titian. It vibrates with alternating passages of light and deepening tones, with rugged cliffs fading away into a clouded, luminous distance. The subject matter of the painting is poetic, recalling the Shakespearean reference to music as the food of love, as Venus, listening to the music of a young lutist, listlessly holds a flute while a viol rests at her elbow. Cupid crowns her with a wreath of flowers. Beyond the parapet behind the figures, the landscape, looking very much like a framed painting, differs in execution from the foreground tableau. Portions of the figure group are finished in a meticulous manner that suggests, as some have pointed out, the intervention of another hand. The view in the landscape should remind us how much later masters of landscape painting owed to this aspect of Venetian art; the composition is remarkably close to the landscape types of Claude Lorrain (1600–1682), and the execution points to Turner (see colorplate 11).

From the transient weather of Giorgione's painting and Titian's poetic impression to the serene timelessness of *The Flight into Egypt* (fig. 129) by Annibale Carracci (1560–1609) the distance is great indeed, but the Venetian connection remains in the idyllic tone of the later work. In many respects Annibale's painting is the purer landscape, despite the foreground reference to the sacred story, since the figures are now distinctly subservient, visually, to the expanse of space. What is particularly significant in this work as part of the evolution of landscape art is the type of "ideal" composition it represents and the long history of its offspring. With minor variations, it will become the "classical" landscape fixed as a type during the seventeenth century by Claude Lorrain. Annibale's painting is constructed according to a scheme that eventually leads to this "classical" formula: a foreground *repoussoir*, or screen, consisting of foreground plane and trees (or a tall architectural form), usually darker in tone than the rest of the picture, which acts as a partial enframement, then, farther back in space, on the opposite side of the picture, another enframement of a similar nature; and finally, between these enframing devices but at a greater distance in space, either a series of planes com-

prised of topographical features, architecture, groves of trees, and the like or, as in Claude's formula, an open space with meandering streams, meadows, distant mountains, or a body of water, all receding into luminous depths near the horizon. This ideal or classical landscape represents a well-tended world, tamed and refined, often replete with architectural reminders of the Greco-Roman past or peopled, in the foreground, by little tableaux of shepherds or scenes from the more pastoral passages from classical myths or the Bible.

The type is well represented in this drawing by Claude (fig. 130). The foreground plane and the trees frame more distant *repoussoirs* of slopes and craggy spits of land marking the course of a meandering river. The stream winds back into a gradually fading view as both light and distance swallow up the land. The trees and foliage in the foreground, while defined with deft, quick strokes that develop here and there a conventionalized shorthand notation, imply a careful observation of nature, giving the general idealistic character of the scene an empirical base. The foliage bursts from the armature of trunks and branches convincingly, rustling with life.

130. **CLAUDE LORRAIN. Landscape with Cattle.** *ca. 1640. Pen and wash drawing. ca. 10 ⅛" × 15 ¾". The Cleveland Museum of Art (Gift of Mr. and Mrs. Edward B. Greene)*

This Claudian formula can be said to have affected our habits of seeing landscape, since its repeated use with minor variations has set up a norm of expectation, a conditioned response to configurations in the landscape that approximate the formula. One need only check the snapshots or color slides recording a vacation or sightseeing trip to find how much we tend to anticipate the formula in the landscapes we choose to record on film. We might also note how frequently the scenic overlooks along the highways have been selected for this same pictorial scheme; the view looks like the pictures. Thus, art—or some conventions it has fostered—affects nature through our conditioned responses to it as we try to preserve the scenic beauty that can only be described as pictorial.

Utilizing some of the pictorial devices of Claude, but transforming his pleasant pastoral world into wild and potentially dangerous places, the Italian artist Salvator Rosa (1615–73) developed a variant of the Claudian landscape. In Rosa's stormy scenes (fig. 131) the skeletons of dead trees mingle with dark grottoes and ravines where *banditti* are likely to lie in wait for the unsuspecting traveler. When romantic fiction of the eighteenth and nineteenth centuries developed its tales of mystery and terror, the landscapes of Rosa were often evoked as appropriate settings.

Alternate traditions to Claude's classical formula, modes of landscape ranging from quite literal representations of the natural world to scenes that deliberately create a mood of brooding fantasy, were developed in Germany and the Low Countries from the fifteenth through the seventeenth century. Dürer's watercolors of landscapes (see fig. 124, p. 177) were empirical records of places visited on his journeys, executed with his characteristic sensitivity to essential detail —patches of reality free of artificial enframements— whereas the Bavarian artist Albrecht Altdorfer (ca. 1480–1538) often painted landscapes that exhibit a picturesqueness bordering on the fantastic, as he sought out the spiky clutch of branches or the melancholy darkness of dense forest growth that would tax the stubbornness of birds or make the wayfarer uneasy at night. Altdorfer's fascination

131. SALVATOR ROSA. Soldiers in a Ravine. *ca. 1660. Oil on canvas. 31″ × 21 ½″. New Orleans Museum of Art (Samuel H. Kress Collection, 1953)*

132. ALBRECHT ALTDORFER. Alpine Landscape with Church. *ca. 1522. Drawing. ca. 8″ × 4¼″. Formerly Museum Boymans van Beuningen, Rotterdam (whereabouts unknown since the Second World War)*

with the macabre potential of tree forms was seldom more effectively expressed than in his otherwise ordinary Alpine landscape with a view of a church, illustrated here (fig. 132). The three tall trees stand like tragic protagonists condemned to a slow, debilitating struggle to survive. The expressive calligraphy of their armatures invites comparisons with Chinese painting (see figs. 105 and 106, pp. 148–49).

In the Low Countries during the mid-sixteenth century, Pieter Brueghel the Elder (1525/30–69) had no peer in landscape art and must be considered to be among the most important landscapists in the history of Western art. His

paintings set in landscapes are more than images of the natural world, for they contain allegorical messages and an abundance of details recording the common life of country folk and villagers. It is in his drawings that one finds pure landscapes.

Although Brueghel was an established master in Antwerp before he commenced his rich outpouring of landscapes, it is with landscape that our firm knowledge of his career begins. Landscape painting, thanks largely to works of the earlier Flemish master Joachim Patinir (ca. 1475–1524), had already achieved recognition as an independent genre in the Low Countries, and we have already noted how landscape features were an important ingredient in the paintings of early Netherlandish artists like Jan van Eyck. Nor was the landscape an insignificant part of the fantasies of Hierony-mus Bosch (see pp. 581–85). Brueghel's fascination with landscape, then, was not a departure from the traditions of the Low Countries but a logical fulfillment of a direction already established.

In 1551 Brueghel left for Italy, returning to his homeland in 1554. During this period he laid the foundations for his career-long involvement with landscape, and the drawings identified with that trip, like the one illustrated here (fig. 133), are evidence of his searching and enthusiastic appetite for the world of nature. Karel van Mander, in his sketch of Brueghel's life first published in 1604, wrote that Brueghel devoured the Alps to spit them out again in the Low Countries; the remark was almost literally true, for the knowledge Brueghel gained during his Italian journey and his travels through the Alps served him as a visual storehouse of motifs he combined and recombined in later years with such intelligence that these composite fictions are organically true and remarkably real, fortified by his continued observation of the world immediately around him. In this sense Brueghel's landscapes are at once universal and particular, the latter characteristic supplying their authentic spirit. The universality of Brueghel's landscapes is underscored by his friendship with the great geographer Abraham Ortelius, although the extent of their relationship is not fully known.

His *Waltersburg* (*Waltersspurg* in the inscription at the top, possibly in Brueghel's own hand) is a fine synthesis of drawing technique and observed phenomena. Through a perceptive variation in the strength of lines, their varied directions reinforcing the spatial flow of surfaces, and a counterpoint of line, dash, and dot, he has recorded not only the textural variety of the scene but an almost impressionistic scattering of light. When compared with the deliberate structure of his paintings (cf. fig. 401, p. 526) and their democratic humanism, such drawings as this appear as unabashed surrenders to the spell of the natural world.

In the next century landscape painting was further developed by Peter Paul Rubens (1577–1640), whose love for the Italian traditions, the Venetian in particular, led to a fruitful blend of northern and Italian strains in landscape art. His splendid *Autumn Landscape with a View of Het Steen,* his country home (colorplate 8), mingles a passion for the organic vitality of the natural world with a poetic mood absorbed through his adulation of Venetian art. With the same sensuousness he lavished on the material substance of flesh, draperies, furs, and ornament in his figural works, he here creates an enchanting stretch of light-filled space that sweeps back diagonally into a hazy distance from the profusion of intimate detail in the foreground and middle range of his composition. This particular work was for a time in the collection of the English amateur artist and man of wealth Sir George Beaumont, where it was admired by one of his acquaintances, John Constable (see pp. 198–200). This painting was to become one of the catalytic agents in the maturation of this great English landscapist of the nineteenth century.

As the seventeenth century closed, the Low Countries could look back on such a brilliant era of landscape painting that it is often considered the time and place where landscape was truly established as a major genre. Among the artists responsible for the popularity of landscape painting at this time is Jacob van Ruisdael (1628/9–82). His work alone is an eloquent defense of the Low Countries as an environment of landscapes, from the dunes around Haarlem to the

133. PIETER BRUEGHEL THE ELDER. Waltersburg. *1554. Sepia ink drawing. 12 ⅝″ × 10 ⅝″. Bowdoin College Museum of Art, Brunswick, Maine (Bequest of James Bowdoin III)*

rolling woodland and stream country of the Dutch-German borderlands. His *Marsh in the Woods* (fig. 134) is a view of nature from which the human presence is all but eliminated, a view at once intimate and heroic. The enclosure of trees lining the still waters like a natural, open nave holds intimations of a sacred place (cf. fig. 141, p. 203), while the generations of trees hint at the cycle of all existence. This is more than a knowing assemblage of the masses and minutiae of a corner of nature; it is a philosophic statement on nature's terms. Entirely different in visual effect and mood, Ruisdael's *View of Haarlem from the Dunes at Overveen* (fig. 135) evokes an atmosphere of quietism: a gentle portrait of the Dutch countryside, the horizontal stretch of the fields,

134. JACOB VAN RUISDAEL. Marsh in the Woods. *ca. 1665. Oil on canvas. ca. 29″ × 39 ½″. The Hermitage, Leningrad (Bruckmann-Art Reference Bureau)*

135. JACOB VAN RUISDAEL. View of Haarlem from the Dunes at Overveen. *ca. 1670. Oil on canvas. ca. 25″ × 22″. Rijksmuseum, Amsterdam (Bruckmann-Art Reference Bureau)*

the great expanse of sky with clouds casting their passing shadows silently on the land. What can be too frequently overlooked in Jacob van Ruisdael's landscapes is what these two pictures reveal: the degree to which his is a dramatic art. With considerable range, he plays every visual note appropriate to the natural character of the scene at the precise pitch and timbre that will make its presence vivid and memorable. For this reason, Ruisdael's landscapes leave a strong afterimage in the mind's eye. It is understandable why they also made such a strong impression on John Constable.

Exemplifying an important development in landscape painting, one of the finest Dutch landscapes of the seventeenth century (fig. 136) renders with unusual fidelity the most elusive of nature's phenomena—the precise quality of natural light under specific weather conditions—and signals an increasing concentration on light as the unifying key in images of the natural and man-made worlds. In his *View of Delft* Jan Vermeer van Delft (1632–75) has sliced off, as it were, a section of the town's picturesque skyline and waterfront and, reaching beyond a mere record of the characteristic shapes and colors in the scene, has brought everything —walls, roofs, towers, barges, clouds, and water—into accord by a pervasive illusion of light-filled space. This is a result of two interdependent elements in his artistry: first, the sensitive adjustment of the values of his colors (that is, their range from light to dark) to the nuances of light reflected and absorbed by the surfaces represented in the picture; and, second, the use of tiny disks or dots of brightness scattered throughout, a system of equivalents for the active dance of light our senses tell us is there. This painting, at once so simple and direct as a visual statement and so subtle in its means, has long held a deserving place in the history of the search for an illusion of absolute reality in images of the sensible world. In this sense it could be considered protophotographic.

There has been considerable interest and some careful research on the possible use of the *camera obscura* (a device of lenses and mirrors, somewhat on the order of a box camera without the film component) by Vermeer and others of

136. JAN VERMEER VAN DELFT. View of Delft. *1658. Oil on canvas. 38½″ × 46¼″. Gemäldegalerie, The Hague (Bruckmann-Art Reference Bureau)*

his era. The entry of the science of optics into the artist's world is a reminder that science, technology, and the arts can share a common ground. In Vermeer's case the connection has been made doubly tempting by the fact that Anton van Leeuwenhoek, a pioneer in the development of the microscope, was the executor of Vermeer's estate and therefore may have been at least an acquaintance of the artist who could have gained from him a more than passing interest in optics. It has been suggested that the disks of light in Vermeer's paintings are phenomena observable through the optical system of the *camera obscura*. Whatever indisputa-

ble evidence may eventually emerge from this line of re-search, it is apparent that Vermeer's art is an exceptionally accurate sensory record. Even when the image is considerably simplified, as in some of his tiny portraits, the sensation of light is remarkably true.

During the eighteenth century, landscape painting continued to occupy the talents of painters across Europe, from the Venetian scenes of Francesco Guardi (1712–93) and Antonio Canaletto (1697–1768) to the rococo artifices of François Boucher (see fig. 320, p. 430) and Jean-Honoré Fragonard (see fig. 339, p. 450). By the latter part of the century, landscape had become an important concern of artists in England, where a body of landscape painting produced in the late eighteenth and the first half of the nineteenth century could be compared to the Dutch output of the seventeenth century in terms of quality and influence. Throughout the eighteenth century there had grown in England a taste for the Italianate classical landscape popularized by Claude, who, although French, is identified more with Italy since he lived and worked there and derived so many of his landscapes from the Italian countryside, the Roman *campagna*. English patronage came largely from the class of English gentlemen who, on the Grand Tour of Europe as a phase of their education, helped disseminate a taste embedded in their memories of Italy.

If Italianate landscape found favor in Britain, it also contributed to a British awareness of its own countryside as a subject for landscape painting. Opposite the ideal serenity of the Claudian scheme was another popular Italian type, Salvator Rosa's melodramatic visions (see p. 186 and fig. 131, p. 187), linked in British imaginations to the darker vein of romantic fiction, like Mrs. Radcliffe's *Mysteries of Udolpho* (1794). Between these two lay an area eventually defined as the "picturesque," a term that had numerous definitions but two general applications: first, merely to signify what was appropriate as a subject for pictures; second, a more specific meaning, to indicate the rough or rustic subject, somewhat wild, unrefined, but not dangerous or especially mysterious. In the tide of a considerable amount

of literature on the picturesque aspects of nature and the enjoyment of them, it became the fashion of gentlefolk to undertake little excursions into the country in search of picturesque beauty as distinguished from ideal beauty or from the sublime (that which, by virtue of its very scale and awesomeness, dwarfed man and drew him into fearful contemplation of its grandeur and suprahuman connotations, a landscape rare in the British Isles but for which Alpine scenery and stormy seas were obvious paradigms). This categorizing of aspects of nature served to define various types of landscape painting and was an important concomitant of a growing involvement of British painters with landscape art.

Interest in varieties of landscape also had its counterpart in the design of English gardens, and a picturesque idiom was added to the older ideal layout of landscape designs on English estates. The exotic, too, came in for its share of attention and imitation, spurred by a growing trade with the Orient and a taste for Chinese porcelains decorated with garden scenes. The voyages of Captain Cook and others and the paintings and engravings interpreting the appearance of strange lands that came from artists accompanying these expeditions and from the free-lance itinerants seeking novel themes added to the range of subjects for landscape art. Since this growing tradition of travel art (see pp. 491–94) aimed at reporting the characteristic appearance of unfamiliar places, it contributed somewhat to an appreciation of scientific naturalism as opposed to the notion that nature, in art, must be purged of the irregularities and imperfections of its common appearance and undergo the glosses of idealization. In this climate English landscape of the early nineteenth century developed.

But other directions, more subjective, were shaping, too. Although a minor figure, the English artist and teacher Alexander Cozens (ca. 1717–86) introduced as a feature of his pedagogical methods an approach to landscape that is of interest in the light of future developments but difficult to assess historically. Hearkening back to a suggestion by Leonardo da Vinci that the artist could find images by contemplating stains on old walls, Cozens advanced the idea of

developing landscapes out of the chance formations of ink-blots on rumpled paper. The example here (fig. 137) derives from this approach, and it is apparent that the impulse behind it is to define the essential masses of a landscape with spontaneous, almost accidental, brush strokes. Cozens's ideas were subject to plenty of ridicule, but that in itself may have helped keep his ideas current. The strong massing of foliage in Constable's sketches and the spontaneity of their execution seem like applications of Cozens's ideas, especially in view of the fact that Constable's patron, Sir George Beaumont, had been a pupil of Cozens's.

Although better known for his portraits, Thomas Gainsborough (1727–88) was a landscape painter throughout his career, beginning with his early years in the Suffolk countryside around Ipswich. The Dutch tradition, as exemplified by Jacob van Ruisdael, was important to his early growth as a landscape painter, as it was to Constable, and his early landscapes have a strong Netherlandish flavor. Their seductive coloring, however, is his own. *The Harvest Wagon* (fig. 138) is a delightful mixture of rococo delicacy and the picturesque mode, while the flickering energy of its execution recalls Rubens.

Like Gainsborough, John Constable (1776–1837) was born in Suffolk, and the English countryside and coast were the themes he pursued all his life. Unlike his great contemporary Turner, Constable did not feel the necessity of foreign travel but remained stubbornly insular. Constable was committed to images of nature for which the sky was, as he put it, the "key note," and, with the capriciousness of English weather providing a constantly shifting reference, he found there an endless source of variations. His large canvases (fig. 139) were the results of patient study, from drawings and oil sketches done out-of-doors (small studies to which he sometimes appended notations of time of day, wind, and other data) to full-scale studies that fixed in more detail the masses, the broken patterns of light on foliage and water stirred by the wind, and the broader underlying patterns of light and shade, his "chiaroscuro of nature." Recording both the material substance of familiar things and the effects of

137. ALEXANDER COZENS. Landscape, *from* A New Method of Assisting the Invention in Drawing Original Compositions of Landscape. *1784–86. Aquatint. The Metropolitan Museum of Art, New York (Rogers Fund, 1906)*

138. THOMAS GAINSBOR-OUGH. The Harvest Wagon. *ca. 1784. Oil on canvas. 48″ × 59″. Art Gallery of Ontario (Gift of Mr. and Mrs. Frank P. Wood, 1941)*

139. JOHN CONSTABLE. View on the Stour near Dedham. *1822. Oil on canvas. 51″ × 74″.* Henry E. Huntington Library and Art Gallery, San Marino, California

changing light, he aimed at a complete image of his world, unified by the general effect of a particular quality of light from the sky. By mingling varieties of color—a green meadow might contain yellows, greens, and blues—and highlighting the shiny, reflective surfaces of leaves with bright points of pigment, often white (Constable's "snow" as it was sometimes called), he both enlivened the textures of his surfaces and augmented the illusion of natural light. The variegated color in three pictures, including *The Haywain* (1821, The National Gallery, London) and *View on the Stour near Dedham* (illustrated here), that he exhibited in the Paris salon of 1824 attracted Eugène Delacroix (1798–1863), whose *Massacre of Chios* (1824, The Louvre, Paris) the French artist later repainted in some areas.

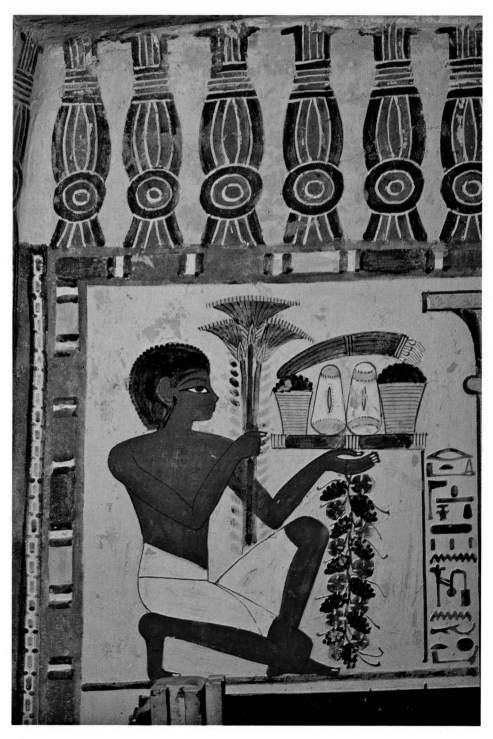

1. Young Boy Bringing Offerings to the Scribe Nakht, *painting from the tomb of Nakht at Thebes.*
Egyptian, Eighteenth Dynasty, ca. 1477–1425 B.C. Height ca. 54". (Photo: Bruce Hungerford)

2. Empress Theodora and Her Court, *chancel mosaic from San Vitale, Ravenna. Byzantine, ca. 547. (Scala)*

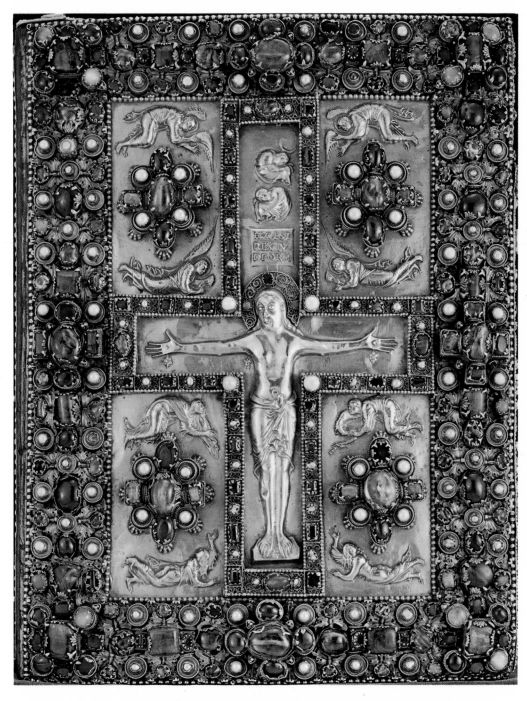

3. **Upper Cover of the Binding of the Lindau Gospels,** *M. 1, front cover. Carolingian, ca. 870. Gold and jewels. 13 ¾″ × 10 ½″. The Pierpont Morgan Library, New York*

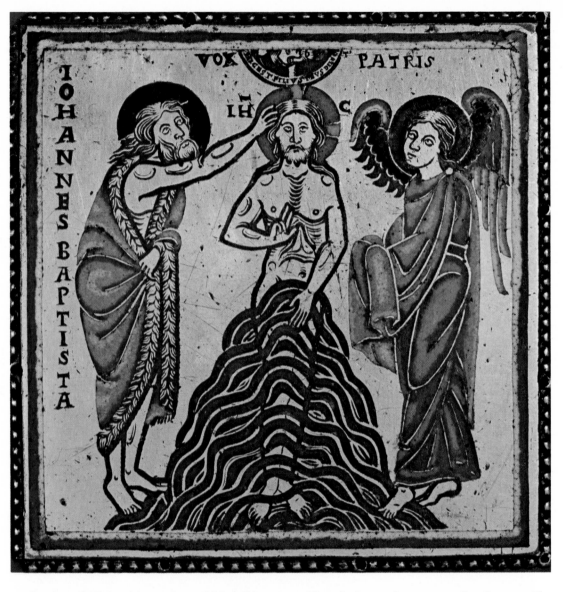

4. Baptism of Christ, *Mosan plaque. Mid-twelfth century. Champlevé enamel on copper gilt. 4″ square. The Metropolitan Museum of Art, New York (Gift of J. Pierpont Morgan, 1917)*

5. King Herod and Soldiers, *detail of the central west window from Chartres Cathedral. Mid-twelfth century. Stained glass.* © *James R. Johnson*

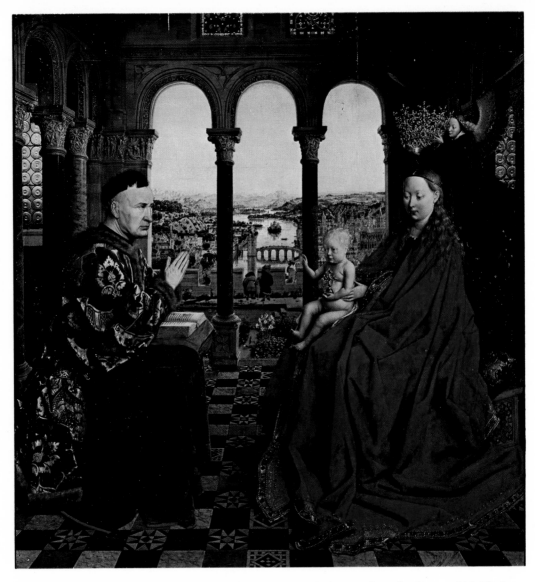

6. **JAN VAN EYCK. Madonna with Chancellor Rolin.** *ca. 1435. Oil on wood panel. 26″ × 24 ⅜″. The Louvre, Paris*

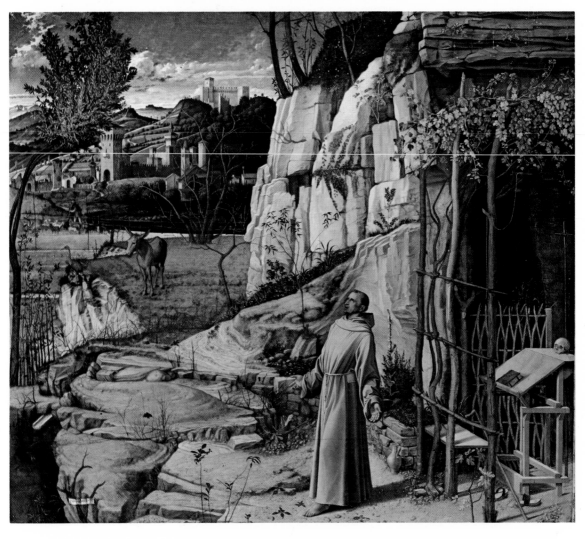

7. **GIOVANNI BELLINI. St. Francis in Ecstasy.** *ca. 1480. Tempera and oil on wood panel. 49″ × 59⅞″.*
Copyright The Frick Collection, New York

8. **PETER PAUL RUBENS. An Autumn Landscape with a View of Het Steen.** *1636. Oil on canvas. 51 ¾" × 90½". Reproduced by courtesy of the Trustees, The National Gallery, London*

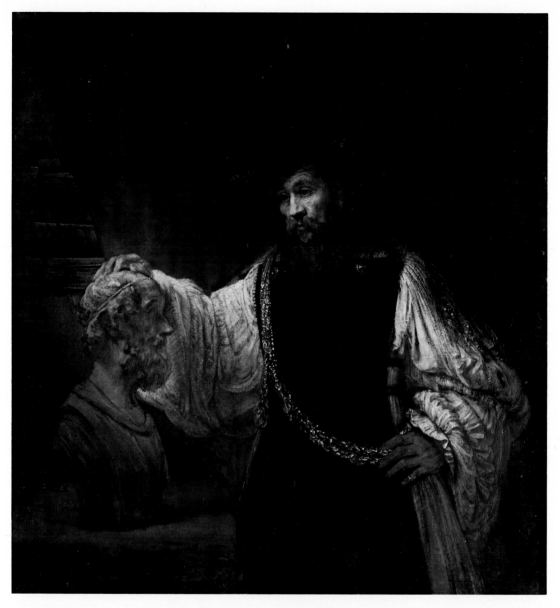

9. REMBRANDT VAN RIJN. Aristotle Contemplating the Bust of Homer. *1653. Oil on canvas. 56½″* × *53 ¾″. The Metropolitan Museum of Art, New York (Purchased with special funds and gifts of friends of the Museum, 1961)*

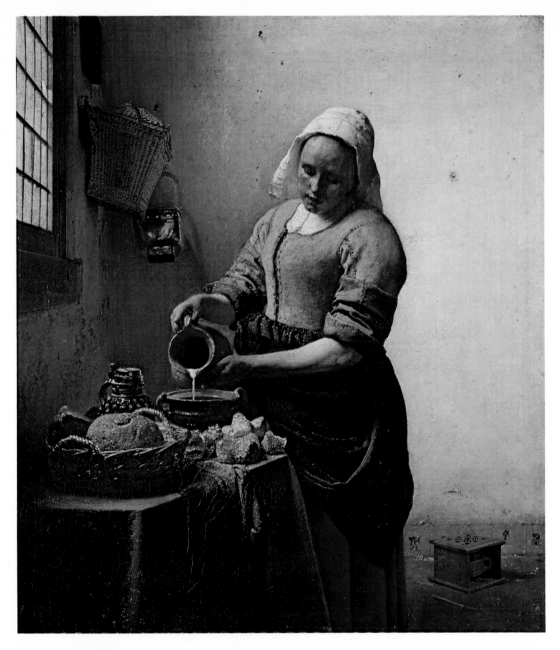

10. JAN VERMEER VAN DELFT. The Kitchen Maid. *ca. 1658. Oil on canvas. 17⅞″ × 16⅛″. Rijksmuseum, Amsterdam*

11. JOSEPH MALLORD WILLIAM TURNER. Rockets and Blue Lights (Close at Hand) to Warn Steamboats of Shoal Water. *1840. Oil on canvas. 36 1/16" × 48⅛". Sterling and Francine Clark Art Institute, Williamstown, Massachusetts*

12. PIERRE AUGUSTE RENOIR. The Luncheon of the Boating Party. *1881. Oil on canvas. 51" × 68". The Phillips Collection, Washington, D.C. (Photo: Henry B. Beville)*

13. **GEORGES PIERRE SEURAT. Evening, Honfleur.** *1886. Oil on canvas. 25 ¼" × 31 ½". Collection, The Museum of Modern Art, New York (Gift of Mrs. David M. Levy)*

14. **VINCENT VAN GOGH. The Starry Night.** *1889. Oil on canvas. 29" × 36¼". Collection, The Museum of Modern Art, New York (Acquired through the Lillie P. Bliss Bequest)*

15. **CLAUDE MONET. Haystack at Sunset near Giverny.** *1891. Oil on canvas. 29½″ × 37″. Courtesy, Museum of Fine Arts, Boston (Juliana Cheney Edwards Collection. Bequest of Robert J. Edwards in memory of his mother)*

16. PAUL GAUGUIN. *D'où Venons-nous? Que Sommes-nous? Où Allons-nous?* 1897. *Oil on canvas. 4'6¾" × 12'3½". Courtesy, Museum of Fine Arts, Boston (Tompkins Collection. Arthur Gordon Tompkins Residuary Fund)*

140. JOSEPH MALLORD WILLIAM TURNER. The Grand Canal, Venice: Shylock. *ca. 1837. Oil on canvas. 58¼″ × 43½″. Henry E. Huntington Library and Art Gallery, San Marino, California*

Although he shared with Constable a remarkable capacity for capturing the ephemeral effects of light, Joseph Mallord William Turner (1775–1851) was a painter of an entirely different order, given to theatrical effects and frequently introducing themes from literary works or history into his landscapes. But these themes were consistently overpowered by the sensuous play of color and light or the cataclysmic forces of nature raging in the paintings. Alpine avalanches, storms at sea, deluges, and other catastrophes were favored themes. An early mastery of architectural rendering and lifelong work in watercolor supplied both the discipline of structure and freedom of execution synthesized in his mature work.

In *The Grand Canal, Venice: Shylock* (fig. 140), one of numerous handsomely colored paintings of a favorite locale, Turner weaves together with delicate precision the airy architecture that encloses the arc of the canal and the flowing, hazy passages of light and dark in the crowds and boats that line the water's edge. The transparency of his effects, as light seems to dissolve materiality, may owe something to the influence of his work in watercolor. The delicate suffusions of color and the resonance of the clustering darks combine in an image that invites analogies with music or poetry.

During the earlier part of his career, Turner was attracted to the compositions of Claude Lorrain and painted several pictures that might be viewed as challenges to the seventeenth-century master. In fact, Turner's will, which left the contents of his studio to England, stipulated that two of his paintings be hung in the National Gallery adjacent to works by Claude. Even in his later work there are echoes of a Claudian device: a low sun in the picture to which the general illumination is keyed. But in Turner's work this concentration of light frequently abandoned Claudian serenity to become the center of a whirlwind of intense illumination that caught up into its vortex clouds and sea, transformed into some dense medium that was neither—or both. A hint of this can be seen in *Rockets and Blue Lights* . . . (colorplate 11). Here the dramatic inclinations of the artist are loosed in a fire storm of cool color and light,

141. **CASPAR DAVID FRIEDRICH. Abbey Graveyard under Snow.** *1819. Oil on canvas. ca. 47″ × 70″.*
National Gallery, State Museum, Berlin (painting destroyed during the Second World War)

lending credence to Constable's remark that Turner painted with tinted steam.

The emotionalizing of nature, so theatrical in Turner and an important current in romantic art, found a more somber practitioner in the German painter Caspar David Friedrich (1774–1840). The *Abbey Graveyard under Snow* (fig. 141) conveys a tragic mood in an atmosphere of frosty silence. In this landscape the human factor is reduced to insignificance by the ancient trees and the empty space that stretches back beyond the sacred enclosure of their trunks to the low-lying horizon. Nature endures eternally, it seems to say, while man and his works are mere birds of passage.

Images of nature carried heavy burdens of meaning during the romantic era, for they were not only avenues to vicarious

experiences of a variety of locales and moods of nature
but frequently surrogates for religious experience as well.
God's temple was manifest in the natural world; its sacred
dome was the sky, the source of light both natural and, by
implication, divine. The little man or groups of figures,
frequently depicted in contemplation of the scene or passing
through it as on a pilgrimage, were, in effect, the suppliants
in this natural temple. With them the viewer could identify
himself. But this was not the only level of meaning to which
the high romantic landscape addressed itself. There was also
the fascination with adventure. Nature's more turbulent
moods might at times intimidate one, and one might stand
in awe of its more majestic aspects; but the mountain was
for scaling, the expanse of ocean for sailing, the plains for
crossing, the forests for penetrating. As a quantity still un-
measured and mysterious, the world of unfamiliar places was
an invitation to adventure, always safe from the viewer's side
of the picture plane.

In the 1850s the American artist Frederic E. Church (1826–
1900) traveled to South America in search of grander land-
scapes than those available in the eastern United States. He
was spurred to this adventure by the writings of Alexander
von Humboldt, whose *Kosmos* (translated into English by
mid-century) included a chapter on landscape painting, an
art he saw as a means of understanding nature and that he
felt would achieve a new brilliance once artists in numbers
discovered the Andean and tropical worlds. The paintings
that resulted from Church's journey were truly encyclopedic
in their accounting of topography and vegetation from the
low-lying tropical valleys up to the savannas, uplands, and
mountaintops ("full-length" landscapes, they have been
called) of the South American regions he visited. They were
compendiums of scientific naturalism; but, at the same time,
they held other meanings for Church's day. They were
stimuli for vicarious adventures perilous only in the imagina-
tions of the viewers, some of whom would see other infer-
ences in the sublime settings, such as evidence of divine
presence in nature. In this version of *Cotopaxi* (fig. 142), the
Ecuadorean volcano Church painted many times, the sub-

ject could become, with very little effort of the romantic imagination, a violent beginning or an awesome conclusion of cosmic implications. If it put man in his place, so to speak, the contemplation of these ideas could also be deliciously terrifying to the romantic.

The panoramic view in this work is characteristic of many of these landscapes, a condition approximating a "look around" from a vantage point. In fact, many people came to look at Church's paintings with their opera glasses in order to study every detail in simulation of travelers in strange lands. The panoramic format is related to the panorama exhibits so popular, first in Europe and later in America, from the late eighteenth century well into the nineteenth. These exhibits, generally depicting some historic event or remote place, were paintings of mural scale presenting a full 360 degrees of vision, with the viewers in

142. **FREDERIC E. CHURCH. Cotopaxi.** *ca. 1863. Oil on canvas. 35″ × 60″. Courtesy of the Reading Public Museum, Reading, Pennsylvania*

an observation area in the center of the encircling painting. With controlled lighting and, where appropriate, such sound effects as could be mustered, the panorama aimed at total reality.

Another type of panorama, especially popular in the United States, was a primitive forerunner of the motion picture: a moving panorama painted on long rolls of canvas, unwound slowly across a stage by mechanical means for which the motive power was often some assistant to the proprietor. A trip down—or up—the Mississippi was the common subject, and one such panorama was advertised as being four miles in length, undoubtedly a substantial exaggeration. Popular entertainment, rarely employing the talents of truly competent artists, such works fall somewhere in a limbo between folk art and theater. Perhaps it could be said that these enterprises, together with the search for exotic subjects and grander landscapes in faraway places, mark the real beginnings of the quest for novelty that has been a feature of the modern era in art.

But the quests for the exotic and the novel had their opposite number in the romanticism of the commonplace, in the sentimentalizing of the lives and surroundings of ordinary people transformed into symbols of the simple virtues of honesty, piety, and the dignity of labor. Both genre and landscape painting participated in this process of ennobling the ordinary, which constitutes a tenuous link between idealism and realism. In France, the paintings of the Barbizon school exemplify this direction as the artists of this loosely knit group, like Jean François Millet (see fig. 239, p. 330), sought material in the rustic life and scenery around the village of Barbizon on the borders of the forest of Fontainebleau.

Although not considered a member of this group, Jean Baptiste Camille Corot (1796–1875) often painted in the same locale. The range of his work transcended the interests of the Barbizon painters, yet he is unquestionably a part of this slender connection between idealism and realism, for the substructure of his compositions often establishes a re-

strained classical order (fig. 143), at times approaching the old Claudian formula. Much of his earlier work displays a firm arrangement of clearly defined shapes, and some paintings in which architectural forms dominate possess a planar structure that invites comparisons with Cézanne. After mid-century, Corot's painting turned more and more toward cool-keyed landscapes, predominantly in muted silvery blues and greens, with wispy passages of foliage and small grace notes of warm colors, often a bright red touch, as foils for the overall coolness of the palette. The fragile

143. JEAN BAPTISTE CAMILLE COROT. Arleux-Palluel (The Bridge of Trysts). *1871–72. Oil on canvas. 23 ¾″ × 28 ¾″. Courtesy of the Art Institute of Chicago (Potter Palmer Collection)*

screens of foliage, executed in small brush strokes, resemble the technique later developed among the impressionists. Although based on the artist's poetic response to the French countryside, the muted colors of these later works, the soft-edged foliage, and the pleasant wooded banks of streams create an atmosphere of serenity and remoteness, as if some dream of an ideal sanctuary for the troubled human spirit had quietly materialized.

It would be a distortion to ascribe idealizations of the commonplace to an artist like Gustave Courbet (1819–77), although his realism did contribute to the celebration of the ordinary, and romantic elements often appear in his work. His landscapes (fig. 144), an important part of his output,

144. GUSTAVE COURBET. Forest Pool. *ca. 1868. Oil on canvas. 61 ¾″ × 44 ¾″. Courtesy, Museum of Fine Arts, Boston (Gift of Mrs. Samuel Parkman Oliver)*

are based on direct observations of the natural world, and there is certainly more chlorophyll in his foliage than most painters of the time allowed; but the qualities in his landscapes that are the most significant historically relate to his technical means more than to his subjects. He was fond of the plasticity of the paint itself, with the result that the surface quality of his landscapes is rich and painterly. As the twentieth century approached, this emphasis on the surface of the painting received more and more attention from landscape painters in France until, in a variety of ways, as we shall see, the old concept of a deep space—the window on the world—that had been so important to Western art from the Renaissance on was packed up with color and textured paint, becoming a thing of surface, even relief, as much as a representation of objects in space. Spatiality, which had contributed so much to the art of landscape, would cease to exert its old authority.

Courbet's program of keeping to the ordinary subjects of one's own time and place (an attitude summed up in his remark that he could not paint an angel because he had never seen one) had its counterpart in the choices of subject matter common to much nineteenth-century American art. Although not the exclusive direction followed in American painting in that century, a vigorous line of American art was primarily involved with genre and landscape subjects representing a distinctly American experience, especially during the middle decades of the century. In the context of an intimate knowledge of the character and moods of ordinary situations and places, the realist Winslow Homer (1836–1910) developed into one of America's most important painters. A keen observer of details, he did not accumulate these in undigested profusion but subordinated them to larger units so that a firm structural discipline, often of the utmost simplicity, marshaled them into strong patterns (fig. 145). This discipline of Homer's was not an intellectual approach like classicism but a fundamental directness—one is tempted to say Yankee economy—that saw through to basic patterns in the visual experience.

Although Homer and many other American painters had

shown an uncommon interest in the varied phenomena of light at the very time French painting was approaching its impressionist phase, it did not become for American artists the basis for a unique painting technique as it did for the French. America acquired its "impressionists" after the fact of French impressionism. Light, for the American artist, was a luminous medium translated from direct observation of its intensity and its object-defining, or object-obscuring, properties into the painting's scale of values. If, for some, light was to acquire other associations, these lay in the realm of its iconography as a symbol for spiritual values.

For the Frenchman Claude Monet (1840–1926), light was to become the basis of a technique that has since become the popular identifying feature of what we call "impressionism" in its technical sense. The first phase in this development can be seen in *La Grenouillère* (fig. 146), in which the view of this resort is a translation of the movement of the

145. WINSLOW HOMER. Early Morning after a Storm at Sea. *1902. Oil on canvas. 30¼″ × 50″. The Cleveland Museum of Art (Gift from J. H. Wade)*

146. CLAUDE MONET. La Grenouillère. *1869. Oil on canvas. 29 ⅜" × 39 ¼". The Metropolitan Museum of Art, New York (Bequest of Mrs. H. O. Havemeyer, 1929. The H. O. Havemeyer Collection)*

water, the foliage, and the figures of vacationers into a broken pattern of patches, dots, loops, and dashes of color, the luminosity of the atmosphere being emphasized by the foil of dark areas. The "impression" of the scene—the spontaneous notation of this color-patch idiom—commands our attention almost as much as the scene itself. Thus, paradoxically, the pursuit of a direct and spontaneous impression of the scene led to a step in the direction of landscape *painting* usurping the priority of the landscape image itself; or, to put it another way, the physical object, the painting, and the act of producing it gained precedence over the evocation of the natural world and the associations attached to it. Fascination with the plasticity of paint as a material substance, seen

earlier in the work of Courbet, and this early impressionism of Monet emphasizing the vocabulary of color patches, almost graphic in their distinctness, are two aspects of technique that merged in Monet's later career into a lyrical style in which system and sensation are in perfect accord (see colorplate 15).

For the impressionists, landscape was not a studio art informed by intensive studies of nature but an on-the-spot (plein air) representation of the scene as it was in an idiom comprised of patches of color matching the colors of objects as modified by light. Into this equation another factor was to be introduced: the breaking up of color areas into a microstructure of small dashes, dots, or commalike strokes of varied colors that would mix optically at the normal viewing distance to form a color sensation that was the sum of the varied colors. Thus, for example, an area composed of separate strokes of various yellows and blues intermingled would mix optically as a green sensation when viewed from the proper distance. This idea was not systematically pursued on a theoretical basis, however, except in a variant form of impressionism—the "divisionism" developed by the neo-impressionist Seurat. The idea grew, in part, out of nineteenth-century scientific studies of color optics that came to the attention of the artists; but earlier related practices had also figured in the work of Constable (see pp. 198–200) and Delacroix, who in his first major work—*Barque of Dante* (1822, The Louvre, Paris)—had depicted the prismatic breakup of light and rendered droplets of water with a rainbow pattern of color. The emphasis placed on color during the impressionist era also owed something to technology, since applied chemistry was producing new hues for the artist that were being widely used.

The collective result of these developments was an art of landscape painting that can be viewed historically from two perspectives: first, as an ultimate illusionism that established an equivalent for nature's light through optical mixtures, a final stage in that process of harmonizing objects and the space around them that had begun in the Renaissance; second, as an artistic watershed at which the course of art was drastically altered by this fusion and its concomitant

stress on the paint surface, as if the receptive hollow of the old window on the world had been packed solid with variegated colors, devouring space and presenting the picture surface itself as a field of action.

The paradox of these two views can be demonstrated by an example that stands in the middle of Monet's career, before his water lily series of the twentieth-century phase of his work really forced the issue. In *Haystack at Sunset near Giverny* (colorplate 15), one of a series on this theme, the illusion of atmosphere and space is maintained by the suffused color-light and the obvious changes in scale between the soft-edged silhouette of the haystack and the faint forms of buildings and hills in the distance; yet, at the same time, the eye of the viewer shifts back and forth from this illusion of lovely, light-saturated space, where even the shadows of the haystack are luminous, to a recognition of the chromatic richness of the surface of the canvas as a physical fact, losing touch with what is represented in the picture.

Georges Seurat (1859–91) died the same year Monet painted this picture of the haystack, but during his brief career—as short as Monet's was long—he transformed the spontaneous art of the impressionists into a disciplined idiom he called "divisionism," more popularly known as "neoimpressionism." A classicist by instinct, he shunned the spontaneity of impressionism and composed his pictures with studied deliberation (colorplate 13). In his major paintings (his studies were more loosely constructed) he applied a precise method of optical mixtures from his knowledge of scientific treatises on color. Although one finds in his works broad areas of muted color under the small strokes and dots with which he built up his color sensations, it is the "pointillist" device of more or less regular color spots that constitutes the most obvious feature of his technique. Apart from the general principles of optical mixture, an important factor in this divisionist system was the knowledge that complementary colors (red and green, yellow and violet, blue and orange) achieve their maximum intensity when adjacent to each other, but when mixed they produce a grayish tone. So in Seurat's system the intensity of a color could be varied by

adjusting colors around it, just as its value could be altered by mixing with white directly on the palette. The complex interplay of these laws of complementaries and optical mixtures demanded tremendous concentration on the part of the artist if he was to utilize them consistently. The structural rigor of Seurat's art makes him one of the precursors of the more formally controlled compositions of twentieth-century abstraction, and in his landscapes, however beguiling the atmospheric screen of color-light, one is conscious not so much of the presence of the natural world as of the agency of art. In the example shown here, the forms in the landscape submit to a geometric order as severe as the disciplined microstructure of color. The world of nature in such works comes close to being even less than a point of departure for the artist; it is reduced instead to a receptive pattern for the orchestrations of color.

The impressionist vision of the natural world was transformed in yet another way by Paul Cézanne (1839–1906), for whom the direct experience of the natural world—his "motif" as he called it—was as essential as it was for the impressionists. Working alone in the south of France, he stubbornly and patiently pursued his goal "to redo Poussin after nature" (to work directly from nature, but to impose on that visual experience a carefully calculated compositional structure akin to that of the earlier French master [see pp. 419–22] without abandoning impressionist color) and thus to make impressionism "solid and durable like the Old Masters." Although the goal is important as motivation, it is not an adequate explanation of what Cézanne actually achieved, for the process produced not a revivified return but a new departure that would make him very important to twentieth-century art. Dissatisfaction with impressionism played a part in all this, not that impressionism was unstructured—the very consistency of its technical means, the color spot, provided a kind of structure—but the substantiality of objects, their sculptural presence, and the geometric structure of space (as in Poussin's classical compositions) had been curtailed by the dissolving alchemy of impressionist color and light. Cézanne wished to get back to the old structure, but without sacrificing the achievements of impressionism. To

do this he fashioned solids in warm (advancing) and cool (retreating) colors rather than in values of light to dark. His concentration on each aspect of the scene before him in nature and the translation of it into a carefully constructed plane of color on his canvas can be said to have its analogy in the patches of clay with which a sculptor builds up his forms. In the period of the late landscapes (colorplate 17), when Cézanne felt he was drawing close to the realization of his aims, he does not depict hollowed-out space with traditionally modeled objects disposed throughout it but, instead, what is in effect a bas-relief of color planes. In this painting of Mont Sainte-Victoire, Cézanne has built up the picture largely with parallel brush strokes laid side by side to create small planes of color. These planes, the building blocks of these landscapes, are penetrated or bounded here and there by strokes more linear in character, a structural skeleton that keeps emerging from the matrix of overlapping planes that form, once their groupings are studied, solid blocks that thrust and counterthrust within the picture.

A letter Cézanne wrote to Émile Bernard on 15 April 1904, during the period when he was painting works like the one in the colorplate, has been frequently quoted. Remarking that nature is more depth than surface, he went on to say that one needs to introduce into "light vibrations" (reds and yellows) enough blue "to give the impression of air." In this painting of Mont Sainte-Victoire, leaving aside the green of the trees and the red roofs, we can see that there are two key color chords: the warm, yellowish tones on the plain and the cool, bluish and violet tones dominant in the sky and on the mountain. As the yellowish tones extend back toward the mountain, they are increasingly penetrated by and mixed with blues and violets, and so they are transformed into the neutralized tonalities of distance. With this device —actually a form of aerial perspective—Cézanne affirms the spatiality of his "motif" while at the same time the planar construction keeps bringing the viewer back to the two-dimensional surface of the canvas. The photograph of Cézanne's "motif" (fig. 147) indicates how the artist's interpolations relate to the site itself as it would look from the approximate spot from which he painted the picture.

Although impressionist plein air painting resulted in works specific in locale and even times of day, the invention of a technique of painting with small strokes of color inserted an inescapable screen of style between the viewer and his apprehension of the scene from nature. The way in which the picture was painted was becoming increasingly significant at the expense of what was painted. This was particularly true in the case of Seurat—and also true of Cézanne, even granting his exhaustive contemplations of his "motifs," for to study the landscapes of Cézanne is as much an exercise in visual analysis as an experience of evoking the natural world.

Another direction away from impressionism was taken by Vincent van Gogh (1853–90), whose work represents an extremely subjective view of nature. Possessed by his own vulnerable and hypersensitive humanity and his quasi-religious submergence in the vital energies he perceived in nature, his images became projections of his emotional identification with the sensory experience of the world around him. But the intense emotionality and sentiment with

147. Photograph of Mont Sainte-Victoire, *from John Rewald,* Paul Cézanne: A Biography, *fig. 51. (Photo: John Rewald)*

which his art was charged did not result in chaotic outpour-
ings, for his art was annealed by the discipline of his deter-
mined self-education as an artist. His career was brief—
some ten years only, a good portion of which was spent
laboriously acquiring even the most rudimentary of skills—
with the final brilliant period of his best-known work falling
between February 1888, when he moved after two years in
Paris to Arles in the south of France, and July 1890, when
he committed suicide at Auvers-sur-Oise.

The sojourn in Paris had thrown him into the new ambience
of impressionist color, and he was attracted, too—pro-
foundly—by the color and emotional content of Delacroix's
art. Millet's sentiment moved him. Like many other Euro-
pean artists of his time he was drawn to Japanese prints and
occasionally painted his own versions of them or included
them in the backgrounds of portraits. His study of Japanese
color woodcuts in Paris (although he had been familiar with
them earlier) must be considered an emphatic aspect of his
discipline. The coloristic expressiveness of his art—so poi-
gnant when placed in the context of his tragic life—tends
to obscure the fact that his painting is essentially a transmu-
tation of linear expression into color. A comparison of his
drawings and paintings from the last two years of his life
shows how consistently his image making was a graphic
process.

Of a painting of an olive grove done in the same month as
The Starry Night (colorplate 14), he wrote to his brother
Theo that he had accentuated outlines as in old woodcuts;
the same statement might well apply to *The Starry Night.*
Usually van Gogh worked directly from nature, but in this
instance the painting is a visionary flight of the artist's imagi-
nation in which the flickering brushwork of impressionism
has been transformed into stabbing, rolling lines, the sky
into a turbulent river of light, and the cypresses into dark
green flames. The little town below seems on the verge of
being consumed by the forces around it. The design is sim-
ple and strong, as it would have to be to withstand the
onslaught of the thick ribbons of paint with which the artist
delineated his forms.

The temptation is always to treat van Gogh's work in a biographical context, and there is some justification for this approach, provided the art itself is permitted to emerge with its own unique qualities intact. This done, that side of his work in which we can find mirrored the dedication, exultation, and despair of his life and which reminds us that both he and Gauguin (see pp. 268–71, 495–98) stand as archetypes of the estranged artist neglected in his time will be balanced by the counterweight of the artistic achievement itself, for van Gogh's art represents the continuity of a tradition. He must be considered an important figure in the traditions of the Low Countries, for his works, as unique as they are, can be examined profitably with respect to their subject matter in the context of the Low Countries and with reference to the great sixteenth- and seventeenth-century masters: the elder Brueghel, Jacob van Ruisdael, the little masters of genre, and even Rembrandt himself. Furthermore, van Gogh's subjectivity and Gauguin's symbolic harmonies carried messages for younger artists early in the twentieth century and became points of departure for the expressionist movement that began to take form in France and Germany by 1905. Structural emphasis in the works of Seurat and Cézanne also

148. JOHN MARIN. Pertaining to Stonington Harbor, Maine, No. 4. 1926. Watercolor. 15 ⅝" × 21 ¾". The Metropolitan Museum of Art, New York (The Alfred Stieglitz Collection, 1949)

149. ALBERT GLEIZES. The City and
the River. *1913. Ink drawing. 7¾″ ×
6¼″. The Solomon R. Guggenheim Mu-
seum, New York*

served as a springboard for new directions when, between
1909 and 1912, a new pictorial space inappropriately dubbed
"cubism" came into being. Landscapes emerged from both
these movements, but in each instance the stylistic idiosyn-
crasies of expressionist and cubist artists dominated the
images of the natural world.

Intimations of this authority of style can be found in the
work of an American painter who found a remarkably per-
sonal language through a synthesis of cubist and expression-
ist modes: John Marin (1870–1953). In his watercolor *Per-
taining to Stonington Harbor, Maine, No. 4* (fig. 148),
Marin's bold washes and slashes of color are impetuously
conceived, expressionistic, charged with the excitement en-
gendered by the breezy sensations of the scene itself, while
all is held, vignettelike, within a loose envelope of lines and

150. **ARSHILE GORKY.** Virginia Landscape. *1943. Pencil and crayon on paper. 20″ × 27″. Collection of Mr. and Mrs. Stephen D. Paine (Photo: Barney Burstein, Boston)*

faint tones that alternately press in on the scene and then spread out from it along the diagonal axes that cross on the triangle of sails in the center. The planar fragmentation of forms derives from cubism and, as has been frequently pointed out, Marin's dynamism is probably related to futurist ideas of speed and motion. His habit of leaving areas of paper untouched in his watercolors recalls a similar practice of Cézanne. But it is also worth noting that the fundamental structure of Marin's compositions is very close to the cubist landscapes (fig. 149) of Albert Gleizes (1881–1953) done between 1913 and 1917 and owes much to that style in particular.

Quite the reverse of the geometric abstractions of cubist landscape are the sensuous, biomorphic delineations of Arshile Gorky (1905–48), whose *Virginia Landscape* (fig. 150)

151. GEORGIA O'KEEFFE. **Black Place III.** *1944. Oil on canvas. 36″ × 40″. Courtesy of Georgia O'Keeffe*

is one of a series of drawings from a summer spent on a Virginia farm. Here the natural world is completely transformed into a congeries of fantastic shapes, symbolic, perhaps, of the generative functions of all living things but expressive, too, of an inner landscape of fantasy and anxiety.

A further indication of the range possible in an art of landscape can be seen by comparing the work of two twentieth-

152. ANDREW WYETH. Brown Swiss. *1957. Tempera. 30″ × 60″. Collection of Mr. and Mrs. Alexander M. Laughlin*

century Americans of different generations: Georgia O'Keeffe, born in 1887, and Andrew Wyeth, born in 1917. In the immaculate landscapes of the Southwest (fig. 151) painted by Georgia O'Keeffe, the image of nature is distilled into refined pictographs symbolic of the essential forces that reside in the natural world. Andrew Wyeth, a modern romantic, records his treasured sensations of the commonplaces of Pennsylvania farm country (fig. 152) and the New England coast in images of remarkable fidelity that often convey an atmosphere of brooding melancholy. Yet, as different as they are, an intimate relationship with nature is for both artists the bedrock of their images.

This discussion of developments in landscape painting began by calling attention to the pictorial devices for rendering spatiality that were essential to support the growth of the art. We have seen how these elements—chiefly perspective projection and equivalents for light and atmosphere—provided the pictorial means for the artist to re-create in his

images of the natural world the sensation of looking through space. We have also seen how attitudes toward the natural world have displayed great variability, encouraging landscape art or discouraging it when the dominant values affecting art generally did not find sufficient worth in the material world to nurture it. We have also observed how pictorial devices, like compositional systems, optical mixtures of color, and even the medium of paint itself, could become the bases for new directions in landscape imagery. Yet always in this equation was man himself, the agent and receptor of the ideas expressed through images of nature, who could eventually turn inward from the appearance and drama of the natural world "out there" to the projection of his "in here" feelings upon images of a natural world in whose vital processes he could mirror his own.

PART

THREE

SACRED AND QUASI-SACRED IMAGES:
VARIETIES AND TRANSFORMATIONS

CHAPTER

6

SACRED IMAGES

The religious beliefs of mankind have been, without doubt, the strongest single force in the history of art. Even prehistoric art was religious in the most elemental sense as a magic ritual serving human survival, and today in some parts of the world there is still a primal relationship between society and natural phenomena, a relationship so intimate and direct that existence itself is held in a delicate balance with the whims of nature. This is particularly true of those areas that are underdeveloped according to standards of today's advanced technology. In such societies the natural world has often become an aggregation of divinities and spirits or a world pervaded by some dynamic vital force manifest even in inanimate objects like stones. Such forces, benevolent or malevolent, must be constantly appeased for the well-being of the society; from this concern grow the society's forms of religious ritual and the arts connected with it.

It was from a situation like this that the tribal art of black Africa (still an active tradition in some areas of the continent) emerged; but it is risky to generalize broadly about it, for our study of African art is still in its infancy. Furthermore, the knowledge we already have clearly reveals that African art has not only a wide variety of styles, but also many distinct functions. Contact with white colonialism and the current proliferation of young nations with ambitions for their own internal development have also affected older African traditions. Art is being produced in Africa today that belongs to an order of creativity other than the traditional art, for it represents the contemporary African artist's response to modern Africa as well as to its ancient roots.

Traditional African art is largely sacred but not exclusively so, for it reflects the essential oneness of the individual, his society, and the mysterious natural powers that govern all existence. As a rule African religions are not characterized by elaborate pantheons of gods, but there are exceptions to this. The Yoruba of Nigeria, for example, are reported to have over four hundred deities—gods of thunder, rivers, iron, smallpox, etc. These religions usually recognize a creator, but he is remote from his creation. The active forces in the world reside in the lesser gods and spirits, in ancestors, and—very significantly—in man's active communication and identification with these forces through his rituals, which often make use of a distinctive African art form: the masks, which we see in the museums completely divorced from their active roles in the movements of the dance where alone they assume their sacred meanings.

Some tentative generalizations can be made about sacred images in African art as a special class and the religious matrix from which they have come. Traditional African religions vary in details from tribal area to tribal area. They generally stress the veneration of ancestors (as spiritual forces immanent in the continuity of family and tribe), nature deities or spirits, and the arts of magic and divination. The latter include the rituals of prophesying or seeking the meanings hidden in events as guides for action, rituals utilizing a variety of means such as studying the entrails of sacrificed animals, the pattern assumed by tossed palm nuts, or the answers received from a spiritual medium. In general, the sculpture, the primary African form for sacred images, is not intended merely to communicate to the beholder the nature of a deity or spirit but is a participant in ritual acts, an active presence, whether it be an ancestor figure, a manifestation of fertility wishes, or a guardian image. They are all intermediaries between man and the forces that affect his welfare but not, strictly speaking, idols that are worshiped.

This intermediary role is apparent in the fetish figures common in African art. A fetish is a small bundle of materials felt to contain strong powers or "medicine" and for which an image is generally the support, with the potent sub-

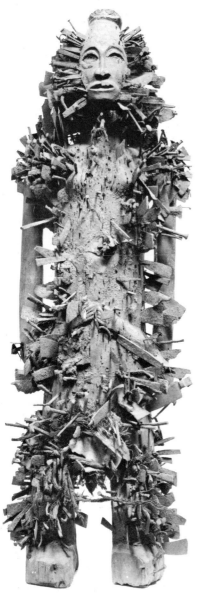

153. Nail Fetish Figure, *from Bakongo, Congo. Wood. By courtesy of the Trustees of The British Museum, London*

stances either hung on the figure or placed in some orifice in it. Thus "armed," the fetish image is regarded as having resources of power that can be put to use on behalf of an individual under the direction of a witch doctor. The nail fetish figure illustrated here (fig. 153) is peculiar to the Bakongo people. It is a unique type in that the individual who is utilizing its power drives a nail or similar piece of metal into it each time. This one was apparently well used before it became a museum piece.

In contrast, an ancestral figure (fig. 154) of the Bambara is not "used" in the sense of the fetish figure, although its powers may be invoked. It *is,* and in its monumental fixity it is expressive of that timeless dimension from which the ancestral spirit functions in the affairs and fortunes of its descendants; despite the tensive play of forms—angular, cylindrical, conical, curved—it projects a quietude not unlike that of ancient Egyptian funerary art.

Although its direct manifestation is most readily observed in the sacred art of these so-called primitive societies, human survival is surely the motivational bedrock of all religion. In the Western world it has been refined out of its elemental state into a desire for an eternal existence beyond life and in Asia into a quest for complete release from a continual cycle of life, death, and rebirth through an ultimate union with an undefinable Absolute. Man's compulsion to eternize his existence has been accompanied through the ages by a search for the meaning of life, an understanding of the universe around him, and a reconciliation with it.

Throughout history and all over the world, the powers of nature embodied in deities, spirits, and demons have developed into divine pantheons of divinities whose presence is evoked by images to which homage is paid or through which man is reminded of his place in the scheme of things and of his obligations to some supernal power. One could even expand the idea of religious commitment to include a variety of secular faiths—for example, a religion of the state, expressed in the sentiments of patriotism or loyalty to a political ideology. Sometimes, when these loyalties happen to

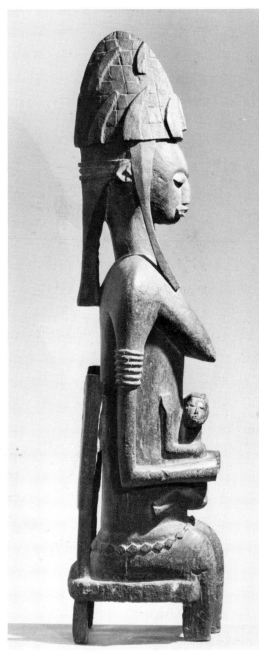

154. Seated Mother and Child Figure. *Mali, Bambara tribe. Wood. Height 48 ⅝". Courtesy of the Museum of Primitive Art, New York (Photo: Charles Uht)*

become identified with a particular individual like a popular hero, the latter becomes a quasi-divine figure, a subject that will be examined in the next chapter (pp. 289–336).

Since theological systems are usually developed to clarify religious beliefs and since religions evolve relatively fixed patterns of ritual, there is inherent in an established religion a strong element of inertia once doctrines have been defined. Religious art tends to create its own relatively fixed imagery; and since the faith becomes identified with its theology and ritual, its art runs the risk of being censured as heresy if it departs abruptly from traditional forms.

But religion also functions in another dimension: in the society with which it is associated. Although its orthodox core resists change, religion does respond to the constantly shifting configurations of society brought about by political and economic circumstances. When a religion has a long history and a wide geographical range, striking changes are sometimes wrought by the special conditions of time and place with social sanction removing the stigma of heresy. Moreover, the style in which religious images are executed has its own built-in dynamics, composed of the accumulated effects of successive small changes here and there that lead eventually to an image that may differ in many ways from its earlier form. Religious imagery, then, is altered and renewed by an energy generated from the social matrix of the religion, by the experience of it in practice, and by the stylistic dynamics of art itself.

Sacred images vary considerably in character. There are types that do not represent the sacred being directly but evoke the presence of deity through symbols or substitute images, a variety sometimes called aniconic imagery. Iconic imagery, on the other hand, depicts the sacred personage directly, but in a formalized manner, often in strict frontality, confronting the viewer with a lofty presence that stresses its otherness and emphasizes the distance between deity and mortal man.

Extreme examples of iconic imagery can be found in the

pre-Columbian art of Mexico and Central America, where the appearance of deity sometimes seems calculated to generate outright fear in the beholder. Illustrated here (figs. 155 and 156) are two images of Coatlicue, the Aztec goddess of earth, life, and death. The differences between the two—and she has other forms as well—indicate that the essential concept of the image of the goddess was as a manifestation

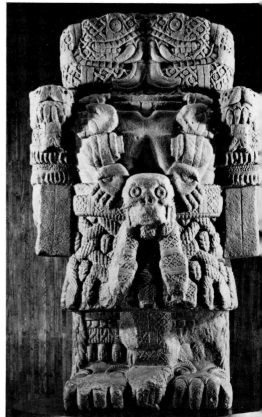

156. **Coatlicue (Goddess of Earth, Life, and Death).** *Aztec, fifteenth century. Black basalt. Height 99″. National Anthropological Museum, Mexico City*

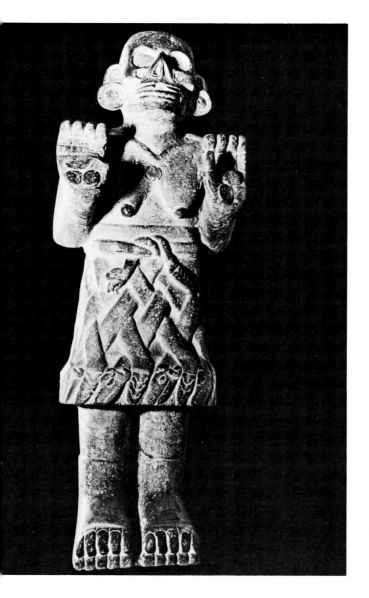

155. **Coatlicue (Goddess of Earth, and Death),** *from Cozcatlan Pueblo. Aztec, ca. 1324–1521. Basalt. 46″ × 15 ⅜″. National Anthropological Museum, Mexico City*

of elemental forces, not as a representation conforming to a single archetypal image. In other words, we recognize her by the accumulation of symbolic parts: the human skull, female breasts, extended hands ready to receive life, clawlike toes that till the earth to bring forth life, and the rattlesnake motif in the form of a kilt or incorporated elsewhere in the image. In fig. 155 these are combined in an aberration of the human form that invokes fear by the macabre character of its departure from normal human appearances; in the other image of the goddess they are combined in a way that spawns another kind of being, inhuman in the extreme, horrific by virtue of its complete otherness.

There are also types of sacred images that transcend the strictly iconical and in varying degrees humanize the forms of deities, sometimes to the extent that they have few traces of remoteness and become immediate, accessible, sympathetic beings (see fig. 186, p. 267), as if the concept of humanity itself had been deified.

Sacred images can display considerable variability within a single faith. Buddhist art, for example, begins with a strong aniconic leaning and then, in illustrations of the Jataka tales of previous incarnations of Buddha, comes down into the popular level of folk traditions and in the gentle Buddha image develops a limited humanization (limited, that is, in that the factor of spiritual remoteness is always present). With its goal of ultimate release into the absolute spirituality of a nirvana where there is no individual existence (unlike the Christian concept of heaven), the fundamental spirituality of the religion is such that the sacred imagery generally maintains a purified iconic character remote from ordinary humanity.

The aniconic strain in Buddhist imagery can be seen in a relief (fig. 157) depicting the temptations of Buddha by the demons of Mara, an evil force, in an attempt to divert him from his meditations. In this portion of the relief we see

157. Cushioned Throne with Assault of Mara, *relief from Ghantasala. Indian, school of Amaravati, late second century. Gray marble. Height 69 ¾". Musée Guimet, Paris*

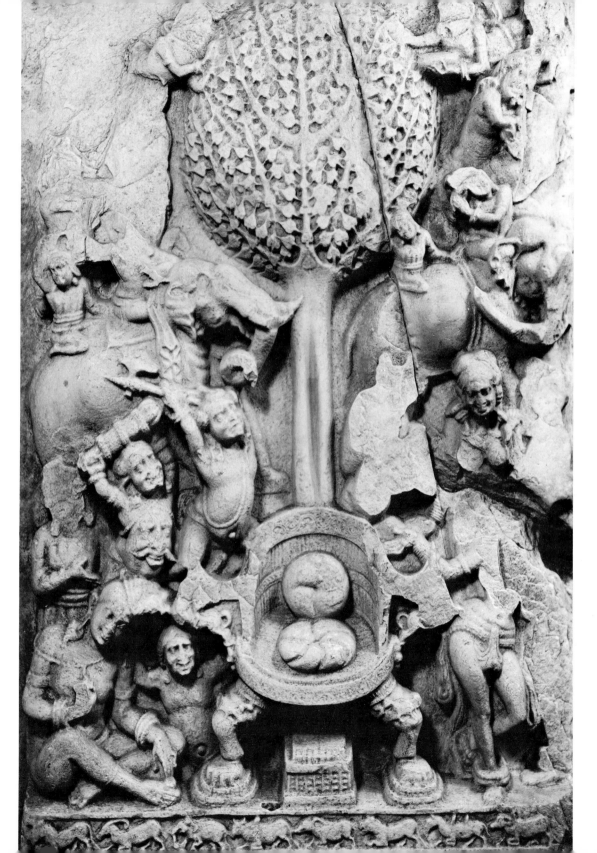

Buddha's presence symbolized by the cushioned throne under the tree beneath which he sat when he reached enlightenment. A similar aniconic image can be found in Christian art where the throne is symbolic of the presence of deity, as in the mosaics at Ravenna in the Orthodox Baptistery (mid-fifth century) where, in one register, images of empty thrones alternate around the interior of the dome with those of altars displaying the Gospels; and in the Arian Baptistery (early sixth century) where the Apostles process toward a combination of altar and throne on which is displayed a jeweled cross.

Whereas the symbolic throne implies a transcendent being, the so-called Jataka tales, a collection of folk stories absorbed into Buddhism, present Buddha as a miracle worker among the people. These tales resemble in many ways the stories of the miracles performed by Christ and the saints. The one illustrated here (fig. 158) is the story of how Buddha subdued the maddened elephant Nalagiri. The roundel relief, quite naturalistic in style, details the narrative in two episodes: the elephant on a rampage of destruction at the left, and, on the right, overcome by the radiance of Buddha who alone remained calm before the beast, bowing to Buddha, who then, according to the story, placed his hand on the elephant's forehead, gentling him henceforth. The theme of kindness conquering animal ferocity begs comparison with the legend of St. Francis and the wolf of Gubbio.

In this relief, Buddha is on a scale with the rest of the figures in the composition, and the entire action, despite the episodic duality of the presentation, is visually integrated within an architectural setting indicative of the street in which the story took place. Anecdotal details throughout invite a "visual reading" of the story, as one takes in the reactions of the spectators at this miraculous event. The transcendent personality of Buddha is here brought into conjunction with the ordinary folklore of the society.

158. Subjugation of the Mad Elephant Nalagiri, *railing medallion from the Stupa of Amaravati. Indian, late Andhra period, late second century. Marble. Height 35". Government Museum, Madras (Federico Borromeo-Scala)*

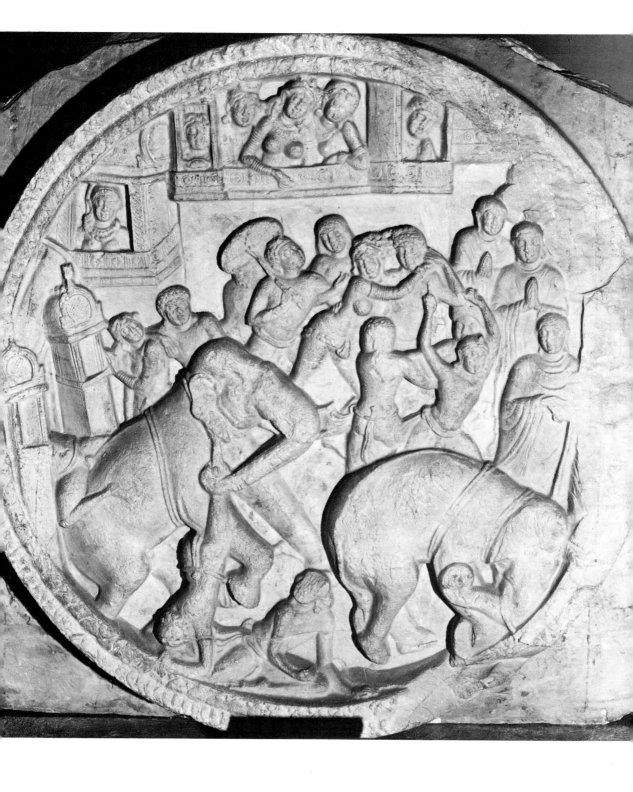

The traditional dates for the life-span of Buddha are ca. 563–483 B.C., making him a contemporary of the Archaic period of Greek art and already an old man at the time of the Persian Wars; but his traditional image in art seems not to have been fully formed until the Kushan period in India (second century A.D.), when the northwest and north central regions were ruled by the Kushan dynasty of central Asian Tatar origins. The Buddha image, as it developed there, is a mixture of Indian elements and classical influence from the Gandharan area in the northwest beyond Kashmir and across the present borders of Afghanistan. The art of Gandhara (fig. 159) was strongly influenced by its Roman contacts and not, as once believed, directly by Hellenistic art from the earlier Greco-Bactrian state in northern Afghanistan and eastern Iran.

In a head of Buddha (fig. 160) from Gandhara, we see four attributes of the standard Buddha image: the *ushnisha*, the cranial protuberance of wisdom, covered in Gandharan art by the topknot of hair resembling a chignon; the *urna*, a tuft of hair between the eyes, signifying, like the sun wheel halo (see fig. 164, p. 241), Buddha's light; the downcast eyes of humility; and the slit, pendulous earlobes, reminders of his renunciation of the worldly life of a prince, for when he put aside his princely estate the heavy jewelry he removed from his earlobes left them permanently stretched.

Whereas these features belong to its Indian iconography, the sculpture also displays a generalized classical conception of the features, with some details, like the lips, remarkably so (cf. figs. 12 and 86, pp. 29 and 119). But the mood of the sculpture penetrates beyond classical calm to a deeper serenity of the spirit for which the simple clarity and elegance of the modeling of the brow and eyes seem fitting metaphors. The Indian aspects of this sculpture do not rest alone with its iconographical attributes and in the spiritual serenity it projects, for there is also an underlying sensuousness—the consequence of the delicate refinement of its features to the point where the precise linearization of brow line, eyes, and lips conveys undertones of disturbing sweetness.

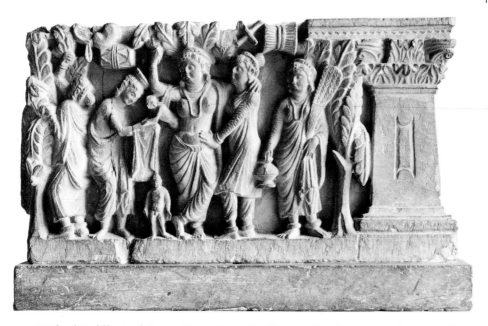

159. Birth of Buddha (and Seven Steps), *from Gandhara. Indian, first to second century. Stone.*
12 ¾″ × 20 ½″. Courtesy of the Art Institute of Chicago (Nickerson Collection)

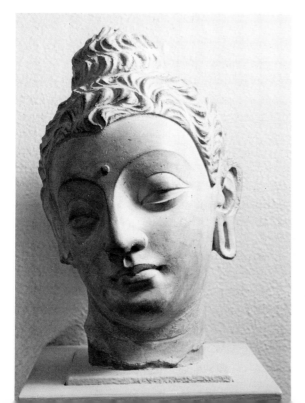

160. Head of Buddha, *from Gandhara. Indian,*
ca. fifth century. Stucco. Height ca. 11 ½″. Vic-
toria and Albert Museum, London

Sensuousness is expressed in quite a different way in another image from the Gandharan region, a fragmentary stucco relief (fig. 161) that probably represents one of the demons of Mara tempting Buddha to cease his meditations. The demon is a haunting image, a supple form that both implores and entices. Its sensuousness derives not from refinement but from the soft, fluid modeling of the form that suggests the materialization of a dream.

The sensuous aspect of Buddhist art is equally apparent in some of the frescoes from the Ajanta caves, particularly in the one representing the "Beautiful Bodhisattva" Padmapani (fig. 162), in which traces of Gandharan classicism can still be seen, although they are almost submerged in the pervasive mixture of lushness, elegance, and devotional humility.

The bodhisattva brings to the fore the role that social pressures and the practices of religion play in altering religious forms. It was probably during the Kushan period that an important development took place in Buddhist doctrine. Its basic spiritual core was not changed, but because, in practice, its demands were such that only a community of monks could reasonably expect the ultimate release, there was pressure for accommodating the masses of the faithful. Therefore, a new school of Buddhism arose, called *Mahayana* ("greater vehicle"), as opposed to the designation of the older form as *Hinayana* ("lesser vehicle"). This new phase of Buddhism changed the nature of Buddha to some extent, moving him from his *Hinayana* role as an earthly teacher (by then relating more to the monastic life) to something like a universal principle or godhead. In compensation for a more remote Buddha, *Mahayana* spawned an entire pantheon of bodhisattvas, or potential Buddhas who postponed their own nirvanas that they might help mankind. A practice called *Bhakti*, an individual's worship of a personal god, current in Hinduism at the time, may have influenced this proliferation of responsive Buddhas in the form of bodhisattvas. Although the concept of the bodhisattva reached out to the faithful, the image of the bodhisattva, like that of Buddha, appears detached from the ordinary world.

161. Demon, *from Hadda. Indian, fifth to sixth century. Stucco. Height 11 9/16". Musée Guimet, Paris*

162. The "Beautiful Bodhisattva" Padmapani, *detail of a fresco from Cave 1, Ajanta. Indian, ca. 600–650. Eliot Elisofon, Time-Life Picture Agency,* © *Time Inc.*

The air of spiritual detachment conveyed by a seated Buddha from Gandhara (fig. 163) does not exclude a response to non-Buddhist stylistic conventions. The image may be thoroughly Indian in the yogic posture and inflated body under the draperies, but the draperies themselves, although elegantly stylized, are reminiscent of the Roman toga and the relative naturalism of Roman sculpture. Buddha's face records its debt to classical Apollos, and the relief on the base of the statue is very similar to provincial Roman art. But the dominant spirit is still Buddhist, expressed by the dignified self-isolation of the figure, as Buddha seems to have withdrawn into his own inner world of meditation.

Completely Indianized (and frequently copied) is a Buddha (fig. 164) representing the spiritual leader preaching in the

163. **Seated Buddha,** *from Gandhara. Indian, Kushan period, second to third century. Schist. 36" × 22½". Seattle Art Museum (Eugene Fuller Memorial Collection)*

164. **The First Sermon,** *stele from Sarnath. Indian, Gupta period, fifth century. Chunar sandstone. Height 63". Museum of Archaeology, Sarnath*

Deer Park at Sarnath. He is seated in a yogic pose, with drapery fanned out on his cushion in a manner that suggests a lotus medallion; the halo, an elaborately decorated sun wheel centered on the *urna,* refers to Buddha's light and his universality; and his hands perform one of the symbolic gestures *(mudras),* in this instance the *dharmachakra mudra,* the "turning of the wheel of the law," which itself is represented, viewed from the front and flanked heraldically by two badly damaged deer, on the base of the throne. The enframing geometry of the throne and sun wheel and the meditative posture of Buddha completely insulate the image from the material world.

Despite the fact that the features displayed in the examples viewed thus far contributed to the formation of a kind of diagrammatic pattern for the Buddha image, time and local conventions have constantly effected numerous variations, demonstrable in any series of images selected from different times and places. A standing Buddha from Mathura (fig. 165), for example, displays a distinctive string-type drapery that flows with geometric precision over the body but at the same time reveals the body beneath, an intrusion on the geometric formalism of the rest of the figure, reminding us of the persistence of the sensuous strain in Indian art.

A Chinese example (fig. 166) from two centuries later, representing the Maitreya aspect, the future Buddha who will come to earth as a deliverer in human form, treats the

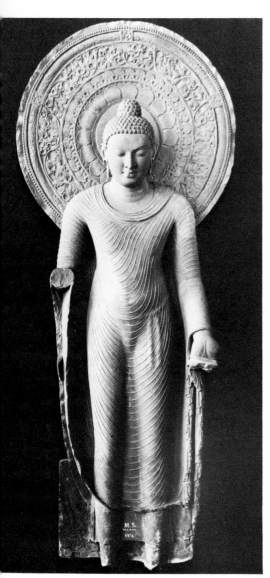

165. Standing Buddha, *from Mathura. Indian, Gupta period, fourth century. Red sandstone. Height 63". National Museum, New Delhi*

166. Maitreya Buddha. *Chinese, Wei dynasty, 536. Gilt bronze. Height with base 24". The University Museum, University of Pennsylvania, Philadelphia*

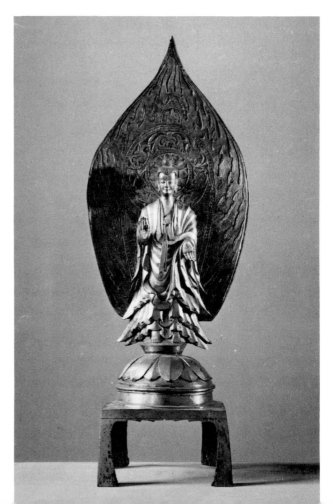

prototypal formula to a thorough transformation. The features of Buddha, while displaying the characteristic benign serenity, are thoroughly Chinese. The drapery develops an existence quite independent of the body, which is completely obscured beneath the heavy festoons and flaring cascades of the drapery folds. The sun wheel no longer dominates the background of the statue but has become a part of a flame-shaped aureole (a symbol of an encircling radiance or glory) that even competes visually with the figure itself. The decorative orientation of the sculpture does, however, achieve a harmonic spirit, as the draperies integrate with the overall design, their flares echoing the lotus petals below to form an effective counterrhythm to the upward-flowing flame patterns of the aureole.

A seated type from Japan (fig. 167) representing Shaka (Shakyamuni, the "historic" teaching and missionary Buddha) is not unlike the Gandhara and Sarnath Buddhas (see figs. 163 and 164, pp. 240 and 241) in the yogic pose, the frontality, and the meditative isolation; but in other respects the image has distinctive Japanese features, including the racial transformation of the face. The drapery appears to have some affinities with both Gandhara and Mathura forms, especially the former; but closer inspection reveals unique features. Unlike the Gandharan folds which develop rounded ridges, each linear fold of the Japanese drapery has a sharp ridge, and the folds flow sequentially in wavelike series whose formalized watery appearance (the Japanese refer to the pattern as *hompa*, "wave") is further emphasized by the wavy, curling folds at the bottom of the statue. The echoes of Gandhara and north India are real enough, however, for the Japanese transformations were imposed on types from those Indian regions as Buddhism spread eastward through China and Korea to Japan. Thus, this Japanese Buddha can be viewed from the standpoint of continuity as well as invention.

Yet another transformation, more striking than the others, comes from Southeast Asia, where sculpture is often characterized by smooth, mannered surfaces and rhythms. A Siamese walking Buddha (fig. 168) also represents the teacher

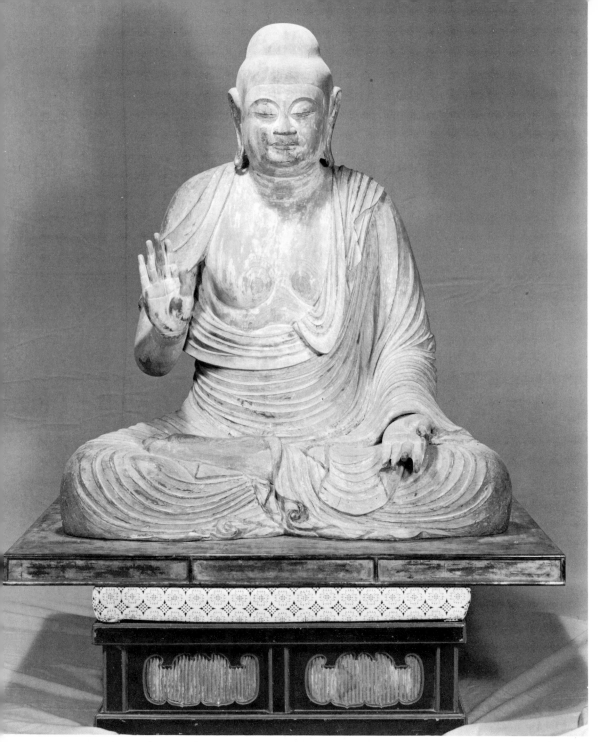

167. Seated Shakyamuni. *Japanese, early Heian period, ninth century. Wood. Height 41″. Muroji Temple (Sakamoto, Tokyo)*

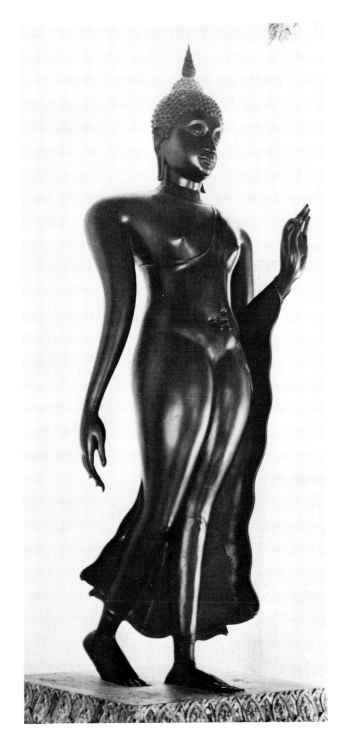

168. Walking Buddha. *Siamese, fourteenth century. Bronze. Height 88". Monastery of the Fifth King, Bangkok*

and missionary, the Shakyamuni aspect, but the sexual ambivalence of the image, its suggestion of sinuous, gliding, elephantine motion, reinforced by the limp arm swaying like an elephant's trunk and by the undulating contours of the hanging drapery, is a visual experience of a distinctly different kind, for its elegant and aristocratic mannerism sets it apart more than any manifestation of spiritual isolation.

An even greater variety of types and transformations can be found in images of Christ, ranging from the aniconic imagery mentioned earlier in this section, through several iconic forms, to a full range of humanized aspects. The earliest images of the Savior reflect the relative simplicity of the early Christian faith with its emphasis on salvation and also the adaptation of pagan subjects to Christian purposes (see pp. 44–45). An early Christian sarcophagus (fig. 169) combines the Good Shepherd theme (cf. fig. 115, p. 165) with the harvesting of grapes by cupids, a mingling of Christian and pagan elements. Even the Good Shepherd image has prototypes in the ancient world, and the early Christian form may be related to the pagan shepherd deity Aristaeus, who was also a patron of all forms of husbandry, including wine making. Statues of shepherds were also popular ornaments in the gardens of Roman villas where they reflected the sentiments of bucolic poetry. At any rate, the Christian

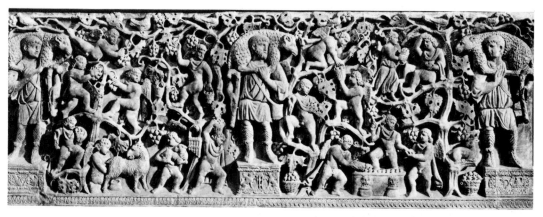

169. **Good Shepherd Sarcophagus,** *from the catacomb of Praetextus, Rome. Late fourth century. Marble. 28 ⅜″ × 91 ¾″ × 44 ⅛″. Lateran Museum, Rome (Alinari-Art Reference Bureau)*

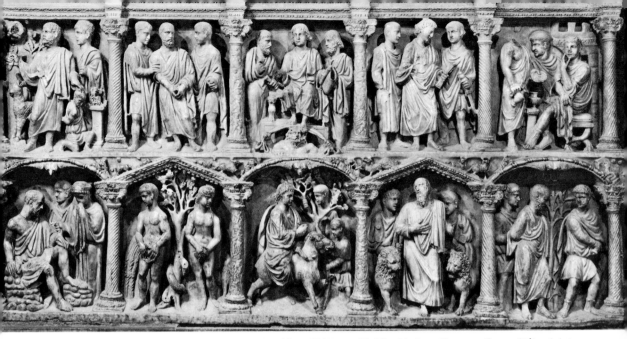

170. **Sarcophagus of Junius Bassus.** *ca. 359. Marble. 46½″ × 96″. The Vatican Grottoes, Rome (Alinari-Art Reference Bureau)*

frame of reference would identify the wine with the Blood of Christ and, through it, symbolize the redemption of mankind. The three Good Shepherd images on the sarcophagus may be a figuration of the Holy Trinity, an inference supported by the pedestals on which they stand (implying that they exist at a different level of reality than the busy vineyard) and by the older appearance of the central figure (God the Father?) who looks toward the youthful shepherd at the right (the Son?), leaving the figure at the left to represent the Holy Spirit (?). But whatever its Christian content, stylistically and thematically the scene also represents continuity with the pagan past.

The sacred imagery of Christianity underwent an important transformation once the faith had been duly recognized and had become the state religion of the Roman Empire. The transformation could be characterized as an imperialization of Christ, fostered by Christianity's identification with the empire. An early stage of the process can be seen in the sarcophagus of Junius Bassus (fig. 170), on which, in the

center of the upper register, a youthful Christ whose image is a blend of philosopher and universal, heavenly sovereign is enthroned between Saints Peter and Paul above a personification of the vault of heaven. In the center of the bottom register the triumphal entry of Christ into Jerusalem is the subject, evoking the idea of earthly rule. The rest of the scenes are episodes from the Old and New Testaments, and, flanking the scene of the enthroned Christ, there are depictions of Saints Peter and Paul being led to their martyrdom. The style of the relief is late Roman, a reminder that the new Christian art still bore a close relationship to pagan prototypes.

The appearance of Christ as the youthful shepherd, philosopher, or emperor, often with Apollonian features, alternates in early Christian art with images of a mature, bearded type—eventually the more common of the two. But in the mosaic on the half-dome of the apse of San Vitale in Ravenna (fig. 171) he is still represented as the youthful sovereign, seated on a blue globe and clothed in imperial purple. The cross-nimbus (halo) behind his head is composed of the same gold mosaic as the sky—the divine light. From beneath the globe the four rivers of paradise pour out toward the flower-carpeted earth on either side. The young Christ is literally holding court. The two angels who flank him introduce St. Vitalis (in court dress at the left of the mosaic reaching out to receive the jeweled gold crown presented to him by Christ) and Bishop Ecclesius (offering a miniature church of San Vitale). Imperial rule—its authority, its granting of honors, and the homage paid it—is the implication of this sacred image, while the frontality of the figures and the essential flatness of their forms, with drapery folds hardly more than shaded lines, are supportive of the formality of the courtly ritual presented and emphasize the mosaic's iconic character.

Whereas the images from the two sarcophagi we have seen are simply transferrals of Christian meanings to existent pagan forms, the Byzantine mosaic represents a definite stylistic transformation as well. To some extent the change must be attributed to the nature of the mosaic medium,

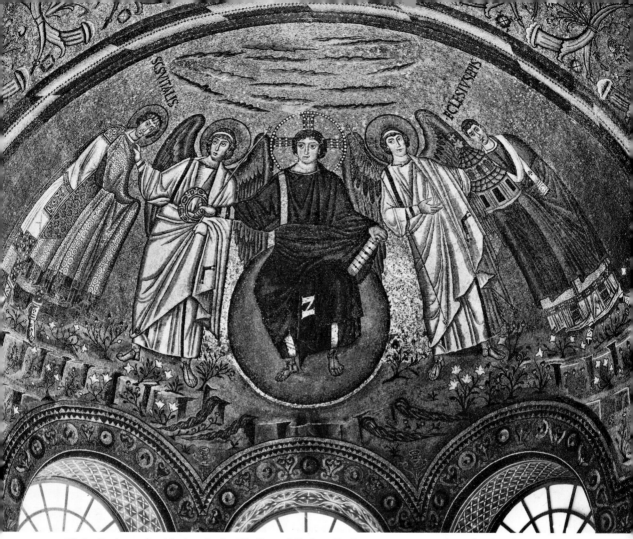

171. Christ Enthroned, with Angels, St. Vitalis, and Bishop Ecclesius, *apse mosaic from San Vitale, Ravenna. 526–47. (Alinari-Art Reference Bureau)*

which literally "paves" an image into being with small, usually squarish, pieces of colored glass or marble *(tesserae)* set into a plaster matrix. Although there are numerous examples of Roman mosaics that imitate the graduated colors and tones of painting, the transitions must be achieved in steps, that is, in a sequence of dark- to light-colored *tesserae* laid side by side to achieve the illusion of continuous change in value. It is very like the separate keys on a piano which, if struck in rapid succession, create the illusion of a continuous scale of sound. It is more "natural," from the standpoint of

the technique of putting together a mosaic, to simplify such sequences as much as possible. It is not unreasonable to assume that Byzantine art underwent the change from illusions of three-dimensionality (expressed through a scale of graduated lights and shadows) to simplified flat and linear patterns partly as a result of the large-scale mural projects in which the mosaic medium was being used. But that alone would not explain the stylistic transformation, for a comparable development can be seen in relief sculpture as well. It was a matter of stylistic change emerging from the interaction of techniques with the view that a sacred image should be more than a representation that could be recognized as sacred by its context or by certain prescribed attributes like the halo or St. Peter's keys. It must also be an image embodying in its very form the concept of a transcendent realm in which imperial authority and divine radiance were joined, just as, in the office of Emperor Justinian, the head of state and the vicar of God were one (see fig. 248, p. 342). Emulation of natural appearances would only dilute the concentrated loftiness and transcendence desired in these images.

During the reign of Justinian, Ravenna on Italy's northern Adriatic coast fell under Byzantine rule, and some of the finest examples of the Byzantine style of mosaic decoration are still to be found there. Sant' Apollinare in Classe (fig. 172), outside Ravenna in what was formerly the port town of Classis, is a basilica (cf. fig. 36, pp. 46–47) with an impressive apse raised above a crypt. The mosaics of the nave have been lost, but those in the half-dome of the apse preserve the Byzantine style of the age of Justinian. In rich colors—gold, green, blue, red, white—these mosaics confront the viewer with a splendid tapestrylike vision of paradise. St. Apollinaris stands, *orans* with arms outstretched, a suppliant for his congregation—the six sheep on either hand—while in the background under the trees three more sheep, signifying Saints Peter, James, and John, look up at the magnificent blue, gold, and red medallion with its cross, witnesses to the Transfiguration of Christ, symbolized by the aniconic form of the medallion. Images of Moses and Elias emerge from clouds in the golden sky on either side of the medallion, and

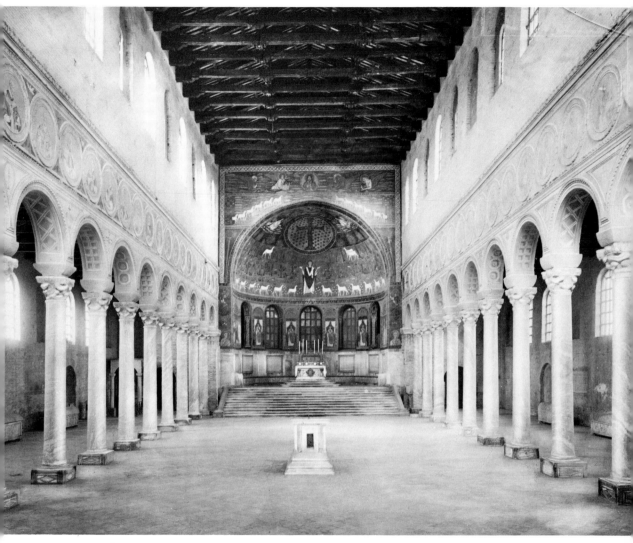

172. Sant' Apollinare in Classe, *Ravenna, interior view toward the apse. 533–49. (Alinari-Art Reference Bureau)*

the hand of God reaches down from above it. This tableau of symbolic imagery, a Western reflection of Byzantine splendor, blends sacred ritual with courtly grace.

Mosaic decoration was, of course, an ideal medium for the imperialization of sacred images. Its rich color and its light-reflecting properties were appropriate to the very idea of royal splendor and court ceremony joined to divine radiance. But Byzantine art suffered a period of crisis generated in imperial circles when image making itself came under fire from an imperial edict supported by those collectively known as "iconoclasts" (or "image breakers"). This was largely a political struggle of true Byzantine complexity between the state and the clergy; but it was also a matter related to the special powers some monks were attributing to sacred images, especially the superstitions built up around the magic properties supposed to emanate from some icons used in a variety of cures and in other wishful rituals. Sacred images do have a propensity to usurp—in the popular mind —values that they were originally intended merely to serve, and the iconoclasts, political motives aside, who were uneasy about the heresy of idolatry must have recognized and feared this process. During this iconoclastic controversy, from the early eighth century to the middle of the ninth century, they sought to prohibit images of sacred personages in the art of the church, desiring a strict interpretation of the biblical ban on "graven images." Iconoclasm was relatively severe in the imperial capital at Constantinople but considerably less so in the provinces, where the imperial edict was not vigorously enforced. During the controversy many images were destroyed and artistic production declined, but when it was over Byzantine art soon entered a second "golden age" that climaxed in the twelfth century.

From the posticonoclastic period come the impressive, unified mosaic decorations in the Abbey Church at Monreale, Sicily, near Palermo, where the history of Christianity is spun out on the walls and where the image of Christ Pantocrator ("Ruler of the Universe") dominates the apse (fig. 173), his arms embracing the space it defines. Below,

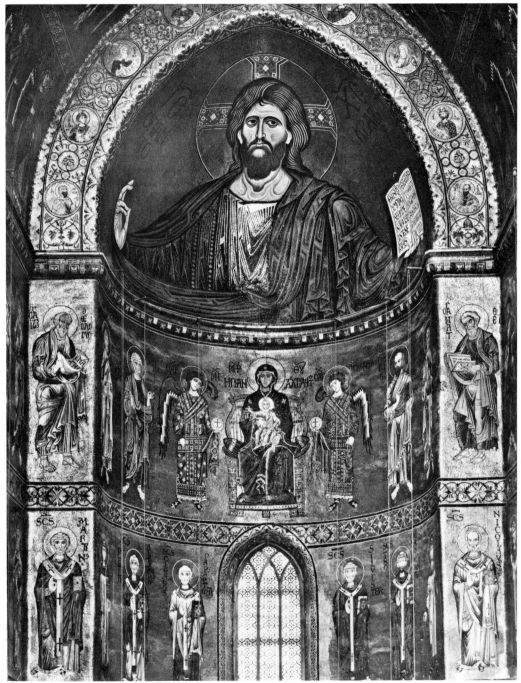

173. **Christ Pantocrator, Virgin, Child, and Saints,** *apse mosaic from Abbey Church, Monreale, Sicily. Twelfth century. (Alinari-Art Reference Bureau)*

the enthroned Virgin and Child hold court. The effect of the iconic image of Christ is overwhelming, not only because of its scale but also because of the forcefulness with which it combines the qualities of majesty, grimness (the mouth and jaw), sorrow (the eyes), and—faintly, almost perfunctorily—compassion (the embracing gesture). Even though there is strong two-dimensional patterning throughout, there is an elaboration of drapery and a new vitality stirring in the figures themselves. Although the decoration of the church was a project far to the west of Byzantium, it is not provincial work and is thought to have been produced by teams of artists sent from Constantinople.

Between the age of Justinian and the rise of the Frankish kings in the second half of the eighth century (which laid the foundations for Charlemagne's ninth-century Carolingian empire), western Europe was culturally at a low ebb— the so-called Dark Ages. Christianity was still reaching out into the hinterlands, however, and in Ireland as early as the seventh century a Christianized Celtic art was flourishing (see fig. 441, p. 578). The ornamental arts that developed among the Celtic-Germanic barbarians were beginning to fuse with the arts of Mediterranean Christendom, and during the reign of Charlemagne, who was crowned emperor of the Romans by the pope in 800, an ephemeral revival of Roman arts and letters took place under royal auspices. The illuminations of Carolingian Gospel books (see figs. 267 and 268, pp. 373 and 375) and Psalms, as in the *Utrecht Psalter* (see fig. 116, p. 167), affirm both the antique heritage and the Celtic-Germanic infusions. Nowhere is this more apparent than in the jeweled cover of the *Lindau Gospels* (colorplate 3), in which the barbarian tradition of jewelry and metalwork is adapted to the ornamentation of a sacred book. When viewed from the side, the mountings of the gems can be seen to be in the form of arcades and turrets; the gems themselves rise above their metal bases like colored domes. With the gems elevated in this way, light is permitted to filter in behind them, enhancing their brilliance. The gold figural reliefs show traces of a classical heritage modified by the ornamental predilections of the north (cf. figs. 29

and 441, pp. 41 and 578). Above the calm form of the crucified Christ are personifications of the sun and moon, with four angels in the two upper fields flanking the cross. In the two lower fields are the three Marys and St. John. The drama of the Crucifixion is thus sensitively shaped in concordance with the demands of an ornamental art.

The tympanum from the Romanesque church of Saint-Trophime at Arles (fig. 174) comes from the mid-twelfth century, only a few decades earlier than the Christ Pantocra-

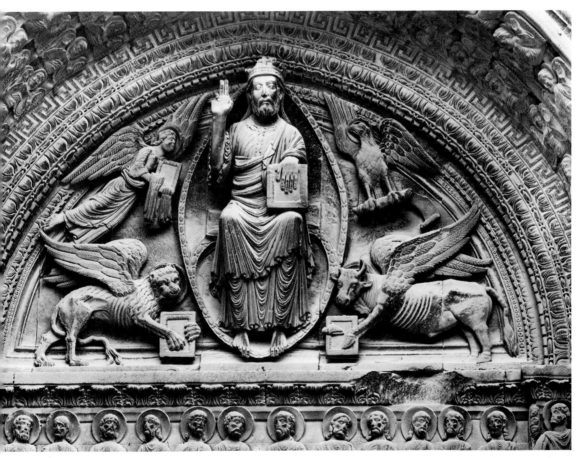

174. Christ and Symbolic Beasts of the Evangelists, *tympanum of the facade of the west portal, Saint-Trophime, Arles. Twelfth century. (Marburg-Art Reference Bureau)*

tor of Monreale. Here we see another imperial Christ, this time presiding over the Last Judgment and surrounded by the symbolic creatures signifying the four evangelists. It is an era of grim-visaged Christs who seem remote from mankind. This "otherness" of the Christ image is common in Romanesque art, but it assumes different forms. The Christ of Saint-Trophime, a region abounding in the remains of Roman antiquity, retains strong echoes of antique style. The tympanum of the central portal in the narthex of Sainte-Madeleine at Vézelay (fig. 175) conveys a different mood through its restlessness and the spidery, attenuated figures. Its theme differs, too, from that of Saint-Trophime. The subject of these reliefs at Vézelay has been identified as an interweaving of several strands of meaning: the Ascension of Christ; the promise of the sending of the

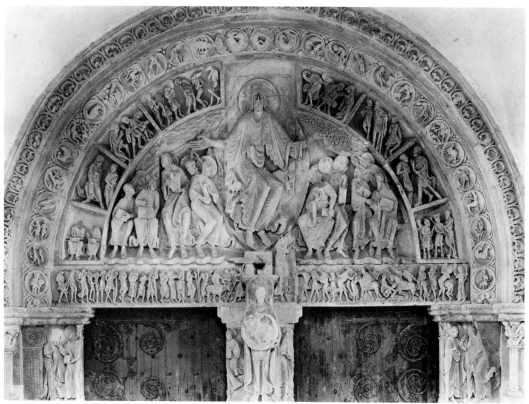

175. The Mission of the Apostles, *tympanum of the central portal of the narthex, Sainte-Madeleine, Vézelay. 1120–32. (Marburg-Art Reference Bureau)*

Holy Spirit, as rays extend from the hands of Christ; and the mission of the Apostles to the far corners of the earth—this at the time of the Crusades, when the mission is charged with current meanings. Around the central tableau of Christ and the Apostles are scenes that amount to an encyclopedia of medieval notions of remote peoples, some quite monstrous. In the archivolt (the outer arch of roundels enframing the tympanum) signs of the zodiac alternate with the labors of the months, giving a temporal as well as geographical context to the mission of the Faith.

From the same century comes a Mosan champlevé enamel plaque representing the baptism of Christ (colorplate 4). Such works as this one, from the Meuse valley, running from northeastern France into Belgium and Holland, comprise some of the finest productions of the enameler's art. Champlevé enamels are made by gouging out of metal plates the areas to be filled with colored pastes made from ground glass and metal oxides. These are then fired at temperatures high enough to melt the glass and fuse it to its metal compartments. In this plaque the simple symmetrical arrangement of figures achieves monumentality despite its small dimensions, and although the images are economically rendered, they have remarkable plasticity. The image of Christ is interesting for its stylized anatomical details, and the gestures of John the Baptist and the angel seem both convincing and purposeful. The representation is remarkably humanized for all the formal constraints of the ornamental medium of enamel work.

From such manifestations of divine authority as these, the development of a thoroughly humanized image of Christ is a long process that extends from the Gothic era, commencing in the twelfth century, to the modern age. Its beginning coincides with the waning of the old feudal system and the growth of urban mercantile centers, the passing of the monasteries as the chief cultural centers of Europe, and the rise of secular schools and universities. The movement away from the self-contained manorial system of feudal society and from the cloisters of monastic life signaled new relationships between individuals and the wider world around them.

Some of the first hints of the presence of a new humanizing spirit in art—some two decades earlier than the Christ Pantocrator of Monreale—appear in the figures from the western portals of the cathedral at Chartres, where, held to their columnar cores and bound to the architectural scheme of the shallow porches, they nevertheless display faint traces of individuality.

By the early thirteenth century *Le Beau Dieu* ("the handsome God") from the cathedral at Amiens (fig. 176), partially freed from the architectural cocoon, stands at the central portal of the cathedral blessing the faithful. More "real" in his fuller dimensions than the figures from Chartres, his draperies gathered in natural folds, he graciously, but with a superior nobility, confronts those who approach him. If he is here more the teacher than the ruler of the universe, he is nevertheless no commoner. The humanity that invests his image is of a different order from the gentle humility of St. Francis of Assisi, who died in Italy at about the time this sculpture was being carved in France.

St. Francis did not envision his Christ in the image of the Pantocrator of Monreale or the aristocrat of Amiens but as the gentle Savior who had traveled dusty roads among the poor and the outcast. The Christ figure in Giotto's paintings comes as close as any to the spirit of St. Francis's image of the Lord. But the darker side—that of a suffering Christ—had a strong hold on the emotions, and some of the most moving sacred images of the late Middle Ages and the Renaissance are those of Christ in agony on the cross. The head of Christ from a German crucifix (fig. 177), dated only a few years earlier than Giotto's frescoes in Padua, is a tortured image, his face a mask of pain, with long strands of hair like large, savagely twisted spikes thrust into the skull. Although his countenance is thoroughly stylized, the departures from strict naturalism actually enhance the reality of the theme, for they are each designed to project the sensation of pain and all merge in a single, unified expression that recalls the features of the Hellenistic *Laocoön Group* (cf. fig. 26, p. 37). But the agony registered on the face of Laocoön strains outward with potential explosiveness; the

177. Head of a Crucifix, *from St. Maria im Kapitol, Cologne. 1301. Wood. (Marburg-Art Reference Bureau)*

176. Le Beau Dieu, *jamb statue from the central portal of Amiens Cathedral. ca. 1220. Stone. Height 10'. Amiens, France (Marburg-Art Reference Bureau)*

agony of the Christ from the German crucifix has drawn inward as if to the hidden nerve centers of the sensation itself.

The emotional potentiality of the Crucifixion motif has its place, too, in Italian art of the fourteenth century. In a portable triptych (fig. 178) the Sienese painter and diplomat Andrea Vanni (ca. 1332–ca. 1414), a friend of St. Catherine of Siena's and one of the circle of followers of the Sienese master Simone Martini (see fig. 251, p. 346), put his delicate Sienese manner to the task of rendering the agitated scene in the central panel. The episodes of the swooning Virgin and the casting of lots for the robe of Christ enhance the narrative aspects of the central scene. The left wing depicts two episodes in the Garden of Gethsemane, and the right wing represents Christ's descent into limbo, crushing Satan under the fallen door. One can speculate whether the emo-

178. ANDREA VANNI. Crucifixion, *triptych. Third quarter, fourteenth century. Tempera on gesso. ca. 21 ¼″* × *45 ½″. The William A. Clark Collection of the Corcoran Gallery of Art, Washington, D.C.*

179. ROGER VAN DER WEYDEN. The Descent from the Cross. *ca. 1435. Tempera on wood panel. 7′2 ⅝″* × *8′7 ⅛″. The Prado, Madrid (MAS)*

tional tone of the central panel is to some extent the effect of the climate of guilt and penance that swept Tuscany in the wake of the Black Death.

More immediate and masterful in its treatment of the theme of Christ's sacrifice is *The Descent from the Cross* (fig. 179) by Roger van der Weyden (ca. 1400–1464). Set as if in a shallow, nichelike space, the dramatic tableau presses forward toward the viewer, heightening its communication. Representational skills, so highly developed in the Low Countries (cf. colorplate 6), are mingled here with a tender, poetic sensibility that marks the artist as a unique figure among his contemporaries in the north. A pliant

rhythm like a melodic line flows through the composition, linking figure to figure, welding surface naturalism to spiritual content and human emotion.

In the same expressive northern tradition as the German crucifix (see fig. 177, p. 259), but slightly more than two hundred years later, Matthias Grünewald (ca. 1480–1528) painted a *Crucifixion* (fig. 180) on the front center panels of his celebrated *Isenheim Altarpiece.* Here the agony on the cross becomes more than a vivid delineation of the sensation of sublime pain, for we realize that the artist has turned the sacrifice into a touching bond of sympathy with suffering humanity: the work was painted for a monastic hospital at Isenheim, where the hopelessly diseased patients could see, on the body of the Savior, sores as terrible as their own, their sufferings symbolically joined to his.

Another agony of Christ, the spiritual torment in the Garden of Gethsemane, is the subject of the work illustrated here (fig. 181) by Domenico Theotocopoulos, called "El Greco" (1541–1614). As if the entire scene were a projection of Christ's inner torment, the earth, rocks, mists, and clouds writhe and surge through the picture's unnatural space, creating by their emotionally charged rhythms and ambiguous relationships the atmosphere of a troubled dream. The illumination, both natural and divine, flows through the painting like tongues of flame, white, golden, roseate. Christ, too, is caught up in the general movement of the composition as he sways toward the angel's message like a fragile apparition floating out of the agitated red and blue draperies. His face, lean, gentle, ecstatic, is absorbed in the heavenly message as if his inner agony were tempered by an ineffable sweetness—and resignation, as he accepts his mission of sacrifice. The Savior, as here conceived by El Greco, is no flesh-and-blood being come among men but a delicate personification of a transcendent spirituality that can be grasped only in a state of heightened emotionalism.

For images of a Christ who is physically tangible and splendid after the manner of the Greek gods, one must turn back

180. MATTHIAS GRÜNE-WALD. The Crucifixion, *from the Isenheim Altarpiece (closed). ca. 1510–15. Panel. 8′10″ × 10′1″. Musée Unterlinden, Colmar (Marburg-Art Reference Bureau)*

181. EL GRECO (DOMENICO THEOTOCOPOULOS). Agony in the Garden of Gethsemane. *ca. 1585. Oil on canvas. 40″ × 51½″. Reproduced by courtesy of the Trustees, The National Gallery, London*

to the Italian Renaissance before El Greco and the emotions of the Counter-Reformation. Combining physical immediacy and spiritual reserve, the Christ of *The Tribute Money*, a fresco by Masaccio (1401–28), done some 150 years before El Greco's painting, represents the collaborative talents of Masaccio and Masolino (ca. 1383–ca. 1447), who did the face of Christ (fig. 182). Human dignity is elevated here to the heroic level appropriate to Christianity's central image and in harmony with the new Renaissance humanism.

In the mid-fifteenth century Donatello (ca. 1386–1466) created several bronze statues and reliefs for the high altar at Sant' Antonio in Padua. Not intended as part of the original scheme, but now placed above the altar, is a bronze crucifix by this sculptor (fig. 183). Although the figure of Christ in this work has been called classical, it cannot be thus described without considerable qualification. The spare, hard-muscled figure, while physically impressive, conveys a spirit other than classical ideality. The bony structure of the features suggests the ascetic: hollow cheeks, deep-set eyes. The handsome head is that of a man of sorrows—not, however, tortured as in some northern Gothic Crucifixions (cf. fig. 177, p. 259), but sensitive, enduring, calm, and thoroughly humanized.

From the last decade of the fifteenth century and the early career of Michelangelo Buonarotti (1475–1564) comes a Christ whose physicality evokes the classical nude without being specifically emulative of it: from the newly rediscovered crucifix (fig. 184) that he carved for the prior of Santo Spirito in Florence, an image in which spiritual purity is proclaimed through an integument of physical beauty.

By the early sixteenth century Michelangelo's images had expanded in physical power and energy (see figs. 200, 291, and 294, pp. 291, 397, and 400), and these works and those of other Italian artists who drew inspiration from them apparently had a profound effect on a young Flemish painter who came to Italy to study at the beginning of the seven-

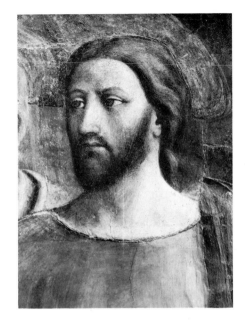

182. MASACCIO. The Tribute Money *(detail, by Masolino). ca. 1427. Fresco. Brancacci Chapel, Santa Maria del Carmine, Florence (Alinari-Art Reference Bureau)*

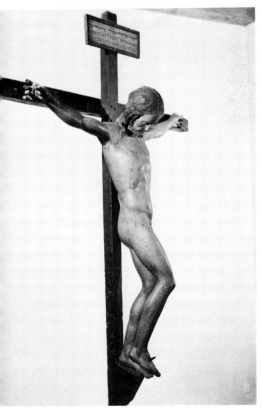

183. DONATELLO. Crucifix. *ca. 1444–47. Bronze. ca. 70 4/5" × 65 2/5". Sant' Antonio, Padua (Alinari-Art Reference Bureau)*

184. MICHELANGELO. Crucifix. *ca. 1492. Painted wood. Height ca. 31 ½". Santo Spirito, Florence (Alinari-Art Reference Bureau)*

teenth century: Peter Paul Rubens. On his return to Antwerp, Rubens painted *The Raising of the Cross* (fig. 185), now in the Antwerp Cathedral, mingling the massiveness and power of Michelangelesque forms with Flemish realism and pushing the energy levels even higher in the concentrated diagonal thrust of the pyramid of figures about the axis of the rising cross. The energies are almost explosive, threatening the confines of the frame—a thoroughly baroque composition that pulls the action out toward the viewer's own space. Rubens's image of Christ is truly heroic, not only in sheer physical splendor, but also in the spiritual strength that radiates from the upturned face. Christ's humanity is here magnified to suprahuman proportions.

The humanization of the image of Christ reaches its fullest expression in works in which a tender and compassionate Son of man is about his work in the ordinary world, as we see him in the paintings and graphic works of the Dutch master Rembrandt van Rijn (1606–69). In the so-called *Hundred Guilder Print* (fig. 186), illustrating—with considerable freedom—passages from chapter 19 of the Gospel of St. Matthew, Rembrandt has created a radiant image of the preacher and healer, a message to suffering humanity in both word and deed in which the orchestration of light and shadow (chiaroscuro) merges with the theme in an eloquent conjunction of form and meaning.

Rembrandt's conception of a tender, compassionate Christ has sectarian as well as personal roots, for the artist is known to have had close connections with the Mennonite sect, which at that time was a liberalizing movement in a sea of strict Calvinism. The Bible was the sole authority of the Mennonites and, in the spirit of the Sermon on the Mount, brotherly love was their constant guide. During this period of his life, Rembrandt was also on excellent terms with members of the Jewish community, which was concentrated near his home in Amsterdam. In the *Hundred Guilder Print* the Mennonite spirit blends with the artist's own capacious humanity to emphasize those aspects of Christ that reached out into the pathos and tragedy of human existence; and in the figures of those assembled one can see unmistakable

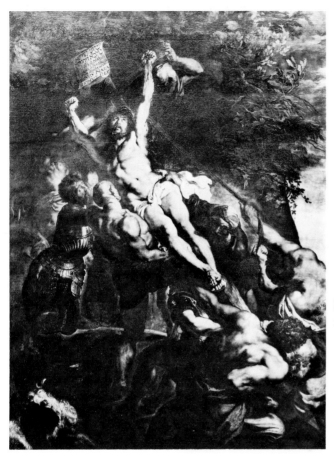

185. *(left)* **PETER PAUL RUBENS. The
Raising of the Cross.** *1610. Oil on wood
panel. 15′2″ × 11′2″. Antwerp Cathedral
(Bruckmann-Art Reference Bureau)*

186. *(right)* **REMBRANDT
VAN RIJN. Hundred Guilder
Print.** *ca. 1648–50. Etching. 11″
× 15½″. By courtesy of the
Trustees of The British Museum,
London*

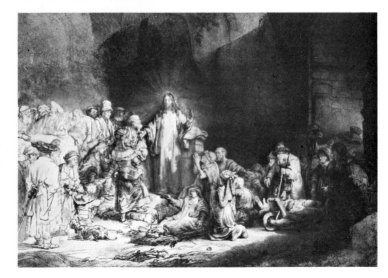

evidence of Rembrandt's own sympathetic involvement with the Jewish ghetto.

Early in his career, Rembrandt painted a melodramatic *Supper at Emmaus* (ca. 1630, Musée Jacquemart-André, Paris) with the figure of Christ silhouetted against an intense light and the two disciples reacting violently as their companion is suddenly revealed to them as their crucified Lord. Almost twenty years later, Rembrandt returned to the theme in another version (fig. 187) in which he shifted the drama in quite another direction—toward a gentle, melancholy, and low-keyed epiphany. In the spacious half-light of the interior, the disciples are shown at the very moment when the identity of their companion first dawns upon them. Christ radiates a mellow light that falls on the figures at the table and on the servant, who is oblivious to the significance of what is happening at the table. The niche in the background suggests the apse of a church, while the table at which the bread is broken evokes the altar. A mood of quietism prevails—a silence in which human drama becomes holy ritual.

By the nineteenth century the tradition of Christian art had become at best a minor concern in the Western world and hardly a major factor in the work of most important artists; the Englishman William Blake is exceptional in this respect (see fig. 453, p. 594). Paintings of Christian themes from this period, unless deliberately emulative of older traditions, are more likely than not to be on the order of genre painting, narrating episodes from the life of Christ, the Virgin, and the saints. There was some of this among the English Pre-Raphaelites, as evidenced in the work shown here (fig. 188) by Sir John Everett Millais (1829–96), one of the founders of the Pre-Raphaelite movement. The scene in Joseph's carpenter shop, where the young Christ has—prophetically—hurt his hand on a nail, reads like the illustration to a story, dutifully respectful of narrative detail and careful to describe a setting that evokes rural England more than the Near East.

Late in the nineteenth century, Paul Gauguin (1848–1903), in some of the works he painted in Brittany, like *The Yellow*

187. REMBRANDT VAN RIJN. Supper at Emmaus. *1648. Oil on wood panel. ca. 27″ × 26″. The Louvre, Paris (Alinari-Art Reference Bureau)*

188. SIR JOHN EVERETT MILLAIS. Christ in the House of His Parents. *1849–50. Oil on canvas. 34″ × 55″. The Tate Gallery, London*

Christ (fig. 189), truly approaches the spirit of devotional art. Alienated from the sophisticated Parisian art world that had rejected him, he was attracted to the naïveté of the Breton peasants and to the faith, laden with superstition, that was part of the rhythm of their lives. Turning their folkways and folk art to his own purposes, he has here expressed with primitivized simplicity a moment of quiet devotion before the cross, set in open fields like a wayside shrine. The crucifix has its origin in a wooden crucifix in the old Chapel of Trémalo near Pont-Aven, where the artist was living at the time. The yellowish appearance of the crucifix in the chapel probably suggested the color in which Gauguin painted the Christ and which is echoed in the color of the fields, against which he has contrasted the red-orange

189. PAUL GAUGUIN. **The Yellow Christ.** *1889. Oil on canvas. 36¼″ × 28⅞″. Albright-Knox Art Gallery, Buffalo, New York (General Purchase Funds)*

190. GEORGES ROUAULT. **Christ Mocked by Soldiers.** *1932. Oil on canvas. 36¼″ × 28½″. The Museum of Modern Art, New York (Given anonymously)*

trees and the blue hues of the women's dresses. The handsome orchestration of color is, however, as much a part of the picture's message as its devotional theme.

Even fewer artists have given serious attention to Christian themes in the twentieth century, but one artist in particular can be considered as being fully within the Christian tradition: Georges Rouault (1871–1958). His *Christ Mocked by Soldiers* (fig. 190), in form reminiscent of the patterns of medieval stained-glass windows (cf. colorplate 5), is the work of a devout Christian who has conceived the theme of a tormented Christ in terms of human pathos.

Just as the image of Christ has changed over the centuries, so has that of the Virgin, ranging from an imperial figure to the tender mother. *Enthroned Madonna and Child* (fig.

191), from the thirteenth century, is a late example of an old Byzantine type that still carries echoes of classical antiquity in the fall of the drapery and in the "architecture" of the throne, which resembles the Roman Colosseum. But the dense pattern of details in the throne and the linearized draperies with their bursts of gold-leaf highlights bespeak a tradition more concerned with expressing transcendent values than material reality. Nevertheless, although it is a conventional device, the gentle inclination of the Virgin's head toward the Christ Child and the delicate modeling of the features of both suggest the presence of an aesthetic somewhat different from that which rendered draperies and throne with such decorative purpose. Traces of a gentle humanity temper the formalized image.

In the central panel of *The Merode Altarpiece* (fig. 192) of the early fifteenth century, the Annunciation is set in a contemporary interior, carefully described and spatially defined. The viewer is instantly conscious of the volume of this hollowed-out space and the bulk of the objects in it. They have full dimensions and weight, unlike the more schematic forms in the *Enthroned Madonna and Child;* compare the draperies, for example. The theme of the central panel of *The Merode Altarpiece* is the Annunciation, but it is not presented as a formal tableau. Instead it takes on something of an everyday quality, as if the Virgin were about to be interrupted by an intruder while she is engrossed with her reading. She is half-reclining, which is informal enough; but her surroundings are deliberately material, like fragments of middle-class property assembled to make the scene an authentic interior of the times. The intensity of focus in the object rendering here is almost obsessive, so that each form asserts its individual identity, with unity achieved by the general illumination of the room. The emphasis on the draperies is further evidence of the artist's pride in his representational skills. Nevertheless, the scene is not without its measure of symbolic content, expressed through the objects themselves: the traditional symbol of the Virgin's chastity—the lilies in the vase on the table—and references to her as the "vessel most clean" in the basin of clear water

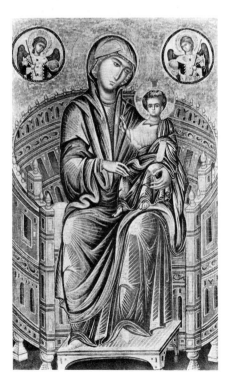

191. Enthroned Madonna and Child. *Byzantine school, thirteenth century. Wood panel. 32 ⅛" × 19 ⅜". National Gallery of Art, Washington, D.C. (Andrew W. Mellon Collection, 1937)*

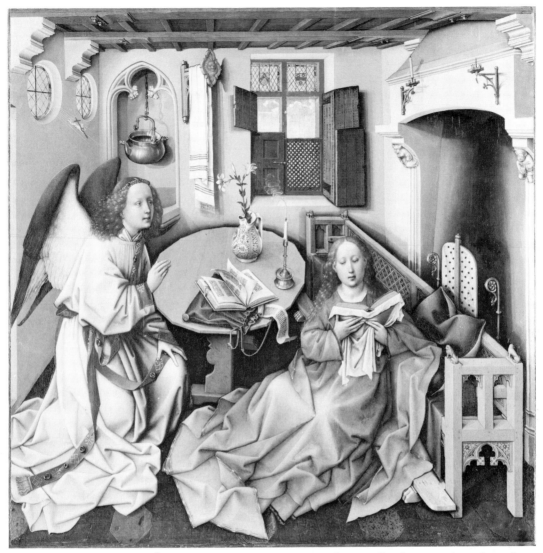

192. THE MASTER OF FLÉMALLE (ROBERT CAMPIN). The Merode Altarpiece *(central panel). ca. 1425–28. Oil on wood panel. 25 3/16″ × 24 7/8″. The Metropolitan Museum of Art, New York (The Cloisters Collection, Purchase)*

hanging in the background with the towel near it. Her piety is expressed through the presence of the holy books, and her posture is one of humility. An unusual feature is the candle on the table, smoking as if its flame had just been snuffed out by the sacred presence. Instead of the customary dove, a small child bears a cross in the midst of golden rays of light

coming in through the window above the angel's head—symbolic of Christ's Incarnation and the future sacrifice of Calvary. The materiality of worldly things is here joined to the world of sacred symbol.

This new materiality in sacred images is equally pronounced in the *Madonna with Chancellor Rolin* (colorplate 6) by Jan van Eyck and accorded even greater intricacy and elegance in details, from the tiled floor and arcade capitals to the jeweled crown and the elaborately documented landscape. The vision of the Virgin and Child that confronts the kneeling Chancellor Rolin is as tangible as he. The middle tones that dominate the interior space pull the composition together and unify its profusion of minutiae. The precision of the ornamental details in these early Flemish works—and their highly finished surfaces—lends them a jewel-like quality that tempers the intense realism and brings it into accord with the same spirit that found in stained-glass windows, reliquaries, and other church appointments fashioned of precious metals and gems a beauty deemed appropriate to the divine realm to which they were dedicated.

The image of the Virgin and Child assumes an idealized humanity in the early sixteenth-century Madonnas of Raphael Sanzio (1483–1520), set in spacious landscapes reminiscent of the artist's native Umbria (fig. 193). The amplitude of classical forms, which Italian artists had fully assimilated by this time, informs the type of beautiful Madonna Raphael created. The sweetness these images radiate may derive in part from Leonardo's Virgins and angels (cf. fig. 126, p. 181), but they are invested with a cool, harmonious grace that is Raphael's own invention.

Although Raphael's Madonnas are brought physically close to the viewer, they are nonetheless remote by reason of their ideality. Quite the opposite is true of *The Madonna of Loreto* (fig. 194), painted by Caravaggio (1573–1610) early in the next century. She is close to the kneeling peasants, as if she were merely leaning against the doorway in front of them; and, lovely as she is, she seems to exist at the same level of reality as the peasants themselves. The heightened

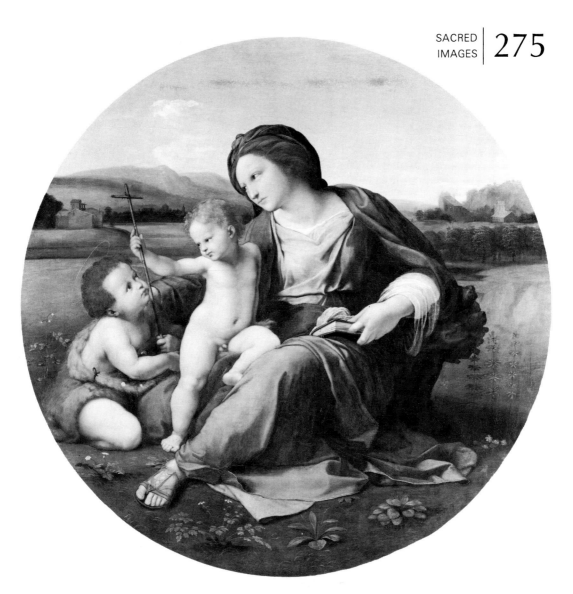

193. RAPHAEL. The Alba Madonna. *ca. 1510–11. Transferred from wood to canvas. Diameter 37 ¼ ". National Gallery of Art, Washington, D.C. (Andrew W. Mellon Collection, 1937)*

reality and immediacy of the vision of the Virgin and Child in this painting is in accord with a vein of popular religion in Caravaggio's time that sought to draw the supernatural into the realm of the real. The sacred mystery was conceived to be tangible to the ordinary—but concentrated—senses of

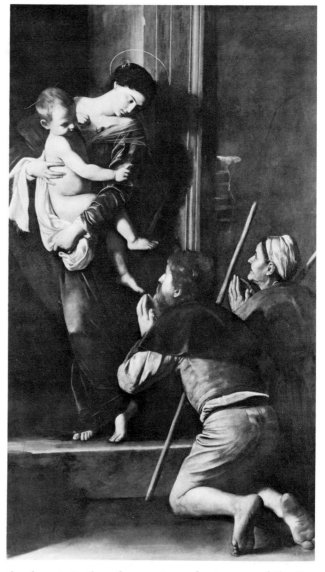

194. CARAVAGGIO. The Madonna of Loreto. *ca. 1604. Oil on canvas. 8′6⅜″ × 4′11″. Sant' Agostino, Rome (Alinari-Art Reference Bureau)*

the devout. In the subsequent popular imagery of the Roman church, however, it was the prettiness of Raphael's Madonnas rather than the somber piety of Caravaggio's images that became the norm.

From this brief survey of types and transformations of sacred images certain salient features have emerged. Foremost among these is the variety of purposes to which sacred

images are addressed. The image may be intended to im-press the beholder with its otherness and to draw him into a reverent or servile relationship to it—the intimidative aspect of sacred imagery. It may inform the viewer of the powers and attributes of deity and of the ritualistic, moral, and ethical obligations of the faithful—the didactic aspect. The sacred image may be intended to participate directly in religious observances either as an immanent manifestation of deity in which certain active powers are held to reside, as a symbolic substitute for deity, or as an intermediary vehicle between mankind and divine forces—the magic aspect. Or it may express a specific orthodox, factional, or individual attitude toward deity as filtered through the consciousness of the artistic personality—the subjective aspect.

Implicit in these features are two lines of energy emanating from the sacred image: one directed toward deity itself, a gathering in of solemn loyalties, homages, fears, and ritual observances; the other directed toward mankind, wherein the image communicates deity's concern for the well-being of humanity. Finally, the forms that sacred imagery assumes derive from attempts to find visual equivalents for those purposes and processes just outlined. This does not always lead to outright invention of unique forms for the immediate purpose, for often forms are the products of borrowing and adapting the nonsacred art available or popular at the moment.

One more category of sacred imagery remains: that of architecture. Normally we think of architecture in practical terms, as space-defining structures meeting the demands of certain functions to be carried out in or about it; and since religious worship and its rituals constitute functions, sacred architecture can be considered in the same light as any other buildings. Sacred architecture has always had dimensions beyond this, however, for another level of purpose is reached in its symbolic character.

The caves in which prehistoric man created his images of beasts cannot be considered architecture in the strictest sense, being natural formations essentially unaltered by him.

But the fact that cave art exists deep within these caverns has suggested to many observers the possibility that these hollows in the earth were considered analogous to the womb of a living earth, a Great Mother, and so a natural place for life to be generated in the images on the walls.

Another natural configuration bears mention here. In the somewhat controversial view of the architectural historian Vincent Scully, the ancient Greek temple, which housed the image of a particular deity, was but a portion of a more extensive architectural concept in which the sacred setting, including both the immediate temple site and the landscape features around it (like the peaks, horns, or clefts of surrounding or distant mountains), were visually and symboli-

195. The Ancient Acropolis (the "Upper City"), *with the* **Parthenon** *(center) and* **Erechtheion** *(left). Greek, fifth century* B.C. *Greek National Tourist Office*

196. **The Great Stupa,** *Sanchi. Indian, Shunga and early Andhra period, third century* B.C. *to first century* A.D. *Government of India*

cally joined by the Greeks to the temple itself to form the architectural whole (fig. 195), the entire set of relationships being expressive of the immanence of deity in the natural world.

Some sacred architecture appears to have been markedly representational in character. The pyramids of Egypt, sacred as the funerary monuments of the god-kings, are said to have represented the primeval hill, the first land to appear above the waters in the Egyptian story of creation. The terraced, pyramidal ziggurats of Mesopotamia, with the shrines of the gods at their summits, were also representational to the extent that they recalled the mountains where the gods were supposed to have dwelt and where both storms and the life-giving streams of water originated.

This earth imagery also appears in the Indian *stupa* (fig. 196), a symbolic representation of the world mountain cov-

ered by the envelope of the celestial dome, surmounted by the tripartite umbrella, a reference to Buddha, the law, and order, significantly overtopping everything else. The railing around the umbrella may derive from the railing around the sacred tree, as the umbrella evokes a further association. Around the solid mount of the *stupa* there is also a prescribed "path of life," which the pilgrim walks counterclockwise, and an outer railing with four gates marking the four directions, like a compass, encircles all this. The entire complex is a symbol of the cosmos. The *stupa* does not "house" a congregational function, but rather approaches the condition of a massive sculptured shrine around which certain ceremonies are to take place. For that matter, the Greek temple is also sculptural, although it has an interior space for sheltering the cult image of a god or goddess. Ceremonies were held outside the temple itself—in the larger "architectural" context of the sacred landscape.

197. Chartres Cathedral. *Begun 1194.*
French Government Tourist Office

The hemispherical form encountered in the *stupa* is a hollow dome in some Christian architecture, where it also has cosmic significance. The interior of the dome in certain Byzantine churches, for example, is covered with splendid golden mosaics, and the image of Christ Pantocrator crowns the apex. The dome is more than a structural form; it is a natural metaphor for the dome of heaven.

Without doubt, the most comprehensive and intricate sacred symbology in architecture is to be found in the Gothic cathedral (fig. 197), which developed at a time when the ecclesiastics who were the custodians of the religious context of the architecture were involved in organizing encyclopedic systems to bring theology, science, and philosophy as well as the ways of faith and reason into a grand harmonic order with everything in its proper and integrated place. In the climate of medieval Scholasticism, as this movement was called, the Gothic cathedral developed—a finely integrated structure whose logical architectural system corresponded in many ways to the universal order as conceived by the Scholastics.

The symbolic ground was prepared by what has sometimes been called the basis of all medieval thought: analogy, that tendency to see and to seek correspondences or likenesses between two different things or situations. By extension this could imply a harmonic principle in the universal scheme of things. Thus, to give a concrete example, certain aspects of the Old Testament could be taken as prefigurations or references to certain aspects of the New Testament, as when the burning bush, a form in which God appeared to Moses, was adduced as a prefiguration of the Virgin, since the bush burned but was not consumed by the fire, just as the divine fire entered the womb of the Virgin without destroying her. So it is that the figure of the Virgin on the north porch at Chartres appears with the burning bush beneath her feet. This habit of correspondences was well entrenched in medieval thought, so the idea that a cathedral might be a symbol of something was not at all farfetched; it became an image of heaven, a vision of the celestial city, by this analogical process.

In the background also lay two important concepts that made it possible for the analogy between the cathedral and the celestial city to have a credible basis. These have to do with geometry and light.

Geometry had special significance in medieval thought through its systematic structure and the universality of its diagrammatic concepts; so the ideal forms of geometry and certain proportions were considered to reflect divine perfection. At the practical level, with respect to the best architectural procedure, geometry was regarded as that without which all architectural practice was unsound: *"Ars sine scientia nihil est"* ("Art without science is nothing"), as a French adviser during the building of the cathedral at Milan put it during the late fourteenth century. By *ars* was meant the practical skills learned through experience in building; by *scientia*, the rational method gained by knowledge of geometry and an understanding of theoretical principles. So by these threads of association the qualities that derived from the structural unity of good architecture were based on geometry, here given sacred meaning, and for that reason capable, in an analogical sense, of leading one to the contemplation of the divine order. In view of these associations it seems only fitting that one Gothic form for the image of God the Creator was as a geometer with a compass.

Light was equally important in medieval thought and a frequent metaphor of beauty as well as of the truth that radiated from God, since it was the least material of natural phenomena and therefore closer in substance to the transcendence of the divine realm. So, in architectural practice, the Gothic window was more than a splendid wall of colored light—it was analogous to divine radiance itself, and in the prismatic loveliness of this light the sacred themes depicted in the glass gained added significance (colorplate 5).

The symbolic aspect of the Gothic cathedral has a precise historical frame of reference, for the beginning of the Gothic style can be isolated with some accuracy: the rebuilding, between 1137 and 1144, of the royal Abbey Church of Saint-Denis outside Paris by a Norman architect under the

direction of Abbot Suger, close friend and adviser to the French king Louis VI. Saint-Denis was the patron saint of royal France, and the site had special meaning for the monarchy in other respects: Charles Martel was buried there, and Pepin and Charlemagne had been installed there as kings. Suger saw his splendid church-to-be in terms of both religious and patriotic symbolism. That the mystical qualities of light figured in the sacred symbolism of the new church is suggested by the writings of Suger himself, in his description of the rebuilding of the abbey church and elsewhere in his accounts of the project. This emphasis on light owed something, too, to the confusion of Saint Denis with a fifth-century mystic, Pseudo-Dionysius, whose writings proclaimed light as the essential element in Creation and the closest of all things to God. Suger was familiar with the medieval literature of light and number symbolism derived from Pseudo-Dionysius and regarded the windows in his church as sacred and their light miraculous—splendid veils, as it were, through which divine illumination could be sensed.

But the symbolic imagery of the Gothic cathedral comprehended earthly things as well as divine transcendence. The cycle of the seasons and the activities associated with them (see fig. 400, p. 525), creatures both real and imagined, the occupations and arts of mankind, the virtues and vices, and history (in a religious context) were all there in the sculpture and the windows. As divinity was present in the world, so the world was present in the cathedral, mirrored evidence of divine creation in the encyclopedic range of the figural decoration.

Later, in the Italian Renaissance, such encyclopedic embellishments were eschewed in favor of a leaner architectural vocabulary adapted from classical antiquity; but the mingling of divine and earthly symbolism was still a feature of architectural concepts and was embodied in their geometry.

Although it is important to recognize that the symbolism of Renaissance architecture involved proportions derived from those of the human body, this should not be construed as a complete turnabout in architectural symbolism from God-

centered to man-centered principles. This human imagery stemmed directly from the writings of the Roman architect Vitruvius, who was of exceptional importance to the Italian Renaissance. Vitruvius had remarked that a well-proportioned man, with arms and legs extended, would fit into both the circle and the square, an image that seems to have haunted many Renaissance artists and architects. Geometric figures, especially the circle, also had a long history of association with the idea of perfection, with the harmonic composition of the universe, and with divinity. Like their medieval predecessors, Renaissance architects thus viewed these geometric forms and their polygonal relatives as the most suitable ones upon which to base the design of churches. The natural world was even called to witness. The Renaissance architect Alberti noted that nature itself preferred the round form above all others and pointed out that bees selected the hexagon as the form for cells in their hives. As in the Gothic age, mathematics was still regarded as a vehicle for reaching knowledge of the nature of God, and the geometric principles of Renaissance church design were of this order. It was felt that the pure and absolute harmony of the divine realm would be sensed by man when in the presence of architecture based upon perfect geometric forms and harmoniously integrated, part by part. So, with both God and man (made in God's image) related to certain geometric figures, the divine and human realms mingled in Renaissance theory; but the sacred symbolism was still the paramount content of the geometry. As a result of this emphasis on circle and square, the design of churches during the fifteenth century began to turn from the old basilica form with its dominant longitudinal axis to the centralized plan (fig. 198). The choice was made on the basis of what could reasonably be called a "sacred aesthetic."

The basilica form persisted, however, and, despite earlier plans for a centralized structure, it was in the form of a basilica that St. Peter's, Rome, the central church of Catholicism, was finally completed (see fig. 419, p. 552). The basilica form can also be found in churches built in this century—even when they are not deliberately emulating

a. *Bramante, 1506*

b. *Bramante-Raphael, 1515–20*

198. Plans for St. Peter's, Rome. *After James S. Ackerman,* The Architecture of Michelangelo *(London: A. Zwemmer, Ltd., 1961), plate 13*

c. *Sangallo, 1539*

d. *Michelangelo, 1546–64*

earlier styles (see fig. 36d, p. 47). Since the basilica plan developed along with church ritual, its form and the function it served were historically linked and mutually compatible, which accounts in large measure for its stubborn survival in sacred architecture.

Independent of historical styles, asserting its own uniqueness, yet subtly linked to the past in its aesthetic and constructional aspects is a relatively small chapel in France: Notre Dame du Haut at Ronchamp (figs. 199a and 199b), designed by Charles Édouard Jeanneret, called Le Corbusier (1887–1965). The site, like a Greek acropolis, overlooks the plain of the Saône from a spur of the foothills that lead back to the Vosges Mountains. It was the site of an old pilgrimage chapel that the elements and war had reduced to a pile of rubble. Le Corbusier's chapel literally rose from the ruins, for the rubble was incorporated in its thick walls.

199a. LE CORBUSIER. Notre Dame du Haut, *Ronchamp, France. 1950–55. (Ezra Stoller © ESTO)*

199b. **LE CORBUSIER. Notre Dame du
Haut,** *interior view, south wall. 1950–55.
(Ezra Stoller © ESTO)*

Like the village chapel it is, Notre Dame du Haut seems
close to the peasantry. The refinements of its design aside,
it has an elemental, somewhat primitive appearance, rooted
to its site like a massive sculpturesque outcropping. It was
constructed, like the old cathedrals of France, by a team of
craftsmen assembled by the architect, who remarked that "a
sense of what was sacred" inspired the project. This sense
is apparent in the character of this chapel "of dear, faithful
concrete," as the architect put it. He wished to create "a
place of silence, of prayer, of peace, of spiritual joy." Both
the interior feeling of sanctuary and the poise of the exterior
affirm this purpose.

For all its apparent bulk, evoking the hull of a ship or some
massive aerodynamic form, the gray roof soars dramatically
above the white walls, not supported by them but resting
instead on hidden piers. The lift of the roof is also felt in
the interior where a space between the top of the thick walls
and the roof lets in a line of light as if the ceiling were
hovering over the interior space. The towers also serve as
light wells, carrying illumination down into two small chap-
els within the church.

The form of the roof—whatever associations it may evoke for the viewer—was actually inspired by a crab shell Le Corbusier found on a Long Island, New York, beach in 1946. Impressed by its strength and lightness, he transposed the structural idea to a roof form consisting of two separate and relatively thin membranes of reinforced concrete.

The design of Notre Dame du Haut, like that of the Greek temple and that of the Gothic cathedral, is also a refined system of mathematical relationships. It is based on a modular device, Le Corbusier's famous "Modulor," derived from the proportions of a man six feet tall. The pattern of embrasurelike splayed windows—so casual at first glance—is composed according to this scheme just as much as the larger proportional relationships throughout the chapel. In this respect the aesthetic aspect of the chapel is related to a long tradition of proportional design set to human scale.

No modular system, of course, can guarantee distinguished architecture, for it must be applied with sensitivity to achieve success. This condition is surely met at Ronchamp. Impressive as a sculptural presence—like a Victory, an angel, a ship's prow—on the heights and effective as an enclosure fulfilling the requirements of a sanctuary, Notre Dame du Haut belongs in the company of the greatest achievements in sacred architecture.

It may be that society will no longer support a widespread tradition of sacred imagery or architecture. Perhaps religious feeling henceforth will be seriously expressed only on individual terms, as in the chapel at Ronchamp or the oeuvre of a Rouault, and our major architectural monuments will serve almost exclusively secular purposes. But the spiritual needs of mankind will be served in one way or another, and channels for their expression will surely be found—as always in the past—through the media of the literary, performing, and visual arts.

CHAPTER 7

THE CULT IMAGE OF THE HERO

The ancestry of the hero image leads back to the myths of antiquity, where, in the Mesopotamian *Epic of Gilgamesh* from the third millennium B.C., we find a very early formulation, fully developed, of the hero type. Created in perfect beauty and physicality, Gilgamesh (like many of the later Greek heroes, part god, part man) was endowed with exceptional courage by the god of storms. He was both a wandering warrior and a builder of temples; his deeds were marvelous, and he sought immortality. In the excellence and scope of his capacities, he is the ideal prototype. There is a nice simplicity and balance to all this, but the hero image in the concepts and art of mankind is not a simple—or stable— equation. The reality of a particular hero image may vary in many respects from the generic type.

Each society creates its own heroes, and as societies and times differ, so may the images of their heroes projected in their art and literature. The traditional hero image is an idealized form with which historical evidence may often be at odds, even when it can be accounted for logically in the values and aspirations of the idealizers. Society's accolades sometimes fall on curious choices.

The image of the hero (or the personage or idea behind it) is to some degree an object of veneration, acquiring an aura of religiosity bestowed by its devotees. It is therefore difficult to dissociate the hero image from the image of deity. It, too, can attract fanatic dedication, as history, for better or for worse, has shown. The substance of the hero, his capacity for great deeds, is assumed to be superior to that of ordinary beings, and the implication has traditionally been that he is

somehow divinely favored, that some timeless quality garnishes his deeds with the immortality denied his being. In fact, it is the very mortality and vulnerability of the hero that provide the essential condition for his heroism. He is expected to place his own splendid but ephemeral life on the line—or his reputation, which not infrequently amounts to the same thing. One is reminded that Achilles was offered a choice by the gods: a long but undistinguished life or a short one full of glory. He chose the latter. The immortality he desired lay not in the shadowy underworld he knew awaited him, but rather in his deeds and the memory of them that would survive his death and that poets would celebrate.

There have been certain images that seem to encapsulate the very substance of a heroic presence to the degree that they have gained a plateau of timelessness. Such an image is the *David* (fig. 200) of Michelangelo, which once stood in front of the Palazzo Vecchio in Florence but in 1873 was removed to the Accademia and replaced in the piazza by a copy. The *David* was made to heroic scale, the figure alone being over fourteen feet in height—a young giant. In its original location it stood as a reminder to all of the energy of the Florentine state. Nothing quite like it had been fashioned before in Renaissance Florence, although the *David* (see fig. 275, p. 381) by Donatello and his earlier *St. George* (fig. 201) must have served the young Michelangelo as inspiration as well as challenge. The strong body of the *David*, finely balanced in a classical *contrapposto* stance, is at rest; but the play of muscles, the tension conveyed by the hands and the turn of the head, the expression on the face, sober, alert, almost fiercely anticipatory, are analogous to the latent power of a coiled spring. It is the perfect embodiment, in human form, of the function of a guardian image. The conflict with Goliath is yet to begin, but the alertness and expression of the statue imply its imminence. Its nudity, of course, recalls the sculpture of the Greco-Roman world and its physical power evokes some Hellenistic works in particular. Michelangelo had undoubtedly studied Hellenistic sculptures, or their Roman copies, during his recent sojourn in Rome, and if the *David* seems to anticipate the superhu-

200. MICHELANGELO. David. *1501–4. Marble.*
Height of figure 14'3". Academy, Florence (Alinari-Art
Reference Bureau)

201. DONATELLO. St. George. *ca. 1415–17. Marble.*
Height 6'10". National Museum, Florence (Alinari-Art
Reference Bureau)

man strength of the figures the artist was to create in the spirit of the Hellenistic *Laocoön Group*, still two years away from rediscovery in Rome when the *David* was completed, it merely confirms Michelangelo's predilection for images of physical splendor larger than life. Michelangelo seems to have joined the allegory of Christian Fortitude to the body of a Greek god. But the *David* is not precisely classical, for the undercurrent of tension within an image at rest has no exact counterpart in the Greco-Roman world. That invention is Michelangelo's own.

Over a century later, another great sculptor, Gianlorenzo Bernini (1598–1680), carved a marble *David*, life-size and in action (fig. 202). Displayed on a lower pedestal than the *David* of Michelangelo, Bernini's statue brings the hero into a more direct relationship with the viewer's world. The impressionable viewer can sense the potential danger of a viewing position in line with the intended trajectory of the stone in the sling. The space in that direction from the statue is truly charged with meaning; the presence of the antagonist is keenly sensed across it. This spatial drama, so explicit in Bernini's work, is a characteristic of his age, the baroque era, and is of a different order than the mere hint of it in the glance of Michelangelo's young giant, whose projection into space is on a plane so elevated in actuality that it seems that an ideal rather than a real conflict lies in the offing. Bernini's figure, however powerful its proportions and however reminiscent of Hellenistic emotional energy its gesture may be, is not a remote ideal. Its overwhelming immediacy places it at a level of reality different from the Florentine statue. The action is not imminent but in progress, caught at the moment just before the stone is released, and the violent twist of the hero's body and the thrust of his legs enlarge the spatial envelope about the figure as a field of action, a field that impinges on the viewer's own space.

202. GIANLORENZO BERNINI. David. *1623. Marble. Life-size. Borghese Gallery, Rome (Alinari-Art Reference Bureau)*

The *David* of Michelangelo is a confident image that embodies Renaissance anthropocentric values. He *is*. Bernini's *David* moves as if in a fury the human body could not contain. The dynamic energy he radiates seems not entirely his own, but a divine fury of which he is the inspired agent.

The Heroic Conflict

The theme of heroic conflict, depicting the hero as a man of action, occupies a preeminent place in the history of the hero image. The hero's adversary and the conflict itself vary as much as the hero: Gilgamesh battled the wild man Enkidu, who then became his heroic companion, the two doing battle with primeval monsters; Prometheus dared defy the authority of Zeus to bring fire to mankind, for which he underwent incredible torture, chained to a mountain; adventurers have struggled through dangerous wilderness places, sailors have challenged the sea, and hunters have contested with wild beasts; and even beasts themselves have been given heroic roles to play in literature and art, beast against beast, beast against man or the forces of nature. The variations are manifold, but one quality is constant: the struggle demands the utmost of the adversaries.

The nature of the heroic conflict is nowhere better represented than in the detail of the Assyrian relief that depicts a magnificent lion taking the arrows of Ashurnasirpal II (fig. 203). Both images, the lion and the king, are manifestations of the power that resides in each of them, and there is no question here but that the action pits strength against strength. The king is close to his quarry and the lion still threatens. The heroic risk is taken, and because the king's adversary is so splendid his impending victory is enhanced. How different from a similar theme from eighteenth-century India (fig. 204), where the hunting of a heroic tiger from concealed stations with the impersonal agency of firearms denigrates the victory and assures an unheroic outcome —for man, not for the tiger.

The hero's adversary may sometimes be an impersonal force. *The Raft of the Medusa* (fig. 205) by Théodore Géricault

(1791–1824) does not single out one hero but presents the heroic struggle as the communal battle of shipwrecked men against the sea. The incident was an actual event, and Géricault took pains to impress the contemporary viewer with its factuality, interviewing some of the survivors and having a

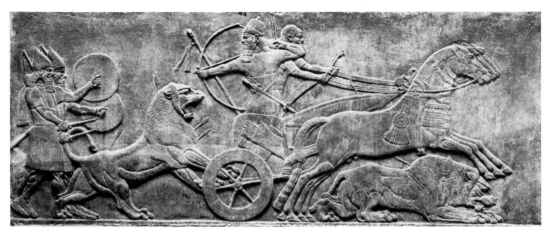

203. **Ashurnasirpal II Killing Lions,** *relief from Nimrud (Calah). ca. 850 B.C. Gypseous alabaster. 39″ × 100″. By courtesy of the Trustees of The British Museum, London*

204. **Tiger Hunt on a River Bend,** *from Rajasthan. Indian, ca. 1790. Color on paper. 9 15/16″ × 19 15/16″. Collection of George P. Bickford, Cleveland*

205. THÉODORE GÉRICAULT. The Raft of the Medusa. *1818–19. Oil on canvas. 16'1" × 23'6".*
The Louvre, Paris (Alinari-Art Reference Bureau)

model of the raft constructed in his studio. The dramatic
lighting, the dead and dying men, the swell of the sea, the
wind in the sail, and the countersurge of figures supporting
at the top of their pyramidal mass the figure of the black
seaman waving a cloth at a ship far away on the horizon are
all calculated to intensify the climax of a desperate struggle
for survival. The dramatic devices that dominate the compo-
sition recall the theatrical side of baroque art and demon-
strate how much the nineteenth-century romantic move-
ment in France, of which Géricault was one of the leading
figures, drew upon the example of seventeenth-century art.
This conflict of the men on the raft was not deliberately
sought as in the Assyrian relief. It fell upon ordinary men
quite unexpectedly and was made more bitter by having
been in part the consequence of inhumanity: the raft had
been cut loose without adequate provisions from the boats

of the *Medusa*, a French frigate that went down off the coast of Africa. The fact that ordinary seamen, in their collective struggle with the odds heavily weighted against them, have here managed—some of them—to win their struggle for life raises them as heroes into a realm formerly occupied only by the highborn and the mighty. One might say that here the hero image has been democratized.

Comparable in some ways to Géricault's collective heroism of ordinary beings is another image, this time from the twentieth century's time of troubles: the familiar photograph of United States Marines raising the flag at Iwo Jima during the Second World War (fig. 206). For at least one generation of Americans this image was the dramatic incarnation of patriotic heroism. It became a symbol that overrode the identities of the men themselves. The individual participants, remembered in their citations, were soon forgotten by the millions who acknowledged the visual record of their action as a heroic image of their time. In the same spirit of collective heroism, but at the level of traditional allegory, is *La Marseillaise* by François Rude (1784–1855) on the Arc de Triomphe in Paris (fig. 207). Although dedicated to the heroes of the French Revolution, the figures of the soldiers are depicted in antique garb, inspired by the allegorical figure above them, an amalgam of Liberty and Victory.

The Death of the Hero

The hero image has sometimes emphasized the hero's death, whether in victory or defeat, and in the Hellenistic *Dying Gaul* (fig. 208) the theme of victory and the death of the hero are given an unusual twist when the image is viewed in the context of the events that fostered it. The statue is a Roman copy of a lost bronze original that was part of a group of bronzes commemorating a victory of Attalus I (241–197 B.C.) of Pergamum in Asia Minor. Here the victory over the Gauls is celebrated not with heroic statues of the victors but with a monument of the vanquished. Struck by the barbaric virility of the Gauls, the Pergamene king apparently ordered the execution of works that would

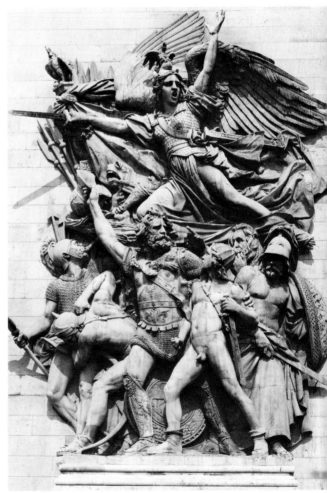

206. JOSEPH ROSENTHAL. Raising Flag on Mount Suribachi (Iwo Jima). *23 February 1945. Photograph. United States Defense Department (Marine Corps)*

207. FRANÇOIS RUDE. La Marseillaise, *relief from the Arc de Triomphe, Paris. 1833–36. Marble. ca. 42' × 26'. (Bulloz-Art Reference Bureau)*

exhibit the quality of the enemy. What is particularly vivid in this example is the sculptor's awareness of the loneliness of the passage from life to death. The Gaul is dying, but his right arm still supports the weight of his torso and declining head. It is his last effort, for in the next moment, the viewer senses, the man will pitch forward on his face. The space between the ground and his sagging head and shoulders is the last theater of action left him, and he appears to resist its pull. The poignancy of that final struggle lends pathos to the image and reminds the viewer that the evolution of art

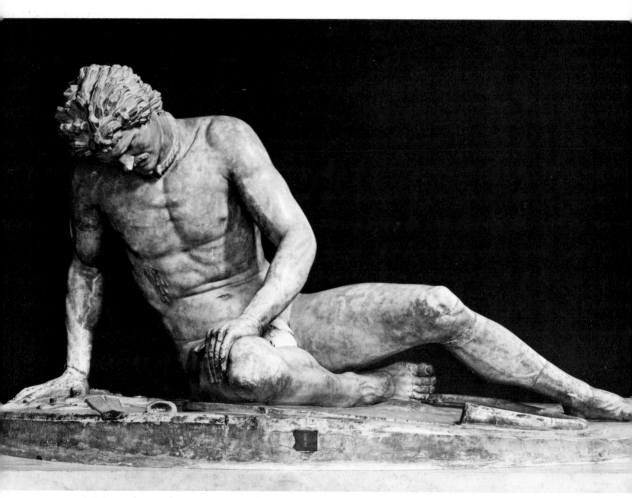

208. **Dying Gaul.** *Roman copy after a Hellenistic bronze original. ca. 230–220 B.C. Marble. Height 36⅝".* *Capitoline Museum, Rome (Alinari-Art Reference Bureau)*

in the Greek world, having mastered the representation of tangible appearances, was by this time probing the intangible realm of the human spirit (see pp. 29–30).

An altogether different image of the hero's death, from a later era but with an antique theme, presents some problems for the modern viewer that are usually glossed over in accounts of the work. The *Milo of Crotona* (fig. 209) by Pierre Puget (1620–94), a monumental work nearly nine feet high, depicts the death of a hero of antiquity who was devoured by a lion while his hand was caught in the crack of a tree stump. Sculpturally it is an impressive piece, based on a substructure in the form of a parallelogram, the sides of which form the axes of powerful twisting movements. The figure of the hero defines two of the sides, and his body stretches in agony as a relatively diminutive lion attacks him from behind. Milo's agony, truly intense, is conveyed in every knotted, straining muscle, recalling the sublime torment of *The Laocoön Group* (see fig. 26, p. 37). But the size and position of the lion remind us of the effects of the visual conditioning that has taken place during the some two hundred years that lie between modern viewers and the creation of Puget's masterpiece. The hero's pain is remarkably real, and no sensitive viewer can escape the realization that the sculptor has managed to convey the impression of a convulsive shudder on the surface of the marble. But it is precisely this aspect of the image that appears at odds with the small scale of the lion. Too often the uninitiated modern viewer's response is one of amusement, denying him the appreciation of the statue's heroic content. The difference in scale between the hero and the lion, the odd circumstances of the tragedy, and the intense realism of the hero's agony are potentially disjunctive visual elements. To a viewer whose initial impression centers on the realistic aspects of the work and who has been conditioned to read human action in literal terms, particularly when it is as vividly portrayed as in this statue, these disjunctive elements appear quite illogical in relation to one other. Therefore, the "willing suspension of disbelief" is hard to achieve.

In the mid-eighteenth century, when Benjamin West

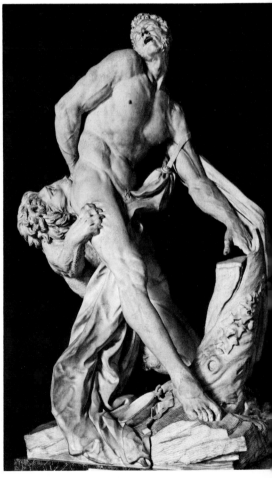

209. **PIERRE PUGET.** Milo of Crotona. *1671–83. Marble. Height 8′10½″. The Louvre, Paris (Alinari-Art Reference Bureau)*

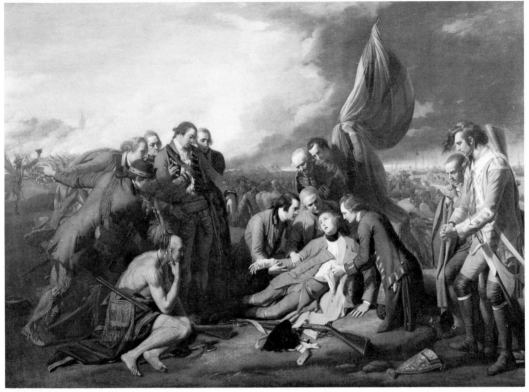

210. **BENJAMIN WEST. The Death of Wolfe.** *1770. Oil on canvas. 59 ½″ × 84″. The National Gallery of Canada, Ottawa (Gift of the Duke of Westminster, 1918)*

(1738–1820) painted his *Death of Wolfe* (fig. 210), it had become customary to represent contemporary historical events by allegorical configurations, usually disguised as classical allusions. West's depiction of the participants in an event from recent history in contemporary costume rather than in the timeless garb of classical antiquity was almost unprecedented. He was not the first to do so, even with this same theme; but his status as a favorite of the English king placed him in an excellent position to set a new precedent. It is not this aspect of the work that most concerns us here, however, but rather West's allusion to the tradition of mar-

tyr images that was not lost upon his educated audience. The mortally wounded English general is shown surrounded by his aides at the climax of his victory over the French near the city of Quebec. The battle flag above him is furled as if in mourning, the emotions of the moment show on the faces of those about him, and the sky is dark in the background beyond. Only the stoic Indian who looks on appears

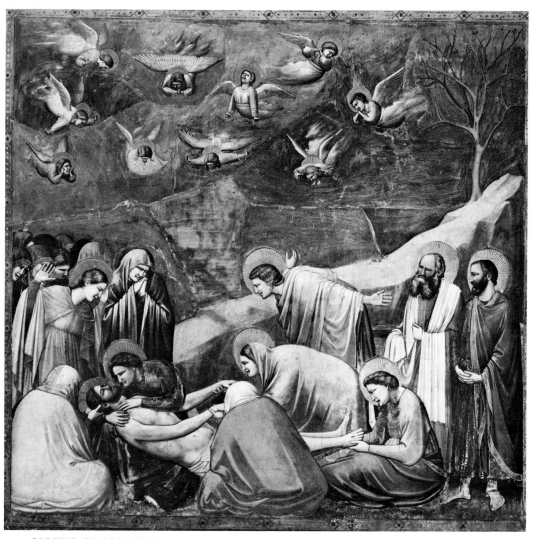

211. GIOTTO DI BONDONE. Lamentation over the Body of Christ. *1305–6. Fresco. Arena Chapel, Padua (Alinari-Art Reference Bureau)*

somewhat removed from the immediate drama; but even he seems, by his contemplative attitude, to be considering the significance of the event. The three men who partially support the general's half-reclining body bend over him like a protecting semidome, a sacred enclosure as it were, suggesting traditional images of martyrdom that can be traced back to such compositions as Giotto's fourteenth-century fresco *Lamentation over the Body of Christ* (fig. 211) and to earlier death scenes of heroes on antique sarcophagi. The dying general, with his slight figure and fragile features, does not fit the classical mold for a hero; but West was aiming at likeness here, and the image agrees with other portraits of the young commander. Appropriately, however, the noble, ecstatic expression on his features suggests the stereotype of the martyr whose triumph is his death, here transferred from the sacred to the secular arena. The cause in whose service he has given his life is the empire. The composition mixes classically balanced figure groups with dramatic baroque postures and lighting, prefiguring the emotional vein of romanticism. History painting of this dramatic and topical variety soon flourished in Europe and in America, where John Trumbull (1756–1843) became its most noted practitioner.

The image of the hero as martyr found its artist *par excellence* in Jacques Louis David (1748–1825), whose career is identified with the neoclassical movement in France (see pp. 435–44), the French Revolution, and its Napoleonic aftermath. In his paintings of *The Death of Marat*, one of which is shown here (fig. 212), David, like West, drew upon a traditional martyr image for his posthumous portraits of the French revolutionary. The arresting device of the limp arm can be traced back through various representations of the dead Christ in entombment scenes—and the example of *The Entombment of Christ* (fig. 213) by Caravaggio is especially relevant—to antique sarcophagus reliefs depicting the deaths of heroes like Meleager and Adonis. The visual allusion would not have been lost on David's circle of admirers, for whom the image would suggest rich associations with heroes, martyrs, and the ultimate sacrifice of Christ. But the painting, for all its reliance on classical and Christian iconography and on a classical armature of verticals, horizontals,

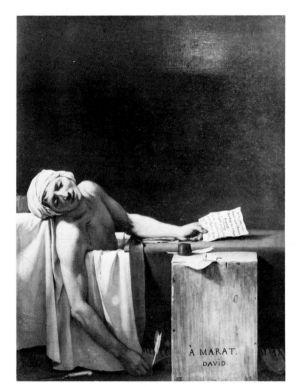

**212. JACQUES LOUIS DAVID. The Death of
Marat.** *1793. Oil on canvas. 65″ × 50¼″. Royal
Museums of Fine Arts, Brussels (Bulloz-Art Refer-
ence Bureau)*

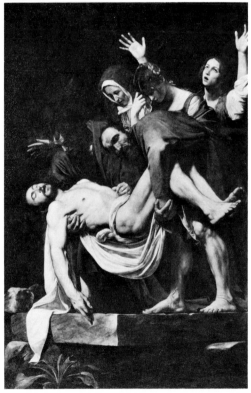

213. CARAVAGGIO. The Entombment of Christ.
*1602–4. Oil on canvas. 9′10″ × 6′8″. The Vatican,
Rome (Alinari-Art Reference Bureau)*

and parallel planes, asserts itself as a unique and remarkably naturalistic image. It should be noted that David's neoclassicism was tempered by his predilection for realistic representation in the Caravaggesque tradition best seen in his portraiture but not entirely absent from his more classicizing history paintings. In fact, the strength of David's work rests largely on this basis. The underlying realism infuses the classical order and rhetoric of his major compositions with striking immediacy, saving them from academic remoteness. These works addressed themselves directly to the sentiments of the revolutionary age into which David was born.

The Death of Marat, when compared with David's earlier and more doctrinaire neoclassical work *The Death of Socrates* (fig. 214), is a daring invention. Almost the entire upper half of the painting is an empty space, except for the tonal

214. JACQUES LOUIS DAVID. The Death of Socrates. *1787. Oil on canvas. 59″ × 78″. The Metropolitan Museum of Art, New York (Wolfe Fund, 1931)*

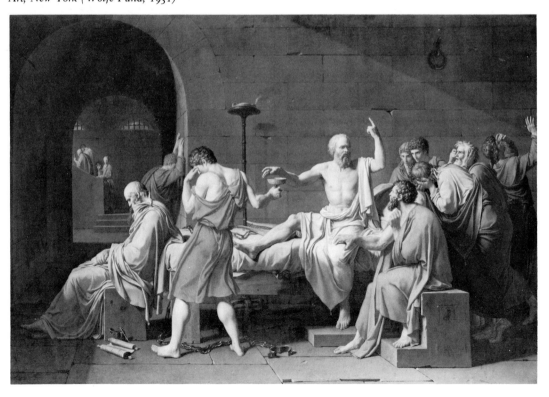

gradation from the darkness on the left to a light middle tone at the right—an austere device that heightens the dramatic illumination falling on the head and shoulders of the dead Marat and recalls more vividly than any other painting by David the example of Caravaggio (cf. fig. 213, p. 303). The intensity of the realism owes something to David's acquaintance with Marat and with the dead revolutionary's habit of attending to his correspondence while in his bathtub, where he sought relief from a troublesome eczema. He was assassinated while bathing by one Charlotte Corday who had brought him a petition which he was reading when she stabbed him and which David shows still in the dead man's hand. The unorthodox setting and the blood-dyed water in the tub are handled with such simplicity and restraint that they do not obtrude into the serene dignity the artist has given Marat's figure. The hero is here beatified by the artist, and the resulting quietude of the picture is one more reminder of the deliberate linkage that sometimes exists between the hero image of the secular martyr and its sacred counterpart.

The martyr as both hero and ordinary man is the universal underlying theme of *The Burghers of Calais* (fig. 215) by Auguste Rodin (1840–1917). It commemorates a specific event in the history of the French town of Calais when it was under siege in 1347 by the forces of the English king Edward III. In response to an ultimatum from him, six burghers offered their lives to save the city, and, even though they were finally spared, they walked out of the city gates as ordered—barefoot, bareheaded, with ropes around their necks, and bearing the keys to the city—fully expecting to be executed.

The project for the Calais monument went through several revisions, and its final form was not what Rodin would have wished. What he intended, after preliminary studies, was to place the individual figures one behind the other directly on the pavement in front of the town hall of Calais, as they might have appeared setting out for the camp of Edward III. In this way, Rodin felt, the modern citizens of Calais could almost rub shoulders with the images and thus sense more

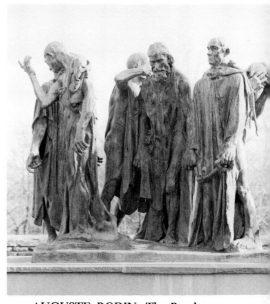

215. AUGUSTE RODIN. The Burghers of Calais. *1886. Bronze. 82 ½″ × 95″ × 78″. The Hirshhorn Museum and Sculpture Garden, Smithsonian Institution, Washington, D.C.*

keenly the sacrifice that was offered for the city. The town committee was not particularly pleased with Rodin's representation of the good burghers, which did not conform to conventional images of heroes. Rodin chose to present them in terms of a variety of human responses to impending death. Their offering of self-sacrifice is thus brought to the level of ordinary humanity. The expressive power of the individual forms is the real heroic ingredient here—and that is Rodin's own conception, even though some details are drawn from Jean Froissart's *Les Grandes Chroniques de France*, written not long after the event.

Heroes of the State and Men on Horseback

The state portrait is often a mixture of idealism, realism, and allegory. It is idealistic in that it elevates the subject to a suprahuman level to endow his person with superior qualities of leadership and character. It is realistic in that it must present him as an individual being so that the ideal facets of his image may be properly identified with him and no one else. It is frequently allegorical in that it must somehow convey the continuity of the state or tradition the subject represents and the significance of that continuity. Not every state portrait meets all these criteria, to be sure, but the first two are clearly necessary to the discharge of the image's official function.

The *Augustus of Prima Porta* (fig. 216) occupies a preeminent position in this tradition. It was intended to be displayed in a niche (the back is unfinished), thus confronting the viewer like the image of a god. The outstretched right arm is a gesture of command. The hipshot stride and proportions recall the "canon" of Polykleitos (see fig. 265, p. 367, and p. 366), and the general bearing of the figure embodies authority. Although there is a degree of idealization in the features of Augustus, revealed in the regularity

216. Augustus of Prima Porta. *ca. 20 B.C. Marble. Height 80".* *The Vatican Museums, Rome (Alinari-Art Reference Bureau)*

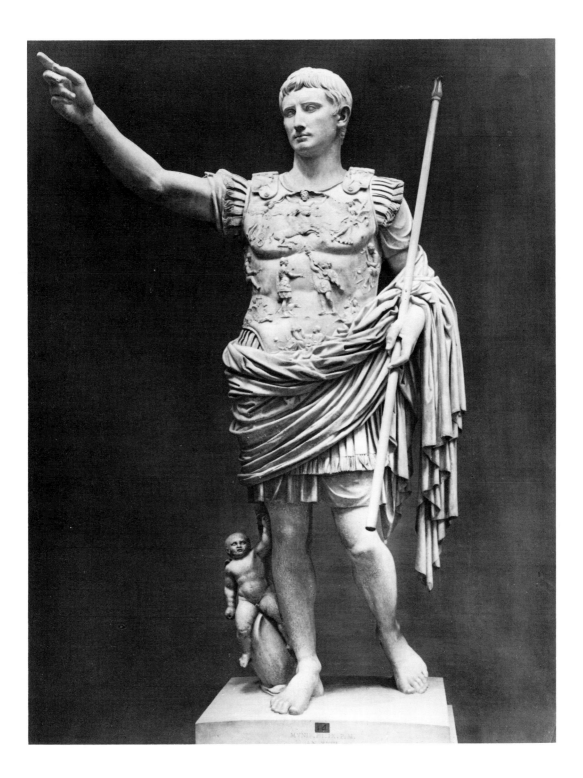

and refinement of the planes of the face, one is struck, when viewing them in isolation from the rest of the figure, by the extent to which they project an individual personality as well; and the obvious attention paid to the details of costume—the elaborate cuirass, the naturalistic rendering of the fringe, and the gathering and pull of the drapery—adds to the reality of the statue's appearance. Augustus presents himself both personally and officially to the viewer. The allegorical content of the image alludes to a tradition in his family that traced its lineage through Aeneas to Aphrodite (Venus), the former's legendary mother, symbolized by the boy on the dolphin; and the reliefs on the cuirass signify the extent, power, and beneficence of Augustan rule. On the breast of the cuirass, beneath the canopy of sky, the goddess of dawn precedes the sun god and his chariot; below this the Parthian eagles (standards) are returned to the Romans, a reference to an important victory; flanking this tableau are captive provinces, and in the lowest zone the earth goddess with a horn of plenty symbolizes the prosperity of Rome under Augustan leadership. The image of this head of state is the perfect embodiment of the lines from Vergil's *Aeneid* counseling the Roman that his destiny is to rule nations, to impose the law of peace, to be merciful to the conquered, and to beat down the proud. The authority proclaimed by this image may not yet be that of a divine ruler, but considering the later prevalence of the idea of divine rulership among Roman emperors, it could be said that the *Augustus of Prima Porta* takes a step in that direction.

The chemistry of the process by which societies fashion their own hero images is complex, but certain readily discernible patterns consistently emerge. One of these is the concentration in the hero image of the ethos of the state or group or institution from which the image comes. The protoimperial image of Augustus, therefore, emphasized values that were embedded in the Roman concept of state and society: authority, law, duty, and the continuity of lineage. As the empire drifted away from its earlier Italic roots, incorporating a variety of cultures within its borders and granting Roman citizenship to non-Italic peoples, values filtered in from the borderlands. The military power

upon which the *Pax Romana* depended exerted its influence as well. Consequently, after the Augustan Age, one finds the Eastern idea of a divine kingship working its effect on the hero image and modifying native Roman realism and its Greek infusion of idealism. The hero image of some of the later emperors becomes in certain instances, as in the head from a colossal statue of Constantine the Great (fig. 217), remote and impersonal, an intimidating image of imperial authority.

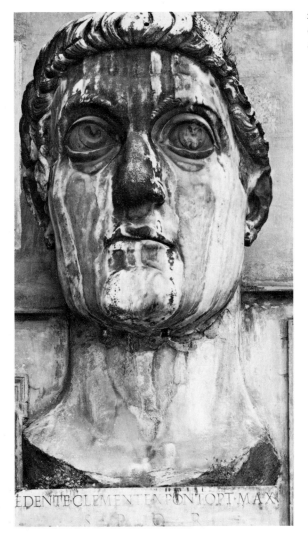

217. Constantine the Great. *Early fourth century. Marble. Height 96″. Capitoline Museum, Rome (Alinari-Art Reference Bureau)*

In the finest state portrait of Louis XIV (fig. 218), who proclaimed that *he* was the state, nothing distracts from the grandiloquence of the personification of absolute monarchy. The dramatic pose of the king, the elaborate swagger of the drapery, the massive column in the half-light of the background, proclaim the majesty of the self-image that the painter, Hyacinthe Rigaud (1659–1743), understood well. *Le Roi Soleil*—the Sun King—is as pompous as an old peacock. How differently—and as truly—did the great Spanish master Diego Velázquez (1599–1660) paint his king, Philip IV! But this is a special case, for Velázquez was

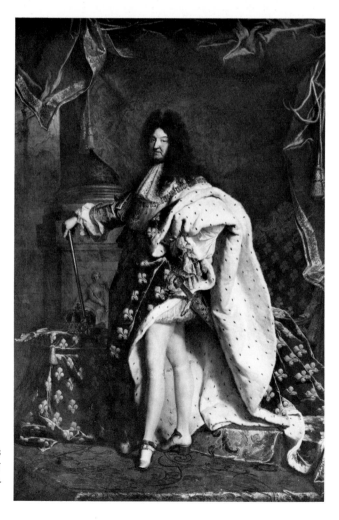

218. HYACINTHE RIGAUD. Louis **XIV.** *1701. Oil on canvas. ca. 9′2″ × 6′3″. The Louvre, Paris (Alinari-Art Reference Bureau)*

219. DIEGO VELÁZQUEZ. Philip IV.
*ca. 1656. Oil on canvas. 25 ¼″ × 21 ½″.
Reproduced by courtesy of the Trustees, The
National Gallery, London*

personally very close to the king for many years. He had
painted his monarch many times, always with the honesty
and directness we expect of this supreme realist, revealing
with innocent candor the unsureness of the sensitive king.
No royal portrait is more touching than the one Velázquez
painted of the aging ruler illustrated here (fig. 219). The very
real personal sadness within the man, not the monarch, is
poignantly revealed.

In the nineteenth century, the French artist Jean Auguste
Dominique Ingres (1780–1867) painted an official portrait
of Napoleon Bonaparte as emperor (fig. 220) in which the
enthroned frontality of the subject is almost identical with
that of Jupiter in the same artist's *Jupiter and Thetis* (1809,
Museum, Aix-en-Provence) and the sumptuousness of the

220. JEAN AUGUSTE DOMINIQUE INGRES. Napoleon Enthroned. *1806. Oil on canvas. 8′8⅝″ × 5′3″. Musée de l'Armée, Paris (Bulloz-Art Reference Bureau)*

court regalia evokes Byzantine splendor. The imperial eagle and the zodiac on the covering of the dais reinforce the image of imperial authority. Although clearly a portrait if one isolates the features of Bonaparte, there is scarcely anything else left of Bonaparte the man. He is completely absorbed by the paraphernalia about him and becomes as remote and impersonal as imperial power. One is tempted to read the emphasis on circularity in throne back, wreath, and collars as sly references to the divine nimbus.

Two paintings by Baron Antoine Jean Gros (1771–1835) also bring the image of Bonaparte close to divinity: *Pest House at Jaffa* and *Napoleon on the Battlefield at Eylau* (figs. 221 and 222). In the first of these, the young general, in contrast to the human weakness of his aides' revulsion, reaches out with healing touch to one of the plague-stricken men; in the second, triumphant on his charger, he stretches

221. ANTOINE JEAN GROS. **Pest House at Jaffa.** *1804. Oil on canvas. ca. 17'6⅝" × 26'3". The Louvre, Paris (Alinari-Art Reference Bureau)*

222. ANTOINE JEAN GROS. **Napoleon on the Battlefield at Eylau.** *1808. Canvas. 6'10 2/3" × 10'4". The Louvre, Paris (Alinari-Art Reference Bureau)*

his arm out over the battlefield in a gesture like a blessing as he rolls his eyes heavenward. A soldier kneels by the mounted general.

One suspects that the Virginia gentleman George Washington would have been distressed to see himself as Horatio Greenough (1805–52) depicted him—in heroic scale, enthroned like Jupiter, and bare to the waist (fig. 223). More appropriate than Greenough's neoclassical enthronement is another image of Washington: the life-size marble portrait (fig. 224) by the French sculptor Jean Antoine Houdon (1741–1828). Although the pose is classical, Washington is depicted in military dress, his left hand resting on the bun-

223. HORATIO GREENOUGH. George Washington. *1832–41. Marble. Height ca. 11′4″. Courtesy of the National Collection of Fine Arts, Smithsonian Institution, Washington, D.C.*

224. JEAN ANTOINE HOUDON. George Washington. *1788–92. Marble. Height 6′2″. State Capitol, Richmond, Virginia*

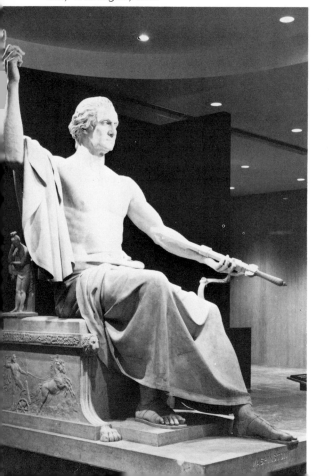

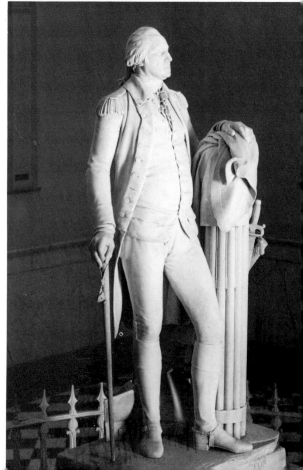

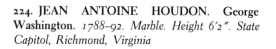

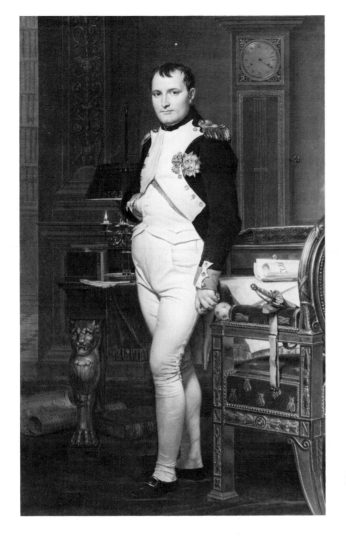

225. JACQUES LOUIS DAVID. *Napoleon in His Study.* *1812. Oil on canvas. 80 ¼″ × 49 ¼″. National Gallery of Art, Washington, D.C. (Samuel H. Kress Collection)*

dle of rods *(fasces)* that symbolized in ancient Rome the authority of magistrates. This reference to Rome seems quite in order considering the extent to which the virtues associated with the Roman Republic were valued at the time. Washington's sword and military cloak hang from the *fasces* and he holds in his right hand a cane, symbolizing the putting aside of his military duties to take up the role of citizen and chief magistrate. Within the perimeter of

226. **JULES BASTIEN-LEPAGE. Joan of Arc.** *1879. Oil on canvas. 8'4" × 9'2". The Metropolitan Museum of Art, New York (Gift of Erwin Davis, 1889)*

eighteenth-century rationalism and the self-image of the young Republic, Houdon managed to reinstate some of the attributes of the *Augustus of Prima Porta.*

Iconographically similar to Houdon's *George Washington* is David's *Napoleon in His Study* (fig. 225). A rather benign Bonaparte is in military dress, but in delightfully homey asides David communicates to the attentive viewer that the leader has been at work for the state well into the early hours of the morning: one last candle burns low at his desk and the

clock indicates that it is about 4:13 A.M. On the chair are symbols of two aspects of the emperor's career, a roll of papers identified as the Code Napoléon and a sword. Although Bonaparte is clearly posing for his portrait, David's touch of painting his stockings sagging about his ankles—and well they might at that hour—is an intimate, informal note. Comparing this picture with the one by Ingres demonstrates how many facets there are to the total public images of such figures.

With sentimental explicitness, a later French artist, Jules Bastien-Lepage (1848–84), painted *Joan of Arc* (fig. 226) in trancelike communion with the spirits of Saints Margaret, Catherine, and Michael, who appear, wraithlike, mingling with the foliage and the light wall behind her, their diaphanous forms contrasting sharply with the photographic clarity of the peasant girl's form. The supernatural and natural are expertly juxtaposed in an image that communicates the visionary innocence of the tragic heroine. Here the tradition of hero imagery has entered the commonplace world of peasant genre in the artist's own garden in Lorraine.

Since heroes of the state have so often been drawn from the ranks of imperial figures and military men, a special type of hero image has evolved: the conqueror on horseback. There is hardly any hero image more commonly seen than the equestrian statues that flourish in public squares and parks throughout the Western world. The proper ancestor of this type is probably the *Marcus Aurelius* (fig. 227) in Rome, where it has been accessible since the Roman era. The philosopher-emperor, however, stretches out his arm in a gesture more of benediction than of authority. The equestrian statue of Can Grande I (Francesco della Scala) (fig. 228) in Verona scarcely seems to belong to the same family of images as the *Marcus Aurelius*. The fantastically caparisoned horse and rider, who leers evilly out at the world, express with disconcerting frankness the cynicism of raw power. It is relatively easy for the modern viewer to see this statue first in a comic light, but soon one reflects uneasily on the message carried by the upraised sword, the eerie mask of the horse, and the visual pun that can be read in the wings on the helmet slung on the rider's back.

227. Equestrian Statue of Marcus Aurelius. *A.D. 165. Bronze. Over life-size. Piazza del Campidoglio, Rome (Fototeca Unione)*

228. Equestrian Statue of Can Grande I (Francesco della Scala), *from his tomb. 1330. Marble. Slightly smaller than life-size. Civic Museum, Verona (Alinari-Art Reference Bureau)*

Like Can Grande della Scala, Renaissance *condottieri* with their private professional armies were men whose lives were dedicated to the pursuit and acquisition of power, either for themselves or for others they served for a price. But two equestrian statues glorifying these soldiers of fortune, Donatello's *Gattamelata* (fig. 229) and the *Colleoni* (fig. 230) by Andrea del Verrocchio (1435–88), project images of power quite different from Can Grande della Scala's and different, too, from each other. The *Gattamelata* ("honeyed cat," a nickname for Erasmo da Narni) sits easily and confidently in the saddle, raising his marshal's baton. The spirited horse, more reminiscent of the Hellenistic bronze horses set above the portals of San Marco in Venice, the republic Erasmo da Narni served, than of Marcus Aurelius's steed, is heavy bodied but graceful. Displayed on a high elliptical base in the spacious piazza in front of San Antonio in Padua, the idealized grace of the image maintains a level of remoteness that is impersonal and unassailable. From the normal viewing position in the piazza it is difficult to read in detail the features of the *condottiere*, but, even so, Donatello's capaci-

229. DONATELLO. Monument of General Gattamelata. *1445–50. Bronze. ca. 11′ × 13′. Piazza del Santo, Padua (Alinari-Art Reference Bureau)*

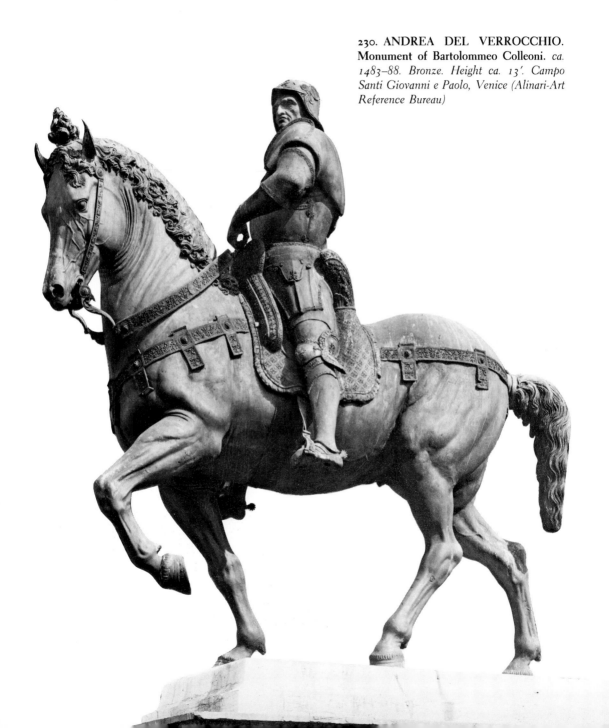

230. ANDREA DEL VERROCCHIO.
Monument of Bartolommeo Colleoni. *ca.
1483–88. Bronze. Height ca. 13′. Campo
Santi Giovanni e Paolo, Venice (Alinari-Art
Reference Bureau)*

ties as a realist define the image of the soldier so incisively that the presence of an individual will is clearly registered. Although not a portrait from life, it is the face and bearing of a seasoned veteran accustomed to command. Commissioned by the Venetian state, the statue represents an official commemoration of the deeds of a military hero of the republic.

One cannot separate the impact of the Colleoni monument from its setting on a lower base in a relatively small piazza in Venice. The contact with the viewer is more intimate and so the aggressiveness of both horse and rider is little short of overpowering. The implied movement of the statue is abrupt: the horse's hooves seem to come down sharply on the base in a stamping action, his muscles bulge and strain, and the rider, twisting in the saddle, thrusts straight and hard down on the stirrups. His face is fierce and hard bitten, his armor so massive and boldly formed that it resembles some engine of war. It is an image of the tough vanity of power, conveyed by the merging of horse and rider into a single, perfectly coordinated gesture.

Whereas the equestrian statue, isolated on its base, must generally make its own lonely statement, the two-dimensional arts can draw upon a variety of devices usually inapplicable to sculpture in order to bolster the meaning of an image. Representations of space and setting can be composed, lighted, colored, and specified in a constant relationship to the depicted human action, reinforcing it however the subject may require. The illusionary world of the picture does not alter its character with shifts in the weather or the angle of natural light, and no surrounding architectural changes affect its setting. The relationships remain in tune with one another. In some respects this is an advantage, but one cannot overlook one special quality that good freestanding sculpture possesses: its meaning must be compressed into an essential form, and the process tempers the image into a finer alloy of its constituent parts and associated meanings. This is the peculiar discipline of sculptural art. In the four equestrian statues just examined, the meanings each holds depend primarily on the intrinsic form of horse and rider and only secondarily on setting. In a sense, they fashion their own space.

But the image of the hero on horseback is by no means confined to freestanding sculpture. The elaborately detailed engraving *Knight, Death, and the Devil* (fig. 231) by Dürer employs subsidiary figures and a landscape setting to define and enhance the meaning of his armored knight. The horse and rider appear to be a blend of the *Gattamelata* and the statue of Colleoni, which Dürer could not have failed to see on his trips to Italy, particularly during his sojourn in the Venetian republic. The knight is no young soldier, but a veteran campaigner like the two *condottieri*. Death accompanies him on an emaciated horse and holds up an hourglass to indicate that the knight's life is measured like the running sand. A grotesque devil follows on cloven hooves and a faithful hound runs along beside the knight. A human skull on the ground ahead of the little procession is a reminder

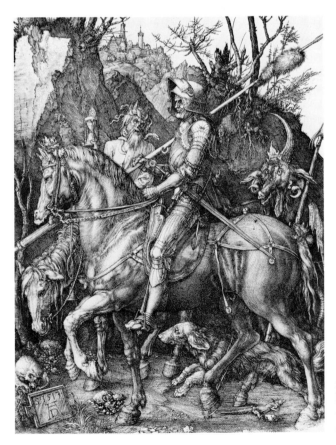

231. ALBRECHT DÜRER. Knight, Death, and the Devil. *1513. Engraving. 9 ⅝″ × 7 ½″. Courtesy of the Fogg Art Museum, Harvard University (Gray Collection)*

of the transitoriness of life and the vanity of worldly things. But the knight rides along as if ignoring these things, intent upon some mission. The landscape through which he rides is craggy. Weathered rock, tree stump, and thorn suggest that the way is hard, and if he seeks, as seems likely, the towered city on the bright mountaintop above, it is also long. It has been suggested that this image represents the archetypal Christian hero—*Miles Christianus*, a Christian soldier on his mission in the world. Apart from the subject,

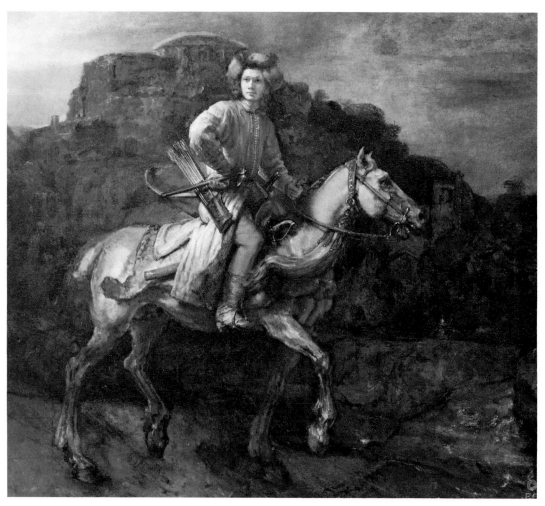

232. REMBRANDT VAN RIJN. Polish Rider. *ca. 1655. Oil on canvas. 46″ × 53″. Copyright The Frick Collection, New York*

the engraving is a superlative example of the art; and the
picturesque, fantastic detail reminds us of the persistence of
northern Gothic imagery well into the era of the Renais-
sance in the north.

Another great northern artist some 140 years later treated
the heroic equestrian theme in a different medium, oil
painting, and in a different vein, surrounding the image
with a mysterious ambience. Rembrandt's *Polish Rider*
(fig. 232) moves through a dark landscape past a hill
crowned by a gloomy fortress. The handsome young rider
appears on the alert for danger, unlike Dürer's knight who
seems oblivious—or inured—to it. The leaning stride of
the horse, augmented by the low angle of the perspective,
imparts not only a vivid sense of movement but also causes
the rider to loom monumentally against the background
and away from the viewer. It has been pointed out that
the costume (probably but not necessarily Polish) as well as
the armament of the rider correspond to that of the east-
ern European light cavalry that was currently engaged in
fighting Turks and Tatars. Viewed in this light, then,
Rembrandt's young soldier may be a latter-day crusader
against the infidel and another *Miles Christianus.*

Armored for battle, with an attendant bearing his helmet,
King Charles I of England is depicted as the royal cavalier
in the equestrian portrait (fig. 233) by Anthony van Dyck
(1599–1641). The lovely, parklike setting reinforces the es-
sentially romantic image of the king. One is tempted to
speculate whether this charming idealization reflects some
self-projection on the part of the artist, who was himself
small in stature like the king, remarkably like him in appear-
ance, and given to aristocratic tastes—a true courtier-artist.
The hero image projected by this painting, for all the martial
display and for all the virtuosity of van Dyck's representa-
tional skills, is remarkably unreal, a chivalric dream image of
the aristocratic hero.

The dashing cavalryman, that last survivor of chivalric
knighthood before wars became mechanized affairs, is de-

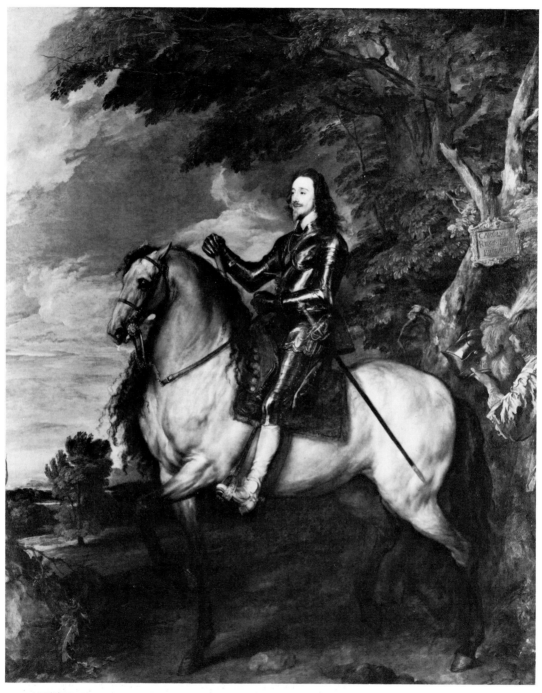

233. ANTHONY VAN DYCK. Equestrian Portrait of Charles I. *ca. late 1630s. Oil on canvas. ca. 12′½″ × 9′7″. Reproduced by courtesy of the Trustees, The National Gallery, London*

picted by Géricault in *Mounted Officer of the Imperial
Guard* (fig. 234). A frantic energy appears to flow through
the spirited Arabian horse and the hussar turning in his
saddle, his plume and sword in counterrhythm to the twist
of his body and the diagonal thrust of the horse's leap. The
precarious combination of gestures of man and horse is a
coordinated unit imparting an empathic energy to the can-
vas that leaves the viewer convinced. Whatever patriotic or
warrior codes this image may evoke, it places the hero image
in a new arena; for it is the living relationship between the
man and the beast that lies at the core of their vitality as
images, as man and horse act as one. One is tempted to

**234. THÉODORE GÉRICAULT.
Mounted Officer of the Imperial
Guard.** *1812. Oil on canvas. 9′7″ ×
6′4½″. The Louvre, Paris (Alinari-Art
Reference Bureau)*

speculate whether the ancient Greeks may have sensed this experience of concerted movement and expressed it organically in their images of the centaur.

Artists, Workers, and Others

The fortunes of the hero image have generally followed very closely shifts in the ethos of the society or the segment of it that sponsored such an embodiment of ideals and sentiments. Formerly the prerogative of gods, mythical heroes, and kings, the hero image has gradually found its way into other sectors of society as power and the pride of self have filtered out from the realm of mythology and the ancient rights of royal descent, divinely sanctioned. Perhaps it is to the ennobled image of man developed in the Greek world that we owe the initial energy for this expansion of the Western hero image. In the Eastern world the dominant religious and philosophic tone of figural art seems not to

235. FUJIWARA TAKANOBU (attributed). **Portrait of Minamoto Yoritomo,** *hanging scroll. Japanese, Kamakura period, 1145–1205. Color on silk. Height 54 ¾". Jingo-ji, Kyoto (Sakamoto, Tokyo)*

have fostered the hero image as a major artistic type. Even in Japan, where the warrior ethic became so prominent a feature, the images of heroes stress aesthetic qualities of formality and refinement over the active role of the hero, as in the impressive portrait of the Kamakura general Yoritomo (fig. 235).

During the Renaissance, when the Western world was looking back toward the Greco-Roman past, the hero image began to drift out of the sacred and royal precincts of the Middle Ages where it had been confined for centuries. Among those who acquired the heroic aura in the Renaissance, the artists themselves were probably the most unexpected newcomers. Freshly acknowledged as men of genius, a few artists enjoyed such status that their creative powers were viewed as divine, and men of no mean accomplishment themselves might express their gratitude for having been born in the time of a Michelangelo. It was an age that prized personal achievement. From this time on, the image of the artist as hero emerged again and again, either in the eyes of a devout circle of admirers or in the artist's own image of himself.

A self-portrait (fig. 236) by the Flemish master Peter Paul Rubens is an eloquent expression of that artist's measure of himself as a heroic being. The low angle of vision lends him a towering presence dramatized by the sweep of hat and cloak. The courtier's sword emphasizes the social status he did indeed possess as an artist-diplomat, and the pride and confidence projected by his features gives the intimation— one could say intimidation—of a powerful will. In a man of lesser capacities this could be read as unwarranted arrogance; in Rubens it can be taken in its legitimate heroic sense.

As an image of the creative genius as hero, no work is more eloquent than one great artist's tribute to another: the statue of the writer Balzac (fig. 237) by Auguste Rodin. The dynamic upthrust of the sculptural mass creates the impression of a defiant energy, monolithic and absolutely self-generated.

236. PETER PAUL RUBENS. Self-Portrait. *1639. Oil on canvas. 42″ × 33½″. Kunsthistorisches Museum, Vienna*

237. AUGUSTE RODIN. Balzac. *1892-97. Plaster. Height 9′10″. Rodin Museum, Paris*

It was probably inevitable that two developments in Western society should bring about a kind of social mobility of the hero image. One of these was the Industrial Revolution, which created a class of workers distinct from the older groups of peasant, farmer, and craftsman. The regimentation of the factories, with overtones of man's subordination to machines and to systems of manufacture, fostered, on the one hand, a glorification of the behemoth of industry and, on the other, a reaction to this new order, ennobling the rural life close to the soil, where it was felt that man was in close communion with the world of nature, the handiwork and presence of God. Both attitudes figure prominently in the romantic era. Eventually, the industrial worker, too, would receive his accolade in the context of class struggle and the Socialist state. The second development of signifi-

cance for art was the spread of democratic ideas attending
the attrition of the monarchies, bringing the elevation, ideo-
logically at least, of the common man. Some measure of
heroic potentiality touched his struggle and his devotion to
honest labor, but largely in the private context of self and
family. These processes were erratic, complicated, and by no
means universal, but by the early nineteenth century their
effects were already being displayed in the arts.

For a common blacksmith to be glorified as a hero—or
rather for a prosperous man to wish his image to be remem-
bered at the forge where he began his career, as was the case
in the example here—would hardly have qualified as a credi-
ble hero image in an earlier era. The old Roman Cincin-
natus, of course, put aside his plow to bear arms for the state;
but it was for his patriotism, not his husbandry, that he was
celebrated as a hero. The American artist John Neagle
(1796–1865) painted *Pat Lyon at the Forge* (fig. 238) in

238. JOHN NEAGLE. Pat Lyon at the Forge.
*1826. Oil on canvas. 93″ × 68″. Courtesy, Museum
of Fine Arts, Boston (Deposited by the Boston
Athenaeum)*

1826. The subject's brawny arms and the heavy hammers suggest the labors attending his rise in the world. It is a thoroughly democratic and materialistic image of a new kind of hero. In France, Jean François Millet (1814–75) glorified the rural life, and his painting *The Sower* (fig. 239), of around 1850, is executed with a broad handling of mass and light that lends the striding form of the farmer an archetypal quality, as if he were the essence of all sowers of fields. Both images, the blacksmith and the farmer, are sentimental; but sentiment regarding the work ethic was widespread, and these heroes of the commonplace world are its manifestations. In the twentieth century, the USSR has sponsored images of the workers who have become in fact new heroes of state. Depersonalized and robotlike, however, they are the agents of a national effort, collective heroes, not individuals acting out their unique heroic struggle.

239. JEAN FRANÇOIS MILLET. The Sower. *ca. 1850. Oil on canvas. 39 ¾″ × 32 ½″. Courtesy, Museum of Fine Arts, Boston (Gift of Quincy Adams Shaw, through Quincy A. Shaw, Jr., and Marian Shaw Haughton)*

240. BENJAMIN WEST. Benjamin
Franklin Drawing Electricity from the Sky.
*ca. 1805. Oil on paper. 13 ¼″ × 10″. Phila-
delphia Museum of Art (The Mr. and Mrs.
Wharton Sinkler Collection)*

Since the early nineteenth century, the hero image has
spread to any calling that can command a high measure of
respect from any quarter. The range is wide.

The great scientific advances from the Renaissance on had
spawned a new class of hero: the man of science. The scien-
tist as hero is dramatically portrayed in Benjamin West's
portrait of Benjamin Franklin (fig. 240) in the act of drawing
electricity from a stormy sky. Whether Franklin was fully
aware of the danger or not, the act was as daring as the
outcome was lucky, for Franklin could have been elec-
trocuted that June day in 1752. West's portrait does more
than portray the event: he embellishes it with the heroic,
wind-stirred gesture of Franklin, his hair and red cloak
tossed by the storm, and with accompanying cherubs who

241. JULIUS SCHRADER. Alexander von Humboldt. *1859. Oil on canvas. 62 ½″ × 54 ⅜″. The Metropolitan Museum of Art, New York (Gift of H. O. Havemeyer, 1889)*

hold the kite string at the right and are occupied with electrical apparatus at the left. The Indian headdress on one of the cherubs at the right establishes the New World setting for the dramatic moment. By such devices West lends this heroic portrait some of the trappings of the baroque allegorical tradition.

A quite different image of the scientist as hero is conveyed by Julius Schrader (1815–1900) in his portrait of Alexander von Humboldt in his old age (fig. 241). During the first half of the nineteenth century, the German scientist and man of letters enjoyed unusual international prestige. In 1869 he was eulogized by Ralph Waldo Emerson as one of the won-

ders of the world "who appear from time to time to show us the possibilities of the human mind, the force and range of the faculties—a universal man." By the mid-nineteenth century, von Humboldt was practically a household word in the New World, memorialized on maps; few major cities had no street named after him. It is as the man of years and wisdom that he is depicted in Schrader's painting: a white-haired old man silhouetted against the sky on a mountaintop with Mount Chimborazo in the background. He is bent over his notebook and seems to be gazing thoughtfully into an

242. THOMAS EAKINS. The Gross Clinic. *1875. Oil on canvas. 96" × 78". Courtesy of Jefferson Medical College, Thomas Jefferson University, Philadelphia*

even deeper space than that which appears behind him. Although painted in the last year of von Humboldt's life, the portrait shows him as he was nearly ten years before. A comparison with a photograph taken in 1850 by C. Schwartz and J. Zschille suggests that the painter may have had access to the photograph. In any event, the portrait is the perfect embodiment of Emerson's view of the universal man.

Thomas Eakins (1844–1916), the American realist, in his painting *The Gross Clinic* (fig. 242), created a heroic image in the person of a renowned surgeon in the operating arena of a medical college. Towering above his associates, with light dramatizing his features, he assumes the role of a new hero of modern life, a soldier of science fighting to save mankind from its physical afflictions.

Heroic motherhood is a recurrent theme in the work of the German artist Käthe Kollwitz (1867–1945), as the woman passionately and relentlessly struggles for her children (fig. 243). The list seems almost endless as one searches out the representations of almost any walk of life and finds here and there among them some hint of heroic posture.

In the twentieth century, the communications media have greatly enlarged the prospects for extending the hero image —and, paradoxically, for destroying it through the exposure of its human flaws. Athletes and statesmen are subject to the same relentless public scrutiny, and popular heroes are made and undone with unprecedented dispatch. The most prolific source of hero imagery in this century has been the film. We have not even begun to appreciate the pervasive influence of this medium, which has probably touched more individuals in this century than any other art form. The art and industry of the motion picture have turned out remarkable phalanxes of heroes of all varieties: from traditional types, enhanced by the effortless assimilation of their active images on the screen, to the actors and actresses themselves, fashioned by their role playing and by the public-relations efforts of the film industry into figures of a modern mythology. The moving images on the controlled field of the motion picture screen are experienced in a dimension that is as real as its empathic intensity and as elusive as the rays of light of which

**243. KÄTHE KOLLWITZ. Death
and Woman Struggling for the
Child.** *1911. Etching. 9″ ×
11 5/16″. The University of Con-
necticut Museum of Art, Storrs (Gift
of Dr. Walter Landauer)*

244. HONORÉ DAUMIER. Don Quixote and the Dead Mule. *ca. 1868. Oil on wood panel. 9 ¾″
× 18 ⅛″. The Metropolitan Museum of Art, New York (Wolfe Fund, 1909)*

it is composed. It is a dimension that mingles with tantalizing vividness both reality and dream.

Finally, this is the paradox of the hero: he must adhere to the dream embodied in his absolutes of virtue or excellence while contesting the real forces that oppose him in the world. In a sense, perhaps, the hero creates his own world with the substance of the dream and stands or falls by it. There can be no compromise. Here is the dilemma of the heroic act: its existence at the border line between the credible and the absurd. The tragedy, pathos, and often, on reflection, the irony of the heroic act stem from this paradox. Honoré Daumier (1808–79) gave it one of its most eloquent forms in his image of Don Quixote (fig. 244).

CHAPTER

8

THE ART OF THE ROYAL COURTS

. . . And, behold, a throne was set in heaven . . .

And he that sat was to look upon like a jasper and a sardine stone: and there was a rainbow round about the throne, in sight like unto an emerald.

And round about the throne . . . I saw four and twenty elders sitting, clothed in white raiment; and they had on their heads crowns of gold.

And out of the throne proceeded lightnings and thunderings and voices: and there were seven lamps of fire burning before the throne . . .

And before the throne there was a sea of glass like unto crystal. . . .

Thus, in part, the Book of Revelation describes the heavenly court on the Day of Judgment. The splendor of the description in its entirety surely reflects a familiarity with Near Eastern courts and Imperial Rome, and the majesty it evokes has its echo in both medieval and later depictions of an imperialized image of Christ and of the Virgin as the Queen of Heaven (see pp. 247–54 and figs. 170, 171, and 173, and fig. 191, p. 272).

Characteristic of the images of both secular and heavenly courts as they are depicted in art is the acknowledgment of the power they represent. This is achieved in either of two ways: by an iconic image of the royal or sacred presence enthroned, confronting the viewer directly and often surrounded by a courtly entourage (as in figs. 171 and 245, pp. 249 and 339); or by a representation of an act of subordination to superior power, as when a secular ruler or a donor is

337

depicted kneeling before the sacred presence or when vassals attend their king or lord (as in figs. 247 and 251, pp. 340 and 346). In the first instance the ritual of acknowledgment takes place between the real viewer and the symbolic image in the work of art—a direct participation; in the second the viewer may, if so inclined, identify himself with the ritual depicted in the work of art—an indirect association of less demanding nature.

In the Angers *Apocalypse* tapestry (fig. 245) the subject is the heavenly court described in the Revelation of St. John the Evangelist, with the Lord enthroned in an aureole of radiance incorporating elements from the apocalyptic vision, flanked by the symbols of the evangelists (derived from the four beasts described elsewhere in St. John's vision) and by the twenty-four elders. The formal, compartmented arrangement of the tapestry's composition, distinctly setting apart the central image from the rest, reinforces the idea of a transcendent presence to which homage is due. As in the vision of St. John, the subordinate figures representing "kings and priests" who "shall reign on earth" assume postures of wonder and submission.

Similar in the dominance of a central image of deity, but differing because of time and place of origin, is the *Amida Shōju Raigo-zu* triptych (fig. 246), a Japanese Buddhist painting of nearly three hundred years earlier than the tapestry. It, too, is based on a vision of deity—the descent *(Raigo)* of Amida Buddha, the Buddha of the West who presided over a paradise obtainable by those who would but adore Amida. Here Amida Buddha is depicted as if floating down toward the viewer—as the trails of clouds indicate—surrounded by musician-angels and bodhisattvas, the entire vision hovering above an earthly landscape, a fragment of which can be seen in the lower left corner of the painting. The loveliness of the vision, the evocation of heavenly music, the refinement of forms and movements, are eloquent invitations to paradise. Although displaying a fundamental symmetry like the French tapestry, the Japanese painting is freer in its effect as the swirling clouds flow across the

245. Elders before the Throne of God, *from the* Angers Apocalypse Tapestries. *Late fourteenth century. Wool. 13′ 1″ × 60′ 8″ (entire). Musée des Tapisseries, Angers, France (Marburg-Art Reference Bureau)*

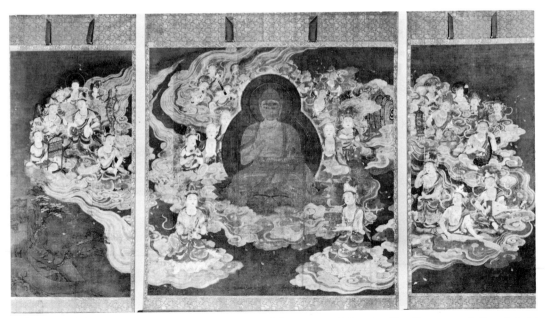

246. Amida Shōju Raigo-zu, *triptych. Japanese, twelfth century. Color on silk. Center panel 82 2/3″ × 82 2/3″; right and left panels each 82 2/3″ × 41 1/3″. Reihōkan Museum, Wakayama-ken, Japan (Sakamoto, Tokyo)*

tripartite division of the painting. But the frontal severity of Amida Buddha, as well as the floating court, reminds the viewer that this is another world than his own.

Throughout the ages, expressions of secular and religious majesty have been presented in similar visual terms, ranging from the sublimity of grand scale—as, for example, in the sheer size of architectural settings designed to dwarf the individual—to the beauty and richness of color and ornament. It has been the aim of much of the art serving religious institutions and the royal courts (and prescribed by them) that their constituents be both awed and enchanted by it. The royal courts and their aspiring imitators have always employed artists to enhance their public images by surrounding the real facts of power and weakness with splendid, seductive, or overwhelming ambiences of art—to decorate palaces, enrich the ceremonies of state, and propagandize the self-image of the ruler and his dynasty for both the present and the future.

The acknowledgment of royal power is the subject of a Persian relief from the royal precincts at Persepolis (fig. 247)

247. Darius and Xerxes Giving Audience, *relief from the south portico of the treasury, Persepolis. ca. 490 B.C. Limestone. Height 8′4″. Courtesy of the Oriental Institute, University of Chicago*

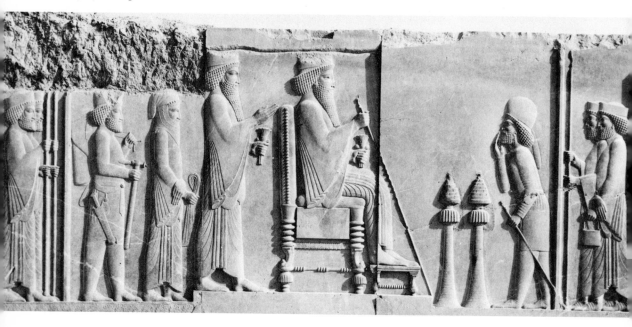

where we see the Achaemenid king Darius and his son
Xerxes (standing behind the enthroned monarch) giving
audience to an emissary who bends to the royal presence,
paying his respects. Both Darius and Xerxes are larger than
the other figures, a time-honored device for emphasizing a
superior position (see also figs. 63 and 69, pp. 86 and 94).
There is no personalization of the images; they are all shaped
after static formulas of figural representation, elegantly con-
toured, decorative in the regular cadences of precise surface
patterns of hair, beard, and draperies, quite remote from
living forms, yet softly sensuous in the gentle modeling of
surfaces. It is as if the formal relationship between ruler and
ruled were reduced to a calm, assured visual symbol that
embodies not only the impersonality of the relationship but
the refinement of courtly protocol as well.

Rarely was the ideal of courtly splendor more brilliantly
brought forth than in the art of Byzantium. In the mosaic
at San Vitale, Ravenna, depicting the Byzantine empress
Theodora (colorplate 2) and her retinue of chamberlains
and ladies-in-waiting, we see in the colorful surroundings
and in the rich court dress not only worldly display but
also allusions to the divine realm as well: Theodora's posi-
tion, centered before an apselike niche, her imperial halo
and purple robe embroidered with the figures of the three
Magi, a note that invites an association with the Virgin
Mary. Like the three Magi, Theodora bears a gift, a jew-
eled gold chalice. Thus, in an image suggesting royal
subordination to divine authority, she appears to be on her
way to a dedication ceremony (a symbolic presence at the
dedication of San Vitale, since she was not there in per-
son, or, in tandem with the companion mosaic of Justinian
and his retinue, a symbolic liturgical procession during
each Mass celebrated there?). Whether the background is
meant to be read as a specific architectural setting or not
(and there is little agreement on this), there can be no
question of the intention to convey an impression of im-
perial magnificence. The solemn frontality of the figures
lends dignity to the procession and echoes the rhythms of
its companion image of Justinian, Maximianus, and their
subordinates on the opposite wall (fig. 248), linking the

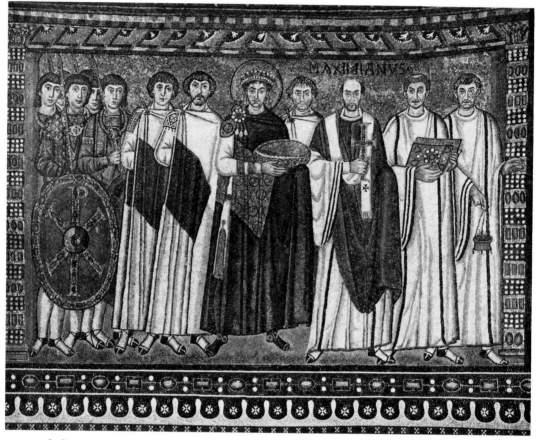

248. Justinian and Attendants, *sanctuary mosaic, San Vitale, Ravenna. Byzantine, ca. 547. (Alinari-Art Reference Bureau)*

two works compositionally across the space of the presbytery. Thus, they form a unified ensemble in conjunction with the enthroned Christ (see fig. 171, p. 249) in the half-dome of the apse a few feet beyond and above them toward which both processions move.

Unlike the Persian relief, some of the faces in the mosaic seem to be individualized, even though all conform to the large-eyed Byzantine type. The face of Theodora, for instance, answers a description of her given by the Byzantine

historian Procopius, and the broad-cheeked lady-in-waiting immediately to her left (the viewer's right) is more than a stereotype of the kind to be seen in the five ladies at the extreme right of the mosaic.

From the same century and a similar situation come a Chinese relief of an empress and her entourage (fig. 249) and a companion piece depicting the emperor in procession, both carved from the blackish limestone cliffs at Lung Men. These two processional reliefs are on either side of the entrance walls of a Buddhist shrine cut into the cliffs, which contains many other reliefs and sculptures, including a large Buddha seated with his favorite disciples. A noteworthy aspect of the relief of the empress and her attendants is the stylistic distance between it and the stereotyped Bud-

249. Empress and Her Court as Donors, *relief from Pin-Yang cave, Lung Men. Chinese, Northern Wei dynasty, 386–535. Limestone with traces of color. 6'4" × 9'1". Nelson Gallery, Atkins Museum, Kansas City, Missouri*

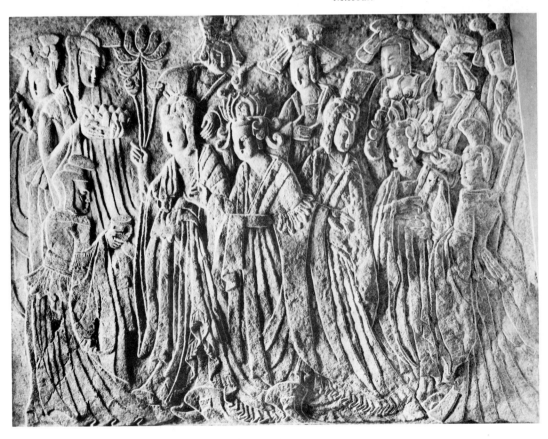

dhist images in the cave-shrine. It is much freer in form than they, which—like most sacred images—have inherent conservative tendencies, hewing to traditional, inherited forms. The linear rhythms of the relief of the empress and her entourage are fluid and graceful, suggesting the forward movement of the procession, and the fine texture of the stone is sympathetic to the execution of detail. Like the Theodora mosaic, this relief represents, in its elegance, an ideal courtly art, but unlike the mosaic it is informally composed, with figures turning to one another, conversing as they move along. The linear emphasis and the flowing lines suggest prototypes in the paintings characteristic of the Wei court.

Both pairs of works—the Justinian and Theodora mosaics and the two Chinese reliefs—have in common their relationships to religious shrines. There is a similarity in their processional themes: all four imperial figures appear as donors, paying their respects to the sanctified place. But there is a thematic difference in the obvious symbolism of the Byzantine mosaics—the twelve figures accompanying Justinian (an obvious allusion to the apostles) and the three Magi on Theodora's robe. The Chinese works, on the other hand, seem relatively reportorial, like graceful transcriptions from life. At another level, however, both the Byzantine and the Chinese works are equally symbolic: they signify the royal presence, if only by proxy, and indicate royal favor toward the sanctuaries that their images grace.

The art of the royal courts shares precisely the forms of sacred imagery, like those in the Angers tapestry (see fig. 245, p. 339), in instances where the monarch is enthroned either in the midst of his court, in the presence of those who pay him homage, or surrounded by symbolic images personifying proper royal attributes, like justice, piety, wisdom, and prudence, as in the illumination from the *Sacramentary of Henry II* (fig. 250) where divine sanction of the royal power appears as Christ places a crown on the emperor's head. The

250. Christ Crowns Henry II, *from the* **Sacramentary of Henry II.** *Regensburg, Germany, early eleventh century. Manuscript illumination. 11 ¾″ × 9 ½″. Bayerische Staatsbibliothek, Munich*

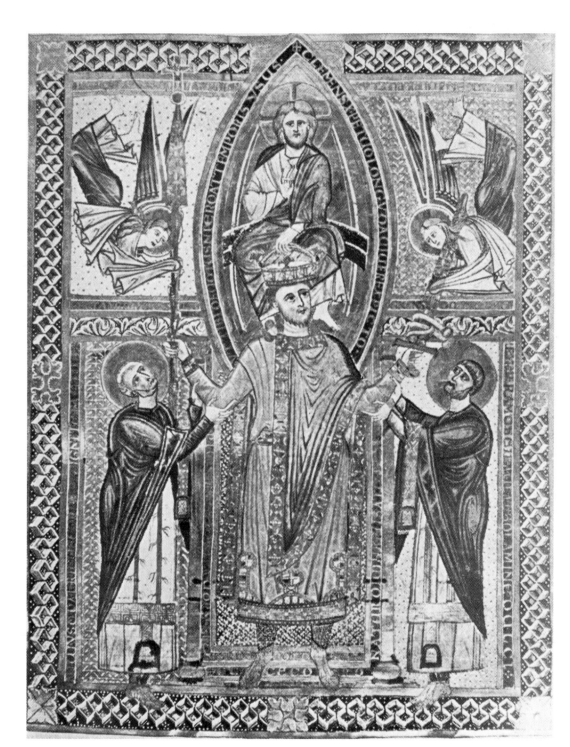

rigid geometricity of the composition with its centralized symmetry and the iconic frontality of Henry II give the illustration a hieratic severity more pronounced than that of the sacred court in the Angers tapestry.

The legitimacy of the monarch's sovereignty, implied by the symbol of divine sanction, is a subject of considerable significance to the royal court. One is reminded of how persistent a theme it was—together with the crisis accompanying the transfer of power from one monarch to the next—in the plays of William Shakespeare. We see a striking expression of this concern in a painting by the Sienese artist Simone Martini (fl. ca. 1315–44) depicting *St. Louis of Toulouse* (fig. 251), who is in the act of crowning his brother Robert, to whom St. Louis relinquished the throne of Naples. Here

251. SIMONE MARTINI. St. Louis of Toulouse Crowning Robert of Anjou King of Naples. *ca. 1317. Oil on wood panel. 78¾″ × 54¼″. National Gallery of Capodimonte, Naples (Alinari-Art Reference Bureau)*

252. HANS HOLBEIN THE YOUNGER. Henry
VIII. *1536–37. Cartoon. 8'5 ½" × 4'6". National Portrait Gallery, London*

St. Louis, himself being crowned by angels, lends his sainted
authority from beyond the grave to the recognition of King
Robert, who worked hard to promote his brother's sainthood
and at whose order the picture was painted, truly an exercise
in self-sanction.

A similar theme is apparent in a drawing by Hans Holbein
the Younger (1497–1543) showing the English monarch
Henry VIII standing spread stanced before the image of his
father, Henry VII (fig. 252). Here, however, the viewer

senses that the quiet, spiritualized figure of the elder Henry is superfluous as a sanctioning force from the other world; Henry VIII stands firmly enough on his own feet.

Not all art of the royal courts falls into such categories as these we have just surveyed. There has also been—apart from portraits—a more personal and intimate view of royalty, an early instance of which appears in ancient Egypt in a relief of Akhenaten, Nefertiti, and the royal princesses (fig. 253). Here, basking in the benign rays of Aten, the sun disk, the royal parents are playfully at ease with their children. Although the composition is symmetrically arranged, the mannered fragility of the images, together with the delicate gestures, projects a sophisticated charm that dispels any sense of formality.

In a much later age, a portrait of court life by Velázquez (fig. 254) breaks through the constraints of formality that dominated court painting and brings the viewer into a startling confrontation with an intimate setting, casually disposed as if one had suddenly stepped into the room, catching everyone off guard. Only when one has studied the painting more

253. The Royal Family (Akhenaten, Nefertiti, and Royal Princesses), *relief from Tell el 'Amarna. Egyptian, ca. 1364–1347 B.C. Limestone. 12 ¼″ × 15 ¼″. State Museum, Berlin (Marburg-Art Reference Bureau)*

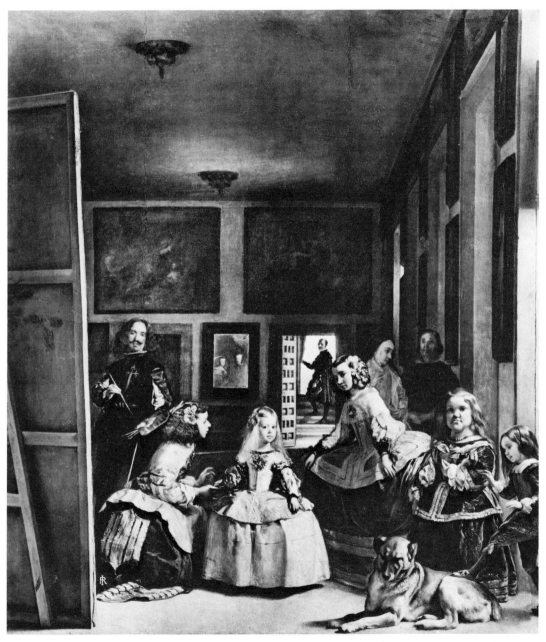

254. DIEGO VELÁZQUEZ. Las Meninas (The Maids of Honor). *1656. Oil on canvas. 10′5″ × 9′. The Prado, Madrid (Anderson-Art Reference Bureau)*

carefully does it become apparent how cleverly the artist has led the viewer into a visual trap. In a little light-filled space defined by the gowns of her maids-of-honor and by the reclining dog, the little princess looks out at the viewer. The light isolates her while the perspective of the room and the symmetry of the shapes on the far wall lead down toward her and emphasize first her presence and then an image reflected in the mirror behind her. It is only then that the viewer realizes that these figures—including the artist himself, working at a canvas on the left—may be looking at the king and queen, reflected in the mirror as they pose for their portraits out in front of the picture's space, where the viewer himself must stand; or, perhaps, it is merely a section of the canvas that is reflected in the mirror. The devices Velázquez has summoned for this tour de force of realism actually subordinate the royal persons to pictorial magic, and they become, as it were, mere parties to the artist's show of virtuosity. In such a work as this, the royal ambience of authority, with its divine and dynastic sanction, is completely absent from the pictorial event, and the viewer senses the presence of an ordinary dimension in the unordinary world of international royalty, a dimension the photograph would one day reveal with impartial clarity (fig. 255).

There is also a strain of courtly art that promotes the aristocratic presence, the refinements of royal breeding, as in the paintings by Anthony van Dyck of the court of Charles I of England (see fig. 233, p. 324).

Finally, there is an area of courtly art that is peculiarly transitory, being created to provide temporary decoration for specific royal events, enriching and indeed often providing the very structure of elaborate ceremonies of state. In Renaissance Italy, for example, even major artists often created paraphernalia for festivals—banners, shields for tournaments or processions, designs for costumes, floats for parades—and numerous small commissions of a decorative nature. These were under civic or guild sponsorship, and the rise of the great monarchies only extended the field. Probably no royal court was more resplendent in its pageantry— the elaborate *fêtes* at Versailles in particular—and more wide-ranging in its sponsorship of the arts than the court of

Louis XIV in its heyday. The Gobelins tapestry manufactory, under royal control, alone produced a vast quantity of fine works to which some of the best artists contributed designs. The decorations of the royal palaces and their furnishings and the festivals and theater Louis XIV so dearly loved employed an army of artists and artisans.

An exemplary instance of the richness of this theatrical artistry in the service of European royalty comes from the seventeenth century, and although the actual monuments and decorations, in toto, have long since disappeared, some fragments and original designs have been preserved. The occasion to which they relate began in November 1634, when the city of Antwerp invited the new royal governor of the Spanish Netherlands, Prince-Cardinal Ferdinand of Austria, to make his "Joyous Entry" into the city—a type of ceremony customarily reserved for monarchs but extended on occasion to royal governors. Prince Ferdinand's entry finally took place in April 1635, by which time the sumptuous decorations had been completed, designed by the great Flemish master Peter Paul Rubens and executed by numerous artists and assistants under his general supervision. The Hapsburg prince was fresh from a military victory over the Swedes at the Battle of Nördlingen, and his entry was to be a celebration of military triumph as well.

The decorations for the royal visit, set up along the line of march through the city, included a large portico with twelve stone statues of Hapsburg emperors under its arches and with a central arch of triumph crowned with an obelisk flanked by twisted columns; there were several elaborate stages and additional triumphal arches along the route. All these structures were wood, framed with carved wooden architectural elements painted to resemble marble or

255. ROGER FENTON. Her Majesty and the Prince. ca. 1850. Photograph. Victoria and Albert Museum, London (Crown Copyright)

stonemasonry, painted wooden cutouts of figural groups, numerous paintings set into the architectural units, banners, and other decoration. Some of Rubens's oil sketches for these designs still exist, as do several of the large canvases and at least one of the cutouts.

Rubens's original sketch for the western (rear) face of one of the triumphal arches along the line of march, *The Arch of Ferdinand* (fig. 256), is dominated by a large picture in the center of the upper story of the arch representing *The Triumphs of Cardinal-Infant Ferdinand.* The painting (executed by Jan van den Hoecke [1611–51] from Rubens's design and retouched later by Jacob Jordaens [1593–1678]) still exists, as do canvases of the two female allegorical figures: *The Liberality of the King,* at the far left next to the statue of *Fortitude* that flanked the central painting; and

256. PETER PAUL RUBENS. The Triumphs of the Cardinal-Infant Ferdinand, *from* **The Arch of Ferdinand.** *1634. Oil sketch on canvas. ca. 59″ × 28 ¾″. The Hermitage, Leningrad*

The Foresight of the King, at the far right next to the statue of an armored Virtue—both by Jan van den Hoecke or one of his assistants. With these, and with Rubens's sketch and an old engraving of the completed arch, it is possible to reconstruct a fairly accurate image of the appearance of *The Arch of Ferdinand* on the day of the ceremony.

Turning to the composition of the arch and the images incorporated in its design, we can see several features closely associated with the art of royal courts in the Western world. First of all, there is the evocation of Roman antiquity, not only in the arch itself, but also in the use of Roman motifs like the arms, armor, and captives that crown the arch right and left (although the arms and armor in this design are contemporary) and in the choice of the triumphal procession, a Roman ceremony, for the subject of the central painting. In royal art the image of Imperial Rome was a constant model, as was the classical tradition in general, evidence of which abounds throughout Rubens's design. Secondly, there is the allegorical factor—the tradition of personifying ideas like liberality, foresight, victory, fortitude, and virtue—an ingredient common in the formal language of courtly imagery. Apart from all this, there is the ceremonial pomp and splendor such designs as this confirm. The artist here is seen in a theatrical role, the impresario of a public drama that both entertains the populace and honors the visiting royal presence. Accustomed as we are to thinking of renowned artists as solitary geniuses, pursuing their own aesthetic commitments, it is sometimes difficult to accept this role of the artist in the service of a communal ceremony in praise of royalty, for such service smacks so much of fleeting entertainment—as if a major modern artist were in charge of the designs for the Tournament of Roses parade at Pasadena, California, every New Year's Day.

PART

FOUR

_____ PROTOTYPAL IMAGES

9. The Classical Tradition in Western
 Art

9

THE CLASSICAL TRADITION IN WESTERN ART

In April 1768, the French navigator Louis de Bougainville dropped anchor off the island of Tahiti in the South Pacific. He was struck by the physical beauty of the natives and remarked that he had never seen better-proportioned figures, suggesting that the men would be excellent models for painting a Hercules or a Mars. A naked Tahitian girl seemed to him to be the embodiment of Venus, so "celestial" was her form. The following year, when Captain James Cook's *Endeavour* arrived at Tahiti, the comparison was made again and often, particularly by Sir Joseph Banks, the influential amateur naturalist who accompanied the expedition. When the Tahitians sang songs of praise to their visitors, Banks likened them to the ancient Greeks, "like Homer of old, . . . poets as well as musicians." Playfully, some of the Tahitians were given the names of Greek heroes. The habit of drawing parallels between the ancient Greeks and the newly discovered Polynesians continued for many decades in the reports of travelers to the South Seas and in the metaphors of writers who made the journey only vicariously. This habit was but one of countless manifestations of the pervasive spirit of a classical tradition in Western thought, sentiment, and art. In this particular instance the tradition was joined to a romanticism embodied in the idea of the "noble savage"—an image of nobility and innocence then claimed for the ancient Greeks as well. This sentiment, lavished on a strange new world, a tropical paradise, gathered yet another image to it: that of a rediscovered Eden. If the innocence and nobility ascribed to these images appeared to some observers to be already tainted, they were reminded that Satan, too, had found that first garden. The syncretic force of these ideas, which will be examined in the

357

next chapter, is a reminder of the intricacy and interdependence that characterizes the fabric of history.

No factor of continuity in Western art has been more persistent or more adaptable than the so-called classical tradition. Since it has been studied so assiduously that its general patterns are well mapped, it provides an excellent case history of the dynamics of an idea and the qualities that endow an idea with longevity.

When the late medieval humanists reaffirmed the greatness of their antique heritage and the Greco-Roman world began to be viewed as a distinct historical entity separated from the present by some one thousand years of a "middle age," the classical tradition emerged from an era of ephemeral revivals into a condition of unbroken continuity. The Renaissance of the fifteenth and sixteenth centuries firmly established the classical tradition as a major current in Western art.

There are certain requisites for the survival of a tradition, particularly if it is to endure through period after period of history. One of the foremost is a high level of prestige and supportive quality at the outset. The classical tradition achieved this. Its own Hellenizing outreach beyond the Greek mainland from the Archaic period through the fourth century B.C. and Hellenistic disseminations into the Roman era derived added impetus from Roman enthusiasm for Greek culture. The power and prestige of Rome added their own energy to the launching thrust. Furthermore, the tradition was based on something of substance, something inherently worthy, for Greek art was at once vital, human, and yet ideal. Such a tradition is adaptable; it has the capacity to absorb new content. As an ideal, the "blank beauty of the antique" could serve many masters yet retain a semblance of its initial form, carrying some echo of its ancient associations. Its idealistic aspects were well suited to this role, for the qualities of order, measure, and reasonableness could be treasured in widely different times and places. Moreover, these qualities were distinctly humanized by the realistic vein in antique art: convincing surface appearance, the variety of physical action, and the exploration of human emotions—all of which enhanced its appeal.

Other factors may not have comparable importance, but they help. One of these, particularly relevant for the classical tradition, is the existence of a supporting humanistic culture outside the visual arts themselves. The literature and philosophy of Greece provided such support, and the lingering authority of these accomplishments, augmented by those of Rome, bolstered the evolving patterns of the classical tradition in the visual arts. An aura of nostalgia also became, in time, attached to the idea of antiquity as an age superior to or simpler and purer than subsequent epochs, thus reinforcing the other attractions of the Greco-Roman past.

Two other factors came from within the continuity of the tradition itself. One was the presence of Christendom as a successor state to the Roman Empire during those centuries when the tradition was in the greatest danger of being submerged and perhaps even lost in the welter of disrupted order after the collapse of the Roman Empire in the West. The continuity provided by the church, bringing some sense of order—as well as history of a special kind—to western Europe was a helpful force. Nor can one afford to ignore the importance, often overlooked, of the learned courts of Islam in preserving a significant body of Greek knowledge to pass on to Europe in due time.

The survival of the classical tradition in Western art must be examined from several angles if we are to understand it, for it is manifested in a variety of ways. The most obvious level is the emulation of antique works of art through images that duplicate the style of the prototypes, often by direct imitation of a specific work. In the same general category is the emulation of the antique that transforms even as it quotes. This is the most common variety over the long history of the tradition, for the transformations involved are often unavoidable in that the artist does not—unless he is producing what amounts to forgery—step out of his own time and place.

To demonstrate the tenacity of specific types within the tradition, one can find no better example than the philosopher image that goes back to the fourth century B.C., known

to us in Roman versions, like the *Sophocles* in the Lateran Museum (fig. 257). In the fourth century A.D., after Christianity had achieved recognition in the Roman Empire, there was still some residue of resistance to the new faith, which came close to being reinstated officially when the emperor Julian the Apostate assumed power. His reign was brief, from 361 to 363, so his opposition to Christianity did not survive. He was a disciple of Neoplatonic doctrine, and his appearance as a pagan philosopher-priest in a statue in the Louvre (fig. 258) would therefore be appropriate to his image of himself. It should be noted that the identity of the subject as Julian has raised some doubts because the figure wears a priestly rather than an imperial diadem; but this may not be significant, and, even if it were, we are still left with an unquestioned quotation from the Greek philosopher prototype executed some seven hundred years after the original.

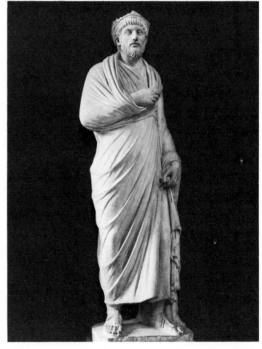

257. Sophocles. *Roman copy of a Greek work of ca. 340 B.C. Marble. Height 80¼". Lateran Museum, Rome (Anderson-Art Reference Bureau)*

258. Julian the Apostate. *Roman, ca. 361–63. Marble. Height 69". The Louvre, Paris (Alinari-Art Reference Bureau)*

259. **Christ as Philosopher between Apostles,** *detail from sarcophagus from Constantinople. ca. 400. Marble. 55 ⅞″ × 55 ¾″. Deutsches Museum, Berlin (Marburg-Art Reference Bureau)*

Around A.D. 400, on a fragment of a sarcophagus from Constantinople (fig. 259), the same philospher image reappears in a representation of Christ between two apostles. But although the pattern of the draperies and the stance of the figure are essentially the same as in the prototype, the image is flatter and the drapery folds are conceived more as linear incisions. To some extent this could be attributed to the fact that this is a relief rather than sculpture-in-the-round, but in the context of the ornate filigree on the ar-

chitectural enframement, it is clear that the image now conforms to a different stylistic idiom that stresses, amon other things, decorative values.

About one thousand years later, between 1419 and 1422, the Florentine sculptor Lorenzo Ghiberti fashioned a bronze statue of St. Matthew (fig. 260) that again recalls the Greek prototype but reveals yet another stylistic modification. The hipshot stance has a Gothic sway and the festoons of drapery are fuller and more pronounced than in the Greek prototype. The rich, curling locks of St. Matthew's hair and beard recall Hellenistic examples, but they are modified by Gothic stylizations. Nevertheless, the ample form of the figure asserting its presence through the drapery is evocative of a reawakened antique spirit.

This emulative aspect may be even more independent in nature and may evoke the spirit of ancient art without actually duplicating its formal structure or precise surface appearance. Such works are but vaguely classical, lying in the penumbra at the outermost edge of the tradition, possessing qualities of dignity, reserve, proportion, or pose that suggest some affinity by remote descent or direct inspiration with the generalizations of antique art. Thus it is that some have detected a "classical" dignity in the simple monumentality of Giotto's figures (see figs. 120 and 211, pp. 173 and 301) or of those in Masaccio's Brancacci Chapel frescoes (see fig. 276, p. 382).

Another aspect of the tradition resides in the love of order and measure expressed not so much in idealizations of the human image as through pictorial composition and architectural design. This is the most elusive of manifestations and invites the question whether instances of it are of pure "classical" descent (reflecting the legacy of a Greek love for rational order and proportion) or merely evidence of a more fundamental inclination to design in terms of coherently articulated structure or systems of modules. It was a belief in the rationality of the Greek ideal that led the nineteenth-century American sculptor Horatio Greenough, in criticizing the rampant Greek revivalism of his time, to remark that

260. LORENZO GHIBERTI. St. Matthew. 1419–22. Bronze. Height 8'10". Or San Michele, Florence (Alinari-Art Reference Bureau)

the builders of a trotting wagon or a well-designed yacht were "nearer to Athens at this moment than they who would bend the Greek temple to every use." He wanted to see Greek principles at work, not imitations of Greek things —yet, ironically, he himself frankly emulated the antique in his statue of Washington (see fig. 223, p. 314). In the realm of twentieth-century architecture, no structures of real significance to architectural history have been built in imitation of Greek temples, even though the fashion had not entirely departed. Nevertheless, the trim articulation and structural clarity of the International style of architecture (see fig. 470, p. 629) that developed after the First World War has often been called "classical" and its coherence viewed as having affinities with rational Greek principles. This problem of classicism in relation to order and measure in design is especially difficult when dealing with those twentieth-century paintings (see colorplate 26) that have sometimes been called "classical"—generally certain abstract works whose compositions reflect a commitment to an architectonic order, being arrangements of color and line in purely geometric configurations.

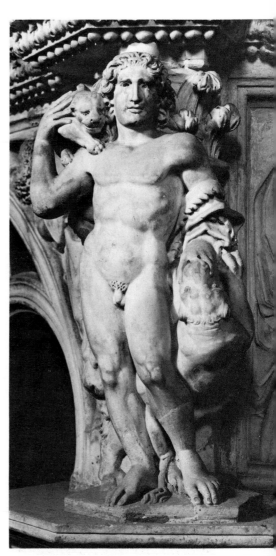

Among the most numerous manifestations of the classical tradition are those that fall in the category of iconography. Specific images from the Greco-Roman past may reappear from time to time in their original identities as heroes or gods even if altered in style, or they may reappear with a residue of the style intact but with their identities having undergone some transformations. For example, in the thirteenth century, Nicola Pisano (fl. ca. 1258–78) carved a marble pulpit for the Baptistery adjacent to the Duomo at Pisa. One of the figures (fig. 261) incorporated in the decoration of the pulpit was of a muscular male nude of squatty proportions, standing in a classical hipshot stance, holding a lion cub on his right shoulder, and grasping a lion by the jaws with his left hand. A club is behind him. The nudity of the figure and the presence of the lion and the club are part of the iconography belonging to pagan images of Herakles (Hercules). Here, however, the pagan image has acquired a Christian meaning as the personification of Fortitude, a Christian virtue. Another association is also connected with it: the image of Samson, the hero

261. NICOLA PISANO. Fortitude, *detail of the pulpit of the Baptistery of the Duomo, Pisa. 1259–60. Marble. Height ca. 22". (Alinari-Art Reference Bureau)*

of the Old Testament, whose battle with a lion parallels Herakles' victory over the Nemean lion. As for the style of the image on the pulpit, it has many qualities that link it to the antique past: the stance, features that are idealized along vaguely classical lines, and attention to the organic play of musculature. But the figure's squatty proportions seem at first too heavy to be derived from a classical prototype, particularly if one assumes that Nicola drew inspiration for it from a Roman sarcophagus, carved with scenes from the story of Hippolytus and Phaedra, that stood nearby in the Campo Santo at Pisa and from which he obviously quoted elsewhere in his work. An image of Hippolytus (fig. 262) from this sarcophagus is close to the *Fortitude,* but the sway of the

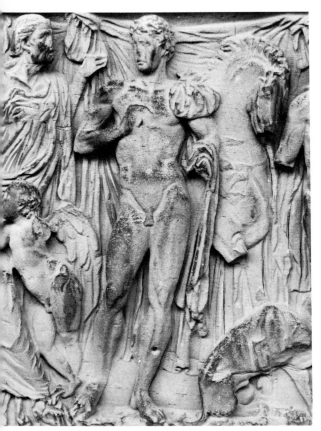

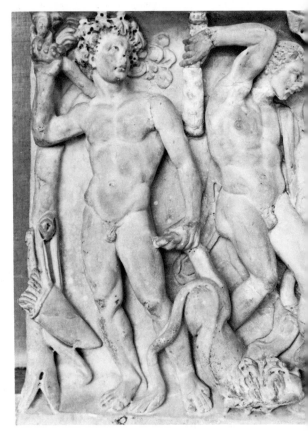

262. Hippolytus, *detail from Phaedra and Hippolytus sarcophagus. Second century. Marble. Campo Santo, Pisa (Alinari-Art Reference Bureau)*

263. Hercules, *detail from a Hercules sarcophagus. German Archaeological Institute, Rome*

body is reversed, and the gestures of the arms and the proportions are different. Much closer in pose and proportion is a stocky Hercules (fig. 263) from a sarcophagus in Rome, and examination of late antique works reveals numerous examples of squatty proportions in figural representations. The precise source for Nicola's *Fortitude* eludes us, but the style of his figure seems less foreign to the classical tradition if it is viewed in the context of late antique works. Stylistically, then, it fits well enough into the continuity of the tradition, but its old meaning has been altered to fulfill new purposes.

The iconography of the classical tradition is rooted in Greek and Roman myths, legends, historical events, and personalities. The imagery involved may be presented in the styles of Greco-Roman antiquity, or it may retain only the cast of characters and garb them in contemporary costume or timeless dress that is only remotely classical. It is well known how these circumstances developed a definite pattern in the later Middle Ages. During this era, whenever a work of art borrowed its form from a classical model it was given a nonclassical, usually Christian, meaning; and when a work of art borrowed its subject from classical antiquity, its form was nonclassical and normally contemporary. This pattern, particularly the latter aspect, can be found in later periods when, generally speaking, classical form had been rejoined with its classical subject matter in art. Thus, to cite one example, Lucas Cranach the Elder (1472–1553) in his *Judgment of Paris* (fig. 264) not only depicted the three goddesses in an unclassical style, but clad his Paris in the armor of the contemporary court of Saxony.

There is also the theoretical aspect to the classical tradition, manifest in the appeal to ancient authority derived both from surviving documents of antiquity and from later treatises based on these early models as well as on the example of ancient art itself. The history of theoretical treatises on art is rather spotty until the Renaissance, after which they appear in abundance.

The antique sources for theories of art are significant factors.

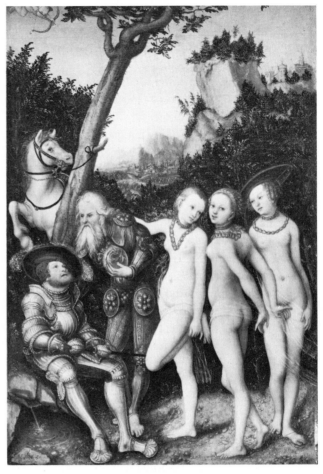

264. LUCAS CRANACH THE ELDER. The Judgment of
Paris. *1530. Oil on wood panel. 13 ½″ × 8 ¾″. Staatliche Kunst-
halle, Karlsruhe (Bruckmann-Art Reference Bureau)*

They comprise two general categories: those that deal
primarily with formal qualities like proportion and measure
and those that treat the poetic content of art. The "canon"
of Polykleitos, a Greek sculptor of the fifth century B.C., is
an elusive ideal measure because its presence can only be
divined from Roman copies of his work; but we are told by
ancient sources that a system of ideal proportions was basic
to his image of the perfect human form, exemplified by his
Doryphoros ("Spear bearer") (fig. 265) which he is supposed
to have called his "canon." Much of our information about

Greek theories comes to us from the Roman writer Pliny the Elder (A.D. 23–79) in his *Historia naturalis,* which drew, for its chapters on art, upon Greek treatises from the third century B.C. An ancient treatise on architecture, the *De architectura* of Vitruvius, a Roman of the first century A.D., influenced Renaissance architectural theory.

Of considerable importance to treatises on art written between the sixteenth and eighteenth centuries was the idea that poetry and painting were closely related in principle, in their subject matter, and in their purposes. The history of this idea goes back to a statement attributed by Plutarch, the Greek biographer of the first century A.D., to a Greek poet, Simonides, that painting is "mute poetry" and poetry "a speaking picture." This idea had been given epigrammatic terseness in the *Ars poetica* by the Roman poet Horace (65–8 B.C.): *"ut pictura poesis"* ("as is poetry, so is painting"), the converse of which was probably more acceptable to the theorists of art who approved the comparison. Fragments of writings of Plato and Aristotle could also be applied to the visual arts, and some ancient judgments were passed along by such Romans as Cicero and Quintilian.

For those who accepted the ancient status of poetry as superior to the visual arts, painting was accorded a place among the liberal arts on the basis of this presumed relationship to poetry. But this position was hardly a universal one, and the Renaissance, with its surging creativity in the visual arts, proclaimed the importance of the latter. Leonardo da Vinci, in his *Trattato della pittura,* went so far as to pronounce painting superior to poetry. For the most part, Renaissance theorists in quest of a tangible image of man in an ample and measurable space directed their attention toward matters of proportion, anatomy, and perspective. Having mastered this, they turned their interests by the latter part of the sixteenth century to other pursuits: to the codification of knowledge gained from the example of the ancients and recent Renaissance masters and to considerations of the fundamental nature of art, its content, and its purposes, evoking once more Horace's epigram, *"ut pictura poesis."* Since there was no ancient treatise on the visual arts having

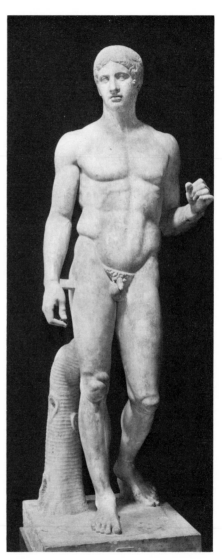

265. Doryphoros ("Spear Bearer"). *Roman copy of an original of ca. 450–440 B.C. by Polykleitos. Marble. Height 78". National Museum, Naples (Alinari-Art Reference Bureau)*

prestige comparable to Aristotle's *Poetics* or Horace's *Ars poetica*, the treatises on art that now emerged owed much to these two models which had addressed themselves primarily to literature.

The result was to impose on painting what has been called merely "a reconditioned theory of poetry" which, for all its shortcomings, did contain much that bore significantly on a central fact in the visual arts: that the representation of human life in its superior rather than its average forms has been an extremely important current in Western art, a current fed by the classical tradition.

Developments within the Classical Tradition

The decades that followed the successful defense of the Greek mainland against Persian ambitions during the first quarter of the fifth century B.C. were the germinal years of the classical tradition in Western art. They marked the emergence of an image of man and deity that was sloughing the formal ties with Egyptian and Near Eastern traditions still present in the Archaic manner of the preceding century.

By the end of the Persian Wars, the human image in sculpture was divested of its stiff Archaic stance, so reminiscent of Egyptian statues: faces lost the bright vacuity of the old apple-cheeked smile, and garments began to respond to more natural movements of the body, discarding the cocoonlike sheath of Archaic drapery. The new image, for all the ideality that pervaded its splendid proportions, too regular and impersonal still for true naturalism, seemed to reflect a pursuit of physicality that its idealized form purified but did not completely subvert (cf. figs. 25 and 86, pp. 36 and 119). It is at this moment in the evolution of Greek art that the general roots of the classical tradition are to be found: when the idealism attending the creation of an image of physical perfection, purged of individuality, achieved a delicate balance with the rendering of that form as a poised but mobile being, its surfaces evocative of real flesh and clinging, flowing drapery. By the middle of the fifth century B.C.,

Greek art seemed almost as much concerned with the display of the real as it was with the affirmation of the ideal.

In its accommodation of both the real and the ideal lay the very condition that made this era of Greek art so adaptable to its subsequent role as the prototypal base for centuries of variations on its forms and revivals of its spirit. Greek art would explore other possibilities, but whether it represented sheer physical beauty or displayed high emotion, it generally favored the refinements of the ideal even as it pursued the truths of the real. Both the physical splendor of the early classical *Poseidon* (or *Zeus*) and the agony of the Hellenistic *Laocoön Group* are grander than life (see figs. 85 and 26, pp. 117 and 37), states of being extended to some higher level of nobility to which mortals can only aspire.

The accomplishments of Greek art have constituted for subsequent phases of Western art a renewable heritage, not an inflexible body of precepts. Although there have been moments in the history of Western civilization when "classicism" acquired the trappings of dogma, as in the French academy of the seventeenth century, the tradition has normally descended across generations in an unsystematic manner as each era, movement, or artist that came under its spell garnered from a wide range of ancient prototypes the models that best suited the aesthetics of the moment or of an individual taste, choices made attractive by the rich variability of Greek—and Roman—art.

Although the idea of a classical tradition rests initially on the example of Greek art, and particularly that of the fifth century B.C., the boundary lines between Greek and Roman art were often blurred in the vision of later eras so that it is frequently more accurate, in determining the spirit of some of the relationships with the past, to speak of a "classical antiquity" subsuming both civilizations. Boundary lines are indeed indistinct when one considers how often Greek works were copied for Roman patrons and the extent to which Roman wall painting reflected, the evidence suggests, developments already begun in the Greek world. Although the ideal current in Greek art had a pronounced effect on

Roman art, by and large the distinctive and native Roman contribution to the imagery of the classical tradition lay in its realistic temper, as it sought the particular rather than the general. As the Roman Empire approached its decline, its art began to turn away from its earlier minglings of naturalism and idealism and to acquire expressionistic and spiritual emphases (see fig. 217, p. 309). By the fourth century A.D., after Christianity had been accepted as a legitimate religion in the Roman Empire, late pagan and early Christian art merged with scarcely any break in continuity as pagan images were frequently adapted to the new content of Christian art.

The Middle Ages never lost touch completely with the classical past. The architectural and sculptural remains of antiquity were still present in many regions as reminders of a splendid heritage that had yet to be recovered. It is difficult for us, accumulating an ever expanding technology, to comprehend the impact these monuments of a lost glory must have had upon the human imagination of those times. During the centuries between the collapse of Roman power in the West and the rise of a Western medieval civilization that began to spread "a white mantle of churches" along the pilgrimage roads after the symbolic millennium of A.D. 1000, there had been very little in the Western world that could convey an image of grandeur at all comparable to that of the Greco-Roman era. In the East, however, a continuation of the old empire had been maintained, as well as a rich assemblage of antique art; when the city of Constantinople was sacked by Crusaders in 1204, quantities of its artistic wealth were carried back to western Europe.

Byzantium was not only a veritable museum of antiquities from the Greco-Roman world; it was also an active continuation of its artistic heritage, and the study of developments in the art of western Europe continues to reveal the important role the old Eastern empire played in the formation of the artistic language of the West. Ivories, manuscript illuminations, and other portable art objects alone had considerable effect on representational art as models of both iconography and style. Artists as well as scholars coming from the

East made their direct contributions in various Western centers. Insofar as the classical tradition itself is concerned, it should be remembered that Byzantine art was constantly returning to its own classical roots in a pattern of "perennial Hellenism," as one scholar has expressed it.

In yet another area Byzantium was an important influence on western European art: treatises on the techniques of art written in the West, from the earliest examples to *Il libro dell' arte* of Cennino Cennini, owed much to Byzantine recipes; and techniques like mosaic and enamel work, as well as panel and wall painting, developed to a considerable extent under the guidance of Byzantine models and practices.

An early sixth-century ivory relief from Byzantium (fig. 266), representing Archangel Michael, is descended from the winged Victories of antiquity, but its classical elements have undergone some transformations. The draperies flow over the figure, admitting its presence; but their ridges tend to gather into firm, veinlike configurations almost as formalized as the regular texture of the feathers on the archangel's wings. Frontality is pronounced even though the head is slightly turned; the figure is somewhat flattened; and its relationship to the ornate architectural setting is illogical to the degree indicated by two possible readings of it. Although the archangel's heels flatten to the upper step, the feet are splayed out as if floating, and the steps are much too small in relation to the archangel's size to be anything but ornament. The upper portion of the body and the wings are on a plane in front of the columns and arch, yet the feet appear to be well behind this plane—unless one reads the fluted blocks at the bottom not as plinths for the columns but as the flanks of the steps, in which case the figure would logically be emerging from the archway. Whichever reading is taken as the correct one, it is clear that the flattening of the figure and the overall emphasis on fine details stress surface rather than substantial volume and depth; and the decorative inclinations of the details strike a formal tone. This is still essentially a classical image, but one that reveals a transforming process at work, approaching a splendid immateriality not of this world, consistent with the new role of classical

266. The Archangel Michael, *leaf of a diptych. Byzantine, early sixth century. Ivory. 17" × 5½". By courtesy of the Trustees of The British Museum, London*

forms in the service of Christianity, particularly in the context of the splendor of the Byzantine Empire.

Revivals of interest in imitating one aspect or another of the ancient civilizations arose sporadically throughout the Middle Ages. The motivations for these revivals can be properly understood only within the general context of a world that had not yet matched the secular achievements of an increasingly distant past but had at hand tangible reminders of its accomplishments. It was quite natural, for instance, that secular power in the Middle Ages, like that of Charlemagne (742–814) or Frederick II (1194–1250), when it aspired to imperial proportions, should turn to the example of the ancient world for many of its cultural models. The very idea of the Holy Roman Empire was a splendid fiction that joined the memory of a former secular glory to the contemporary reality of a sacred institution that had succeeded the Western Roman Empire as a universal state.

There were several points during the Middle Ages when a renascence of interest in classical antiquity furthered the continuity of the tradition. During the seventh and eighth centuries in Rome, and extending to other parts of Italy, there was an ephemeral revival encouraged, no doubt, by artists from the old Hellenistic areas of the East who had emigrated to Italy in the wake of Arab conquests and the iconoclastic suppressions in Byzantium. These were not unrelated events. The Byzantine Empire was engaged in a seesaw struggle with Islam, which had spread in a great pincerlike movement from Arabia westward across North Africa into Spain and east and north into the Balkans. The Byzantine iconoclastic controversy, initiated under Emperor Leo III (717–740), was a movement to prohibit the use of images of Christ, the Virgin, and the saints. It was based theologically on the commandment forbidding "graven images" and perhaps to some extent on the desire to appeal to the strong Islamic and Jewish sanctions against such religious images in an effort to extend Christianity. This also had its political overtones (see p. 252). The iconoclastic controversy lasted until a council in 787 approved of the use of images, and by the middle of the next century it had died

out. The West was thus briefly the unwitting beneficiary of
these events since Byzantium had been the direct inheritor
of a continuing and evolving tradition rooted in its own
classical past.

By the ninth century, when the court of Charlemagne was
engaged in the revival of a Latin (Roman) spirit in letters
and arts and in an attempt to equate Charlemagne's Caro-
lingian empire with Imperial Rome, the effort to acquire
literacy in Latin soon spread to a more general espousal of
Latin culture. An illuminated manuscript (fig. 267), sup-
posedly found buried with Charlemagne, contains represen-
tations of the evangelists that are strong echoes of Roman

267. The Evangelist Mark, *from
the* Coronation Gospels. *Carolin-
gian, ca. 800–810. Manuscript illu-
mination. 12 ¾″ × 9 ⅞″. Kunsthis-
torisches Museum, Vienna*

painting, modeled in light and shade and set in landscapes. Some Roman prototype or a close relative was surely the model, and it has been suggested that the presence in the Frankish north of artists from Byzantium or Italy would account for the authentic Latinity of this Carolingian "renaissance."

But transplanted traditions frequently evolve unexpected features, and in a few decades Carolingian classicism in some instances was showing new qualities. The evangelist St. Mark from the *Gospel Book of Archbishop Ebbo of Reims* (fig. 268), while obviously retaining many elements from some classical prototype—in the pose in general, the dress, the hints of light and shade, and the presence of landscape details—is charged with a new expressive force. His legs seem about to spring and his face, turned toward the inspiration that comes from the word of God, is both receptive and tense, surely an attempt to express the impact of the divine message. But the most dramatic transformation has been in the rendering of the draperies, which surge about the figure with electric energy, translating volume into flux. It has often been pointed out that this cursive restlessness in the image of the evangelist recalls the intricate interlacements of Celtic manuscript illuminations and may represent here the intrusion of the northern Teutonic-Celtic spirit. One obvious condition is overlooked in such observations: that the decorations of Celtic manuscripts—closely allied in spirit and form with metalwork and enamels (see fig. 441, p. 578)—are precisely and patiently crafted and their complicated interlacements are not without a geometric logic. This evangelist is of a different order, for he seems almost consumed by the passion expressed in the nervous impatience of the illuminator's strokes. No better symbol could be found for the evangelical energy that marked the spread of Christianity throughout the West. The classical tradition has here entered a truly medieval phase.

The Carolingian renaissance fostered by Charlemagne lasted for several decades after his demise but gradually declined and with the death of his son Charles the Bald in 877 was finished. The last third of the tenth century saw

268. **St. Mark,** *from the* Gospel Book of
Archbishop Ebbo of Reims. *Carolingian,
816–35. Manuscript illumination. ca. 10 ¼"
× 8 3/16". Municipal Library, Épernay,
France (Giraudon)*

another of these renascences, the so-called Ottonian renais-
sance, but it was not as close to antique sources in its spirit
as the Carolingian renaissance had been. It drew largely
upon early Christian, Byzantine, and Carolingian models.

In the twelfth-century revival of the classical tradition, there
was a nostalgia for the lost antique world that approached
the spirit of the later Italian Renaissance—hence its desig-
nation as "proto-Renaissance." It brought the focus back to
artistic prototypes from the pre-Christian past and was

marked by a humanism that revived the interest in Roman literature and good Latin style. Universities like Oxford and Paris were growing out of the old cathedral schools. It was at this time that the *Mirabilia urbis Romae* ("The Marvels of Rome") appeared, an antiquarian guidebook to the city; during this period, too, the collecting of ancient art assumed significant proportions.

In the early twelfth century, the sculptor Wiligelmus (or Guglielmo, fl. ca. 1170) carved two relief plaques that were set into the facade of the Duomo at Modena, Italy (fig. 269). They depicted drowsy cupids holding wreaths and leaning on downturned torches. To one of these plaques the sculptor added, at the viewer's right, an odd bird, variously identified as the mythical phoenix, a pelican, or an ibis. The iconographical problems posed by the bird do not especially concern us here. What is significant in the context of the classical tradition is that the sculptor has obviously been inspired by some antique Cupid, perhaps from a Roman sarcophagus. Despite the rude, provincial manner of the carving, the relief has much about it of a genuine antique spirit, and whatever subtle variations in meaning the different identities of the bird establish, there would seem to be a didactic significance to these reliefs not inconsistent with ancient references to sleep and death.

269. MASTER WILIGELMUS. Cupid with Inverted Torch and Ibis, *from west facade of Modena Cathedral. ca. 1170. Stone. (Alinari-Art Reference Bureau)*

"Imperator Fredericus Secundus Romanorum Caesar Semper Augustus"—thus the twelfth-century emperor Frederick II saw himself. Although of the German Hohenstaufen line, Frederick preferred his southern domains in Apulia and Sicily, where he set about reviving Roman traditions, issuing his gold coins *(augustales)*, and setting up a lavish court along Roman imperial lines with admixtures of Oriental despotism. Nicola Pisano, who came from Apulia, may have served his apprenticeship in the south where the Augustan revival of Frederick II was under way. But he is known for works he created in Tuscany in central Italy. In the reliefs for the pulpit in the Baptistery at Pisa, Nicola Pisano utilized several images derived from antique reliefs gathered in the Campo Santo nearby (see pp. 363–65). Among these was a marble vase (fig. 270) carved in reliefs depicting a Dionysiac procession. In Nicola's pulpit relief *The Presentation at the Temple* (fig. 271), the image of old Dionysos,

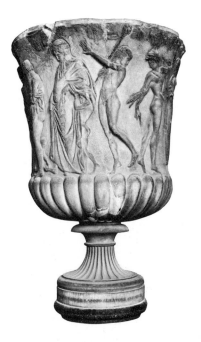

270. **Vase with Dionysiac Procession.** *Second to first century* B.C. *Pentelic marble. Campo Santo, Pisa (Alinari-Art Reference Bureau)*

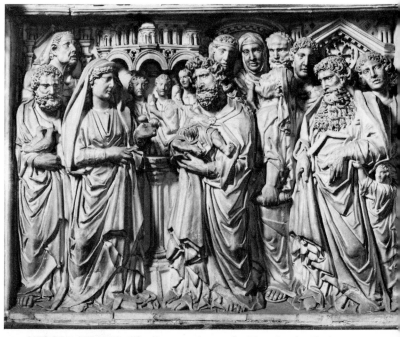

271. NICOLA PISANO. **The Presentation at the Temple,** *detail of the pulpit of the Baptistery of the Duomo, Pisa. 1259–60. Marble. ca. 33 ½″ × 44 ½″. (Alinari-Art Reference Bureau)*

supported by a young satyr while his sandals are being removed, is transformed into a representation of the aged Simeon being supported by a boy. The transformations in style are more striking. Although the bulk and dignity of Nicola's figures reflect his study of the antique and their squatty proportions are consistent with some late antique works, the angular folds of the draperies are definitely not classical. Here the sculptor seems responsive to contemporary style in another medium, for the structure of his draperies comes close to that in Italo-Byzantine painting.

Curiously enough, one of the most convincing reappearances of a classical spirit in the postantique world before the Italian Renaissance is to be found not in the tradition's old homeland of the Mediterranean world but in the Gothic north. Probably the most famous example is the *Visitation* group (fig. 272) from the French Gothic cathedral at Reims, figures long considered to be of Renaissance date because

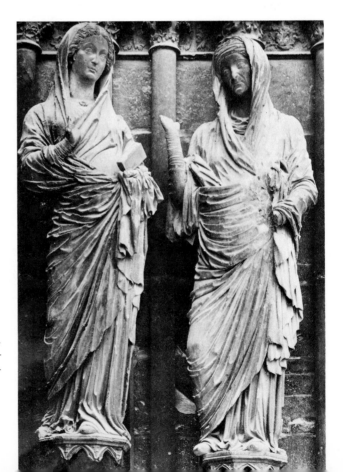

272. The Visitation, *from the west portals, center doorway, Reims Cathedral. ca. 1225–45. Stone. Height 10′2″. (Marburg-Art Reference Bureau)*

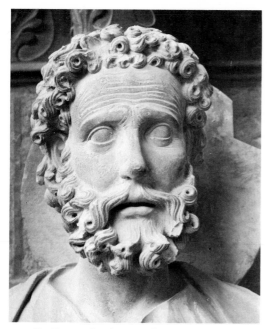

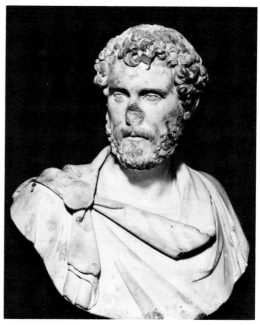

273. **St. Peter** *(detail), from left portal of the north transept, Reims Cathedral. ca. 1230. Stone. (Marburg-Art Reference Bureau)*

274. **Antoninus Pius.** *National Museum, Rome (Anderson-Art Reference Bureau)*

their style was so thoroughly classical but now assigned to the thirteenth century. Both the Virgin and St. Elizabeth are dressed in Roman fashion, quite close, it has been noted, to a vestal type of the Augustan Age. The form and gesture of their bodies are revealed through the drapery as it pulls against flexed legs and clings to shoulders and arms. Their features, while reflecting a medieval spiritual grace, display, in the case of the youthful Virgin, hints of classical idealism, and in the case of the more mature St. Elizabeth, a realism recalling the faces of Roman matrons. Less well known but equally striking in its classical tone is the head of the *St. Peter* (fig. 273) from the north transept at Reims, which resembles portraits of Antoninus Pius in the National Museum at Rome (fig. 274). This "Gothic classicism" is difficult to trace to specific antique prototypes, although it has been suggested that there were possibly still many examples of antique statuary in Reims in the thirteenth century.

Many small, portable Greek and Hellenistic sculptures in bronze, silver, and terra-cotta are so close to these Reims statues in style that they are the most likely sources. However much actual works from the classical past may have informed these Gothic works, one element should not be overlooked: there was a strong current of realism in Gothic sculpture coexistent with the more abstract and spiritualized forms like the swaying Virgins. In their material humanity they parallel the humanized images from Greco-Roman times. From whatever sources the sculptors who carved them learned the classical idiom, they had so completely assimilated the ancient manner that what they produced in that vein was not a superficial veneer of antiquity but its authentic spirit reawakened to serve a new purpose.

It was in Italy that a resurgence of the antique spirit was to have its richest development. In the early fourteenth century, the human form in Giotto's frescoes for the Arena Chapel in Padua (see figs. 120 and 211, pp. 173 and 301), while not specifically classical, displays a relieflike modeling and a generalized simplicity that invites comparison with antique sculpture as well as with that of Pisano (cf. fig. 271, p. 377) and the French north. The draperies, conforming to the tradition of timeless classical robes, further encourage the parallel. The dignity of these figures, their tangibility, their human expression, and their monumentality (both singly and as groups) not only evoke the antique spirit but also confirm why the Renaissance masters of the next century looked to Giotto as the forerunner of their age.

The Renaissance was from the beginning as much an idea as an event. It began with the notion that the times were different from the Middle Ages and saw itself as a new era. The humanists of the fourteenth century, chief among them the Italian poet Francesco Petrarca or Petrarch (1304–74), had a great deal to do with this new awareness. Petrarch conceived of this new age as a rebirth of the classics, a revitalization of Italian culture based on the Latin and Greek styles of the ancients as exemplified in the original texts.

Another literary figure, Giovanni Boccaccio (1313–75), claimed that Giotto "restored to light this art of painting which for centuries had been buried." His praise of the reality of Giotto's images, coupled with Petrarch's "back to the classics," defines two important aspects that characterized the art of the Renaissance: its concern for achieving convincing images of man and the "real" world and its appreciation and emulation of the art of classical antiquity.

Probably the first truly Renaissance nude evoking the physical beauty of the antique was on Lorenzo Ghiberti's bronze panel presented in the competition (1401–2) for what are now the north doors of the Baptistery in Florence, done by Ghiberti, as the winner of the competition, between 1403 and 1424. The subject is the Sacrifice of Isaac, and two of the competition panels are preserved: Brunelleschi's (the runner-up) and Ghiberti's winning piece, both now in the Bargello, Florence. Ghiberti's nude Isaac, kneeling on the altar, about to be sacrificed by his father Abraham, is a supple form, fully realized anatomically and thoroughly classical in its blending of reality and idealism.

But it was Donatello who took the boldest steps in recreating the classical nude. His bronze *David* (fig. 275) is possibly the first freestanding nude since antiquity—a revolutionary thing in itself. Remarkably realistic as a rendering of an effeminate preadolescent youth, its graceful *contrapposto*, the generalized features, the antique relief on the helmet of Goliath, whose head lies at David's feet, and the victor's wreath that forms the base of the bronze statue are reminders of the degree to which Italian Renaissance art was acquiring a classical vocabulary during the quattrocento. There appears to be no precise model for Donatello's *David* in Greco-Roman art, nor need one assume that such a prototype exists—or did exist. Donatello's accomplishment was to recover the spirit of the antique nude within the context of Renaissance humanism. The sensuous beauty of the statue parallels the antique without imitating it.

In his *Gattamelata* (see fig. 229, p. 318), specific antique

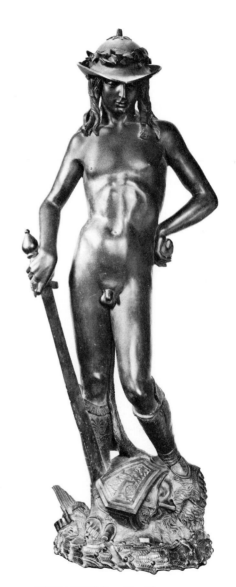

275. DONATELLO. David. *1430–32. Bronze. Height 62 ¼". (Alinari-Art Reference Bureau)*

works may have served as inspirational models: the equestrian bronze of Marcus Aurelius (see fig. 227, p. 317) and the bronze horses above the portals of San Marco in Venice. Here Donatello seems to have been at some pains to evoke the image of a Roman general by mingling Roman details with the fifteenth-century armor.

The now darkened fresco of *The Tribute Money* (fig. 276), painted by Masaccio around 1427 for the Brancacci Chapel in Santa Maria del Carmine in Florence, exemplifies the harmonic union of the quest for reality with the spirit of antique art. Here Masaccio extends the shallow space of Giotto into atmospheric distance and endows the figures with a density that recalls both the weight and groupings of figures in Giotto's frescoes of the previous century. The boxlike enclosure of figures around Christ in the central episode continues the spatial geometry of Giotto's compositions. Modeling the figures in a true chiaroscuro, Masaccio creates a sense of real light bathing the foreground space and figures, an appropriate accompaniment to the atmospheric distance. The quiet dignity of these figures, extending again the example of Giotto, is equally evocative of antique sculpture, although their immediate prototypes may be early fifteenth-century works like Ghiberti's *St. Matthew* (see fig. 260, p. 362) deprived of its Gothic sway or, more likely, the *Four Crowned Martyrs* (fig. 277) of Nanni di Banco (ca.

276. MASACCIO. The Tribute Money. *ca. 1427. Fresco. Width 8'8¾". Brancacci Chapel, Santa Maria del Carmine, Florence (Alinari-Art Reference Bureau)*

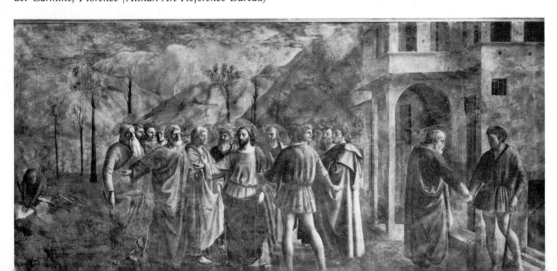

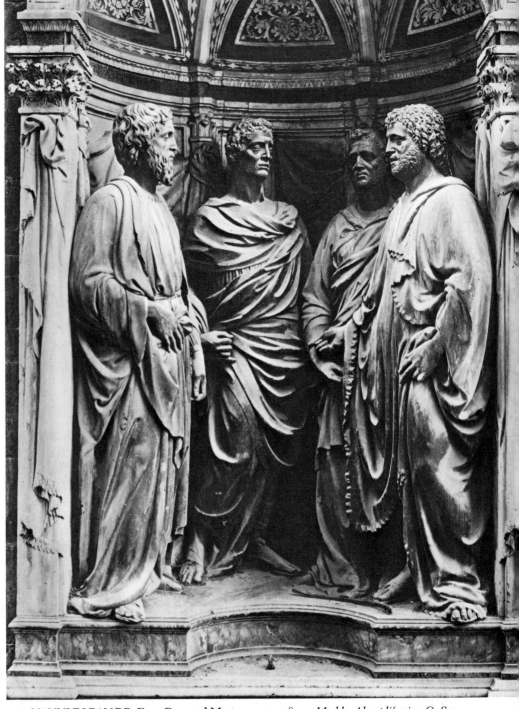

277. NANNI DI BANCO. Four Crowned Martyrs. *ca. 1408–14. Marble. About life-size. Or San Michele, Florence (Brogi-Art Reference Bureau)*

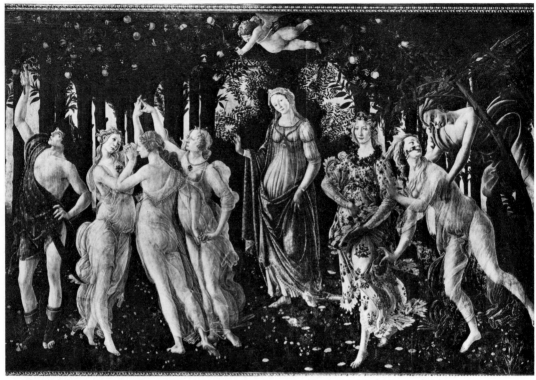

278. SANDRO BOTTICELLI. Primavera. *ca. 1477–78. Tempera on wood panel. 6′7 15/16″ × 10′3 ⅝″. Uffizi Gallery, Florence (Alinari-Art Reference Bureau)*

1385–1421), so close to the Roman sculpture the latter artist had studied. The simple clarity of Masaccio's spatial design is a manifestation of the love of order and balance associated with the classical tradition.

Turning from the sober pavane of Masaccio's weighty figures to the lighter movement and delicate forms of *Primavera* (fig. 278) by Sandro Botticelli (1445–1510) is like stepping into another world, beyond reality and incomparably lovely. Despite numerous attempts to decipher its meaning, this work still remains elusive, like the fragile beauty of the creatures who inhabit it. The subject—or subjects, for it may contain several interwoven threads of meaning—is

probably derived from the allegorical play of the Florentine
Neoplatonists in the circle of the Medici family, with whom
Botticelli was a favorite. The painting also abounds in possi-
ble allusions to the Medici family, and indeed it was painted
for a relative of Lorenzo the Magnificent. Classical my-
thology provides the cast. In a lovely orange grove and in a
glade richly embroidered with flowers, a robed Venus
framed by an arch of trees appears to preside over the rituals
in the immediate foreground. At the right a zephyr grasps
the fleeing nymph, Chloris, his touch transforming her into
the next figure, Flora, goddess of spring (Primavera). The
flowers wafted out of the nymph's mouth fall over and
mingle with the flowered garment of Flora, who in turn
scatters flowers from her diaphanous robes. Whatever it may
signify in the general context of the painting's iconography,
the three figures at the right are a pretty metaphor of the
coming of spring. The three Graces dancing at the left are
targets (or at least one of them is) for the blindfolded Cupid
who draws his bow armed with an arrow tipped with flame.
At the far left, Mercury points with his caduceus upward
beyond this beautiful, enclosed world. What reproductions
always fail to convey is the embroiderylike handling of the
paint in the rendering of the setting, which only adds—
when one is in the actual presence of the work—an even
greater unreality to the precious scene. Botticelli's mytho-
logical paintings confirm the embrace of antiquity by the
intellectual circles of the Renaissance; and even when alle-
gory mingles classical and Christian meanings (as when,
according to flexible Neoplatonic ideas, a celestial Venus
and the Virgin Mary alike were sources of divine love), the
immediate impression is often more pagan than otherwise.

In a later work, *The Calumny of Apelles* (fig. 279), Botticelli
essays a re-creation of a lost painting by the ancient Greek
master Apelles that had been described by Lucian, a second-
century Greek writer. Lucian's description had been trans-
lated into Latin early in the fifteenth century, and Alberti,
around 1435, had recommended it as a subject for painters.
His advice seems to have been ignored until, toward the
close of the century, Botticelli picked up the theme. The
cast is faithful to the literary prescription, but the handling

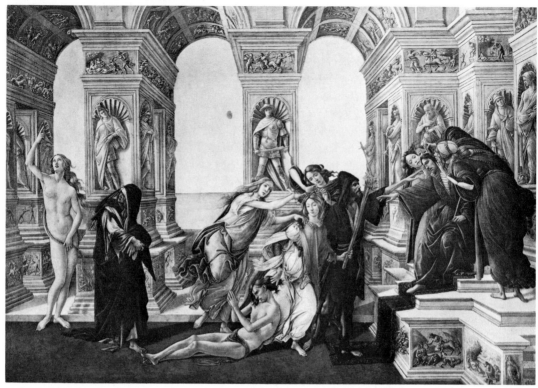

279. SANDRO BOTTICELLI. The Calumny of Apelles. *ca. 1496. Panel. 24¼″ × 35¾″. Uffizi Gallery, Florence (Alinari-Art Reference Bureau)*

of the theme is Botticelli's own. Ass-eared Midas, Injustice enthroned, listens to Ignorance and Suspicion who whisper to him as a bearded Jealousy or Hatred, accompanied by Deceit and Fraud, approaches. Calumny with a torch drags a youth, praying as well he might, while a dark-robed old woman, Penitence, tears her garments and naked Truth points heavenward. The architectural setting is as heavily embossed with relief as the realm of Venus in the *Primavera* was rich with flowers and fruit. The tension between the austere substructure of architecture and its maddening profusion of reliefs reinforces the frenetic action of the figures. Unquestionably this painting carries an emotional burden that prefigures some aspects of sixteenth-century mannerism. It has been suggested, too, that this emotional-

ity, present in other late works by Botticelli, is possibly a reflection of a conversion to the fanaticism of Savonarola, a Dominican monk who denounced the worldly Florentine society as steeped in sin and on the verge of destruction. The suggestion that *The Calumny of Apelles* may be a painting of protest against the execution of Savonarola—if the picture can be shown to have been painted as late as 1498— seems to have some merit. But whether or not it was given levels of meaning beyond that of its ancient prototype, *The Calumny of Apelles* represents a special case of classical quotation: an attempt to reconstruct a lost work from antiquity.

Sometimes the antiquarian elements in the works of Renaissance artists can be traced directly to specific works of antiquity to which the artists had access. Probably the most complete antiquarian among Italian Renaissance artists was Andrea Mantegna (ca. 1431–1506). From the time of his early training in Padua he was attracted to antique statuary and architecture. Since his work so frequently contains "quotations" from monuments in Rome, it is likely that he had observed these firsthand. The extent of his antiquarian interests can be observed throughout his work; but one of the most obvious cases is his *Introduction of the Cult of Cybele at Rome* (fig. 280), based in part on sarcophagus reliefs and executed in tones imitative of stone, frankly proclaiming the intention that it be read as a relief, a reconstituted antique image. This work has been traced to a Roman sarcophagus (fig. 281) now in the Los Angeles County Museum of Art. A "career" sarcophagus, it belongs to a common type that illustrates in a series of stereotyped scenes the life of a prominent citizen from his childhood through military service, involving barbarians pleading for clemency before him, a sacrificial scene, and a marriage scene, the entire series occupying the two ends and the front side of the sarcophagus. This sarcophagus seems to have been a very popular source of imagery. Apparently its prominent location in the early sixteenth century—in the atrium of Old St. Peter's, Rome, documents indicate—made it readily accessible to artists inclined to utilize antique figure groups or individual figures in their own compositions.

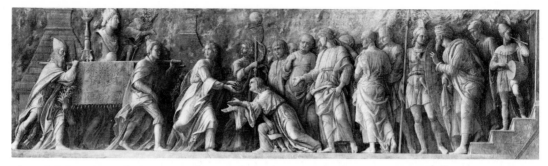

280. **ANDREA MANTEGNA. Introduction of the Cult of Cybele at Rome.** *1504. Monochrome on canvas. 2'5" × 8'9½". Reproduced by courtesy of the Trustees, The National Gallery, London*

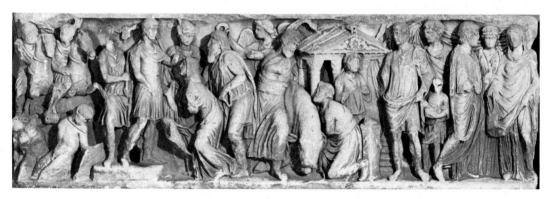

281. **Sarcophagus with Scenes from the Life of a Roman General,** *front. Roman, second century B.C. Marble. 28½" × 89". Los Angeles County Museum of Art (William Randolph Hearst Collection)*

Mantegna, in developing his composition for the *Introduction of the Cult of Cybele at Rome,* utilized the pleading barbarian woman from the sarcophagus for the similar figure in the center of his painting; and the figure of the deceased standing to the right of the temple in the sacrificial scene of the relief was the model for the standing figure to the right of the kneeling woman in the painting. The agitated figure in front of the kneeling woman in the painting is probably derived (with modifications in the head and arms) from the figure to the left of the bull in the sacrificial scene on the sarcophagus. The bust of Cybele being carried in from the left in Mantegna's painting apparently came from another source, a Roman bust in the artist's possession.

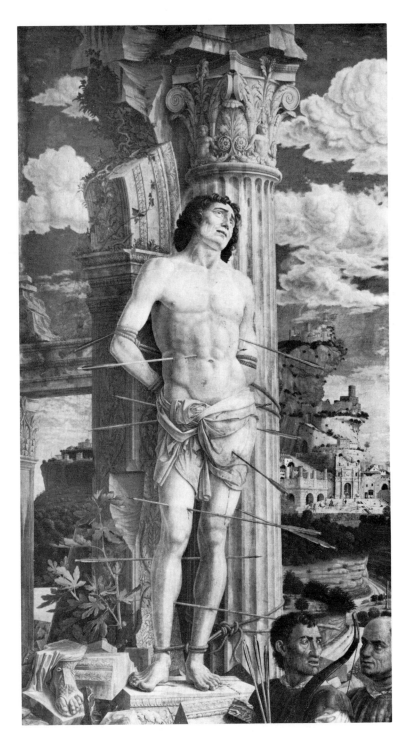

282. ANDREA MANTE-GNA. St. Sebastian. *ca. 1455–60. Tempera on canvas. 26 ¾″ × 11 ⅞″. The Louvre, Paris (Agraci-Art Reference Bureau)*

Mantegna's interest in the architecture of antiquity can be seen in his *St. Sebastian* (fig. 282); the martyr is bound to a column of the Roman composite type engaged to the remains of an arch. The architectural fragment has been identified as a section of the Basilica Julia in the Roman Forum; other Roman ruins, freely associated, appear in the background to the right. The cool tonality and hard surface quality of the painting are quite in keeping with the nature of the stony sources, and the torso of the saint is no less antique in this sense than the fragment of a Roman statue in the lower left corner of the painting.

This characteristic hardness of form in Mantegna's work (which does soften somewhat in his late frescoes in the Palazzo Ducale in Mantua) may well be the consequence of his love for antique marbles and architectural details; so absorbed were these into his conception of tangible volume and clearly defined space that his compositions often seem to have been visualized as stony surfaces and only then enriched with color. Unfortunately, some of the frescoes that best display Mantegna's phenomenal powers were a casualty of the Second World War. Painstaking restoration with salvable fragments give today's viewers only a ghost of their former state, and one must turn to photographs taken before the damage to comprehend the quality of the detail. Wherever one looks in sections of these images, form is not merely painted; it is firmly constructed as if from some essential substance. In the *St. Sebastian*, some portions of the restored frescoes, and other works (like the *Agony in the Garden*, ca. 1464, The National Gallery, London; or the *Crucifixion* from the predella of the *St. Zeno Altarpiece*, 1456–59, The Louvre, Paris), even the geology is Mantegna's own. The constructional aspects of Italian Renaissance art are nowhere more clearly diagrammed than in Mantegna's work.

The classical tradition reached Germany through Albrecht Dürer's interest in the Italian Renaissance and in remnants of the art of antiquity available in Italy. His admiration for Mantegna is well known, and as early as 1494 (the year he

first traveled to Italy) Dürer copied in pen and ink an engraving by Mantegna, dated around a year earlier (*Battle of Sea Gods*, Albertina, Vienna). In his intense study of nature and in his dedication to theoretical treatises, Dürer may also be compared to Leonardo da Vinci. He was, without doubt, a true Renaissance man despite the strong Gothic vein in his art. His style, conditioned by the linearity of his work as an engraver, remained essentially northern, searching out the minutiae of visual experience (see fig. 410, p. 539). But classical elements are sifted into his work, as in the heroic monumentality of his engraving *Knight, Death, and the Devil* (see fig. 231, p. 321) and in classical allusions in several other engravings.

The classical style of the High Renaissance reached its most graceful manifestation in the work of Raphael, who achieved a remarkably harmonic conjunction of lucid, spacious composition with an image of humanity that owed much to the idealizations of classical antiquity. He was well acquainted with antique art (sculpture, architecture, the minor arts, and examples of painting uncovered in the ruins of Rome), and he quoted liberally from a variety of these sources in his own work and in the work of his assistants whom he supervised. But the striking feature of his use of antique prototypes is the degree to which he dominated them, turning their properties to his own ends, until the source is quietly submerged in his own graceful manner.

In his *School of Athens* (fig. 283), the spatial grandeur of the composition evokes a remembrance of the most ambitious architectural designs of ancient Rome and serves the artist as a fitting stage for his theme: the soaring intellectual designs of the ancient philosophers who had contributed so profoundly to subsequent patterns of Western thought. The central figures of Plato and Aristotle are framed by the expanding rank of arches and stand where the orthogonal lines of the picture's perspective converge. These two figures are visually and conceptually the focal point of this tribute to the intellectual achievements of the ancients, and from

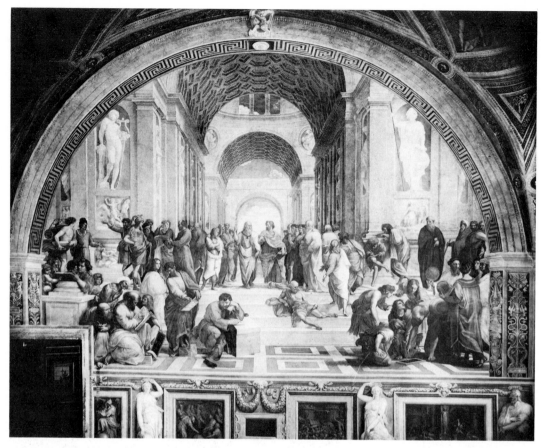

283. RAPHAEL. The School of Athens. *1510–11. Fresco. Width ca. 25'3". Stanza della Segnatura, The Vatican, Rome (Alinari-Art Reference Bureau)*

their pivotal center the rhythmic flow of this convocation of philosophers expands outward and forward to embrace the architectonic space. This fresco represents an ideal concept —a heroic metaphor—not historical reconstruction. The Greek philosophers never discoursed within surroundings like these that Raphael has created. This spacious interior derives from his familiarity with the ruins of antiquity and from his knowledge of the architectural conceptions of his contemporary Donato Bramante (1444–1514), who was then at work on designs for St. Peter's, Rome, which the architecture in the painting seems to prefigure. Although the figures themselves are more explicitly classicized than

those of Masaccio, the solemn dignity of the assemblage recalls the Brancacci Chapel frescoes (see fig. 276, p. 382) of the quattrocento master.

A charming and playful aspect of Raphael's classicism is to be seen in the Villa Farnesina in Rome, where Raphael and his assistants decorated the ceiling of the garden loggia, the Loggia de Psiche (fig. 284). The designs are Raphael's, but the execution of them is largely by others. Appropriately, Raphael's ceiling designs transform the room into an open pavilion by defining the groins of the vaults with painted supports of thickly massed leaves, flowers, and fruits which in turn support a similarly embellished rectangular framework for paintings of the story of Cupid and Psyche, made

284. **RAPHAEL AND ASSISTANTS.** **Loggia de Psiche.** *1518–19. Fresco. Villa Farnesina, Rome (Alinari-Art Reference Bureau)*

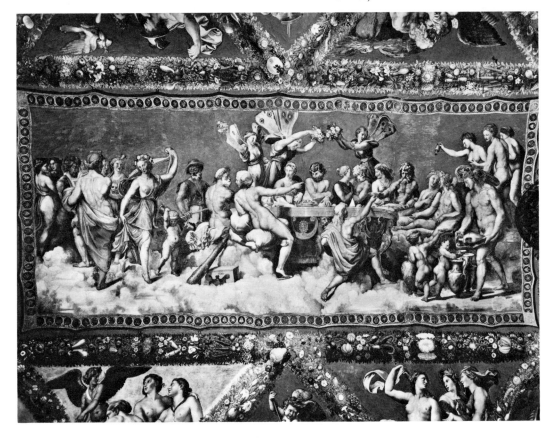

to look like tapestries tightly stretched between these supports. Graceful nude figures, *putti*, and birds occupy the open spaces between the flowering supports, so that the entire ceiling gives the effect of some garden pavilion of the gods. It is as if the fanciful decoration of Roman villas had been recast in Renaissance terms.

Another work of the Renaissance that treats the inviting subject of the loves of the gods is Titian's *Bacchus and Ariadne* (fig. 285), painted for Alfonso d'Este, duke of Ferrara, as one of an ensemble of four paintings to be displayed together in a single room. The first of these works was Giovanni Bellini's *Feast of the Gods* (1514, National Gallery of Art, Washington, D.C.), the background of which Titian altered to harmonize with his own works done between 1516 and 1523 that rounded out the ensemble, including the *Festival of Venus* and *Bacchanal of the Andrians*, both in the Prado, Madrid, and the *Bacchus and Ariadne*. The subject of the latter is derived from antique sources including Ovid, Catullus, and Philostratus and contains quotations from several antique works of art or antique types. Titian was known as a connoisseur of ancient art and probably possessed a number of objects himself. He is known to have had a cast of *The Laocoön Group* and his work displays numerous references to it, for he used it as one might a living model. The figure of the snake-entwined man at the right of the painting is related to *The Laocoön Group* (see fig. 26, p. 37), as is the figure brandishing the goat's leg. Bacchus, leaping from his chariot toward the recoiling Ariadne, probably comes from an Orestes sarcophagus like the one in the Lateran Museum in Rome (fig. 286), where the furious Orestes is the prototype. The leopard- (cheetah-?) drawn chariot recalls antique reliefs of the Triumphs of Bacchus and the meeting of Bacchus and Ariadne. The lovely landscape setting, one of Titian's finest, enhances the voluptuous theme. The antique world, as Titian paints it in his mythologies, is a realm of indulgent, fleshy pleasure, quite distinct from the idealized elegance of Botticelli or the playful fancy of Raphael's Loggia di Psiche. There is none of the marble hardness of Mantegna, but instead the surfaces are evocative of real flesh and soft, pliant draperies.

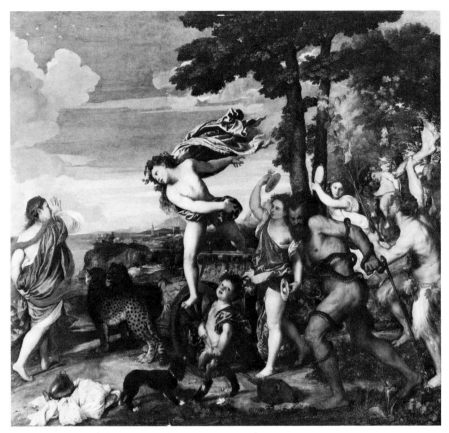

285. TITIAN. Bacchus and Ariadne. *1523. Oil on canvas. 69″ × 75″. Reproduced by courtesy of the Trustees, The National Gallery, London*

286. Orestes Sarcophagus. *Roman, 130–34. Greek marble. ca. 44″ × 84 3/5″. Lateran Museum, Rome (Alinari-Art Reference Bureau)*

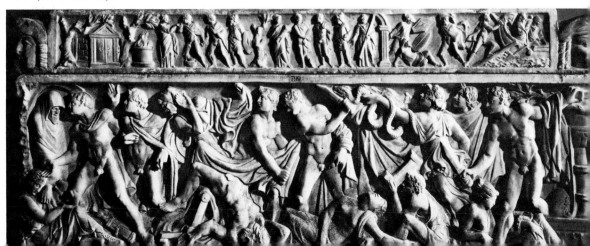

Titian's use of the antique prototypes was free and uncommitted to their ancient identities. The antique prototype always seems to be translated into a sensuous visual language derived from a study of the real world.

It is difficult to view Michelangelo within the classical tradition because—like Leonardo da Vinci—he transcended it. The awesome energy of his creations was such that it became a generative force of its own within the evolutionary processes of Western art. There are, however, undeniable classical elements in his work. He greatly admired such Hellenistic statuary as *The Laocoön Group* and the *Belvedere Torso* (fig. 287), whose physical power so matched his own artistic intention that their forms merged quite naturally into his own images. A classical vocabulary was embedded in his own dramatic and sculpturesque architecture. His response to the example of antique art is already apparent in one of his earliest works, the marble relief *Battle of the Centaurs* (fig. 288). Roman battle reliefs undoubtedly lie behind its crowded mass of figures, but the knotted energy that twists and turns throughout the composition is an expression of the young sculptor's own restless powers. In his *Bacchus* (fig. 289) of a few years later, he seems completely captivated by a pagan sensuousness embodied in the smooth physique of the god of wine, so different from the taut *David* (see fig. 200, p. 291) he was yet to carve. The *Bacchus*, made for the wealthy Jacopo Galli, was sketched (fig. 290) by the Dutch mannerist artist Maarten van Heemskerck (1498–1574) during the 1530s. Standing in the antique garden of the Casa Galli in Rome, with the right hand missing, it seems perfectly at home among antique fragments. Even Raphael is supposed to have been deceived by the work, thinking it an antique statue. Michelangelo's *Moses* (fig. 291) not only reminds us of the prophets of the Sistine Ceiling, but also contains echoes of *The Laocoön Group*, as do the so-called *Dying Slave* and the *Rebellious Slave* (both 1513–16) in the Louvre—all intended for the grand tomb of Pope Julius II, which was never to be completed as the artist wished and ended as a modest wall tomb, with the *Moses*, not in the great basilica of St. Peter's, but in the little church of San Pietro in Vincoli, Rome.

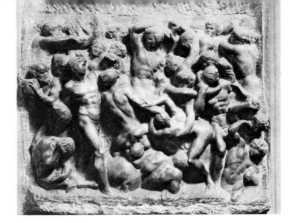

288. MICHELANGELO. Battle of the Centaurs. *ca. 1492. Marble. 33 ⅛″ × 35 ⅜″. Buonarroti Gallery, Florence (Brogi-Art Reference Bureau)*

287. APOLLONIUS. Belvedere Torso. *ca. mid-first century B.C. Marble. Height 62 ⅝″. The Vatican Museums, Rome (Alinari-Art Reference Bureau)*

290. *(above)* MAARTEN VAN HEEMSKERCK. Courtyard of the Casa Galli, Rome, with Michelangelo's Bacchus in the Foreground. *1532–36. Pen and ink drawing. ca. 5 ⅛″ × 8″. Art Division, The New York Public Library (Astor, Lenox and Tilden Foundations)*

289. *(left)* MICHELANGELO. Bacchus. *1497–99. Marble. Height 82″. Bargello, Florence (Alinari-Art Reference Bureau)*

291. *(right)* MICHELANGELO. Moses. *ca. 1513–15. Marble. Height 8′4 ½″. San Pietro in Vincoli, Rome (Alinari-Art Reference Bureau)*

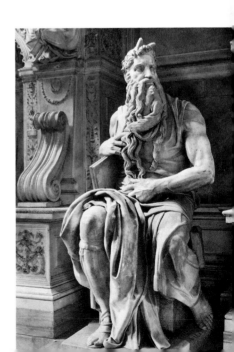

In the Sistine Ceiling, undertaken at the command of Julius II and probably with extensive advice from within the papal court, Michelangelo brought together in the final scheme an impressive admixture of pagan antiquity and the Old Testament, depicted by means that seem to comprehend the major arts of architecture, sculpture, and painting which his career involved. The format for the figural images is a painted architecture that imposes its own internal logic upon the chapel's flattened vaulting (fig. 292). Massive ribs, painted as if springing (illogically, in terms of the existing architecture of the chapel) from the spandrels above the window zone on either side of the chapel, reach across the ceiling. Intersecting these is a painted cornice that runs down each side of the vault above the spandrels and around the ends of the ceiling. These two elements form a series of compartments down the center that contain four large and five smaller scenes from the story of Genesis. Nude infant caryatids in pairs, painted to resemble marble statuary, interrupt the continuity of the painted ribs below the cornice line and frame the series of pagan sibyls and Old Testament prophets who alternate with each other in the spandrels. A prophet is also placed at each end of the ceiling in this zone below the cornice. The lower portions of the spandrels are painted to form bases for the thrones upon which the sibyls and prophets are seated. These figures, conceived in heroic

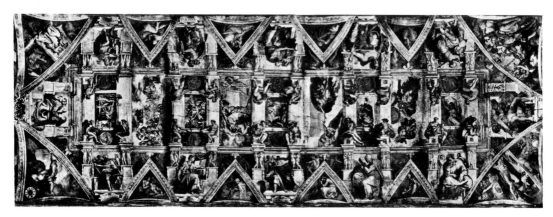

292. MICHELANGELO. Ceiling of the Sistine Chapel. *1508–12. Fresco. 43′ × 118′. The Vatican, Rome (Anderson-Art Reference Bureau)*

scale, the nude youths *(ignudi)* (fig. 293) seated on pedestals above the cornices and flanking each corner of the five smaller scenes of the Genesis story, and the scenes themselves are painted in natural but muted colors. Somewhat more darkly painted are the vaulting compartments and lunettes above the windows on either side of the chapel, which contain figures representing the ancestors of Christ. In the triangular sections formed by the projection of the window vault compartments into the area between the enthroned sibyls and prophets are nudes painted in a bronze color. The *ignudi* flanking the smaller Genesis scenes hold cloth strips that support medallions painted to simulate

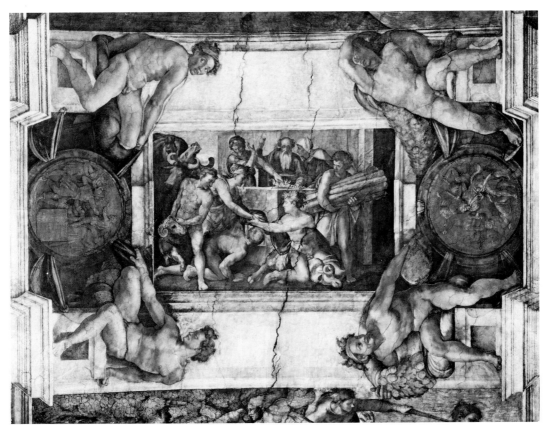

293. MICHELANGELO. The Sacrifice of Noah, *detail of the* **Sistine Ceiling.** *1509. Fresco. The Vatican, Rome (Alinari-Art Reference Bureau)*

bronze. The sibyls, prophets, and *ignudi* are conceived in sculpturesque terms. The entire program thus appears to encompass the arts and must be considered a germinal monument for the development of later baroque ceiling decoration. In physical power the prophets and sibyls are commensurate with such Hellenistic works as *The Laocoön Group*, but each is expressive of a different character—sometimes the nature of its prophecies, sometimes its relation to the scenes near it, as in the case of the awestricken *Jonah* (fig. 294) who seems to view directly the first episode of Genesis just above him. The physical splendor of the figures on the Sistine Ceiling links them in a general way to the classical tradition, but in some instances the relationship is more precise. Particularly discernible in some of the *ignudi*,

294. MICHELANGELO. The Prophet **Jonah,** *detail of the* **Sistine Ceiling.** *1508–12. Fresco. The Vatican, Rome (Alinari-Art Reference Bureau)*

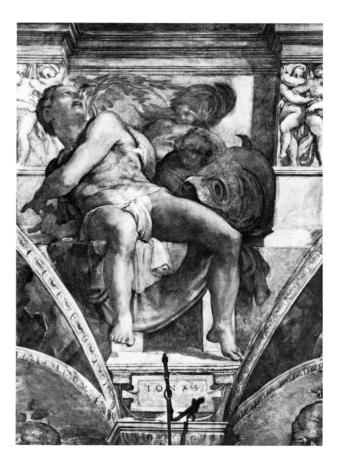

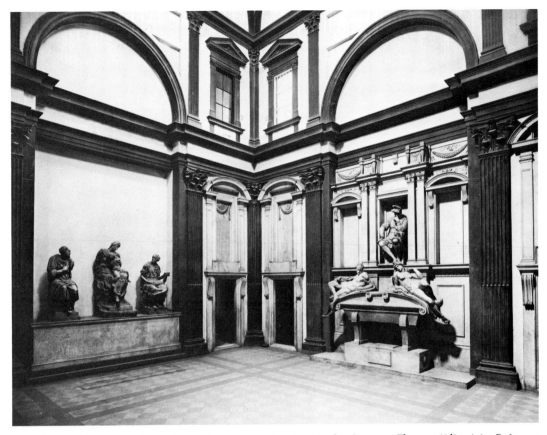

295. MICHELANGELO. Medici Chapel. *1524–34. New Sacristy, San Lorenzo, Florence (Alinari-Art Reference Bureau)*

for example, is the admiration Michelangelo had for the *Belvedere Torso* (cf. figs. 287 and 293, pp. 397 and 399).

Some years later Michelangelo was to have an opportunity to orchestrate painting, sculpture, and architecture, not in painted illusion but in actuality. However, like the tomb of Julius II, the Medici Chapel in the new sacristy of San Lorenzo, Florence (fig. 295), was never to be completed according to the artist's intentions. The paintings he planned for it were never executed, and even some of the sculptures were left unfinished. It is complete enough, however, to form an impressive architectural and sculptural ensemble, a testimonial to the accommodations of classical

elements to the demands of Michelangelo's own vision. The artist designed the lighting of the interior of this funerary chapel to create the soft illumination that suffuses the space, the sculptures, and the architectural details with a quietude that photographs of it, registering the *pietra serena* architectural framework too darkly, usually fail to convey. The tombs of the two Medici—Giuliano, duke of Nemours, and Lorenzo, duke of Urbino—face each other across the chapel, and the statues of the two dukes, seated in niches above the sarcophagi on which recline allegorical figures representing the Times of Day, look in the direction of the *Medici Madonna* at the end of the chapel opposite the altar. The *Medici Madonna* is flanked by statues of St. Cosmas and St. Damian, both done by pupils of Michelangelo. The

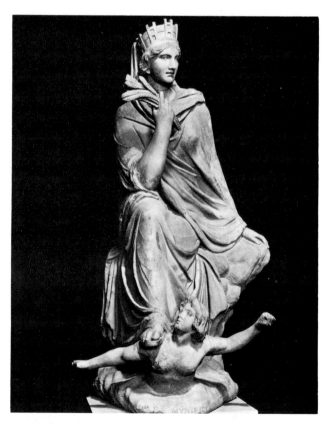

296. MICHELANGELO. Medici Madonna. *1524–34. Marble. Height 89⅜″. New Sacristy, San Lorenzo, Florence (Brogi-Art Reference Bureau)*

297. Tyche of Antioch. *Roman copy of a Greek original by Eutychides, ca. 300 B.C. Marble. Height 37¾″. The Vatican Museums, Rome (Alinari-Scala)*

unfinished *Medici Madonna* (fig. 296) is a curious image: her crossed legs, a rarity among Madonna images, recall a Hellenistic allegorical figure, the seated *Tyche of Antioch*, a Roman copy of which is in the Vatican Museums (fig. 297); and the relationship between Mother and Child is not like the usual *Virgin lactans*, for the Child turns to her with a violent twisting motion, burying his head between her breasts as if seeking refuge. Nor does the Virgin really press him to her breast. The Child's movement is entirely self-generated, and her expression, indeed her entire mood, is one of resignation and sadness.

The statues of the two dukes (figs. 298 and 299), clad in armor simulating in a general way that of Roman antiquity, are clearly idealized images, not portraits in the usual sense, and Michelangelo's own remarks concerning the figures confirm this. They also remind us of the continuity of imagery within Michelangelo's own work, since they recall the figures of sibyls and prophets enthroned on the Sistine Ceiling, as well as the *Moses. Lorenzo*, for example, incorporates aspects of both the *Isaiah* (fig. 300) and the brooding *Jeremiah* (fig. 301) from the Sistine Ceiling; and in *Giuliano* one again senses, in addition to the *Moses*, the presence of the *Belvedere Torso* (see fig. 287, p. 397). The figures of the Times of Day, however eloquently they testify to Michelangelo's unique manipulations of the human form for expressive purposes, are the legitimate descendants of numerous reclining figures from antiquity: river gods (four of these were planned for placement on the floor below the sarcophagi), pedimental figures, and such works as the *Ariadne* in the Vatican Museum (fig. 302).

The architectural form of the wall tomb arrangement is an amalgam of the Roman triumphal arch and features from Michelangelo's design for the facade of San Lorenzo (fig. 303), which he had been so disappointed in not being permitted to build. The firm patterns of verticals and horizontals and the symmetrical arrangement of the statuary are classical enough and in harmony with the soft lighting of the interior, but one is not long in the chapel before becoming aware of disturbing undercurrents. There is a contradictory

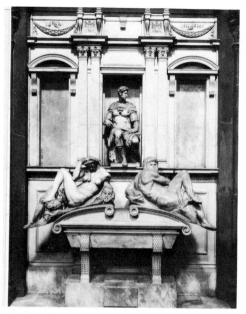

**298. MICHELANGELO. Tomb of Giuliano de'
Medici.** *1524–34. Marble. Height of central figure
71". New Sacristy, San Lorenzo, Florence (Alinari-
Art Reference Bureau)*

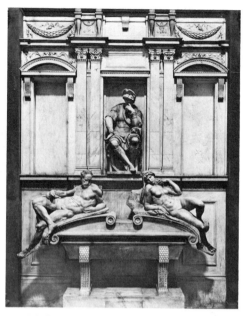

**299. MICHELANGELO. Tomb of Lorenzo de'
Medici.** *1524–34. Marble. Height of central figure
71". New Sacristy, San Lorenzo, Florence (Alinari-
Art Reference Bureau)*

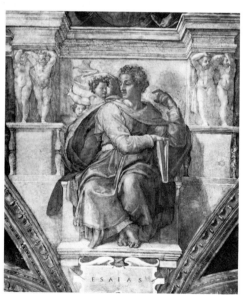

300. MICHELANGELO. The Prophet Isaiah,
detail of the **Sistine Ceiling.** *1508–12. Fresco. The
Vatican, Rome (Alinari-Art Reference Bureau)*

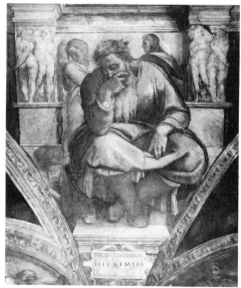

**301. MICHELANGELO. The Prophet Jere-
miah,** *detail of the* **Sistine Ceiling.** *1508–12.
Fresco. The Vatican, Rome (Alinari-Art Reference
Bureau)*

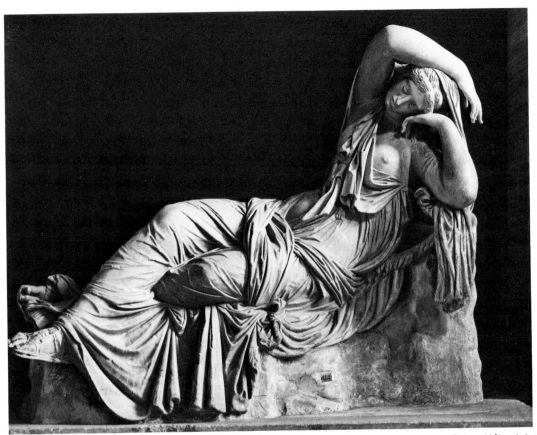

302. **Ariadne.** *Reconstructed cast of a Greek original of ca. 240 B.C. The Vatican Museums, Rome (Alinari-Art Reference Bureau)*

303. MICHELANGELO. Model for the Facade of San Lorenzo. *1518. Wood. 7′ × 9′4″. Buonarroti Gallery, Florence (Alinari-Art Reference Bureau)*

mixture of internal tension and lassitude in the figures. The Times of Day on the slanting lids of the sarcophagi seem to be perched precariously, and viewed from the altar, the sculptural forms of both tombs appear to be cascading from the niches of the dukes. The forced gestures and the alternating stretch and compression of body forms are hardly new in Michelangelo's work, but here they seem to acquire greater emphasis than before. The somber tone of the chapel can develop sinister accents when one observes the sad Madonna and the Child who turns his back to the chapel, the mask and bird of *Night*, the masks in molding and capitals, the ugly animal features on Lorenzo's money box, and that duke's face shadowed by the helmet and obscured by the light-gathering left hand he holds to his chin. One is reminded of the troubled decades of the early sixteenth century in Italy, during which the Protestant movement split the church and gathered force; the Eternal City itself was sacked, in 1527, by the imperial forces of Charles V. Coeval with this, the mannerist crisis in Italian art was breaking up the classical harmonies of the High Renaissance. Whatever settlement the voluminous speculations on the true interpretation of the Medici Chapel may eventually reach, it cannot be unrelated to the crises of this era. Always there will be the irony that these two minor figures of the colorful Medici galaxy who are glorified by these tombs could scarcely be more undeserving of the honor. For the classical tradition in Western art, the Medici Chapel will continue to be a fascinating example of the adaptability of classical prototypes to the demands of later eras and the personal styles of highly individual artists.

During the course of the sixteenth century, the rational balance, order, and spiritual dignity of High Renaissance classicism, exemplified so well in Raphael's *School of Athens*, gave way to an era in which a variety of stylistic directions were pursued before the realism of Caravaggio (see pp. 274–76, 528) and the baroque era emerged at the end of the century. One of the styles of this period, taking shape around the time of Raphael's death in 1520, has been dubbed "mannerism," originally a derogatory term that recently has gained respectability and has acquired a special status of its own.

The term was originally applied to certain artists who worked in Rome and Florence, developing various aspects of the work of Raphael and Michelangelo into artificial—that is, "mannered"—art. The refined sensuousness of Botticelli, as well as the emotionality of his late works, both qualities conveyed by his pliant line, must also be considered part of the genesis of mannerism.

Generally speaking, mannerism at the outset was characterized by an emotional subjectivity that resulted in images with strangely forced gestures, irrational warping of the human form, shifts in the scale of figures and groups, a frenzied mood, and unorthodox color frequently described as "acid." For the classical tradition mannerism has rather special implications, for it has been viewed as an "anticlassical" style. Whether this is always justifiable is a debatable question, depending on how narrowly one defines "classicism"; but there is no question that some aspects of mannerism stand in an almost reactive relationship to the balanced order and restraint of the purest examples of High Renaissance classicism. Even in the work of Raphael's school, this disturbance can be found. In *Fire in the Borgo* (fig. 304), a work designed

304. **RAPHAEL. Fire in the Borgo.** *1514–17. Fresco. Width ca. 22'. Stanza dell' Incendia, The Vatican, Rome (Alinari-Art Reference Bureau)*

by Raphael but executed by his pupils, the setting lacks the symmetry of the architectural staging in his earlier Vatican frescoes like the *School of Athens* (see fig. 283, p. 392), and the scale of both figures and architecture changes abruptly between foreground and deep space. There are curious juxtapositions of agitation and gracefulness, and the rhythms running through the figural groupings have a frenzied cadence that is echoed in the relatively cluttered wedging together of architectural elements. The contrast to his *School of Athens* is quite striking. There are, nevertheless, some echoes of antique prototypes in some of the figures and in architectural details like the row of three columns, probably derived from ruins in the Roman Forum. Yet, overall, the painting marks a definite departure from the tenets of High Renaissance classicism.

The degree to which art of the mannerist movement broke with the High Renaissance can be seen in one of the fresco decorations by Raphael's pupil Giulio Romano (1499–1546): the Sala dei Giganti ("Room of the Giants") in the Palazzo del Té at Mantua (fig. 305). Although the theme is

305. GIULIO ROMANO. Sala dei Giganti ("Room of the Giants"), *detail. 1532–34. Fresco. Palazzo del Té, Mantua (Alinari-Art Reference Bureau)*

from classical mythology—the destruction of the giants by the thunderbolts of Jupiter—the room is painted so as to deny the planes of the walls, an explosive composition that gives the viewer in the room an uneasy feeling that everything is collapsing around him. No more extreme example could be found of mannerist departures from High Renaissance balance and order and, despite its mythological theme, no more anticlassical statement within the sixteenth century.

One of the strangest paintings to emerge from the mannerist milieu of the mid-sixteenth century is *An Allegory* (also known as *Exposure of Folly* or *Venus, Cupid, Folly, and Time)* (fig. 306), by Agnolo Bronzino (1503–72). In its agitated compression of figures into a shallow foreground

306. AGNOLO BRONZINO. An Allegory. *1542–45. Oil on wood panel. 57½″ × 45¾″. Reproduced by courtesy of the Trustees, The National Gallery, London*

space, in its cold, strident color, in the mannered elegance of the gestures, it is thoroughly mannerist. Yet the allegory is a form prevalent in the classical tradition, and, for that matter, the pressure of figures toward the foreground plane is not unlike the nature of sarcophagus reliefs. Time and an angry figure (Truth?) appear to struggle with a drapery that could either veil the foreground tableau or reveal it when pulled away. Cupid fondles Venus while a *putto* seems about to throw roses on the pair. At the viewer's left Envy claws at her hair, and at the right, behind the *putto,* a dangerously sweet image of Deceit, whose right and left hands are reversed, holds a honeycomb and a scorpionlike creature. From beneath her garments an incongruous scaly tail and a lion's leg emerge. Masks in the lower right reinforce the image. It is a completely ambivalent allegory that projects the confusion of values in a troubled age: on one hand, the sins of luxury; on the other, erotic pleasure. Neither meaning would have escaped the painting's aristocratic audience.

At the end of the century, an antimannerist movement was initiated by a Bolognese family of artists, the Carracci. Chief among them was Annibale Carracci, who advocated a return to nature and the classics, including High Renaissance masters as well as the example of ancient art. Echoes of Michelangelo and of Raphael's mythological paintings as well as classical antiquity are obvious in Annibale's frescoes in the gallery of the Palazzo Farnese in Rome. Annibale Carracci was called to Rome by the Cardinal Odoardo Farnese in 1595 to work on decorations of the Palazzo Farnese, one of the most classical of Renaissance palaces, engaging the talents of several architects, including Michelangelo. The Farnese family had an extensive collection of antique art that could only have reinforced Annibale's own classicizing predilections. After work on the decorations of a small room, the Camerino Farnese, Annibale began, in 1597, to paint the frescoes of the ceiling vault in the Farnese Gallery, a larger room intended to display a portion of the Farnese collection of antique sculpture. The theme of these decorations, the loves of the gods, was drawn from Ovid's *Metamorphosis;* the scheme of the ceiling frescoes, complementing the intended function of the room, was, in effect, a

307. **ANNIBALE CARRACCI. Polyphemus and Galatea,** *detail of a ceiling fresco. 1597–1601. Gallery, Palazzo Farnese, Rome (Gabinetto Fotografico Nazionale)*

gallery of pictures set amid representations imitative of sculptural decoration. The episode of *Polyphemus and Galatea* (fig. 307) occupies one end of the ceiling vaults and is painted as if it were a framed picture, partially covering the feigned architectural ornament and flanked by *ignudi* painted in natural colors. The corners of the ceiling vaulting are painted as if open to the sky above a balustrade on which cupids stand. Echoes of the Sistine Ceiling are strong, and the various levels of illusion—simulated sculptural ornament, framed pictures, nude youths and cupids, and open

sky—create a transition from the real to the pictorial space that was to establish a precedent for later baroque ensembles, for the entire ceiling seems like an extension of the real space of the room.

The panel representing Polyphemus singing to Galatea, who is preoccupied with the presence of her lover, Acis, at whom the frustrated Polyphemus hurls a large rock in the panel at the opposite end of the vaulting, echoes both Michelangelo and, in some aspects of the giant's pose, *The Laocoön Group*. These decorations have implications for both the baroque classicism of Poussin and the exuberant baroque of Rubens, who was impressed by the gallery decorations when he was studying in Italy. Indeed, the Farnese Gallery became a place of study for generations of artists, promoting the idea of nature "corrected" by the idealizations of antique art.

Very early in the seventeenth century, Annibale Carracci's *Flight into Egypt* (see fig. 129, p. 183) revived the pastoral loveliness of Venetian landscapes of the High Renaissance in a composition whose orderly calm and framing devices of trees appeared in idealized landscapes, accompanied by antique ruins or temples and mythological allusions, as late as the nineteenth century. Its idyllic temper also recalls some Roman landscapes (see fig. 113, p. 163).

Classical antiquity continued to make its presence felt even in the realistic style of Caravaggio, who could hardly be called a classicist. Indeed a classicistic critic of the seventeenth century condemned Caravaggio's works as "the ruin of the art of painting." Literal representation is such a pronounced feature of Caravaggio's images that his paintings have been called "naturalistic," but by no means do they exemplify an absolute naturalism, as we shall see. In what has been called "a playful adaptation" of Michelangelo's marble *Victory* (1527–28, Palazzo Vecchio, Florence), Caravaggio's *Victorious Amor* (fig. 308), which is also related to the *ignudi* from the Sistine Ceiling (see fig. 293, p. 399), has transformed Cupid into a brazen urchin whose image fully embodies the idea of mischief. The naturalistic

308. **CARAVAGGIO. Victorious Amor.** *ca. 1600. Oil on canvas. 60 ⅝″ × 43 ¼″. State Museum, Berlin (Marburg-Art Reference Bureau)*

treatment of the subject is made all the more striking by the dramatic light and shadow. The tangibility of the wings suggests a study of real wings, an observation documented by a reference to Caravaggio's borrowing about this time for a period of several months a pair of bird's wings from another artist. But the naturalism of the painting is in the service of an allegory of the type common within the classical tradition, as Cupid—here intended to symbolize earthly love—is depicted triumphant over the intellectual life and ambition for renown. Among the vanquished are music, geometry, and astronomy (the objects in the lower left and the starry globe behind Cupid); military glory (the armor); literary accomplishments (the open volume and the quill pen behind the armor); fame (the laurel branch on the book); and even kings (the crown and scepter on the table).

References to classical antiquity appear elsewhere in Caravaggio's work: in his *Young Bacchus* (fig. 309) and *Head of Medusa* (1596–97) in the Uffizi, for example. In *The Young Bacchus*, in particular, there are some qualities too easily overlooked in the context of the artist's compelling naturalism. The regularization of the features of the model, of the contours of shoulder, arm, and hands, of the drapery lines, and of the leaves and fruit falls short of complete idealization but is very close to the process of classicizing an image. For example, the leaves and fruit are presented in a blend of naturalistic color and forms drafted in such a way that details or particularities are simplified, reduced to generalizations. In the rendering of the transparency of glass, the refraction of light is ignored, so that details seen through the glass are not distorted, evidence that Caravaggio's naturalism is not entirely empirical. There is more generalization in Caravaggio's work than is credited in the popular notion of his style. Because he chose to generalize particulars in a limited way, rather than to eliminate them through drastic generalization and idealization, his work retains the impression of a thoroughgoing naturalistic art, which it is not. There are sections of his paintings that would not be out of place in classicizing works, but this is not sufficient to make him a classicist. Caravaggio was an artist of remarkable individuality, an innovator who brought to the context of

309. CARAVAGGIO. The Young Bacchus. *1593–94. Oil on canvas. 37 2/5″ × 33 ½″. Uffizi Gallery, Florence
(Alinari-Art Reference Bureau)*

traditional classical and Christian themes elements from the reality of the commonplace world that retained in his art their commonplace identities. But the naturalism this entailed was still rooted in characteristic Italian conceptualizations, not in purely optical sensation. In this respect Caravaggio's work has at least a tenuous link with the Renaissance and with the classical tradition.

Because the physical immediacy of Caravaggio's subjects is so intensified by the naturalistic aspects of his style, by the dramatic lighting he developed in such works as *The Calling of St. Matthew* (see fig. 402, p. 527), and by his tendency to utilize a perspective that places the viewer close to the level of the subjects and thrusts the forms in the picture out toward the viewer's own space, he has often been considered a "proto-baroque" artist. To the extent that this "Caravaggism" was carried to various parts of Europe by his followers and became a distinct current in seventeenth-century art, the designation is valid. The baroque, however, is a complicated phenomenon that subsumes a variety of styles and concepts that range far beyond Caravaggio's manner. Indeed, the term "baroque" seems to have become too ambiguous to be passed over without some explanation of its various applications. Its origins are obscure but point to an initial meaning as something contorted or even bizarre, and eventually it became associated with that which is theatrical or bombastic. Yet it has also acquired a chronological dimension as a term signifying the art of the seventeenth century in general. Therein lies much of the difficulty in applying it as a stylistic term, for the seventeenth century produced a remarkable variety of types and styles (see figs. 131, 136, 232, 254, 312, 314, 403, 415, and 431, pp. 187, 195, 322, 349, 420, 422, 529, 544, and 564).

Apart from the naturalistic current embodying close observation of nature, which fortified the development of landscape, genre, and still life painting in the seventeenth century, there was a strong allegorical tendency (see pp. 541–44, for example). The duality of naturalism and allegory, it has been observed, had its counterpart in seventeenth-century science and metaphysics. In addition, this baroque era fostered a

psychological awareness manifest in themes of ecstasy, martyrdom, and humor; and in the prevalence of involvement with the dramatic possibilities of space, light, and time in seventeenth-century art and architecture, there is evidence of a fascination with continuity and the infinite. The diverse expressions of these many interests give the art of this period its sometimes startling variety. Thus, when confronting the term "baroque," one must identify the immediate context within the wider scope of the era. From such a perspective it is possible to accommodate under the same general rubric such divergent positions as Poussin's orderly compositions (see figs. 312 and 313, pp. 420 and 422), Rubens's exuberant energy (see fig. 185, pp. 267, and colorplate 8), and Rembrandt's humanity (see figs. 186 and 187, pp. 267 and 269).

310. PETER PAUL RUBENS. Minerva Protects Pax from Mars. *1629–30. Oil on canvas. 6'8⅛" × 9'9 5/16". Reproduced by courtesy of the Trustees, The National Gallery, London*

In the seventeenth century, allegory's function as a vehicle for elaborating ideas can be seen in *Minerva Protects Pax from Mars (Allegory of the Blessings of Peace)* (fig. 310) by Peter Paul Rubens, which praises the benefits of peace as opposed to the evils of war. Fully baroque in the active sweep of movement throughout the picture space and characteristic of Rubens in the ample bodies, rich colors, and textures, the painting is also full of the classical allusions so common to allegory since the Renaissance. The goddess Minerva (wisdom and civilization) pushes Mars (war) away from the foreground scene. A flying *putto* bears Mercury's wand, the caduceus (symbolizing wealth and prosperity). In an arc of forms diametrically opposed to and larger than the arc formed by the raging Fury in the opposite corner, the ordinarily wild spirits of the maenads, the satyr, and the leopard are gentled; and the central figure of Peace offers her breast to a child, as a satyr and *putti* present the luscious fruits to children. An antique cast is assembled to act in an allegorical tableau.

Few artists have assimilated the classical tradition as completely and transformed it as naturally into a personal style as Peter Paul Rubens. His education in the literary classics of antiquity was remarkably thorough and his knowledge of antique art, which he collected, was extensive. The list of drawings he did in Italy from classical sculptures is like a catalog of the renowned antique works known at that time. But, as he himself pointed out in a treatise on the imitation of antique statues, it was important to avoid the appearance of stone when working from such models. He did this always in his paintings, for his figures, regardless of how much they may owe to his study of classical statuary, are never frozen images. It is as if he looked beyond the embodiment in marble toward the life it implied. His paintings of ancient themes touch practically every corner of classical mythology; his many allegories employ a wide range of classical personages; and his paintings of Christian themes contain numerous "quotations" from antique sculpture. Although his *Venus and Adonis* (fig. 311) is indebted to Titian's invention of Adonis's abrupt parting from Venus (different from

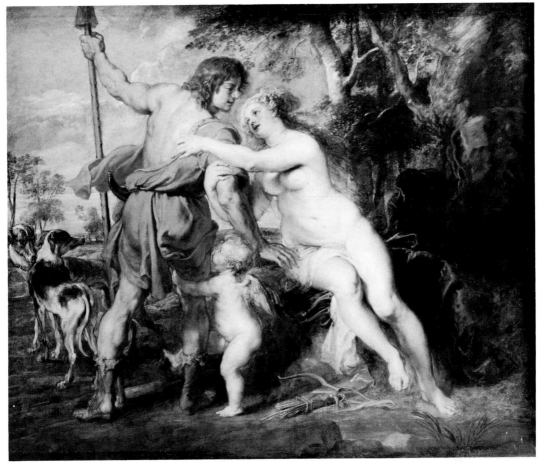

311. PETER PAUL RUBENS. Venus and Adonis. *1635. Oil on canvas. 77 ½″ × 94 ⅝″. The Metropolitan Museum of Art, New York (Gift of Harry Payne Bingham, 1937)*

the episode in Ovid's *Metamorphosis*) and the figure of Venus owes something to the dying Glauce (or Creusa), Jason's betrothed, on Medea sarcophagi, the ample, voluptuous forms, flowing with vitality, are his own amplifications of classical physicality, tempered by the example of sixteenth-century Italian art, particularly of Michelangelo.

In the same century, the French artist Nicolas Poussin (1594–1665) also stands as an exemplar of the classical spirit

in Western art. His work relies heavily—but not exclusively —on themes from the Greco-Roman world and reveals a thorough knowledge of the forms of antique art, from which he frequently quotes or develops adaptations. His compositions are carefully arranged and proportioned; distances and spatial intervals between objects convince us of their measurability; and the objects themselves, whether figures, architecture, trees, or hills, are clearly rendered. The qualities of measure and proportion inherent in the classical tradition are nowhere more manifest than in the paintings of Nicolas Poussin: his forms are subjected to a geometric discipline that shapes them toward ideality. Very little if anything is the product of chance. In his studio he even utilized a miniature stage—equivalent to the picture space in which

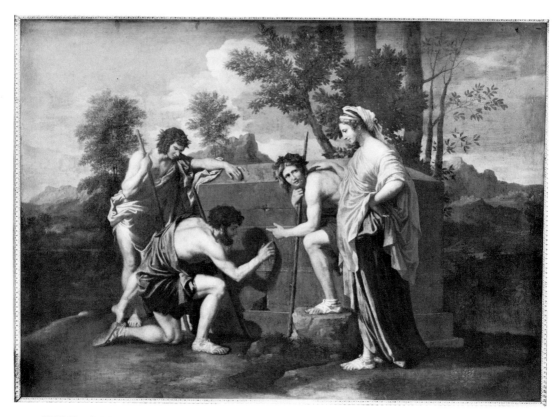

312. NICOLAS POUSSIN. The Shepherds in Arcadia (Et in Arcadia Ego). *ca. 1640. Oil on canvas. ca. 34″ × 48″. The Louvre, Paris (Alinari-Art Reference Bureau)*

his figure groups were to be placed—and arranged small figures in it to work out his compositional schemes. The method was rational and controlled. The dogmatic aspects of French classical theory in art were well served by such a deliberate intellectual approach. But the artist Poussin has other dimensions. There is no lack of feeling in his work, and much of it is a poetic evocation of a lost golden age viewed with nostalgia and melancholy. Nor is there a lack of sensuousness in his idealizations, for there are rich residues of Venetian landscape pastorales and lovely skies, and his color was appreciated by that supreme colorist, the Englishman Turner, in the nineteenth century.

The poetic side of Poussin's art can be seen in his *Shepherds in Arcadia (Et in Arcadia Ego)* (fig. 312), in which a gentle melancholic mood casts its spell over the Greek shepherds contemplating an inscription on an ancient tomb. Death is present, life is transient, even in Arcadia, a remote pastoral area of ancient Greece celebrated in poetry as a haven of bliss. This painting, engraved in at least three versions, has been shown to have been very popular in the eighteenth century. As the subject of an English poem, *The Monument in Arcadia*, published in 1775, it appealed to the sentiments expressed in pastoral poetry.

In *The Birth of Venus* (fig. 313), painted for Cardinal Richelieu, Poussin's classicism serves the spectacle of pageantry and recalls similar themes on Roman sarcophagi; and in *The Rape of the Sabine Women* (fig. 314) he deals with an episode from Roman legend. *The Rape of the Sabine Women* is an excellent example of several facets of Poussin's art. He juxtaposes the intricate turbulence of the lower half of the picture with the large, simple divisions of the upper half, but the action in the lower section consists of groups that are frequently frozen into separate statuesque tableaux that recall Hellenistic prototypes, and gestures frequently parallel one another in regular cadences. It differs from the movement in Rubens's *Minerva Protects Pax from Mars* in that it has an essentially static base.

In the same century even Rembrandt was not immune to

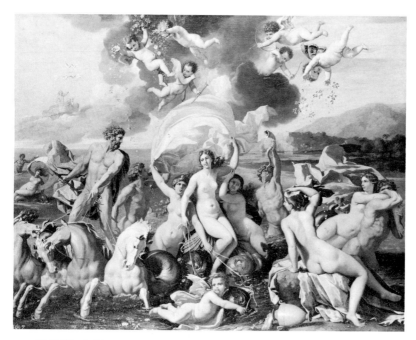

313. NICOLAS POUSSIN. The Birth of Venus. *1638–40. Oil on canvas. 45 ¼″* × *58″. Philadelphia Museum of Art (George W. Elkins Collection)*

314. NICOLAS POUSSIN. The Rape of the Sabine Women. *ca. 1635. Oil on canvas. 60 ⅞″* × *82 ⅝″. The Metropolitan Museum of Art, New York (Harris Brisbane Dick Fund, 1946)*

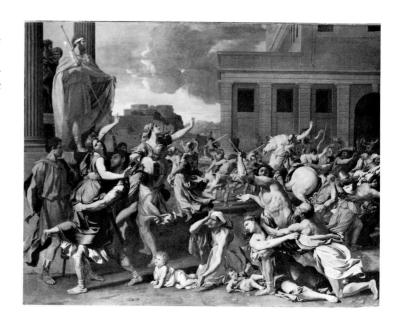

the invitations of classicism; in his etching *Christ Presented to the People* (fig. 315), he composes the picture along symmetrical lines that recall High Renaissance design. But although there is considerable evidence of his appreciation for the Italian Renaissance in his collections and in such things as his drawings after Mantegna (one of which was after the Italian master's drawing of *The Calumny of Apelles*), Rembrandt never adopted classical proportions for his figures: he remained close to unidealized humanity. The human condition was a recurring focus of his probing art.

Rembrandt's *Aristotle Contemplating the Bust of Homer* (colorplate 9) brings directly into his imagery a famous antique bust of the blind poet, known in many copies and of which Rembrandt appears to have had a plaster cast. It has been demonstrated, however, that the title is inadequate to

315. REMBRANDT VAN RIJN. Christ Presented to the People. *1655. Drypoint etching, seventh state. ca. 14⅛″ × 18″. By courtesy of the Trustees of The British Museum, London*

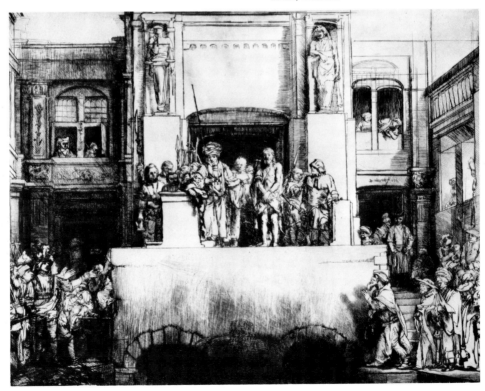

the subject, even misleading. The image of Aristotle (not in antique costume) is that of a melancholy man in a contemplative state—but the bust is not the focus. Aristotle is not really looking at it, but staring at his own thoughts, as it were. The key lies in the golden chain and the medallion embellished with the profile of Alexander (whose tutor Aristotle had been). The philosopher's left hand, iconographically of less importance than the right, touches the chain, a symbol of the favor of kings. Thus, the theme of the painting has been interpreted as the contemplation of alternate values, the more lasting ones symbolized by the bust of Homer and the more transitory ones by the chain. Rembrandt's glowing dialogue of light and darkness is a fitting ambience for the thoughtful man who contemplates the moral choices that confront mankind. The image conjures three major figures from the Greek past—one more reminder of the tenacious grip the antique world held on Western imagination, of the heroic amplification time gave these personages from the past, and of the adaptability that distance lent their images. But one should also remember that the classical ingredients are only the shadows against which Rembrandt plays out the substance of his message.

In the same century that witnessed the careers of Rubens, Poussin, and Rembrandt, the Italian sculptor Gianlorenzo Bernini brought his comprehensive talents to bear on the continuity of the classical tradition. In both his sculpture and his architecture, a classical vocabulary was transcribed into new variations, often expanded dramatically but still controlled. Bernini's *Apollo and Daphne* (fig. 316) presents a popular antique theme, dramatically rendered in an image that incorporates idealized antique forms with extreme naturalism. Apollo's love for the nymph Daphne and his relentless pursuit of her caused her to be changed, in answer to her pleas for deliverance, into a bay tree just at the moment the god touched her. Bernini's tour de force has no precedent in earlier sculpture. The subject is such that it falls more naturally in the province of the painter, and possibly it was from such sources that the sculptor derived his inspiration. The covert subject behind the myth is the very process of metamorphosis itself, which Botticelli so gracefully depicted in

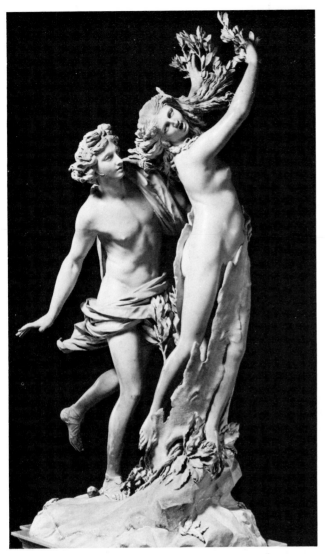

316. GIANLORENZO BERNINI. Apollo and Daphne. *ca.
1622–24. Marble. Height without base ca. 95 2/3″. Borghese Gal-
lery, Rome (Alinari-Art Reference Bureau)*

the transmutation of Chloris to Flora in the *Primavera* (see
fig. 278, p. 384, and pp. 384–85). One recognizes, readily
enough, the features of the *Apollo Belvedere* (see fig. 87, p.
121) in Bernini's god and the echoes of Nereids and maenads
in the nymph. The sculptural techniques, it has been ob-
served, are close to those of Imperial Rome—the drilling

technique in the hair and the high polish of the flesh. But it is the process of transformation itself that fascinates the viewer and brings him into empathic relationship with the image: the light, upward sweep of Daphne's form as the abrasive surface of the tree's bark begins to envelop her; the nymph's flowing hair and outstretched hands already becoming leafy delicacies, her toes reaching down into roots; and the respective expressions of the two figures at the climax, surprise and mingled ecstasy and terror. That Bernini could achieve such convincing naturalism in the face of the dual obstacles of marble forced beyond its natural limits and of a drama so utterly fantastic is a mark of his consummate skill. Here he has gone well beyond the classical tradition in giving expression to one of its myths.

In 1665 Bernini was called to France by Louis XIV's minister, Colbert, to design a facade for the east front of the palace of the Louvre that would befit the royal style of the French king and express the idea of the absolute monarchy he embodied. Bernini's designs were rejected, and the project, in grand bureaucratic manner, was turned over to a committee of three. The result (fig. 317), largely the vision of one of them, Claude Perrault (1613–88), not an architect but a devotee of ancient architecture, was decidedly Roman in feeling and restrained in comparison with Bernini's exuberant designs. Its formal severity, not without elegance, set the tone for a French classicism that was to be expanded on an overwhelming scale in the design of Louis XIV's palace and grounds at Versailles (fig. 318). Although details and some interiors at Versailles seem to edge toward the lavishness of Italian baroque, the overall plan of the grounds and the expanse of the garden facade impose a monotonous geometric tyranny on the environment as strict as Louis's absolutism. The vocabulary of this extensive complex is full of classicisms, from architectural details to statuary. Versailles and its significance for the monarchy indicated the degree to which classicism and strict control over art marked seventeenth-century France. The Académie Royale de Peinture et de Sculpture had been founded in 1648 and by the 1660s, when Louis XIV was ruling in his own right, its curriculum was rigidly prescribed, reflecting the classicism

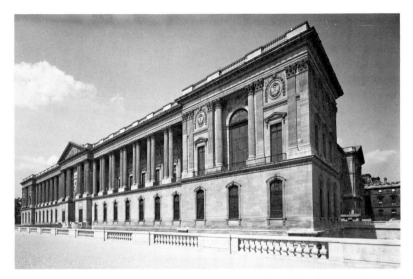

317. CLAUDE PERRAULT. The Louvre, *east facade. 1661–78. Paris (Garanger-Giraudon)*

318. Palace of Versailles. *1669–85. French Government Tourist Office*

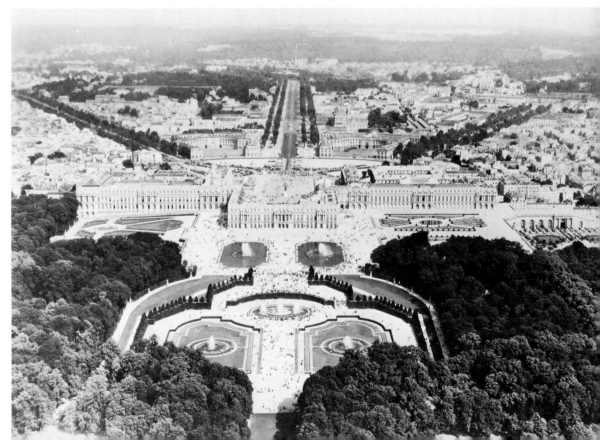

of Poussin's art, frozen into doctrine, and deferring to the authority of ancient art and the Renaissance classicism of Raphael. Predictably, before long there were signals of artistic discontent and the first French Revolution was really not the political one but a revolt in the arts. It did not, however, take leave of the classical tradition entirely; instead, it was centered on a dispute over the relative merits of drawing and color under the rubrics of "Poussinistes" (the conservative element, in disregard of Poussin's very real merits as a colorist, maintaining that drawing, presumed to be more intellectual, was superior to color) and "Rubénistes" (the rebel element, appropriately choosing Rubens as their inspiration, arguing that color was superior, being more true to nature and having wider appeal—the last a sentiment of dangerous implications).

After the death of Louis XIV in 1715, the Rubénistes

319. ANTOINE WATTEAU. Pilgrimage to Cythera. *1717. Oil on canvas. 51″ × 76½″. The Louvre, Paris (Alinari-Art Reference Bureau)*

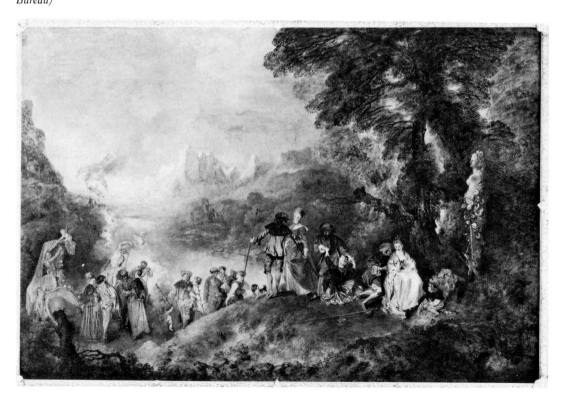

emerged the victors and the rococo art that followed soon after was not only addicted to charming color, but also often lighthearted and playfully erotic, as if in reaction to the restrictive atmosphere of the court of Louis XIV. But not all rococo art was merely playful. Horace's phrase *"ut pictura poesis"* could find no realization more apt than in the lyrical paintings of Antoine Watteau (1684–1721). His *fêtes galantes*—scenes of subdued merrymaking in lovely parks softly and warmly lit—are distillations of visual poetry. The creatures who people them appear too delicate for life in a world itself too fragile to be real, like the dream of a golden age gathered for a fleeting moment into an image as ephemeral as mist. In his *Pilgrimage to Cythera* (fig. 319), pairs of lovers languorously take leave of the enchanted garden where they have been paying homage to the goddess of love. The Ionian island of Cythera (or Kythera) was in ancient times the center of the cult of Aphrodite, the Greek goddess of love; but the lovers in Watteau's painting are clearly of another age. The statue of the goddess of love and the melancholy departure serve as reminders of both the timelessness of their homage and the transience of happiness. The classical allusion is only peripheral to the real subject of the painting.

But rococo art drew as consistently upon classical mythology as any of its predecessors, and parallels between French rococo art and certain aspects of Roman painting have been apparent for some time. Ancient theater exerted considerable influence on styles of Pompeiian painting, just as theater played an important role in the work of Watteau, who not only studied with a painter of theater scenes, but also was closely associated with the stage himself, as both his themes and compositions attest. Furthermore, the rococo interest in the exotic—the *chinoiserie* fostered by the China trade (see pp. 505–6)—parallels the Roman fascination with themes of Egypt and the Nile. Both exoticisms have been shown to be equally fanciful. But relationships between rococo art and the art of antiquity can also be quite clear, as in *Diana Leaving the Bath* (fig. 320) by François Boucher (1703–70), where the form of Diana has been linked to a nymph in the Hellenistic group *Invitation to the Dance* (fig.

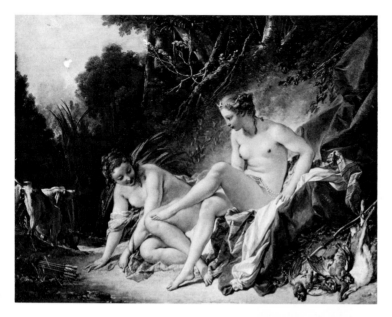

320. FRANÇOIS BOU-
CHER. Diana Leaving the
Bath. *1742. Oil on canvas. 22"*
*× 28 ¾". The Louvre, Paris
(Alinari-Art Reference Bu-
reau)*

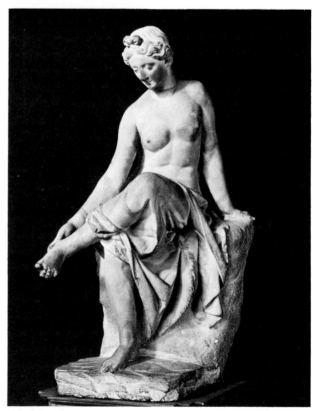

321. Nymph, *from* Invitation to the Dance.
*Hellenistic. Uffizi Gallery, Florence (Alinari-
Art Reference Bureau)*

321), of which there are many Roman copies; and in the small terra-cotta *The Intoxication of Wine* (fig. 322) by Claude (Michel) Clodion (1738–1814), reflective of Hellenistic and Roman eroticisms.

The hedonistic prettiness of rococo art was not the only current in eighteenth-century European art to retain close ties with the ongoing classical tradition. The forces that would fashion a new classical style—neoclassicism—were in the making, a style that would become as closely identified with the political revolutions toward the end of the century as the rococo was with the French court and its circle of aristocracy. By the middle of the eighteenth century, the excavations begun a few decades earlier at the Roman sites of Pompeii and Herculaneum, buried since A.D. 79 in volcanic ash from Mount Vesuvius, were drawing new waves

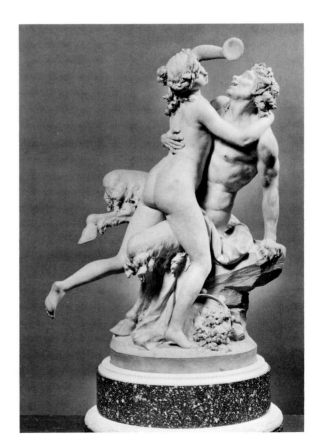

322. CLAUDE (MICHEL) CLODION. The Intoxication of Wine. *ca. 1775. Terracotta. Height 23 ¼". The Metropolitan Museum of Art, New York (Bequest of Benjamin Altman, 1913)*

of attention toward the antique world. Moreover, throughout the century, antiquarian pursuits had led Europeans into the old Greek heartland, then in Turkish hands, in search of ancient marbles. Greek originals now began to enter European collections in numbers; and the classical tradition, nurtured heretofore by collections in Italy, largely Roman or Roman copies of Greek originals, Roman ruins, and the rational classicism of the Renaissance, had new sources of inspiration. In 1762 James Stuart and Nicholas Revett published the first of their five volumes of *The Antiquities of Athens* with engraved plates and measured drawings of Greek architecture, the results of their travels in Greece between 1751 and 1753. In 1755 Johann Winckelmann published a pamphlet, "Thoughts on the Imitation of Greek Works in Painting and Sculpture," and in 1764 *The History of Ancient Art*, the first time the art of the ancient world —even including brief accounts of Egyptian and Persian art —had been systematically surveyed. Knowledge of the ancient past was significantly extended by all this activity.

The antiquarian and archaeological interests of the eighteenth century also fostered a new genre in art: paintings that brought together an imaginary exhibition of ancient art, as in the works of Giovanni Paolo Panini (1691–1765). Some of these were fanciful relocations of Roman ruins with renowned ancient sculpture scattered among them, while other paintings by Panini depicted collections of works in galleries where they were being viewed by connoisseurs. In the latter case, pictures on the walls might be views of ancient (and sometimes more recent) Roman architecture. The French artist Hubert Robert (1733–1808) followed Panini's example in some of his works, but in a lighter, less pedantic vein, as in the fanciful paintings that relocate well-known monuments of ancient architecture. The example here (fig. 323) places the Roman Pantheon above a waterfront landing, with a corner of the Palazzo dei Conservatori at the far left. But "souvenir" images of the Roman scene received their most extensive treatment and widest distribution in prints. Giovanni Battista Piranesi (1720–78), an Italian etcher, architect, and dealer in antiques, published during his lifetime an impressive series of plates on ancient,

323. HUBERT ROBERT. Le Port de Ripetta à Rome. *1766.*
Oil on canvas. ca. 46 9/10" × 50". École des Beaux-Arts, Paris

Renaissance, and baroque Rome. Widely circulated (editions numbered in the thousands), they deliberately enhanced the grandeur of the Eternal City while circulating knowledge (not always archaeologically accurate) of the ancient monuments and exerting considerable influence upon the development of the neoclassical movement. Among his numerous publications were the four volumes of *Le antichità romane* (1756) and *Della magnificenza ed architettura de' Romani* (1761), the preface of the latter countering Winckelmann's praise of Greek art as being superior to Roman.

Piranesi's etchings habitually include picturesque details of setting and figures that often lend his work a romantic flavor (fig. 324). But this romantic tinge within the classical tradition is yet another instance of the poetic current in classicism (see pp. 357, 367–68) indicative of that flexibility with which the love for antiquity frequently accommodated the dominant temper of a later era. In his early series of the 1740s, *Carceri* ("Prisons"), Piranesi created images of an architecture that never was, massive beyond belief (fig. 325). The more impressive Roman ruins are probably the prototypes for some of these visions, but a remarkable imagina-

324. GIOVANNI BATTISTA PIRA-
NESI. Autre Vue de la Façade du Pronaos,
plate 6 from Differentes Vues . . . de l'An-
cienne Ville de Pesto, *representing the*
"Basilica" at Paestum (ca. 550 B.C.). 1778–
79. Etching. 19 ¼" × 28 ⅛". The Met-
ropolitan Museum of Art, New York (Rogers
Fund, 1941)

325. GIOVANNI BATTISTA PIRANESI. A Lofty
Arch with Vistas onto an Arcade Surmounted by a
Frieze, *plate 4 from* The Prisons. *Mid- to late 1740s.*
Etching. 21 ⅜" × 16 ¼". The Metropolitan Museum of
Art, New York (Harris Brisbane Dick Fund, 1937)

tion has seized upon their bulk and enlarged them into gargantuan chambers of torture. There is an element of romanticism in this, too.

As a recognizable movement, neoclassicism began in Europe around 1760 and was in full swing in the first decades of the nineteenth century. Stimulated by the rash of archaeological explorations in Italy and the publications mentioned earlier and in part a reaction against the playful art of the rococo age, neoclassicism reached back to ancient themes that stressed nobility of spirit and moral strength—virtues that produced a more sober vision of antiquity than the bathing Dianas and preening Venuses of Boucher. Neoclassicism tended to stress a simple clarity of form. Its plainness was appropriate to the moral purpose it frequently assumed in reaction against the aristocratic taste of the rococo spirit and in concord with the somewhat puritanical sentiments of the increasingly influential middle class. What also sets neoclassicism apart from earlier classicizing phases of Western art is its historicism. It is often self-conscious in its pretenses to archaeological accuracy and frequently assumes the posture of illustrating history and mythology. The archaeological discoveries at Pompeii and Herculaneum influenced this aspect of the movement by providing a new kind of authenticity. Although the actual fragments of antique artistry and major architectural monuments from the Greco-Roman era had been around for centuries, once Pompeii and Herculaneum were being uncovered, artists were given a privileged view into entire communities and into the daily life of the ancient Roman that a catastrophe had miraculously preserved. In the eighteenth century, too, knowledge of Greek pottery—both black-figured and red-figured vases— was becoming widespread, and in their varied scenes and refined linear styles, artists were discovering fresh material. The ancient world seemed much closer by virtue of this widening knowledge of its material remains.

At the same time, neoclassicism was not a complete reorientation of the classical tradition; its idealizations were grounded in earlier attitudes. Nature, for example, was not to be neglected, but it was to be a nature purified of its

blemishes, a process, it was believed, best demonstrated by ancient art, as Charles du Fresnoy's seventeenth-century *De arte graphica* proclaimed in these lines, taken from William Mason's eighteenth-century translation:

'Tis Painting's first chief business to explore,
What lovelier forms in Nature's boundless store,
Are best to Art and antient Taste allied,
For antient Taste these forms has best applied. . . .

Content to copy nature line for line,
Our end is lost. Not such the Master's care,
Curious he culls the perfect from the fair;
Judge of his art, thro' beauty's realm he flies,
Selects, combines, improves, diversifies,
With nimble step pursues the fleeting throng,
And clasps each Venus as she glides along.

Du Fresnoy's Latin poem had begun with the words *"Ut pictura poesis . . . ,"* and neoclassicism's archaeological bias did not completely obliterate the old dictum, although at times neoclassical evocations of the antique world seem closer to prose than to poetry.

Concurrently with these developments, eighteenth-century notions of progress in human society and of the perfectibility of mankind were influenced by the example of ancient art held up as an image of perfection—not a new role for it, as we have seen. In ancient art and in other respected accomplishments of the golden age of antiquity—literary and philosophical—the eighteenth-century intellect could find historical reassurance to support its philosophical optimism. In such a climate began the rise of a democratic revolt against the old aristocratic order; and the reformatory spirit of the age, fostered by English political and economic theories and the works of the eighteenth-century French philosophes—Voltaire, Diderot, Montesquieu, among others—went hand in hand with reexaminations of human society. It was a new look forward, but the art that was to serve it most was another manifestation of the classical tradition. By looking back to the example of the Greco-Roman past, this new spirit found there the precise mixture of idealism, humanity, simplicity, and dignity that suited its didactic

purposes. Neoclassicism was to become, temporarily and in part, a vehicle of revolutionary ideas.

But as always, the classical tradition proved to be receptive to a variety of content. The French artist Joseph-Marie Vien (1716–1809) exhibited in the Paris salon of 1763 *The Selling of Cupids* (fig. 326), a work derived from a Roman painting uncovered near Naples. The severe lines of the composition, the clarity, the simple statuesqueness of the figures, are distinctly neoclassical features; but the playfully erotic subject matter is still in the spirit of the rococo, however much it owes to its Roman prototype. The bawdy

326. JOSEPH-MARIE VIEN. The Selling of Cupids. *ca. 1763. Oil on canvas. 37 ⅜" × 46 ½".*
Fontainebleau Chateau (Giraudon)

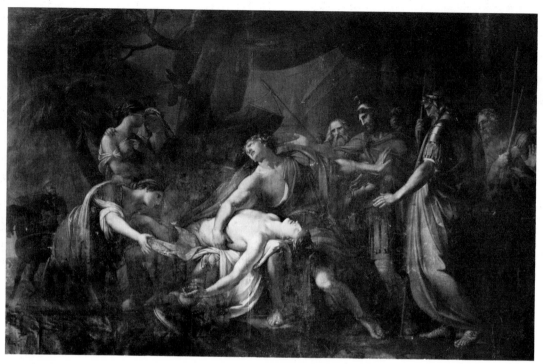

327. GAVIN HAMILTON. Achilles Mourning over Patroclus. *ca. 1765. Oil on canvas. 8'3 ½" × 12'10". Tom Scott—Scottish National Portrait Gallery (Lord Seafield Collection)*

gesture of the little cupid held up for inspection was Vien's addition. Painted at the same time, but in the tone of its subject matter more completely neoclassical, *Achilles Mourning over Patroclus* (fig. 327), by the Scots artist and antiquarian Gavin Hamilton (1723–98), features dramatic lighting and emotionality reminiscent of the baroque age. Hamilton was one of the first neoclassical artists, and engravings of his works, widely circulated, had considerable influence. The German artist Anton Raphael Mengs (1728–79), a major figure in the neoclassical movement, was a friend of his fellow countryman Winckelmann and was affected by the historian's precepts regarding art. His classical compositions, like the *Parnassus* (fig. 328), reveal, however, the weaknesses of his eclectic approach: an

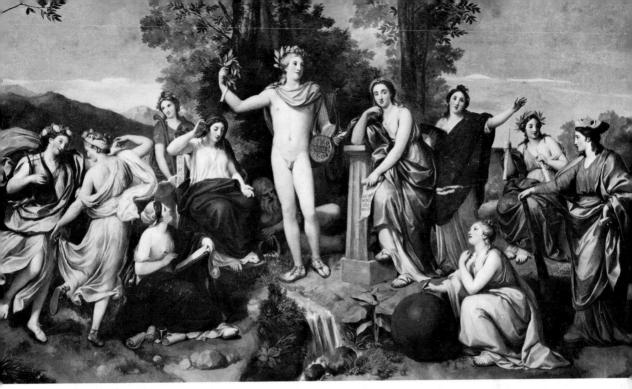

328. **ANTON RAPHAEL MENGS. Parnassus.** *1761. Mural. ca. 9′10″ × 22′4″. Villa Albani, Rome (Anderson-Art Reference Bureau)*

uncoordinated attempt at Raphael's design, the attractions of a Venetian-like setting, and figures that studiously evoke antique form but are rendered as separate sculpturesque entities.

The artist generally regarded as the supreme neoclassical master was Vien's erstwhile pupil Jacques Louis David, whose *Oath of the Horatii* (fig. 329) seems to epitomize the major aspects of the movement. Rendered with "noble simplicity," this image of an oath taking that placed duty to the state above family ties and personal sentiments was the ideal embodiment of Roman virtue. The compositional structure supports well the determined stoicism pervading the picture's didactic message. The lean, unembellished theater of action and the distinct separation of the grieving women from the aggressive men lends the grandeur of isolation to the oath, which David has shaped as an architect might fashion a truss—stability achieved through a balancing of

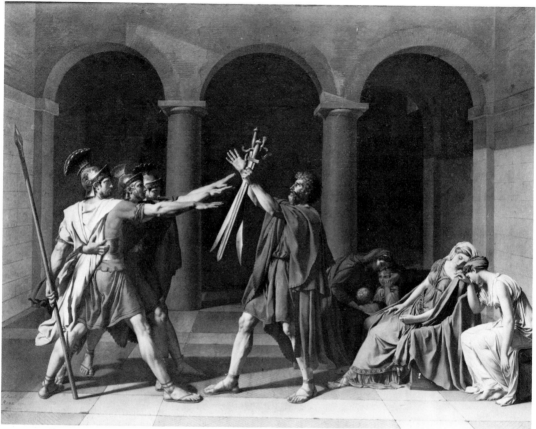

329. JACQUES LOUIS DAVID. Oath of the Horatii. *1784. Oil on canvas. ca. 11′ × 14′. The Louvre, Paris* (Alinari-Art Reference Bureau)

dynamic thrusts. It is quietly echoed in the subdued arch system of the courtyard setting. The figures of the men, boldly lit in a Caravaggesque manner, stand out with startling reality despite the idealizations their forms involve. Indeed it is this mixture of reality and idealism that gives the images their peculiar force. The ideality provides the necessary psychic distance to support the rhetoric of their gestures, and the tangibility of their figures makes them immediate. It was in their potentiality as expressions of nationalism and patriotic dedication that works like this

recommended David as the artist of the Revolution when it came a few years later and made relatively easy his later transfer of loyalty to Bonaparte as the symbol of a new France.

Although the Italian neoclassicist Antonio Canova (1757–1822) also served the circle of Bonaparte on occasion, he was without David's political orientation. Canova's world seems ivory towered and charming compared with David's, another reminder of the variety of approaches accommodated within the neoclassical movement. Canova's marbles are exemplary of the thorough craftsmanship of Italian stonework as well as of his avid absorption of antique idioms. His *Perseus with the Head of Medusa* (fig. 330), based on the *Apollo Belvedere* (see fig. 87, p. 121) and the Rondanini *Medusa* (second half of the fifth century B.C., Glyptothek, Munich), exemplifies his commitment to recapturing the forms of classical antiquity; it reminds us how inspiration from the art of the past can lead to the border line of mere imitation. Sometimes Canova's sculptures reveal a literalness often found in neoclassical art, as in his statue of Napoleon's sister, *Pauline Borghese as Venus* (fig. 331). Canova cleverly registered the impression of the lady's weight on the

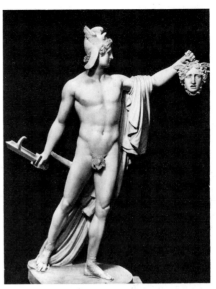

330. ANTONIO CANOVA. **Perseus with the Head of Medusa.** *1800. Marble. 94 ½″ × 64 1/16″ × 38 3/16″. The Vatican Museums, Rome (Alinari-Art Reference Bureau)*

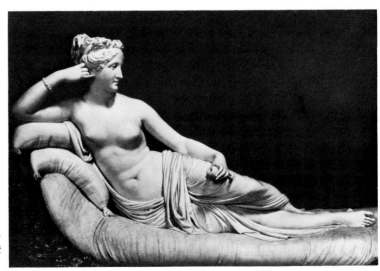

331. ANTONIO CANOVA. **Pauline Borghese as Venus.** *1808. Marble. 70″ × 81″. Borghese Gallery, Rome (Alinari-Art Reference Bureau)*

upholstered couch, which is itself rendered so literally that the idealized figure becomes oddly real.

Within the neoclassical tradition, pronounced emulation of antique art is most apparent among the sculptors, like Canova; or the Dane Bertel Thorvaldsen (1770–1844), who restored the late Archaic pedimental sculpture from the Temple of Aphaia at Aegina; or the Englishman John Flaxman (1755–1826), who was associated with the ceramist Josiah Wedgwood (1730–95), for whom he designed friezes, medallions, and cameos. Flaxman's engraved designs for illustrations to the Homeric epics (fig. 332), published in 1793, while owing something to antique reliefs and sculpture, are more striking for their obvious relationship to the linearity of the images in Greek vase painting. These designs by Flaxman combine large, simple forms with delicate detail rendered in a pure line that fluctuates slightly in strength to produce selective accents along the contours. The cool formalism of Flaxman's illustrations has one quality that bears special mention: the carefully designed intervals between shapes. The artist seems as much concerned about the shapes of the spaces between as with the shapes of the figures or objects represented. Since the immaculate wire-thin line of Flaxman's designs is rather abstract in character and emphasizes the plane of the picture's surface rather than depth, his works have sometimes been cited as prefigurations of modern art. This forces too heavy a burden on Flaxman's images; they are, after all, not far removed from the kind of pure line engraving that was commonly used to reproduce, in almost diagrammatic fashion, paintings and sculptures in outline form for printed books. More important to consider, with respect to Flaxman's reduction of images to pure linear configurations, is the influence he exerted on his friend William Blake (see fig. 453, p. 594), who engraved some of his illustrations, and upon the linear style of Ingres (see figs. 333 and 335, pp. 444 and 446). Whatever relationship he bears to later developments is best regarded through such intermediaries as these. The very qualities that have impelled some to place him in the context of developments that were to lead away from Renaissance perspective can also be explained within the context

of Greek vase painting (see figs. 88 and 399, pp. 122 and
524). On black-figured vases (see fig. 2, p. 2), the strong
silhouettes of figural representations and the concomitant
refinement of their outlines place considerable emphasis on
the spaces between the silhouetted forms. These spaces,
acted upon by the figural outlines, become positive shapes
in their own right. The same is true of red-figured vases, on
which the black backgrounds simply reverse the earlier
black-figured relationship between figural representations
and the spaces around them. In transcribing this lesson to his
linear designs, Flaxman created an equivalent relationship.

This reduction of antique-inspired imagery to purely linear
configurations was one of the effects of attempts on the part
of some neoclassical artists to return with self-conscious,
archaizing purpose to the older classical sources, bypassing

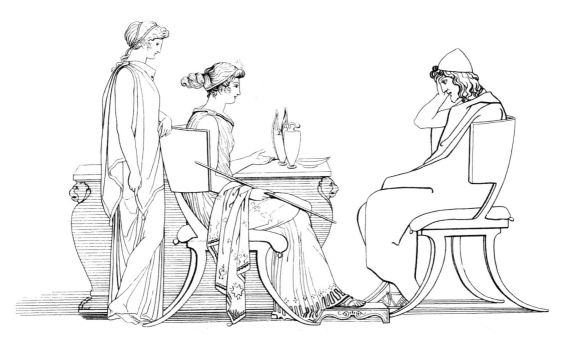

332. JOHN FLAXMAN. Ulysses at the Table of Circe. *Drawing by John Flaxman, engraved by Parker and Blake, from The Heritage Club edition of* The Odyssey. *Reproduced by permission of The Heritage Club, Avon, Connecticut*

the more familiar antique models. Greek vases as well as Archaic and early classical reliefs were the chief antique prototypes for their image making. It is unfortunate that we know so little about the actual work of the *Primitifs*, a group of rebel students of Jacques Louis David, led by Maurice Quaï (ca. 1779–1804), an artist who seems to have extended the Flaxman (or Greek vase) linearity to large canvases. It has been suggested that Ingres, in some of his more thoroughly linear conceptions like *Venus Wounded by Diomedes* (fig. 333), may reflect the style of the *Primitifs* with whom he must have been acquainted as a student of David.

333. JEAN AUGUSTE DOMINIQUE INGRES. Venus Wounded by Diomedes. *ca. 1803. Oil on canvas. ca. 10¼″ × 12½″. Collection of Robert von Hirsch, Basel*

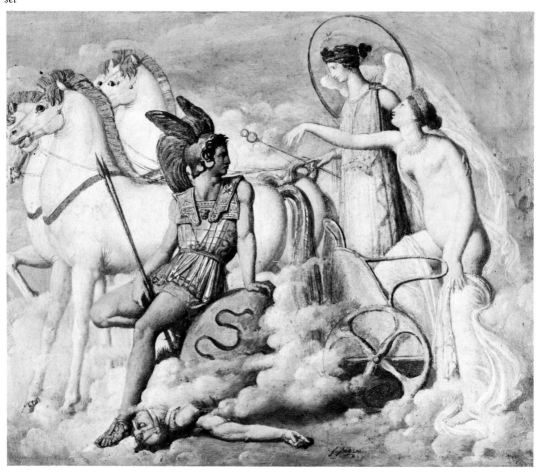

Jean Auguste Dominique Ingres was studying with David at the beginning of the nineteenth century and carried the precepts of classicism well into the new century, but not without some significant transformations. The close study of nature that pervades his art, as well as the exotic elements, reminds us that he was not insulated from other currents that were running strong in the first half of the nineteenth century. Quotations from ancient art abound in Ingres's work, quotations often mixed as to period within the same work or derived from intermediate sources like Flaxman, Raphael, or archaeological publications. He derived the pose of *The Bather of Valpinçon* (fig. 334) from a familiar Nereid

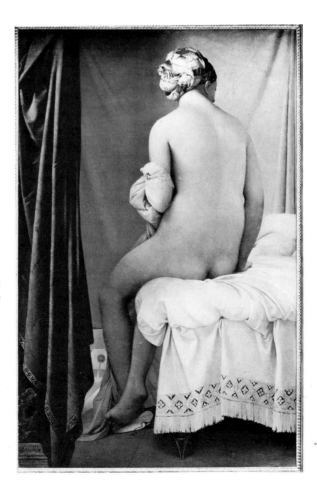

334. JEAN AUGUSTE DOMINIQUE IN-GRES. **The Bather of Valpinçon.** *1808. Oil on canvas. 56⅝″ × 38¼″. The Louvre, Paris (Alinari-Art Reference Bureau)*

image that has a long history of survival within the classical tradition, but the surface realism of her nude form and of the drapery is clearly studied from life. The refinement of the outlines of her body have a classical purity; but the presence of the turban, the slipper by her foot, and the peek-a-boo glimpse of a pool suggest the Near Eastern exoticism that was to be a recurring element in his art and one that dramatizes the degree to which he shared interests with the romantic movement. At once classical, realistic, and exotic, she is the precursor of the more overtly exotic *Odalisque* (harem slave girl) of 1814 (fig. 335). In *The Bather of Valpinçon* there are overtones, too, of Raphael (see fig. 284, p. 393), an artist whom Ingres especially revered.

Ingres's classicism must be viewed from two perspectives, the first of these being his theoretical position that perpetuated attitudes quite close to those expressed in such seventeenth-century treatises as du Fresnoy's *De arte graphica* and which Ingres's personal prestige upheld long

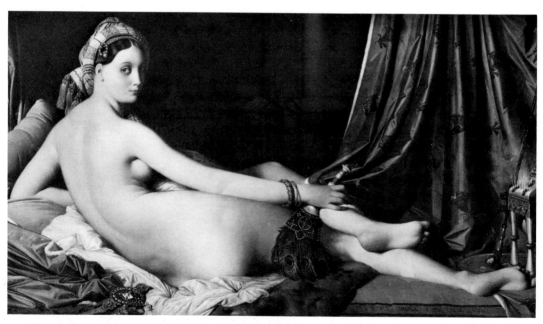

335. JEAN AUGUSTE DOMINIQUE INGRES. Odalisque. *1814. Oil on canvas. 35 ¼″ × 63 ¼″.*
The Louvre, Paris (Alinari-Art Reference Bureau)

after other positions had attracted younger artists away from classicism. The second is the essential linearity of his art, the emphasis he placed on refined, elegant contours derived, in part, from his admiration for the idealizations of antique art and the classical style of the Renaissance.

The mixture of classical and exotic elements that one finds in Ingres's odalisques is not without some logic. During the first two decades of the nineteenth century, Greece was in Turkish hands, and by 1821 the Greeks were in open rebellion, seeking their independence, which they finally achieved at the end of the 1820s. A slave girl, evoking by her nudity images of Greek goddesses, in the exotic setting of an Eastern harem, would be in keeping with European sentiments that had long considered the Muslim world an antagonist. It is precisely this situation that is evoked in *The Greek Slave* (fig. 336) of the American sculptor Hiram Powers (1805–73). A crucifix hangs near her right hand. Her form is derived from ancient Aphrodites, but she is a Christian slave of the Turks. The message carried by the statue to its nineteenth-century viewers was of the recent Greek struggle for independence—and the idea of freedom itself.

By the middle of the nineteenth century, the classical tradition had lost the consistent appeal it had held for artists since the Renaissance. Traces of it could be found in official art (even well into the twentieth century) particularly in public architecture and its decoration, but as a vital continuity it had begun to break up. Realism, photography, impressionism, and the drift toward abstraction in art established imagery that held little room for the ingredients of the old classical tradition. Nevertheless, in individual cases—an artist here and there or a series of works—the echoes of the old continuity could still be found.

Pierre Puvis de Chavannes (1824–98) moves like a pale shade of classicism through the chromatic impressionist and postimpressionist scene of the later nineteenth century. In him the Horatian *"ut pictura poesis"* found its last consistently classical adherent of sufficient stature to win the respect of important artists. Paul Gauguin, especially, found

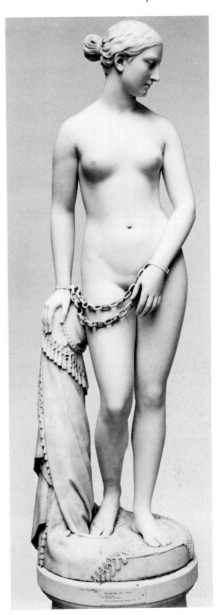

336. HIRAM POWERS. The Greek Slave. *1846. Marble. 65″ × 19½″. In the W. W. Corcoran Collection of the Corcoran Gallery of Art, Washington, D.C.*

his work a source of inspiration, and Gauguin's masterpiece *D'où Venons-nous? Que Sommes-nous? Où Allons-nous?* (colorplate 16) owes a great deal to the serene, panoramic compositions of Puvis de Chavannes. In *The Sacred Grove* (fig. 337), pale, classicized figures are assembled like marble statuary in a dream garden. The flat, planar arrangement of the landscape setting, for all its explicit detail of flowers, foliage, and reflections in still pools, is as decorative as a tapestry wall—and quite as unreal. It is an image of a golden age recollected with a quiet resignation to the knowledge that the dream is dead. Its gentle, nostalgic tone recalls Poussin's Arcadian tranquillities but is quite unlike the seventeenth-century master in its basic structure, being flat, tapestrylike, and not an architectonic composition (cf. fig. 314, p. 422).

Of the impressionists only Pierre Auguste Renoir (1841–1919) seems to have been especially attracted to the old wellsprings of classicism, but it was never an attraction purely classical in character. In his early *Diana* (fig. 338) only the subject has any claim to the classical tradition. The goddess assumes an academic studio pose and the execution is realistic after the manner of Courbet, whose work also inspired the image of the fallen deer, a decidedly unclassical

337. PIERRE PUVIS DE CHA-VANNES. **The Sacred Grove.** *1884. Oil on canvas. 35 ½" × 82". Courtesy of the Art Institute of Chicago (Potter Palmer Collection)*

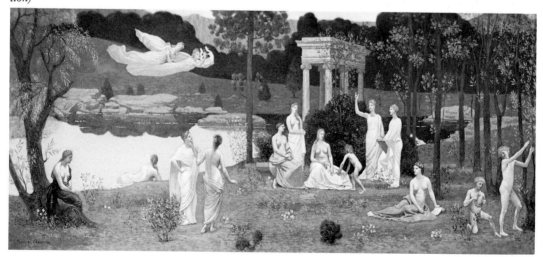

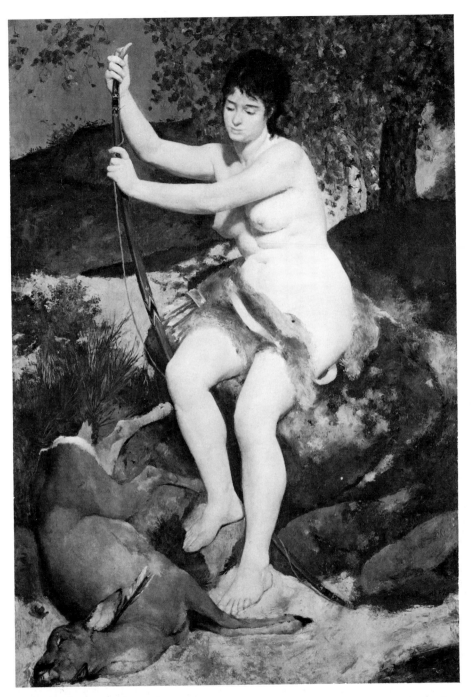

338. PIERRE AUGUSTE RENOIR. Diana. *1867. Oil on canvas. 77″ × 51 ¼″. National Gallery of Art, Washington, D.C. (Chester Dale Collection, 1962)*

form. Since the painting was submitted to the Paris salon of 1867, Renoir may have felt that the subject would help its chances of acceptance. (It did not.)

Despite the privations he suffered in his struggle for recognition, the major theme of Renoir's work soon became the good life and a happy world directly, spontaneously, and hedonistically observed. It is therefore no mere coincidence that his most "classical" works should have a genuine kinship with both the fleshy exuberance of Rubens and the playful indulgences of Boucher (see fig. 320, p. 430) and Jean Honoré Fragonard (1732–1806) (fig. 339). In 1881–82, on a tour abroad, Renoir fell briefly under the spell of the

339. JEAN HONORÉ FRAGONARD.
Bathers. *ca. 1765. Oil on canvas. 25 ¼" × 31 ½". The Louvre, Paris (Alinari-Art Reference Bureau)*

340. **PIERRE AUGUSTE RENOIR.** The **Bathers.** *1887. Oil on canvas. 46⅜″ × 67¼″. Philadelphia Museum of Art (The Mr. and Mrs. Carroll S. Tyson Collection)*

Italian Renaissance (particularly Raphael) and Pompeiian wall painting, and for a time his figures acquired a new sculpturesque solidity, his line a classical firmness. In a major canvas, *The Bathers* (fig. 340), painted a few years after his return to Paris, his figures have a hard-edged, relieflike form that departs sharply from the loose, chromatic richness of his *Luncheon of the Boating Party* (colorplate 12), a work that can be considered the brilliant finishing piece of the period before his trip abroad. The immediate prototype for *The Bathers* was a seventeenth-century relief by François Girardon (1628–1715), a sculptor whose style reflects both his study of Hellenistic art and the French mannerists. Although this phase of Renoir's work has generally been regarded somewhat less than enthusiastically by his critics, it was an extremely important one for him personally. Renoir's style of these years came to fruition later on in the early

341. PIERRE AUGUSTE RENOIR. The Judgment of Paris. *ca. 1914. Oil on canvas. 38″ × 46″. Collection of Henry P. McIlhenny, Philadelphia*

twentieth century, when he returned to classical themes like *The Judgment of Paris* (fig. 341). While not classical in style, such works as this and the nudes Renoir drew and painted from the late 1880s on are modeled in a sculptural manner; but it is a diffractive modeling that owes its surface quality to the experience of impressionism just as its sculptural core owes its strength to Renoir's "classical" interlude. The late sculptures (fig. 342), the modeling of which he only supervised (his hands had been for some time badly crippled by

**342. PIERRE AUGUSTE RENOIR. Small
Venus Victorious,** *with base showing* **The Judg-
ment of Paris.** *1913, base 1915. Bronze. Figure
23 ¾" × 12 ¼" × 7 ¾"; base 9 ½" × 9" ×
9 ½". The Hirshhorn Museum and Sculpture
Garden, Smithsonian Institution, Washington,
D.C.*

343. AUGUSTE RODIN. Danaid. *1885.
Marble. 13 ¾″ × 28 1/3″ × 22 ½″. Rodin
Museum, Paris*

arthritis), recall antique Venuses; but their surfaces are im-
pressionistically rendered.

Although he was not a classicist, Auguste Rodin thoroughly
understood the inner qualities of Greek sculpture that gave
life and heroic presence to the human form, and his subjects,
so often drawn from mythology, reveal a genuine sympathy
for the classical tradition (fig. 343). The soft, diffusive mod-
eling of flesh in his marbles recalls the Praxitelean style,
however different his melting forms may be from any dis-

tinct classical prototypes. Both Renoir and Rodin must be considered in relation to the classical tradition as artists who reconstituted the classical spirit in the matrix of an essentially nonclassical form. For them, as for the ancient Greeks, the human form, strong or sensuous, was the ultimate receptacle for gathering the vitality of life. In his published conversations Rodin rejected the idea advanced by the academies of art that Greek sculpture was essentially an intellectual ideal. For him the sculpture of the Greeks "passionately testified to their worship of the flesh."

Aristide Maillol (1861–1944) saw Greek sculpture differently and preferred the severe forms of early classical sculpture to the more sensuous art of the Parthenon era and later. *The Mediterranean* (fig. 344), therefore, is descended from

344. ARISTIDE MAILLOL. The Mediterranean. *1902–5. Bronze. Height 41″, at base 45″ × 29¾″. Collection, The Museum of Modern Art, New York (Gift of Stephen C. Clark)*

the kneeling figures from the pediments of the Temple of Zeus at Olympia, but the schematic simplifications of the figure, its frank geometry, reveal how close he was to the consciousness of abstract configurations that others were to develop more dramatically during the next few decades.

The reclining figures (fig. 345) of Henry Moore (b. 1898) have been compared to figures that were similarly posed in Greek sculpture; but the English sculptor's mountainous images seem to have been eroded out of living rock by wind, sand, and rain rather than shaped by tools in the hands of the artist. They have the appearance of archetypal images that lie beyond the normal dimensions of time and space. They transcend the simplifications of Maillol and present an organic structure that is so elemental, so fundamentally definitive of the reciprocal relationship of solid mass to space, that one's imagination could easily see them as primeval

345. HENRY MOORE. Recumbent Figure. *1938. Stone. 35″ × 52 ¼″ × 29″. The Tate Gallery, London*

sources for the human image in all sculpture. While not classical in any traditional sense, they are not outright negations of the classical tradition. They are virile, modern affirmations of the organic structural principles that also underlay the Greek sculptor's intuitions of the architecture of the human form. In this sense they celebrate different principles than the ones exemplified by Renoir and Rodin. To relate Moore to the classical tradition by noting only the superficial resemblance of his reclining figures to antique river gods or to recumbent figures in Greek pedimental sculpture would be to miss the significance of the relationship that does exist between Moore's work and the sculpture of the Greeks. The figural sculpture of Henry Moore lies almost beyond the reaches of the classical tradition proper, sharing its anthropomorphism but at a heroic, archetypal level. His figural art seems to belong to the earth as primordial prototypes of a new race.

At this juncture in the history of Western art, the relationship of the classical tradition to modern art becomes acutely problematic. The proportion, order, and balance so important to the classical tradition have been repeatedly claimed for the geometrically oriented styles of modern abstract art, but it can be seriously questioned whether applying the term "classical" to such art is not stretching the terminology beyond its capacity to be truly meaningful. Abstract art—particularly if it "abstracts" from the human form—may hold some residue of classicism; purely nonobjective art, probably never. To sever completely principles of proportion, order, and balance from the anthropocentric imagery of the classical tradition is to lose an essential aspect of that tradition.

The evolution of the classical tradition into twentieth-century idioms occurred along divergent lines. Two distinct aspects of the twentieth century—its preoccupation with psychology and the dreamworld and its mounting mechanization—were significant factors in the transformation of the old tradition. Giorgio de Chirico and Fernand Léger are prominent examples of how artistic imagery responded to the forces of a new era.

The continuity of the classical tradition has been so predominantly associated with rationality that one is surprised to encounter it within the irrational and disturbing context that lies on the romantic borderlands of surrealism. But there one does indeed find it—in the paintings of Giorgio de Chirico, born in Greece in 1888 of Italian parents. Thoroughly educated in the classics and surrounded in his youth by tangible reminders of the ancient Greek civilization, it is not unusual that his art should reflect in some way this early exposure. What is unusual is the remarkable form allusions to the classical world assume in his art. The process by which this came about was no orthodox recall of the antique. The catalyst was probably de Chirico's experiences

346. GIORGIO DE CHIRICO. The Soothsayer's Recompense. *1913. Oil on canvas. 58⅜″ × 71″. Philadelphia Museum of Art (The Louise and Walter Arensberg Collection)*

in Munich, where he had been sent to complete his education. Here he discovered the paintings of Arnold Böcklin (1827–1901) and the writings of Nietzsche. Böcklin's haunting romanticism and Nietzsche's descriptions of the spacious, arcaded piazzas of Turin, his acute perception of the significance of the void, of an emptiness that lends magical presence to objects in it, had a profound effect on the young artist. The dimensions of time suspended and of space at once infinite and circumscribed seemed to haunt de Chirico. His paintings of the second decade of the twentieth century clearly reflect this (fig. 346). The spaces lit by unearthly light, inhabited out of normal context by isolated, strange objects, classical statues, or lonely figures, casting shadows as substantial as themselves, are mysterious settings that defy rational definition. Perfectly preserved sites of indeterminate time and place, they seem to await a human population that has left them and may never return. Such settings are not ruins, yet they are remarkably evocative of the dialogue between architectural remains and surrounding space that de Chirico must have sensed atop the Athenian Acropolis or that one can find in the empty streets and squares of Pompeii or in a deserted piazza. De Chirico's imagery is essentially romantic, resonant with a nostalgic love of the classical past, affirmed by the empty arcades and by the statuary that inhabits his enigmatic paintings. That he should later in his career deny these earlier works seems only the natural concomitant of his love for enigma.

The strong formal structure of the work of Fernand Léger (1881–1955) owes something to his attraction to David's neoclassicism. Respect for David, Ingres, and Puvis de Chavannes came naturally to artists like Léger who were inclined toward geometricity in their forms. Léger's classicism was highly personal, but, paradoxically, this intimacy resulted from its subjugation to a depersonalized presentation of the human image. The human form, sometimes remotely classical in facial schema and in pose, retains a generic human identity and a firm sculpturesque presence in Léger's mature art (fig. 347), but it is compressed into a mechanistic mold. His figures, in this phase of his work, are truly modern hybrids—half-humanized, half-mechanized, like monumen-

347. **FERNAND LÉGER. Three Women (Le Grand Déjeuner).** *1921. Oil on canvas. 72 ¼″ × 99″.*
Collection, The Museum of Modern Art, New York (Mrs. Simon Guggenheim Fund)

tal puppets that have evolved as ideal physical adaptations to an environment dominated by the machine. They are heroic in scale and simplicity, bonded to their machinelike existence by lines as unyielding as iron bands and by edges honed like steel. Yet welling up now and then through their mechanistic presence is a persistent sensuousness, an irrepressible suppleness that seems to resist complete detachment from human life. Surely no other artist has so successfully managed to fill the hiatus between organic life and the machine. These figures, to use Léger's own phraseology, are indeed "beautiful machines," and therein lies their fragile connection with the prototypal images of classical antiquity.

The kinship of Léger's new race of classical figures with the

classical images of Picasso is too pronounced to be disregarded; but if Picasso's images are immediate prototypes for Léger, Léger's figures are completely recast from them, translated into purely twentieth-century syncopation. In the years immediately after the First World War, Pablo Picasso turned from cubism to a distinctly classical phase. His paintings of this period are often images of monumental nudes, clubby and massive of body but with features rendered as bold paradigms of classical physiognomy (fig. 348). The calm simplicity of these images suggests a period of regathering energy for this restless artist, and within a short time Picasso was once again extending his cubist idiom, this time into new expressive paintings (see fig. 436, p. 569). In his

348. PABLO PICASSO. The Bather. *1922. Oil on wood panel. 7 ⅜" × 5". Courtesy of the Wadsworth Atheneum, Hartford (Ella Gallup Sumner and Mary Catlin Sumner Collection)*

graphic works, however—lithographs, drypoints, etchings, and linoleum cuts—the classical phase continued in overtly antique themes derived from mythology and in intimate genre and erotic subjects. Satyrs, centaurs, minotaurs, Greek heroes, and gods mingle with nude sculptors and their models. In many of these latter examples, antique statues are being contemplated by sculptors and models, the entire image rendered in a mobile, spontaneous line that recalls the linear elegance of Greek vase painting, as in his etching *Sculptor, Model, and Statue of a Nude Holding Drapery* (fig. 349). His illustrations for an edition of Aristophanes' *Lysistrata*, published in 1934 (fig. 350), are among the liveliest of Picasso's images in this linear, classicizing vein. They remind us, nevertheless, of the extended—and perhaps increasingly artificial—life of the classical tradition that can survive within the occasional and limited function of illustrating classical texts.

349. PABLO PICASSO. Sculptor, Model, and Statue of a Nude Holding Drapery. *1933. Etching. 10½″ × 7⅝″. Collection of Mr. and Mrs. Charles O. Matcham*

350. **PABLO PICASSO. Illustration to Aristophanes' Lysistrata.** *1934. 8¾" × 6". From an etching made by Pablo Picasso for* Lysistrata; *illustration copyright © 1934, 1962 for The Limited Editions Club; reproduced by permission of The Heritage Club, Avon, Connecticut*

It may be that the classical tradition in anything like its former vitality now truly belongs to the past, that it can never again inspire artists, as it once did, to create images that embody in their heroic tone, in their idealized humanity, or in their physical loveliness the spirit of that ancient heritage of beauty and excellence. Perhaps we have worn the tradition thin by overworking selected prototypal images, by identifying the tradition too consistently with traces of Apollos and Aphrodites and old histories and myths. In that context there may be nothing left but nostalgia of the dreamiest kind, an insubstantial sentiment on which to build an art—unless that yearning carries a poignancy born of anguish and desperation or has the disturbing, enigmatic quality of de Chirico's dreamworld. It may be that henceforth the artist, unlike Odysseus, cannot (or will not) find his way back. But to those for whom the imagery of Western art's long history will continue to bear a regenerating and inspiring force, the classical tradition will remain at the very least a reminder of the power of images to renew themselves.

PART

FIVE

_____ EXOTIC IMAGES

10 WESTERN VISION AND THE PRIMITIVE WORLD

The Florentine artist Piero di Cosimo (1462–1521) was, according to contemporary accounts, an eccentric man. He was afraid of fire and lightning, loved animals, disliked to interfere with nature's ways by pruning or picking his fruit trees or pulling the weeds in his garden, was not fond of urban noises, and seems to have thrived on the hard-boiled eggs he prepared by the dozens both for his convenience and for the conservation of the fire. He was, one might say, a natural man. His imagery, also, was in some respects unorthodox. His *Hunting Scene* (fig. 351) of 1490 shows a wild place where men and beasts and composite creatures like the satyr and centaur fight and slay one another and where forest fires break out from natural causes. It is, for all its lovely surfaces, a raw, primitive world in which life is "nasty, brutish, and short." But its meaning is probably not complete in itself, for it apparently belongs to a group of several works by this artist that have as their collective theme the precivilized life, ranging from these primordial struggles to the amenities of a pastoral life, so delightfully presented in *The Discovery of Honey* (fig. 352). As a group these works appear to expound an evolutionary view of human society. Whatever the actual basis for the artist's point of view (perhaps derived from Roman sources and the writings of Italian humanists), he was clearly one for whom the natural world was a keenly felt presence. In the Renaissance, he was one of many artists who were beginning to examine the world with fresh vision—a world that was acquiring new dimensions with the voyages of Columbus, Vasco da Gama, Magellan, and others.

In the last decades of the fifteenth century, when the New

351. PIERO DI COSIMO. A Hunting Scene. *1490. Tempera on oil on wood panel. 27 ¾″ × 66 ¾″.*
The Metropolitan Museum of Art, New York (Gift of Robert Gordon, 1875)

352. PIERO DI COSIMO. The Discovery of Honey. *ca. 1500. Tempera on wood panel. 31 3/16″*
× 50 ⅝″. Worcester Art Museum, Worcester, Massachusetts

World was rediscovered by western Europeans, the Renaissance in European art was well under way. It, too, had been in part a rediscovery. Looking back across the centuries of the Middle Ages, the cultivated and creative men of the Renaissance discerned an antique world they were inclined to view as a golden age. In its apparent affirmation of human values, in its pervasive man-centeredness, this antiquity seemed to address itself directly to the new spirit that had been gathering in Europe for some time. Moreover, in literary arts, the habits of classical style and allusion that were fostered by Italian humanism were significant factors in shaping the conceptual bases of thought and speculation. Thus, at the very moment in history when an unfamiliar world was being explored in the Western Hemisphere, the most influential centers of art in Europe—Italy and the Netherlandish north—were exploring the appearance of their familiar world both empirically and theoretically as they wrought in their different ways a tangible, credible image of man and a means of creating an ample and rational pictorial space. At the same time, in Italy, an underlying tone of idealism provided by the example of antique art was being assimilated into the mainstream of artistic production (see pp. 380–406). During the two centuries after the rediscovery of the New World, while its coasts were being charted, its interiors probed, and, eventually, its coastal areas sparsely and spottily settled, the effects of the Renaissance were transforming the imagery of European art. Initially, however, this seems to have had little effect on images of the New World.

When the Italian poet Giuliano Dati published in 1493 a metrical version of Christopher Columbus's account of his first voyage to the New World as it was communicated to the Spanish sovereigns, it was accompanied by a woodcut illustration (fig. 353) showing the Spanish king gesturing across a symbolic sea no wider than a stream, on the opposite shore of which Columbus in a tiny ship looks on a group of nude, long-haired natives. Two other tiny ships, perhaps the rest of his fleet, lie in "midstream." The woodcut signifies the event, but only as a sign that it took place in the service of the Spanish crown and that the land discovered was a

353. **Illustration Accompanying Columbus's Letter to Sanchez,** *from Giuliano Dati, La lettera dellisole che ha trovato nuovamente il Re di Spagna. 1493. Woodcut. 4 ⅝" × 4 ⅜". Rare Book Division, The New York Public Library (Astor, Lenox and Tilden Foundations)*

primitive region. The style of the woodcut is undistinguished but charming, in the vein of the popular printed illustrations of the time that were supplanting painted illuminations after the development of the printing press and movable type. There is no compulsion here to convey information about the New World in an empirical sense; it might just as well have been an illustration for some fairy tale.

There was indeed a sense of wonder about both the New World and the mysterious East (a passage by sea to the Indies was being sought) accompanied by an expectation of finding marvels beyond belief. About 1519 an account of recent explorations included woodcuts depicting a hoofed elephant with a howdah resembling a castle tower, a griffin carrying off a man, a phoenix, a naked Cyclops with a club, and a family of cannibals (fig. 354). Reports of cannibalism in the New World led to the frequent appearance of such images, but the artist of this woodcut has relied upon European conventions for his representations of the unfamiliar

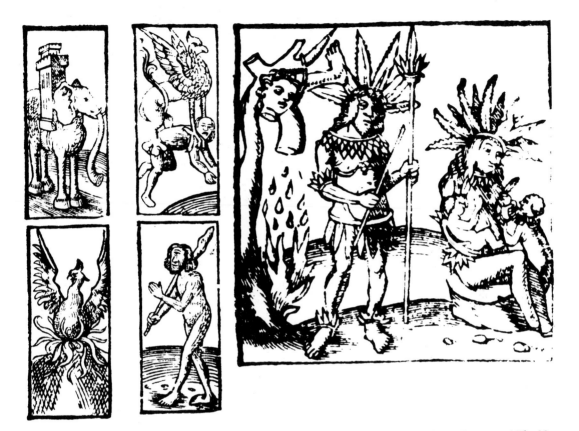

354. Page of Illustrations *from* The New Lands, *by Jon van Doesborgh. 1519. Woodcuts. Courtesy of The New York Public Library (Astor, Lenox and Tilden Foundations)*

Indians: the man is bearded like Europeans, he stands in a vaguely classical pose, and the victim's head roasting above the fire resembles a classical fragment. Details of costume are inventions, probably based on vague descriptions of the inhabitants of the New World.

The gallery of curiosities accompanying the cannibals was not an uncommon thing. Classical and medieval folktales and legends provided European imaginations with a fantastic menagerie of oddities. The centaur, the griffin, the minotaur, and other composite creatures were already familiar images

from the ancient world. Legendary monsters and human
aberrations were often placed in the sculptural decoration of
churches (see fig. 438, p. 575). In the tympanum of the
Romanesque church of Sainte-Madeleine at Vézelay, for
example, a variety of odd beings supposed to inhabit remote
corners of the world represent a field of missionary endeavor
for the Apostles of Christ (see fig. 175, p. 256).

Literature continued to grant such oddities a life. A four-
teenth-century English author, for example, relying on me-
dieval lore and the travels of Marco Polo and others, pub-
lished a widely translated work under the title *The Travels
of Sir John Mandeville*, in which the writer recorded his
fictitious adventures in the Near and Far East. It would
appear that the imaginations of travelers to the New World
were often conditioned by such tales as these in much the
same manner as twentieth-century imaginations have been
stirred by tales of science fiction. Speculations on the possi-
bility of there being in fact monstrous creatures of one sort
or another frequently led to a ready acceptance of rumors
of their existence in regions beyond the civilized world
known to Europeans. In 1595 Sir Walter Raleigh, in search
of the fabled El Dorado, sailed up the Orinoco in South
America and in his account of the adventure was quite
willing to believe the existence of a race of headless men in
the interior of Guiana who would be very like the beings
illustrated (fig. 355; cf. pp. 576–81) in Sebastian Münster's
Cosmographia, published in 1544.

The appeal of the unfamiliar also found its way into popular
entertainment, as evidenced by a woodcut of 1551 (fig. 356),
published to commemorate a pageant (supposedly including
a group of real Brazilian Indians) that was held the previous
year in honor of Henry II of France. A medley of anecdotes
spread out in cartographic fashion, it purported to be a
representation of life among the Brazilian Indians; but it is
hardly more than a fanciful view of a primitive world, evok-
ing in its happier passages an image of life in the Garden of
Eden.

In the seventeenth century references to the earth's ex-

355. **Monsters,** *from Sebastian Münster's* Cosmographia. *1544. Woodcut. 2⅜″ × 3½″. Spencer Collection, The New York Public Library (Astor, Lenox and Tilden Foundations)*

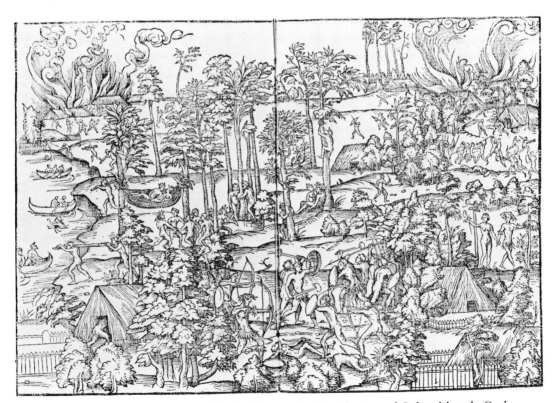

356. **Brazilian Indians,** *illustration from* Entrée à Rouen *by Robert le Hoy and Robert Jehan du Gord. 1551. Woodcut.*

panded geography can be found in allegorical groups representing the four continents (Europe, Asia, Africa, and the Americas). The images representing Africa and the Americas were often generalized figures of Negroes and Indians; the African figures were ethnographically more correct, probably because European artists were more familiar with their appearance. One of the most dramatic examples of this conventional allegory is in the ceiling painting of the church of Sant' Ignacio in Rome (fig. 357), where these four allegorical groups appear in the lower registers of the ceiling decoration. At the apex of the American group is a massive, feathered Amazon, a blending of the classical female warrior with her New World counterpart as she was believed to exist in South America. The allegory of the four continents is appropriate to the main subject of the ceiling—*The Apo-*

357. FRA ANDREA POZZO. America, *detail from* The Apotheosis of St. Ignatius. *1691–94. Fresco. Ceiling of the nave, Sant' Ignacio, Rome (Alinari-Art Reference Bureau)*

358. GIANLORENZO BERNINI AND ASSISTANTS. **Fountain of the Four Rivers.** *1648–51. Travertine and marble. Piazza Navona, Rome (Anderson-Art Reference Bureau)*

theosis of St. Ignatius—considering the worldwide missions of the Jesuits, the religious order founded by St. Ignatius in the 1530s. A variant of this allegory is the subject of the sculpture on the *Fountain of the Four Rivers* (fig. 358), designed by Bernini but executed largely by his assistants, in the Piazza Navona, Rome. Here the continents are evoked by allegorical figures representing the Danube, the Ganges, the Nile, and the Río de la Plata, each accompanied by supposedly appropriate floras and faunas.

By this time other kinds of images, particularly of the inhabitants of the New World and their surroundings, were beginning to appear in European art. These were the first by artists who had actually been to the New World, but, as will be seen, they had their limitations and their visual prejudices. A new problem arises at this point. Before artists

worked on the spot or from memories of new lands they had seen, the images of the primitive world offered to European viewers were either pure fancy or dependent on travelers' descriptions, often unreliable either because of inadequate observation and communication or excessive embellishment, if not downright fabrication. Now a handful of artists of varying capacities (but none of the first rank) were beginning to travel to these new quarters of the earth, and the images they were to create, some of which were to be very influential in shaping European ideas of primitive societies, reveal a curious mingling of empirical vision and conventional habit. These images were disseminated in the form of engravings reflecting the engraver's own style as well as that of the original drawings or paintings from which the engravings were made, thus compounding the problems involving the artists' visual conditioning and technical capacities. What the European viewer was finally served was a well-edited report that frequently contained as much fiction as fact. Although these engravings were intended to inform the curious about the character of this strange new world, they were also designed to appeal to current European tastes, and the changes wrought by the engravers reflected the widespread taste for classical stereotypes fostered since the Renaissance as well as certain mannered formulas in the rendering of the human figure acquired by artists in their training. The most influential—and the most impressive—series of engravings were those issued in the late sixteenth century by a Flemish engraver working in Frankfurt, Théodore de Bry (1528–98), assisted by his son, John Théodore (1561–1623). The originals for these engravings were works by a Frenchman, Jacques le Moyne de Morgues (d. 1588), and an Englishman, John White (fl. 1584–93).

Jacques le Moyne de Morgues was a French artist who went to America in 1564 as a member of René Goulaine de Laudonnière's expedition to establish a French colony in Florida. His duties were to map the coast and harbors and to portray the appearance of the natives and their settlements, their customs, and anything that was peculiar to the region. When Spanish troops destroyed the French settlement in September of the following year, the artist escaped

359. JACQUES LE MOYNE
DE MORGUES. René de
Laudonnière with King
Athore. *ca. 1564. Gouache draw-
ing on parchment. 7″ × 10¼″.
Prints Division, The New York
Public Library (Astor, Lenox
and Tilden Foundations. Be-
quest of James Hazen Hyde)*

360. THÉODORE DE BRY.
René de Laudonnière with
King Athore, *after Jacques le
Moyne de Morgues. 1591. En-
graving. 5⅞″ × 8⅜″. Rare
Book Division, The New York
Public Library (Astor, Lenox
and Tilden Foundations)*

and settled in London. There he spent the next twenty years
working on paintings in watercolor derived, no doubt, from
drawings and notes he had made while in Florida. De Bry
acquired these after the artist's death, and the engravings
made from them were published in Frankfurt in 1591. The
originals disappeared, but in 1901 one of them was discov-
ered in Paris and is now in the New York Public Library (fig.
359). It depicts an Indian chief and de Laudonnière with

some of their followers at a column erected by an earlier French expedition, which the Indians had come to revere. The high-keyed, delicate colors, the fine costume of the French leader, and the pale nudity of the chief with his beads, pendants, and constellations of tattoos give the small painting a character more of pageantry than reporting. Although de Bry's engraving of this scene (fig. 360) is quite faithful in most details, there are minor alterations and the change in medium has rendered the forms somewhat heavier in appearance. These are insignificant differences, however, and the mannerisms of the French artist seem to have been quite acceptable to the engraver. In the engraving that depicts the chief and his queen on a walk (fig. 361), the scene has the spirit of a royal procession. The chief strikes an exaggerated hipshot pose—a barbaric Apollo— and the figure of his queen displays proportions resembling

361. THÉODORE DE BRY. The King and Queen Take a Walk, *after Jacques le Moyne de Morgues. 1591. Engraving. 5 ¾″ × 8 ¼″. Rare Book Division, The New York Public Library (Astor, Lenox and Tilden Foundations)*

·39·

those in mannerist engravings of the period. The same cast, with different paraphernalia, could play the roles of Greeks or Romans.

De Bry's engravings after John White's watercolor drawings reveal more about the alterations that can take place between original and engraved works. White's drawings were either made in Elizabethan Virginia between 1585 and 1587 or developed from sketches and notes made then. At any rate, they are closer than Le Moyne de Morgues's works to their source. White was a less sophisticated artist than Le Moyne de Morgues, and the Indians in his works—with one possible exception—lack the classical overtones of the chief in the Frenchman's watercolor. His work is frankly documentary. He appears to be concerned that his Indians possess distinctive racial features, and his representations of the Indian towns of Pomeiock and Secoton are almost diagrammatic in their descriptive intent, imparting information about the mat-and-bark shelters, the location of fields, and the character of the ceremonial areas (fig. 362).

When we compare de Bry's plates with White's originals in the British Museum, we note immediately the degree to which White's image of the American Indian has undergone a transformation at the hands of the engraver. An examination of one such transformation will serve to emphasize de Bry's editorial presumptions. White's watercolor drawing (fig. 363) of an Indian dance is a crude but animated rendering of aboriginal choreography. The various steps of the dance appear to be indicated with a spontaneous spirit that evokes the full energy of each gesture. The engraving (fig. 364) has frozen these into stiff tableaux that announce their European character so insistently that White's authenticity is submerged in mannered conventions. His rendering of the ceremonial stakes topped by rough, masklike heads has been translated into smoother forms with faces that reflect a European origin; and the three embracing figures in the center of the dance circle have lost the jumbled spontaneity of White's images and have assumed the familiar symmetry of the antique Graces. This same process can be observed throughout the engrav-

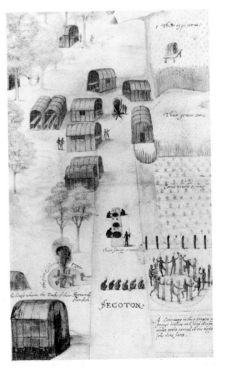

362. JOHN WHITE. The Village of Secoton. *ca. 1585–87. Watercolor drawing. 12 ¾″ × 7 ¾″. By courtesy of the Trustees of The British Museum, London*

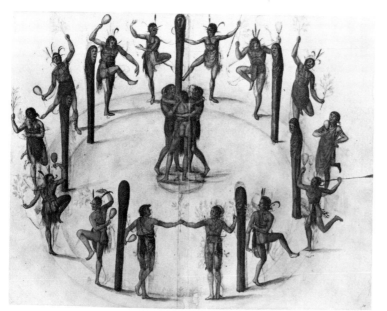

363. JOHN WHITE. A
Religious Dance. *ca. 1585–
87. Watercolor drawing.
10 ¾″ × 14″. By courtesy of
the Trustees of The British
Museum, London*

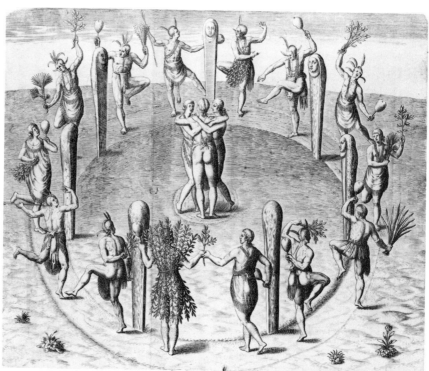

364. THÉODORE DE BRY. A Religious Dance, *after John White. 1590. Engraving.
11 ⅜″ × 14″. By courtesy of the Trustees of The British Museum, London*

ings after White. A modest documentary of the New World has been compromised by the preconceptions of the Old.

The year 1636 was an important date for images of the New World. In that year an ambitious military and scientific expedition led by Prince Maurice of Nassau-Siegen left Holland to establish a Dutch colony around Pernambuco in northeast Brazil. The artists and naturalists who accompanied Prince Maurice produced an impressive body of work that recorded carefully the floras, faunas, native inhabitants, and characteristic landscape there. Among the artists in the entourage were Frans Post (ca. 1612–80) and Albert Eckhout (fl. 1636–64). The Brazilian landscapes by Post and the paintings and drawings of Brazilian Indians and other local types by Eckhout are the products of Dutch realism. Their Brazilian paintings and drawings, some of which were executed in the New World, are the first known works to depict the unique local characteristics of any portion of the New World with anything like thoroughgoing realism, White's efforts notwithstanding. Eckhout's *Tapuya Dance* (fig. 365) places the viewer on the spot, and each dancer emerges from the wild dance as an individual portrait. The resemblance of some of the poses to those in the de Bry engraving after White (see fig. 364, p. 480) may be a coincidence resulting from a similar stamping dance, although the

365. ALBERT ECKHOUT. Tapuya Dance. *ca. 1637–44. Oil. Copenhagen National Museum (Ethnographic Collection)*

possibility of Eckhout having been influenced by the earlier work cannot be ruled out.

Post's *Ox Wagon* (fig. 366) is handled with characteristic Dutch realism. It is a catalog of a portion of the tropical world. In the left foreground is a bank of thick vegetation surmounted by two large trees entwined with parasitic vines and hung with the nests of tropical birds. Beyond the road and the cart and figures who emerge from behind this screen of vegetation, the fields, broken by groves of trees, slope gradually to a river flowing on a gentle diagonal into the deep space at the right. The composition, for all its realistic detail, has the basic structure of the "classical" landscape developed in Italy during the early seventeenth century and may represent Post's concession to convention. It is the compositional scheme he favored for the rest of his life.

366. **FRANS POST. The Ox Wagon.** *1638. Oil on canvas. ca. 24" × 34 2/3". The Louvre, Paris (Giraudon-Art Reference Bureau)*

367. **FRANS POST. Landscape with Procession of Negroes.** *1660s. Panel. ca. 13″ × 18″. Oliveira Lima Library, The Catholic University of America*

Frans Post continued to specialize in Brazilian scenes for the remainder of his career, recording with nostalgic fondness his memories of the region's light and atmosphere, its Portuguese ruins, its plantations, sugar mills, broad vistas, and its people—like tiny afterthoughts of nature—now gathered in little clusters, now flowing like a stream along winding paths in these panoramic views. In his later works done after he returned to Holland, Post abandoned the crisp details of his Brazilian period and his work developed a romantic softness, as if all were seen through a veil (fig. 367). This change in his work demonstrates the underlying tension between the task of recording unfamiliar visual data and the influence of artistic conventions within the artist's native

tradition. When Post was separated from his firsthand New World experiences by time and distance, the works he then based on these experiences became increasingly reliant on conventions of European imagery, and the images of Brazil grew less and less specific.

As the voyages of exploration continued into the eighteenth century, it became customary to employ artists as members of the ship's company or as supernumeraries for the purpose of recording whatever visual data might enhance reports of the voyage after the return home. As in the case of de Bry's engravings after White, however, the preconceptions of the artist often modified the original image in the process of transposing it onto the printed page of a published report.

Often, however, the original works show a blend of empirical observation and conventional forms. The painter William Hodges (1744–97), a pupil of Richard Wilson (1714–82), an English artist renowned for his classical landscapes, accompanied Captain James Cook on his second voyage (1772–75). Although Hodges had been thoroughly exposed to the classicism of Wilson's landscapes, he appears to have been uncommonly aware of the scientific demands of his duties; the works he executed on the voyage display considerable interest in the phenomena of light and weather that would have been of interest to a navigator like Cook. Many of Hodges's drawings and paintings from this voyage also reflect the naval practice of taking offshore views of coastlines which, for piloting purposes, must be topographically correct. Nevertheless, it is also apparent that Hodges time and again fell back on classical conventions whenever the landscape invited it.

While it represents a specific Tahitian scene, Hodges's *A View Taken in the Bay of Oaitepeha (Tautira)* (fig. 368) also reveals its relationship to classical landscape formulas and idealizations, recalling the landscapes of Claude Lorrain (see fig. 130, p. 185) as well as the example of Richard Wilson. The tropical vegetation and the soft light set the mood for an Arcadian idyll restaged in the South Seas. The Tahitian girls bathing in the foreground evoke images of bathing

368. WILLIAM HODGES. A View Taken in the Bay of Oaitepeha (Tautira). *ca. 1776. Oil on canvas. 36 ½"*
× 54 ½". Lent by the Admiralty to the National Maritime Museum, Greenwich, England

nymphs despite their tattoos. The twisting maiden with her
back to the viewer is the descendant of numerous sea
nymphs on antique Nereid sarcophagi and a close cousin to
similar creatures in earlier portrayals of the Triumphs of
Galatea and Amphitrite and the Birth of Venus (see fig.
313, p. 422). The light and topography might be pure Tahi-
tian, but no cultivated eighteenth-century viewer would
miss the classical allusions.

However scientific and practical the aims of the eighteenth-
century voyages may have been, the attention they focused
on the primitive quarters of the world was not without its
emotive accompaniment. Many observers, with all the nos-
talgia fostered by a long history of adulation of things an-

tique, continued to associate the primitive world with Arcadian fictions and Greek gods and goddesses, and they added the concept of the noble savage that was rapidly taking shape in the eighteenth century. This idea had its roots in the notion of a golden age of antiquity wherein life was simple and blissful and man virtuous. Life in this golden age came to be associated in a figurative sense with the Garden of Eden (regardless of the inherent logical problems relating to the doctrine of Original Sin), and when the tropical New World, and later Polynesia, became known to Europeans these associations were soon attached to the supposed felicity of the new primitive paradises the explorers had found. These new regions were viewed as the proper settings for the noble savage, who was conceived as the embodiment of virtues that could be used to remind European man of his sins and European society of its flaws. He was, in effect, a didactic image.

For those who believed in the instinctive goodness of man, the natural luxuriance of the tropics was appropriate to an image of primitive man as happy and uncomplicated, dwelling childlike in a latter-day Eden. For those who saw the physical attributes of a Polynesian through a classicizing veil, the tropical world he lived in could easily become a rediscovered Elysium or Isles of the Blessed. The situation was somewhat different in North America—at least north of Virginia—where a sterner wilderness and the reports of Indian warfare that accompanied British-French rivalry combined to give the noble savage less gentle attributes; he was more likely to be compared to Spartan warriors or stoic Romans. Any antique statue that possessed, in eighteenth-century eyes, an aura of nobility or physical beauty might evoke the image of an Indian warrior, a noble savage.

The story is told of Benjamin West, fresh from Pennsylvania, viewing for the first time the famous *Apollo Belvedere* (see fig. 87, p. 121) in Rome and delighting his companions with his remark that it resembled a Mohawk warrior. His words were hardly his sole property, since similar sentiments had been expressed earlier in an English novel, John Shebbeare's *Lydia*, published in 1755, in which the hero, an American

Indian, is thus described: "The air, attitude, and expression of the beauteous statue of Apollo, which adorns the Belvidera palace at Rome, were seen animated in this American the instant he discharged his deadly shaft." (The description goes on to suggest that Greek sculptors might have profited from studying this noble Indian, thus paying the compliment in reverse!) But not all the literature influential in fixing an image of the Indian was as sympathetic as this. Some dwelt on the savagery of Indian warfare and the terrors of captivity; the noble savage had his counterimage, too, and an audience that gave it heed.

The latitude to be found in images of primitive warriors can be shown by comparing two paintings on the same subject, the death of Captain James Cook in 1779 at the hands of Hawaiians. The event drew considerable attention, and several painted versions appeared, based on the account in *A Voyage to the Pacific Ocean*, published in London in 1784 under the joint authorship of Cook and his lieutenant, James King. Cook's exploits were also acclaimed in drama and poetry, and one of the most popular verses was Anna Seward's "Elegy on Captain Cook," published in 1780, which mingles numerous classical allusions with romantic imagery. It has been suggested that her view of Cook's death attributes the act to a few treacherous individuals who did not truly reflect the character of the race; but another view is found in W. Fitzgerald's "Ode to the Memory of the Late Captain James Cook," also of 1780. Fitzgerald sees in the act proof of the "vengeful" character of "th' inglorious native" given to "sullenness, with low'ring eye." The painted versions by Johann Zoffany (1734/5–1810) and George Carter (d. 1795) mingle these two points of view. Zoffany's version (fig. 369) goes even further, to lend the event the character of a conflict between two heroic figures, one European, the other a noble, savage warrior whose image evokes that of an ancient Greek. Carter's painting (fig. 370) depicts a heroic Cook about to ward off the approach of one native who grasps the barrel of his musket as a wild-eyed warrior is about to deliver the death stroke from behind Cook's shoulder. The light uniform of the English captain sets him off from the dark press of natives on the

369. JOHANN ZOFFANY. Death of Captain Cook. *1779. Oil on canvas. 54″ × 72″.*
National Maritime Museum, Greenwich, England

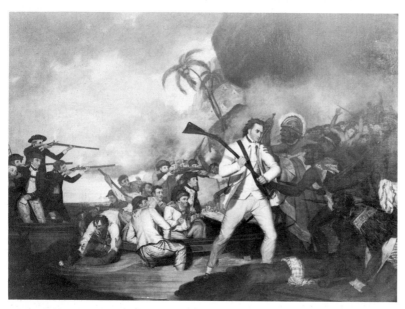

370. GEORGE CARTER. Death of Captain Cook. *ca. 1780. Oil on canvas.*
59½″ × 84″. National Library of Australia, Canberra

right, isolating him despite the nearness of his crew, who are mostly occupied with their own safety as they push their boats away from the shore. Zoffany gives the scene a setting more remote from the viewer and the action a more histrionic tone. Cook lies on the ground in the pose of a fallen gladiator, while the warrior approaching him with a knife assumes a posture reminiscent of the *Discobolos* (fig. 371) in reverse. The Hawaiian's headdress, quite authentic, so similar to Greek helmets in general form, enhances the classical allusion. It is history painting on a contemporary theme comparable to West's *Death of Wolfe* (cf. fig. 210, p. 300).

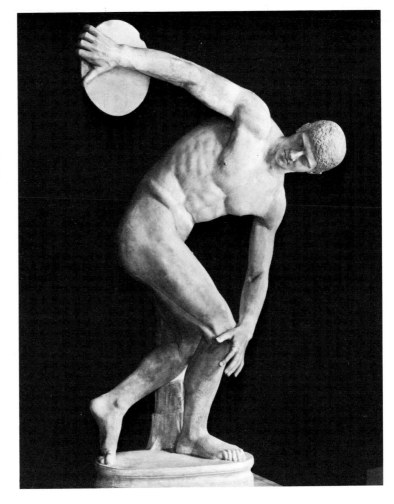

371. Discobolos. *Roman copy after a bronze original of ca. 450 B.C. by Myron. Marble. Height 58 ¼". National Museum, Terme, Rome (Alinari-Art Reference Bureau)*

As the New World and Oceania became better known through the activities and reports of explorers, colonists, and missionaries—and, one must add, transformed by these same agencies—these minglings of Greek and Roman, noble savage, Arcadia, Eden, and tropical paradises often gave way to other impressions less idealized. The image of the primitive, as usual, shifted according to the preconceptions, experiences, and motives of his observer. The literary fiction of the noble savage could survive contact with neither the real savage nor the savage whose state had been altered by European trade and colonization. Idealized conceptions of such purity as the noble savage rarely survive embodiment in ordinary mortals or life in human society, and so it was with the lovely but too fragile reincarnation of a primeval paradise.

Nevertheless, the noble savage was made to order for the romanticism of the late eighteenth century and the early nineteenth century, and his heyday coincides with it. He is, of course, rarely found in painting or sculpture today (one hesitates to say "never," because he has always assumed a number of guises) but he has clearly survived as a common image in at least one popular art form—the motion picture. Nor is the idea he embodied a thing of the past, regardless of transformations in modern society, for one suspects that whenever the harried urbanite contemplates a simpler life close to nature he is entering, somewhat wistfully perhaps, the same realm that eighteenth-century man envisioned.

The softened romantic aura that was gathering about the image of primitive societies in the late eighteenth century is evident in a painting (fig. 372) by John Webber (1750/52–93), who accompanied Cook on his last voyage. Webber's portrait of a nubile Raiatean maiden sets a seductive mood as the girl displays her physical charms against a moody tropical background. The degree to which romantic fancy accompanied the realistic documentation of the voyages can be seen in two other works by Webber. His watercolor *The Plantain Tree in the Island of Cracatoa* (fig. 373), apparently done on the spot, is a direct transcription of a scene; he gave more attention to rendering the characteristics of the tree as

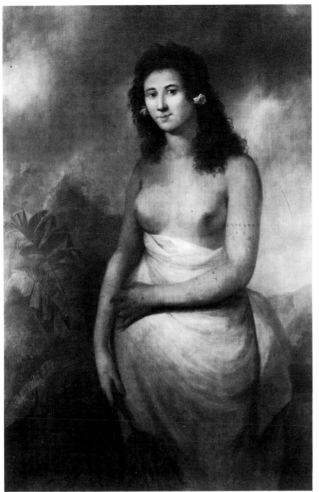

372. JOHN WEBBER. Poedooa, Daughter of Oree. *1778. Oil on canvas. 56″ × 37″. National Maritime Museum, Greenwich, England*

he perceived it directly than to constructing compositional niceties. But in an aquatint, *The Fan Palm in the Island of Cracatoa* (fig. 374), although equally cognizant of botanical particularities, he has created a fanciful tropical paradise that seems as well tended and artificial as a botanical garden. Nor is its idyllic flavor impaired by the presence of the resting maiden at the right. Such exotic landscapes, presumably imparting information about the peculiarities of a place, are frequently encountered as illustrations in the travel literature

of the late eighteenth and nineteenth centuries. Accounts of Cook's voyages were sometimes accompanied by engravings derived from the official publications but reengraved again and again. They helped to promote a widespread interest in exotic landscape and genre scenes, which in turn led to the emergence of a tradition of travel art created by independent wandering artists who sought their subjects in out-of-the-way places. The independent enterprises of these adventurous artists often found their way into periodicals, scenery books, and panorama exhibitions. Travelers' anecdotes and folklore from distant lands were combined in the travel literature with engraved and, later, lithographed illustrations depicting the landscape, habitations, people, and customs of strange lands. By the early nineteenth century, the tradition was in full swing.

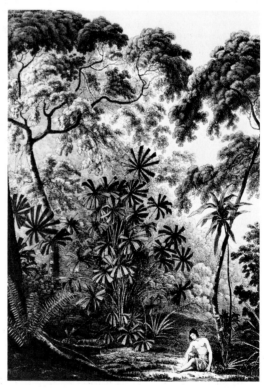

373. JOHN WEBBER. The Plantain Tree in the Island of Cracatoa. *1780. Watercolor. 16½″ × 14½″. National Library of Australia, Canberra (Rex Nan Kivell Collection)*

374. JOHN WEBBER. The Fan Palm in the Island of Cracatoa. *1770. Colored aquatint. 14⅛″ × 10⅝″. National Library of Australia, Canberra (Rex Nan Kivell Collection)*

The mingling of romantic sensibility and scientific natural-
ism that marks the work produced in conjunction with the
eighteenth-century voyages of exploration carried over into
the tradition of travel art. It received significant encourage-
ment from the prestigious German scientist and man of
letters Alexander von Humboldt, whose descriptions of the
primeval landscapes of the tropics the young Charles Dar-
win read so avidly outward bound from England aboard
H.M.S. *Beagle*. As a young man, Humboldt had traveled
extensively in the tropics of the New World, and in his
accounts of these experiences he tempered empirical, scien-
tific observations with romantic responses to the sensory
impact of that region of virgin forests and grand mountains.
His language stirred the imaginations of a wide audience for
generations, and his enthusiasm for the primeval wilderness
of the tropics drew many enterprising artists to it.

The general character of this tradition is well represented in
the adventurous life and the work of the English artist
Augustus Earle (1793–1838), who served briefly as drafts-
man aboard H.M.S. *Beagle* on the voyage that launched
Darwin's career. Before this, between October 1827 and
May 1828, Earle was in New Zealand, still a wild country
torn by wars among the Maori. The drawings and watercol-
ors relating to his New Zealand adventures were supple-
mented by his own account of his sojourn there, published
in 1832. In his descriptions of the conditions he witnessed
in New Zealand, he was the optimistic creature of the En-
lightenment; but in his reliance on intuition and impulses
when he dealt with the natives, in his love of the mysterious
and his fascination with adventure for its own sake, in his
restless wandering about the world, he was very much a
romantic. He was partly captive to eighteenth-century ideas
regarding the noble savage, spoke easily of Greek bodies in
describing the Maori, and evoked images of Achaean fleets
in his descriptions of Maori war canoes. Mingled with these
classicizing images were the observations in his narrative and
in his art that document with the curiosity of a student of
primitive societies a realistic portrait of the strange world he
visited. Earle sought the particular aspect of each locale and
endeavored to portray the features of the natives not as

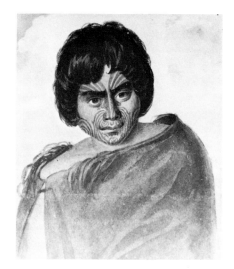

375. AUGUSTUS EARLE. A New Zea-
lander. *ca. 1827. Watercolor. 8⅜″ ×
7⅜″. National Library of Australia, Can-
berra (Rex Nan Kivell Collection)*

stereotypes but as individuals. He was, for his time, unusu-
ally appreciative of the arts of wood carving and tattooing
among the Maori. Several of his watercolors conscientiously
record the appearance of the elaborately carved facades of
Maori buildings and storehouses. His portrait *A New Zea-
lander* (fig. 375) catches an intense personality behind the
tattooed patterns on the Maori's face. Although the original
is not so identified, it was reproduced in Earle's account of
his adventures as the portrait of a tattooer whose work the
English artist admired.

Among the many artists who found the primitive world a
fascinating subject during the nineteenth century was the
American George Catlin (1796–1872) who traveled in the
North American plains west of the Mississippi and later in
South America. His mission was a mixture of romanticism

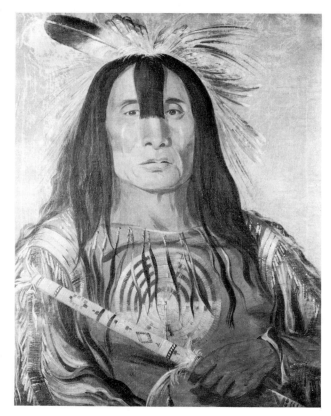

376. GEORGE CATLIN. Stu-mick-o-
sucks (The Buffalo Bull's Back Fat, Black-
foot Head Chief). *1832. Oil on canvas. 29″
× 24″. Courtesy of the National Collection
of Fine Arts, Smithsonian Institution, Wash-
ington, D.C.*

and an unusual dedication to the task of recording a way of life and the appearance of the people who lived it before—as he feared—they disappeared from history. Catlin's Indian portraits depict with painstaking detail the physical appearance, dress, and artifacts of the native American (fig. 376), and some of his compositions representing life on the plains have considerable picturesque vitality despite his shortcomings as a draftsman. Touring Europe with a collection of his paintings and a troupe of Indians, he disseminated more widely than anyone before him an authentic image of the American Indian.

What is clear from examining the works of most of the nineteenth-century travelers to primitive regions is the documentary tendencies they exhibit. The view of the primitive world had entered what one might call an anthropological stage, as images consistently took on the character of data collecting. In this respect, the work recalls the isolated example of the seventeenth-century Dutch artists when they were in Brazil. But the romantic drama that so frequently entered the nineteenth-century image of the primitive world was an expression of another attitude. It was an emotional response engendered by the old concept of the noble savage and his counterimage and enhanced by the spirit of adventure that appealed to the generations of the romantic era. They saw in the primeval world that still existed in remote corners of the globe a realm of romantic escape—real for some daring spirits, vicarious for most—from a Western civilization that seemed to them already old, tired, and perhaps hopelessly corrupted.

By the late nineteenth century, one major artist of the period, Paul Gauguin, found a peculiarly individual expression within the context of the primitive world. He was consistently attracted to a primitive life—even his fondness for Brittany, a relatively primitive section of France, supports this—and his selection of remote Polynesia as a location in which to work is in itself an indication of the strength with which the romantic attraction of a primeval world influenced his decisions. Although other factors were surely involved, again and again in his letters and other writings

one senses the pervasive influence of a romantic spirit, even though he once contrasted his own attitude with that of van Gogh by referring to the latter as a romantic and himself as a primitive. Gauguin represents a mixture of primitive romanticism and a self-conscious stylistic quest for a reorientation of the formal and symbolic aspects of art; his style reached for its formal precedents beyond recent European developments like impressionism to pre-Renaissance and non-European sources. This stylistic outreach was wide and varied. It included medieval art, particularly in the compartmented color areas bounded by line as in cloisonné enamels and stained glass; Japanese prints, which were exciting discoveries for many European artists in the latter part of the nineteenth century; Cambodian and Javanese sculpture, which Gauguin had seen in the 1889 World's Fair in Paris; European folk art; Egyptian and Persian art. Gauguin was not insulated, of course, from the European art of his own time—even from the pale, remote classicism of Puvis de Chavannes (see fig. 337, p. 448). What is significant with respect to Gauguin's attraction to the primitive world is that the art of primitive societies really had so little to do with his own style. His woodcuts, which have been said to reflect his contact with the art of the South Seas, contain very little of a stylistic nature that cannot be accounted for in his previous work and in the technical procedures of his carving. Gauguin's deep involvement with the primitive world lay at another level, in the mysterious bond he sensed between man and nature in the South Seas, which had some affinity to the simple piety he observed among the Breton peasants. No one could accuse Gauguin of being a religious man in the orthodox sense, but there was an element of primitive religiosity in the symbolism of his art that frequently gave his major works an iconic resonance. In *Ia Orana Maria* ("We hail thee Mary") (fig. 377), painted during his first sojourn in Tahiti, Gauguin has expressed a religious sentiment reminiscent of some of his Breton works, like *The Vision after the Sermon* (1888, National Gallery of Scotland, Edinburgh) and *The Yellow Christ* (see fig. 189, p. 270), in imagery that blends the Tahitian scene with forms derived from Javanese reliefs from Borobudur, photographs of which he had in his possession (fig. 378). The luxuriant

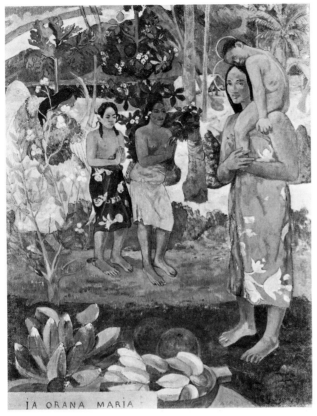

377. **PAUL GAUGUIN. Ia Orana Maria.** *1891. Oil on canvas.*
44 ¾" × 34 ½". The Metropolitan Museum of Art, New York
(Bequest of Samuel A. Lewisohn, 1951)

color, mingling bold patterns with delicate nuances, seems
also a celebration of his initial response to the beauty of the
tropical island.

Gauguin found the primitive Tahiti and the Marquesas (to
which he moved in 1901) already tainted by the European
presence, but there was still in the simple life of the natives
among whom he lived some residue of the old ways he tried
to reach. In the islands, his predilection for reducing images
to bold pattern was complemented by a rich, often sensuous
color that accurately and poetically registered the luxuriance
of the tropical world. The harmonic unity of pattern and
color was the visual equivalent of the idea of a primitive life

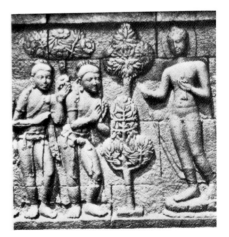

378. **Buddha Meeting the Monks on the
Road to Benares,** *relief from the Temple at
Borobudur. Javanese, ca. 850–900. From
John Rewald,* History of Post Impressionism.
*Art Division, The New York Public Library
(Astor, Lenox and Tilden Foundations)*

in which nature and man were truly one. In this respect, although in a formal sense his style owes more to the Orient than to Polynesia, he came closer than any other Western artist—with the possible exception of Henri Rousseau—to feeling and expressing the idea of a primeval paradise that had for so long haunted the Western imagination. Ironically, he did so under a personal cloud of frustration, anxiety, and even at times despair.

His large, enigmatic canvas (colorplate 16) *D'où Venons-nous? Que Sommes-nous? Où Allons-nous?* ("Where do we come from? What are we? Where are we going?") seems to symbolize perfectly the submergence of human life in the rhythm of this elemental world and the sense of some inscrutable presence residing in it. One is reminded of the artist's impressions in his small book *Noa Noa* ("retouched" by his friend Charles Morice and in feeling close to Pierre Loti's romantic novel *Rarahu*, which Gauguin knew and which was also set in Tahiti): when walking up into the mountains with a Tahitian friend on the path ahead of him, he became aware of the androgynous grace of his companion and imagined that it was not a human being there but "the Forest itself, the living Forest, without sex—and yet alluring." Although some of the figures in *D'où Venons-nous?* . . . can be traced both to Javanese reliefs and to works of his Breton years and the idol is not Polynesian, the large painting establishes the mood of the islands in a way no literal record could convey. Gauguin's dedication to symbolic content enabled him to reach levels that earlier had eluded Hodges and, contemporary with Gauguin, the American John La Farge (1835–1910).

By quite another route—in Paris, no closer to the tropical world than a botanical garden, and possibly through a memory of Mexico where he may have served in the band of French forces supporting Emperor Maximilian in the 1860s —an unsophisticated and remarkably gifted artist was able to draw the dream of a primeval paradise into a focus both materially real and incredibly magical. Henri Rousseau (1844–1910) was a true "primitive" himself, but not in the usual sense in which the term is applied to his work: the

naïve, untrained artist whose images are at once childlike in
their innocence, frankness, and simplicity of statement and
thoroughly craftsmanlike and painstaking in their execution.
Rousseau's work was all of this, but much more. He was a
"primitive" in a more fundamental way. He instinctively
touched the magical level of the primitive world (fig. 379)
with imagery laden with the traditional exotics of European
art: romantic forests, lush and flowering; tigers and lions;
pale Eves and dark natives; moonlight and sunset over jun-
gles. He reached that level, one senses, because everything
he depicted was more than a representation to him. Each
leaf, flower, and creature was a re-creation in the most direct

379. HENRI ROUSSEAU. La Charmeuse des Serpents. *1907. Oil on canvas. 66½″ ×
74½″. The Louvre, Paris (Agraci-Art Reference Bureau)*

and unselfconscious way, as if it were the primordial archetype materialized by his brush. This is true even when his subject was not exotic but a vase of flowers or a conventional still life of homely objects. His paintings are infused with a magical life close to the animism of the primitive world. He touched it not with the comprehending primitiveness of Gauguin, but with the innocent wonder of a primitive soul. It was precisely this quality that later artists, directly inspired by primitive art, seem to have left in the shadows as they revealed to the Western world only the formal substance of African and Oceanic art.

Until Gauguin made an effort to live the primitive life and Rousseau instinctively caught its essence from a distance, most Western artists had viewed it from the outside, a temporary way station in a pursuit of the unfamiliar and the picturesque, something to be documented like floras and faunas, or a didactic device with moral and philosophical functions to perform. The primitive world, as a body of subject matter for the artist, had not affected the style of Western art. European style had been imposed on images of the primitive world, and this was even to a considerable degree true of Gauguin, who came to the islands after his style had been essentially formed. It was not until the twentieth century that the primitive world had its turn at shaping European styles.

Primitive art had been collected as early as the seventeenth century, and by the late nineteenth century ethnological interest in the primitive world was reaching the status of a precise discipline. But aesthetic interest of a kind that would recommend primitive art as a stylistic force was limited. European art first had to move decisively in the direction of abstraction before primitive art could become an influence of any significance on its forms. Both the form and content of primitive art were then so foreign to the European context that some impulse was required from within European art itself to bridge the gap. This came toward the end of the nineteenth century and in the early years of the twentieth century when attention was shifted toward abstract and symbolic values and away from the surface appearances of

the world and the ephemeral effects of the world's light sought by the impressionists. The example of Paul Gauguin was unquestionably of great importance to this process, and the appearance in his paintings of primitive idols and details of Polynesian carving probably helped to call attention to the formal qualities of primitive art.

Around 1904, in Paris, artists Maurice de Vlaminck (1876–1958), Henri Matisse (see pp. 606–8), and André Derain (1880–1954) began collecting African masks and sculpture, and in Germany about the same time artists like Ernst Kirchner (see p. 621), Emil Nolde (1867–1956), Erich Heckel (1883–1970), and Karl Schmidt-Rottluff (b. 1884) were discovering primitive art in the ethnological museum at Dresden. During 1906 and 1907, while working on *Les Demoiselles d'Avignon* (fig. 380), which represents one of

380. **PABLO PICASSO.**
Les Demoiselles d'Avignon.
1907. Oil on canvas. 96" × 92". Collection, The Museum of Modern Art, New York (Acquired through the Lillie P. Bliss Bequest)

381. **CONSTANTIN BRANCUSI. Prodigal Son.** *ca. 1914. Oak with limestone base. Height 17½"; base height 12½". Philadelphia Museum of Art (The Louise and Walter Arensberg Collection)*

the early stages in the development of cubism, Picasso became acquainted with African art, and several drawings and paintings he executed between 1907 and 1909 show how intensely he was studying and absorbing its forms. *Les Demoiselles d'Avignon* was not begun under the influence of African art, however. In fact, the two figures on the right whose faces are so evocative of African masks were reworked in an African vein after the composition was set, and it was probably the pre-Roman sculpture of Picasso's native Spain (some of which had been unearthed near Málaga, the artist's birthplace) that was the primary factor in developing the figures along archaic (cf. figs. 21 and 22, pp. 33 and 34) lines. Much has been written about the role of primitive art in the development of cubism, but the question whether it was a significant catalyst or merely a subsidiary exploration in the evolution of the cubist style remains open. Surely the impact of primitive art played a role, but the genesis of cubism is complicated by the fact that it was a formal, structural style interwoven with the architectonic inheritance from Cézanne (see fig. 470, p. 607, and colorplate 17). More could be said for the emergence of an African influence in Picasso's work from the mid-1920s through the 1930s, but by that time it had been thoroughly absorbed into the artist's creative process. Echoes from African masks appear in faces, and shapes that recall African sculpture pervade many of his figures (cf. fig. 436, p. 569). Those who first became enthusiastic about African sculpture, however, were attracted to it for reasons that were largely irrelevant to the significance of the works in African terms. It was the geometricity of these images, the bold simplifications, the startling juxtapositions of cylinder and plane, of convexity and concavity, that attracted the artists. They undoubtedly saw what they wanted to see: confirmations of as well as further suggestions for their own stylistic explorations. The spirit, the dynamism, that lay behind these images (see pp. 227–29), if felt at all, was probably no more than the intuition of a mysterious presence. The impact of the art lay essentially in the realm of form.

Although Picasso did some sculpture between 1906 and 1908 that shows the influence of African forms, most of his

382. **Guardian Figure,** *from the Bakota area, Gabon. Nineteenth or twentieth century. Wood overlaid with copper and brass. By courtesy of the Trustees of The British Museum, London*

383. **AMEDEO MODIGLIANI. Head.** *ca. 1910. Stone. 27 ¾" × 9 ¼" × 6"; base height 3". Philadelphia Museum of Art (Gift of Mrs. Maurice J. Speiser)*

work done at that time in response to primitive art was in two-dimensional media. The sculpture (fig. 381) of Constantin Brancusi (1876–1957) and both the painting and sculpture of Amedeo Modigliani (1884–1920) reveal quite openly the formal impact of primitive art. With the encouragement of Brancusi, Modigliani did a series of sculptures that project something of the character of primitive idols (fig. 382), and the faces in some of his paintings have strong echoes of

African masks; but they are gentled, sophisticated, thoroughly absorbed into his personal haunting and sensual style (fig. 383). Brancusi's sculpture reduces the three-dimensional mass to bold, simple forms in wood and stone, and although it shows unmistakable signs of the formal vocabulary of primitive art, the primitive element has undergone a transformation that brings it close to the brutality of mechanistic forms. Jacques Lipchitz's (1891–1973) deliberately iconic *Figure* (fig. 384) is even closer to primitive images in a formal sense; paradoxically, in its metallic buttressing and symmetry, it is equally evocative of the world of the machine.

The example of primitive art helped to free sculpture in the twentieth century from the tyranny—sometimes benevolent, sometimes not—of old European traditions, a nice poetic justice in view of a long history of yearning for the revivifying simplicity of a primitive world. David Smith's late work (see fig. 489, p. 653), so technologically affirmative, a celebration of the welding torch and the abrasive polish, and the ultimate simplicity of Tony Smith's *Black Box* of steel (see fig. 490, p. 655) are by no means the offspring of African or Oceanic art; but they may owe a little to the discovery by European artists early in the twentieth century of the refreshing unfamiliarity of primitive art.

384. JACQUES LIPCHITZ. **Figure.** *1926–30. Bronze. 85 ¼″ × 38 ⅝″. Collection, The Museum of Modern Art, New York (Van Gogh Purchase Fund)*

EASTERN VISION AND THE WESTERN WORLD

In the previous section we have seen how the European artist, involved with the values of his own age and conditioned ideologically and technically to the traditions of his own society, responded in a variety of ways to the unfamiliar world of primitive cultures—responses approximated in any situation in which an artist of one society is confronted in his image making by the unfamiliar configurations of another. In utilizing that experience in his own work (if he is doing more than merely copying a foreign idiom), he translates it into the visual "code" of his own style and makes it intelligible to those for whom his work is normally intended. So the artist often bends the unfamiliar to conform substantially to the familiar, and therefore communicative, conventions of his own tradition. This is as true of the Oriental artist as it is of the artist in the Western world.

From the Asian point of view, for example, the European was every bit as exotic a creature as the Asian was to the European. But there was also a unique aspect to the Asian-European relationship: the production by Asians of objects, images, and decorations in imitation of European forms intended for markets in the West, as in Chinese exports of porcelain ware to Europe and America.

Beginning in the mid-sixteenth century when Portuguese traders established a base at Macao on the China coast, the China trade carried to Europe, and later to America, a vast quantity of decorated porcelains in which the traditions and tastes of East and West were often mingled. These porcelains were manufactured up the Yangtze and inland at a pottery center, Kingtehchen, where good water from the

Chang River, a fine-textured clay (*kaolin,* or China clay), and a type of felsitic rock that was crushed to form both a clay additive and a major portion of the glaze were close at hand. Sometimes the decorations were applied at Kingteh-chen before the porcelains were glazed, but often they were painted over the glaze and refired at lower temperatures in Canton, the chief export center in south China. Although some wares were Chinese in form and decorated in a Chinese manner, the relative cheapness of Chinese porcelains (making them highly profitable as trade items) as well as their good quality led to the manufacture in China of wares designed according to European types and decorated with European motifs sent to China to be copied by Chinese artists. In some instances, however, a Chinese form was adapted to European purposes. The familiar teacup, for example, is a modification of the Chinese teabowl with the shape altered slightly and handles added. The saucer under the cup is a European addition to the tea-drinking ritual, which was Chinese in origin.

In two examples illustrated here, we can see varying degrees of East-West mixtures in the decorations typical of China trade ware: both decorations accommodate Western tastes, one by emulating a Western style, the other by utilizing a Western theme. A punch bowl (fig. 385) made for the English market, probably between 1750 and 1760, is decorated on opposite sides with identical black-and-white scenes of a concert copied from a contemporary English engraving (fig. 386). The Chinese artist, while adapting the composition of the engraving to the shape of the bowl, has imitated to some extent the hatched line technique of the engraving. Between the two English concerts are representations of a Chinese orchestra, somewhat smaller in scale, also executed in imitation of an engraving. Between the concert scenes are small vignettes of Chinese landscapes, and around the inside of the rim of the bowl is an ornamental pattern that some opinion would ascribe to eighteenth-century European sources, although it incorporates elements similar to motifs found on Chinese ceramics as far back as the Sung dynasty. In the general appear-

385. China Trade Punch Bowl. *Eighteenth century. Hard-paste porcelain decorated in grisaille, sepia, and gilt. Height 6½"; diameter 16 3/16". The Metropolitan Museum of Art, New York (Gift of the Winfield Foundation, 1951. The Helena Woolworth McCann Collection)*

386. The Concert. *British, eighteenth century. Engraving. The Metropolitan Museum of Art, New York (Harris Brisbane Dick Fund, 1917)*

ance of its decoration, however, the bowl seems to be comfortably Westernized.

Also of mixed inspiration is the decoration on a porcelain plate (fig. 387) made in China about the same period and probably intended for the Continental market. A scene representing the baptism of Christ generally follows Western prototypes (cf. fig. 114, p. 165), but both Christ and John the Baptist are decidedly Chinese and the setting is suggestive of a rice paddy framed by conventional Chinese foliage. The winged *putti* in the border are derived from European sources but transformed into plump Chinese figures. Whether the stronger Chinese flavor of this porcelain results from a less adaptable artisan or from his being furnished with a more sketchy or incomplete European model for the decoration is a question beyond answering; but there is no question that the decoration of this plate is more spontaneous in execution and, despite the Western theme in the center and the quasi-European border, more Oriental in general appearance than the punch bowl.

387. Baptism, *from a Chinese export plate. 1750–70. Painted porcelain. Diameter ca. 9". Courtesy, Museum of Fine Arts, Boston (Helena Woolworth McCann Collection)*

388. **Allegorical Representation of Emperor Jahangir Seated upon Hourglass Throne.** *Indian, Mogul, School of Jahangir, seventeenth century. Color and gold. 10″ × 7 1/8″. Courtesy of the Smithsonian Institution, Freer Gallery of Art, Washington, D.C.*

Sometimes the relationship between Eastern and Western elements is elusive. A Mogul painting (fig. 388) from Muslim India of the same era as the preceding two works blends Persian flatness and decorative elegance with a naturalism peculiar to the Mogul style, the latter quality being apparent in the exacting portraiture. Among the figures is a European emissary to the Mogul court, not distinguished from the others by any deviation in style, but with Western features sensitively portrayed, the consequence of the curious mixture of naturalism and delicacy in the Mogul court style. The cherubs above the fragile sun-moon halo and those at

the base of the hourglass throne are intrusions from the West and in their generalized forms appear as such, whereas the Renaissance carpet, although explicitly Western, seems less obtrusive by reason of its intricate decorativeness, which brings it visually close to the other patterns of purely Oriental origin. The European in this picture could very nearly have stepped out of a northern Renaissance painting, and, indeed, the Mogul emperor Akbar and his son Jahangir, who appears here on the hourglass throne, possessed European paintings that their court artists freely studied. But the striking image of the European in this work cannot be attributed solely to European influences on Mogul artists, for these influences, such as they were, were fully synthesized with Persian decorativeness and a native Indian naturalism. The mixture of delicacy and realistic detail in the European's image is the product of this fusion.

Another work (fig. 389) from India, coming slightly later in the seventeenth century, depicts a Dutch trader enjoying his leisure in an idyllic landscape. He is smoking a long pipe, but

389. European Gallant in Restoration Costume, *side panel of a box. Indian, Deccan, ca. 1660. Papier-mâché, painted and lacquered. Victoria and Albert Museum, London (Crown Copyright)*

from the position of his hands it is apparent that the Indian artist must have misunderstood some European picture of a musician playing a flute which he used as a model for this image. Although the young man's costume is European, his features are Indian, and the lovely setting and deer belong to the East. Such a work demonstrates the difficulties attending the creation of cross-cultural images—mainly the persistence of the artist's native tradition and the prevalence of misconceptions about foreign imagery.

From China, in the following century, comes a work (fig. 390) that represents a unique cross-cultural circumstance: a European who is painting in a manner that appears at a quick glance to be quite Chinese, but on more careful study displays many intrusive elements imported from Europe.

390. LANG SHIH-NING (GIUSEPPE CASTIGLIONE). **One Hundred Horses at Pasture,** *section of a hand scroll. Ch'ing dynasty, early eighteenth century. Ink and color on silk. 37 3/16" × 25'5" (entire scroll). Collection of the National Palace Museum, Taipei, Taiwan, Republic of China*

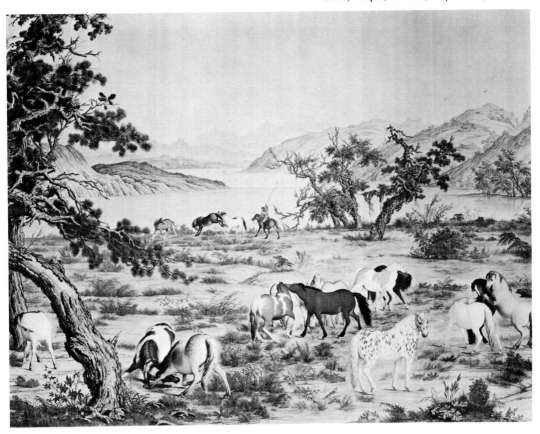

The artist, an Italian Jesuit priest, Giuseppe Castiglione (1688–1768), came to the court of the Ch'ing emperor Ch'ien Lung already equipped with modest European painting skills (demonstrated in portraits done at the Ch'ing court) and proceeded to study the Chinese style. While it is obvious that he mastered many aspects of Chinese painting, his work mixes into the Chinese syntax the Western vernacular of light and shadow as well as a realistic rendering of surface appearances. The result is ambivalent.

Probably the richest concentration of Eastern images of Western man came out of Japan during the nineteenth century when trading and diplomatic relations between Japan and the Western world began to expand. Japan, however, had not been entirely isolated from the West before 1853, when Commodore Matthew Perry of the United States initiated the new era on his expedition to the island empire. Portuguese traders and Jesuits were there by the mid-sixteenth century, and evidence of this European presence in Japan can be seen in a Japanese screen (fig. 391) of the early seventeenth century. It is painted with scenes of Westerners playing music in a bucolic setting and is clearly an imitation of a Western style of painting; but although

391. **Westerners Playing Their Music,** *one of a pair of six-fold screens. Japanese, Tokugawa period, ca. 1610. Color and gold leaf on paper. ca. 3′ × 10′. Eisei Bunko Foundation, Tokyo (Sakamoto, Tokyo)*

392. European Ship Unloading Cargo, *folding screen. Japanese, Momoyama period, sixteenth century. Color and gold leaf on paper. ca. 3'9⅝" × 11'. The Imperial Household Agency, Tokyo (Sakamoto, Tokyo)*

many European features have been skillfully imitated, there are intrusions of Japanese elements, particularly in the background setting. The result is a charming hybrid, strongly Westernized. By contrast, another Japanese screen (fig. 392) of about the same time depicts a Portuguese carrack (a type of merchant ship) and sailors in a thoroughly Japanese manner. The subject is "exotic," but the style is native. Clearly, the difference between these two works results chiefly from divergent artistic intentions. The second work reveals a careful study of the foreign motif but deliberately translates it into the Japanese idiom.

In the late 1630s Japan was closed to the West, but by 1641 the Dutch East India Company was able to commence a trading relationship from an artificial island in Nagasaki harbor. The suspicion of foreigners that had precipitated their expulsion remained, however, and even for some time after Perry's expedition and the subsequent opening of the port of Yokohama to Western trade, foreigners were permit-

ted only limited access to the Japanese mainland. Nevertheless, there seems to have been considerable curiosity about the foreigners, and it has been estimated that between 1860 and 1863 alone some six hundred wood-block prints documenting the Western presence around the time of the opening of Yokohama harbor engaged the talents of more than forty Japanese artists. Prints depicting Westerners at Nagasaki had been produced since the middle of the eighteenth century and were the work of local artists of lesser stature than the masters who created the finest Japanese wood-block prints from the artistic center at Edo (Tokyo). (In fact, the fine color wood-block prints, known to the Japanese as *Ukiyo-e*—"Pictures of the floating world," the fleeting or transient world, frequently involving theater subjects—were themselves accorded little serious attention by the Japanese upper class and connoisseurs but made their appeal instead to the mercantile and entertainment levels of Japanese society. It is ironic that the first serious attention Western artists paid to the pictorial arts of Japan came through the *Ukiyo-e* introduced to Europe during the last half of the nineteenth century.) The images of Westerners in Japanese wood-block prints seem to have been accommodated to the Japanese style with some difficulty. Because the artists were accustomed to working within the formulas growing out of the stylizations of their painting tradition, which had so many roots in Chinese art (see p. 141), the foreign image presented new problems in visualization. Conditioned by the striking patterns and flowing rhythms of traditional Japanese dress and developing the refined line and color shapes within the context of traditional costume, they seem to have found Western dress, particularly that of the men, an unsympathetic and inflexible subject.

In a print from the first quarter of the nineteenth century (fig. 393), there is a fundamental awkwardness in the articulation of the European figures and their gestures, as we see an artist of limited capacity attempting to infuse the foreign shapes with Japanese line and pattern. Sadahide (1807–ca. 1873), one of the best artists to produce prints of Westerners, is much more successful in his color woodcut of a German merchant and his wife (fig. 394). Thanks partly to the

393. European Gentleman and Lady.
Japanese, first quarter, nineteenth century. Color wood-block print. By courtesy of the Trustees of The British Museum, London

394. SADAHIDE. Merchants Visiting Yokohama. A Prussian Couple.
1861. Color woodcut. 14⅜″ × 9⅞″. Philadelphia Museum of Art (Purchased)

patterns of the lady's costume, the artist was able to exploit pattern in the Japanese manner. But even apart from that happy circumstance, the posture of the man is relatively easy and graceful. Although the few decades that lie between the two works may suggest that increased familiarity with the Westerner has resulted in a more effective mix of European image and Japanese style, one must emphasize the obvious differences that do occur between artists of different talents.

395. Sailor and Girl. *Japanese, nineteenth century. Wood-block print. ca. 14 ½ " × 9 ⅞ ". By courtesy of the Trustees of The British Museum, London*

396. TŌTŌYA HOKKEI. Chinese Objects from Hikita in Karamono (Osaka Hikita Karamono), *from the series* **Three Cities (Santo no Uchi).** *Japanese, ca. 1820. Color woodcut. 8 " × 5 ½ ". University Art Museum, Berkeley, California (Gift of the Estate of William Dallam Armes, Berkeley)*

In a late nineteenth-century print (fig. 395), the two contrasting figures are realistically related to each other by their gestures, and the simplicity and bold contrasts of the sailor's uniform make it reasonably adaptable to the stylizations of the wood-block medium. Nevertheless, the image of the sailor still seems an obtrusive note against the traditional pattern of his companion's robes. In this series of prints, there is an attempt to render characteristic European features, but the tendency toward retaining Oriental eyes nudges the images in the direction of "Japanization."

An attempt to achieve a convincing foreign image in the wood-block medium is exemplified in a delightful fashion in a Japanese print from the early nineteenth century (fig. 396) in which we see a water fountain, peacock feathers, and a framed European painting. What is striking about the print is the attempt to imitate the varnished surface of the European picture by coating it with glue. Like varnish, the glue has discolored with age, adding a realistic dimension the Japanese artist probably could not have anticipated.

The works illustrated thus far in this section were created in Asia. Now let us turn to an image (fig. 397) created by an Asian artist working in the West, painting a Western scene. The Oriental tradition remains dominant, and in observing this mixture of strangeness and familiarity, we can realize how much Western conventions of spatial projection, light and shadow, and techniques hedge our ideas of Western landscape. Always there is the persistent tug of native tradition whenever the artist confronts the unfamiliar, a tendency to modify strange images in the direction of familiar forms; only when the artist is deliberately imitating a foreign idiom (as in fig. 391, p. 512) does the tradition give way to any extent—but even then some traces of it will usually well up through the surface of the alien style.

397. WANG CHI-YUAN. Autumn Leaves Are Falling on the Heights Looking across the Hudson River. *1955. Water-ink. 47" × 23". Collection of the artist*

PART

SIX

IMAGES REAL AND FANCIFUL

CHAPTER 12

THE ART OF THE COMMONPLACE

Throughout most of human history, the highest forms of art and architecture have served religious and secular institutions or have expressed values associated with or derived from organized religion, the concepts of kingship, and the purposes of the state. The economic support of art and architecture has come chiefly from these institutions. Recently other sectors of society, ranging from individual patrons, unattached to church or state, to entrepreneurs and business and educational institutions, have become more important factors in the social history of art. Art was not aimed, for most of its history and to any significant degree, at the celebration of the ordinary. The lives of the masses of menial workers—slaves, freedmen, peasants, and artisans —and the commonplaces of ordinary life in the home, the fields, the streets, and the taverns have been the inarticulate corners of history. Yet, through literature and a variety of public records, some knowledge of what it may have been like in those places here and there throughout time has been preserved; and some portion of this information has come to us through works of art that, apart from this social content, contain some striking imagery from an aesthetic point of view.

There has probably always been an art of the commonplace, although today we might not readily identify the most ancient examples of it as such. We tend to associate the art of the commonplace almost exclusively with "genre" art (that which depicts human situations from the ordinary, everyday world, public and private, comic and serious) and with still life; and because these types of art developed remarkably during the seventeenth century, we tend to go

back no further than that period of time when we define the art. We do not, for example, ordinarily think of prehistoric art in these terms; but its subject matter, so expressive of the very substance of daily existence, was commonplace enough while yet being tremendously important in its content and intentions—an art of the commonplace need not be trivial. On the other hand, there was surely nothing exalted about the cave paintings, despite their significance to the society, and nothing exotic about them, despite their probable magical intent; for the ancient hunting societies lived in an environment chiefly populated by the wild game upon which they depended for their livelihood. Therefore, rituals of image making aimed at serving these needs were natural developments. Nor was there really any significant separation of categories in this prehistoric art: it was all one and all of vital meaning.

When mankind began to superimpose on the phenomenal world around him fixed ideas of deity and to develop within his society such institutions as kingship, royalty, and priesthood as distinct classes, the art that served these strata in particular assumed an uncommon status and developed attributes peculiar to the classes it served.

We find in the art of the ancient Egyptian dynasties, for example, images that depict the kings and gods (see figs. 11 and 61, pp. 28 and 84), entities signifying a higher order than the ordinary world of transient things. Yet the commonplace was not entirely excluded from these levels, since the decorations of the royal tombs—and those of officials who held high offices—contained a great deal of imagery from the commonplace, workaday world: scenes of farming, herding, fishing, commerce, services, and the crafts (see fig. 1, p. 2). These were not, of course, images created for their own sake; rather, they were depictions of activities that symbolized prosperity and supported the life-styles of royalty and officialdom. From the eternity of the afterlife in the tomb, the funerary image of the deceased could watch, with comfort and satisfaction, these pictorial counterparts of a prosperous land, the estates of the dead. In these common-

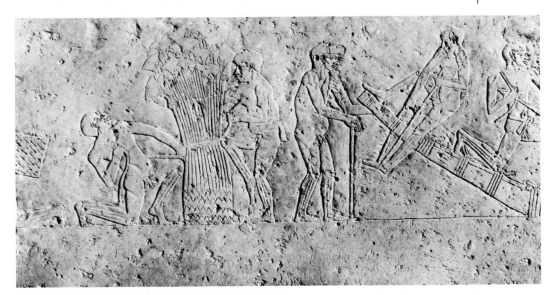

398. Old Man Gossiping with Boat Builders, *mural from north wall of rock tombs at Meir. Egyptian, Middle Kingdom, ca. 2080–1640* B.C. *The Egypt Exploration Society*

place scenes, well observed and explicitly recorded, lie the deepest roots of genre art.

The Egyptian relief illustrated here (fig. 398) shows an old man apparently conversing with boat builders. The artist is careful to describe the various activities of the boatyard, as papyrus stalks of which boats were made are bound together and the boats themselves shaped. But such scenes are not independent works. They are part of a larger ensemble, just as the little details of human action in Assyrian reliefs of a later date are subsidiary to the purpose of recording the triumphs of Assyrian kings (see figs. 78 and 80, pp. 105 and 107).

It was probably in the Greek world that the commonplace motif was freed from its old attachment to royal art, and in the vase paintings of the Greeks there is frank delight in depicting ordinary human activities; they are no more explicit, surely, than those on the walls of Egyptian tombs, but they are now asserted as independent vignettes of daily life,

intimate scenes—comic, lovely, or simply noncommittal. In the work of the Eretria Painter (fig. 399), the artist has decorated one face of the vessel with an intimate and inconsequential scene: a young woman who appears to be dressing as she removes her clothing from a chair that has an embroidered cushion and a footstool. She wears a necklace, a fillet to bind her hair, and a thigh band with a pendant attached to it. A perfume vase is on the floor. For all the economy of line in this work, it describes the details of the scene with precision, while the grace and intimacy of the image make it discreetly erotic. Such a subject would not seem out of place in the company of the playful rococo art of the eighteenth century (see figs. 322 and 339, pp. 431 and 450).

399. THE ERETRIA PAINTER *(attributed).* **Woman Dressing,** *red-figured lekythos. Athenian, ca. 430–420 B.C. Height 3 9/16". The Metropolitan Museum of Art, New York (Fletcher Fund, 1930)*

Another aspect of the commonplace can be found in medieval art where it assumes an emblematic character. In the sculpture of the Gothic cathedrals, the various seasonal activities of rural life are frequently depicted in conjunction with signs of the zodiac (fig. 400), where they signify the months of the year. Such scenes could be called "genre" only in a very limited sense; but they are related to the history of this category, and in such later works as the illuminations to *Les Très Riches Heures* (see fig. 122, p. 175) we see a more elaborate stage of the development that is genre-like in substance while displaying landscape features as well.

By the sixteenth century this old image of the seasons is masterfully enlarged by Pieter Brueghel the Elder in his

400. Signs of the Zodiac and Labors of the Months, *from the west facade, Amiens Cathedral. 1220/25–35. Stone. Diameter of each quatrefoil ca. 30".* a. **June** *(Marburg-Art Reference Bureau)* b. **July** *(Bulloz-Art Reference Bureau)* c. **August** *(Bulloz-Art Reference Bureau)*

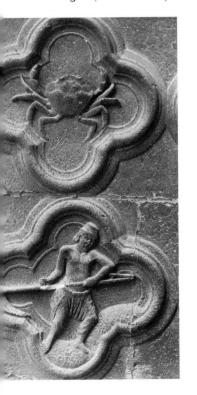

harvesting scene (fig. 401), one of a series of landscape-genre pictures he painted on the general theme of the seasons. Although dominated by the sweep of the landscape setting, the genre elements are equally important to the picture, as peasants labor and take their rest. We sense the authenticity of these episodes. The artist seems to be recording the way it was in the countryside among the people who individually cast few shadows across history, being remembered only as a collective mass. In such works as this, the artists of the Low Countries during the next century found precedent and encouragement for their extensive involvement with the art of genre painting. By comparing the genre elements of Brueghel's work with the

401. PIETER BRUEGHEL THE ELDER. The Harvesters. *1565. Oil on wood panel. 46½″ × 63¼″.*
The Metropolitan Museum of Art, New York (Rogers Fund, 1919)

Egyptian relief (see fig. 398, p. 523), we sense how close to the later genre type were the tomb reliefs and paintings of ordinary life in ancient Egypt.

In some instances during the sixteenth century, the commonplace became more than a subsidiary motif in religious art as well, and Pieter Brueghel's example comes immediately to mind. In such works as *The Numbering in Bethlehem* (1566, Royal Museums of Fine Arts, Brussels), one is confronted with a snowy village scene of Brueghel's own time. In the lower left of the picture a crowd gathers, and only after taking in the general scene of village activities does one see near the central foreground a man leading a

402. CARAVAGGIO. The Calling of St. Matthew. *ca. 1597–98. Oil on canvas. 11′1″ × 11′5″. Contarelli Chapel, San Luigi dei Francesi, Rome (Anderson-Art Reference Bureau)*

donkey on which rides a young woman wrapped in a heavy robe. So familiar is this configuration as part of the normal image for the Flight into Egypt that the connection is immediately made and the identities of Joseph and Mary "great with child" stand out from the matrix of village genre. It is a very ordinary world Brueghel has painted, and the sacred theme seems to enter it almost surreptitiously.

It was another artist, however, whose conjunction of sacred theme and commonplace incident aroused the most attention. Caravaggio's *Calling of St. Matthew* (fig. 402) seems at first to be a scene of the low life of the tavern, possibly an interrupted game of chance, as one young man counts his coins at the table. The light that filters dimly into the room from a source outside the picture space at the right theatrically illuminates the figures at the table. One of the young blades, his back to the viewer, twists dramatically on his seat like a costumed *ignudo*, drawing attention to the two intruders at the right, one of whom, with a faint halo hovering over his head, gestures toward the older man at the table. The gesture reverses the stretch of Adam's arm in the *Creation of Man* from Michelangelo's frescoes on the ceiling of the Sistine Chapel. Only at this point do the visual clues fall into place, and the calling of Matthew the tax gatherer to follow Christ emerges from the shadowy scene as the subject of the painting. Caravaggio, in departing from the idealizations common to religious art in Italy by depicting the sacred themes in commonplace, naturalistic terms, was sharply criticized in certain conservative quarters; but he appears to have been addressing himself to a "down to earth" movement within the church at this time, wherein such an ordinary—some would have said "vulgar"—setting and *dramatis personae* would not appear at all blasphemous but, on the contrary, eloquently immediate and meaningful in a religious sense.

In the seventeenth century, genre painting in the Western world developed on an unprecedented scale. Such works as *An Old Woman Cooking Eggs* (fig. 403) by Velázquez and Jan Vermeer's *The Kitchen Maid* (colorplate 10) are exemplary manifestations of this burgeoning art. Veláz-

403. DIEGO VELÁZQUEZ. An Old Woman Cooking Eggs. *1618. Oil on canvas. 39″ × 46″. The National Galleries of Scotland, Edinburgh*

quez's painting, like Caravaggio's, is set in a dark interior with a light source outside the picture space bringing the forms of the young boy, the old woman, and the various objects in the scene into strong relief. There is a striking naturalism in what is portrayed. With expository vividness everything asserts its individual concrete reality right down to such details as the knife lying across the bowl, casting its shadow on the bright inner surface of the dish. Since each object proclaims its presence so distinctly against the darkness of the room, the viewer's attention shifts actively from one point to another. The diagonals of spoon, pestles, and knife and the varied ellipses of the dishes lend rhythmic patterns to the play of accents. Scattered as the composition is, there is yet a deliberate arrangement to the forms that evokes the still life, while the images of youth and old age are rendered as portraits, highly individualized, inviting the viewer to speculate on the human relationships that might exist.

Interior scenes by Vermeer have often been compared to still life because they underplay the human presence in favor of the quiet arrangement of forms, all bathed harmoniously in the clear light that floods the rooms. It is this aspect of

The Kitchen Maid that contrasts markedly with the painting by Velázquez. The overall pattern of lights and darks is simpler in the Dutch work, and the light becomes a total atmosphere rather than islands of illumination in an ambience of darkness, as in the Spanish painting; but more significantly, there is not in Vermeer's work the Spanish master's obvious concern with the individuality of the human presence. Vermeer's figures, for all their tangibility, are somewhat anonymous. The objects and surfaces in the Vermeer are no less substantial than in the Velázquez, but their reality is less individually assertive; they are everywhere submissive to the general illumination. This quietude and lack of human drama has led some observers to place such paintings at the outer edges of the field of genre painting, preferring instead to consider them as a variety of "human still life." The atmosphere of serenity conveyed by the orderly households depicted in Vermeer's work has often been cited as the epitome of Dutch burgher values: comfortable, secure domestic tranquillity.

This serenity and absence of human drama could not be said to characterize either Adriaen Brouwer (1605/6–38) or William Hogarth (1697–1764), in whose works human situations are played out with obvious relish. Brouwer's *Smokers* (fig. 404) has all the features of an episode that a quick glance

404. **ADRIAEN BROUWER. The Smokers.** *1636–37. Oil on wood panel. 18″ × 14⅜″. The Metropolitan Museum of Art, New York (The Michael Friedsam Collection, 1931)*

might have caught in any ordinary seventeenth-century tavern in the Low Countries. It is good-naturedly irreverent and, although informally arranged, deliberately plays to its audience, the viewer. The prankish tone, facial expressions, and comic gestures invite comparisons with the art of mime and suggest an affinity with the comic theater.

An element of theater is also characteristic of Hogarth's paintings and engravings done in series as episodes of moralizing stories, which he likened to "representations on the stage." The engravings of these, through their extensive printings, were widely circulated and attained considerable

405. **WILLIAM HOGARTH.** The Orgy, *plate 3 from* **The Rake's Progress.** *1735. Engraving. 12 ½″ × 15 ¼″. Prints Division, The New York Public Library (Astor, Lenox and Tilden Foundations)*

popularity by virtue of the double appeal of their lessons and comic relief.

In the episode from *The Rake's Progress* illustrated here (fig. 405), we see a young man of aristocratic birth who is well on the way to squandering the fortune of a wealthy bourgeois wife (who is not present, of course, in this house of prostitution). Episodic pictures like this are loaded with visual clues that link the series together. There is much about them that invites comparison with the narrative techniques of the modern comic strip, while the moralizing content establishes Hogarth as an important social critic of his age and invests his work with a didactic, quasi-literary purpose. Hogarth's series of paintings and engravings—*The Harlot's Progress* (1733), *The Rake's Progress* (1735), and *Marriage à la Mode* (1745)—contain a wealth of eighteenth-century paraphernalia and topical situations that not only lend authenticity to the settings but also, in many instances, create a web of visual metaphors and iconographical elements that reinforce the central moralizing message. The burden of these visual analogies, which often clutter his works and which could become tiresome, is lightened by the delightful heartiness of his narrative style.

This tendency of British art to join essentially literary and social functions to the visual arts has often been cited by art historians. A later instance of this characteristic is a painting that achieved great popularity in the latter part of the nineteenth century: *The Last of England* (fig. 406), by Ford Madox Brown (1821–93), in which the major emphasis is the emotions of a young couple with an infant (completely hidden except for a tiny hand emerging from the shelter of its mother's cloak) who are emigrating to "Australia's fields," according to a sonnet the artist wrote in conjunction with the picture. The painting was inspired by the emigration of a sculptor acquaintance, Thomas Woolner, to the Australian gold fields in 1852 and by Brown's own ephemeral notion, while in dire financial circumstances, of emigrating to India. The young man is Brown's self-portrait and the young woman is his wife. He considered this a historical painting on the subject of the emigration movement that

406. **FORD MADOX BROWN. The Last
of England.** *1852–55. Oil on wood panel.
32 ½″ × 29 ½″. City Museum and Art Gal-
lery, Birmingham, England*

culminated in the mid-1860s and intended it to express two
contrasting emotions at the last view of the homeland from
the deck of an emigrant ship: the brooding, melancholy
thoughts of the young couple and the resentment of the
man in the upper left who angrily shakes his fist at the
departing shore. An admirer of Hogarth, Brown carried the
earlier artist's example of social themes into the Victorian
age.

So intent was Brown to establish an air of absolute authen-
ticity to the scene that he painted it for the most part "in
the open air on dull days" in order to achieve the quality of
light characteristic of blustery sea air. The flesh tones, he
reports, were done on cold days. The thoroughgoing natural-
ism of the scene demonstrates the documentary obsessive-
ness to which he has surrendered, emphasizing every com-
monplace detail of ship and costume within range.

The pathos—pity and sympathy for the young couple—at
which the artist aimed was a quality frequently evoked in the

work of another artist of the nineteenth century: Vincent van Gogh, whose expressionistic style was absolutely diametric to the naturalism of the English artist. In *The Potato Eaters* (fig. 407), van Gogh wished to achieve an image of this family of poor peasants that would be the visual counterpart of the elemental roughness of their labor, digging the earth "with those very hands they put in the dish." A peasant picture, he felt, should smell of "bacon, smoke, potato-steam," and so it should not have a "conventional smoothness." With reference to the peasants painted by Millet, whose work he admired, van Gogh once remarked that they seemed "to have been painted with the earth they sow in."

407. **VINCENT VAN GOGH. The Potato Eaters.** *1885. Oil on canvas. 32 ¼″ × 45″. Kröller Müller Museum, Otterlo, The Netherlands*

This represents a new approach to the commonplace in art, one in which the technique itself—as well as the color, the quality of the line, and the character of the forms in the picture—is intended to be directly expressive of the painter's emotional attitude toward the subject, quite different from Brown's literal imagery. In van Gogh's painting, the rough life of the peasant has its equivalent in the roughness of the artist's mode of depicting the subject. The implication here is that an artist's style should be in accord with the nature of his subject, the logical consequences of which, if carried to the extreme, would be either to limit the artist to subjects for which his native style was suited or to impel him to alter his manner of painting according to the subject he was depicting. If such choices would appear to be less crucial when the artist's style is frankly naturalistic—in which case the viewer's own emotional response to the subject would depend relatively more on his predilections—it is also true that even under these circumstances the artist is not entirely neutral, as Brown demonstrates in *The Last of England;* for his exploitation of qualities of light, facial expressions, gestures, and even compositional arrangements can also influence the viewer's response.

This consonance of style and subject is achieved with unusual charm in Renoir's *Luncheon of the Boating Party* (colorplate 12), depicting a casual gathering of happy people under an awning at Bougival along the Seine. The flickering brushwork lays a radiance over the surfaces of forms that animates the mood of the painting as lightly as the breeze appears to stir the scalloped edge of the awning. The luxuriant color, rich in soft, filtered light, is the perfect ambience for this self-indulgent scene. This painting is not only one of the most engaging of hedonistic images; it is also one of the finest impressionist works, for as the transience of nature's light was a quality the impressionists courted, it is here caught with a relish reechoed in the subject matter itself.

Although the couple in *American Gothic* (fig. 408) by Grant Wood (1892–1942) would probably not have approved of Renoir's party, they illustrate the same harmony of style and

408. GRANT WOOD. American Gothic. *1930. Oil on beaver
board. 29 ⅞″ × 24 ⅞″. Courtesy of the Art Institute of Chicago
(Friends of American Art Collection)*

theme. Wood mingles a grim fidelity to the sober subject
with stylizations reinforcing that stiff-backed adherence to
the regimen of a way of life that constitutes the basic theme
of his painting. The pitchfork in the farmer's hand (which,
incidentally, holds it with familiar ease) takes on the appear-
ance of a ritual object, and the severe pattern of its tines
echoes the neat lines of the architectural background. The
geometric regularity of the clumps of foliage behind the
buildings also has its echo in the underlying geometry that
simplifies the forms and features of the couple, a striking
contrast to the forms in Brown's painting. Thus, the artist
has not only rendered an image of convincing reality; he has
also led the viewer toward recognition of a quality of life in
rural Iowa that the artist himself sensed with an intensity
that blended dispassionate objectivity with simplicity and

affection. The physical presence of ordinary people that Grant Wood projects so vividly in *American Gothic* reflects to some extent the artist's experience as a student in Munich, where he came under the spell of early Flemish and Gothic paintings (cf. fig. 179, p. 261, and colorplate 6) before returning to his native Iowa. The precision and concentration with which he depicts the homey details of his subject represent a legacy from his European experience but also serve as reminders (when we view the work in the company of figs. 403 and 416, pp. 529 and 545) of one significant aspect of the long history of the art of the commonplace: the degree to which it has been permeated by a fascination with objects.

This is probably only one concomitant of a more pervasive attraction to the challenge of representation itself, of being able to project on a flat surface the illusion of three-dimensionality and spatial extension. To render the image of an object in such a way as to elicit from the performance admiration for its verisimilitude, or to trick the eye (if only for a moment) into accepting the image as the thing itself, is a skill that has often been the subject of stories about artists as far back as ancient times. The root system of the tradition of still life painting—which is essentially an arbitrary assemblage of objects as the subject of a picture—reaches into this level of interest, for above all other manifestations of the art of the commonplace, still life has been preeminently the art of celebrating the object, or an arrangement of objects, for its own sake. Yet even here there are qualifications that must be made, for some still life objects, like musical instruments, fruit, or flowers, have often been charged with meanings beyond their generic identities to assume allegorical significance in the work of art.

Like genre painting, still life became a popular art form during the course of the seventeenth century, particularly in the Low Countries. But there are earlier examples of paintings that approach the still life in character. Although far from being still life painting in the strictest sense, the representations of offerings or food piled up like a pictographic

inventory on the walls of ancient Egyptian tombs (colorplate 1) have at least the ingredients of the art of still life. It was probably in ancient Greece, however, that still life painting as we know it began. Pliny the Elder tells of a Greek painter who, in addition to painting such humble subjects as interior scenes and donkeys, painted pictures of foodstuffs; and the story about birds flying down and pecking at grapes painted on a theater curtain by Zeuxis, while in all probability an embellished anecdote, points to the existence of a skillful imitative art of commonplace subjects close to still life and links the early history of still life to a naturalistic taste. In Roman times, a well-known floor mosaic depicted a clutter of leftovers from dining, as if scattered there on the floor after a banquet—not precisely a still life, but emphasizing the naturalism of the commonplace subject—and some Roman paintings like the one illustrated here (fig. 409) could properly be called still life.

Here the artist is not only intent upon representing various objects; he attempts to convey the sense of light-penetrated space as well. This type of painting seems to have been a plebeian art, as opposed to the more aristocratic taste for mythologies, and it appears to have enjoyed considerable popularity. It is probably related to another com-

409. Peaches and Glass Jar, *detail of a fresco from Herculaneum. Roman, ca.* A.D. *50. National Museum, Naples*

monplace art of the times, that of painted shop signs that signified with appropriate images the trade of the proprietor.

The art of the Middle Ages had little place for still life images except as ornamental details, but by the Renaissance the ancient attraction to the still life object was revived. Numerous examples can be found in paintings from both Italy and the north, where minor details (see figs. 192, 282, and 285, pp. 273, 389, and 395) begin to assert themselves as tangible objects.

Although not, strictly speaking, a still life but a "mini-landscape," the *Large Piece of Turf* (fig. 410) by Albrecht Dürer is so evocative of floral pieces that one is tempted to view it and other pictures of fragments of nature as still life of sorts. A botanist would have no difficulty in identifying the various grasses and plants in this scientifically accurate study. Such a work exemplifies northern naturalism at its most intense level and demonstrates the extent to which the

410. ALBRECHT DÜRER. Large Piece of Turf. *1503. Watercolor and gouache on paper. 16⅛″ × 12½″. Albertina Collection, Vienna*

most commonplace of subjects could attract the observant eye of the Renaissance artist.

In the art of marquetry or *intarsia* (inlays of various kinds of wood), still life had one of its most unusual manifestations in the Renaissance. Rising to popularity during the fifteenth century, *intarsia* was often the decoration for paneled rooms (fig. 411). On the walls, open cupboards and shelves filled with a variety of objects were depicted in carefully shaped and fitted inlays. The illusion of a ghostly reality emerging from the variegated brownish tones of the wood depended largely upon the tricks of perspective that fascinated the Renaissance artist. By the sixteenth century the art of *trompe l'oeil* painting (literally, "fools the eye"), which had much earlier achieved a high level of effectiveness in Roman wall painting (see fig. 111, p. 159), was flourishing in Italy and the north under the direct influence of Italian *intarsia*.

411. Detail of a Wall from the Studio of Federigo da Montefeltro. *1470s. Intarsia. Ducal Palace, Urbino (Alinari-Art Reference Bureau)*

412. JACOPO DE' BARBARI. **Partridge
and Arms.** *1504. Oil on limewood panel.
19¼" × 16½". Alte Pinakothek, Munich
(Bruckmann-Art Reference Bureau)*

A painting (fig. 412) by Jacopo de' Barbari (1435/36–
1511/16) is largely inspired by *trompe l'oeil intarsia* and by
the naturalistic art of the Low Countries and Germany with
which he had contact. The painting may have been in-
tended as an allusion to hunting and war, and it has been
suggested that it may have been related to another still life
by this artist that depicts a mandolin and a glass, possible
references to gentler pursuits. The possibility of an allegori-
cal meaning attached to the painting reminds us that still
life, however much it may have concentrated on the literal
representation of commonplace objects—game, flowers,
foodstuffs, and utensils—was also, in many sectors of its
history, an effective transmitter of allegorical messages.

A widespread variety of allegorical still life was the *vanitas*
type which, in one way or another, expressed the transitori-
ness of human existence. This might be conveyed by objects

413. JAN DAVIDSZ. DE HEEM. Still Life with Lobster. *ca. 1650. Oil on canvas. 25″ × 33 ¼″. The Toledo Museum of Art (Gift of Edward Drummond Libbey, 1952)*

like the human skull, an hourglass, or a burning candle. Such objects bore obvious implications for human mortality—examples of *memento mori* ("remember that thou must die")—while other approaches to the idea utilized an accumulation of objects that were by their very nature short lived. Flowers, for instance, were common metaphors for transience, although some varieties were also sacred symbols, like the lily associated with the virginity of Mary. Sometimes flowers were painted in conjunction with *memento mori* objects as a variety of the *vanitas* still life.

A still life (fig. 413) by Jan Davidsz. de Heem (1606–83/84) is probably an example of another, but related, type of allegory in which a choice array of foodstuffs is accompanied by

a watch, a reference to the Puritan ethic of temperance—the goods of self-indulgence together with a reminder that time extracts its tribute from human life. The visual message is at once evocative of the pleasures of the good life and of the admonition that there always be moderation in the pursuit of it. The butterfly, another symbol of the transitory, also appears in de Heem's painting, where it reinforces the idea conveyed by the watch.

Still life was also an appropriate vehicle for allegories of the five senses because it brought together the images of objects alluding to hearing, smell, taste, touch, and—obviously, considering that it was a visual art—sight. Other types of still life used objects like musical or astronomical instruments to signify the various arts or sciences. These meanings attached to pictures of inanimate or ordinary things were intended by the artist to give added significance to them and can be compared to the mythological or religious themes that frequently accompanied landscape paintings. There was, to be sure, some element of seeking justification for the commonplace in all this, but still life did not always require such reinforcements. Apart from the frequent veneer of allegory, still life painting, particularly in the Low Countries, also manifested a frank appreciation for the comfortable life and the sensual pleasures of the table without benefit of moralizing messages.

The portrait of "low life" types is another facet of the art of the commonplace; it is seen at its best in the work of Frans Hals (ca. 1580–1666), whose *Malle Babbe* (fig. 414) is a lively character study of a drunken old woman with an owl on her shoulder. From a technical standpoint alone—the spontaneous brushwork, the quick, summarizing statement—Frans Hals's work in this vein is appealing and of considerable importance to such nineteenth-century artists as Édouard Manet; but there is more to this work than just an impression of a common type. One might speculate whether the sounds of the old woman's carousing could be associated with the cries of this bird of night, but it has been convincingly demonstrated that other associations do indeed link the woman with the bird as something more than

414. FRANS HALS. Malle Babbe. *ca. 1650. Oil on canvas. 29½″ × 25″. Die Hexe von Haarlem (Bruckmann-Art Reference Bureau)*

a pet. There is an allegorical connection here comparable to the meanings sometimes conveyed by still life. While associated with Athena and her Roman counterpart Minerva as a symbol of wisdom, the owl had other, less complimentary, roles to play. As a bird of darkness who shunned the light, it was also a symbol of sin. From this unenlightened condition other meanings—stupidity and foolishness—were not far off. The owl was also a symbol of vulgarity and drunkenness: "drunk as owls," as the saying goes. It is to these latter aspects of owl symbolism that the bird and the foolish *Malle Babbe* relate.

Some still life paintings customarily viewed as easel pictures have actually served utilitarian purposes of a very ordinary nature—as doors to cupboards or as fire screens placed in openings of fireplaces when these were not in use. For exam-

415. CAREL FABRITIUS. The Goldfinch. *1654. Oil on wood panel. 13 ¼" × 9". Gemäldegalerie, The Hague (Bruckmann-Art Reference Bureau)*

ple, *The White Tablecloth* (ca. 1760) by Jean Baptiste
Siméon Chardin (1699–1779), a painting now in the Art
Institute of Chicago, was once such a fire screen. The pic-
ture's high angle of vision, as if the viewer were looking
down at it from a few feet away, was appropriate to its
position in the opening of a fireplace. *The Goldfinch* (fig.
415) by Carel Fabritius (1622–54) was formerly a door to a
small cupboard or cage. While not a still life in the strictest
sense, the *trompe l'oeil* character of Fabritius's picture links
it to the still life tradition. Its touching intimacy depends in
part on the viewer's sympathetic response to the tiny crea-
ture chained to its perch; but the experience is fortified by
the *trompe l'oeil* nature of the image, with the panel on
which the picture is painted rendered as if it were the
light-struck wall itself, so that the perch and its occupant
appear to be projected out into the viewer's own space. The
presence of the bird thus asserts itself more positively, ac-
quiring unusual visual "weight" within its austere context.

**416. JEAN BAPTISTE SIMÉON CHAR-
DIN. Pipe and Vessels for Drinking.** *ca.
1760–63. Oil on canvas. 12½″ × 16½″.
The Louvre, Paris (Agraci-Art Reference
Bureau)*

Even inanimate things can sometimes acquire remarkably evocative identities. One is reminded of the French writer Marcel Proust, for whom associations linked to a madeleine and a cup of tea triggered the memory of his youth. Chardin, also an important genre painter, whose work Proust admired, was keenly aware of this silent life of things and his still life *Pipe and Vessels for Drinking* (fig. 416) endows the most ordinary objects with significance. As his personal symbols of domestic serenity, the articles in the painting seem invested with sentiments akin to those one occasionally attaches to souvenirs valued for their associations with treasured memories or comfortable habits. The softened granular surfaces of his forms, here marshaled in dignified orderliness, seem to soak up the light and transform it into a part of their own substance, giving back to the visual experience an empathic energy very close to a feeling of pathos.

This aura of quiet drama, implying that the human presence lingers while temporarily absent, has sometimes been invoked by interior scenes that approach the still life in character, being empty of human occupants. This mood is captured in the fleeting impression of a *Room with Balcony* (fig. 417) by Adolf von Menzel (1815–1905), painted early in his long career. The quick notations of his brush are like prefigurations of the later impressionists in France. Light pours into the room, animating its surfaces; the curtain stirs in the air from the balcony; and the silhouette of the empty chair invites. The space is no mere emptiness but is itself a waiting presence.

The evocative moods of commonplace interiors have long attracted the American artist Andrew Wyeth, whose paintings transform the ingredients of sentimentality into memorable images that hint quietly of time's erosive will and the forces of nature that implement it. He infers their processes through depicting the marks they leave on ordinary things left exposed and vulnerable. In *Wind from the Sea* (fig. 418), we have the obverse of Menzel's inviting room, and although we can see only a small fragment of the interior space the visual clues are sufficient to evoke the rest of the

417. ADOLF VON MENZEL. Room with Balcony. *1845. Oil on paper. 23″ × 19″. National Gallery, State Museum, Berlin*

418. ANDREW WYETH. Wind from the **Sea.** *1947. Tempera. 18½″ × 27½″. Private Collection*

barren room. The cold sky, reflected in the sliver of water, the dark, low line of trees, the brown field, and the wind's presence as it blows the sun- and rain-rotted curtain and lifts the brittle window shade define his elegiac theme in matter-of-fact tones.

One is reminded, in this last series of paintings of ordinary objects and places, of how much our lives are involved with things, with the familiar sensations we miss when we are in strange surroundings for an extended period of time, and the reassuring comfort of habits that refuse to be dislodged by the novelties of new pleasures and places we may deliberately seek. The art of the commonplace, when one reviews its variety in historical perspective, is surely evidence of man's incessant fascination with the world around him and confirmation, too, of the possibilities for aesthetic experience that lie in the simplest things and the most ordinary human situations. We will see other manifestations of the art of the commonplace in the chapter on twentieth-century art.

13 ART, PROPAGANDA, AND PROTEST

We are so accustomed to thinking of works of art as signifi-cant cultural objects enshrined in museums and histories of art or as precious commodities offered to the clientele of art dealers that we tend to overlook the fact that art has often been deployed as a social or political weapon. Throughout history, art has promoted or attacked numerous causes, and a vast amount of the world's artistic production—now some-what neutralized by exhibition walls and the passage of time —once functioned as propaganda (or, in the broadest sense of the word, persuasion) and, in substantially fewer and more recent instances, as a means of protest. In either case, its function was to draw its intended viewers into accord with the ideology or point of view expressed through its imagery. In some instances the same image might serve as an instrument of both propaganda and protest.

These social and political uses of art have proliferated during the past two centuries as the natural accompaniment to the confrontations of modern society in which, in every public medium available, individuals and institutions persistently, even desperately, have advanced their competing interests. As the channels for the expression of these interests have multiplied—the daily press, periodicals, the documentary capabilities of the photograph, the film, television, the pub-lic display of art, and overall the rapidly developing tech-niques for the mass reproduction of images—it is to be expected that these channels would carry a heavy traffic of messages.

We have already seen in earlier chapters a variety of images whose intent was to promote ideologies, institutions, even

individuals. Several artists (see figs. 220, 221, 222, and 225, pp. 312, 313, and 315) served Napoleon Bonaparte in capacities that can be considered propagandistic in that they helped to identify his person with the archetypal image of the national hero or to present him as a paradigm of imperial majesty. Sculptures of George Washington by Houdon and Greenough (see figs. 223 and 224, p. 314) likewise have their propagandistic coloring. While no stretch of the imagination could equate the specific roles and ambitions of Bonaparte and Washington, the functional aspects of their images in art share some common ground as they elevate their subjects above ordinary mankind. At the same time, the image of a relatively obscure individual (see fig. 238, p. 329) can be called propagandistic to the extent that it proclaims the virtues of a work ethic through which an ordinary man may rise to prominence and wealth within a democratic society. On a larger scale, in the didactic output of Soviet art, the worker and the soldier have assumed aggressive proportions as the symbols of selfless service to the state. Despite the differences in the systems they represent, the images of Pat Lyon and a Russian worker share common ground.

It could even be argued that all art in the service of religious institutions, all art celebrating nationalistic themes or sponsored by ruling dynasties, and perhaps all art with a moralizing intent constitute to some extent instruments of propaganda. For example, the military exploits of Assyrian kings, carved in relief for the walls of their palaces to record their conquests and to impress the viewer with the invincibility of the king, were patently propagandistic in tone (see fig. 80, p. 107); episodes from the Roman emperor Trajan's campaigns carved on his column in Rome not only recounted but glorified his victories in the field; the Roman triumphal arch, erected throughout the empire, was a conspicuous reminder of imperial power that subsequently spawned a host of similar monuments around the world, ranging from such permanent nationalistic symbols as the Arc de Triomphe de l'Étoile in Paris to temporary decorations for festivals celebrating the visits of royalty to European cities (see fig. 256, p. 352); the glories of Gothic art—the cathedrals, their sculpture and stained glass—were artistic fields of praise for what was conceived as a higher power than secular authority;

the time-honored prestige of classical architecture was held a fitting form with which to convey a message of strength, dignity, or beauty deemed appropriate to a wide variety of institutions from governmental agencies to libraries, banks, museums, and universities, as can be seen in buildings around the world. The list could go on and on.

The propagandistic connotation of architecture has always been a feature of that art, since the intimidations of sheer size, impressive spaces, and lavish surroundings impose on the viewer caught in the architecture's ambience messages that make him aware of the authority, resources, and underlying ideas necessary to produce and maintain such edifices (see figs. 197 and 318, pp. 280 and 427). Particularly in the case of religious architecture, the symbolic significance of a structure may be a dominant feature of its architectural purpose (see pp. 277–88) and thus carry to the beholder a message of awe-inspiring content. This symbolic aspect may even, in some secular architecture, become as important to its sponsors as the efficiency of the structure in its role of accommodating the specific activities—educational, governmental, mercantile—for which it was supposedly designed. Its message-bearing function thus becomes a domineering silent partner to its operational function.

This propagandistic aspect of architecture sometimes bears a curious kinship to the art of the theater, since it may develop a dramatic sequence for the viewer within the dimensions of time and space and lead him through a series of spatial episodes to a climax. One of the most impressive examples of this unfolding of an architectural drama, conceived over the centuries of its construction as an experience to impress the beholder with the grandeur of the papacy and its spiritual outreach, is the complex of St. Peter's, Rome (fig. 419). When it was completed, one entered the embrace of the piazza from small streets, in what must have been a sudden and elevating sweep of space. As it stands today, with the recent clearing of buildings from the area between it and the Tiber, one approaches the complex along the broad Via della Conciliazione for several blocks, the Basilica of St. Peter's looming ever nearer. Then the space opens out

419. St. Peter's, Rome. *Nave and facade by Carlo Maderno, 1607–15; colonnade by Gianlorenzo Bernini, designed 1657.* *(Alinari-Art Reference Bureau)*

into the arms of Bernini's colonnades to define the large oval of the Piazza di San Pietro with its two fountains and central obelisk. Then—Roman traffic permitting—one can traverse the piazza itself or seek the curving shelter of the colonnades. From the large trapezoidal piazza beyond the colonnades, one mounts the steps to the basilica itself—the exterior climax—and enters the church where this long axial movement through the exterior space of the complex gives way to a brief interlude in the counteraxis of the portico-narthex. From here one can enter the nave and come out eventually under the crescendo of space capped by the great dome, under which looms Bernini's *baldacchino*, the huge

bronze canopy that shelters the main altar, behind which is Bernini's splendid *Throne of St. Peter*, the architectural and liturgical climax of the interior. It is difficult to imagine anyone entering this architectural drama and remaining unmoved by its sequence of expanding and contracting spatiality that drives toward the final climax under the dome.

The propagandistic role that architecture often assumes or has thrust upon it has borne from time to time the brunt of acts of protest. As a symbol of an institution or an idea against which some faction in society may be contending, its destruction or desecration may become a ritual of exorcism for the contending faction. In this sense, many events of distinctly different character—the destruction of Carthage by the Romans, of the Bastille by French revolutionaries, and of portions of the Watts area in Los Angeles by rioting black residents—bear some relation to each other as symbolic acts in which deep resentment and protest were among the active ingredients.

Whereas architecture bears its persuasive message by inference, painting and the graphic arts have characteristically come more directly to the point when employed for purposes of propaganda or protest. Against the background of the revolutionary era in Mexico during the early decades of this century, for example, the Mexican "renaissance" of mural painting was strongly politicized as propaganda for the ideals of the revolution and thus stands in public buildings as a constant reminder to the Mexican people of the agonies attending the birth of their modern nation and their heritage from pre-Hispanic times, frequently alluded to in the themes and style of the murals themselves. In frescoes for the National Palace in Mexico City (fig. 420), Diego Rivera (1886–1957) packed the space with an assemblage of figures representing the entire history of Mexico from the vision of an ancient golden age under the god Quetzalcoatl through periods of conflict to what the artist conceived as a modern golden age in the new Mexico.

A similar nationalistic emphasis inspired in part by the Mexican example runs through many of the surviving murals in

420. **DIEGO RIVERA. History of Mexico,** *central bay. 1929–35. Fresco. National Palace, Mexico City. Art Division, The New York Public Library (Astor, Lenox and Tilden Foundations)*

the United States dating from the depression years and sponsored by the Works Progress Administration as part of federal support for the arts in a period of economic crisis. In these murals, Mexican and American alike, a frequent characteristic is the massiveness and physical energy projected by the human protagonists, as if the messages of praise or social protest could be carried only by physically powerful, dynamic images. If in some instances the pictorial rhetoric seems shrill and overblown as we see it in retrospect, its intensity is at least an index to the high feelings that prevailed when the images were created.

A variety of mural protest that happens, at the same time, to be an act of affirmation can be seen today in many American cities. It is a part of the efforts of urban minorities to find visible public channels through which they may signal their discontent, their social and economic frustrations, and their search for identity. The bleak walls of buildings become supports for murals carrying messages from the people of a neighborhood, as in *The Wall of Dignity* (fig. 421) in Detroit, a brick wall facing a vacant lot decorated with panels depicting the history of black people.

Such a wall as this once was—a barren feature of the ghetto landscape—served the American artist Ben Shahn (1898–1969) as a poignant, evocative background—a bricked-up sky—in his painting of a boy playing ball in an empty lot (fig. 422). The juxtaposition of the youth and his environment is a poetic indictment of surroundings that undernourish the human spirit; like *The Wall of Dignity* in its more aggressive and public way, it mingles protest with affirmation.

In an unconventional statement of protest, the artist Mel Edwards (b. 1937) created an environment (fig. 423) for an exhibition at the Whitney Museum of American Art. The portion of the environment shown here joins the wounding connotations of barbed wire and chain to an image evocative of a rising stage curtain as the festoons of chain, suspended by the wire, recall the gathering of a curtain's lower edge as it is carried aloft. This barrier of linear rhythms, at once fragile and brutal in a purely linear sense and inert and

421. Wall of Dignity, *Detroit, 1960s. Painted brick wall. (Photo: J. Edward Bailey III)*

*Hoplessness.
Ghettos ore possable anyplace*

422. BEN SHAHN. Vacant Lot. *1939. Tempera on board. 19″ × 23″. Courtesy of the Wadsworth Atheneum, Hartford (Ella Gallup Sumner and Mary Catlin Sumner Collection)*

423. MEL EDWARDS. Curtain for William and Peter. *1969. Barbed wire and chain. ca. 8′ × 19′. Collection of the artist*

aggressive as material substance, is a symbolic gesture. Like so many "cool" assemblages in contemporary art, it is visually minimal, but it communicates meanings that force the viewer beyond its material leanness.

As an art form, the mural, by virtue of its great size and public location, is ideally suited to explicit sociopolitical messages; but works on a smaller scale may also serve similar purposes. Genre painters, for instance, have often found subject matter in social and political themes and presented them in such a way as to lend their work some tinge of propagandistic functions. *The Verdict of the People* (fig. 424) by the American artist George Caleb Bingham (1811–79) is on the surface an ordinary genre painting of the American scene in the mid-nineteenth century; but however much it may be an informed observation of frontier society, developed from the numerous drawings from life Bingham characteristically employed, the painting is not without an editorializing purpose as it subserves the idea of a grass roots democracy selecting its own leadership. But Bingham's paintings on political themes are not one-sided panegyrics, for, as one can see in a related work like *The County Election* of 1851–52 (St. Louis Art Museum), he frankly indicated the hard cider and whiskey influence in garnering cheap votes. In such instances the nationalistic propaganda is modified by a quiet vein of protest. Bingham's orderly classical compositions, merging masses of people into well-knit groupings in dignified architectural settings, infuse the implied messages with an air of consequence.

Political commentary of a more obvious kind found its natural expression in another art form.

"Well, what are you going to do about it?"
The effective answer to this challenge by politician William Marcy Tweed, whose corrupt organization dominated the politics of New York City between 1866 and 1871, came partly from the hand of a German-born cartoonist, Thomas Nast (1840–1902). Nast's cartoons in *Harper's Weekly* castigating the Tweed ring (fig. 425) contributed to the downfall of Boss Tweed as ruler of New York's Tammany Hall, the seat of a social and patriotic organization that had be-

424. GEORGE CALEB BINGHAM. *The Verdict of the People.* *1855.* *Oil on canvas.* *45 ½″* × *64 ¼″*. *Collection of the Boatmen's National Bank of St. Louis*

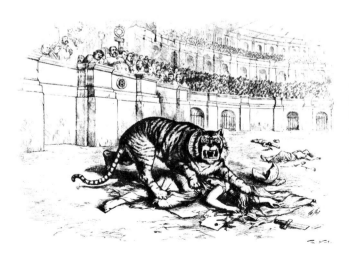

425. THOMAS NAST. The Tammany Tiger Loose—What Are You Going to Do about It? *from* Harper's Weekly, *11 November 1871. Cartoon. Prints Division, The New York Public Library (Astor, Lenox and Tilden Foundations)*

come increasingly political since its late eighteenth-century beginnings. During the campaign against him, generated by the New York press, Tweed was less concerned over the newspaper articles—since a large number of his adherents were illiterate—than he was with "them damned pictures" by Thomas Nast. Partly as a result of the array of anti-Tweed journalism, Tammany forces were defeated in the 1871 elections, and in 1873 Tweed himself was sentenced to prison, where he died in 1878 after one escape that was foiled when Spanish authorities, apparently aided in their identification of the fugitive by a Nast cartoon, returned him. As Tweed sensed instinctively, the advantage of the cartoon image as a journalistic weapon lay in its graphic clarity, in its capacity to link up in a flash a whole series of associations in the viewer's mind. The efficiency of the cartoon in distilling a message into an immediate and succinct communication assured its widespread use as a medium of both propaganda and protest. Both of these factors are obvious in Nast's image: it protests the rapacity of the Tweed ring, symbolized by the Tammany tiger, and evokes the emotionally charged image of Christians being slaughtered in the Roman arena to label Tweed, depicted in the role of arrogant emperor, as the personification of evil power.

Whereas some cartoons like this might have the effect of stirring the viewer to quick anger against some antagonist

426. HONORÉ DAUMIER. Gargantua, *from* La Caricature, *15 December 1831. Lithograph. 8 ½" × 12".*

or situation, others have taken a different approach, equally effective, by subjecting "the enemy" to the erosive consequences of ridicule. No practitioner of this art has been more adept than Honoré Daumier. His cartoon of the French king Louis Philippe as a gluttonous Gargantua literally devouring the resources of the nation (fig. 426) and the cumulative effect of this and other works in which he attacked the bourgeois monarch, whose unfortunate physique and features were easily caricatured as pear-shaped forms, earned Daumier six months in prison for his political *esprit.* Although he had numerous predecessors in the field of satirical cartoons, particularly in England, Daumier's tremendous production of political and social satire from the 1830s into the 1870s in the Paris journals *La Caricature* and *Le Charivari* firmly established political and social cartoons as institutions in the field of journalism.

But Daumier's art reached beyond the ordinary levels of journalistic satire, for it was nourished by deep veins of humanity and psychological insight. He created an entire society of human images whose situations, drives, and revealed characters constitute an encyclopedia of the human condition. His grasp of the human form as an expressive vehicle has been likened to that of Michelangelo, as the artist Charles François Daubigny (1817–78) sensed when he saw the Sistine Chapel frescoes and exclaimed "Daumier!" Rising to a trenchant commentary on humanity's foibles that rivals Aristophanes, Daumier exercised a rare capacity for enlarging specific social and psychological situations by imbuing them with universal significance. The cutting edge of his wit was consistently tempered by his sympathy for the vulnerability of the human spirit. He blended malice with pathos, the comic with the tragic, to a degree that ranks him (along with Molière and Cervantes, whom he admired) among the great social commentators of all time.

Daumier's sympathy for the human struggle led him, quite naturally, to admiration for Rembrandt, whose example is also apparent in the juxtapositions of light and shadow that often infuse his works with dramatic character. None of Daumier's works hints more strongly of this affinity than his

427. **HONORÉ DAUMIER. The Third-Class Carriage.** *1862. Oil on canvas. 25 ¾″ × 35 ½″. The Metropolitan Museum of Art, New York (Bequest of Mrs. H. O. Havemeyer, 1929. The H. O. Havemeyer Collection)*

painting *The Third-Class Carriage* (fig. 427), in which the physical confinement of a railway compartment brings people together for a time but leaves them essentially alone in their self-contained worlds. A quiet understatement, this painting nevertheless takes its place as one of the most eloquent dramatizations of a pervasive loneliness in the midst of the urban crowd.

Sympathy for the unfortunate social and economic status of classes of people has been the functional aim of many works of art during the past two centuries. Jean François Millet

painted many pictures of the peasant life he observed in the vicinity of the village of Barbizon on the borders of the forest of Fontainebleau not far from Paris. Although many of these works seem to dignify the simple lives of these people close to the soil and to lend them heroic stature as they loom against expanses of field and sky, some are invested with a contrary theme that deplores the extent to which unremitting labor on the edge of poverty can brutalize the human soul. Such a work is his *Man with the Hoe* (fig. 428), which equates physical weariness with spiritual exhaustion and barrenness—a document of protest.

428. JEAN FRANÇOIS MILLET. **Man with the Hoe.** *1859–62. Oil on canvas. 32″ × 39½″. Private Collection, San Francisco (Photo: Courtesy of the M. H. De Young Memorial Museum, San Francisco)*

Such missions as this have been dramatically exemplified in the work of some photographers who have engaged in documenting the lives of the working classes. One of the most eloquent in this category is the work of the American photographer Lewis Hine (1874–1940), whose *Child in a Carolina Cotton Mill* (fig. 429) is a visual editorial on the conditions of child labor. His visual means are as thrifty as the implications of the image are manifold. A young girl, whom he intends the viewer to perceive as a slave to the monotony of her factory hours, tends the ranks of humming spindles. He has selected an angle of vision that emphasizes the long console of machinery and isolates the figure of the child against its impersonal presence. The very fact that this is an unembellished slice of life makes his image all the more poignant and effective. Hine first began to use the camera

429. LEWIS HINE. Child in a Carolina Cotton Mill. *1908. Photograph. International Museum of Photography at George Eastman House, Rochester, New York*

in 1903 and, drawn to social commentary, was soon photographing immigrants as they arrived at Ellis Island. Later he followed up the immigrant population as it settled into a life of factory labor and tenement dwelling. The photograph shown here is from a series published between 1907 and 1914 for the National Child Labor Committee, part of a reform movement.

Equally resonant with empathy for the victim of social injustice is *Wanted Poster #6* (fig. 430), a painting by the black artist Charles White (b. 1918). Emerging from a matrix of flags overlaid with stenciled legends such as might be affixed to crates of cargo, but which are in fact excerpts from that portion of the Constitution of the United States concerning the return of fugitive slaves before the Civil War, the images of sad-faced black youths confront the viewer like fragments of a dream. White studied in Mexico with muralists David Alfaro Siqueiros (see pp. 566–68) and Diego Rivera and has himself painted murals on the theme of black people in American life and history, works that reflect his acquaintance with the art of the Mexican masters. His more recent works, generally in black and white media, are developed with his personal blend of striking realism and rich tonalities. The protest is angry but controlled and more often than not surmounted by the artist's commitment to the idea of human dignity.

No target of protest has engaged some artists more completely in recent centuries than the horror and tragedy of war. Once a subject that held quite different appeals for artists—acts of courage and heroic sacrifice, the spirited movement of horsemen in battle—more and more, as military conflict was divested of its old chivalric aura, the theme of war began to haunt the arts in less attractive forms.

Beginning with the seventeenth-century war prints of Jacques Callot (1592–1635), which treated the darker aspects of the subject with unprecedented objectivity (fig. 431), the way was opened in art to protests against the evils of war. The most familiar of these is undoubtedly *The Disasters of War*, a series of eighty-five etchings created by Fran-

430. CHARLES WHITE. Wanted Poster #6. *1969. Oil on board. 59″ × 27″. Private Collection (Photo: Forum Gallery, Inc., New York)*

431. JACQUES CALLOT. The Pillage of a Farmhouse, *from* **Les Grandes Misères de la Guerre.** *1633.*
Etching, second of three states. 3 ¼" × 7 5/16". Cincinnati Art Museum (Bequest of Herbert Greer French)

432. FRANCISCO GOYA. For That You Were Born, *plate 12 from* **The Disasters of War.** *1810–12.*
Etching and lavis. 5" × 7½". The Metropolitan Museum of Art, New York (Harris Brisbane Dick Fund, 1932)

cisco Goya between 1810 and 1813 but not published until 1863, long after the artist's death.

The Disasters of War consists of three groups of plates, the first and largest group being episodes from the fighting between Spanish patriots and troops from Napoleon's armies in the years between 1808 and 1813. The second group of plates depicts the tragedies of the winter of famine in Madrid (1811–12), and the final group is a series of fanciful allegories on the inhumanity and horror engendered by the war. Although the work of a Spanish patriot, *The Disasters of War* reaches beyond partisan propaganda that praises the fighting spirit of the Spanish people confronting a foreign invader. While Goya may sometimes dramatize the machinelike implacability of French execution squads and the lust of French troops killing and raping noncombatants, he also brings the conflict down to incidents in which individual acts of violence stand out as documents of human brutality on both sides. The underlying theme of man's inhumanity to man emerges with eloquent simplicity and directness.

In the twelfth plate of the series (fig. 432), a man vomiting blood staggers drunkenly at the edge of a grotesque tangle of bodies that he will soon join. An ominous cloud of smoke rises from behind the pile of corpses like some hovering evil presence. The ironic title, *For That You Were Born*, completes the message of protest. It seems irrelevant to ask whether the man is Spanish or French. Elsewhere, as in the thirty-ninth plate (fig. 433), the visual message may be even more brutal, and the title—*Brave Deeds against the Dead* —is bitter and scornful. These are more than factual reports, for they record the revulsion of a sensitive individual toward the brutishness of which his fellow creatures are capable in images of agonizing protest at a time in history when other artists (see figs. 221, 222, and 234, pp. 313 and 325) were depicting the events of the Napoleonic Wars in tones of romantic heroism.

The contrasting modes continued. In the twentieth century, wrenched again and again by wars around the world, pro-

433. FRANCISCO GOYA. Brave Deeds against the Dead, *plate 39 from* **The Disasters of War.** *1812–15.*
Etching and lavis. 6 3/16″ × 8 3/16″. The Metropolitan Museum of Art, New York (Rogers Fund, 1922)

tests dramatizing their terror have mingled with images proclaiming the heroism of patriotic sacrifice and posters urging each side to its duty, denouncing the atrocities of the enemy. In these efforts, the public art of the film has been an effective means of propagandizing the desired responses in times of war and, in the reflective aftermaths, of promoting antiwar sentiments—a recurring cycle of conflicting emotions.

A painting that dramatizes the plight of the innocent victim is *Echo of a Scream* (fig. 434) by David Alfaro Siqueiros (1896–1974). Intensely expressive in its shrill, phosphorescent weavings of light, it employs a realistic technique in the

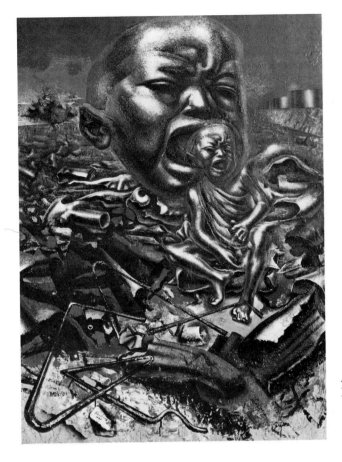

434. DAVID ALFARO SIQUEIROS.
Echo of a Scream. *1937. Duco on wood*
panel. 48″ × 36″. Collection, The Museum
of Modern Art, New York (Gift of Edward M.
M. Warburg)

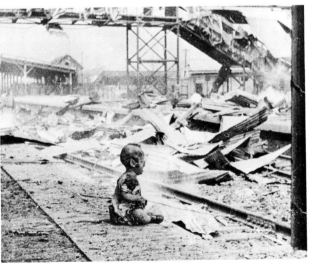

435. H. S. WONG. Chinese Baby Sitting
in Bombed Ruins of Shanghai's South Sta-
tion. *17 September 1937. Photograph. UPI*

rendering of the terror-stricken child; by repeating the child's head, much enlarged, it thrusts upon the viewer a visual crescendo that evokes the sound itself.

Siqueiros's image recalls the photograph of a Chinese baby sitting, dazed and crying, in the bombed ruins of Shanghai's South Station, a portion of a newsreel sequence taken by cameraman H. S. Wong at the time of the Japanese attack on 17 September 1937 (fig. 435). The image was surely selected for its appeal to the emotions of the potential viewers—some 136 million, it has been estimated. The modern mass media of newsreel and newspapers that displayed it initially (and *Life* magazine, which reprinted it) provided this picture an exceptionally wide audience and aroused sentiments ranging from compassion for the pathetic infant to antiwar feelings and condemnations of Japanese aggression that were often in themselves emotions of violence. As a demonstration of the effectiveness of mass media imagery, this picture was a dramatic success. It demonstrated, too, the peculiar efficiency of the photographic image as a medium for propaganda and protest, for it projected that special ambience peculiar to the photograph—the knowledge that it is a directly recorded fragment of reality, regardless of the selectivity of the photographer's eye, as if the image had, in effect, recorded itself.

The newspaper medium and the photographic image are both relevant factors in another work from the same year as these last two pictures: Pablo Picasso's *Guernica* (fig. 436). Although Picasso's choice of a black, white, and gray palette may owe something to the example of Goya's *Disasters of War*, the rows of vertical strokes in the body of the wounded horse evoke the image of newsprint, so often a feature of cubist collages in which actual cuttings from newspapers were often pasted on the canvas, a technique used in some of Picasso's own earlier works. It was also from the news media that Picasso learned of the incident that moved him to select this subject for the mural he had been commissioned to prepare for the Spanish Pavilion at the Paris World's Fair. The news reports of the bombing of the Basque town of Guernica by General Franco's air forces on

28 April 1937 was the catalyst that decided the theme of Picasso's creative effort. The result was a rhetorical outburst of expressive forms adapted to cubist planar devices (cf. fig. 380, p. 501, and colorplate 23) already embedded in Picasso's visual vocabulary, forms that also utilize some of the distortions wrought by the camera lens when objects thrust close are abnormally enlarged. Picasso had exploited this phenomenon earlier to achieve an equivalent for movement, particularly in his pictures of bathers cavorting on beaches. The exaggerated stretch of some of the gestures in *Guernica* derive, in part, from these earlier images. Indeed, the genesis of *Guernica* goes back far beyond 1937, for the forms that emerged in the multitude of sketches, studies, and in the large canvas itself can be traced to prototypes in several works executed during the previous two decades and called up spontaneously in the furious pace he set while developing *Guernica.* Concentrating on the terror of civilian victims of war, as Goya had done in some of the *Disasters of War,* Picasso created an image that has since become a symbol of impassioned reaction to the character of modern warfare, even though—unlike Goya—he was physically far removed from the incident that provided his subject.

If *Guernica* was to some degree a spontaneous explosion of

436. PABLO PICASSO. Guernica. *1937. Oil on canvas. 11′5 ½″ × 25′5 ¾″. On extended loan to The Museum of Modern Art, New York, from the artist*

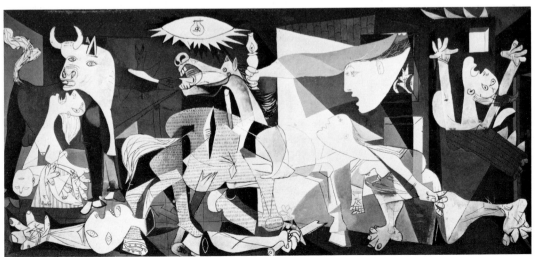

the artist's anger, its intensity registered in the stabbing lines and aggressive shapes, it was also a calculated allegory. Picasso himself has pointed out the significance of the bull as a symbol of darkness and brutality and of the horse as a collective metaphor of the people who are its victims— exemplified more obviously, at another level, in the screaming mother holding her dead child in the shadow of the dark body of the bull. Curiously enough, considering the modern idiom in which it is painted, certain aspects of the *Guernica* combine with its general theme and the allegorical elements that support it to bring the work into a main current of Western art close to the traditional field of history painting (cf. figs. 222 and 369, pp. 313 and 488). The painting's size is characteristic of the latter genre, while the overt triangular massing of forms with its apex at the outstretched hand holding the lamp evokes the long classical tradition of Western art by recalling the arrangement of sculpture in the gables of Greek temples or a favored compositional scheme of the High Renaissance. There is perhaps a sardonic note in this.

The deliberate use of art as an instrument of propaganda or as a means of protest results in a very public art, for it demands a wide audience for maximum effectiveness. At times, as we have seen, its message may be bold, even shrill; but the most pervasive form in which we encounter it is one of gentler persuasion. Today this latter form of propagandistic art is so widespread that scarcely anyone in technologically advanced societies is untouched by it. The entire range of commercial art, for example, is a ubiquitous presence advertising goods and services in newspapers, magazines, mailings, window displays, book jackets, and television commercials. Whether one is inclined to consider all these "serious" art or not, it is clear that they are active forces in everyday life and evidence that image making vies with the spoken and printed word in exercising considerable influence on the desires and opinions of human society.

CHAPTER 14
IMAGES OF FANTASY

All of us live in two worlds—an exterior world of more or less rational relationships, of simple causes and effects that we understand and to which we accommodate ourselves as we function in our familiar social contexts; and an interior world of fantasies, dreams, and unresolved relationships we do not as yet comprehend. These two worlds do not constitute an unequivocal duality, however, for they interpenetrate, blurring the boundaries of human experiences.

What we popularly call "experience" is the ongoing mental process of receiving, sorting, and filing the stimuli and messages that come to us from our daily lives. The accumulation constantly impinges on each subsequent moment of our existence; the dominant relationships shape the pattern of our thoughts and actions. Thus the experiences of both exterior and interior worlds mingle in our consciousness, though some of their blended elements are buried so deeply that they seldom rise to the surface; when they do, their forms may seem strange or even disturbing to the more regularly exercised patterns by which we live. These unfamiliar configurations, which can be made tangible through art, belong to the realm we variously call "fantastic" or "irrational."

But we must distinguish, in images of fantasy, between the strange realm that is born of private fantasies and remains unique and the realm of what we might call a tradition of fantastic art. This is not to say that ancient forms belonging to this tradition—sphinx, Chimera, griffin, centaur, and the like—did not originate in the interior regions of a human imagination, but only that their continued reappearance in

art constitutes not a series of new creations but the ongoing existence of a fantastic image modified only by stylistic changes as the centuries have passed. Nevertheless, this tradition of fantastic imagery has given impetus to the imaginations of those who have fashioned their own variations of it, so the process is continually being renewed by each subsequent issue of mankind's wilder adventures in creative imagination.

The sources for fantastic art are embedded in the trappings of myths, legends, folklore, superstitions, dreams, hallucinations, and the deliberate, sometimes playful, flights of artistic imagination. Western civilization has been so thoroughly pervaded by the force of the Greek "miracle"—rational knowledge—that reason, logical relationships, and orderly development of ideas have become fundamental criteria for our conceptions, often relegating free associations and wild leaps of the imagination to the limbo of the unreal. But, in the visual language of art, challenges to reason have a special reality of their own. Surely mankind's imaginative capacity to assemble fragments of experience into new patterns is one of the bases of all creativity in the arts; but the force of imagination assumes special significance when it reaches beyond the relatively familiar and credible images of the exterior world directly perceived by the senses or known indirectly through scientific or historical record. For centuries artists have explored both exterior and interior worlds, and for some the strange interior spaces—their luminosities as well as their shadows and mysteries—have proved the more fascinating field for image making.

In the ancient world the human imagination produced numerous fantastic and hybrid forms—monsters and gods of mixed human and animal characteristics—as the questions posed by the mysteries of the natural world were answered in terms of tangible analogues for the intangibilities of nature (see pp. 115–16), often, it should be noted, with considerable logic in the selection of appropriate attributes. Demons and spirits were conceived as resident forces within natural phenomena, and they assumed a great variety of appearances ranging from the ideal to the monstrous. Over

the centuries the more fantastic of these ancient images, handed on from civilization to civilization, preserved in sculpture, painting, architectural decoration, and the minor arts, have resurfaced again and again and mingled with later fantasies. The denizens of a nightmare born of the fear of darkness and the unknown, the tortures of guilt, or the threat of hell have augmented the repertoire of fantastic imagery. Indeed, there has been a persistent connection, in the Western world, between fantastic images and the idea of evil. The Fall of Man and the rebel angels, Christianity's apocalyptic theme of a final judgment and punishment of mankind, and the Christian's dread of Satan's efforts to ensnare the human soul are themes in which this connection is manifest, and they have fostered a fair share of imaginative art.

Fantastic imagery, however, has not invariably assumed a nightmarish character: it has also found a place in visions of paradise and heavenly spheres. These two polar flights of human imagination—the vision of a lovely paradise and the nightmare of hell—have been energized in part by considerations of human conduct and are to some extent symbols of reward and punishment. As darkness and terror become the natural ambience of evil's minions, light and loveliness permeate the heavenly image and fantasies of unearthly splendor have sought to reflect the idea of a divine perfection. When translated into images of earthly paradises, the interior vision gives its luminous coloring to an idealized garden bathed in divine light and full of flowering meadows, crystalline waters, and trees of ripening fruit. Small wonder, then, that the first Westerners to view the islands of the Pacific fancied themselves in a rediscovered Eden (see pp. 484–92).

Whereas these particular contrasting fantasies of the lovely and the horrific can be placed in relatively obvious contexts, others are more elusive. The possible metaphoric relationships between many fantastic images and the ideas they were intended to embody may persist in eluding our understanding because we lack the precise key to their meanings, which, in some instances, may be forever locked in the

artist's own interior domain. Because so much of the world's fantastic art is surrounded by the mystery of its full meaning, it appeals strongly to human curiosity.

The ever-present difficulty of deciphering fantasies is manifest in an enigmatic theme from ancient art where images of animals act as humans. One of the most charming of these comes from the inlaid decoration on the sound box of a harp found in the excavations of Sumerian Ur (fig. 437). In the uppermost of the four registers a mythical hero, sometimes identified as Gilgamesh, supports two human-headed bulls, a heraldic arrangement so common in the ancient Near East as to constitute a formula. Its decorative symmetry sets it apart from the other registers in which a wolf and a lion carry food and drink; a donkey, a bear, and an animal of uncertain identity engage in a musical recital, the donkey playing a harp like the one to which the decoration was affixed; and in the lowest register appear a scorpion-man, a goat, and a large jar. The meaning of this fantasy escapes us. That the *Epic of Gilgamesh* identifies a scorpion-man as guardian of the region of sunrise is of little help in deciphering it. We are reminded, of course, of later animal fables; it may be that these images represent myths ancestral to such tales. There must have been some tradition of animal fantasies like these, for other works of a similar nature are found in the art of the ancient Near East.

Remarkable affinities with ancient Near Eastern animal fantasies appear in medieval times in such works as the carved capitals in the crypt chapel of Canterbury Cathedral, where one example depicts a fox playing a flute while a griffin strums a harp; on another face of the capital (fig. 438), a winged hybrid—half-ram, half-woman—performs on a viol while a goat astride a dragon who bites his wrist plays a recorder. Here, too, the meaning is elusive. These images may be merely the fancies of the carver, but it is more likely that they are variations of a current metaphor for *Ignorantia*, usually in the form of an ass at the harp—a beast makes music but knows not what he plays. This image was well known in the Middle Ages through the writings of Boethius (ca. 475–525), a Roman philosopher whose *De consolatione*

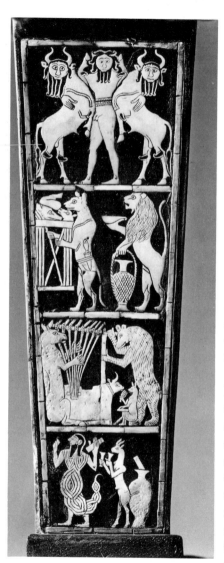

437. Plaque from the Sound Box of a Harp, *from Ur. Sumerian, ca. 2600 B.C. Shell inlay. Height 8½". University Museum, University of Pennsylvania, Philadelphia*

438. **Capital,** *from Crypt Chapel of St. Gabriel, Canterbury Cathedral. First quarter, twelfth century.* *(Photo: Professor G. Zarnecki, Courtauld Institute of Art, University of London)*

philosophiae, familiar to the literati of the era, made use of an old Greek proverb, "An ass listened to a lyre, a sow to a trumpet," and so the image of an ass playing the harp or lyre was sometimes called the Ass of Boethius. The proverb and the variation at Canterbury are also reminders that, earlier, in the ancient world, there seems to have been some tendency to link various animals with the invention of music, a more flattering role for the musician-beast.

Animal fantasies were not confined to the Near East and the Western world; in Japan, satirical picture scrolls depicted deities and nobles as animals (fig. 439). Their charm is due in no small way to the animated line through which expression and movement, caricaturing human behavior, are so true that the boundaries between human and animal identi-

439. TOBA SOJO *(attributed).* **Monkeys Worshiping a Frog,** *section of a hand scroll, from the* Choju Giga. *Japanese, twelfth century. Ink on paper. Height 12". Benridō Company, Tokyo*

ties are almost erased, and the natural settings further enhance the credibility of the images.

An entirely different category of animal fantasies, which we have already encountered in an earlier chapter (see figs. 32, 33, and 34, pp. 42 and 43), transformed natural appearance into bizarre ornamental idioms. Appropriately, since it was the product of nomadic peoples, this art was first confined to small portable objects (fig. 440) like jewelry, weapons, and harness decorations. It flourished among such peoples as the nomadic Scythians who ranged from the Eurasian steppes to south Russia and made forays into the Balkans and the Near East between the eighth and fourth centuries B.C. A fantastic "animal style" spread as waves of nomadic and uprooted barbaric and semibarbaric tribes pushed against one another up to the fringes of the Mediterranean world during a great migration era, eventually to overrun the deteriorating Roman Empire in the fifth century A.D.

The most elaborate form of this animal imagery developed in the manuscripts of Christianized Ireland, which never lost touch with its ancient Gaelic lore full of marvels and magic, a realm of fantasy that could only reinforce this

440. **Stag,** *from Kostromskaya, barrow 1,
shield center piece. Scythian, seventh or sixth
century* B.C. *Chased gold.* 7½" × 12½".
The Hermitage, Leningrad

decorative art. Here the animal form was blended with a
complex, knotted interlacement that seems to have come
from Asian sources, traveling complex routes of dispersion
over the Eurasian world to Coptic Egypt, Ireland, and the
Scandinavian north, mingling en route with the fantastic
animal style of the steppes and their borderlands.

Nowhere in the art of the early Middle Ages is the element
of fantasy more pronounced and yet at the same time more
deliberately controlled than in Irish manuscripts, stone carv-
ing, and metalwork. This is an art formed of the union of
opposites: abstract decorative principles, remarkably geo-
metric, expressed in a visual vocabulary of organic, restless,
vinelike interlacements, often in the form of strange biting
and clawing beasts and birds whose extremities emerge from
serpentine windings that tie their elongated bodies into
complex knots. This Celtic art appears to shun the two
extremes—strict adherence to abstract geometricization
and literal representation of living forms—by simply cross-
breeding them. In the *Book of Durrow* one finds swirling,
spiraling, knotting ribbons which, for all the studied geome-
try of their clock-spring tensions, seem less mechanical than
organic; in the example shown here (fig. 441), the precise
rectilinear fields of the page are packed with the writhing
knots of fantastic animal forms. It is a world of imagery that

441. **"Carpet" Page,** *beginning of the Gospel of St. John, from the* Book of Durrow. *Celtic, ca. 680. Manuscript illumination. ca. 9 11/16″ × 6 3/16″. Reproduced by permission of the Board of Trinity College, University of Dublin (Photo: The Green Studio, Ltd.)*

seems at once to accept limitations and to deny them, a controlled restlessness in which forms that blend animal and plantlike features are continually constricting and devouring one another, not with indiscriminate abandon, but in a well-choreographed ritual of movement within the frame of page and compartment. The magic and metamorphosis that haunted the fabulous world of pagan Irish myths is embedded but just barely contained in the geometric order of these illuminations for Christian manuscripts.

Fantasy unconfined by the prescribed hieratic forms of sacred art was often freely exercised in the play of the illuminator's imagination when designing elaborate initials for manuscripts. Although a type of initial that involves inhabited scrollwork is prevalent enough to suggest a basic formula, there is considerable variety in details. In the example shown here (fig. 442), the frail human form, caught in the trap of tangled vines that sprout monstrous creatures in place of flowers, struggles to free itself as from the snares of a wicked world—the realm of the fantastic serving the admonitory message of the church. Sources for some of these images of strange creatures lay in the bestiaries, collec-

442. Inhabited Initial, *from the beginning of the Book of Job, Ms. Auct. E. Infra I, f. 304. Probably done at Winchester, mid-twelfth century. Manuscript illumination. 5 11/16″ × 5 ½″. Copyright Bodleian Library, Oxford*

tions of fables embellished with moralizing content chiefly about creatures real and legendary. These date back to sources around the fourth century, but they enjoyed wide popularity in the later Middle Ages.

An image appearing frequently in Christian art and destined to have a long history (cf. fig. 446, p. 586) was the mouth of hell devouring the damned at the Last Judgment or, in some instances, the rebel angels. This motif was even extended to secular manuscripts where, in one instance—in a bestiary type, *Marvels of the East*—an artist has placed a double meaning on the idea of the jaws of hell (fig. 443). Here the image of the jaws, usually depicted as the gaping mouth of a dragonlike monster, becomes a hybrid form in which the closing jaws are composed partly of an opening in the earth and partly of an emerging devil gathering sore-covered bodies for his own jaws. Within the pincer enclosure of devil and earth, other mortals suffer the torment of the damned. At the edge of this trap stands the figure of the legendary magician Mambres (or Jambres) who has come to the mouth of hell to call up the ghost of his brother Jannes. The two brothers, both sorcerers summoned by the pharaoh, had opposed Moses and Aaron in Egypt, duplicating their miracles in order to discredit them. The ghost Jannes, saying that he was justly condemned to hell, warned his brother to do good in his life. A large portion of the manuscript is an illustrated bestiary that describes a series of creatures who collectively represent a catalog of types of imaginative projections: exaggerations of normal appearance (rams the size of oxen, ants as large as dogs); aberrations of the human form (cynocephali—men with dogs' heads, horses' manes, teeth of boars, and breath of fire—and men without heads who have eyes and mouth in their chests; cf. p. 472); outrageous monsters (beasts with eight feet, two heads, and eyes of gorgons); and wish-dreams (trees that bear jewels).

Images such as these spilled over into church decorations as well, where their potential for keeping the faithful on their good behavior was sometimes offset by priestly distrust of their real effects, an apprehension that was sufficient to move the reform churchman Bernard of Clairvaux (1090?–

443. The Magician Mambres, *from Marvels of the East. British, First half, eleventh century. Ink on vellum. Full-page miniature. By courtesy of the Trustees of The British Museum, London*

1153) to write a letter of protest concerning these "ridiculous monsters" and to deplore the possibility that viewers would be tempted to wonder about such things instead of meditating on the will of God. Bernard's conviction that the fantastic might prove dangerously fascinating in and of itself also calls attention to the capacity of fantastic art, by its very strangeness, to obscure its underlying meaning, a condition nowhere better demonstrated than in the questions long raised by one of the most impressive flights of the artistic imagination, a work of the Renaissance era but one rich in content from the medieval world: *The Garden of Earthly Delights*, so-called (figs. 444 and 445), by Hieronymus Bosch (ca. 1460–1516).

The earliest known description of Bosch's painting, written

by the Spanish priest Sigüença in 1605, identifies it as a symbolic representation of the vanity of earthly pleasures. In the twentieth century many scholars, stimulated by the fantasies of surrealist art (which found in Bosch a kindred spirit) and by the inherent attraction of Bosch's own incredible and puzzling creations, have wrestled with the frustrating task of decoding this particular work, generally accepting as a point of departure Sigüença's explanation and seeking to decipher the symbolic content of discrete images in this context. Explanations have been sought in folklore, astrology, alchemy, the practices of heretic sects, and sexual symbolism. Recent suggestions, on which the author here relies (specifically those of Ernst Gombrich and Bo Lindberg), while not

444. HIERONYMUS BOSCH. The Garden of Earthly Delights, *closed triptych. ca. 1500. Oil on wood panel. 86⅝″ × 76¾″. The Prado, Madrid (MAS)*

ruling out some of these interpretations of details, have provided an enlarged scope for the general theme of the painting.

The wings of *The Garden of Earthly Delights* fold over the central panel to form what appears to be an important key to the meaning of the entire ensemble (fig. 444). This is a painting in grisaille (tones of grey) depicting a transparent globe whose equatorial section is an extensive landscape surrounded by waters. From the clouds hovering above the land faint, curved, luminous bands extend downward. These have been interpreted as reflections on the surface of the transparent sphere, but the identification of them (or at least

445. HIERONYMUS BOSCH. The Garden of Earthly Delights. *ca. 1500. Oil on wood panel. Center panel 86½″ × 76¼″; wings 86½″ × 38″ each. The Prado, Madrid (MAS)*

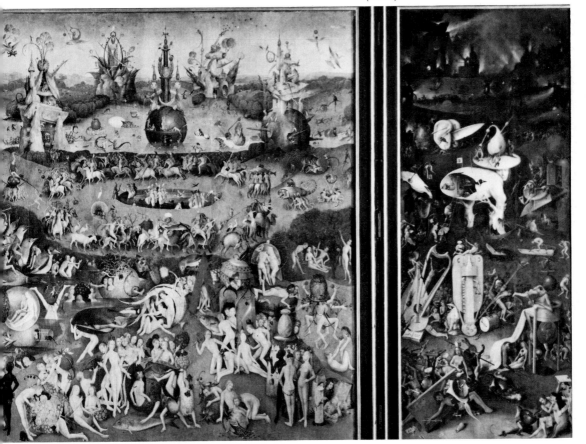

one of them) as a rainbow suggests that the small image of God the Father in the upper left corner outside the sphere and the inscription across the top of the two panels (*"Ipse dixit et facta sunt/Ipse mandavit et creata sunt"*: "For he spake and it was done; he commanded and it stood fast [or "was created"]," Psalm 33:9 and elsewhere in the Bible) may refer to something more than the third day of Creation when the land was made to emerge from the waters, the usual interpretation. God sent the rainbow as a token of his covenant with Noah that no more would he cause the Flood to destroy the world. God points to the open book he holds as if the words in the inscription were spoken of the covenant. If this interpretation is correct, the grisaille can be viewed as a reference to the receding waters of the Deluge. The central panel then becomes more than an exposition of the varieties of earthly pleasure after the Fall of Man and can be viewed as the artist's imaginative reconstitution of the world as it was in the time of Noah before the Flood, with a pleasure-seeking mankind unaware of its impending doom.

Furthermore, medieval commentaries on the nature of the world before the Flood stressed that antediluvian man lived on the fruits of the earth, an image that abounds in the central panel; and it has also been noted that the common sin of that world was taken to be fornication, allusions to which are among the motifs in this curious triptych. The left wing, while depicting the Garden of Eden, also shows that evil and violence (in the form of dark creatures emerging from the waters and animals fighting others and eating their flesh) have already penetrated the garden, alluding to Eden after the Fall of Man. Here the possibility of layers of meaning consistent with medieval practice becomes apparent, justifying linkage of the older interpretation of the grisaille as the third day of Creation to its more recent expansion to include as well the representation of the world emerging from the waters of the Flood, an interpretation fortified by the presence of buildings in the landscape. Thus, the grisaille may be assumed to figure both events, the left wing to represent Eden before and after the Fall of Man and the central panel the world as it was in the days of Noah before the Flood and, possibly, as it would continue to be thereafter—still a sinful

place—until the final cleansing of the Last Judgment. This
brings us to the right wing which contains images associated
in Bosch's oeuvre, it has been noted, with both hell and the
Last Judgment, completing the pattern of two levels of
meaning. Despite the still incomplete decipherment of the
multitude of details in this rebus, its general theme now looks
more and more like a moralizing vision of the world from the
third day of Creation to the Last Judgment, a vision in which
the lesson of the Flood may be the pivotal idea, as Gombrich
has suggested. The host of apparently irrational images,
many of them resembling three-dimensionalized manuscript
initials (for example, the dancing figures surmounted by an
owl in the lower right corner, compared with fig. 442, p. 579),
have tended by the force of their compelling fantasy to
obscure the possibility of a rational pattern of content that
joins all portions of the triptych into a single cohesive concept
—a comprehensive sermon on the failings of mankind and
the ultimate terror, judgment, and fire that will one day end it
all.

Bosch's predilection for fantastic imagery is carried on in the
art of the Low Countries, particularly in the work of Pieter
Brueghel the Elder, whose *Dulle Griet* (fig. 446) contains
many images reminiscent of the earlier artist and is perhaps
even more difficult to interpret firmly, as indicated by many
inconclusive attempts to identify the subject. It is apparent
from her position in the foreground and from her size in
relation to the other figures that the wild-eyed striding
woman—Dulle Griet or Mad Meg, as she is sometimes
called—must be central to the theme. She was viewed early
in the seventeenth century as a "Dulle Griet who is looting
at the Mouth of Hell," and this has persisted in the title
through many interpretations. She has been variously called
a personification of wrath or of avarice, a Fury or a goddess
of vengeance, a children's bogey-woman, and Fortitude,
among others. Recently she has been interpreted as an im-
age of Fortune taking back her gifts in a setting related to
the upper hell of Dante's *Inferno*. Whatever the real theme,
the painting is such an elaborate catalog of grotesqueries
that the variety of interpretations already advanced each
have some visual support: anger and violence on the bridge

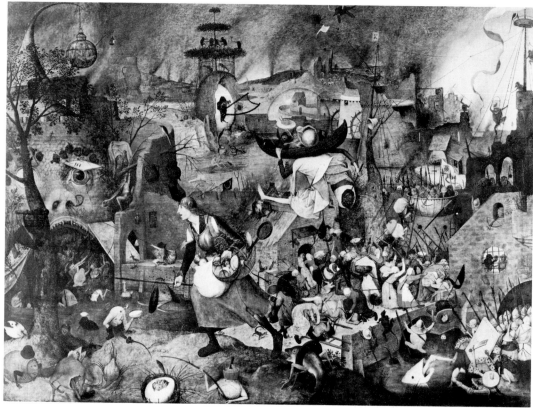

446. PIETER BRUEGHEL THE ELDER. Dulle Griet. *1562. Oil on wood panel. 45 ¼″ × 63 ⅜″. Musée Mayer van den Bergh, Antwerp*

as women battle demons, greed in Mad Meg's loot and in the anal flush of coins from the Bosch-like figure on the rooftop behind her; her face could be fury or madness, and she carries some attributes of Fortune. One is tempted to view the traditional image of the mouth of hell at the left, with its paraphrase of a jester's cap, as a face that mocks us while we wander through this fantastic nightmare searching for meaning.

Apart from its obvious and specific metaphoric character, the mouth of hell represents a more general type of imagina-

tive association: that of relating the visual conformations of one class of objects to another, quite unrelated, class. Outside the realm of the fantastic, it was this process of association that Leonardo da Vinci brought into focus when he suggested that artists might quicken "the spirit of invention" by studying the patterns on walls stained by damp or on unevenly colored stones and find in them hints of landscapes, battle scenes, human expressions—"an infinity of things." It was this process, too, that Alexander Cozens (see pp. 197–98) made the basis of a pedagogical method. It also lay behind the search for correspondences that has attracted so many composers, poets, and artists down through the ages as they have sought a kind of harmony or equivalence of the senses whereby certain patterns of musical sounds might represent visual impressions or evoke emotional states or certain colors symbolize sounds, emotions, or ideas and states of being. The French poet Arthur Rimbaud (1854–91), whose hallucinatory imagery impinges on the fantastic, went so far as to assign colors to vowels, and the evocative impressions of the French composer Claude Debussy (1862–1918) were poetic amalgams of visual and auditory sensations. In the sixteenth century, the Italian artist Giuseppe Arcimboldo (ca. 1527–93) invented a method of transcribing color into music, the idea behind the color-organ or color-piano; and his paintings literally compel the viewer to exercise the process of association.

Arcimboldo's paintings belong to a special class of fantastic art so designed in terms of visual correspondences that its images switch back and forth from one identity to another. The example of his work illustrated here (fig. 447) is a bizarre accumulation of images, each with its own distinct identity but forming together a collective image that suppresses visually (the instant we recognize the larger image) the separate identities of its constituent parts. At the time this was painted, the artist was working at the court of Emperor Maximilian II in Vienna and Prague—thus the elaborate gold collar with the pendant double-headed eagle of the Hapsburg dynasty. This is the single element in the picture that seems to represent only itself. Throughout the rest of the picture a wide range of fiery manifestations, from

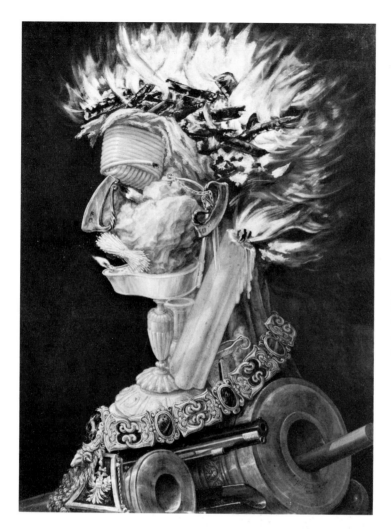

447. GIUSEPPE ARCIM-BOLDO. Le Feu. *1566. Oil on wood panel. ca. 26⅜″ × 20½″. Kunsthistorisches Museum, Vienna*

light-giving and body-warming functions to terrible destructiveness, is gathered into a profile "portrait" to fashion an allegory of fire. Candle and lamp mingle with the fuses and artillery of war, while the tousled hair is a crackling bonfire curiously evocative of sound. The viewer's experience of the picture moves alternately from the identity of its parts, each naturalistically rendered, to recognition of the image they conjoin to create; it is a pendulum swing between reality and fantasy. Like the necessary bond between the exaggerations and the identity of a subject essential to effective caricature,

the relationship between the parts and the whole in Arcimboldo's fantastic images is so balanced that the anthropomorphic presence becomes an eerie reality for the viewer. Unlike caricature, however, fantastic art of Arcimboldo's variety relies on a truly imaginative leap of the viewer's own perceptions, a visual game of hide-and-seek not unlike that which transforms the inkblots of the familiar Rorschach test into unexpected images. The difference between the inkblot and Arcimboldo's fantasies lies, of course, in the relative freedom of the viewer in the former instance and the inescapable visual trap set by Arcimboldo.

Arcimboldo's allegorical "portraits" differ from the fantastic hybrids created by Bosch, Brueghel, and other northern artists in that the final image aspires to normal human appearance, the grotesqueness, as we have seen, being a factor

448. Miniature with Horse. *Indian, sixteenth or seventeenth century. Bibliothèque Nationale, Paris*

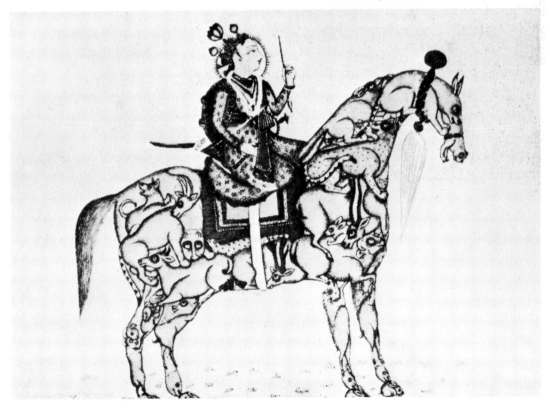

of the parts that compose it. In this respect Arcimboldo's work is closer to images of animals from India and the Near East whose bodies are filled, as if by elaborate tattooing, with accumulations of smaller animal and human forms wedged tightly together (fig. 448).

The example of fantastic art from the Low Countries (while not irrelevant to the work of Arcimboldo and his followers, for it was known in Italy) is of greater significance to the macabre vein that surfaces later in Francisco Goya's art, since the Spanish artist not only had access to *The Garden of Earthly Delights* in the royal collection at Madrid but was himself possessed of a temperament unusually receptive to Bosch's fantasies.

Goya's fantasies are far from being clever derivatives of

449. FRANCISCO GOYA. Woman Abducted by a Horse, *plate 10 from* **Los Proverbios (Disparates)** *ca. 1815–24. Etching and aquatint. 9 ⅝″ × 13 ¾″. The Metropolitan Museum of Art, New York (Harris Brisbane Dick Fund, 1924)*

450. **FRANCISCO GOYA. The Sleep of Reason Brings Forth Monsters,** *plate 43 from* **Los Caprichos.** *1793–96. Etching and aquatint. ca. 8½" × 6". The Brooklyn Museum Collection*

Bosch's imagination, for the Spanish artist created his own unique nightmare world: in his series of etchings from 1796 to 1798, called *Los Caprichos;* in the series from 1814 to 1820 published long after his death under the title *Los Proverbios* (originally called *Disparates*—"follies" or "curiosities"—by the artist himself); in numerous drawings; and in the dark paintings executed shortly after the *Disparates.* In one of his most enigmatic works, from the *Disparates,* a rearing horse abducts a smiling woman while huge rats devour humans in the background (fig. 449).

Goya's strange images are not mere exercises in fantasy, for they were conceived with a moral purpose that saw the evil in human nature as an immanent and immediate reality. They were surely charged with the melancholy of his own private torment and isolation, aggravated by his mental anxieties and his growing deafness. In one of his most haunting images from *Los Caprichos* (fig. 450), a man (the artist himself, collateral evidence indicates) cradles his head in his arms while the darkness behind is filled with hovering owls and bats as a large cat looks out warily from behind the man's chair—all predatory creatures of the night, but here the night of the artist's own soul. On the desk is the legend *"Il sueño de la razon produce monstruos"* ("The sleep of reason brings forth monsters").

In 1819, when Goya was seventy-three, he moved outside Madrid to a house that became known as the "Quinta del Sordo" ("House of the Deaf Man"). There on the dining room walls, he painted the large, terrifying works that stand as one of the most dramatic private documents any artist has ever produced. The image of a demonic old Saturn tearing at the flesh of one of his children (fig. 451) originally flanked one of the doors to the room. Although it may owe something to Rubens's painting of the same subject (1636–38, The Prado, Madrid), or to one of the traditional aspects of Saturn as a symbol of cruelty, and is related to other works by Goya himself, the conception is so wildly terrifying that it suggests a new and desperate private meaning. On the long wall adjoining this painting was the *Witches' Sabbath* (fig. 452) in which a black goat intones to a gathering of grotesque witches. The subject of witchcraft had appeared from time to time in Goya's earlier works and parallels have been drawn between this painting and the saturnine theme of melancholy in Goya's art; but the undercurrent of frenzied emotion that stirs this macabre convocation sets the dominant mood and hints of madness and terror, of humanity deformed by evil and reason lost in superstition.

In the double isolation of total deafness and old age, Goya lived a hermitlike existence at Quinta del Sordo, and the images on the walls seem like a final testament, a summing

451. FRANCISCO GOYA. **Saturn Devouring His Children.** *1819–23. Fresco transferred to canvas from wall at Quinta del Sordo. ca. 57″ × 32″. The Prado, Madrid (Anderson-Art Reference Bureau)*

452. FRANCISCO GOYA. Witches' Sabbath. *ca. 1820–23. Fresco transferred to canvas from wall at Quinta del Sordo. 4′7⅛″ × 14′4½″. The Prado, Madrid (MAS)*

up of all the years during which he had worked in the midst of political intrigues, war, his mounting afflictions, and now in the realization that it was all coming to an end. It is his own private apocalyptic vision.

For Goya's contemporary, the mystic, poet, and artist William Blake (1757–1827), the creative faculty was characterized by its capacity to receive visions like a sensitive recording apparatus, visions, he claimed, that were brought to him day and night by heavenly messengers. He seems to have viewed "inspiration" in both its literal and theological senses: an energy breathed into him and a direct influence from divine sources. Scorning mere "copiers" of the natural world, Blake created a body of visionary art that ranged from the grotesque to the beatific. Although his style is highly personal, it represents a blend from a variety of sources he had thoroughly absorbed: the decorative aspects of medieval art, the grace of Italian mannerist forms, engravings of Oriental art, emblem books, Michelangelo, and the simplified linear classicism of John Flaxman. The catalysts were his discipline as an engraver and poet's sensibility, which

453. WILLIAM BLAKE. The Number of the Beast is 666. *ca. 1805–10. Watercolor. 16 ⅜″ × 13 ¼″. The Philip H. and A. S. W. Rosenbach Foundation, Philadelphia*

brought the sources together in a visual language essentially linear and as rhythmically cadenced as a poetic line. As an illustrator of the Book of Job, Milton's *Paradise Lost*, Dante's *Divine Comedy*, and other works endowed with rich imagery, Blake had ready-made visions to draw upon; but he was never a literalist at the task. He transformed and elaborated on his material. In this example (fig. 453), Blake draws upon chapters 13 and 14 of the Revelation of St. John the Divine, depicting the faithful falling down before the Lamb of God on Mt. Sinai, while a seven-headed monster—symbolic of blasphemy—recoils at the sound of a voice from heaven as his dragonlike protector seems to be motioning him to leave the scene. The alchemy of Blake's imagination, working through the medium of his supple line, has translated the vision of St. John into a dramatic ritual, in effect the unfolding movement of some supernatural ballet.

Although Blake's fantasies seem to come upon the English scene as unexpected phenomena, he was not an isolated figure, for there was a considerable body of imaginative imagery in art and literature during the late eighteenth and early nineteenth centuries, as a romantic phase in Western art gathered momentum. Goya in Spain, the German romantics, and in England the Swiss-born John Henry Fuseli (Johann Heinrich Fuessli, 1741–1825) also contributed in highly individual ways to this vein of fantastic art.

Fuseli was a friend of William Blake's, but his world of dramatic fantasy sets a darker tone; unlike Blake he fancied himself to be a demonic presence. A young English painter, Benjamin Robert Haydon (1786–1846), in recalling a visit to Fuseli, reported walls covered with "galvanized devils—malicious witches brewing their incantations—Satan bridging chaos, and springing upwards like a pyramid of fire. . . ." The latter part of the description could be applied to some of Blake's images as well—like the one illustrated here —but Fuseli often seems to pull his images out of the substratum of private dreams and nightmares, inviting erotic Freudian interpretations as well as comparisons with later surrealism. This example (fig. 454), one of several versions Fuseli painted, was extremely popular, being engraved

454. JOHN HENRY FUSELI. The Night-mare. *1785–90. Oil on canvas. 40″ × 50″. The Detroit Institute of Arts (Gift of Mr. and Mrs. Bert L. Smokler and Mr. and Mrs. Lawrence A. Fleischman)*

or etched in aquatint four times between 1782 and 1802. The exaggerated gracefulness of the sleeping young woman, elegantly mannerist in conception, contrasts dramatically with the wild-eyed horse who peers from around the curtain and the grotesque fiend who crouches atop the woman and glares evilly out at the viewer. The luminous body of the young woman shining in the darkness enhances the palpability of the evil presences, like a nightmare made disturbingly real, and draws the viewer into an emotional response to the scene comparable to the empathy that links audience with performance in the theater.

Romantic fantasy with barbaric and theatrical overtones surfaced in Eugène Delacroix's versions of the *Death of Sardanapalus* (fig. 455), derived in part from a play by Lord Byron. Delacroix has represented the Oriental ruler on his deathbed surrounded by his treasure and the frenzied sacrifice of his horses and concubines. The mood of horror is modified, however, by Delacroix's rich color and painterly execution. In this respect it contrasts markedly with Fuseli's melodrama.

Whereas Fuseli's interest in psychological states seems inclined to express itself in tangible melodramatic terms, a fragile, poetic sensibility graces the fantasies of the French artist Odilon Redon (1840–1916) even when the forms that well up from the "unconscious" (for which fantasy was the messenger, in Redon's view) assume bizarre and frightening appearances. Reaching his maturity as an artist at a time when impressionism, with its concern for the light of the real world, had become the dominant mode in French art, Redon bathed his images in a luminescent twilight from some elusive realm that only partially materializes out of an indeterminate space without fixed horizons, a floating, silent world that glides in and out of our senses like a passing dream.

Like Hieronymus Bosch, Redon found the temptation of St. Anthony a fascinating subject. His illustrations to Gustave Flaubert's *Tentation de Saint-Antoine* contain some of his most fantastic imagery; but, unlike his predecessor, he re-

peatedly turns away from the utterly horrific toward a gentle fantasy. In his image of Oannes (fig. 456), a primordial deity who appears to St. Anthony proclaiming that he was there in the watery chaos before the beginning of things where eyes without heads floated like mollusks (the subject of another lithograph from the same series that reveals his interest in the microscopic world), Redon creates a composite being whose form is an embellishment of Flaubert's description of a fish with the head of a man. Redon extends the image of Oannes to suggest as well a coiling asp, evoking the serpent on the headdress of Egyptian pharaohs and relating the apparition to the Nile, into which Oannes plunges after he has spoken to the saint. The ambivalence of Redon's image floating in the darkness develops a mood that is trancelike and remote; its elegant design mitigates its potential horror.

455. EUGÈNE DELACROIX. Death of Sardanapalus. *1844 (version of the 1827 painting in The Louvre, Paris). Oil on canvas. 29 ⅛″ × 36 ⅝″. Collection of Henry P. McIlhenny, Philadelphia*

456. ODILON REDON. Oannes: Moi, la Première Conscience du Chaos, *illustration for Gustave Flaubert's* Tentation de Saint-Antoine. *1896. Lithograph. 10 ¾" × 8 ½". Spencer Collection, The New York Public Library (Astor, Lenox and Tilden Foundations)*

The tone of reverie that pervades Redon's fantasies reappears in the work of such twentieth-century artists as Marc Chagall (b. 1889), whose later lyrical fantasies (fig. 457) have the same gentle dreaminess as Redon's *Ophelia in the Flowers* (fig. 458), in which the ghostly profile of the girl floats by delicate flowers under the dark tower of Elsinore.

Fantastic art in the twentieth century has encompassed a range even wider than that of the past centuries, as it has explored fresh directions opened up by psychoanalysis, new systems of pictorial organization developing out of cubism, and what may be the most dramatic pictorial revolution of the modern world, the arts of photography and the motion picture. These are best viewed in the context of twentieth-century developments, the subject of the next chapter.

457. MARC CHAGALL. Around Her. *1945. Oil on canvas. 51 ⅝″ × 42 ⅞″. Musée Nationale d'Art Moderne, Paris*

458. ODILON REDON. Ophelia in the Flowers. *1905. Pastel. 25″ × 36″. Collection: Marlborough Fine Art, London*

PART

SEVEN

MODERN IMAGES

15 SOME ASPECTS OF TWENTIETH-CENTURY ART

During the first two decades of the twentieth century, Western art underwent a series of remarkable transformations. Looking back from the relatively short perspective of three-quarters of a century, one is inclined to view the years since 1900 as an era marked more by disjunctions than by continuity. It is also tempting to view the fast-breaking pattern of successive movements in art as symptomatic of the rapidity with which ideas and knowledge about mankind, the world, and the universe were undergoing drastic revisions and realignments during the same period. Important aspects of Sigmund Freud's researches into the human psyche and the dreamworld, Max Planck's quantum theory concerning the transfer of light and energy by atomic and subatomic particles, and Albert Einstein's theory of relativity which overturned the concepts of space and time as absolute entities were all formulated before the end of 1905. Human consciousness was confronted with new realities, potentially shattering.

Nevertheless, as earlier chapters have shown, many of the traditional functions, categories, and themes of art continued, as in the past, to express man's image of himself and his relationship to the natural world, to serve institutional as well as private values, to be expressive of spiritual concerns, to celebrate the joy of life, or to mock human failings and pretensions.

Against speculations regarding causal relationships between philosophical, scientific, and technological developments and concurrent developments in art one must weigh the visual evidence from the continuity of image making itself,

603

as one step led to another, gathering momentum for the creative leaps. It was the very rapidity of the changes—like the flashing of a magician's hands—that tended to veil the continuity and create the illusion of abruptness as each new style emerged. However far man's knowledge of the microcosmic and macrocosmic extremes of the universe was being pushed into borderless areas beyond ordinary sense perception, the artist still confronted his media of expression with the same old sensory apparatus. What had changed for the artist was an awareness of new dimensions and the possibilities for visual explorations so far removed from the familiar, visible world as to break contact with its surface appearance. Thus many artists turned away from representational images and toward new abstract and expressive forms.

During the years around the turn of the century in Paris, four events occurred that can be viewed as symbolic of the new order of things: the important Cézanne exhibition in 1899 and the exhibitions of Seurat, van Gogh, and Gauguin in 1900, 1901, and 1903 respectively. The showing of Gauguin's work was held at the newly formed Salon d'Automne exhibition which, two years later, introduced the first major new movement of the century: the chromatically expressive paintings of *"Les Fauves"* ("wild beasts"), as they were dubbed by an unsympathetic art critic. By the time the First World War ended in 1918, European art had produced a series of dramatic new directions in image making.

Between these new directions of twentieth-century art and nineteenth-century impressionism lay the bridge formed by the critical reactions to impressionism embodied in the works of Cézanne, Seurat, van Gogh, and Gauguin. Impressionism itself, although firmly committed to rendering the surface appearance of the visible world (an allegiance acknowledged by Western art since the Renaissance), had already prepared some of the ground for new directions. Through its microstructure of broken color, its vibrant screen of brush strokes from which light-drenched images emerged (see colorplate 15), impressionism had transformed the old transparent plane of the "window on the world" into a surface that asserted its own presence as a colored field.

This was at least the prefiguration of an autonomy of the painted surface and the beginning of a new reality that held within its orchestrations of colors and lines its own right to be, quite independent of representational considerations. To some extent, this colored screen of brushwork was a variety of formal structure, but it was not considered as such by many artists who had grown restive with impressionism by the late 1880s.

The artists who reacted against impressionism during the last two decades of the nineteenth century found impressionism's overriding concern with optical sensation a trap to avoid. The impressionists' compositions, in concordance with their aim of capturing the fleeting sensations of light —the most ephemeral of nature's phenomena—were often casual. To artists like Cézanne, Seurat, van Gogh, and Gauguin, impressionism was a phase of naturalism. They sought other goals, to them more substantial, more permanent, and more receptive to intentions beyond the replication of the natural world bathed in nature's light. Although each of these four artists reacted in distinctly personal ways, they represent two divergent thrusts away from impressionism. Cézanne and Seurat developed the microstructure of impressionism into more formal and deliberate idioms (see pp. 213–16). Van Gogh and Gauguin manipulated line into expressive and decorative arabesques and turned color from its earlier descriptive role toward emotional and symbolic functions (see pp. 216–18, 495–98). The more constructional aspects of twentieth-century art, like cubism, stem largely from the Cézanne-Seurat roots, while the varieties of twentieth-century expressionism derive substantially from van Gogh and Gauguin.

Van Gogh's remark about using color arbitrarily to express oneself more vigorously could serve as an acceptable credo for *"Les Fauves,"* whose debut in 1905 gave the Paris art world a seismic shock. As one observer—the artist Maurice Denis (1870–1943)—put it, this lively new group of painters was practicing "painting for its own sake, the pure act of painting." Yet, as revolutionary as these artists appeared, they had learned much from earlier sources, among them

the intense color of Gauguin and van Gogh and a loose color-patch brushwork largely derived from Paul Signac (1863–1935), a neoimpressionist. Nor were their subjects particularly new: figures, landscapes, still life. What fauvism did contribute was to free color in painting, to an unprecedented degree, from its dependence on color as perceived in nature. André Derain (1880–1954), one of the fauvist painters, remarked that they treated colors like sticks of dynamite, exploding them to create light.

The major figure among *"Les Fauves"* was Henri Matisse (1869–1954). A supreme colorist, his approach was both instinctive and sure, creating harmonies that are luminous, resonant, and hedonistic. His *Femme au Chapeau* (colorplate 18), a portrait of Mme. Matisse, is a fine example from the short-lived fauvist movement. Freely, even savagely, brushed, the color is nevertheless remarkably controlled in its harmonic relationships, and despite the raw vigor of its execution a subtle, somber elegance emerges from the lively matrix of color sensations. It is a factor of the artist's unerring instinct for poise. The eloquent simplicity of the model's eyes and the firm, graceful contour of her face seem to prefigure the artist's later linear shorthand, while the subject itself stands at the beginning of a half-century of Matisse variations on the theme of the elegant and sensual female.

A large canvas of the same period, *Joie de Vivre* (fig. 459), is comparable, in its pastoral theme and monumentality, to Cézanne's *Large Bathers* (fig. 460); but whereas in Cézanne's composition the nude figures cluster into rootlike bases for the arching trees, Matisse's figures emerge from linear arabesques that weave throughout his composition in sensual rhythms, melodic and dancelike. Both works recall the classical pastorale (cf. figs. 129 and 130, pp. 183 and 185) but in pictorial terms quite unrelated to earlier traditions, for their spatial relationships belong not to the natural world but to the arbitrary constructions of the painters' personal visions. Figures and landscape, in both cases, join in natural communion as if they were of the same substance, recalling the harmony between man and nature achieved in Gauguin's *D'où Venons-nous . . .* (colorplate 16).

459. HENRI MATISSE. Joie
de Vivre. *1905–6. Oil on canvas.*
68 ½″ × 93 ¾″. Copyright 1975
by The Barnes Foundation, Mer-
ion, Pennsylvania (Photo: Angelo
Pinto)

460. PAUL CÉZANNE. The
Large Bathers. *ca. 1898–1905.*
Oil on canvas. 83″ × 98″. Phila-
delphia Museum of Art (Pur-
chased: The W. P. Wilstach Col-
lection)

Joie de Vivre points unmistakably to the grace of Matisse's later work, to its essential joyousness and its decorative counterpoint of color and line. The circling dancers in the center lead directly to the large versions of dancers a few years later, where a simpler, bolder relationship is formed between figures and ground. This phase of Matisse's work, as he moved away from his fauvist period, is epitomized in *The Red Studio* (colorplate 19), a large painting that defines a new order of picture making. The room is a flat surface of English red, with the floor plane and furnishings suggested by simple, almost elusive, outlines. Even the corner of the room is merely evoked by the relative positions of paintings in the studio. These paintings are the real inhabitants of this red ambience—Matisse's own works, identifiable by their schematic color patterns. Pictures and furnishings form antiphonies of color and line in dialogue with the red surroundings, and the entire ensemble generates an ambivalent spatial effect: the colors are flat, asserting the autonomy of the two-dimensional surface of the canvas; yet the armature of line and the disposition of objects about the studio define fairly normal spatial relationships. One senses the hollow of the room, but at the same time the red pushes forward to inundate the visual experience. Thus, plane and space become one and interchangeable. This fluctuant quality constitutes Matisse's harmonic *espace spirituel* ("spiritual space"), a new dimension created not by illusions of real space but by orchestrations of resonant colors.

The spatial relationships in another interior, *Dining Room in the Country, Vernon* (colorplate 20) by Pierre Bonnard (1867–1947), are by comparison relatively traditional but not precise, and the painting recalls, in the passages of broken color, the techniques of impressionism. The glowing colors, however, suggest not equivalents for the light of the natural world but a transcendent radiance. Their heightened luminosity charges the atmosphere with a lyricism expressive of the aromatic weight of summer airs, the delicious lassitude of warm days in the country. The intimacy of Bonnard's work carries impressionist themes well into the twentieth century, but the artist's passionate regard for color freed from literal dependence on nature pushes beyond im-

pressionist representation into a total experience where objective vision and subjective mood are magically joined. This painter, who once remarked that he did not know how to invent, was surely one of the most inventive of colorists.

Claude Monet also carried impressionism into the twentieth century. In the great series of paintings depicting water lilies floating on the pond in the artist's garden at Giverny, he, too, transformed the style. In his old age, with his eyesight failing, Monet distilled the essential illusionism of the style to its irreducible essence and enlarged it to environmental proportions on huge, panoramic canvases. These horizonless water-landscapes (colorplate 22), however representational they remain, are in many ways as inventive as Matisse's *Red Studio* and involve a different but parallel spatial ambivalence. Abandoning the spatial orientation of bordering landscape, Monet has concentrated on the stretch of water itself, so that the viewer looks only across its reflective surface and into its depths. Three levels of density are interwoven here: the reflections in the pond; the transparent medium of the water, the most elusive, visually, of the three; and the sketchy flotillas of lily pads that define and give directional thrust to the plane of the water's surface. The reflections and the plane defined by the lily pads read as two intersections perpendicular to each other, even though we know that reflection, in reality, is only a mirror effect on the surface of the pond. But the illusion of perpendicularity is there: the impression that the reflections of clouds plumb the depths of the pond just as the clouds themselves pile up into the sky. Thus, the water is not so much directly represented as evoked, its dimensions set by reflections and floating lily pads. The illusion is complete but ambivalent, too, for the viewer's perception is constantly forced from one of these elements to another—and yet to a fourth: the plane of the canvas surface itself, defined by the screen of brush strokes through which the illusion filters back. Meditation in the presence of a serene fragment of nature had carried a lifelong refinement of visual perception to the level of pure sensation on the very threshold of abstract art.

Monet's late works suffered a temporary eclipse in popular-

ity, however, and—like his secluded water garden—appeared to be isolated from what was going on elsewhere, to be afterthoughts from another era. It was not until after the Second World War that serious attention was again focused on the significance of these paintings which were now hailed as kindred in spirit to abstract expressionism. The main thrust of European art during Monet's last twenty years had been in other directions, including the constructional vein of modern art established by cubism and its relatives.

Cubism was the invention of two artists, Pablo Picasso and Georges Braque (1882–1963); but hovering over the invention like a guiding spirit was Paul Cézanne. The years 1906–7, which mark the beginning of cubism's development, also coincided with memorial showings of Cézanne's work in Paris. It was at this time that Picasso painted his aggressive large canvas *Les Demoiselles d'Avignon* (see fig. 380, p. 501), a germinal work in the history of cubism, with colors and planar construction somewhat reminiscent of Cézanne and figures clearly related to Cézanne's series of *Bathers*. Like a counterresponse to Matisse's *Joie de Vivre*, which had been exhibited some months earlier, *Les Demoiselles d'Avignon* sets a mood not of joyousness but of something vaguely sinister. Apparently it was first conceived as an allegory. In one of the preliminary studies, the figure at the left was a man carrying a skull—a *memento mori*—but that idea was abandoned in the final work. Indeed the meaning of the painting is obscure, and even the title was given to it years later by a friend of the artist's who was led to believe that the nudes were prostitutes in a brothel on Avignon Street (Carrer d'Avinyo) in Barcelona.

While Picasso was working on the painting, his fascination with African sculpture and masks led to the grotesque features of the figures at the right. Among other sources for the imagery is pre-Roman Iberian sculpture whose strong archaic flavor is echoed in the figures at the left, modifying their Cézannesque origins, while the outermost of these also recalls Archaic Greek *kouroi* (cf. figs. 21 and 22, pp. 33 and 34). These elements are not central to the question of cubism. It is rather the dense, compacted space, shallow as a

relief with no true voids between figures, and the locking and wedging together of planes that point to later cubism.

Neither Picasso nor Braque had been working in this vein before. Picasso's prior "blue" and "rose" periods could be called romantic symbolism, and Braque had been painting in a fauvist idiom. After seeing *Les Demoiselles d'Avignon* in Picasso's studio, Braque went on, in 1908, to develop landscapes constructed in a similar planar fashion (fig. 461). The exhibition of these paintings that year and the next inspired the critic responsible for naming *"Les Fauves"* to describe Braque's landscapes as *"cubiques,"* and another inadequate label entered the history of art.

461. GEORGES BRAQUE. **Maisons à l'Estaque.** *1908. Oil on canvas. 28 ¾" × 23 11/16". Kunstmuseum, Bern (Hermann and Margrit Rupf Collection)*

By 1910 cubism had reached its so-called analytical phase exemplified by such works as Picasso's portrait of the art dealer Daniel-Henry Kahnweiler (fig. 462). Now the styles of Braque and Picasso were almost identical. They had discarded their earlier color to paint largely in gray and tan tonalities, presumably in order to stress the structural aspects of their "analysis," which consisted, in effect, of dissecting the objects they were painting into various views and sections and reassembling them in a new order. These fragments were arranged or embedded in a series of transparent

462. PABLO PICASSO. Daniel-Henry Kahnweiler. *1910. Oil on canvas. 39 ⅝″ × 28 ⅝″. Courtesy of the Art Institute of Chicago (Gift of Mrs. Gilbert W. Chapman)*

and luminous planes wedged and locked together to form a visual puzzle that only here and there revealed hints of the objects' original identities. Scattered textural variations were introduced among the interpenetrating planes by a mosaic of brush strokes derived from neoimpressionism. As cubism approached the point where links to the familiar external world would be lost through the complete fragmentation of objects, Picasso and Braque began to introduce recognizable elements into cubist compositions: lettering, imitations of wood grain, and even actual materials like the oilcloth lithographically printed to simulate chair caning that Picasso used in a still life of 1912. With this development, which also involved considerable emphasis on decorative patterns of color, cubism entered another phase of its history which Kahnweiler dubbed "synthetic."

The combination of painting or drawing with various materials like cut paper resulted in a new technique that

463. GEORGES BRAQUE. **Musical Forms (Guitar and Clarinet).** *1918. Pasted paper, corrugated cardboard, charcoal, and gouache on cardboard. 30 ⅜″ × 37 ⅜″. Philadelphia Museum of Art (The Louise and Walter Arensberg Collection)*

came to be known as collage (from *coller*, "to paste or glue"). Georges Braque's *Musical Forms* (fig. 463) combines various kinds of pasted paper, corrugated cardboard, charcoal, and gouache (opaque watercolor) in a synthetic cubist composition that plays off the identity of the materials against the images they combine to create. This technique of mixing media was to have lively implications for three-dimensional art in the form of assemblages of materials and objects (see figs. 487, 499, and 501, pp. 651, 668, and 670).

While rejecting the perspective system of space construction that had been the norm since the Renaissance, cubism nevertheless retained its hold on the forms of the external world. Cubist works fall readily into such traditional categories as figure, portrait, still life, and landscape painting. In time, even some echoes of traditional space and volume rendering began to work their way back into cubist painting, as in *Mandolin and Guitar* (colorplate 23) by Picasso, where hints of light and shadow are clearly present, although reduced to a decorative system of flat patterns. The thrust of the floor plane into the space of the room is defined by the pattern of floor tiles and—combined with the plane of the tabletop, the trace of perspective in the balcony window and the door at the right, the balcony railing, the patch of sky, and the walls of the room—it does much to evoke traditional space rendering. A comparison of this rather boxlike space and the flow of the contours of the color shapes with Picasso's *Guernica* (see fig. 436, p. 569) reinforces the conviction that the later work relied heavily on such works as *Mandolin and Guitar* for its formal structure, however different its explosive subject matter.

Cubism's influence was widespread in the years before the First World War as many sectors of modern art responded to its concepts. One of these was futurism, an Italian movement launched in 1909 with the publication of the first futurist manifesto in Paris by the poet Filippo Tommaso Marinetti (1876–1944). The next year saw the beginning of a series of manifestos issued by several young artists who supported Marinetti's position, among these Giacomo Balla (1871–1958), Gino Severini (1883–1966), and Umberto

Boccioni (1882–1916). A nationalistic movement, futurism denounced the adulation of the past which, in its proponents' view, had relegated Italy to the role of a museum for the Western world and had hampered its prospects for progress in twentieth-century materialistic terms. Futurist enthusiasm for the dynamism of the modern age was aptly expressed by Marinetti's declaration that a roaring automobile was more beautiful than the *Nike of Samothrace*. The futurists soon found the shifting planes of cubist structure a means of expressing the speed and dynamism they extolled, and after 1911 cubist elements were much in evidence in the short life of futurist art. The war which the futurists ardently supported and of which Boccioni was a casualty disrupted the movement and it soon died.

In another variant of cubism, Marcel Duchamp (1887–1968) evoked the dynamism sought by the futurists, but independently of them, in his *Nude Descending a Staircase, No. 2* (fig. 464). Combining cubist structure with ideas from sequence photography, he created what he called a "static representation of movement." When the work was exhibited in the New York Armory Show of 1913, it was easily the most talked-about painting in the exhibition, drawing fire from conservative critics and a public barely conditioned to accept impressionism. Duchamp's mechanizations of the human form in two other works of 1912 (*The Passage from Virgin to Bride*, The Museum of Modern Art, New York; *The Bride*, Philadelphia Museum of Art, The Louise and Walter Arensberg Collection) went even further, as if interior anatomy had been turned inside out to form some kind of organic distilling apparatus or a fleshy engine room. These works, particularly the latter, represent shifts away from cubism toward the realm of fantasy, and with another work in the Louise and Walter Arensberg Collection—Duchamp's *Chocolate Grinder, No. 1* of 1913—must be considered as important steps leading to *The Bride Stripped Bare by Her Bachelors, Even* (see fig. 469, p. 626), which will be considered later in this chapter in another context.

The cubist system transformed Western art more completely than any previous development by replacing the logic

464. MARCEL DUCHAMP. Nude Descending a Staircase, No. 2. *1912. Oil on canvas. 58″ × 35″. Philadelphia Museum of Art (The Louise and Walter Arensberg Collection)*

of natural appearances as the normative base for image making with a new geometric order independent of natural appearances. Its logic was self-contained, essentially "hermetic," that is, sealed off in its own intellectualized structure. It created a constructional system by which a pure abstraction could be attained merely by eliminating the embedded references to objects from the external world. This step the cubists did not take. But other artists did, chief among them the Dutch painter Piet Mondrian (1872–

1944), who followed through to the logical consequences of the cubist invention, to the creation of a new abstract art.

Although Mondrian had begun his career in Holland as a painter of realistic landscapes, facets of his early work were especially prophetic of the future course of his art. He developed a predilection for painting pictures of "houses with dead, blank windows," as he put it, and flowers—not bouquets, but single flowers which, he said, permitted him to concentrate on their structure. There was already a reductive process at work in his art, and it reached unprecedented levels of austerity and purity in what was to form the core aesthetic of a movement that became known, in 1917, as *De Stijl*, also the name of a magazine the movement began publishing that year as an organ of its principles.

This reductive process in Mondrian's art—to cite one theme —led through a series of stylized paintings of trees (fig. 465) becoming more and more schematic until, by 1912, the tree form (the sole motif in these pictures) had become a pattern of lines spreading out from an implied vertical axis bisecting the picture format. Viewed in series, the process is perfectly logical and orderly. When the last stage is viewed alone, it is difficult, indeed sometimes impossible without knowledge of the preceding steps, to project upon the rhythmic pattern of lines the precise image of the tree that the configuration still truly signifies.

During this process, in 1910, Mondrian had moved to Paris, and there, by his own admission, cubism became a catalyst for his own development. He saw clearly the direction cubism inferred but did not pursue. By around 1920, having returned to Holland just before the First World War, Mondrian arrived at his mature style, which he called "neoplasticism"—a white canvas subdivided by narrow black vertical and horizontal lines, with some of the subdivisions painted uniformly in primary colors, red, yellow, or blue (colorplate 26). The elemental purity of this form seems to have expressed for Mondrian an underlying ideal reality that all the variety of colors and forms in nature only obscured. He was convinced that one did not create this pure abstraction by

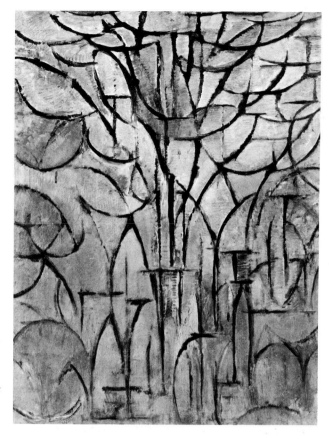

465. PIET MONDRIAN. Tree. *ca. 1912. Oil on canvas. 37″ × 27½″. Museum of Art, Carnegie Institute, Pittsburgh (Maillol-Mondrian Fund)*

stylizing or abstracting from natural forms but by working directly with fundamental relationships—like verticals and horizontals. Paradoxically, he had reached this conclusion after going through that very process in his own works some years previously. To Mondrian, the absolute abstraction of his neoplastic art was more than a mere formal principle: it was a spiritual truth, and his paintings were the manifestations of a utopian vision, temporary substitutes for a future universal harmony in "a society of harmonious proportions."

At the same time the *De Stijl* movement was formed in Holland a similar, but independent, development took place in Russia: suprematism. This was the creation of Kasimir Malevich (1878–1935), whose definition of suprematism as "the supremacy of pure emotion in art" does little for one's

understanding of his purposes other than to infer intentions of achieving a mystical purity in his painting. After experimenting with a variety of styles, he turned in 1913 from a cubist-oriented idiom to the pure abstractions of suprematism, involving simple geometric shapes clustered in dynamic arrangements on the canvas. The first suprematist work he exhibited was a black square on a white background. His final suprematist compositions of around 1918 were of white geometric shapes—squares and crosses—on white canvases. These works, purged as they were of all references to objective reality, were his manifestations of "the feeling of nonobjectivity"—the feeling that gave rise to his creative act. There was a decided religiosity in the positions taken by both Mondrian and Malevich, and their works have been characterized as icons of the modern world. Before such paintings, this suggests, modern man can contemplate absolutely fundamental values of order, harmony, and feeling.

Whereas Mondrian conceived the goal of art as a reduction to a universal and impersonal unity, the Russian artist Wassily Kandinsky (1866–1944) made his original contribution to the development of an abstract art along a different gradient. Mondrian, in optimistic accord with the idea of scientific and technological progress, looking toward a harmonic equilibrium between man and his material surroundings, saw subjective vision and emotion as obstacles to the fulfillment of an ideal union of the individual with the universal order. Kandinsky, for whom the advances of science were signals not of certainty but of doubt, pursued the route of sensation and subjective feeling. His was a spiritual experience, like Mondrian's: yet it was not Mondrian's rigorous, rational approach, but an emotional, ecstatic, and Christian embrace of paradox and mystery. He spoke of art as being like religion, developing in sudden explosive illuminations, like lightning, "fireworks in the heavens." There was in his view an abstract realm of art distinct from nature and the representation of natural forms, reached not by principles but by the stirrings of an inner voice sounded in the welter of sensations. Thus, Kandinsky is identified with expressionism (in its general sense, a basic way of perceiving reality in terms of an intense and restless

emotionality affecting both subject matter and form) as much as with the development of abstract art.

It is significant that Kandinsky cited three experiences of special importance to him as an artist, all of which were experiences of immediate sensations. The first was in front of one of Monet's paintings of haystacks. Previously—for this was in the late 1890s—Kandinsky had known only realistic art, and he was shaken by the realization that he did not recognize a subject in Monet's painting. He saw only the vibrating colors—"a painting" in which the representational element seemed no longer indispensable. The second experience was at a performance of Wagner's *Lohengrin*, where suddenly the sounds of the music became visual, a wild ensemble of colors and lines in his mind's eye. The idea grew that painting could have this musicality and a similar power to move one emotionally. The third experience came much later in front of one of his own landscapes. He had come back to his studio at dusk, still absorbed in some sketches he had been working on, when he abruptly saw in front of him "an indescribably beautiful picture." Its subject was incomprehensible to him. All he saw were forms and colors. Then he recognized it as one of his own works standing on its side against the wall. This sudden mystery would not come to him the next day, for the unexpected magic had been superseded by the knowledge of what had happened and he kept seeing the subject through the colors. But the experience further impressed him with the possibility—and the desire—for an art of abstraction.

In Munich between 1910 and 1913 Kandinsky's paintings became expressive arrangements of color and line, freely and impetuously rendered and retaining few overt references to natural forms but still evocative of landscape (colorplate 21). These emotional works were often given abstract titles (and numbers) that invite comparisons with music. Some were entitled *Improvisation,* which suggests the degree to which the subjective associations of the artist were involved in the creative act. During this period he wrote his essay *Über das Geistige in der Kunst* ("On the Spiritual in Art"), published in 1912, articulating the theoretical basis for his exploration of abstract art. The year before its publication Kandinsky

and the young German painter Franz Marc (1880–1916) formed the Munich group of artists called *Der Blaue Reiter* ("The Blue Rider") after the title of a work by Kandinsky and the name of an almanac he and Marc published. *Der Blaue Reiter*, together with the earlier Dresden group, *Die Brücke* ("The Bridge"), that shifted its base to Berlin about the time the Munich group was formed, constituted the central force in German expressionism in the years before the First World War.

The leader of *Die Brücke*, which was founded in 1905, was Ernst Ludwig Kirchner (1880–1938), whose bold, direct style paralleled that of *"Les Fauves"* and was equally indebted to Gauguin, van Gogh, and the Norwegian artist Edvard Munch (1863–1944), whose residence in Germany from the 1890s until 1908 had made him an important presence in the development of German expressionism. *Die Brücke* was so named as a bridge from academic art to a new expression in accord with modern life; however, *Die Brücke* artists' attitudes toward the modern urban scene were often more critical than celebrant, although they found in it much color and excitement. Kirchner's street scenes (fig. 466) were obsessed with the isolation and anonymity of the people in the crowd, fashionable but lost. Instinct was more important than knowledge to *Die Brücke* artists, who responded impetuously to a variety of stimuli, including the exotic arts of Melanesia and Africa in the ethnographic museum at Dresden and to the expressionistic tone of medieval German art, particularly Gothic woodcuts.

By 1911, when *Die Brücke* artists had moved to Berlin, Herwarth Walden's *Der Sturm* ("The Storm") gallery and his magazine of the same name became a new outlet for German expressionism. The advent of the First World War was a shattering blow to both *Die Brücke* and *Der Blaue Reiter* artists: Franz Marc and August Macke (1887–1914) of the latter group were both killed in action during the war, and Kirchner was invalided out of the army in 1916 to suffer a serious nervous breakdown. The remainder of his career was spent in Switzerland, where he committed suicide on the eve of the Second World War.

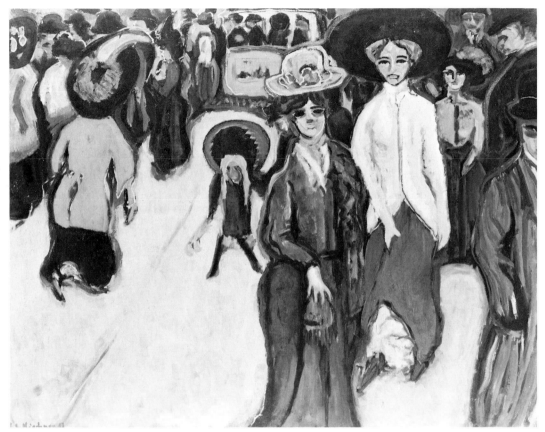

466. ERNST LUDWIG KIRCHNER.
Street, Dresden. *1908. Oil on canvas.*
59 ¼″ × 78 ⅞″. Collection, The Museum of
Modern Art, New York (Purchase)

The experiences of the First World War were traumatic
ones for another expressionistic German artist, Max Beck-
mann (1884–1950), who had served in the medical corps.
The plight of the wounded and dying in the field hospitals
left its mark, and his art was to be haunted by visions of
cruelty and torture (fig. 467). The art of protest found in
him an agonized eloquence. When the Nazis came to power
in Germany, he was listed as a "degenerate artist" and
dismissed from his teaching position in Frankfurt. He had
begun his important triptych, *Departure*, a disturbing alle-
gory on the agonies of his world, in Frankfurt and completed

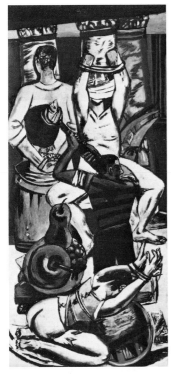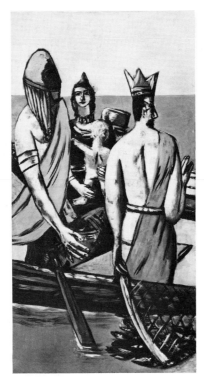

467. **MAX BECKMANN. Departure,** *triptych. 1932–33. Oil on canvas. Center panel 84 ¾″ × 45 ⅜″; side panels each 84 ¾″ × 39 ¼″. Collection, The Museum of Modern Art, New York (Given anonymously)*

it in Berlin in 1933. Despite intensive study of the iconography of this painting—which is highly personal—it remains elusive and enigmatic. It is appropriate that the work has often been hung on the same floor as Picasso's *Guernica* (see fig. 436, p. 569).

The catastrophes and dislocations brought about by the two world wars had profound effects on the course of European and American art. Beyond the inevitable destruction of works of art, there were effects of a more subtle nature, as artists moved to new surroundings, as creative spirits reacted to the events and to the implications they held for humanity and the physical world. One no-

ticeable effect was a decline in vitality and a retreat from radicalism after the First World War among some of the avant garde of the prewar years. Some movements, like Italian futurism, came to an end with the war. But reactions to the conflict did encourage a new current of radicalism as some artists, disillusioned by the conviction that Western civilization was flawed, turned to anarchic demonstrations against long-held notions of what constituted "art." Although this reaction was not exclusively, even predominantly, in the visual arts, artists played a role in its dynamics. Dada was its central manifestation. Accounts differ as to how the term "Dada" was chosen but it was in accord with the nihilistic tone of the movement.

Officially—for the movement issued manifestos proclaiming its identity—Dada began at Zurich in 1916, but the attitude defined by Dada had already been around for some three or four years and by 1919 was active in many other European centers—Berlin, Cologne, Hanover, Paris—and in New York. One important thrust of the Dadaists was the goal of undermining the presumptions of Western society, which they identified as bourgeois and corrupt. Reason, they felt, was a hoax and should be attacked by courting irrationality and paradox. Their activities included wild pranks and deliberately nonsensical performances—the precursors of the "happenings" of the years after the Second World War.

The Zurich group was dominated by literary figures: the Roumanian poet Tristan Tzara (1896–1963) and German writers Richard Huelsenbeck (b. 1892) and Hugo Ball (1886–1927). The Alsatian artist Jean (Hans) Arp (1887–1966) joined the group and contributed some of the earliest Dada manifestations in a series of collages with pieces of paper cut or torn at random and supposedly "arranged according to the laws of chance." In actuality these collages (fig. 468) clearly reflect the creative sensibility and control of the artist; they have little of the shock effect of the Dada performances.

Before the Zurich movement, Marcel Duchamp's agile wit was presenting works that were fully in the spirit of Dada.

As early as 1913 he mounted a bicycle wheel atop a wooden stool. The form was curiously evocative of a spinning wheel, but, a frank hybrid, it projected even more the aspect of futility, as its utilitarian components of motion and rest canceled out each other's functions. This was the beginning of a series of Duchamp "ready-mades"—common manufactured objects exhibited unaltered except for the addition of titles or signatures. In 1914 he exhibited a metal bottle rack, the following year a snow shovel entitled with grim humor *In Advance of the Broken Arm*, and in 1917 a porcelain urinal entitled *Fountain* and signed "R. Mutt." These teas-

468. JEAN (HANS) ARP. Collage with Squares Arranged according to the Laws of Chance. *1916–17. Collage of colored papers. 19 ⅛″ × 13 ⅝″. Collection, The Museum of Modern Art, New York (Purchase)*

ing objects, apart from their sly irreverence, posed fascinating questions about the boundary lines between manufactured objects and works of art through the agency of forms having minimal inherent aesthetic interest, placed in situations emphasizing their mocking "antiart" messages.

For all his cool intellectual detachment, Duchamp's interest in objects seems not to have been, in effect, entirely iconoclastic. It was not unmixed with an elegant taste, evident in one of his major pieces, *The Bride Stripped Bare by Her*

469. MARCEL DUCHAMP. The Bride Stripped Bare by Her Bachelors, Even (The Large Glass). *1915–23. Oil and lead wire on glass. 9′1 ¼ ″ × 5′9 ⅛ ″. Philadelphia Museum of Art (Bequest of Katherine S. Dreier)*

Bachelors, Even (fig. 469), a work on glass engineered with precision and accompanied by documentation that charted in detail its genesis. It was comparable to the presentation of a total architectural project from the initial analysis of the problem to the final plans and model. This documentation was assembled at random in an album, the *Green Box* of 1934, containing ninety-three facsimile notes and studies relating to the final work. The facsimile aspect of the *Green Box* collection was extended in a deluxe edition of twenty and a regular edition of three hundred of these albums, raising questions regarding the creation of multiples of a work of art that would be pursued by other artists at a later date. In the areas of printmaking and bronze casts, of course, the multiple concept had been long accepted. *The Bride Stripped Bare by Her Bachelors, Even* has also been twice executed in replica, in 1961 and in 1966, but in its original form before the glass of the original was broken in shipment after an exhibition in 1926. Reassembled by Duchamp in 1936 and sealed between sheets of plate glass in a steel frame, the work was considered by the artist to have been enhanced by the accidental web of fractures. Although preliminary ideas and studies relating to the work go back as far as 1912, actual execution began in 1915 and was left incomplete in 1923. Now, with the fractures preserved, another aspect, appropriately Dada, was added to its conscious formal and iconographic program: the element of pure chance.

Duchamp's documents and extensive interpretations by others notwithstanding, *The Bride Stripped Bare by Her Bachelors, Even* remains an enigmatic work. Its subject, while erotic, is presented in dehumanized terms that mechanize sexuality. Futility and frustration are implied by the distinct separation of the upper half, representing the bride, from the lower half, representing the bachelors whose forms suggest game pieces manipulated by machinery. As a freestanding form it inevitably draws its surroundings into its own frame of reference. One sees objects and people through the glass or reflected on its surface. They mingle with Duchamp's configurations in spontaneous and ephemeral associations—yet another instance of pure chance.

Although the Dada movement had run its course by the early 1920s, its effects were lasting and not entirely in the realm of nihilistic antics. Dada, if nothing else, had left a new legacy of freedom to Western art, giving the artist license to exploit the accidental and to explore in any direction chance might lead the unfettered imagination. In the work of the adherents of the movement in its heyday, this was to remain a factor long after Dada itself gave way to surrealism and former Dadaists became a part of this new avant garde. For later generations of artists, particularly after the Second World War, Dada would still have relevance. But by the early 1920s, another important force was exerted on European art that was quite the antithesis of Dada—not a movement, but an institution, a training ground for a new kind of artist who would take a positive stance with respect to the contemporary world and its technological and industrial aspects.

It began when the German architect Walter Gropius (1883–1969) took over the directorship of the Schools of Fine Arts and Crafts at Weimar in 1919, consolidated them (for he made no distinction between artist and craftsman), and renamed the new institution *Bauhaus* ("House of Building"). Gropius held the machine and industry to be potential allies rather than antagonists of art, and the Bauhaus curriculum reflected this conviction in its dual program: the study of form and the study of materials, their properties, and the techniques—including industrial—for their use. With considerable impetus from Gropius and the Bauhaus, the International style of architecture—trim structures of steel, reinforced concrete, and large areas of glass—developed during the 1920s. The boxlike character of its forms, deemed expressive of machine efficiency, also owed much to pioneering modern architecture in Holland and Germany earlier in the century and to *De Stijl* aesthetics and Russian constructivism that had been absorbed by the Bauhaus. The principles of this new architecture were exemplified in the Bauhaus building designed by Gropius at Dessau (fig. 470) when the school moved there in 1925 from Weimar. The style spread rapidly, favored by its simplicity and adaptability—influential economic factors. The Nazis closed the school in 1933,

470. WALTER GROPIUS. Bauhaus Building. *1925–26. Dessau (Photo: Courtesy of The Museum of Modern Art, New York)*

and Gropius, who had left his post in 1928, came to the United States in 1937, after some time in England, to teach at Harvard University. At the same time, one of his successors at the Bauhaus, the German architect Mies van der Rohe (1886–1969), settled in Chicago. The presence in the United States of these and other European architects of the International style was soon felt in American architecture, and American followers perpetuated the style.

Although architecture and design had been major emphases in the Bauhaus curriculum, Gropius brought to the school several important European painters to serve as master teachers. One of the students, later a teacher there, Josef Albers (b. 1888), also came to the United States to teach at Yale University's School of Fine Arts. He was to exert considerable influence on abstract art in America. Among the master teachers at the Bauhaus were Kandinsky, whose

loose, expressionistic style now turned to an abstruse symbolic language of geometric configurations; and Paul Klee (1879–1940), a German-Swiss artist whose inventive fantasies are unusually dependent on a spontaneous interchange between image and idea. The whimsical playfulness of such works as the *Twittering Machine* (fig. 471) recalls the sly humor of Marcel Duchamp without being Dadaist in character, for the visual inventiveness of Klee's images lies in the realm of a highly personal pictorial poetry, and however irreverent his whimsy it is always rooted in a finely honed aesthetic. Independent of specific movements, Klee's works like *Twittering Machine* demonstrate that levity can be a vehicle for ideas that lead beyond laughter to the recognition of human absurdities.

471. PAUL KLEE. Twittering Machine.
*1922. Watercolor, pen, and ink. 16¼" ×
12". Collection, The Museum of Modern
Art, New York (Purchase)*

472. JEAN TINGUELY. Homage to New York. *1961. Mechanical assemblage. Before its self-destruction in the garden of The Museum of Modern Art, New York (Photo:* © *David Gahr, 1961)*

A Swiss artist of a later generation, Jean Tinguely (b. 1925), has expressed similar ideas in his kinetic works made from the artifacts of modern technology. He also approached the nihilistic spirit of Dada in his *Homage to New York* (fig. 472), a complicated mechanism assembled from a variety of junk and designed to destroy itself after it was set in motion. The act of self-destruction finally staged was only partial, but this machine with a built-in suicidal will evokes the image of a mechanized civilization helplessly devouring itself through its own ingenuity and processes.

A playful (but hardly Dada) pioneer form of kinetic sculp-

ture set in motion by natural means—a current of air, the brush of a hand—was developed by the American Alexander Calder (b. 1898). Utilizing biomorphic and geometric shapes cut from sheets of metal and suspended, precisely counterbalanced, on supports of metal rods and linked wires (fig. 473), Calder invented his own unique genre: the mobile. The novelty of this sculptural concept was that its total mass was the product of the concerted motion of its various units through space. Any single configuration of it was therefore only a partial image, the temporary appearance of an arrested process. The relative unpredictability of its precise sequential movement or combinations of movements is another instance of the element of chance, but here modified, as it were, by being designed into the work of art as the inevitable by-product of its very structure.

473. ALEXANDER CALDER. International Mobile. *1949. Aluminum and steel. Area ca. 20′ × 20′. The Museum of Fine Arts, Houston (Gift from D. and J. de Menil. In memory of Marcel Schlumberger)*

474. ALEXANDER CALDER. Black Widow, *stabile. 1959. Painted sheet steel. 7'8" × 14'3" × 7'5".*
Collection, The Museum of Modern Art, New York (Mrs. Simon Guggenheim Fund)

The novelty of Calder's invention, the emphasis it places on
patterns of pure motion, and (for all the associations that
might be made with the movement of forms in nature) its
essentially abstract and self-contained aspects have tended
to focus attention on the mobile's formal qualities. In his
"stabiles," earthbound forms constructed of sheet metal
and painted in black, white, or primary colors, Calder has
produced strikingly bold sculptures that are the precise op-
posite of the linearized mobile constellations (fig. 474). Oc-
casionally he has combined the two approaches by utilizing
a stabile form as the support for mobile elements. Calder's
work represents a successful union of the current of playful-
ness in twentieth-century art with the constructional ab-
straction fostered by cubism and its offspring. Indeed,
Calder has acknowledged that Mondrian's art led him to

consider how fine it would be if those abstract forms could be made to move.

In some respects, the German artist Kurt Schwitters (1887–1948) represents a similar relationship between the deliberate constructional aspects of twentieth-century art and the accidental element. Although in his Hanover years around 1920 he established his *"Merz"* variety of Dada, his work contains such strong manifestations of constructional principles derived from cubism's use of collage, particularly Picasso's three-dimensional constructions, that he must be considered a special case, *sui generis.* His Merz poetry of letters, numbers, and meaningless sounds and the label itself, however, were pure Dada. He cropped the letterhead of a commercial *(Kommerz)* bank for a collage and thereafter used its second syllable as a rubric for his hermetic ideas. In 1924, in his house at Hanover, he began to create an environment out of a variety of materials, filling up the interior with constructions that transformed it into a self-contained, magical architecture (fig. 475). The Merz forms impinged on space to the extent that they seemed to reject the human presence. He continued to create Merz interiors for the remainder of his life, in Norway where he moved in 1935 and, after 1940, in England. Merz had become a way of life for Schwitters, who remarked in 1921, "Now I call myself *Merz.*"

Although Dada's antiart gestures can be viewed as part of the general climate of reaction against an art based on the representation of the material world, they did not produce a distinct Dada style. Duchamp and Schwitters, for example, manifest highly individual characteristics in their works. Furthermore, they display aesthetic choices and craftsmanship that could hardly be considered indicative of pure antiart attitudes. It is rather in Duchamp's witty irreverence toward traditional views of the work of art as an aesthetic object and in Schwitters's deliberate cultivation of his Merz way of life that the Dada strain is apparent. There was from the beginning a game-playing—and role-playing—tone to the Dada movement. The paradox and enigma Duchamp courted, even his "retirement" from art to become a chess player, stress this point.

475. KURT SCHWITTERS. Merzbau (Cathedral of Erotic Miseries). *Begun 1924; destroyed before completion in 1943. Collage-construction. (Photo: Niedersachsische Landesgalerie, Hanover)*

No Dada statement was more indicative of the movement's love for the puzzle than *The Enigma of Isidore Ducasse* (fig. 476) by Man Ray (b. 1890), an American artist who became closely associated with Duchamp. Tying sackcloth around a sewing machine, Man Ray created a three-dimensional puzzle piece whose point of departure was the remark by Ducasse (who wrote under the name of Le Comte de Lautréamont): "Beautiful as the accidental encounter of a sewing machine with an umbrella on an operating table." This packaging of objects has been pursued recently by Christo (Javacheff), born in Bulgaria in 1935, who has expanded the concept to include visions of wrapping up Manhattan skyscrapers.

The freedom from conventional techniques of image making that early twentieth-century movements stimulated is also manifest in the inventive methods used by another artist associated with Dada at the outset of his career and later with the surrealist movement: Max Ernst (b. 1891). Two techniques he developed—*frottage* and *decalomania*—emphasize surface texture in lending to objects depicted a

476. MAN RAY. The Enigma of Isidore Ducasse. *1920 (ed. 1972). Photograph. Collection of Luciano Anselmino, Turin*

magic realism that heightened the artist's pictorial fantasies. *Frottage* was achieved by pencil rubbings on paper over wood grain, leaves, and other surfaces, duplicating their qualities in the form of a negative impression. *Decalomania* was a method of creating rich textures in oil paint by compressing it when wet through laying canvas or some other surface over the paint and then pulling it away. The accidental patterns created by this process achieved mysterious encrusted or porous effects (fig. 477) that Ernst would often expand by further development of the surfaces, as he did also with *frottage*. The images created in part by the use of such techniques were particularly sympathetic to the surrealist emphasis on automatic writing, of which, indeed, Ernst considered *frottage* to be the real equivalent.

477. **MAX ERNST. The Temptation of St. Anthony.** *1945. Oil on canvas. 42 ½″ × 50 ⅜″. Wilhelm-Lehmbruck Museum, Duisburg, Germany*

omnipotence = unlimited power

Surrealism, although its immediate roots lay in the Dada circle of artists and writers, belongs to the older tradition of the art of fantasy. As a modern instance of it, surrealism owes much to the psychoanalytical explorations of Sigmund Freud at the beginning of the century. But the movement is also related to other twentieth-century developments in art, as the work of the individual artists involved stems from a variety of sources and represents a wide range of styles. Like Dada, surrealism is not a term that defines a style of art. It is, rather, a designation for a life-style, or, perhaps, a kind of religion that was conceived as leading eventually to a new state of freedom for mankind. Although its official beginning can be dated precisely—the publication of the first surrealist manifesto in late 1924 by the French poet André Breton (1896–1966)—there were earlier twentieth-century manifestations of its spirit, which was not without strong romantic overtones through its emphasis on imagination.

Breton, who had been drawn into the Dada circle that eventually settled in Paris after the First World War, was at first inclined to see surrealism as having its voice in literature rather than the visual arts, but he acknowledged certain artists whose work he felt could be associated with the movement. Some of these now seem to be unlikely candidates, but one of them, Giorgio de Chirico (see fig. 346, p. 458, and pp. 458–59), must be considered a precursor of surrealist art.

The haunted spaces of de Chirico's broad piazzas and shadowy arcades seem like images from a remarkably vivid world of dreams. Belief in "the omnipotence of the dream" was one of the bases of Breton's surrealism and a union of reality and dream was a stated goal. The surrealist method—"pure psychic *automatism*"—would involve, in literary terms, the automatic writing Freud had utilized as well as word associations. This associational approach could readily be adapted to the visual arts, and it found a presurrealist manifestation in the work of the Russian-Jewish painter Marc Chagall.

In *I and the Village* (fig. 478) of 1911 Chagall, who had come to Paris the previous year, has set fragments of memo-

478. MARC CHAGALL. I and the Village. *1911. Oil on canvas. 75 ⅝″ × 59 ⅝″. Collection, The Museum of Modern Art, New York (Mrs. Simon Guggenheim Fund)*

ries and folklore from the village life of his childhood into a free, curvilinear cubist structure of interlocking planes. The lyrical mood of this work—"lyrical explosion" Breton had called these Paris years of Chagall's—is conveyed not only in the imagery but also in his orchestration of the varied hues of red, green, blue, and yellow. The free associations and daydreams of Chagall's paintings of this period are conceived in the full spirit of the surrealist movement yet to come. The visionary floral motif recalls the work of Redon (see fig. 458, p. 599), but generally overlooked is the impact of this rather exotic art on the cubist-dominated art in Paris between 1910 and 1914. The reintroduction of color to cubism after its relatively monochromatic analytical phase may owe something to Chagall's presence.

This was Chagall's boldest period. The lyrical element seems

to have gained over the years, gentling his work into whimsical reveries, as in *Around Her* (see fig. 457, p. 599), a painting that reflects the artist's sadness over the death of his wife the year before. Her image inclines toward the circular vision of her home as a bridal train from the couple in the upper right trails off into her form. This dreamworld Chagall has consistently created is a reminder of the affinities between visionary romanticism and surrealist art.

Although Paul Klee (see fig. 471, p. 630) was, strictly speaking, outside the surrealist movement itself, his work was shown in the first surrealist exhibition of 1925, and, like Chagall, he had developed in his art visual ideas that were in accord with surrealism before that movement was officially launched. There was an element of automatic writing in Klee's methods, for he began a work without preconceived content and permitted the forms to develop to the point where some association between the pictorial elements and his experience—a memory, a sudden thought—gave it an identity that would lead to its completion. His picture was both "made" and "found." Klee's weaving together of natural forms and fantasy was augmented by its tantalizing content, a blend of gentle but ironic wit and refined sensibility. He courted the visual pun and his titles were not mere labels but an integral part of the aesthetic experience, for they cooperated with his images in stimulating a train of associations spinning off and into the visual art.

The Spanish surrealist artist Joan Miró (b. 1893) was influenced by Klee's witty and poetic style, particularly in his transformation of natural forms into hieroglyphic symbols, sometimes droll and childlike in their simplicity, but always sophisticated in their execution. *Dutch Interior I* (colorplate 24), a delightful parody of a Dutch painting, exemplifies this blend of deliberate naïveté and a cultivated, supple style. The spontaneous playfulness that floats and wriggles through so much of Miró's work seems to transcribe a happy communion with an animated world of forms half-real, half-fabulous, alert with vitality. Their emblematic character endows them with a mythic presence, as if archetypal fanta-

sies buried in the subconscious had been summoned up for some magic ritual. It is this quality most of all that links his work to the surrealist movement.

A different aspect of surrealism is displayed in the work of another Spanish artist, Salvador Dali (b. 1904), whose fantasies are rendered in a meticulous style that pits the utter irrationality of the total image against the naturalistic clarity of its constituent parts (fig. 479). Like the earlier Arcimboldo (see fig. 447, p. 588), Dali plays with the viewer's perceptions, drawing him back and forth between levels of illusion: the identity of individual objects and the sudden

479. SALVADOR DALI. Apparition of a Face and a Fruit Dish on a Beach. *1938. Oil on canvas. 45″ × 56⅝″. Courtesy of the Wadsworth Atheneum, Hartford (Ella Gallup Sumner and Mary Catlin Sumner Collection)*

recognition of the paradoxical images they contrive to create. In the work shown here, the foreground beach becomes a tabletop and a woman's head emerges from a fruit dish, while the hairy fruits merge with the body of a dog whose forehead is a hill and whose muzzle is a river flowing out of the distant landscape. Spatial discontinuities abound, like the abrupt transformations in a dream. As the artist has given free play to his associative capacities, so, too, does the viewer as one becomes fascinated with the game that shapes this rebus.

Dali's "hand-painted dream photographs" lead one to the consideration of the photograph and the film as media for projecting surrealist imagery. Dali himself produced surrealist films in which disturbing transmutations and shocking images blur the boundaries between the plausible and the implausible. Indeed, the film has been the receptive beneficiary of ideas generated by the surrealist movement—and appropriately, for no other medium (and one should include television in this category) has as much capability of transforming reality before the viewer's eyes or of involving the spectator emotionally with a process developing on the hypnotic screen.

In the realm of still photography, no practitioner has been more sensitive to possibilities for the simultaneity of reality and dream than Jerry N. Uelsmann (b. 1934). His dual exposures and multiple printings create composite images in which the intense naturalism of discrete objects brought together on the same plane of reality form haunting enigmatic juxtapositions. *Bless Our Home and Eagle* (fig. 480) was made with two exposures of the film, one-half of the lens being covered as the other half was exposed. Both the empty building and the eagle's head emerge from an infinite darkness that equivocates their spatial relationships, a situation further complicated by the reflections of windows in the eagle's eyes, which make it clear that the bird was photographed indoors. The fierce vitality of the bird is also a contradiction of sorts, since it is a mounted specimen. The total image, full of paradox, defies rational explanation—and yet its components are vividly "real."

480. **JERRY N. UELSMANN. Bless Our Home and Eagle.** *1962. Photograph. Collection of the artist*

The question of reality is peculiarly provocative where photography is concerned. Of all media this is the one that appears to have the most direct relationship to the real world: the photographic image shapes itself, in a sense, from the very light that makes that world visible. Light-sensitive film records directly, so the images it captures are the negative imprints of the thing itself, a projection of it, as much a part of it as its own shadow—and more revealing. Thus the exceptional power of the photograph to bring the viewer and the viewed into the same plane of reference, sometimes even erasing in the viewer's consciousness the intermediary role of camera and photographer.

By the time a purely abstract art was created, the fixed photographic image had been in existence for around three-

quarters of a century and was building its own body of distinguished work, but widespread recognition of its qualities and potentialities as a unique art form were only then beginning to be appreciated. Its documentary use was recognized almost from the start, and the decline of portrait painting must be partially attributed to the rise of the portrait photograph. The photograph was also seized by artists as a useful tool to record appearances for use in painting as one might use, for example, a sketch or a preliminary study of a figure or some other form. At times, photography was seduced by painting as the photographic image was manipulated to achieve "painterly" or impressionistic qualities. But the influence was often the other way around and certain spatial effects and foreshortenings peculiar to the camera image soon found their way into the painter's vocabulary. If the efficiency of the photograph in recording the literal image of the real world has sometimes been credited with stimulating the thrust toward an abstract art, abstraction has reciprocated. Photographers like Edward Weston (1886–1958) have found their equivalents for abstract art in forms from the natural world (fig. 481). There can no longer be any doubt that the invention of the fixed photographic image by Nicéphore Niépce (1765–1833) and Louis J. M. Daguerre (1787–1851) between 1826 and 1837 was a technological and artistic development of paramount significance for the visual arts.

Photography, the motion-picture film, and television, as relatively new media for the artist, call attention to the role that technology has always played in the arts, developing new materials and techniques that have revolutionized one aspect or another of our creative processes throughout history. The potter's wheel, the invention of paper, the metallurgy and techniques for bronze casting, the printing press, the etching of metals with acid, the development of lithography, the invention of plastics, all represent technological contributions to the arts. Given the rapid advances that have been made in technology over the past century, it is understandable why recent art has spun off in so many diverse directions, for the artist has always been quick to take advantage of current technology in response to the cultural dy-

481. EDWARD WESTON. Artichoke Halved. *1930. Photograph. Courtesy of The Museum of Modern Art, New York*

namics of his times. Art and technology are, in fact, reciprocal relationships: the exploring artist's search for the best medium with which to express his ideas may lead him to new materials and processes; and, conversely, the discovery of a new material with novel properties may itself generate new ideas for the artist. Augmenting the technological explosion is the unprecedented mobility and flux—physical, social, ideological—of twentieth-century life. Old traditions and categories have broken down in the rush of new currents

and relationships, and in the visual arts the boundary lines between painting, sculpture, and architecture have lost much of whatever precision they once had.

In this century, few areas of the arts have absorbed more from this cultural fluidity and its technological accompaniment than the field of sculpture. High-temperature cutting and welding of metals and the invention of plastics, for example, have made possible an expanding range of sculptural forms. The technologies of modern lighting and electronics have opened such entirely new systems for the three-dimensional and spatial arts that the terms "sculptor" and "sculpture" seem to have been rendered inadequate.

For centuries the dominant sculptural image was the human form. In the course of the twentieth century its preeminence has been diminished by a flood of new forms, and even in such figurative works as Brancusi's *Prodigal Son* (see fig. 381, p. 502) the organic human presence is scarcely evoked, and in the same sculptor's later *Bird in Space* (fig. 482), the subject is reduced to a streamlined metaphor of flight, flashing, bladelike, to evoke some unspecified aerodynamic form. The high polish of the surface—like that in Trova's *Wheel Man* (see fig. 504, p. 673)—translates organic form into the language of a machine-tooled world, precisely engineered and quite impersonal.

Isamu Noguchi (b. 1904) was for a time an assistant to Brancusi and his *Kouros* (fig. 483) parallels the elegant purity of much of Brancusi's work. Remarkably sensitive to the inherent qualities of his materials, Noguchi uses them with wit and authority. Thematically a delightful parody of the Archaic Greek *kouros*, this work owes its structural character to both cubist and constructivist ideas.

On the expressive side of modern figural sculpture is *The Song of the Vowels* (fig. 484) by Jacques Lipchitz, whose earlier works show a strong attraction to African sculpture and structural dynamics derived from cubism. *The Song of the Vowels* is a massive configuration, like some gigantic vocal organ but composed of two contrapuntal images: a

482. CONSTANTIN BRANCUSI. Bird in Space. *1925. Polished bronze. Height 49 ¾". Philadelphia Museum of Art (The Louise and Walter Arensberg Collection)*

483. ISAMU NOGUCHI. Kouros *(in nine parts). 1944–45. Pink Georgia marble, slate base. Height ca. 9′9″; base 34⅛″ × 42″. The Metropolitan Museum of Art, New York (Fletcher Fund, 1953). Reproduced by permission of the artist*

harpist whose taut body leans back to support the winglike harp and, in an opposing movement, a form evocative of a dark Nike poised above the viewer.

Richard Lippold (b. 1915) has created wire sculptures delin-

484. JACQUES LIPCHITZ. The Song of the Vowels. *1931–32. Bronze. Height 12'1 ½". University of California, Los Angeles (Gift of The UCLA Art Council and Mr. and Mrs. Norton Simon. Photo: John Swope)*

eated by filaments that catch the light and mark off intervals and spaces, like some galactic spider's web spun with Euclidean precision (fig. 485). It is more a structure of voids than of solids. Its linear elements trace configurations like those our eyes follow from star to star in the night sky, in a kind of diagrammatic space drawing. By selective lighting, Lippold's symmetrical forms are made to appear suspended magically in space, as if supported by their own fields of energy. They are the precise opposites of Henry Moore's massive earthbound figures (cf. fig. 345, p. 456) or Pomodoro's weighty concretions.

The sculpture of Arnaldo Pomodoro (b. 1926), while chiefly limited to simple geometric masses—spheres, disks, and cubic shapes—often does not emphasize the geometricity but rather the "excavations" that bite into the mass. These

17. **PAUL CÉZANNE. Mont Sainte-Victoire.** *1904–6. Oil on canvas. 28⅞" × 36¼". Philadelphia Museum of Art (Purchased: The George W. Elkins Collection)*

18. HENRI MATISSE. Femme au Chapeau: Mme. Matisse. *1905. Oil on canvas. 32″ ×
23 ½″. Anonymous collection*

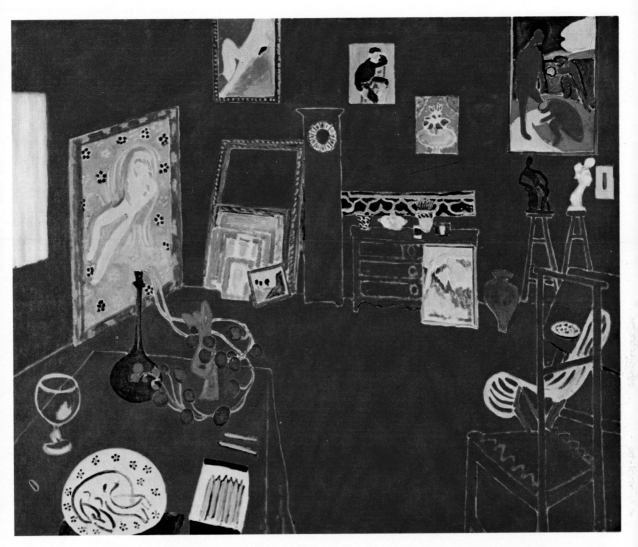

19. HENRI MATISSE. The Red Studio. *1911. Oil on canvas. 71 ¼″ × 86 ¼″. Collection, The Museum of Modern Art, New York (Mrs. Simon Guggenheim Fund)*

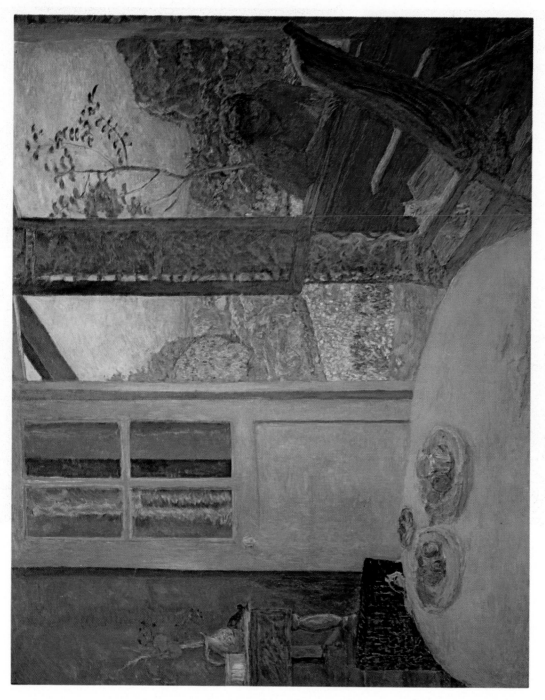

20. **PIERRE BONNARD**. Dining Room in the Country, Vernon. *1913. Oil on canvas. 64 ¾″ × 81″. The Minneapolis Institute of Arts*

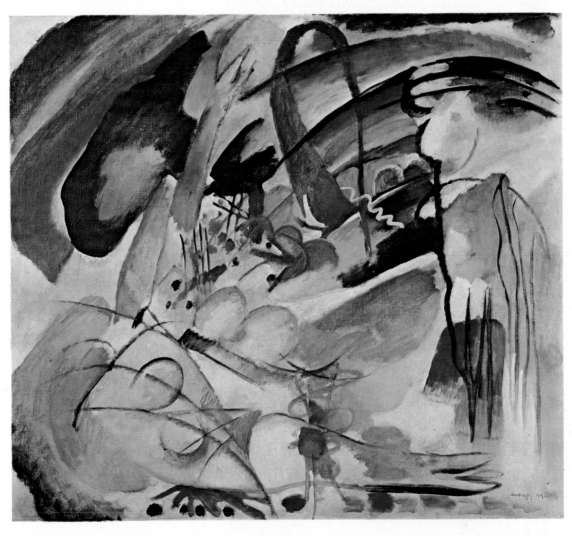

21. WASSILY KANDINSKY. Improvisation 33 for "Orient." *1913. Oil on canvas. 34 ¾" × 39 ¼". Collection of the Stedelijk Museum, Amsterdam*

22. **CLAUDE MONET. Water Lilies,** *center panel of a triptych. ca. 1920. Oil on canvas. 6'6" × 14'. Collection, The Museum of Modern Art, New York (Mrs. Simon Guggenheim Fund)*

23. PABLO PICASSO. Mandolin and Guitar. *1924. Oil with sand on canvas. 56⅛" × 79¾". The Solomon R. Guggenheim Museum, New York*

24. JOAN MIRÓ. Dutch Interior I. *1928. Oil on canvas. 36⅛″ × 28¾″. Collection, The Museum of Modern Art, New York (Mrs. Simon Guggenheim Fund)*

25. GEORGES ROUAULT. **The Old King.** *1916–36. Oil on canvas. 30¼″ × 21¼″.*
Museum of Art, Carnegie Institute, Pittsburgh (Photo: Elton Schnellbacher)

26. **PIET MONDRIAN. Opposition of Lines: Red and Yellow.** *1937. Oil on canvas. 17″ × 13″. Philadelphia Museum of Art (The A. E. Gallatin Collection)*

27. JACKSON POLLOCK. Mural. *1950. Oil on canvas. 72" × 96". Galerie Beyeler, Basel*

28. STUART DAVIS. Owh! in San Paõ. *1951. Oil on canvas. 52 ¼″ × 41 ¾″. Collection of the Whitney Museum of American Art, New York*

29. MARK ROTHKO. No. 8. *1952. Oil on canvas. 80½″ × 68″. Collection of Mr. and Mrs. Burton Tremaine, Meriden, Connecticut*

30. AD REINHARDT. Red Painting. *1952. Oil on canvas. 60″ × 82″. Collection of Mr. and Mrs. Sidney Kohl (Photo: Courtesy of Marlborough Gallery, Inc., New York)*

31. FRANK STELLA. Sinjerli Variation IV. *1968. Polymer and fluorescent polymer paint on canvas. Diameter 10′. Collection of Mr. and Mrs. Burton Tremaine, Meriden, Connecticut*

32. PAUL JENKINS. **Phenomena Saturn Burns.** *1974. Acrylic on canvas. 6'5" × 13'. Collection of Joanne du Pont (Photo: Gimpel & Weitzenhoffer Ltd., New York)*

485. RICHARD LIPPOLD. Variation within a Sphere, No. 10: The Sun. *1954–56. Gold-filled wire, 22k. ca. 11′ × 22′ × 5′6″. The Metropolitan Museum of Art, New York (Fletcher Fund, 1956)*

interior regions have the look of ancient ruins, as if one were standing atop the Roman Colosseum peering down into its eroded interior. In *Sphere Number 6* (fig. 486), the outer surface opens to reveal an inner sphere, which in turn has the appearance of being worn away to reveal its interior structure, whose dominant rhythms are in opposition to the eroded portions of the outer sphere. Pomodoro's work consistently stresses this interior-exterior dialogue, which, together with the structural patterns of the penetrations, may reflect his early training as an architect. If Lippold's constellations could be said to evoke an image of a perfect order in the universe, Pomodoro's spheres show us faulted, cratered planets in a process of disintegration symbolized by ominous ruins.

486. ARNALDO POMODORO. Sphere Number 6. *1963–65. Bronze. Diameter 47 ½". The Hirshhorn Museum and Sculpture Garden, Smithsonian Institution, Washington, D.C.*

Utilizing wire armatures stretched with fabric (fig. 487), Lee Bontecou (b. 1931) assembles reliefs of elegant patchwork that have the appearance of elaborate ducts or cellular orifices enlarged from microscopic forms, a blending of mechanistic and organic imagery. Their convoluted surfaces are often suggestive of vortical membranes that, fetishlike, might secrete some magical substance. In these expressive assemblages the form transcends its materials and establishes its own mysterious and concentrated mood.

487. LEE BONTECOU. Untitled. *1962. Welded metal and canvas. 55″ × 58″ × 15″. Private Collection, New York (Photo: Charles Uht)*

Likewise surpassing her materials, Chryssa (b. 1933) has transformed the commonplace of the garish neon sign into striking fluorescent patterns that define sculptural form with linear repetitions of controlled light contained by minimal compartments of plexiglass (fig. 488). While not overtly Pop art, Chryssa's constructions, by drawing upon the technology of a commercial art product, are at least peripheral to the spirit of that movement (see pp. 662–68).

488. CHRYSSA. Fragments for the Gates to Times Square. *1966. Neon and plexiglass. 81″ (with base) × 34 ½″ × 27 ½″. Collection of the Whitney Museum of American Art, New York (Gift of Howard and Jean Lipman)*

David Smith (1906–65), whose late *Cubi* series of sculptures (fig. 489) marks the final stage of a distinguished creative growth, can be said to have transformed rather than rejected natural forms. His forged and welded sculpture is related, technically, to the old craft of blacksmithing, which was a part of his Midwest ancestry, and to industrial practices. During the Second World War, for example, he worked as

a welder in a defense plant. But another facet of his art is of equal significance: his beginnings as a painter very much involved him with cubist ideas. Indeed, it has often been noted that his work is a translation into sculpture of pictorial ideas, frequently intended to be seen from a single, frontal point of view. Figural, still life, and landscape associations

489. DAVID SMITH. Cubi XVI. *1963.*
Stainless steel. 11′ × 5′ × 2′9″. Albright-
Knox Art Gallery, Buffalo, New York (Gift of
The Seymour H. Knox Foundation, Inc.)

abound in his work and sculptures like his *Hudson River Landscape* (1951, Whitney Museum of American Art, New York) transcribe the subject in terms of linearized configurations that are, in their effect, bold metal drawings in which the voids can be read as space-defining planes.

Cubi XVI, still remarkably organic despite its rigorous abstract geometry, gestures in space like a human form. Although some works in the *Cubi* series seem more architectural than figural, they maintain as a group, especially when viewed in the open landscape (as Smith designed them to be seen), a presence that confronts the organic growth of trees and the massing of landscape forms with another natural life—a crystallized, dynamic echo of the natural world. This *Cubi* series is formed of welded stainless-steel hollows, whose scored surfaces literally dance with reflected swirls and arabesques of light, as if radiating their own photothermic energy.

David Smith's turning to bold geometric forms in the *Cubi* series seems to have paralleled the "hard-edge" abstraction that was gathering momentum in the field of painting. Other sculptors went even further, reducing sculpture to the most elementary volumes, like the square and the rectangular box, displayed singly or in series. Donald Judd (b. 1928) and the architect Tony Smith (b. 1912) are representative of this vein of contemporary sculpture. Tony Smith's *Black Box* (fig. 490) is a relatively small work, but some of his constructions are on a monumental scale and achieve an architectural presence. Collectively, these immaculately simple forms represent a well-defined body of work that has been called Object or, more precisely, Minimal sculpture. Taking advantage of industrial materials and techniques, these sculptors have made extensive use of molded plastics and fiberglass, as well as steel and aluminum. The cool, impersonal purity of these works suggests that the idealities of Mondrian and Malevich at last have their counterparts in sculpture.

The reductive geometric simplicity of Minimal sculpture was part of the aftermath of the expressionism that had dominated the New York art scene in the years after the

490. TONY SMITH. Black Box. *1962. Steel. 22 ½" × 33" × 25". Collection of Mr. and Mrs. Norman Ives (Photo: Barbara Dreier)*

Second World War. In painting, the so-called postpainterly abstraction, on the rise by the mid-1960s, also stressed a reductive process, primarily in terms of pure, untextured color and flat patterns that derived their visual power from bold, direct chromatic relationships, color to color (see colorplate 31). Both Minimal sculpture and this new abstract painting were part of a general reaction against New York abstract expressionism (or action painting), a movement that marked the first time American art had embarked on a course that was to have a genuine impact of international scope. In a broader perspective, perhaps, the rise of abstract expressionism could be viewed as but one symptom of the new international status of leadership the United States was to inherit from the events surrounding the war.

It is debatable whether abstract expressionism (a term also applied to Kandinsky's abstractions; colorplate 21) could be considered a true "school" of art—as its alternate designation, the New York school, would have it—but there is no denying its vital presence nor the fact that, despite its variety

of personal styles, which makes it difficult to define with the same clarity as a movement like cubism, it represented a collective thrust. Its genesis goes back at least to the 1930s, during the years of the Great Depression, when several of the artists associated with the postwar movement were employed on federal Works Progress Administration arts projects. Probably more important than the intrinsic value of what was produced under the WPA program (still to be fully revealed and assessed, although a start has been made) was the opportunity it provided for some talented young artists to work at their profession when the situation throughout the country was such as to make it very likely that many would be forced out. Every bit as important, however, was an elusive ingredient in the program: the fact that it was a milieu in which artists found a social base, as it were, something supportive of their necessary creative isolation.

Artistic and political events in Europe had their effects, too. There was a growing sense in America of the implications of a European polarity, on one hand a self-conscious geometric abstraction developing out of cubism and, on the other, the Dada-surrealist current. Ingredients from both were to affect the growth of abstract expressionism. Moreover, the presence in the United States of many European artists—like Piet Mondrian, Max Ernst, and Hans Hofmann (1880–1966)—was an important stimulus. By the early 1940s there were indications that abstract art in America, which had been predominantly related to cubism and its various geometric progeny, was developing in new directions. The first New York one-man show of Jackson Pollock (1912–56) in 1943 could be taken as a signal. His large canvases of this period, with their bold, restless brush tracks, equivocal references to natural forms, human and animal, enigmatic signs scrawled like graffiti, and titles that seemed to be reaching for the world of myth, projected a crude vitality as of painting rebarbarized.

Soon Pollock was working in a semiautomatic fashion that recalls the improvisatory aspects of Kandinsky's free expressionism and the surrealist emphasis on automatism. With his large canvases spread out on the floor, Pollock dripped

free-running house paints, lacquers, and aluminum paints in sweeping motions across the canvas, sometimes sprinkling sand into the wet paint for added surface quality. In this fashion he built up a thicket of superimposed lines interspersed with spattered or poured areas of color. As he worked over it, Pollock was—as he said—literally in his painting, in an easy give-and-take with the growing tangle of color. Although Hofmann had experimented with dripping color before this, as had Ernst (by letting paint drip from a can swung from a cord back and forth in symmetrical rhythms over a canvas), Pollock was the first to expand the process to a heroic scale.

Like Monet's water-landscapes (cf. colorplate 22), Pollock's large abstractions (colorplate 27) create an environmental feeling through their size and overall composition without a definite focal point. Somewhat like Monet's painting, too, is the alternating experience of the surface texture and the depth, as one penetrates the dense cloud of superimposed lines. Sometimes figural hints seem to emerge from the swinging tracks of paint, only to fall back into the ensemble of Pollock's intricate choreography. The physical gesture of the painting act is so directly recorded that the viewer's eyes, tracking along the lines, can reconstruct passages of the action and reconstruct in a fragmentary, vicarious way the exuberant action of its execution.

Whereas the sweeping gestures of Pollock's painting method in the phase of his work illustrated here resulted in a labyrinthine overall texture that tended to absorb the linearity, the gestural aspects of the paintings of Franz Kline (1910–62) maintain an isolated, self-assertive presence (fig. 491). Bold, rough-hewn slashes of black paint applied with broad brushes define heroic forms like giant calligraphy or dynamic structural systems against the white grounds that are not entirely neutral but join with the black here and there as equally assertive shapes. Where black and white meet, black paint over white and white paint over black alternate along the boundaries in a mutual exchange of qualities that weld figure and ground together. In the mid-1950s Kline brought color back into his paintings, but with the same bold execution.

491. **FRANZ KLINE. Figure** 8. *1952. Oil on canvas. 80 ½″ × 63 ½″. Collection of Mr. and Mrs. Harry W. Anderson, Atherton, California*

Equally frank in its gestural aspects is the painting of Dutch-born Willem de Kooning (b. 1904), who of all the abstract expressionists was the most involved with the human figure. In his series of women (fig. 492), the slashes and drips of paint seem actually to attack the canvas in a savage melee of color that often has, paradoxically, delicate, sensitive chromatic passages. Indeed, one might say that these images represent sensuousness brutalized, with nerve ends raw. There is something archetypal about these women, as if the primal, large-breasted fertility figure (cf. fig. 47, p. 63) were reemerging as a disturbing demonic apparition in a neurotic world. More than the other abstract expressionists, de Kooning maintains, in the loose structure underlying the feverish execution, a cubist logic. Thus, his work can be viewed as a synthesis, with automatic gestural expressionism, of the cubist and surrealist currents in modern art.

Not all abstract expressionism was of the gestural variety exemplified by Pollock, Kline, and de Kooning. Mark Rothko (1903–70) represents another significant aspect of it in which soft-edged forms, rectilinear in character, emerge as luminous masses evocative of landscapes (colorplate 29). Like clouds expanding, contracting, drifting, they appear to be in a process of becoming rather than in a state of being. Here the tradition of landscape painting is transformed into serene environments, lyrical in color, meditative in mood— "in-scapes" of the reflective mind in accord with Rothko's interest in Oriental philosophy.

492. WILLEM DE KOONING. Woman and Bicycle. *1952–53. Oil on canvas. 76½" × 49". Collection of the Whitney Museum of American Art, New York (Photo: Geoffrey Clements)*

The gestural aspects of abstract expressionism, so much like personal handwriting, are transformed in the late 1950s and 1960s by artists like Morris Louis (1912–62) and Paul Jenkins (b. 1923) into fluid, diaphanous veils of color that stain the canvas as if flowing into its fabric of their own free will (colorplate 32). The elegance they project is the antithesis of the raw emotional expressiveness in the gestural abstractions of Pollock and Kline.

The new wave of abstraction (sometimes called "postpainterly abstraction") that followed abstract expressionism and is exemplified in the work of such artists as Jules Olitski (b. 1922) and Frank Stella owes something to the chromatic luminosity of Rothko's painting and to the work of another artist associated with the abstract expressionist group, Ad Reinhardt (1913–67), whose geometric abstractions (colorplate 30) quite literally emanate from pure optical effects. In many of his works the values and intensities of the colors are so close to each other that the geometric configurations of the color areas emerge gradually to the viewer's perception, the effect being very much like that of one's eyes becoming accustomed to the dark after coming from a lighted room. Reinhardt's personal mysticism, rooted in Oriental philosophy, sought the absolute of a pure, timeless art divested of individual style. In this respect he parallels the goal of Mondrian, but unlike Mondrian his visual effects are achieved by pure sensation as the agent of his paintings' structure. In this respect he is much closer to the spirit of Malevich's white-on-white compositions.

The pure optical emphasis of Reinhardt's work and the exhaustive explorations of color by Joseph Albers must be considered as seminal influences on another movement that developed by the mid-1960s: Op art. Totally abstract, works of this category are based on retinal sensation, that is, on the interactions of color that create optical vibrations, as in the work of Richard Anuszkiewicz (b. 1930); on the shifting spatial illusions that can be created by combining positive and negative shapes or wavy lines varying in thickness, as in the hypnotic patterns (fig. 493) created

493. BRIDGET RILEY. Current. *1964. Synthetic polymer paint on composition board. 58 ⅜″ × 58 ⅞″. Collection, The Museum of Modern Art, New York (Philip Johnson Fund)*

by Bridget Riley (b. 1931); and on various other devices. Some of the chromatic effects are not unlike those found in arrangements of colored dots long used in tests for color blindness. The sensorial aggressiveness of this art, virtually locking the viewer's eyes in its optical clamps, is sometimes vertiginous in its effects on the observer. Once in its presence, one cannot avoid visual interchange with this perceptual abstraction.

Assertive, too, is the hard-edged abstraction of artists like Frank Stella (b. 1936), whose *Sinjerli Variation IV* (colorplate 31), utilizing fluorescent colors, derives its patterns from the dynamics of the circular format itself: diameter, chords, and arcs. Its visual impact is strong by virtue of its bold color and the interlocking rhythms of straight and curved stripes, set off from one another by wiry lines. As some colors advance more than others, a kind of spatial tension is set up that has little to do with traditional methods of spatial projection, although overlappings do contribute to the effect. These, however, in reacting with the ad-

vancing and retreating colors, sometimes shift from "be-
hind" to "in front" and the visual tension is further com-
plicated. Such works as these, with no referents but them-
selves, are as self-contained as Tony Smith's *Black Box* (see
fig. 490, p. 655). They do, however, have a kind of em-
blematic presence, which is true of a great deal of "post-
painterly" abstraction.

Another reaction to the abstract expressionist movement
came in the form of a new art of the commonplace, a
celebration of the common object and popular culture. Pop
art, as it came to be known, seems to have had two indepen-
dent beginnings—in England and in the United States, with
English Pop art having a slight chronological advantage.
When one begins to look for antecedents, however, the early
edges of the movement become blurred, and we have yet to
sort it all out. The old fascination with objects that makes
picture catalogs so intriguing, the Dada wit (which also took a
new look at common things), the irrational juxtapositions of
surrealism, futurism's enthusiasm for the machine, the tech-
niques of collage and assemblage, the delightful naïvetés of
folk art, the enameled metal and plastic signs of our urban
roadside strips, the billboard, the comic strip, the film, televi-
sion, the packaged product, pinball and jukebox machines
that light up, and probably hundreds of other categories of
things all form part of the mix out of which Pop art was born.
One must add to this the entire range of abstract art—for
although Pop art has sometimes been viewed as a return to
representational art by those who longed desperately for it
during the years dominated by abstraction, the techniques,
composition, and color of both the new abstraction and Pop
art have much in common.

Although not a Pop artist, the American painter and jazz
enthusiast Stuart Davis (1894–1964) was one of the first to
paint as the dominant motif in his works a popular packaged
object (for example, his *Lucky Strike* of 1921, The Museum
of Modern Art, New York); throughout his career the jazzy
ebullience of the urban scene fed his art (colorplate 28).
Davis himself drew resources from the lessons of cubism,
from Miró (cf. colorplate 24), and from the melodic lines

and syncopated rhythms of jazz. Like many of the Pop artists, he celebrated the color and sign language of the material, popular culture of the urban world.

Jasper Johns (b. 1930) has been viewed as a Pop artist by some, by others as a point of departure for Pop art. In his encaustic paintings of flags whose patterns well up through a painterly impasto, Johns had at least blurred the boundary lines between object and painted image. A further playing off of object and art is evident in such bronzes as his ale cans of 1964 (fig. 494). Of neither the same size nor the same material as the original objects, and with painted labels and bronze bases, they are once removed from reality, irreverently assertive as art objects and overtly reminiscent of Duchamp's ready-mades.

494. JASPER JOHNS. Painted Bronze. *1964. Painted bronze. 5½" × 8" × 4½". Collection of the artist (Photo: Courtesy of the Leo Castelli Gallery, New York)*

The series of replica-pictures of Campbell's soup cans by Andy Warhol (b. 1925) are fully Pop, and his replicas of Brillo boxes, for instance, are hardly distinguishable from the real thing. Using commercial techniques of silk-screening, he created series-pictures of Marilyn Monroe, Elizabeth Taylor, and Jacqueline Kennedy that beg comparison with sheets of photographers' proofs or the single frames of motion picture film. For the Pop artist, popular personalities were as much a public commodity as familiar brands on the supermarket shelf. His life-size portrait of the rock-and-roll star Elvis Presley in a movie role (fig. 495) uses the silk-screen technique and a multiple image that links the static picture to a film sequence. Its frontality and size lend it an iconic tone, as if it were the cult image of a popular hero.

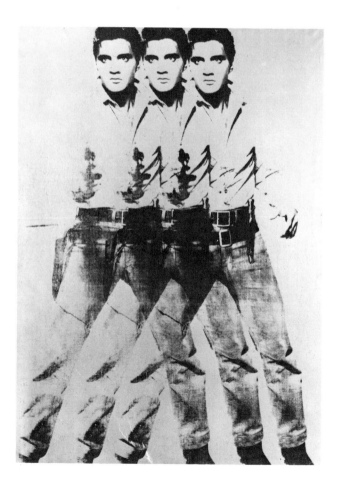

495. ANDY WARHOL. Elvis. *1964. Acrylic and silk-screen enamel on canvas. 82″ × 60″. Collection of Giuseppe Agrati (Photo: Courtesy of the Leo Castelli Gallery, New York)*

Another facet of popular culture has been utilized by Pop artist Roy Lichtenstein (b. 1923) in his parodies of comic-strip images blown up to heroic scale (fig. 496). In playful attacks on the exuberant brushwork of the abstract expressionist action painters, he has done mural-sized, cartoon-style pictures of brush strokes and drips. In more recent works Lichtenstein has enlarged upon the idea of painting large-scale Ben Day screens (dots used in advertising and comic strips to achieve gray tones). Utilizing variations of the magnified dots of color screen printing, he has created mechanical equivalents for Monet's broken color in a series of Pop versions of Monet's paintings of haystacks and the facade of the cathedral at Rouen.

Robert Indiana (b. 1928) has transformed the emblematic commonplaces of traffic signs and railroad boxcar insignias into a new heraldry that often carries an obvious burden of satirical messages. While this content is not characteristically Pop, it does strike a popular chord in that the message

496. ROY LICHTENSTEIN. I Can See the Whole Room and There's Nobody in It. *1961. Oil on canvas. 48″ × 48″. Collection of Mr. and Mrs. Burton Tremaine, Meriden, Connecticut*

usually conforms to the common denominator of social consciousness as it is expressed through the current public media. *The Demuth American Dream No.5* (fig. 497), in its visual aspects, is derived from a work by the earlier American artist Charles Demuth (1883–1935), whose *I Saw the Figure Five in Gold* (1928—also Indiana's birthdate—The Metropolitan Museum of Art, New York) was, in turn, a tribute to his poet friend William Carlos Williams, one of whose poems inspired the symbolic message. Indiana's cruciform emblem, executed with the precision of a commercial sign painter, is clearly intended as an indictment of values commonly held in various sectors of modern society—not exclusively American, however.

497. ROBERT INDIANA. The Demuth American Dream No. 5. *1963. Oil on canvas. 12′ × 12′ (five panels each 48″ × 48″). Art Gallery of Ontario (Gift from the Women's Committee Fund, 1964)*

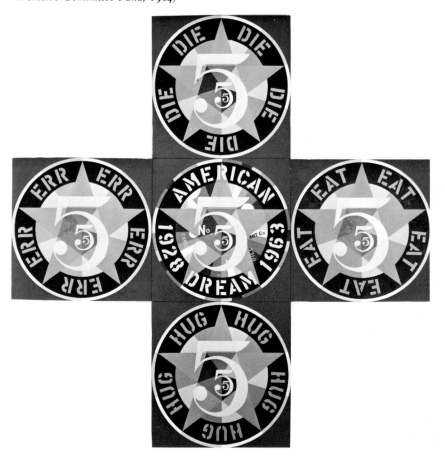

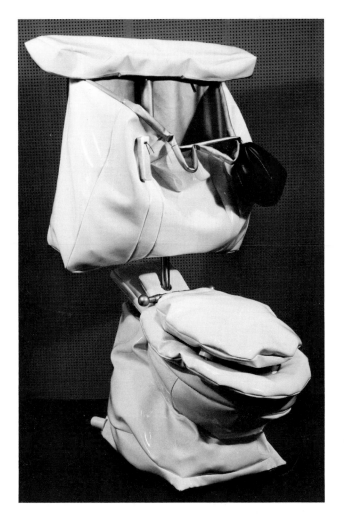

498. CLAES OLDENBURG. Soft Toilet.
1966. Vinyl, kapok, wood, liquitex, and chromed-metal rack. 55″ × 28″ × 33″. Collection of Mr. and Mrs. Victor W. Ganz (Photo: Sidney Janis Gallery, New York)

Some observers have been inclined to view Pop art as a neo-Dada movement, but there are too many dissimilarities beyond the obvious connections to relegate Pop art to a revivalist status. The soft sculptures of Claes Oldenburg (b. 1929) do have something in common with Dada in their deliberate paradox. These giant effigies of such common objects as a hamburger, a slice of cake, light switches, an electric fan, or a typewriter are made from canvas or vinyl stuffed with kapok. His *Soft Toilet* (fig. 498), however, does more than echo the impudence of Duchamp's *Fountain* (see p. 625), for it deliberately contradicts the concept of the

ready-made by converting the substantiality of the original object into a collapsible mass. This "city nature," as Oldenburg calls his soft sculpture, has a peculiar quality of life, like some nonvertebrate creature divested of its protective shell, helpless and pathetic despite its giantism. The irony of this art does not have the demonic bite of Dada and was not born of the same spirit of rejection; it celebrates rather than attacks. In time it may even be viewed as an inverted variety of romanticism, for the "coolness" of Pop images does not entirely override a sentimental choice of subject matter.

This core of sentiment sheathed in coolness is a quality that invests the sculpture of Marisol (b. 1930) with a disarming personality that augments its wit. Marisol's work evokes associations with folk art and toys brought into an autobiographical context by the frequent employment of her own striking features—carved, painted, or photographed (fig. 499).

499. MARISOL. Women and Dog. *1964. Wood, plaster, synthetic polymer paint, and miscellaneous items. 72″ × 82″ × 16″. Collection of the Whitney Museum of American Art, New York (Gift of the Friends of the Whitney Museum of American Art)*

The sense of individual identity that Marisol's figures project is deliberately purged from the plaster figures of George Segal (b. 1924). Set in realistic environments (fig. 500), Segal's human forms, at once substantial and wraithlike, cast from the live model, recall the pathetic plaster casts made by archaeologists from the natural molds formed in the volcanic ash from Mt. Vesuvius by the bodies of the victims at Pompeii. Segal's humans inhabit their surroundings but are isolated from them by their dehumanized whiteness. The message of alienation is quietly stated.

The tableaux of Edward Kienholz (b. 1927) are quite different. They are aggressive vehicles of protest, anger, or bitterness—and, at times, humorous or sentimental under their repelling surfaces. Kienholz's assemblages are three-dimensional genre pictures that combine nightmarish irrationality with the mundane reality of the everyday world. Like natural history habitat groups, they present the viewer with an image of mankind in his natural surroundings, but surround-

500. **GEORGE SEGAL. The Gas Station.** *1963. Plaster and mixed media. 8'6" × 24' × 4'7". The National Gallery of Canada, Ottawa (Reproduced by permission of the artist)*

ings so adjusted by the artist that they convey more than surface resemblances.

Kienholz frequently uses a punning device that may be either partly verbal or entirely visual, as in the dish of horehound candies in his interior of a house of prostitution, or in the mason-jar necklace on the old lady in *The Wait* (fig. 501) that contains, preserved, the tiny figurines that represent her memories as she sits among other mementos, waiting for death. Although aspects of Kienholz's work link it to Dada, surrealism, and Pop art, its moralist vein sets it apart as an agent of the artist's social and moral conscience. In this respect, his antecedents lie in the likes

501. EDWARD KIENHOLZ. The Wait. *1964–65. Assemblage and mixed media. 6′8″ × 12′4″ × 6′6″. Collection of the Whitney Museum of American Art, New York (Gift of the Howard and Jean Lipman Foundation, Inc.)*

of Hogarth and Goya as much as in the twentieth-century movements. His pervasive subject is human vulnerability in an impure world.

This sense of the human dilemma has been a significant current in both the literary and the visual arts during the twentieth century, and it is expressed early in the work of Georges Rouault. During his fauvist years around 1905–7, his work revealed the conflict between the sensuous and the repulsive in his theme of the prostitute: gross forms with yet some residue of seductive appeal. But a spiritual crisis in his life turned his painting back to religious themes, rendered in a style that emulates the stained glass of medieval cathedrals (colorplate 25; cf. colorplate 5). His work acquired a

502. DOROTHEA LANGE. **Migrant Mother, Nipomo, California.** *1936. Photograph. Collection, The Museum of Modern Art, New York (Purchase)*

devotional aura to the extent that even a sad-faced clown or a hard-visaged king became sacred images transfigured by their inner torment.

The brooding, poignant tone of Rouault's figural paintings strikes a universal chord, as they seem to be reaching for an archetypal image of human suffering. But suffering touches individual lives, and here another medium has been the eloquent spokesman: photography. Dorothea Lange (b. 1895), in her portrait of a migrant mother in California during the Great Depression (fig. 502), holds up to the viewer a tally sheet of the accountings of poverty, written in the lines of the woman's face, her eyes, and the eloquent, tentative gesture of her hand. In her field notes, the photographer recorded that the migrant family was camped by a field where the crop had failed, and the tires from the car that might take them to another location had been sold for food. The woman was thirty-two years old, with seven children. These were the facts; Dorothea Lange's sensitive photograph tells us more, as art will.

Sculpture, too, has dealt with human tragedy and pathos, with the theme of existential isolation in an impersonal

503. ALBERTO GIACOMETTI. City Square. 1949. Bronze. 9 ⅜″ × 25 ⅜″. Collection of the Ratner family (Photo: Herbert Matter)

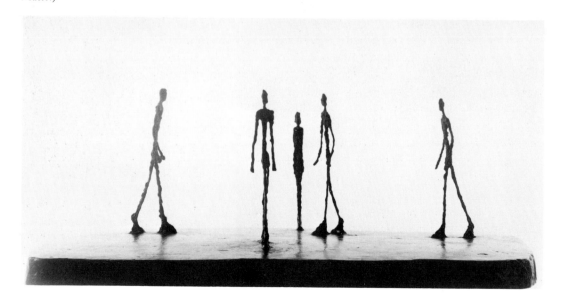

universe. This was the particular province of Alberto Giacometti (1901–66), whose *City Square* (fig. 503) is an eloquent dialogue between space and the human form. Giacometti's voids are highly charged with an aggressive emptiness that seems to eat into the figure's mass, eroding it down to the lean core of its sustaining spirit. Isolated, lonely, these figures only appear to act with purpose, sleepwalking, as it were, through the motions of life.

The idea of the lonely crowd may not have been the artist's intention here, but to the modern viewer this may seem to be the case. By contrast, the heroic posture of Rodin's *Balzac* (see fig. 237, p. 328) calls attention to an earlier concept of man in confrontation with his world. If some measure of humanity and self-determination seems to have been dessicated along with the physical mass of Giacometti's figures, it has departed by a different route in the hybrid human-machines of Ernest Trova (b. 1927). His sleek *Wheel Man* (fig. 504) is perfectly adjusted to the impersonality of his locked-in state, and the thought occurs that man can be fashioned in the image of the machine.

The *Man-Men* series of Robert Hansen (b. 1924) sounds a different, somewhat Oriental, note regarding man's relationship to his world. Attracted to Oriental philosophy early in his career, Hansen reinforced this predilection during a year in India, and many of his poured lacquer images derive from his profoundly personal response to the religious ideas of the East, tempered by his own visual wit. The figures in his *Man-Men Galaxy* (fig. 505), reduced to hieroglyphic simplicity, are iconic forms whose "otherness" is a transcendent vision. The circling galaxy—mandala, flower, burst of light—evokes both the physical stream of generations and the spiritual bonds of a purified humanity, the whole a symbolic image of universal harmony.

This survey of twentieth-century art has shown several fairly distinct lines of development among the welter of styles that have emerged over the past three-quarters of a century. One of these has been the thrust toward a pure, nonobjective art in which meaning is coessential with form, in which the

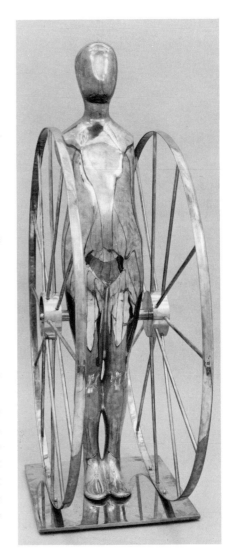

504. **ERNEST TROVA. The Wheel Man.** *1965. Silicone bronze with three layers of silicone lacquer; base covered with black plastic. 60 ⅛″ × 47 ¾″ × 21″; base 23″ × 23 ⅛″ × 23 ⅛″. The Solomon R. Guggenheim Museum, New York*

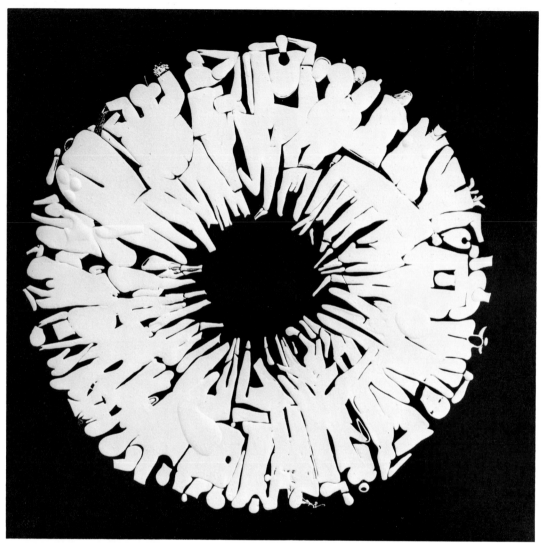

505. **ROBERT HANSEN. Man-Men Galaxy.** *1966. Lacquer on masonite. 48″ × 48″. Long Beach Museum of Art (Museum Purchase Grant)*

work of art as idea and object is an end in itself. This was the logical goal toward which cubism took the first partial steps, where *De Stijl* and suprematism sought a level of absolute purity, and where Op and Minimal art found their justification. There was also, concurrently, a movement away from an art that records the outward appearance of

things toward the record of a subjective experience of the world—how experience *feels* to the individual sensibility tuned to its nuances. This was the route of expressionism.

Perhaps the overarching question all along was the nature of reality for the modern artist, or, put another way, where validity of expression lay for him. The question spawned another: Where are the boundaries between art and life? The artistic anarchy of Dada was part of the question and one of its answers: that it was all largely absurd, beyond reason. Partly from this and partly from earlier probings came the search for a greater reality, one that lay both behind the appearances of things whose silent presence seemed to hold some power over human responses, and beneath the conscious, rational life, welling up when reason slept or was circumvented. This was the direction taken by surrealism.

For others reality was a more tangible thing, manifest in the commonplaces of everyday life, in the popular culture, its media, products, and personalities. Here Pop art found its themes as well as most of its forms, and here, too, was the breeding ground for a new wave of realism that developed in America in the 1960s, stressing a cool, impersonal image, in some instances cultivating the appearance of color photography enlarged to mural scale.

But in the midst of all these developments, older veins have persisted, older functions have been served, and the image of man, as from ancient times, has continued to challenge the artist as he searches for his place in the scheme of things.

CHAPTER 16 FROM WHERE WE ARE NOW...

At this point in time, with three-quarters of the twentieth century behind us, we can see clearly enough the immediate effects of the new directions artists were exploring in the first two decades or so of the century. To look ahead from where we are now and toward what new forms art may take in the future is quite another matter. Prophecy, even with careful attention and sensitivity to relevant data, is always a game of chance.

There is probably very little risk, however, in postulating an increasing utilization by artists of industrial technology, ranging from electronics and computer systems to production techniques. The process is already well under way, particularly in kinetics and light art in its broadest sense. In the field of kinetics, the motorized works of the Russian constructionist Naum Gabo (b. 1890), Marcel Duchamp, and Man Ray around 1920; the mobiles of Alexander Calder which appeared about a decade later; and, more recently, Jean Tinguely's motorized complexes may now be viewed as the primitives of a distinct direction for sculpture—or, more precisely, a mutation of sculpture. Visions of its future now have a science-fiction aura as the possibilities of artificial intelligence and synthetic "organisms" made possible by electronic refinements are suggested. Significant steps in this direction have already been taken by such sculptors as Nicholas Schöffer (b. 1912), who has created sculpture that responds to variations of sound and light in its environment (fig. 506). There has also been speculation about the possibility of creating forms that would respond and interact directly with the human organism itself. The ancient myth of Pygmalion has acquired new dimensions. Pursuing this

677

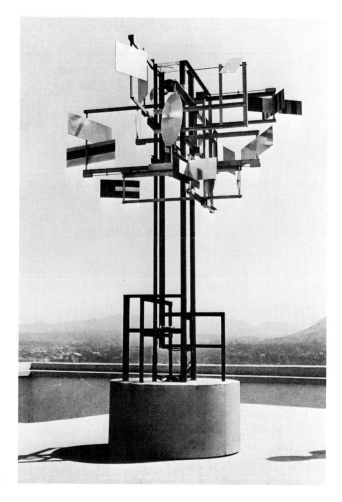

506. NICHOLAS SCHÖFFER. CYSP 1.
1956. Steel and aluminum with electronic elements. Height 94 ½". Galerie Denise René, Paris. Reproduced by permission of the artist

line even further would logically lead to the creation of something like living systems capable of a wide range of activation. Worth serious reflection are the implications a realm of such automatons holds for humanistic values—whether or not they were created for artistic reasons, whether or not they are purely mechanistic or actually living systems. The art of living systems is presently in a very primitive state in works like Hans Haacke's (b. 1936) plexiglass cube whose shallow compartment at the top contains a thin layer of soil and grass. Similar in spirit to Duchamp's ready-mades, such pieces lack the revolutionary impact of the latter's gesture, but they do harbor potentialities yet to

be explored, once the artist has at hand the technology to get beyond scientific demonstration model, gardening, vivarium, and landscape architecture concepts.

Linked somewhat to kinetics are the time-motion possibilities that film, video (television), and other light-oriented projection techniques have generated. Of particular interest are recent developments in video (fig. 507) by such artists as Keith Sonnier (b. 1941). It is impossible to illustrate adequately such art forms, since they exist as totalities only in the dimension of time. (The same is true of programmed light displays of the type created by Howard Jones [b. 1922].) The major problem video art faces—from the standpoint of viewer as well as artist—is moving beyond the in-

507. KEITH SONNIER. Still from Animation II. *1974. Color video. Reproduced by permission of the artist (Photo: Gemini Gel)*

fluence of film art. Video's major assets lie in its economic feasibility, its potential audience through video tape recorders and cassettes, and its adaptability to computer, synthesizer, and electronic manipulation. The unique quality of luminous color that can be achieved by video art—so strange in normal commercial television—has many intriguing prospects, since it is possible, electronically, to "paint" with color a black-and-white videotape. Synthesizers fed by several video cameras simultaneously can mix and develop unusual sequences of forms and colors. The intimacy of television viewing, as opposed to the large screen and audience factors of film, also creates a special condition for this art. The video artist must finally find that point where the technological aspects of the medium are fully in his command, rather than the other way around.

Another area of sensitive technology open to the artist lies in the field of computer graphics which can transpose mathematical formulations into visual schema. A type of drawing machine can also be operated from computers. Art produced by these means surely represents a depersonalized style as hermetically pure as a mathematical formula.

Eschewing such delicate systems, often relying instead on the brutal energy of earth-moving equipment, are the so-called earth artists, who have found in the open country both their medium and their primary gallery. The historical antecedents for this new form of expression lie in a number of distinct areas: the topographical manipulations of landscape architecture; the archaeological excavation that creates its own peculiar forms of earth profiles, trenches, and labyrinthine systems; the earthen mounds of such prehistoric societies as the Hopewell Indian culture of the Ohio-Mississippi basin, the burial barrows of Great Britain, and a host of other ancient earth configurations; roadways and aircraft-landing strips; strip mining; and the agricultural conformations associated with tilling the soil, ranging from the straight-furrowed expanses of prairie fields to contour-plowed rolling land and the striking terraced hillsides in the rice-producing regions of the Far East. The distinction between these manifestations of earthworks and the creations

508a. ROBERT SMITHSON. Spiral Jetty. *1970. Black rock, salt crystals, earth, and red water (algae). Coil 1500' long, ca. 15' wide. Great Salt Lake, Utah. Estate of Robert Smithson and John Weber Gallery (Photo: Gianfranco Gorgoni)*

508b. *Detail of fig. 508a. Estate of Robert Smithson and John Weber Gallery (Photo: Gianfranco Gorgoni)*

of the contemporary earth artist lies chiefly in the concept —a statement made for its own sake, not as the by-product of some other purpose. One unique aspect of earth art is its relationship to viewer, patron, and exhibition site. It can be experienced *in situ* from the ground or from an aircraft or by proxy through an exhibition of photographs, maps, and blueprints—primary and secondary gallery situations, as it were. The problem of acquisition is a matter of real estate. The *Spiral Jetty* (figs. 508a and 508b) in Great Salt Lake, Utah, designed by Robert Smithson (1938–73), when viewed from aircraft, is one of the more spectacular manifestations of earthworks, constructed of rocks, salt, and crystals, curling out into the heavy saline waters like a coral reef with intelligent purpose. Viewed at ground level it becomes a richly textured environment.

Earth art, in transforming fragments of our natural environment out of its own stuff, so to speak, bears at least a peripheral relationship to the ecological movement in general. What the future holds for each, or both in collaboration, is impossible to predict; but, as with the mechanically technological arts, economic priorities and energy problems will surely determine to some extent the scope of these new developments, limiting the scale to which they might conceivably aspire.

One development since the nineteenth century has been the shift toward *process,* toward emphasis on how a form comes into being, and finally to a focus on the process itself. We have already seen one clear manifestation of this in the *Green Box* documentation of Marcel Duchamp's *Bride Stripped Bare by Her Bachelors, Even.* The "happenings" that were staged so frequently in the years after the Second World War, traceable to the earlier Dada events and possibly to the slapstick comedy of the silent film, were another type of process art, in this case, one from which no permanent art object emerged, other than the incomplete documentary record of photographs. Recently, process art has assumed more extreme forms under the general rubric of conceptual art, subsuming several varieties of activity. The most extreme—or "pure," if you will—example is the art-language wing that engages in linguistic analysis of art con-

cepts and presuppositions. Less dematerialized forms of conceptual art involve the detailed documentation in photographs, notes, maps, blueprints, etc., of past events, sometimes an itinerary undertaken for the purpose—a kind of multimedia diary; or, on a spatially intimate scale, an intense concentration on a series of body movements or some other limited process which may or may not be recorded in photographs or film. The future of this direction seems problematic as an identity apart from documentation, record keeping, and analysis as they relate to a broad spectrum of activities of which art is only one.

In the midst of the several new directions that artists have taken in this century, transcending the older categories and techniques of art, there are voices that prophesy the end of art as we have conceived it to be up to the present, and at least the end of painting and sculpture in anything like their traditional forms. With mankind's sense of history, the penchant for preserving the artifacts of the past and reinterpreting them in the light of present visions and needs, such a total demise seems unlikely. Each present is an unstable compound of past accomplishments, insights, and conditionings reassembled by new catalytic agents, and each new adventure is provisioned by history in the broadest sense. What we can be sure of is the inexorable process of continuity and renewal in the arts and the continued assertion of human identity by those who value their own—unless, of course, technology proves, in the long run, to be mankind's Achilles' heel. But, thus far, however much subsequent developments have altered the concepts and conditions of the mid-nineteenth century, the concluding sentence of Charles Darwin's *Origin of Species* continues to be as relevant as it is sublime:

There is grandeur in this view of life, with its several powers, having been originally breathed by the Creator into a few forms or into one; and that, whilst this planet has gone cycling on according to the fixed law of gravity, from so simple a beginning endless forms most beautiful and most wonderful have been, and are being evolved.

PART

EIGHT

SYNOPTIC TABLES

(These tables include political, social, and religious history; science and technology; literature and drama; architecture, painting, and sculpture. Events important to the history of art are preceded by a —; boldface numbers refer to illustrations in this book.)

	AFRICA	ASIA
25,000 B.C.		
20,000 B.C.		
10,000 B.C.	New Stone Age (ca. 7000–4000) Predynastic period, Egypt (ca. 4500–3100)	—Plastered skulls, Jericho (7000–6000) **53, 54** —Painted beakers, Susa (ca. 5000–4000) **56** —Jomon ceramics in Japan (ca. 5000) Sumerians settle in lower Mesopotamia
4000 B.C.	Sailboats in Egypt (after 3500) —Wall painting, Hierakonpolis (ca. 3200) **31** Union of Upper and Lower Egypt (ca. 3100); Dynasties I–II (ca. 3100–2780) —Narmer Palette (ca. 3100) **42, 69** Old Kingdom, Egypt; Dynasties III–IV (ca. 2780–2280)	Pictographic writing, Sumer (ca. 3500) Wheeled vehicles in use, Sumer (3500–3000) Potter's wheel, Sumer (ca. 3250) —Ziggurat at Uruk (before 3000) Bronze implements and weapons, Sumer
3000 B.C.	Hieroglyphic writing, Egypt (ca. 3000) —Funerary precinct and step pyramid of King Zoser at Saqqara, Egypt (ca. 2750) **11** —Hesi-Re wood reliefs, Saqqara (ca. 2650) **10** —Great Pyramids at Giza, Egypt (2570–2500) —Statues of Khafre (ca. 2530)	Harappan culture in India (ca. 3000–2000): oldest known layer of Indian civilization Early dynastic period, Sumer (ca. 3000–2340) Cuneiform writing, Sumer (ca. 2900) —Statues from Abu Temple, Tell Asmar (ca. 2700–2500) **58** —Inlaid harp from Ur (ca. 2600) **437** Hunting societies in Siberia give way to herding and agriculture
2500 B.C.	—Statues of Mycerinus, or Men-kau-Re (ca. 2580) **8** Earliest known *Book of the Dead* inscribed at Saqqara (ca. 2494–2345) First Intermediate period, Egypt; Dynasties VII–X (2270–2100) —Funerary temple of Mentuhotep at Deir el-Bahri Middle Kingdom, Egypt; Dynasties XI–XIII (2134–1788)	Akkadian dynasty (2340–2180) —Bronze head of Akkadian ruler and Naram-Sin stele (ca. 2300–2200) **62, 63** —Hsia dynasty, China (2205–1766); bronzes for ritual use —Statues of Gudea (ca. 2150) **65** —Ziggurat at Ur (ca. 2100) **57** Indus valley civilization, northwest India (before 2000)
2000 B.C.	—Middle Kingdom rock-cut tombs at Beni Hasan —Portraits of Sesostris III (ca. 1850) End of Middle Kingdom; Hyksos in Egypt, bringing horses and wheeled vehicles;	Aryans invade India (ca. 2000–1000) Hammurabi founds Babylonian dynasty, establishes law code (ca. 1760) Mathematics and astronomy flourish in Babylon

EUROPE

NEW WORLD AND OCEANIA

25,000 B.C.	—Cave paintings, Lascaux (ca. 20,000) **49** —Altamira (ca. 15,000–10,000) **46** —Venus of Willendorf (15,000–10,000) **47**	
20,000 B.C.		Beginnings of slow migration from Asia to New World (ca. 20,000) Llano sites (hunting culture): Texas, New Mexico (15,000–8000); mammoth, Pleistocene horse, long-horned bison Folsom sites (hunting culture): New Mexico, Colorado (11,000–10,000); long-horned bison, elephant, camel
10,000 B.C.	Danubian agriculture, central and western Europe (4500–4000)	Llano sites (hunting culture, 10,000–5,000); long-horned bison, elephant, modern bison, antelope
4000 B.C.	Mediterranean seafaring (ca. 4000)	
3000 B.C.	Seafaring settlements along western Mediterranean and Atlantic coasts	
2500 B.C.	Minoan civilization fully developed (ca. 2100)	La Perra preceramic culture in Mexico (ca. 2500); beginnings of agriculture
2000 B.C.	—Megalithic (prehistoric stone) monuments flourishing (2000–1500); Stonehenge, England (ca. 1800–1400) Minoan civilization flourishing on Crete (ca. 1700–1500)	

AFRICA

ASIA

EUROPE

NEW WORLD AND OCEANIA

(2000 B.C.) —Palace of Minos, Knossos, Crete
(1600–1400)

1500 B.C. —Mycenaean citadels at Mycenae and Tiryns
(ca. 1400–1200)
Mycenaean civilization at its height on Greek
mainland (ca. 1300)
—Lion Gate at Mycenae (ca. 1250)
Trojan Wars (ca. 1200)
Heroic age in Greece (ca. 1200–800)
Collapse of Mycenaean civilization (ca.
1150–1100)
Dorian invasion of Greece (ca. 1100)
Iron Age in Greece

Village cultures develop in Mesoamerica
(1500–200)
Early Preclassic period in Mesoamerica (ca.
1500?–1000); pottery making

1000 B.C. Homer, Greek poet (fl. ca. 850)
Greeks adopt alphabetic writing (ca. 800)
—Geometric bronzes (8th century) **18, 19**
— *"Mantiklos" Apollo* (ca. 700–675) **20**
—Archaic period, Greek art (ca. 660–480)
—*Kroisos (Kouros from Anvysos)* (ca. 525) **22**
Aeschylus, Greek dramatist (525–426)
Pythagoras, Greek philosopher and
mathematician (fl. ca. 520)
Athenian democracy (510)
Roman Republic begins (509)
Celtic peoples in region from England and
Gaul to the Black Sea

Polynesian migrations to Pacific islands begin
(ca. 1000)
Formative period of Maya civilization:
Mexico, Honduras, Guatemala (ca. 1000
B.C.–A.D. 300)
Chavin culture in Peru (until beginning of
Christian era)
Zapotec civilization in Mexico (Monte Albán
I, ca. 650–200)
Cuicuilco Pyramid (600–200)

AFRICA

ASIA

500 B.C.	Nok culture in Nigeria (until early Christian era) —Earliest known sculpture in the Sudan First known manufacturers of iron in western Africa	Taoism develops in China (ca. 500–400) —Relief of Darius and Xerxes giving audience, treasury, Persepolis (ca. 490) **247** Taoism develops in China (ca. 500–400) Period of Warring States in China (481–221) Bronze Age in Southeast Asia and Indonesia (Chinese influence)
400 B.C.	Alexander the Great conquers Egypt (332–30) Ptolemaic dynasty, Egypt (332–30)	Alexander defeats Persia (331) Maurya period, India (322–185)
300 B.C.	Dominance of Meroë (ca. 250–early years A.D.) Carthage defeated by Rome (241)	Yayoy culture in Japan (ca. 300 B.C.–ca. A.D. 200)—also called New Stone Age Asoka, Maurya king (272–232) Bronze Age in Japan Ch'in dynasty in China (ca. 221–206) —Great Wall of China (221–210) Han dynasty, China (202 B.C.–A.D. 220)
200 B.C.	Carthage destroyed by Rome (146)	Composition of *Mahabharata*, Indian epic (200 B.C.–A.D. 200)
100 B.C.	End of Ptolemaic dynasty in Egypt (30) Roman rule in Egypt	—Chaitya Hall, Bhaja, India —Great Stupa at Sanchi, India **95, 196**

EUROPE

NEW WORLD AND OCEANIA

	EUROPE	NEW WORLD AND OCEANIA
500 B.C.	Persian Wars (499–478) Sophocles, Greek playwright (496–406) —"*Kritios Boy*" (ca. 480) **23** —Early classical period, Greek art (ca. 480–450) Hippocrates, Greek physician (b. 469) —Pedimental sculpture, Temple of Zeus, Olympia (ca. 460) **86, 89** Periclean age in Athens (ca. 460–429) Travels of Herodotus, Greek historian (ca. 460–440) —*Doryphoros* of Polykleitos (ca. 450–440) **265** —Parthenon (448–432) **195** —Classical period, Greek art (ca. 450–330) Aristophanes, Greek playwright (ca. 448–after 338) Peloponnesian War (431–404) Plato, Greek philosopher (427–347) —Erechtheion (421–405) **195** Euripides, Greek playwright (d. 406)	
400 B.C.	Socrates, Greek philosopher (d. 399) Plato founds the Academy (ca. 387) Aristotle, Greek philosopher (384–322) Alexander the Great, king of Macedon (356–323) —Hellenistic period, Greek art (ca. 330–100)	Olmec civilization developing in Mexico, central Gulf coast region
300 B.C.	Euclid, Greek philosopher (fl. ca. 300–250) Archimedes, Greek mathematician and inventor (287–212) First Punic War (264–241); Rome defeats Carthage Eratosthenes of Cyrene calculates size of globe (ca. 240) —*Dying Gaul* (ca. 230–220) **208**	
200 B.C.	—*Nike of Samothrace* (ca. 200–190) **90** —*Laocoön Group* (ca. 160–140) **26** Rome annexes Macedonia (147) Cicero, Roman orator, statesman, philosopher (106–143)	Monte Albán II, Mexico (ca. 200 B.C.–A.D. 200) Transitional Classic period of Mexico, beginning of the golden age (ca. 150 B.C.–A.D. 300) Teotihuacán I, "pyramid" civilization (ca. 150 to beginning of Christian era) in central Mexican plateau region
100 B.C.	Catullus, Roman poet (84?–54?) Vergil, Roman poet (70–19) Horace, Roman poet (65–8) Julius Caesar subdues Celtic tribes in Gaul (58–49); becomes dictator of Rome (49–44)	Olmec civilization reaches Guatemala and El Salvador Mound Builders flourish in southeast U.S. (ca. 50); mica silhouettes, carvings on bone and shell, finely carved stone pipes

	AFRICA	**ASIA**
(100 B.C.)		
A.D. 1	Ptolemy, Greco-Egyptian mathematician and astronomer (d. 160) —Funerary portraits in encaustic, Faiyûm, Egypt	Buddhism reaches China (ca. 25) Crucifixion of Jesus (ca. 30) Kushan period (including Gandhara) in northwest and north central India (ca. 50–320) Mahayana and Hinayana Buddhism Scythian-Sarmatian culture from south Russia to India Contact with Goths (ca. 150)
A.D. 200		—Tomb culture in Japan (ca. 200–700); Haniwa (clay figurines), artifacts Iron Age in Japan (200–552) End of Han dynasty, China (220) —Six Dynasties period, China (220–589); votive bronzes Sassanian Empire, Persia (ca. 226–ca. 640)
A.D. 300	Ethiopia converted to Coptic Christianity (before 380)	Gupta period, India (320–647) —Standing Buddha from Mathura **165** Huns from Asian steppes driven west by Chinese appear in Black Sea region Spread of Buddhism in China during the Northern and Southern dynasties (386–589) Invention of stirrup in China
A.D. 400	Vandals migrate from Spain into North Africa (429), moving eastward as far as Tunisia by 430 —Coptic Christian art in Egypt matures in late 5th and 6th centuries	Silk cultivation brought to eastern Mediterranean from China —*The First Sermon*, stele of Buddha from Sarnath **164** —Colossal Buddha, Cavezo, Yun-Kang, Shansi, China (2nd half 5th century)

EUROPE

(100 B.C.)

—*Odyssey Landscapes* (ca. 50 B.C.) **112a, 112b**
Ovid, Roman poet (43 B.C.–A.D. 18)
Augustus Caesar (27 B.C.–A.D. 14)
Vitruvius, *De architectura*
—*Augustus of Prima Porta* (ca. 20 B.C.) **216**

Eskimos appear on north coast of North America (ca. 50)

A.D. 1

Seneca, Roman statesman and philosopher (ca. 3 B.C.–A.D. 65)
Pliny the Elder (23–79), *Historia naturalis*
Tacitus, Roman politician, historian (ca. 55–ca. 117)
—Colosseum, Rome (72–80)
Eruption of Vesuvius buries Pompeii, Herculaneum, Stabiae (79)
—Column of Trajan (106–13)
—Pantheon, Rome (118–25)
Galen, Greek physician and anatomist (ca. 130–201)
—Equestrian statue of Marcus Aurelius (r. 161–80) **227**

Teotihuacán II (to ca. 300)
Nazca culture, south coastal valleys, Peru (to ca. 800)
Mochica culture, north coastal region, Peru (to ca. 800)
Adena-Hopewell (Mound Builder) culture, Mississippi-Ohio basin (to ca. 800)

A.D. 200

First wave of Gothic migrations
Persecution of Christians in Rome (250–302)
Plotinus, Roman philosopher (d. 270); Neoplatonism
Reign of Roman emperor Diocletian (284–305)
Mithraism popular in Roman Empire

Monte Albán II–III (ca. 200–350)
Basket weaver culture, Arizona

A.D. 300

Edict of Milan, Christianity legalized in Roman Empire (313)
—Constantine the Great (r. 324–37) **217**
—Basilica of Constantine (ca. 310–20)
—Arch of Constantine (312–15)
—Old St. Peter's, Rome (begun 333)
—Sarcophagus of Junius Bassus (ca. 359) **170**
Second wave of Gothic migrations set in motion by pressure from Huns in East (ca. 375)
Roman Empire divided into Eastern and Western empires; Christianity becomes state religion of Roman empires (395)

Teotihuacán III (ca. 300–650); Classic period in central Mexico
Classic period of Maya civilization (ca. 317–987); hieroglyphic writing, architectural development, advanced arithmetic, astronomy, calendar
Monte Albán III A (350–700)
Classic period in Oaxaca; Zapotec pottery works

A.D. 400

Rome sacked by Visigoths (410) who move on into Spain
Huns defeated in Gaul (451)
Split between Eastern and Western Christianity (451)
St. Patrick (d. ca. 461) founds Celtic church in Ireland
Fall of Western Roman Empire (476)
Clovis, ruler of Franks (481–511)
Ostrogothic kingdom in Italy (493–540)

Corn growing brought north from Mexico
—Pyramid of Quetzalcoatl, Teotihuacán, Mexico (before 500)

AFRICA	ASIA

A.D. 500

North Africa reconquered by Belisarius (533–55)

—Ajanta frescoes, India (ca. 500–650) **162**
Asuka period, Japan (552–645); introduction of Buddhism from Korea
Mohammed (570–632), beginning of Islam
Sui dynasty unites all China (589)

A.D. 600

Muslim conquest of Egypt (640–42); conquest spreads across North Africa
Muslim expedition against Nubians (651–52)
Treaty with Nubians provides slave trade agreement

Medieval period in India (ca. 600–1200)
—T'ang dynasty, China (618–909); Mandarin system develops; arts flourish
Hegira (Mohammed's flight from Mecca, 622)
Beginning of Muslim conquests
Nara period, Japan (645–794)
Koran (652)
—*Descent of the Ganges*, stone relief, Mahamallapuram, South India **99**
Omayyad caliphs, Damascus (661–750)
—Wang Wei (699–759), ink landscapes

A.D. 700

Ancient kingdom of Ghana, centered about 500 miles northwest of boundaries of present-day Ghana, first mentioned by Arab historian al-Fazari in 8th century (already a developed state, founded about 3rd century A.D.)

Porcelain invented in China (ca. 700)
Early Muslim penetration into India (712–43)
Paper making introduced to Near East from China
Kojiki (fanciful account of Yamato rulers) completed (712)
Abbasid caliphate (Baghdad) begins (750)
—Kaitasantha Temple, Ellora, India (ca. 750–ca. 850)
Heian period, Japan (749–1185); early phase: Jogan (to 897)
—Kondo (Golden Hall), Toshodai-ji, Nara, Japan (ca. 759)
—Temple at Borobudur, Java (late 8th century) Buddhist **378**

A.D. 800

Copper in use in sub-Saharan Africa (9th century)
Kingdom of Ethiopia dominates southernmost Red Sea coast and shore of Gulf of Aden, receiving tribute from Muslim traders

Earliest printed book, China (868)
Late phase of Heian period, Japan: Fujiwara period (897–1185)

EUROPE

NEW WORLD AND OCEANIA

A.D. 500

—*The Archangel Michael,* ivory relief (early 6th century) **266**
Golden age of Byzantium under Justinian (r. 527–65)
—San Vitale, Ravenna (526–47) **171, 248, colorplate 2**
—Hagia Sophia, Constantinople (Istanbul) (532–37)
—Sant' Apollinare in Classe, Ravenna (533–549) **172**
St. Benedict (d. 543) founds Benedictine order
Lombard kingdom in north Italy (568)
Gregory the Great (pope, 590–604) strengthens papacy

—Pyramid of the Sun, Teotihuacán, (ca. 510–660)

A.D. 600

Byzantium loses Near Eastern and African provinces to Muslims (632–732)
—Sutton Hoo ship burial, England (before 655) **29**; Celtic-Germanic art
—*Book of Durrow,* Irish illuminated manuscript (ca. 680) **441**; Celtic Christian art

Teotihuacán IV (ca. 650–1000)

A.D. 700

Muslims invade Spain (711–18)
Composition of *Beowulf,* English epic
Muslims defeated by Franks at Tours (732)
Pepin the Short crowned king of Franks by St. Boniface (751); reconfirmed by pope (754)
Independent Muslim (Moorish) state in Spain (756)
—Mosque at Cordova, Spain (786–987)
—Palace chapel of Charlemagne, Aachen (792–805)
Earliest Viking raids on England

Monte Albán III B (ca. 700–1000)
Hohokam culture, Arizona

A.D. 800

Charlemagne (r. 768–814) crowned emperor by pope (800); Carolingian empire, from northern Spain to western Germany and northern Italy
Revival of interest in Latin classics at Carolingian court

Mixteca-Puebla mountain civilization around Oaxaca, Mexico (ca. 800–1521)
Toltec civilization in Mexico (ca. 856–1250), central plateau, later to Yucatan
Metallurgy for ornaments becomes widespread in Mesoamerica

AFRICA	ASIA

(A.D. 800)

A.D. 900

Fatimid caliph arrives at new capital al-Qâhira (Cairo), Egypt (ca. 973)
Ghana reaches peak of power; chief mercantile and intellectual center in Sudan (990)

Five Dynasties period, China (907–60)
Earliest documented use of windmills, Near East
—Northern Sung dynasty, China (960–1127); golden age in literature and painting
Lady Murasaki Shikibu (978?–1031?), *The Tale of Genji*, Japan
Avicenna (980–1037), Persian writer on medicine and sciences
—Fan K'uan, Northern Sung painter (fl. 990–1030); *Travelers among Mountains and Streams* 104
—Temples at Khajuraho, India; Hindu; northern medieval 98

A.D. 1000

—Yoruba bronze portraits of ancestors
Muslims penetrate sub-Saharan Africa (after 1000)
—Earliest stages of stone architecture at Great Zimbabwe, Southern Rhodesia (from 11th to 15th century)
Conversion to Islam of Songhai (1010), Tekrur (1040), Mali (1050), Ghana (1076), Kanem (ancestor of Bornu, ca. 1090)

—Kuo Hsi, Northern Sung painter (1020–ca. 1090); *Early Spring* 105
Jerusalem taken by First Crusade (1099)

EUROPE

NEW WORLD AND OCEANIA

A.D. 800)

—*Coronation Gospels* (ca. 800) **267**
—*Gospel Book of Archbishop Ebbo* (816–35) **268**
—*Utrecht Psalter* (ca. 820–32) **116**
Horse collar adopted in western Europe, improving efficiency of draft animals
—Crucifixion relief, cover of *Lindau Gospels* (ca. 870) **colorplate 3**
Alfred the Great, Anglo-Saxon king of England (r. 871–99?)

Tiahuanaco culture develops around Lake Titicaca in southeastern Peru
Norse colonization (Iceland, 860; Greenland, 986)

A.D. 900

Vikings in Normandy
Monastic order of Cluny founded, France (910)
Otto I crowned emperor by pope (962)
Hugh Capet (r. 987–96) founds Capetian dynasty, France

Mimbres pottery culture, New Mexico (ca. 900–1200)
Maya-Toltec period, Mexico (Chichen Itzá, Yucatan, ca. 987–1185)
Tiahuanaco culture from Peruvian highlands spreads to coast and highlands from northern Peru to Chile

A.D. 1000

First paper manufactured in Europe by Spanish Muslims
Christianization of Scandinavia (11th century)
—Bronze doors of Bishop Bernward for St. Michael's, Hildesheim (1015)
—Ottonian sculpture
Collapse of Moorish caliphate of Cordova, Spain (1034)
—Pisa Cathedral (1053–1272), Italy; Tuscan Romanesque
Schism between Roman and Greek churches (1054)
Norman conquest of England; Battle of Hastings (1066)
—St. Étienne, Caen, Normandy (begun ca. 1068); Norman Romanesque
—*Bayeux Tapestry* (ca. 1073–83)
Peter Abelard, French philosopher and theologian (1079–1142)
—St. Sernin, Toulouse (ca. 1080–1120); pilgrimage church type
—Durham Cathedral, England (1093–1130)
First Crusade (1095–99)
Cistercian order founded (1098)

Monte Albán IV (ca. 1000–1300)
Leif Ericson sails to North America (1002)
Classic phase of Pueblo culture, southwestern U.S. (ca. 1050–1300)
Inca civilization develops in highlands around Cuzco, Peru

AFRICA

ASIA

A.D. 1100

Omar Khayyam (fl. ca. 1100)
—*Amida Shōju Raigo-zu* triptych (Descent
of Amida Buddha), Heian period, 12th
century, Japan **246**
—Southern Sung period, China (1127–1279);
golden age in literature and painting
—Angkor Wat, Cambodia (1st half of 12th
century)
Kamakura period, Japan (1185–1333)
Saladin captures Jerusalem (1187)
—Hsia Kuei, Southern Sung painter (1180–ca.
1230); *Pure and Remote View of Stream
and Hills* **107**
—Ma Yüan, Southern Sung painter (fl. ca.
1190–ca. 1224); *Landscape in Wind and
Rain* (attributed) **106**
Richard I of England negotiates truce
allowing Christians access to Holy
Sepulcher, after failure of Third Crusade
Conquests of Genghis Khan (ca. 1197–1227)

A.D. 1200

Negroid peoples assume power in Mali (ca.
1235)

Sixth Crusade of Frederick II cedes
Jerusalem, Nazareth, and Bethlehem to
Christians by diplomatic negotiation;
Frederick crowned king of Jerusalem; treaty
denounced by Pope Gregory IX
—Chao Meng-fu, Yüan dynasty painter
(1254–1322); famous also for his calligraphy
South China falls to the Mongols under
Kublai Khan (1260–94)
—Yüan dynasty, China (1279–1368); all arts
in decadence

EUROPE

NEW WORLD AND OCEANIA

.D. 1100

Rise of universities

Averroës (Ibn Rushd), Moorish philosopher (1129–98)

—*The Mission of the Apostles*, tympanum, central portal, narthex, Ste.-Madeleine, Vézelay (1120–32) **175**

—Abbey Church of St. Denis (1137–44); Gothic style begins

Second Crusade, preached by St. Bernard of Clairvaux (d. 1153), begins in 1147 and ends in failure

—Notre Dame de Paris (begun 1163)

Vernacular literature: fables, *chansons de geste*, troubadours, minnesingers; Walther von Vogelweide (ca. 1170–ca. 1230), Bavarian minnesinger

Third Crusade (1189–92), led by Emperor Frederick Barbarossa, King Philip Augustus of France, and King Richard I (Lion-Hearted) of England

—Rebuilding of Chartres (1194–1220) **197**

A.D. 1200

Fourth Crusade (1202–4) diverted to sack Constantinople

Nibelung epic, Germany (ca. 1205)

St. Dominic (1170–1221) founds Dominican order (1216)

Magna Carta (1215)

Fifth Crusade (1217–21) preached by Pope Innocent III; aimed at Egypt, but failed

—Amiens Cathedral (begun 1220)

—Salisbury Cathedral (1220–70)

St. Francis of Assisi (d. 1226); Franciscan order approved 1223

—Reims Cathedral (ca. 1225–99)

Emperor Frederick II (1194–1250) establishes splendid court at Palermo; Oriental luxury, learning, and ephemeral classical renascence; leads Sixth Crusade—a diplomatic rather than military venture

Mongol invasion of Russia (1237)

Arabic (Indian origin) numerals introduced to Europe

—Villard de Honnecourt's sketchbook (ca. 1240)

—Nicola Pisano, pulpit, Baptistery, Pisa (1259–60) **261, 271**

Dante, Italian poet (1265–1321)

Marco Polo's travels to China and India (ca. 1275–93)

St. Thomas Aquinas, Italian Scholastic philosopher (d. 1274)

Navahos enter Pueblo country as nomadic raiders

Mayapan period of Maya civilization, Yucatan (ca. 1200–1450)

<table>
<tr><td></td><td style="text-align:center">AFRICA</td><td style="text-align:center">ASIA</td></tr>
</table>

(A.D. 1200)

A.D. 1300

—Ni Tsan, Yüan dynasty painter (1301–74)
—Ming dynasty, China (1368–1644); Blanc de Chine porcelain
Muromachi period, Japan (1392–1573)

A.D. 1400

—Benin begins production of bronzes (15th century)
Portuguese traders reach Cape Verde and mouth of Senegal (1444–45)
Portuguese at Gold Coast (1471)
Cam discovers mouth of Congo River (1482–84); Portugal establishes diplomatic relations with Congo

—Sesshu, Japanese painter (1420–1506); *Haboku Landscape* 108
—Shen Chou, Ming dynasty, scholarly painting (1427–1509)
—Kano Masanobu, Japanese painter (1434–1530); Kano school, decorative style
—Full development of cloisonné in China (ca. 1450); Ching-Tai
—Wen Cheng-ming, pupil of Shen Chou (1470–1559)
—Kano Motonobu, Japanese painter (1476–1559); Kano school
da Gama reaches India (1498)

EUROPE

NEW WORLD AND OCEANIA

(A.D. 1200) —Cimabue, *Madonna Enthroned* (ca. 1280–90)
Muslims conquer last Christian stronghold in Holy Land (1291)
First documented use of spinning wheel in Europe (1298)

A.D. 1300 Formation of nation-states (ca. 1300–1400)
First Estates-General in France (1302)
First large-scale production of paper in Italy and Germany
Petrarch, Italian poet (1304–74)
—Giotto, Arena Chapel frescoes, Padua (1305–6) **120, 211**
—Duccio, *Maestà Altarpiece* (1308–11) **119**
Exile of papacy at Avignon (1309–76)
Boccaccio, Italian writer (1313–75)
Dante completes *Divine Comedy* (ca. 1321)
First large-scale production of gunpowder; cannon developed by 1326
—Equestrian Statue of Can Grande I (Francesco della Scala) (1330) **228**
Hundred Years' War between England and France (begins 1337)
Black Death (1348–49)
Peasants' Revolt in England (1381)
Chaucer's *Canterbury Tales* (ca. 1387)

Monte Albán V (ca. 1300–1521)
Aztec civilization, Mexico, comes to central plateau from the north (ca. 1324)

A.D. 1400 —Competition for Baptistery doors, Florence, won by Ghiberti (1401–2); doors begun 1403, completed 1424
—Leon Battista Alberti, theorist and architect (1404–72)
—Limbourg Brothers, *Les Très Riches Heures du Duc de Berry* (1413–16) **122**
—Brunelleschi, cathedral dome, Sta. Maria del Fiore, Florence (1420–36); Church of San Lorenzo, Florence (1421–69)
—Ghiberti's second pair of doors for Baptistery, *Gates of Paradise* (1425–52)
—Master of Flémalle, *The Merode Altarpiece* (ca. 1425–28) **192**
—Masaccio, *The Tribute Money*, Brancacci Chapel, Florence (ca. 1427) **182, 276**
—Donatello, *David* (ca. 1430–32) **275**
Prince Henry the Navigator (1394–1460) of Portugal promotes exploration
François Villon, French poet (b. ca. 1431)
—Hubert and Jan van Eyck, *The Ghent Altarpiece* (completed 1432)
Marsilio Ficino, Neoplatonist (1433–99)
Gutenberg invents printing with movable type (1446–50)

Decline of Maya civilization; division into smaller states
—Sacsahuaman fortifications, Cuzco, Peru (mid-15th century)
Columbus reaches the New World (1492)
—Machu Picchu, Peru (ca. 1500)

AFRICA

ASIA

(A.D. 1400)

A.D. 1500

Ottoman Turks conquer Egypt (1517)
English merchants in Guinea (1550)
Slave trade between Africa and Americas
 begins (1562)
Portuguese build fort at Mombasa on East
 African coast (1593)

Portuguese established at Goa on west coast
 of India (1510)
Portuguese merchants in Canton, China
 (1513)
Suleiman the Magnificent becomes ruler of
 Turkey (1520)
Mogul dynasty established in India (1527)
—Hasegawa Tohaku, Japanese painter
 (1539–1610)
Portuguese reach Japan (1542–43)
Jesuits (St. Francis Xavier) in Japan (1549)
European trading base established on China
 coast at Macao by 1557
Momoyama period in Japan (1573–1615)
—Tawaraya Sotatsu, Japanese painter
 (1576–1643)
Foreign missionaries barred from Japan (1587,
 not immediately enforced)

EUROPE

NEW WORLD AND OCEANIA

AFRICA **ASIA**

(A.D. 1500)

A.D. 1600	Portuguese forced out of Gold Coast by	Dutch open trade with Japanese (after 1609)
	Dutch (ca. 1642)	Edo (Tokugawa) period in Japan (1615–1868)
	Dutch establish small colony at Cape of Good	Early Edo period (1615–1716)
	Hope (1652)	—Hishikawa Moronobu, beginning of *Ukiyo-e*

EUROPE

NEW WORLD AND OCEANIA

(A.D. 1500) Turkish expansion threatens Vienna (1525)
Palestrina, Italian composer, conductor of
 Vatican choirs (ca. 1525–94)
Castiglione, *The Courtier* (1528)
Copernicus's heliocentric theory of planetary
 system (1530–43)
Machiavelli, *The Prince* (1532)
Ignatius of Loyola founds Jesuit order (1534)
Henry VIII of England establishes Anglican
 church (1534)
Michelangelo, *Last Judgment* (1534–41)
Calvin, *Institutes of the Christian Religion*
 (1536)
Vesalius, *De humani corporis fabrica* (1543)
Council of Trent (1545–63); Counter-
 Reformation
Tycho Brahe, Danish astronomer (1546–1601)
Cervantes, Spanish novelist (1547–1616)
—Vasari, *Lives of the Most Eminent Painters,
 Sculptors, and Architects* (1550, rev. ed.
 1568)
Elizabeth I of England (r. 1558–1603)
—Vasari, the Uffizi, Florence (begun 1560)
Alexander Knox founds Presbyterian church
 (1560)
—Accademia del Disegno formed in Florence
 (1563)
Shakespeare, English dramatist and poet
 (1564–1616)
Dutch revolt against Spain (1568)
Defeat of Turkish sea power at Lepanto
 (1571)
Donne, English poet (1572–1631)
Saint Bartholomew's Day massacre of French
 Protestants (1572)
—Rubens (1577–1640) **185, 236, 256, 310,
 311, colorplate 8**
Drake circumnavigates the globe (1577–80)
Dutch independence (1581)
Defeat of Spanish Armada by English (1588)
—Poussin (1594–1665) **312, 313, 314**
—Caravaggio, *The Calling of St. Matthew*
 (ca. 1597–98) **402**
Descartes, French scientist and philosopher
 (1596–1650)
Edict of Nantes establishes religious toleration
 in France (1598)
—Velázquez (1599–1660) **219, 254, 403**

A.D. 1600 Gilbert's treatise on magnetism (1600)
—Rembrandt (1606–69) **186, 187, 232, 315,
 colorplate 9**
Corneille, French playwright (1608–84)

Jamestown, Virginia, founded (1607)
French settlement at Quebec (1608)
Santa Fe established as Spanish administrative
 center in New Mexico (1609)

AFRICA

(A.D. 1600) African slave trade thrives (ca. 1650–early
1800s)

ASIA

wood-block prints (1625–95); center at Edo
(modern Tokyo)
—Taj Mahal, India, built (1632–53)
Japanese isolation from Europeans begins
(1639)
Ch'ing dynasty in China (1644–1912)
—Ogata Korin, Japanese painter (1658–1716)
—Okumura Masonobu, two-color prints,
Japan (1686–1764)
—Lang Shih-ning (Giuseppe Castiglione),
painter at Ch'ing court (1688–1768) **390**

EUROPE

A.D. 1600)

—Rubens, *The Raising of the Cross,* Antwerp
 Cathedral (1610) **185**
King James version of Bible (1611)
Romanov dynasty established in Russia (1613)
Napier's treatise on logarithms (1614)
Thirty Years' War (1618–48)
Molière, French playwright (1622–73)
—Rubens, *The History of Marie de' Medici,*
 series of large canvases for Luxembourg
 Palace (1622–25)
—Bernini, *David* (1623) **202**
Cardinal Richelieu, adviser to Louis XIII,
 strengthens royal power in France
 (1624–42)
Harvey describes circulation of blood (1628)
Spinoza, Dutch philosopher (1632–77)
Locke, English philosopher (1632–1704)
Racine, French dramatic poet (1639–99)
—Rembrandt, *The Night Watch* (1642)
Newton, English natural philosopher
 (1642–1727)
Cardinal Mazarin governs France during
 minority of Louis XIV (1643–61)
Leibnitz, German philosopher (1646–1716)
—French Royal Academy of Painting and
 Sculpture founded (1648)
—Rembrandt, *Supper at Emmaus* (1648) **187**
Charles I of England executed (1649);
 commonwealth under Cromwell (1649–53)
Hobbes, *Leviathan* (1651)
—Velázquez, *Las Meninas* (1656) **254**
—Colonnade for piazza, St. Peter's, Rome,
 designed by Bernini (1657)
Boyle's Law formulated (1660)
Louis XIV, absolute monarch of France (r.
 1661–1715)
Milton, *Paradise Lost* (1667)
—Palace of Versailles (1669–85) **318**
Vivaldi, Italian composer (1675–1743)
—Sir Christopher Wren, St. Paul's Cathedral,
 London (1675–1710)
—Salon exhibitions begin in Paris (1673)
Bunyan, *Pilgrim's Progress* (1678)
Vienna again besieged by Turks (1683)
Handel, Austrian composer (1685–1759)
Louis XIV revokes Edict of Nantes (1685)
Bach, German composer (1685–1750)
Glorious Revolution in England (1688);
 English Bill of Rights
Voltaire, French writer (1694–1778)

NEW WORLD AND OCEANIA

—Palace of the Governors, Santa Fe, N.M.,
 completed (1614)
First African slaves introduced into what is
 now the U.S. (1619)
Plymouth, Massachusetts, founded (1620)
New Amsterdam (New York) settled by
 Dutch (1625)
Australia first sighted in early 17th century by
 Portuguese and Spanish navigators
Dutch establish colony in northeastern Brazil
 (1636)
New Zealand and Tasmania discovered by
 Dutch navigator Tasman (1642)
Dutch forced out of northeastern Brazil by
 Portuguese (1654)
British seize control of Dutch settlement,
 New Amsterdam, renamed New York
 (1664)
King William's War (1688–97), corresponding
 to European War of the Grand Alliance;
 frontier attacks on British colonies

AFRICA

ASIA

A.D. 1700

Portuguese forced out of Mombasa by Oman
 sea power
Sierra Leone settled by English (1787)
Napoleon in Egypt; Battle of the Pyramids
 (1798)

—Suzuki Harunobu, Japanese artist of *Ukiyo-e*
 school (1725–70)
—Kitigawa Utamaro, Japanese artist of
 Ukiyo-e school (1753–1806)
British and French in India
British East India Company destroys French
 power in India (1757)
—Katsushika Hokusai, Japanese artist
 (1760–1849); *Thirty-six Views of Mount
 Fuji,* wood-block prints, *Ukiyo-e* school
First British governor-general of India (1784)
—Toshusai Sharaku, Japanese artist of *Ukiyo-e*
 school (fl. 1790–95, d. 1801)
—Ando Hiroshige, Japanese artist
 (1797–1858); *Fifty-three Stages of the
 Tokaido Highway,* wood-block prints,
 Ukiyo-e school

EUROPE

NEW WORLD AND OCEANIA

A.D. 1700

Peter the Great (r. 1682–1725) Westernizes Russia

—Watteau, *Embarkation to Cythera* (1717) **319**

Defoe, *Robinson Crusoe* (1719); *Moll Flanders* (1722)

Swift, *Gulliver's Travels* (1726)

Gay, *The Beggar's Opera* (1728)

Haydn, Austrian composer (1732–1809)

—Hogarth, series of engravings, *The Harlot's Progress* (1733); *The Rake's Progress* (1735) **405**

—Chardin, genre and still life paintings (from 1730s to 1779) **416**

Linnaeus, *Systema naturae* (1737)

Frederick the Great of Prussia defeats Austria (1740–48)

Lavoisier, French chemist (1743–94)

Diderot, *Encyclopédie* (1751–72)

Johnson, *Dictionary* (1755)

Seven Years' War pits England, Prussia against France, Austria (1756–63)

Mozart, Austrian composer (1756–91)

—William Blake, English painter and poet (1757–1827) **453**

Blast furnace perfected for iron smelting (ca. 1760–75)

Catherine the Great of Russia (r. 1762–96)

Rousseau, *Social Contract* and *Émile* (1762)

—Fragonard, *Bathers* (ca. 1765) **339**

Watt perfects steam engine (1765–76)

—Royal Academy of Arts founded in London (1768)

—West, *The Death of Wolfe* (1770) **210**

Beethoven, German composer (1770–1827)

Hegel, German philosopher (1770–1831)

Sir Walter Scott, Scots writer (1771–1832)

Priestley discovers oxygen (1774)

—Friedrich (1774–1840) **141**

Goethe, *Sorrows of Werther* (1774)

—Clodion, *The Intoxication of Wine* (ca. 1775) **322**

Gibbon, *Decline and Fall of the Roman Empire* (1776–87)

Smith, *Wealth of Nations* (1776)

Kant, *Critique of Pure Reason* (1781)

—Reynolds, *Mrs. Siddons as the Tragic Muse* (1784)

—David, *Oath of the Horatii* (1784) **329**

First balloon crossing of English Channel (1785)

Lord Byron, English poet (1788–1824)

Queen Anne's War (1701–13), corresponding to the War of the Spanish Succession in Europe; phase of English-French struggle in North America

King George's War (1745–48), linked to the War of the Austrian Succession in Europe; part of English-French conflict in North America

—Copley commences career as portrait painter in late 1750s

New World phase of Seven Years' War: French and Indian War (1756–63)

French defeated by English and colonial troops at Quebec (1759)

—American painter West leaves Pennsylvania for Europe and London (1760) **210, 240**

Treaty of Paris (1763) gives Canada and the West to England

Discovery of Tahiti (1767)

—Copley's portrait of Paul Revere (ca. 1768–70)

Spanish colonize California (1769)

—Jefferson begins work on his home, Monticello (1770)

—Copley leaves Massachusetts for London (1774)

American Revolution (1775–85)

Paine, *Common Sense* (1776)

Captain Cook discovers Hawaii (1778)

—Trumbull, *Battle of Bunker's Hill* (1786)

U.S. Constitution adopted (1789)

Whitney invents cotton gin (1793)

von Humboldt's scientific explorations of American tropics (1799–1804)

—Bulfinch, Boston State House (1799)

AFRICA

ASIA

(A.D. 1700)

A.D. 1800

Mehemet Ali rises to power as Egyptian
pasha and founds new royal line (1805)

Americans found Liberia (1820; independent
1847)

British expedition from Tripoli crosses the
Sahara, discovers Lake Chad (1822)

France conquers Algeria (1830–47)

Livingstone in Africa (1841–73,
intermittently)

Exploration of the Sahara by Richardson
(1845–46)

Diamonds discovered in South Africa
(1867–70)

Suez Canal opened (1869)

Partitioning of Africa begins (1876)

Egypt brought under British control
(1883–1907)

Boer War in South Africa (1899–1902)

Opium War (1839–42)

British established at Hong Kong (1841)

U.S. treaty with China opens China ports
(1844)

Japanese ports opened as result of
Commodore Perry's visit (1854)

Second Opium War (1856–60)

Sepoy Rebellion in India (1857); rule in India
transferred from British East India
Company to British crown

Vietnam becomes a French colony (1858–85)

First Sino-Japanese War (1894–95) ends with
defeat of China

EUROPE

NEW WORLD AND OCEANIA

A.D. 1700)

French Revolution (1789–97); King Louis
XVI beheaded (1793)
Shelley, English poet (1792–1822)
Keats, English poet (1795–1821)
Laplace's nebular hypothesis (1796)
Wordsworth and Coleridge, *Lyrical Ballads*
(1798)
Coup d'état in France; Napoleon becomes
First Consul (1799)
Balzac, French novelist (1799–1850)

A.D. 1800

Volta invents electric battery (1800)
Goethe, *Faust*, Part I (1803); Part II (1833);
dies (1832)
Napoleon proclaimed emperor of the French
(1804)
Lord Nelson defeats French fleet at Trafalgar
(1805)
English slave trade abolished (1807)
Chopin, Polish composer and pianist
(1810–49)
Napoleon's Russian campaign fails (1812)
Dickens, English novelist (1812–70)
Wagner, German composer (1813–83)
Verdi, Italian composer (1813–1901)
Napoleon abdicates (1814), is exiled to Elba,
returns, is defeated at Waterloo (1815)
Stephenson's first locomotive (1814)
—Ingres, *Odalisque* (1814) **335**
—Goya, *Disasters of War* (ca. 1814; first
published 1863) **432, 433**
—Géricault, *The Raft of the Medusa*
(1818–19) **205**
Baudelaire, French poet (1821–67)
Flaubert, French novelist (1821–80)
Faraday discovers principle of electric dynamo
(1821)
—Constable, *The Haywain* (1821)
Greeks declare independence from Turkey
(1822)
—Delacroix, *The Massacre of Chios*
(1822–24)
First railway completed in England (1825)
Ibsen, Norwegian poet and dramatist
(1828–1906)
Slavery abolished in British West Indies
(1833)
Brahms, German composer (1833–97)
Queen Victoria crowned (1837)
—Turner, *The Slave Ship* (1839)
Daguerreotype photographic process (1839)
Zola, French novelist (1840–1902)

—Allston leaves U.S. to study at Royal
Academy, London (1801)
Louisiana Purchase (1803)
Lewis and Clark Expedition (1803–6)
Slaves in Haiti revolt, gain independence
(1804)
—Fulton's steamboat tested on Hudson
(1807)
Allston returns to U.S. after spending five
years on Continent, chiefly in Italy (1808)
—Jefferson's Monticello completed (1809);
classical "Federal" style
Poe, American writer (1809–49)
—Allston returns to England (1811) with
young artist S. F. B. Morse
War of 1812 (1812–15)
—Debret and French artistic mission in
Brazil (1816)
Latin American revolutions achieve
independence from Spain (1817–25)
—Allston returns to U.S. (1818)
—Jefferson's designs for campus, University of
Virginia (1818–25)
Monroe Doctrine proclaimed (1823)
—National Academy of Design founded in
New York (1825)
Erie Canal opened (1825)
—Cole, leading painter of Hudson River
school of landscape, travels to Europe for
first time (1829–32)
McCormick invents reaper (1831)
—Gothic revival architecture developing in
U.S. (1830s); reaches peak around
mid-century
James, American novelist (1843–1916)
Morse perfects telegraph (1844)
Mexican War (1846–48)
—Bingham achieves national attention for
paintings by 1847 **424**
Gold discovered in California (1848)
—Death of Cole (1848)

AFRICA **ASIA**

(A.D. 1800)

EUROPE

(A.D. 1800)

—Turner, *Rockets and Blue Lights . . .* (1840) **colorplate 11**

Joule formulates first law of thermodynamics (1847)

Communist Manifesto (1848)

Congress of Vienna (1848)

Second French Republic (1848)

—Paxton, Crystal Palace, London (1850–51)

Kelvin formulates second law of thermodynamics (1851)

Louis Napoleon becomes French emperor (1852)

Crimean War (1853–55)

—Courbet's "Pavilion of Realism," Paris International Exposition (1855)

Shaw, British writer (1856–1950)

Darwin, *Origin of Species* (1859)

Bessemer patents process for converting pig iron to steel (1860)

Unification of Italy (1860–70)

Russia abolishes serfdom (1861)

—Garnier, Opera House, Paris (1861–75)

—Salon des Refusés, Paris (1863); Manet, *Le Déjeuner sur l'Herbe*

Debussy, French composer (1862–1918)

—Death of Delacroix (1863)

Tolstoy, *War and Peace* (1864–69)

Pasteur develops germ theory (1864)

Mendel publishes experiments in genetics (1865)

Marx, *Das Kapital* (1867–94)

Nobel invents dynamite (1867)

—Death of Ingres (1867)

Pirandello, Italian novelist and dramatist (1867–1936)

Franco-Prussian War (1870–71)

Maxwell, *Electricity and Magnetism* (1873)

—First impressionist exhibition, Paris (April 1874)

—After 1875 Cézanne works mostly in the south of France near Aix-en-Provence; returns to Paris for brief periods only

Apollinaire, French writer (1880–1918)

Pasteur develops methods of vaccination and inoculation (1880–85)

—Renoir, *The Luncheon of the Boating Party* (1881) **colorplate 12**

Pasteur and Koch prove germ theory of disease (1881)

Joyce, Irish writer (1882–1941)

—Gauguin gives up business world to devote full time to painting (1883)

NEW WORLD AND OCEANIA

Melville, *Moby Dick* (1851)

—Inspired by writings of von Humboldt, Church makes first visit to South America to paint

—American painter Homer apprenticed to lithographer (1854/55)

Whitman, *Leaves of Grass* (1855)

First transatlantic cable (1858–66)

First oil well drilled in Pennsylvania (1859)

U.S. Civil War (1861–65)

—Homer's first paintings in oil (1862) **145**

Emancipation Proclamation (1863)

—Brady, war photographer, portraits of Lincoln

French puppet government in Mexico (1864–67) under Emperor Maximilian ends with emperor's execution

—U.S. Capitol, with present dome and wings, completed (1865)

Assassination of Lincoln (1865)

Russia sells Alaska to U.S. (1867)

Canada granted dominion status (1867)

J. A. and W. A. Roebling, Brooklyn Bridge, New York (1869–83)

First transcontinental railroad in U.S. (1869)

—Richardson, Trinity Church, Boston (1873–77)

—Eakins, *The Gross Clinic* (1875) **242**

Mark Twain, *Tom Sawyer* (1876)

Bell patents telephone (1876)

Edison invents phonograph (1877)

Muybridge photographs galloping horse with line of cameras to catch successive phases of action, California (1878)

Edison invents light bulb (1879)

War of the Pacific; Peru and Bolivia vs. Chile (1879–84)

—American painter Ryder at height of his career (1880s–1890s)

—Richardson, Marshall Field wholesale store, Chicago (1885–87)

Emancipation of slaves in Brazil (1888)

Eliot, American poet (1888–1904)

O'Neill, American playwright (1888–1953)

Edison perfects motion picture (1896)

Faulkner, American writer (1897–1962)

Spanish-American War (1898)

Hemingway, American writer (1898–1961)

—Sullivan, Carson, Pirie, Scott and Company Department Store (originally Schlesinger and Mayer Store), Chicago (1899–1904)

AFRICA

ASIA

(A.D. 1800)

A.D. 1900

Entente Cordiale gives Britain free hand in
 Egypt, France free hand in Morocco
 (1904)
Egypt under constitutional monarchy (1923)
Ethiopia conquered by Italy (1936)
Ethiopia liberated by British troops (1941)
Egypt attacks Israel and is defeated (1948)
Apartheid officially established in South Africa
 (1948)
Army coup in Egypt forces abdication of king
 (1952)
Mau Mau terrorism in Kenya (1952)
British leave Suez Canal Zone (1954)
Suez crisis (1956); Egypt seizes canal, is
 attacked by British and French; Israelis
 invade Egypt
African colonies gain independence after 1957
Congo independent; civil war breaks out
 (1960)
Revolution breaks out in Angola (1961)
Arab-Israeli "Six-Day" War (1967)
Republic of Biafra proclaimed; civil war in
 Nigeria (1967–70)
Barnard performs first human heart
 transplant, South Africa (1967)
Arab-Israeli "Yom Kippur" War (1973–74)

Rebellion against U.S. occupation of
 Phillippines ends (1901)
Russo-Japanese War (1904–5) ends with
 Russian defeat
Revolution in China; republic established by
 Sun Yat-sen; emperor abdicates (1912)
Civil strife in China after 1919
Gandhi presses for Indian independence after
 First World War
Turkey becomes a republic (1923)
Chinese Communists retreat north (1927)
Chiang Kai-shek unites most of China
 (1927–28)
Japan invades Manchuria (1931); second
 Sino-Japanese War, lasts until end of
 Second World War (1945)
Commonwealth of Philippines established
 (1935) as transition to complete
 independence from U.S.
Hiroshima and Nagasaki hit by atomic bombs
 (1945)
Independence of Philippines (1946)
British rule ends in India (1947); India and
 Pakistan separate states
Israel becomes independent (1948)
Communist forces win in China; Chinese
 People's Republic established (1949);
 Chang Kai-shek government retreats to
 Taiwan
Indonesia becomes sovereign country (1949)
Korean War (1950–53)
—Le Corbusier, High Court Building,
 Chandigarh, India (1951–56)

EUROPE

NEW WORLD AND OCEANIA

(A.D. 1800)

Nietzsche, *Thus Spake Zarathustra* (1883)
—Seurat, *Sunday Afternoon on the Island of the Grande Jatte* (1884–86)
First vehicle propelled by gasoline internal combustion engine (1895)
—van Gogh in Paris (1886–88), then to southern France (Arles); dies (1890)
—Monet's series of paintings of haystacks (1891) **colorplate 15**
—Gauguin leaves for Tahiti (1891), returns to France (1893), and leaves for the islands for the last time (1895)
Roentgen discovers X rays (1895)
Marconi invents wireless telegraph (1895)
—Rodin, *Balzac* (1892–97) **237**
Berthold Brecht, German playwright and poet (1898–1956)
Curies discover radium (1898)

A.D. 1900

Planck formulates quantum theory (1900)
Freud, *Interpretation of Dreams* (1900)
Pavlov's experiments with conditioned reflexes (1900)
—Salon d'Automne of 1905 launches fauvist painters in France; French expressionism
—*Die Brücke* artists organize in Dresden (1905); German expressionism
Einstein develops theory of relativity (1905)
Sartre, French writer (b. 1905)
—Gaudi, Casa Milá, Barcelona (1905–10)
—Picasso, *Les Demoiselles d'Avignon* (1907) **380**
—Futurist manifesto (1910)
—*Der Blaue Reiter* artists organize in Munich (1911); German expressionism
—Malevich's suprematism (ca. 1913)
Stravinsky, *Rite of Spring* (1913)
Camus, French writer (1913–60)
First World War (1914–18)
—Dada movement in Lucerne, Switzerland (1916)
Bolshevik Revolution in Russia (1917)
—*De Stijl* movement begins, Holland (1917)
Schoenberg, 12-tone composition (1921–23)
Mussolini's Fascists take over Italian government (1922)
—Surrealist manifesto (1924)
—Bauhaus buildings designed by Gropius in Dessau, Germany (1925–26) **470**; International style
—Le Corbusier, Villa Savoye, Poissy, France (1929–31)

Commonwealth of Australia formed (1901)
First powered aircraft flight, Wright brothers (1903)
—Stieglitz (1864–1946) establishes his galleries at 291 Fifth Avenue and promotes modern art
Ford begins assembly-line production (1909)
—Wright, Robie House, Chicago (1909); Prairie style
Peary discovers North Pole (1909)
Mexican Revolution (1910)
Amundsen reaches South Pole (1911)
—New York Armory Show (1913) **7**
Panama Canal opens (1914)
U.S. enters First World War (1917)
Regularly scheduled radio broadcasts begin (1920)
Scopes evolution trial in Tennessee (1925)
Lindbergh flies solo across the Atlantic (1927)
First regularly scheduled TV broadcast in U.S. (1928)
Stock market crash in U.S. (1929); world depression
Franklin Roosevelt establishes New Deal (1933)
—WPA Arts Projects support American artists during the depression
Pearl Harbor bombed by Japanese (1941); U.S. enters Second World War
Atomic fission achieved in laboratory (1942)
—Wright, The Solomon R. Guggenheim Museum, New York (1942–59)

AFRICA

(A.D. 1900)

ASIA

Southeast Asia Treaty Organization (1955)
—Kenzo Tange, Governmental Offices,
 Takamatsu, Japan (1955–58)
China explodes atomic bomb (1964)
Massive U.S. military buildup begins in
 Vietnam (1965)
Arab-Israeli "Six-Day" War (1967)
Indo-Pakistani War (1971)
Communist China admitted to UN (1971)
Last American troops leave Vietnam (1973)
Arab-Israeli "Yom Kippur" War (1973–74)
India explodes atomic bomb (1974)
Revolution on Cyprus; Turkish troops invade
 island (1974)

EUROPE

(A.D. 1900) Hitler's Nazis come to power in Germany
(1933)
Spanish Civil War (1936–39)
—Picasso, *Guernica* (1937) **436**
Hitler annexes Austria (1938), Czechoslovakia
(1939)
Second World War (1939–45)
—Le Corbusier, Unité d' Habitation,
Marseilles, France (1946–52)
North Atlantic Treaty Organization
established (1949)
USSR explodes atomic bomb (1949)
—Le Corbusier, Notre Dame du Haut,
Ronchamp, France (1950–55) **199a, 199b**
Genetic code cracked by Watson and Crick
(1953)
Death of Stalin (1953)
Sputnik, first satellite, launched by USSR
(1957)
—Nervi, Sports Palace, Rome (1957)
France explodes atomic bomb (1960)
First manned flight into space, USSR (1961)
Death of Churchill (1965)
Death of de Gaulle (1970)
Solzhenitsyn wins Nobel Prize for literature
(1972), emigrates from Russia (1974)
Greek junta government falls; democracy
reinstated (1974)

NEW WORLD AND OCEANIA

First large-scale atomic explosion, Los Alamos,
New Mexico (1943)
Second World War ends (1945)
United Nations Charter signed in San
Francisco (1945)
Organization of American States (1948)
U.S. inaugurates Marshall Plan (1949)
—Abstract expressionism develops in New
York; Pollock, Kline, Rothko, de Kooning,
and others; first American art movement to
have international influence **491, 492;
colorplates 27, 29**
—Felix Candela, restaurant at Xochimilco,
Mexico (1951)
First hydrogen bomb exploded (1954)
Polio vaccine developed by Salk (1954)
U.S. Supreme Court rules against racial
segregation in public schools (1954)
—Utzon, Opera House, Sydney, Australia
(designed 1956)
—Niemeyer, designs for Brasilia, new capital
of Brazil (begun 1956)
U.S. tests Intercontinental Ballistic Missile
(1957)
First U.S. satellite launched (1958)
Columbia-Princeton Electronic Center
established for electronic music (1959)
Castro comes to power in Cuba (1959)
—Op art and "postpainterly" abstraction on
rise by mid-1960s **493**
—Pop art flourishing in 1960s **494–98**
Cuban missile crisis (1962)
Assassination of President Kennedy (1963)
U.S. Mariner IV transmits photos of Mars
(1965)
Race riots in Watts, Los Angeles (1965)
—Fuller, U.S. Pavilion, Expo 67, Montreal,
Canada (1967)
—Safdie and others, Habitat, Expo 67,
Montreal, Canada (1967)
First manned landing on moon (U.S.
astronauts, Armstrong, 1969)
—New realism develops during 1960s
—Photorealism prominent in 1970s
Pentagon Papers published (1971)
Apollo 17, last U.S. manned space flight to
moon (1972)
Break-in at Democratic headquarters in
Watergate complex, Washington, D.C.
(1972)
Impeachment proceedings against President
Nixon (1974)
President Nixon resigns (1974)

GLOSSARY

(Words in boldface within the definitions are defined elsewhere in this glossary.)

abstract art—Those forms of twentieth-century art that do not present the natural appearance of objects; they are often referred to as nonrepresentational or nonobjective. See figs. 463, 465, colorplates 26, 27.

abstract expressionism—A movement of **abstract art** that emerged in New York City during the 1940s. It attained singular prominence during the 1950s and was the first important school of American painting to declare independence from European styles and to influence the development of art abroad. It emphasized personal expressiveness and qualities of brush stroke and texture, and it glorified the act of painting itself. See fig. 491, colorplates 27, 29.

acrylic—A synthetic plastic resin; in solvent, used as the vehicle for acrylic paints. Fast-drying acrylic paints are often used today in place of oils.

aerial perspective (or **atmospheric perspective**)—A means of achieving the illusion of space or distance in a painting by diminishing the brilliance and distinctness of color areas and shapes as the distance from the foreground increases. It is an attempt to achieve a pictorial equivalent for the effects of atmospheric conditions observable in nature.

altarpiece—A panel (painting or sculpture) placed above and behind an altar.

ambulatory—The passageway in a church that leads around the apse (see **basilica**) and **choir**; also, a covered passageway in a cloister or atrium.

amphora—A two-handled jar with a somewhat egg-shaped body; generally used for storage (see fig. 17). One type of Greek amphora was awarded as a prize in games—the ancestor of our trophy cups.

aquatint—An **intaglio** printing process by which a porous ground of resin or other substance is applied to the metal plate and fused to it by heating. When immersed in acid the effect of the acid is to penetrate the tiny pores in the ground and etch a surface that, when inked and printed, creates a grainy, gray value. By controlling the length of the immersion and by "stopping out" some areas already etched and reimmersing the plate a variety of values or tones can be developed. The term also refers to the print made from the inked plate. See fig. 450.

arch—A curved or pointed span over an opening.

Archaic period—In ancient Greece, the period extending from around 700 B.C. to around 480 B.C. The **kouros** statue was a characteristic form during this era, and **black-figure** vase painting developed at this time. Toward the end of the era, the **red-figure** style of vase painting was invented.

architectonic—Having structural qualities similar to those of architecture.

architrave—In classical architecture, the lowest section of the **entablature,** between the **frieze** and the **columns.**

baptistery—A building, or an area set aside in a church, where baptism takes place.

baroque—Originally a derogatory term denoting a bizarre or excessively contorted art; still sometimes used to indicate a flamboyant manner, style, or gesture. In general practice *baroque* refers to the art and architecture of the seventeenth century, but since the art of this century is so varied, the term is imprecise as a stylistic term.

basilica—1. A large Roman hall used for administrative and assembly purposes. 2. The basic form of the early

Christian church, rectangular in plan, with the entrance on one of the ends and a nichelike extension of the interior space called the *apse* at the other. The central, axial area between entrance and apse is called the *nave*, which may be flanked by side aisles. The nave, generally higher than the roofs of the side aisles, may be lighted by windows in that area above the aisle roofs called the *clerestory*. Basilicas sometimes have an area between the nave and the apse called the *transept* (or *bema*). This runs at right angles to the axis of the nave and may extend beyond the side walls of the basilica to give the church a cruciform shape. Sometimes the basilica was preceded by an open square or rectangular courtyard surrounded by colonnaded ambulatories, with the one along the front of the church forming a kind of **narthex,** or vestibule. See figs. 36, 172.

bestiary—An anthology of allegories and descriptions of real and imaginary beasts, their habits and significance; popular in the Middle Ages.

black-figure—A technique of vase painting that developed during the **Archaic period** in ancient Greece. It is characterized by figures and objects painted in black silhouette form against the reddish buff color of the clay (see fig. 2). Interior details were created with incised lines, and sometimes a **polychrome** effect was achieved by overpainting (after firing) some black areas with purplish red and with white.

boss—1. A knoblike projection on any surface. 2. In architecture, an ornament that covers the intersections of ribs in a ceiling.

bottega—The artist's workshop, from the Italian word for "shop"; also applied to the group of assistants working with the master artist.

bust—A sculpture of a person's head and shoulders. See fig. 274, colorplate 9.

Byzantine—The style of art and architecture produced in Byzantium under the Eastern Roman Empire; also, works done under Byzantine influence as in Venice and Ravenna and in Syria, Greece, Russia, and other Eastern countries. **Mosaic** decoration achieved great monumentality and expressive power in the Byzantine style. See figs. 173, 248.

calligraphy—The art of writing, which in the East has been consistently practiced as a fine art. See fig. 101.

capital—The molded or sculptured top member of a **column**.

cartoon—1. A preparatory study or drawing made to scale before executing a **fresco** or a painting (see fig. 252). 2. A comic drawing, or a drawing done in the style of a comic drawing but with serious, usually satirical or polemic, intent, as in the political cartoon (see figs. 425, 426).

cathedral—The principal church of a diocese and the seat of the bishop.

centaur—In Greek mythology, one of a race of creatures with the bodies of horses and the heads, shoulders, and arms of a man.

chiaroscuro—Italian term, meaning "light-dark," referring to dramatic use of light and shade in a painting.

choir—The space in a **cathedral** or abbey church reserved for the singers and clergy, usually between the transept and the apse (see **basilica**). In a parish church this area may be called the *chancel*.

classical Greek style—The style that began to develop around 480 B.C. (after the Persian Wars) and extended to the **Hellenistic** era (beginning around the middle of the fourth century B.C.). It is marked by greater naturalism than the **Archaic** style, but it is tempered by a strong idealistic quality expressed largely in terms of perfected proportions. See figs. 85, 86, 265.

cloisonné—Method of decorating metal surfaces (such as vases, jewel boxes) in which metal strips, or *cloisons*, are soldered to the object to form a design of cells that are filled with colored **enamel** in paste form. The object is then heated to fuse the enamel to the surface.

collage—A work produced by gluing pieces of natural or manufactured materials to a surface to produce all or part of a work of art; often used in combination with painting or drawing. See figs. 463, 468.

colonnade—A row of **columns** spanned by **lintels.**

color patch—A technique of painting with small patches or broken areas of color.

color spot—Term sometimes used to designate the technique of painting with small spots of color (see colorplate 13). See also **divisionism.**

column—A vertical support, circular in cross section, consisting (in classical architecture) of base, shaft, and **capital** —except for the Doric order, which has no base.

composition—The organization of forms in a work of art.

constructivism—Russian art movement founded around 1913 stressing abstract constructive principles which had considerable effect on western European **abstract art**, particularly sculpture.

contrapposto—The stance of a human figure in which the weight is shifted to one leg, with the other leg slightly bent. The line of the shoulders and that of the hips are then thrown out of parallel, and often the trunk is slightly rotated as well. See figs. 216, 265.

cornice—The projecting course of masonry that crowns a building; the upper, projecting course of an **entablature;** or a **molding** that marks the line of junction between a wall and ceiling.

crypt—An underground chamber in a church.

cubism—One of the earliest movements in modern **abstract art**, it began in France about 1909 partly as a rebellion against **impressionism**. Its exponents transformed natural forms into abstract, geometric arrangements of intersecting, overlapping, and interlocking planes. Pablo Picasso and Georges Braque were its founders. See figs. 463, 464, colorplate 23.

Dada—An international nihilistic movement (1916–22) among artists and writers who attacked all conventional standards of aesthetics and behavior. It officially originated in Zurich, and in 1924 many Dadaists joined the **surrealist** movement. See figs. 468, 469, 475, 476.

diptych—An **altarpiece** composed of two sections; also applied to secular paintings in two sections.

divisionism—The technique of painting with small strokes or spots of separate colors that mix optically to form another color, the sum of those constituent color spots. Synonymous with **neoimpressionism.** See colorplate 13.

dome—A hemispherical shell over a square or cylindrical space.

drypoint—An **intaglio** printing process in which the lines are scratched on a plate with a needle (rather than a burin or graver as in **engraving**) which leaves a burr and produces a rich, velvety effect in printing.

enamel—1. Vitreous colored paste that hardens when subjected to high temperatures (see colorplate 4). 2. A modern commercial paint sometimes used by artists.

engraving—An **intaglio** printing process in which lines are cut into a metal plate which is then inked and wiped,

leaving the incised lines filled with ink. Damp paper is placed on the plate and both are run through a press. The term also refers to the print made from the engraved plate. See fig. 231.

entablature—That portion of the classical orders of architecture supported by the **columns,** consisting of the **architrave,** the **frieze,** and the **cornice.**

etching—An **intaglio** printing process by which a metal plate (usually copper) is first covered with an acid-resistant ground through which the design to be printed is scratched. The plate is then immersed in acid, which bites into the exposed metal, transferring the scratched design into the plate. Printing ink is worked into the acid-bitten portions of the plate, and the unetched portions are wiped clean. The print is taken by placing dampened paper on the inked—and warmed—plate and running the plate and paper through the rollers of an etching press. The term is also applied to the print made from the plate. See fig. 186.

expressionism—A style of art in which the natural object is distorted to communicate an inner vision or feeling. See fig. 492.

Fauves—"Wild beasts"; a name given to a group of French painters who explored an expressionist style characterized by bold distortion of forms and vivid color. Though a short-lived movement (1905–8), its influence was basic to the evolution of twentieth-century **expressionism.** See fig. 459, colorplate 18.

fetish—An object deemed to have magic powers.

finial—An ornament on the end of a shaft or, in architecture, on the end of a pinnacle or spire. See fig. 32.

fresco—Painting done with lime-proof pigments ground in water and applied to a lime plaster surface before that surface has dried. It is painted after the surface has begun the drying process so that the pigment penetrates the plaster to some extent and, after the plaster dries, is held fast in the body of the plaster itself. Used in **mural** painting.

frieze—1. A long, continuous ornamental band, usually sculptured but sometimes painted on a wall or other surface —as in the decoration on a vase or a **sarcophagus.** 2. The plain or sculptured band on a classical **entablature** between the **cornice** and the **architrave.**

genre—1. A genus or type. 2. In more specific usage, a type of painting or sculpture that depicts subjects from ordinary daily life. See figs. 403, 404.

Geometric Greek style—The style characterized by geometric ornamental motifs and simple schematic and silhouetted renderings of human and animal forms (see figs. 17, 18, 19); developed during the so-called dark ages of Greece, between around 1100 B.C. (after the fall of the older Mycenaean civilization) and around 700 B.C., when the Greek city-states became clearly defined. It is during the last century or so of this period that the finest Geometric art was produced, and it was during this era (probably in the ninth century B.C.,) that the Homeric epics were written down. The term *geometric* might also be used in a more general sense to characterize the underlying sense of geometric regularity in later Greek art of the classical era.

Gothic—The dominant structural and aesthetic style in Europe from the twelfth to the fifteenth centuries. Its architecture is characterized by lightness of construction and soaring spaces (see fig. 197). Sculpture and vast expanses of **stained glass** were integrated in the Gothic **cathedral** (see figs. 176, 272, 400, colorplate 5).

gouache—A **watercolor** given body and opacity by the addition of a neutral filler such as whiting (calcium carbonate), a chalky powder. A gouachelike effect can be achieved by adding white pigments such as zinc white or Chinese white to watercolor, but this is not a true gouache. Casein colors, combining pigments with a binder manufactured from soured skim milk, also have a gouachelike effect.

grass script—A form of free, cursive Chinese **calligraphy**.

grisaille—Painting in gray monochrome to represent objects in relief.

hand scroll—A Far Eastern painting on silk or paper that is stored rolled up and viewed by unrolling from right to left. Its format is horizontal, and it may reach lengths of as much as forty feet. See figs. 103, 107.

hanging scroll—A Far Eastern painting on silk or paper, mounted on paper and cloth and stored rolled up. Usually the format is vertical, and it is viewed by hanging it, unrolled, on a wall. See fig. 104.

hatching (or **hatched-line technique**)—A technique of drawing in terms of fine lines drawn close together or crossing to build up darks for effects of shading. The technique is also used in **engraving**, **etching**, and painting.

Hellenistic—Referring, in art, to the period that falls roughly between the time of Alexander the Great and the Roman conquest of the Greek world. See figs. 13, 14, 16, 90.

icon—An image of a sacred person, or persons, that is an object of veneration.

iconography—The study of the symbolic or religious meaning of images (persons, objects, or situations) in works of art.

ignudo (pl. **ignudi**)—Nude youth. See fig. 293.

illumination—The decoration—picture, ornament, or initial letter—in a manuscript. See figs. 116, 122, 267, 268, 441, 442.

impressionism—A late nineteenth-century French school of painting that attempted to depict transitory visual impressions. Impressionist works were usually painted directly from nature using broken color to achieve luminosity and to represent sunlight. See colorplates 12, 15, 22.

intaglio—A design cut into a stone or wood or engraved or etched in a metal plate. It is the reverse of a **relief**. The term also refers to the print made from an intaglio plate.

intarsia—A form of wood inlay or **marquetry**, probably developed in Siena in the thirteenth century and derived from Oriental inlays of ivory upon wood. Several varieties of differently colored woods were used to achieve effects comparable to painting. See fig. 411.

International style—(1) Referring to the courtly style, chiefly in painting but also in sculpture, that developed in the French and Burgundian courts around the end of the fourteenth century and rapidly spread throughout western Europe. It was marked by graceful, aristocratic decorativeness combined with a naturalism that focused upon the particulars of visual experience of the natural world. See fig. 122. (2) An architectural style formed in Holland, Germany, and France during the 1920s which later spread around the world. It is characterized by a geometric simplicity, lack of traditional ornament, enclosure of space by a minimal use of material (thus the large areas of glass), and a tendency to organization in terms of regular units rather than by such principles as an overall symmetry. It stressed the intrinsic qualities of the materials of its construction rather than applied ornamentation. It has proved very sympathetic to modern building technology. See fig. 470.

kouros—statue of a standing nude youth common in **Archaic Greek** times. See figs. 21, 22.

krater—An ancient Greek wide-mouthed vase, used for mixing wine with water. See fig. 88.

lekythos—A narrow-necked, one-handled Greek vessel used for storing oil. See fig. 2.

linoleum cut (or **lino-cut**)—A **relief** printing process in which linoleum, generally mounted on a wood-block backing, is cut or gouged out to leave standing on its original surface the design or image desired to be printed. Printing ink is rolled on the surface, paper laid on the inked linoleum block, and the impression taken either by a press or by rubbing the paper with a spoon or other instrument.

lintel—A horizontal beam or block of stone that spans an opening.

lithograph—A print produced by the planographic process of lithography which involves a surface design drawn on a perfectly smooth stone or metal plate with a lithographic (grease) crayon or tusche (a grease ink). After a chemical treatment, printing ink may be rolled on the moistened stone or plate, the water repelling the ink from the places untouched by crayon or tusche, accepting the ink where the crayon or tusche have been applied. A print on dampened paper is then taken from the inked stone or plate by running it through a lithographic press. See fig. 426.

loggia—A roofed gallery with an open **colonnade** on one or more sides.

lozenge—A diamond-shaped form, or one roughly so.

lunette—A semicircular area formed on the walls of a vaulted room, or a semicircular window or opening. See fig. 283.

mace head—The knoblike head of a mace, a staff or club derived from a weapon and carried as a mark of office by certain officials.

Madonna—The Virgin Mary. *Madonna lactans:* the Madonna nursing the Christ Child.

mannerism—In general, a style marked by a self-conscious, somewhat artificial quality, sometimes highly formal, sometimes subjective and emotional. Specifically it refers to a style that developed between the High **Renaissance** and the **baroque** era—between around 1520 and 1600. See figs. 181, 305, 306.

marquetry—Wood inlay, especially in cabinetwork. See fig. 411.

mezzotint—An **intaglio** printing process in which the surface of a metal plate is uniformly roughened by a rocker —a tool that is rocked back and forth on the plate until its teeth create an even-textured burr over the entire surface. If inked and printed at this stage, the plate would print a rich black. Variations from this black through grays to white can be obtained by scraping the surface to remove the burrs, in varying degrees, down to a smooth, polished surface where desired. The term is also applied to the print made from the inked plate.

miniature—A small picture in a manuscript or a small portrait, sometimes on ivory.

Minimal art—A term used to indicate the work developed by several artists during the 1960s, particularly in the United States, who aimed at reducing art to basic geometric forms (in sculpture) and to pure color patterns and fields (in painting), completely eliminating representational and illusionistic factors. See fig. 490.

mobile—A sculpture made of movable parts that can be set in motion by air currents. See fig. 473.

molding (or **moulding**)—A continuous narrow band of ornament, either projecting or recessed, on a wall or base of a **column**.

mosaic—A design formed by embedding small pieces or cut cubes (**tesserae**) of marble or glass in damp mortar. See colorplate 2.

mural—A large painting done directly on a wall, or one affixed to a wall. Sometimes the term is applied to a large painting that is of mural scale, even though it has not been designed for a particular architectural setting, as is the case with true mural art.

narthex—A porchlike vestibule at right angles to the axis of the nave (see **basilica**) in a basilican church and forming an entrance area to the church.

neoclassicism—A revival of interest in classical antiquity spurred in part by the discoveries and excavations of Pompeii and Herculaneum and affecting art by imposing on it a somewhat severe and sculpturesque style in emulation of the art of Greece and Rome. It began around 1760 and gave way by the 1820s. See figs. 326–33.

neoimpressionism—See **divisionism**.

Nereid—A sea nymph, one of the many daughters of the sea god Nereus.

new realism (or **neorealism**)—A revival of naturalistic images rendered in a matter-of-fact way that has developed since the mid-1960s. In a variant form called photorealism the artist documents visual experience in paintings that emulate color photography, sometimes enlarging such **genre** as portraiture to heroic proportions with striking effects. In sculpture, this direction has produced figural art rendered life-size and in natural colors—like habitat groups in natural history museums.

odalisque—An Oriental slave girl or harem concubine.

oil painting—Painting done with color pigments ground in oil, usually linseed oil.

Op art—An art movement that developed by the mid-1960s stressing the interaction of colors or wavy patterns of line to create optical vibrations of an aggressive sort that literally dazzle the eye. See fig. 429.

orans—An image in early Christian catacomb painting of a person with arms raised in prayer. This image seems to go back as far as ancient Egypt.

painterly—Originally, as used by Heinrich Wölfflin in his *Principles of Art History*, a term designating an approach to art that emphasizes the broad effects of mass, light, and shade as opposed to linear definition; now often extended to designate any approach that involves a loose, spontaneous handling of the paint.

palette—1. In ancient Egypt a stone slab, often decorated with shallow **relief**, upon which pigments for ceremonial cosmetics were ground in a depression for the purpose (see figs. 66, 69). 2. A surface, traditionally of wood (now often a sheet of glass), upon which a painter lays out his colors. 3. The particular range or choice of colors a painter uses.

pediment—1. In classical architecture, the triangular area at each end of a building bounded by the roof slopes and the horizontal **cornice** and often filled with sculpture (pedimental sculpture). 2. Any ornamental feature having this shape and surmounting a door, window, or other form.

picturesque—1. Signifying that which is appropriate as a subject for pictures. 2. Indicating the rough or rustic subject, somewhat wild and unrefined but not dangerous or especially mysterious.

pietra serena—A gray limestone used extensively as a decorative stone in Tuscany (the region of Italy around Florence, Pisa, and Siena).

pilaster—A column, rectangular in cross section, engaged to a wall and projecting slightly from it.

plinth—The square member forming the lowest section of a **column** base; also applied to the projecting base of any structure and to a block that functions as the base of a statue or a pedestal.

polychrome—Made up of many colors.

Pop art—An art movement originating in the 1950s that drew its forms largely from the popular culture of commercial advertising and its techniques, the comic strip, billboards, and movie posters, and the like.

postimpressionism—The work of various French artists at the end of the nineteenth century who rejected **impressionism** and sought individual solutions to problems of formal clarity and emotional content which they felt impressionism did not solve. See colorplates 14, 16, 17.

Praxitelean style—Referring to the sensuous, delicately modeled sculptural style associated with the name of the Greek sculptor Praxiteles (fl. ca. 370–ca. 330 B.C.).

predella—In a nonfolding Gothic or Renaissance **altarpiece**, the lowest horizontal section of painting, usually of scenes from the lives of the holy figures represented in the main section of the altarpiece.

primary colors—The hues red, yellow, and blue.

putto (pl. **putti**)—From the Italian word meaning "boy." A term applied to small cupid- or cherublike figures in Roman art; in Christian art it became a small, nude angel of childlike proportions. A popular image in **Renaissance** and later European art.

realism—In general and somewhat loose usage, any art that tends to represent nature without idealizing it—that is, "close to nature" in appearance. More specifically, it refers to a nineteenth-century trend led by Gustave Courbet that sought an "unidealized" art in both form and subject matter.

red-figure—A technique of vase painting developed in Greece around 530 B.C. Figures and objects to be represented were first drawn in line with black glaze material and then the spaces around filled in. The red-buff color of the clay when fired then showed the figures as reddish forms against the overall lustrous black glaze of the main body of the vase. See figs. 88, 110.

register—One level of a design or composition where two or more tiers of figures or other motifs are arranged vertically, one above the other; or, in print making, the accurate synchronization of two or more colors when each color is printed by a separate block, plate, or **lithographic** stone.

relief—In sculpture, a three-dimensional projection of figures or other forms from a flat background of which they are a part.

Renaissance—The period in European art marked by a strong humanistic current and by a reawakened interest in the arts and letters of classical antiquity as models of perfection. It was also a period during which the arts of painting and sculpture displayed a new interest in nature, as observed directly or as conceived through such formal schemata as systems of perspective (see fig. 109) and idealized proportions. (See figs. 282, 283.) It is generally held to have begun in Italy around 1400 and to have lasted well into the 1500s, when its proponents shared the end of the Renaissance with the **mannerist** artists. During the Middle Ages there were brief "renascences" or antique revivals, as in the early ninth-century court of Charlemagne and the thirteenth-century court of Frederick II.

repoussoir—In landscape painting in particular, a compositional device, somewhat like the flats at the wings of a stage, that extends out into the picture space roughly parallel to the picture plane, serving as an enframement for a central opening into deeper space. The *repoussoir* is characteristic of the classical landscape compositions of Claude Lorrain (see fig. 130).

rococo—A style of architecture, painting, and decoration popular during the eighteenth century in France and other parts of Europe and notable for its delicate elaboration of motifs. See fig. 339.

Romanesque—The style of architecture that prevailed throughout Europe from the mid-eleventh to the mid-twelfth century (and much later in certain areas) and incorporated elements of style from buildings of the Roman Empire and elements of **Byzantine** and Eastern origin. Its development owes much to the primacy accorded to **vaulting**.

romanticism—In general and loose usage, any quality in art that stresses subjective emotion and poetic sentiment over rational form or strict **realism**. Specifically it refers to a widespread movement in the arts with its roots in the eighteenth century but coming to maturity by the 1820s and 1830s. It was in part a reaction against the formalism of the neoclassical movement but in some respects was related to it, since, like **neoclassicism**, it became involved with reviving past styles. It also sought inspiration in the unfamiliar, and therefore fascinating, exotic quarters of the world, like the Islamic world and the Orient. Romanticism tended to stress color, and some phases of the movement, particularly in France (Géricault and Delacroix, for instance), expressed a heightened emotionality and portrayed a physical exuberance that linked them in spirit to the more dramatic phases of **baroque** art. See figs. 205, 234.

roundel—In architecture, a small decorative disk, painted or sculptured; or a circular section of a **stained-glass** window.

sarcophagus (pl. **sarcophagi**)—A coffin made of stone, often elaborately carved; from the Greek word meaning "flesh-eating." See figs. 169, 170.

sculpture-in-the-round—Sculpture that is carved or cast as a freestanding form that can—in principle, at least—be viewed from any of its sides. When set in a niche or in the gable of a Greek temple, however, the viewing angles are necessarily limited. Egyptain stone sculpture tended not to be true sculpture-in-the-round, since the figure was usually attached at the back to the residue of the original stone block (see fig. 11).

secondary colors—The hues orange, green, and purple, achieved by mixtures of two primary colors.

sinopie—Preliminary or guiding sketches in reddish pigment underneath the outer layer of plaster on which a **fresco** is painted.

spandrel—The roughly triangular area enclosed by the curve of one side of an **arch** and an adjacent right angle; or the area enclosed between two adjoining arches and a horizontal member atop the arches.

spatiality—The illusion of space created in a painting or drawing.

stabile—The term used by the American sculptor Alexander Calder to designate his sculptures that were designed as static forms, as opposed to his **mobiles**, fashioned to move. See fig. 474.

stained glass—Colored glass, used especially in the windows of Gothic **cathedrals**. The glass was either colored by metallic oxides in the melting pot or by fusing a thin film of colored glass to a clear glass base. Sometimes a paint of powdered glass and iron oxide, which when fired would fuse to the glass, was used to define details. The pieces of colored glass were held in place by channeled lead strips fused together by heat at junction points. See colorplate 5.

stele (pl. **stelae**)—A carved stone slab or marker used as a commemorative monument. Grave stelae are the most common kinds. See figs. 15, 63, 64.

still life—A painting of inanimate objects, flowers, fruits, foodstuffs, etc. See figs. 412, 413, colorplate 23.

stucco—A fine plaster or cement used to coat walls or to form decorative **reliefs**.

stupa—A Buddhist dome-shaped monument containing relics. See fig. 196.

suprematism—A Russian art movement, founded in 1913 by Kasimir Malevich, stressing an art free of representation, an art of pure geometric forms—that is, nonobjective.

surrealism—A literary and art movement influenced by Freudianism which sought to express the imagination and the unconscious as revealed in dreams, free of conscious control and convention. It was founded in Paris in 1924 and was a prominent international movement that many artists of the Dada group joined. See fig. 479.

tactile—Appealing to the sense of touch.

tempera—Painting in which the color pigments are ground in egg yolk diluted with water for fluid application. Egg tempera may also employ an emulsion (in place of the egg yolk and water) consisting of the whole egg—with the membrane around the yolk removed—oil, and dammar varnish, with water added for thinning.

terra-cotta—Italian, meaning "baked earth." Clay is modeled or molded and baked until very hard. Used for architectural decoration and for pottery and sculpture.

tesserae—Small squares, cubes, or pieces of colored glass, marble, or semiprecious stones set into cement to form **mosaics**.

tondo—A frame or painting circular in form.

triptych—An **altarpiece** composed of three sections. The central section is frequently the widest, and when the altarpiece is of the folding variety the two outer sections may fold to cover the center. The term is also applied to secular paintings in three section. See figs. 178, 445, 467.

trompe l'oeil—A form of painting that represents its subject as if it were extending out into the real space of the viewer. Naturalistic in character, such painting—as the French indicates—literally "tricks the eye." See figs. 411, 412.

Tyche—The Greek goddess of chance or fortune.

tympanum—In medieval architecture, the semicircular area between the **arch** and the **lintel** above a doorway, usually ornamented with sculpture.

vault—1. An arched roof or ceiling of several varieties: a *barrel vault* being semicircular in cross section; a *groin vault* being one formed by the intersection of two barrel vaults; a *ribbed vault* being one in which there is a framework of ribs under the intersections of vaulting sections; and a *fan vault* being one in which several ribs radiate, close together, in the shape of a fan (characteristic of English Perpendicular **Gothic**). 2. An underground chamber.

video—Television.

volute—The spiral ornament characteristic of the Greek Ionic order.

wash—In **watercolor**, a thin, transparent film of color. Its counterpart in oil painting would be called a *glaze*.

watercolor—A painting medium (or a work done with this medium) in which the color pigment is ground in gum arabic, soluble in water. Generally watercolors are done on paper. See figs. 124, 148, 453.

woodcut—A print made from an inked block of wood (with the grain running lengthwise on the block) cut into by gouges or chisels. It is a "relief" print in that the areas not cut away therefore stand out above the rest of the block. These areas receive the ink.

yaksha (masc.), **yakshi** (fem.)—In India, originally local nature spirits, later brought into the pantheon of Hindu and Buddhist divinities.

ziggurat—Form of temple common to the Sumerians, Babylonians, and Assyrians. It was a pyramidal structure, built in receding tiers, with a shrine at the summit. See fig. 57.

BIBLIOGRAPHY

This list is in two sections, the first being organized according to general categories that will assist the reader in locating information on various aspects of art and the second being a selected bibliography arranged according to the chapters of this book. Annotations accompany the titles in both sections where such comment seems appropriate.

Asterisks (*) indicate that a book is available in paperback.

SECTION ONE

General Bibliography

Chamberlain, Mary W. *Guide to Art Reference Books*. Chicago: American Library Association, 1959.
*Lucas, E. Louise. *Art Books: A Basic Bibliography on the Fine Arts*. Greenwich, Conn.: New York Graphic Society, 1968.
Art Index. New York: H. W. Wilson, 1929–. This is a listing, continuous since 1929, of articles on art that have appeared in the most important art periodicals and journals, selected internationally. Useful features are the listings of reproductions and book reviews.

Encyclopedias and Biographical Dictionaries

Bénézit, Emmanuel. *Dictionnaire critique et documentaire des peintres, sculpteurs, dessinateurs et graveurs*. 8 vols. Paris: Gründ, 1948–55. Reprint 1957. Brief biographical entries on artists. A useful feature is the reproduction of artists' signatures.
Cummings, Paul. *A Dictionary of Contemporary American Artists*. 2nd ed. New York: St. Martin's Press, 1971. Reflects questionnaires sent to artists. Illustrated.
Lake, Carleton, and Maillard, Robert, eds. *A Dictionary of Modern Painting*. 3rd ed. London: Methuen, 1964. Handy volume with brief entries. Illustrated.
Maillard, Robert, ed. *New Dictionary of Modern Sculpture*. New York: Tudor, 1971. Handy volume. Illustrated.
Seuphor, Michel [pseud.]. *Dictionary of Abstract Painting with a History of Abstract Painting*. New York: Tudor, 1957. Also contains a useful synoptic table of developments and events in the history of abstract painting in Europe and America. Illustrated.
Thieme, Ulrich, and Becker, Felix. *Allgemeines Lexikon der bildenden Künstler*. 37 vols. Leipzig: Seemann, 1908–50. The standard authoritative biographical dictionary. Entries on even the obscure artists, where it is less reliable. Even without a reading knowledge of German, the reader can decipher some of the information. For the student of art history, "Thieme-Becker" is indispensable. Since it was published over a long period of time, entries in the earlier volumes may require substantial supplementary material.
Vollmer, Hans. *Allgemeines Lexikon der bildenden Künstler des XX Jahrhunderts*. 6 vols. Leipzig: Seemann, 1953–62. A continuation of Thieme-Becker.
Encyclopedia of World Art. 15 vols. New York: McGraw-Hill, 1959–68. Contains extensive bibliographies. Well illustrated.
McGraw-Hill Dictionary of Art. 5 vols. New York: McGraw-Hill, 1969. Well illustrated.

There are many other works in this category, some general, some dealing with limited areas. For listings consult the Chamberlain and Lucas works cited above in "General Bibliography."

Other Useful Reference Works

Columbia University. *Catalog of the Avery Memorial Architectural Library.* 12 vols. Boston: G. K. Hall, 1963.

Metropolitan Museum of Art, New York, Library. *Catalog.* 25 vols. Boston: G. K. Hall, 1960. Five supplements to 1973. Vols. 24–25 are listings of sales catalogs. These two publications reproduce the card catalogs of these libraries. Also useful are the published catalogs of the British Museum Library, the Library of Congress, the Bibliothèque Nationale, and the Kunsthistorisches Institut in Florence.

International Directory of Arts. 9th ed. 2 vols. Berlin: Deutsche Zentraldruckerei AG, 1967–70. In English, German, French, and Italian. Addresses and information on museums, art galleries, collectors, publishers, college and university art departments, artists, etc., around the world. It is not always up to date, since revisions from edition to edition depend on responses from listed institutions and individuals, nor is it complete; but it is, nevertheless, a useful reference.

General Works

*Arnheim, Rudolf. *Art and Visual Perception.* Berkeley: University of California Press, 1954.

Bazin, Germain. *The History of World Sculpture.* Greenwich, Conn.: New York Graphic Society, 1968. A picture book.

Clark, Sir Kenneth. *Civilisation: A Personal View.* New York: Harper & Row, 1969.

————. *The Nude: A Study in Ideal Form.* New York: Pantheon, 1956.

Elsen, Albert E. *The Purposes of Art.* 2nd ed. New York: Holt, Rinehart and Winston, 1967.

Fletcher, Sir Banister. *A History of Architecture on the Comparative Method.* 17th ed. New York: Scribners, 1967.

*Focillon, Henri. *The Life of Forms in Art.* New York: Wittenborn, 1957.

Gombrich, E. H. *Art and Illusion.* New York: Pantheon, 1960. The psychology of representation in art.

*————. *The Story of Art.* 12th ed. New York: Phaidon, 1972.

*Hauser, Arnold. *The Social History of Art.* 2 vols. London: Routledge, 1951. Also in a four-volume paperback edition (New York: Random House, Vintage, 1957–58).

Janson, H. W. *History of Art.* Rev. ed. Englewood Cliffs, N.J.: Prentice-Hall and Abrams, 1969.

Kepes, Gyorgy. *The Language of Vision.* Chicago: Theobald, 1945.

Knobler, Nathan. *The Visual Dialogue.* 2nd ed. New York: Holt, Rinehart and Winston, 1968.

*Kubler, George. *The Shape of Time.* New Haven: Yale University Press, 1962. A challenging essay that presents a concept of historical sequence based upon a series of linked sequences of early and late manifestations of the same action.

Lee, Sherman. *A History of Far Eastern Art.* Englewood Cliffs, N.J., and New York: Prentice-Hall and Abrams, 1964.

*Panofsky, Erwin. *Meaning in the Visual Arts.* Garden City, N.Y.: Doubleday, 1957.

*Pevsner, Nikolaus. *An Outline of European Architecture.* 6th ed. Baltimore: Penguin, 1960.

*Read, Sir Herbert. *Art and Society.* London: Faber and Faber, 1950.

Rosenberg, Jakob. *On Quality in Art: Criteria of Excellence, Past and Present.* Princeton: Princeton University Press, 1967.

Venturi, Lionello. *Painting and Painters.* New York: Scribners, 1945.

Anthologies

Goldwater, Robert, and Treves, Marco, eds. *Artists on Art.* New York: Pantheon, 1945.

*Herbert, Robert L., ed. *Modern Artists on Art.* Englewood Cliffs, N.J.: Prentice-Hall, 1964.

*Holt, Elizabeth G., ed. *A Documentary History of Art.* 3 vols. New York: Doubleday, Anchor, 1957–66. Originally *Literary Sources of Art History* (Princeton: Princeton University Press, 1947).

*Kleinbauer, W. Eugene, ed. *Modern Perspectives in Art History.* New York: Holt, Rinehart and Winston, 1971.

*Spencer, Harold, ed. *Readings in Art History.* 2 vols. New York: Scribners, 1969.

*Sypher, Wylie, ed. *Art History: An Anthology of Modern Criticism.* New York: Random House, Vintage, 1963.

There is also the extensive Sources and Documents series of anthologies on various periods of art published by Prentice-Hall under the general editorship of H. W. Janson.

SECTION TWO

Chapter 1: The Artist and His Milieu

The bibliography for this chapter falls into two main categories: sources and documents, including treatises by artists; and recent studies of the training, status, and role of the artist. In the first category the reader is referred to the Sources and Documents series and to Elizabeth G. Holt, *A Documentary History of Art*, both cited in section 1 ("Anthologies"), which also include selections from treatises by artists. The most important source of information on the artists of the Greek and Roman eras is Pliny the Elder's *Chapters on the History of Art*, translated by K. Jex-Blake with commentary by E. Sellers (London: Macmillan, 1896; reprinted Chicago: Argonaut, 1968).

The milieu of the medieval cathedral builders is defined in Erwin Panofsky, ed., *Abbot Suger on the Abbey Church of St. Denis and Its Art Treasures* (Princeton: Princeton University Press, 1946); and Panofsky's short essay *Gothic Architecture and Scholasticism** (Latrobe, Pa.: Archabbey Press, 1951) has also been printed in paperback (Cleveland: World, Meridian, 1957).

The training and techniques of late medieval artists are set forth in Cennino Cennini, *Il libro dell' arte (The Craftsman's Handbook),** translated by D. V. Thompson, Jr., 2 vols. (New Haven: Yale University Press, 1932–33; in paperback, New York: Dover, 1960).

For the Renaissance, the following works are important:

Alberti, Leon Battista. *On Painting.* Translated by J. R. Spencer. New Haven: Yale University Press, 1956.

————. *Ten Books on Architecture.* Edited by Joseph Rykwert. London: Tiranti, 1955.

*Castiglione, Baldassare. *The Book of the Courtier.* Translated by T. Hoby. New York: Dutton, 1956. A Renaissance work that provides an intimate view of the atmosphere in the highest levels of the society of the time, from which most of the artists' patronage came.

Cellini, Benvenuto. *Autobiography.* Edited by John Pope-Hennessy. New York: Phaidon, 1960. A fascinating account by a mannerist artist.

Dürer, Albrecht. *Writings.* Translated by W. M. Conway. Edited by Alfred Werner. New York: Philosophical Library, 1958.

Leonardo da Vinci. *Leonardo da Vinci on Painting: A Lost Book (Libro A).* Edited by Carlo Pedretti. Berkeley: University of California Press, 1964.

————. *The Notebooks of Leonardo da Vinci.* Translated by Edward MacCurdy. New York: Harcourt, Brace, 1938.

————. *Treatise on Painting.* Translated by A. P. McMahon. 2 vols. Princeton: Princeton University Press, 1956.

Michelangelo. *Letters.* Translated by E. H. Ramsden. 2 vols. Stanford: Stanford University Press, 1963.

Richter, Jean P. *The Literary Works of Leonardo da Vinci,* compiled and edited from the original manuscripts. 2nd ed. 2 vols. London and New York: Oxford University Press, 1939.

Vasari, Giorgio. *The Lives of the Painters, Sculptors, and Architects.* Translated by G. du C. DeVere. 10 vols. London: Medici Society, 1912–15; also translated by A. B. Hind. 4 vols. New York: Dutton, 1927. This is the most important source for Renaissance art, written by a mannerist artist conscious of the great achievements of the Renaissance. It must, however, be checked against subsequent research for accuracy.

An important seventeenth-century source is the *Letters* of Peter Paul Rubens, edited by Ruth Magurn (Cambridge, Mass.: Harvard University Press, 1955). For the following century there is Sir Joshua Reynolds, *Discourses on Art,* edited by Robert R. Wark (San Marino, Calif.: Huntington Library, 1959).

The following sources are recommended for the nineteenth century:

Cézanne, Paul. *Letters.* Edited by John Rewald. London: Cassirer, 1941.

Constable, John. *Correspondence.* Edited by R. B. Beckett. 2 vols. London: Her Majesty's Stationery Office, 1962 (vol. 1), 1964 (vol. 2).

Degas, Edgar. *Letters.* Edited by Marcel Guérin. Oxford: Cassirer, 1947.

Delacroix, Eugène. *Journal.* Translated by Lucy Norton. London: Phaidon, 1952. Also translated and edited by W. Pach. New York: Crown, 1948.

*Gauguin, Paul. *The Intimate Journals of Paul Gauguin.* Translated by Van Wyck Brooks. Bloomington: Indiana University Press, 1958.

————. *Letters to His Wife and Friends.* Edited by M. Malingue. Cleveland: World, 1949.

Leslie, Charles Robert. *Memoirs of the Life of John Constable.* London: Lehmann, 1952. First published in 1843, it has seen several editions.

Pissarro, Camille. *Letters to His Son Lucien.* Translated by Lionel Abel. Edited by John Rewald. 2nd ed. New York: Pantheon, 1943.

van Gogh, Vincent. *Complete Letters.* Translated by Mrs. J. van Gogh-Bonger and C. de Dood. 2nd ed. 3 vols. Greenwich, Conn.: New York Graphic Society, 1959.

Whistler, James McNeill. *The Gentle Art of Making Enemies.* London: Heinemann, 1916. Other editions from 1890 on.

For the twentieth century the following are recommended:

Chipp, Herschel B. *Theories of Modern Art: A Source Book by Artists and Critics.* Berkeley: University of California Press, 1969. An excellent survey of the artists' attitudes and their milieu beginning with the late nineteenth century.

Henri, Robert. *The Art Spirit.* Compiled by Margery Ryerson. Rev. ed. Philadelphia: Lippincott, 1951. Reflects the New York studio and classroom scene in the earlier part of the century.

Sloan, John. *Gist of Art.* New York: American Artists Group, 1939. An autobiography.

————. *John Sloan's New York Scene: From the Diaries, Notes, and Correspondence, 1906–1913.* New York: Harper & Row, 1965.

Much can be gleaned, too, from the series of publications by Alfred Stieglitz: *Camera Notes* (1897–1902) and *Camera Work* (1903–17).

Other twentieth-century works are cited in the bibliography for chapter 15.

In the category of studies of the techniques, training, status, role, and milieu of the artist there are many fine works. The following is a small sampling of these:

Adam, Sheila. *The Technique of Greek Sculpture in the Archaic and Classical Periods.* London: Thames and Hudson, 1967.

Antal, Frederick. *Florentine Painting and Its Social Background.* London: Kegan Paul, 1948.

Beazley, Sir John D. *Potter and Painter in Ancient Athens.* London: Cumberledge, 1944.

*Burckhardt, Jakob C. *The Civilization of the Renaissance in Italy.* Translated by S. G. C. Middlemore. 3rd rev. ed. London: Phaidon, 1950. A classic in the literature on the Renaissance and still one of the best introductions to the temper of that period. What is of particular relevance for the arts is the theme of creativity that threads through the book.

*Dickinson, G. Lowes. *The Greek View of Life.* Ann Arbor: University of Michigan Press, 1958.

Egbert, Virginia Wylie. *The Medieval Artist at Work.* Princeton: Princeton University Press, 1967.

Gombrich, E. H. "The Early Medici as Patrons of Art." In *Norm and Form: Studies in the Art of the Renaissance.* London: Phaidon, 1966.

Grenier, Albert. *The Roman Spirit in Religion, Thought, and Art.* Translated by M. R. Dobie. New York: Knopf, 1926.

Grivot, Denis, and Zarnecki, George. *Gislebertus, Sculptor of Autun.* New York: Grossman, Orion, 1961. A study of a Romanesque sculptor and his work.

Hartt, Frederick. "Art and Freedom in Quattrocento Florence." In *Essays in Memory of Karl Lehmann,* edited by Lucy F. Sandler. New York: Institute of Fine Arts, New York University, 1964.

Haskell, Francis. *Patrons and Painters.* New York: Knopf, 1963. A study of relations between the artist and his society in the baroque era.

*Huizinga, Johan. *The Waning of the Middle Ages.* London: Arnold, 1963. Also a Doubleday Anchor paperback (1956). A classic study of the end of the Middle Ages in France and the Netherlands.

Klingender, Francis D. *Art and the Industrial Revolution.* Rev. ed. London: Evelyn, Adams and Mackay, 1968.

Laurie, Arthur P. *The Materials of the Painter's Craft in Europe and Egypt from Earliest Times to the End of the XVIIth Century.* Philadelphia: Lippincott, 1911.

Lucas, Alfred. *Ancient Egyptian Materials and Industries.* 3rd rev. ed. London: Edward Arnold, 1948.

Marshall, Lillian B. *Patrons and Patriotism: The Encouragement of Fine Arts in the United States, 1790–1860.* Chicago: University of Chicago Press, 1966.

Martindale, Andrew. *The Rise of the Artist in the Middle Ages and Early Renaissance.* New York: McGraw-Hill, 1972. Brief survey with extensive bibliography.

Meiss, Millard. *Painting in Florence and Siena after the Black Death.* New York: Harper & Row, 1964.

Noble, Joseph V. *The Techniques of Painted Attic Pottery.* New York: Watson-Guptill, 1965.

Pevsner, Nikolaus. *Academies of Art, Past and Present.* Cambridge: Cambridge University Press, 1940. Also new ed. New York: Da Capo Press, 1973. An important study of the training of artists and the academic tradition.

Sakanishi, Shio. *The Spirit of the Brush.* London: Murray, 1957. An anthology of Chinese writings on the art of painting.

Taylor, Henry O. *The Medieval Mind.* 4th ed. 2 vols. Cambridge, Mass.: Harvard University Press, 1959.

Wittkower, R., and Wittkower, M. *Born under Saturn.* New York: Random House, 1963. A study of the psychology of artists.

Chapter 2: Continuity and Renewal: Tradition and Invention in Art

The following works are recommended for further reading on developments in Egyptian, Aegean, and Greek art:

Aldred, Cyril. *Old Kingdom Art in Ancient Egypt.* London: Tiranti, 1949. *Middle Kingdom Art in Ancient Egypt.* London: Tiranti, 1950. *New Kingdom Art in Ancient Egypt during the Eighteenth Dynasty, 1570–1320 B.C.* 2nd ed., rev. London: Tiranti, 1961. This series constitutes one of the best surveys of ancient Egyptian art. Also by the same author is *Development of Ancient Egyptian Art from 3200–1315 B.C.* London: Tiranti, 1952.

Hayes, William C. *The Scepter of Egypt.* 2 vols. Cambridge, Mass: Harvard University Press, 1953–59.

Iversen, Erik. *Canon and Proportions in Egyptian Art.* London: Sidgwick and Jackson, 1955.

Lange, Kurt, and Hirmer, Max. *Egypt.* London: Phaidon, 1956. An excellent picture book.

Lucas, Alfred. See bibliography for chapter 1.

Michalowski, Kazimierz. *Art of Ancient Egypt.* New York: Abrams, 1969. A handsome volume, with fine color-plates.

Smith, W. Stevenson. *Art and Architecture of Ancient Egypt.* Pelican History of Art. Baltimore: Penguin, 1958.
————. *A History of Egyptian Sculpture and Painting in the Old Kingdom.* 2nd ed. New York: Oxford University Press, 1949.

These works are useful for further study of Greek art:

Adam, Sheila. See bibliography for chapter 1.

Beazley, Sir John D., and Ashmole, Bernard. *Greek Sculpture and Painting to the End of the Hellenistic Period.* Cambridge: Cambridge University Press, 1966. First published over forty years ago, this is still the best compact survey of this material.

Bieber, Margarete. *The Sculpture of the Hellenistic Age.* Rev. ed. New York: Columbia University Press, 1961.

Carpenter, Rhys. *The Esthetic Basis of Greek Art of the Fifth and Fourth Centuries B.C.* Rev. ed. Bloomington: Indiana University Press, 1965.
————. *Greek Sculpture.* Chicago: University of Chicago Press, 1960.

Marinatos, Spyridon, and Hirmer, Max. *Crete and Mycenae.* New York: Abrams, 1960.

Mylonas, George E. *Mycenae and the Mycenaean Age.* Princeton: Princeton University Press, 1966.

Richter, Gisela M. A. *Archaic Greek Art against Its Historical Background.* New York: Oxford University Press, 1949.
————. *A Handbook of Greek Art.* 4th ed. London: Phaidon, 1965.
————. *Kouroi: Archaic Greek Youths.* 2nd ed. New York: Oxford University Press, 1960.
————. *The Sculpture and Sculptors of the Greeks.* Rev. ed. New Haven: Yale University Press, 1950.

For references to the "animal style" the reader can consult the following works:

Borovka, Gregory. *Scythian Art.* Translated by V. G. Childe. New York: Paragon Reprint, 1967.

Bunker, Emma C., et al. *"Animal Style" Art from East to West.* New York: The Asia Society, 1970. This is an exhibition catalog, interesting for the geographical range of the work presented. Fully illustrated.

Chang, Kwang-chih. *The Archaeology of Ancient China.* Rev. ed. New Haven and London: Yale University Press, 1968.

Porada, Edith. *The Art of Ancient Iran.* New York: Crown, 1965.

Rice, Tamara Talbot. *The Scythians,* 3rd rev. ed. London: Praeger, 1961.

Rostovtsev, Mikhail I. *The Animal Style in South Russia and China.* Princeton: Princeton University Press, 1929.

An excellent introduction to Christian iconography is in paperback: Emile Mâle, *The Gothic Image*,* translated by Dora Nussey (New York: Harper & Row, Torchbook, 1958). This is a translation from the third French edition (1910) and was originally published in English by J. M. Dent and Sons, London, and E. P. Dutton, New York, in 1913 as *Religious Art in France of the Thirteenth Century: A Study of Mediaeval Iconography and Its Sources of Inspiration*. Other works recommended are Anna B. Jameson's series of useful references: *The History of Our Lord*, 4th ed., 2 vols. (London: Longmans, 1881); and *Legends of the Madonna, Legends of the Monastic Orders, and Sacred and Legendary Art*, 2 vols. (Boston: Houghton-Mifflin, 1911). A. N. Didron, *Christian Iconography*, translated by E. J. Millington, 2 vols. (New York: Frederick Ungar, 1965), is a handy reprint of the 1851 translation. In addition, there is Gertrud Schiller's *Iconography of Christian Art*, vol. 1, translated by Janet Seligman (Greenwich, Conn.: New York Graphic Society, 1971). This is the first part of a translation of the second German edition of a work originally published in 1966. Volume 1 deals with the inconography relating to Christ. There are many iconographical studies, and the reader might wish to consult the Chamberlain or E. Louise Lucas reference works cited in section 1 for other titles.

An excellent example of the application of iconographical methods is Adolf Katzenellenbogen, "The Central Tympanum at Vézelay: Its Encyclopedic Meaning and Its Relation to the First Crusade," *Art Bulletin* 26 (1944), which also appears, with slight editing, in Spencer, ed., cited in section 1, vol. 1, pp. 251–64.

Mention should also be made here of Erwin Panofsky's *Studies in Iconology: Humanistic Themes in the Art of the Renaissance** (New York: Harper & Row, 1962), first published in 1939. The first chapter of this book is a fine introduction to the entire subject of meaning in a work of art.

For connections between the art of pagan antiquity and Christian art, the reader should consult Emerson Swift, *Roman Sources of Christian Art* (New York: Columbia University Press, 1951), available also in a reprint (Westport, Conn.: Greenwood Press, 1970). For a general view of early Christian art, see Charles R. Morey's *Early Christian Art*, 2nd ed. (Princeton: Princeton University Press, 1953), and Wolfgang Volbach's work of the same title (New York: Abrams, 1962).

Chapter 3: The Ancient Beginnings

For further reading on prehistoric art, the reader can consult the following works:

Bataille, Georges. *Lascaux: Prehistoric Painting*. Translated by A. Wainhouse. Cleveland: World (Skira), 1955. Handsome color illustrations.

Breuil, Henri. *Four Hundred Centuries of Cave Art*. Translated by Mary E. Boyle. Montignac, France: Centre d'Études et de documentation Préhistoriques, 1952. A work by a pioneer in the field.

Davies, Oliver. *West Africa before the Europeans: Archaeology and Prehistory*. London: Methuen, 1967.

Frobenius, Leo, and Fox, D. C. *Prehistoric Rock Pictures in Europe and Africa*. New York: Museum of Modern Art, 1937.

Graziosi, Paolo. *Paleolithic Art*. New York: McGraw-Hill, 1960.

Marshack, Alexander. *The Roots of Civilization*. New York: McGraw-Hill, 1972. An important study that raises new questions about the content of prehistoric art, suggesting that some indecipherable prehistoric markings may have been a system of notations based on lunar phases.

Hawkins, G., and White, J. B. *Stonehenge Decoded*. New York: Doubleday, 1965.

Leroi-Gourhan, André. *Treasures of Prehistoric Art*. New York: Abrams, 1967. Beautifully and profusely illustrated.

Sandars, N. K. *Prehistoric Art in Europe*. Pelican History of Art. Baltimore: Penguin, 1968.

The art of Egypt and the ancient Near East can be studied in considerable detail through selections from the following list, in addition to the titles for Egypt cited in the bibliography for chapter 2.

Akurgal, Ekrem. *Art of the Hittites.* New York: Abrams, 1962. Handsomely illustrated.

*Frankfort, Henri. *The Art and Architecture of the Ancient Orient.* Pelican History of Art. Baltimore: Penguin, 1955.

* Frankfort, Henri, et al. *The Intellectual Adventure of Ancient Man.* Chicago: University of Chicago Press, 1946. Available in paperback as *Before Philosophy* (Baltimore: Penguin, 1970). A handy study of the religious and mythic backgrounds of the Egyptian and Mesopotamian civilizations.

Groenewegen-Frankfort, H. A. *Arrest and Movement.* Chicago: University of Chicago Press, 1951. An important study of the conventions of Egyptian and Mesopotamian art.

* Lloyd, Seton. *The Art of the Ancient Near East.* New York: Praeger, 1961. A convenient survey.

Parrot, André. *The Arts of Assyria.* Translated by Stuart Gilbert and James Emmons. New York: Golden Press, 1961.

———. *Sumer: The Dawn of Art.* Translated by Stuart Gilbert and James Emmons. New York: Golden Press, 1961.

Strommenger, Eva, and Hirmer, Max. *5000 Years of the Art of Mesopotamia.* Translated by Christina Haglund. New York: Abrams, 1964.

* Wilson, John A. *The Burden of Egypt.* Chicago: University of Chicago Press, 1951. Available in paperback as *The Culture of Ancient Egypt* (Chicago: Phoenix Books, 1956).

Wooley, Sir Charles L. *Ur of the Chaldees.* Baltimore: Pelican, 1954.

Chapter 4: Images of Man, Nature, and Divinity: West and East

The reader should consult the works on Greek art cited in the bibliography for chapter 2 for further information about the images of nature, man, and the gods in ancient Greece. For the sculptures associated with the Temple of Zeus at Olympia, there is Bernard Ashmole and Nicholas Yalouris, *The Sculptures of the Temple of Zeus* (London: Phaidon, 1967).

Vincent Scully's brilliant and very controversial work, *The Earth, the Temple, and the Gods,** first published by Yale University Press in 1962, is available in a revised paperback (New York: Praeger, 1969). An architectural historian of the modern era, Scully challenges the view that Greek temple architecture was somewhat haphazardly located in its settings and has sought a rationale in an architectural synthesis of temple and sacred landscape. For balance, one would do well to read the review of this book by Homer A. Thompson in *Art Bulletin* 45, no. 3 (1963): 277–80. Also relevant to this chapter are M. P. Nilsson, *Greek Popular Religion* (New York: Columbia University Press, 1940); Hugh Lloyd-Jones, *The Justice of Zeus* (Berkeley: University of California Press, 1971); and E. G. Suhr, *Before Olympos* (New York: Helios, 1967).

There are numerous editions of Homer's *Iliad** and *Odyssey,** and both are available in paperback editions. For Hesiod, see his *Theogony,* edited by M. L. West (Oxford: Clarendon Press, 1966). Thomas Bulfinch's *The Age of Fable* is a good source for mythology and is available in many editions. See also Robert Graves, *The Greek Myths,* 2 vols. (Baltimore: Penguin, 1955); Walter Otto, *The Homeric Gods,* translated by Moses Hadas (New York: Pantheon, 1954); and J. G. Frazer's *The Golden Bough,* abr. ed. (New York: Macmillan, 1951). Frazer's *The Worship of Nature,* the Gifford Lectures, University of Edinburgh, 1924–25 (New York: Macmillan, 1926), and G. R. Levey, *The Gate of Horn* (London: Faber and Faber, 1948), are also recommended in conjunction with the material for this chapter.

For further reading on the art of India treated in this chapter, the following selections are suggested:

Coomaraswamy, Ananda K. *The Transformation of Nature in Art.* Cambridge, Mass.: Harvard University Press, 1934.

Kramrisch, Stella. *The Art of India.* 3rd ed. New York: Phaidon, 1965.

Rosenfield, John M. *The Dynastic Arts of the Kushans.* Berkeley: University of California Press, 1967.

Rowland, Benjamin, Jr. *The Art and Architecture of India.* Pelican History of Art. Baltimore: Penguin, 1953.

Wheeler, Sir Mortimer. *The Indus Civilization.* 3rd ed. Cambridge: Cambridge University Press, 1953.

Zimmer, Heinrich R. *The Art of Indian Asia: Its Mythology and Transformations.* Edited by Joseph Campbell. 2nd ed. 2 vols. Princeton: Princeton University Press, 1955.

The following works are recommended for Chinese art:

Cahill, James. *The Art of Southern Sung China.* New York: Asia House Gallery, 1962.

_____. *Chinese Painting.* Cleveland: World (Skira), 1960.

Kuo Hsi. *An Essay on Landscape Painting.* Translated by Shio Sakanishi. London: Murray, 1935.

Lee, Sherman. See section 1 bibliography.

Rowley, George. *Principles of Chinese Painting.* Princeton: Princeton University Press, 1959.

Sickman, Laurence, and Soper, Alexander. *The Art and Architecture of China.* 2nd ed. Pelican History of Art. Baltimore: Penguin, 1960.

Sirén, Osvald. *Chinese Painting: Leading Masters and Principles.* 7 vols. New York: Ronald Press, 1956–57.

Sullivan, Michael. *The Arts of China.* Berkeley: University of California Press, 1973.

_____. *The Birth of Landscape Painting in China.* Berkeley: University of California Press, 1962.

_____. *An Introduction to Chinese Art.* Berkeley: University of California Press, 1961.

Sze, Mai-Mai. *The Tao of Painting.* 2nd ed. Bollingen series, vol. 49. Princeton: Princeton University Press, 1963.

Chapter 5: The Evolution of Landscape Art in the West

Since the inclusion of titles for each of the artists mentioned in this chapter would extend this bibliography beyond reasonable limits, the reader is referred to the section on individual artists in the book by E. Louise Lucas listed in section 1 under "General Bibliography" and to listings in the *Art Index*. The Pelican History of Art volume for the relevant locale and period will also be useful, as will its bibliography. Other works the reader may consult with profit are:

Bergström, Ingvar. *Revival of Antique Illusionistic Wall-Painting in Renaissance Art.* Stockholm: Almqvist and Wiksell, 1957.

Born, Wolfgang. *American Landscape Painting.* New Haven: Yale University Press, 1948.

Bunim, Miriam. *Space in Medieval Painting and the Forerunners of Perspective.* New York: Columbia University Press, 1929.

Burke, Edmund. *A Philosophical Enquiry into the Origin of Our Ideas of the Sublime and the Beautiful.* Edited by J. T. Boulton. London: Routledge and Kegan Paul, 1958. First published in 1757.

* Clark, Sir Kenneth. *Landscape into Art.* Boston: Beacon Press, 1961.

Coke, Van Deren. *The Painter and the Photograph.* Rev. ed. Albuquerque: University of New Mexico Press, 1972.

Cuttler, Charles D. *Northern Painting: From Pucelle to Bruegel.* New York: Holt, Rinehart and Winston, 1968.

Gardner, Albert Ten Eyck. "Scientific Sources of the Full-length Landscape: 1850." *Metropolitan Museum Bulletin* 4 (1945):59–65.

Gombrich, E. H. "Renaissance Artistic Theory and the Development of Landscape Painting." *Gazette des*

Beaux-Arts 41 (May 1953):335–60 and 372–80. Also important to landscape art are portions of Gombrich's *Art and Illusion,* cited in section 1.

Hartt, Frederick. *History of Italian Renaissance Art.* New York: Abrams, 1969.

Hipple, W. J., Jr. *The Beautiful, the Sublime, and the Picturesque in Eighteenth-Century British Aesthetic Theory.* Carbondale: Southern Illinois University Press, 1957.

Hofmann, Werner. *The Earthly Paradise: Art in the Nineteenth Century.* Translated by Brian Battershaw. New York: Braziller, 1961.

Homer, W. I. *Seurat and the Science of Painting.* Cambridge, Mass.: M.I.T. Press, 1964.

Hussey, Christopher. *The Picturesque: Studies in a Point of View.* London and New York: G. P. Putnam, 1927.

Huth, Hans. *Nature and the American.* Berkeley: University of California Press, 1957.

* Lee, Rensselaer W. *Ut Pictura Poesis: The Humanistic Theory of Painting.* New York: Norton, 1967. First appeared in *Art Bulletin* 22 (1940):197–269. While landscape is only of marginal concern in this work (via its treatment of concepts of nature) the more advanced student of landscape art will find much in it of real substance.

Loran, Erle. *Cézanne's Composition.* 3rd ed. Berkeley: University of California Press, 1963.

Meiss, Millard. *French Painting in the Time of Jean de Berry.* London: Phaidon, 1967.

Novak, Barbara. *American Painting of the Nineteenth Century.* New York: Praeger, 1969.

Rathbone, Perry T., et al. *Mississippi Panorama.* Exhibition catalog, City Art Museum of St. Louis, Mo., 1950.

Rewald, John. *The History of Impressionism.* Rev. ed. New York: Museum of Modern Art, 1961.

————. *Post-Impressionism from van Gogh to Gauguin.* 2nd ed. New York: Museum of Modern Art, 1962.

Richter, Gisela M. A. *Perspective in Greek and Roman Art.* London and New York: Phaidon, 1971.

Stechow, Wolfgang. *Dutch Landscape Painting of the Seventeenth Century.* London: Phaidon, 1966.

Turner, Richard. *The Vision of Landscape in Renaissance Italy.* Princeton: Princeton University Press, 1966.

White, John. *The Birth and Rebirth of Pictorial Space.* Rev. ed. London: Faber and Faber, 1967.

* Wölfflin, Heinrich. *Principles of Art History.* Translated by M. D. Hottinger. New York: Dover, 1963. This classic study of formal distinctions between Renaissance and baroque art, first translated into English in 1932, has sections throughout that are relevant to landscape.

Chapter 6: Sacred Images

For further reading in African art there is a rapidly increasing bibliography. The following two works will each provide a good general background:

Wassing, René S. *African Art: Its Background and Traditions.* Translated by Diana Imber. New York: Abrams, 1968.

Wingert, Paul S. *The Sculpture of Negro Africa.* New York: Columbia University Press, 1959.

A brief survey of some of the work of contemporary African artists can be found in Ulli Beier's *Contemporary Art in Africa* (New York: Praeger, 1968).

The best introduction to pre-Columbian art is George Kubler's *The Art and Architecture of Ancient America.* Pelican History of Art (Baltimore: Penguin, 1962).

For Buddhist art, in addition to the general works on Indian and Chinese art cited for chapter 4 and Sherman Lee's *A History of Far Eastern Art,* cited in section 1 ("General Works"), the following are recommended:

Hallade, Madeleine. *Gandharan Art of North India and the Graeco-Buddhist Tradition in India, Persia, and Central Asia.* New York: Abrams, 1968.

Marshall, Sir John. *The Buddhist Art of Gandhara.* Cambridge: Cambridge University Press, 1960.

Paine, Robert T., and Soper, Alexander. *The Art and Architecture of Japan.* 2nd ed. Pelican History of Art. Baltimore: Penguin, 1960.

Vogel, Jean Philippe. *Buddhist Art.* London and New York: Oxford University Press, 1936.

Willetts, William. *Chinese Art.* 2 vols. Baltimore: Penguin, 1958. Contains an excellent survey of the spread of Buddhism and its art.

Yashiro, Yukio. *2000 Years of Japanese Art.* New York: Abrams, 1958.

For further reading on the Christian tradition in art, consult the bibliography on Christian iconography, cited in chapter 2; the bibliographies for individual artists in E. Louise Lucas, cited in section 1; the Pelican History of Art series; and the following selections which will provide information on particular aspects of the tradition.

Ackerman, James S. " 'Ars sine scientia nihil est': Gothic Theory of Architecture at the Cathedral of Milan." *Art Bulletin* 31 (1949):84–111.

* Beckwith, John. *Early Medieval Art.* New York: Praeger, 1964. A good survey, beginning with Carolingian art. Supplement with books by Henry and Talbot Rice cited below.

* Focillon, Henri. *The Art of the West in the Middle Ages.* Translated by Donald King. Edited by Jean Bony. 2 vols. New York: Phaidon, 1963. A classic.

Hartt, Frederick. See bibliography for chapter 5.

Henry, Françoise. *Irish Art in the Early Christian Period, to 800 A.D.* Ithaca: Cornell University Press, 1967.

————. *Irish Art during the Viking Invasions, 800–1020 A.D.* Ithaca: Cornell University Press, 1967.

* Hinks, Roger P. *Carolingian Art.* London: Sidgwick and Jackson, 1935.

Johnson, James R. *The Radiance of Chartres.* New York and London: Random House and Phaidon, 1964. A study of the stained-glass windows.

* Kitzinger, Ernst. *Early Medieval Art in the British Museum.* Bloomington: Indiana University Press, 1964. An excellent short survey.

Kordakov, Nikodim. *The Russian Icon.* Translated by E. Minns. Oxford: Clarendon Press, 1927.

Martindale, Andrew. *Gothic Art.* New York: Praeger, 1967.

*Morey, Charles Rufus. *Christian Art.* New York: Longmans, Green, 1935. A brief survey of Christian art from its earliest manifestations to the seventeenth century. Still a useful introduction to the Christian tradition. An excerpt is in Spencer, ed., cited in section 1, vol. 1, pp. 153–60.

Palol, Pedro. *Early Medieval Art in Spain.* New York: Abrams, 1967.

Panofsky, Erwin. *Early Netherlandish Painting.* 2 vols. Cambridge, Mass.: Harvard University Press, 1954. An important study focusing on fifteenth-century painting in the Low Countries.

Porter, A. Kingsley. *The Crosses and Culture of Ireland.* New Haven: Yale University Press, 1931. An important seminal study.

* Saalman, Howard. *Medieval Architecture.* New York: Braziller, 1962. A compact survey. For more complete coverage, one should consult the Pelican History of Art series and the bibliographies in these volumes.

Simson, Otto von. *The Gothic Cathedral.* New York: Pantheon, 1956.

Strzygowski, Josef. *Origin of Christian Church Art.* Translated by O. M. Dalton and H. J. Braunholtz. Oxford: Clarendon Press, 1923. Stresses the influence of the East. Cf. Swift, cited in the bibliography for chapter 2.

* Talbot Rice, David. *Art of the Byzantine Era.* New York: Praeger, 1963. A well-illustrated survey.

Voyce, Arthur. *The Art and Architecture of Medieval Russia.* Norman: University of Oklahoma Press, 1966.

Ward, Clarence. *Medieval Church Vaulting.* Princeton: Princeton University Press, 1915.

Waterhouse, Ellis K. *Italian Baroque Painting.* London: Phaidon, 1962.

Wessel, Klaus. *Coptic Art: The Early Christian Art of Egypt.* New York: McGraw-Hill, 1965.

There are many more specialized studies, of which the following works are a sampling:

Breasted, James H. *Oriental Forerunners of Byzantine Painting: First Century Wall Paintings from the Fortress of Dura on the Middle Euphrates.* Chicago: University of Chicago Press, 1924.

Evans, Joan. *Cluniac Art of the Romanesque Period.* Cambridge: Cambridge University Press, 1950.

* Katzenellenbogen, Adolf. *Allegories of the Virtues and Vices in Medieval Art from Early Christian Times to the Thirteenth Century.* New York: Norton, 1939.

_____. *The Sculptural Programs of Chartres Cathedral: Christ-Mary-Ecclesia.* Baltimore: Johns Hopkins University Press, 1959.

Kitzinger, Ernst. "The Byzantine Contribution to Western Art of the Twelfth and Thirteenth Centuries." *Dumbarton Oaks Papers* 20 (1966):25–47.

Meiss, Millard. *Giotto and Assisi.* New York: New York University Press, 1960.

_____. "Light as Form and Symbol in Some Fifteenth Century Paintings." *Art Bulletin* 27 (September 1945): 171–81.

Porter, A. Kingsley. *Romanesque Sculpture of the Pilgrimage Roads.* 10 vols. Boston: Marshall Jones, 1923. Available in a three-volume reprint edition (New York: Hacker, 1965).

Smith, E. Baldwin. *Architectural Symbolism of Imperial Rome and the Middle Ages.* Princeton: Princeton University Press, 1956.

_____. *The Dome.* Princeton: Princeton University Press, 1950. An important work on the symbolism of the dome.

* Stubblebine, James, ed. *Giotto: The Arena Chapel Frescoes.* New York: Norton, 1969. An anthology of sources and scholarship on a major monument of Christian art.

Swift, Emerson. *Hagia Sophia.* New York: Columbia University Press, 1940. A study of the most important Byzantine church.

Chapter 7: The Cult Image of the Hero

The bibliography for this chapter is largely "buried" in other bibliographies already cited and in the bibliographies for chapters 8 and 9. The reader should consult E. Louise Lucas, cited in section 1, for individual artists; the relevant Pelican History of Art volumes and their bibliographies; the entries and bibliographies in the *Encyclopedia of World Art;* and appropriate headings in the *Art Index. The Epic of Gilgamesh** is available in a paperback edition, translated by Nancy Sandars (Baltimore: Penguin, 1960).

The following works bear special mention:

Campbell, Joseph. *The Hero with a Thousand Faces.* 2nd ed. Princeton: Princeton University Press, 1968. A psychoanalytical study.

Elsen, Albert E. *Rodin.* New York: Museum of Modern Art, 1963.

_____. *Rodin's Gates of Hell.* Minneapolis: University of Minnesota Press, 1960.

Ettlinger, L. D. "Exemplum Doloris: Reflections on the Laocoön Group." In *De Artibus Opuscula XL: Essays in Honor of Erwin Panofsky,* edited by Millard Meiss. 2 vols. New York: New York University Press, 1961.

Fishwick, Marshall. *The Hero, American Style.* New York: McKay, 1969. A popular, breezy, but worthwhile account.

Held, Julius S. "Rembrandt's 'Polish Rider.'" *Art Bulletin* 26 (1944):246–65.

Jenkins, M. D. *The State Portrait.* Monographs on Archaeology and the Fine Arts, no. 3 (New York: College Art Association, 1947).

Levy, Gertrude R. *The Sword from the Rock: An Investigation into the Origins of Epic Literature and the Development of the Hero.* London: Faber and Faber, 1953.

Lindsay, Jack. *Death of the Hero: French Painting from David to Delacroix.* London: Studio, 1960.

McCoubrey, John. "Gros's *Battle of Eylau* and Roman Imperial Art." *Art Bulletin* 43 (June 1961):135–39.

Mitchell, Charles. "Benjamin West's 'Death of General Wolfe' and the Popular History Piece." *Journal of the Warburg and Courtauld Institutes* 7 (1944):20–33.

Norman, Dorothy. *The Hero: Myth, Image, Symbol.* New York: World, 1969.

Pope-Hennessy, John. *Italian High Renaissance and Baroque Sculpture.* 3 vols. London: Phaidon, 1963.

_____. *Italian Renaissance Sculpture.* London: Phiadon, 1958.

Wecter, Dixon. *The Hero in America: A Chronicle of Hero-Worship.* Introduction by Robert Penn Warren. New York: Scribners, 1972.

Wind, Edgar. "The Revolution of History Painting." *Journal of the Warburg and Courtauld Institutes* 2 (1938–39):116–27.

Chapter 8: The Art of the Royal Courts

The author is especially indebted to the stimulating book by Michael Levey, *Painting at Court* (New York: New York University Press, 1971), for many of the ideas in this chapter. As in the previous chapter, a recitation of all the sources in which threads of this chapter may be traced out more fully would repeat many works already cited. The reader is advised to consult titles on individual artists and periods for further information on works discussed in this chapter. The basic source for the section on Rubens's decorations for the entry of Prince-Cardinal Ferdinand of Austria into Antwerp is John Rupert Martin's exemplary study in the Corpus Rubenianum series, *The Decorations of the Pompa Introitus Ferdinandi* (New York: Phaidon, 1972).

Chapter 9: The Classical Tradition in Western Art

My interest in the classical tradition was first stimulated many years ago by Professor Darrell Amyx in his classes on Greek art at the University of California. How many of my ideas are rooted in those years is difficult to determine, but, somewhat later, more specific interests and ideas were formulated in the late Benjamin Rowland's course on the classical tradition at Harvard and in a seminar with the late Otto J. Brendel on the Renaissance and classical antiquity. For any student of the classical tradition the *Journal of the Warburg and Courtauld Institutes* is an invaluable source of information, and the reader would do well to familiarize himself with this important publication. Since background for the tradition lies in the Greco-Roman past, the reader should refer to those portions of earlier bibliographies that deal with the art of Greece and Rome. The following list may be considered a working survey of the artistic background, to which should be added works on mythology and the epics of Homer and Vergil.

Hanfmann, George M. A. *Roman Art.* Greenwich, Conn.: New York Graphic Society, 1964.

Maiuri, Amadeo. *Roman Painting.* Cleveland: World (Skira), 1953. Fine colorplates.

Pfuhl, Ernst. *Masterpieces of Greek Drawing and Painting.* Translated by Sir John Beazley. Chicago: Argonaut, 1967.

Richter, Gisela M. A. See bibliography for chapter 2.

Robertson, Donald S. *Handbook of Greek and Roman Architecture.* Cambridge: Cambridge University Press, 1954.

The literature on the classical tradition is extensive. The following list is a selection of works that collectively cover the main lines of the tradition:

Alpers, Svetlana. *The Decoration of the Torre de la Parada.* New York: Phaidon, 1971. A thorough study of a series of works by Rubens on subjects from classical mythology and particularly from Ovid.

Bergström, Ingvar. See bibliography for chapter 5.

* Blunt, Sir Anthony. *Artistic Theory in Italy.* Oxford: Clarendon Press, 1940.

———. *The Paintings of Nicholas Poussin.* London: Phaidon, 1968.

Bober, Phyllis P. *Drawings after the Antique by Amico Aspertini: Sketchbooks in the British Museum.* Studies of the Warburg Institute, no. 21. London: Warburg Institute, 1957.

Brendel, Otto J. "Borrowings from Ancient Art in Titian." *Art Bulletin* 37 (1955):113–25.

———. "The Classical Style in Modern Art." In *From Sophocles to Picasso,* edited by Whitney J. Oakes. Bloomington: Indiana University Press, 1962.

———. "Prolegomena to a Book on Roman Art." *Memoirs of the American Academy in Rome* 21 (1953).

Clark, Sir Kenneth. See section 1, "General Works."

———. *Rembrandt and the Italian Renaissance.* New York: New York University Press, 1966.

Eitner, Lorenz, ed. *Neoclassicism and Romanticism, 1750–1850.* 2 vols. Sources and Documents series. Englewood Cliffs, N.J.: Prentice-Hall, 1970.

Freedberg, Sydney J. *Painting of the High Renaissance in Rome and Florence.* 2 vols. Cambridge, Mass.: Harvard University Press, 1961.

* Friedlaender, Walter F. *From David to Delacroix.* Cambridge, Mass.: Harvard University Press, 1952.

———. *Mannerism and Anti-Mannerism in Italian Painting.* New York: Columbia University Press, 1957.

Gombrich, E. H. "Botticelli's Mythologies: A Study in the Neoplatonic Symbolism of His Circle." *Journal of the Warburg and Courtauld Institutes* 8 (1945):7–60.

———. "*Icones Symbolicae:* The Visual Image in Neo-Platonic Thought." *Journal of the Warburg and Courtauld Institutes* 11 (1948):163–92.

* Hamlin, Talbot F. *Greek Revival Architecture in America.* New York: Oxford University Press, 1944.

Hartt, Frederick. *Michelangelo: The Complete Sculpture.* New York: Abrams, 1969.

———. See bibliography for chapter 5.

Held, Julius S. *Rembrandt's Aristotle and Other Rembrandt Studies.* Princeton: Princeton University Press, 1969.

Highet, Gilbert. *The Classical Tradition in Western Literature.* New York: Galaxy, 1957.

* Honour, Hugh. *Neo-Classicism.* Harmondsworth, England: Penguin, 1968.

Irwin, David. "Gavin Hamilton: Archaeologist, Painter, and Dealer." *Art Bulletin* 44 (June 1962):87–102.

Krautheimer, R., and Krautheimer-Hess, T. *Lorenzo Ghiberti.* Princeton: Princeton University Press, 1956.

* Lee, Rensselaer W. See bibliography for chapter 5.

Martin, John Rupert. *The Farnese Gallery.* Princeton: Princeton University Press, 1965.

———, ed. *Rubens before 1620.* Princeton: Princeton University Press, 1972.

Mongan, Agnes. "Ingres and the Antique." *Journal of the Warburg and Courtauld Institutes* 10 (1947):1–13.

* Murray, Peter. *The Architecture of the Italian Renaissance.* New York: Schocken, 1963.

Oakeshott, Walter F. *Classical Inspiration in Medieval Art.* London: Chapman and Hall, 1959.

* Panofsky, Erwin. "Durer and Classical Antiquity." In *Meaning in the Visual Arts,* pp. 236–85. Garden City, N.Y.: Doubleday, Anchor, 1955.

———. *Problems in Titian, Mostly Iconographic.* New York: New York University Press, 1969.

———. *Renaissance and Renascences in Western Art.* 2nd ed. Stockholm: Almqvist and Wiksell, 1965. The classic study of the revivals of antiquity to the Italian Renaissance. Extensive bibliography.

* ———. *Studies in Iconology: Humanistic Themes in the Art of the Renaissance.* New York: Oxford University

Press, 1939. As a Harper Torchbook paperback, first published in 1962, it has in the new preface some addenda by the author.

Parker, Harold T. *The Cult of Antiquity and the French Revolutionaries.* New York: Octagon, 1965.

Praz, Mario. "Herculaneum and European Taste." *Magazine of Art* 32 (December 1939):684–93. The effect of the excavations in Italy on arts and letters.

_____. *Studies in Seventeenth-Century Imagery.* 2 vols. London: The Warburg Institute, 1939. Volume 2 is an extensive bibliography.

* Ripa, Cesare. *Baroque and Rococo Pictorial Imagery: The 1758–60 Hertel Edition of Ripa's Iconologia* Edited by Edward A. Maser. New York: Dover, 1971. A pictorial catalog of allegorical images designed by Ripa for use by poets and orators but which, given pictorial form, was to be used widely by artists. Provides an insight into the role of emblems (often with classical content) in seventeenth-century art.

* Rosenblum, Robert. *Transformations in Late Eighteenth-Century Art.* Princeton: Princeton University Press, 1967.

Rowland, Benjamin, Jr. *The Classical Tradition in Western Art.* Cambridge, Mass.: Harvard University Press, 1963.

Saxl, Fritz. "Rembrandt and Classical Antiquity." In *Lectures,* vol. 1, pp. 298–310. London: Warburg Institute, 1957.

Saxl, Fritz, and Panofsky, Erwin. "Classical Mythology in Medieval Art." *Metropolitan Museum Studies* 4 (1933):228–80.

* Seznec, Jean. *The Survival of the Pagan Gods.* Translated by Barbara F. Sessions. New York: Pantheon, 1953.

* Shearman, John. *Mannerism.* Baltimore: Penguin, 1967.

Smyth, Craig H. *Mannerism and Maniera.* Locust Valley, N.Y.: Augustin, 1963.

Stechow, Wolfgang. *Rubens and the Classical Tradition.* Cambridge, Mass.: Harvard University Press, for Oberlin College, 1968.

Vermeule, Cornelius. *European Art and the Classical Past.* Cambridge, Mass.: Harvard University Press, 1964.

Waterhouse, Ellis K. "The British Contribution to the Neo-Classical Style." *Proceedings of the British Academy* 40 (1954):57–74.

Weitzmann, Kurt. *The Joshua Roll: A Work of the Macedonian Renaissance.* Studies in Manuscript Illumination, no. 3. Princeton: Princeton University Press, 1948.

_____. *Greek Mythology in Byzantine Art.* Princeton: Princeton University Press, 1951.

* _____. "The Survival of Mythological Representations in Early Christian and Byzantine Art and Their Impact on Christian Iconography." *Dumbarton Oaks Papers* 14 (1960):43–68. Also available in W. Eugene Kleinbauer's *Modern Perspectives in Art History,* cited in section 1 ("Anthologies").

White, John. See bibliography for chapter 5.

Wiebenson, Dora. "Subjects from Homer's *Iliad* in Neoclassical Art." *Art Bulletin* 46 (March 1964):23–38.

Wittkower, Rudolf. *Architectural Principles in the Age of Humanism.* New York: Random House, 1965.

_____. *Gian Lorenzo Bernini: The Sculptor of the Roman Baroque.* 2nd ed. London: Phaidon, 1966.

Wölfflin, Heinrich. *Classic Art.* 2nd ed. London: Phaidon, 1953.

Chapter 10: Western Vision and the Primitive World

The most important works in this area are Australian art historian Bernard Smith's *European Vision and the South Pacific, 1768–1850: A Study in the History of Art and Ideas* (Oxford: Clarendon Press, 1960), which is expanded from his earlier article "European Vision and the South Pacific," *Journal of the Warburg and Courtauld Institutes* 13 (1950):66–100; and H. N. Fairchild's seminal work of many years ago, *The Noble Savage: A Study in Romantic*

Naturalism (New York: Columbia University Press, 1928). Certain works of Alexander von Humboldt and Charles Darwin are also essential: von Humboldt's *Cosmos* (especially vol. 2), translated by E. C. Otté (London: Bohn, 1849); his *Aspects of Nature*, 2 vols., translated by Mrs. Sabine (London: Longman, Reese, Orme, Brown, Green, and Longman, 1849); Darwin's *Diary of the Voyage of H.M.S. "Beagle,"* edited by Nora Barlow (Cambridge: Cambridge University Press, 1933); and *The Life and Letters of Charles Darwin . . .* , 3 vols., edited by Francis Darwin (London: John Murray, 1887).

The literature on this subject is so extensive that only a sampling of titles can be included here, but the following works provide, collectively, a decent introduction to the material supporting this chapter:

Banks, Sir Joseph. *Journal of the Right Hon. Sir Joseph Banks during Captain Cook's First Voyage.* Edited by Sir Joseph D. Hooker. London and New York: MacMillan, 1896. This is also relevant to portions of the chapter on the classical tradition.

Beaglehole, J. C. *The Exploration of the Pacific.* 2nd ed. London: Black, 1947.

* Boas, Franz. *Primitive Art.* New York: Dover, 1955.

Bougainville, L. Antoine de. *Voyage round the World.* Translated by J. R. Forster. London: J. Nourse, 1772. Also relevant to the chapter on the classical tradition.

Catlin, George. *Letters and Notes on the Manners, Customs, and Conditions of the North American Indians.* New York: Wiley and Putnam, 1841. Numerous reprints and editions.

de Terra, Helmut. *Humboldt: The Life and Times of Alexander von Humboldt, 1769–1859.* New York: Knopf, 1955.

Earle, Augustus. *A Narrative of a Nine Months' Residence in New Zealand, in 1827; together with a Journal of a Residence in Tristan D'Acunba, an Island Situated between South America and the Cape of Good Hope.* London: Longman, Rees, Orme, Brown, Green, and Longman, 1932. Also available in an edition with introduction and notes by Eric H. McCormick (New York: Oxford University Press, 1966).

Gauguin, Paul. See bibliography for chapter 1.

* ———. *Noa Noa.* Translated by O. F. Theis. New York: Nicholas Brown, 1919.

*Goldwater, Robert. *Primitivism in Modern Art.* New York: Harper & Row, 1938. In paperback, rev. ed. New York: Vintage, 1967. An important study.

Huth, Hans. See bibliography for chapter 5.

Hutton, C. E., and Quinn, D. B. *The American Drawings of John White, 1577–1590, with Drawings of European and Oriental Subjects.* 2 vols. Chapel Hill: University of North Carolina Press, 1964.

Kahnweiler, D.-H. "L'art nègre et le cubisme." *Présence Africaine*, no. 3. Paris-Dakar, 1948.

Larsen, Erik. *Frans Post, Interprète du Brésil.* Amsterdam and Rio de Janeiro: Colibris Editora, 1962.

Lorant, Stephan. *The New World: The First Pictures of America* New York: Duell, Sloan & Pearce, 1946. An excellent picture book with accounts of John White and Jacques le Moyne de Morgues's and de Bry's engravings after these artists.

Lovejoy, A. O; Boas, George; et al. *A Documentary History of Primitivism and Related Ideas.* Baltimore: Johns Hopkins University Press, 1935.

Mitchell, Charles. "Zoffany's 'Death of Captain Cook.' " *Burlington Magazine* 84 (March 1944):56–62.

Parry, Ellwood. *The Image of the Indian and the Black Man in American Art, 1500–1900.* New York: Braziller, 1974.

Sanford, Charles L. *The Quest for Paradise: Europe and the American Moral Imagination.* Urbana: University of Illinois Press, 1961.

Smith, Robert C. "The Brazilian Landscapes of Frans Post." *Art Quarterly* 1, no. 4 (1938), pp. 239–67.

Whitney, Lois. *Primitivism and the Idea of Progress.* Baltimore: Johns Hopkins University Press, 1934.

Chapter 11: Eastern Vision and the Western World

A good, brief, pictorial introduction to this material, with emphasis also on the African image of the European, is C. A. Borlund's well-illustrated survey, *The Exotic White Man: An Alien in Asian and African Art* (New York: McGraw-Hill, 1969). More limited in scope, but more thoroughly developed, is Yoshitomo Okamoto's *The Namban Art of Japan*, translated by Ronald K. Jones (New York and Tokyo: Weatherhill-Heibonsha, 1972), "Namban" being the art that is produced from contact between Japanese and Europeans. John G. Phillips, *China Trade Porcelain* (Cambridge, Mass.: Harvard University Press, for the Winfield Foundation and the Metropolitan Museum of Art, 1956), offers a good introduction to this subject. T. Volker's *The Japanese Porcelain Trade of the Dutch East India Company after 1683* (Leiden: E. J. Brill, 1959) should also be consulted. Sherman Lee's *History of Far Eastern Art*, cited in section 1, has some material of this nature, as does the excellent catalog, *Art Treasures from Japan*, of selected works from public and private collections in Japan, published jointly by the Los Angeles County Museum of Art, the Detroit Art Institute, the Philadelphia Museum of Art, and the Royal Ontario Museum, Toronto, in 1965. A trade edition was published by Kodansha International, Tokyo and Palo Alto, Calif., in 1971. Another catalog of interest is *Foreigners in Japan*, an account of Yokohama prints and related woodcuts in the Philadelphia Museum of Art, 1972. For a view of the impact of Western art movements on the Far East, the reader should consult Michael Sullivan's *Chinese Art in the Twentieth Century* (Berkeley: University of California Press, 1959) and the exhibition catalog *The New Japanese Painting and Sculpture* (New York: Museum of Modern Art, distributed by Doubleday, 1966). Tanio Nakamura's *Contemporary Japanese-Style Painting*, translated and adapted by Mikio Ito (New York: Tudor, 1969), reveals how much Western art has infiltrated traditional painting in Japan.

Chapter 12: The Art of the Commonplace

The following works are recommended for further study of the art of the commonplace:

Antal, Frederick. *Hogarth and His Place in European Art.* New York: Basic Books, 1962.

Bergström, Ingvar. *Dutch Still-Life Painting in the Seventeenth Century.* Translated by Christina Hedström and Gerald Taylor. New York: T. Yoseloff, 1956.

Boas, George. *Courbet and the Naturalistic Movement.* New York: Russell, 1938.

Brown, Milton W. *American Painting from the Armory Show to the Depression.* Princeton: Princeton University Press, 1955.

* Finch, Christopher. *Pop Art: The Object and the Image.* New York: Dutton, 1968.

Friedlaender, Walter F. *Caravaggio Studies.* Princeton: Princeton University Press, 1955.

Friedländer, Max J. *From van Eyck to Bruegel: Early Netherlandish Painting.* 2nd ed. New York: Phaidon, 1965.

————. *Landscape, Portrait, Still Life.* Translated by R. F. C. Hull. Oxford: Cassirer, 1949.

Goldscheider, Ludwig. *Vermeer: The Paintings. Complete Edition.* 2nd ed. London: Phaidon, 1967.

Grossman, F., ed. *Bruegel: The Paintings. Complete Edition.* 2nd rev. ed. London: Phaidon, 1966.

Lassaigne, Jacques. *Spanish Painting.* 2 vols. Cleveland: World (Skira), 1952.

Lister, Raymond. *Victorian Narrative Paintings.* New York: Potter, 1966. Chiefly a picture book.

López-Rey, José. *Velázquez: A Catalogue Raisonné of His Oeuvre.* London: Faber and Faber, 1963.

Maison, K. E. *Honoré Daumier: Catalogue Raisonné of the Paintings, Watercolours and Drawings.* 2 vols. Greenwich, Conn.: New York Graphic Society, 1967.

Meiss, Millard. *French Painting in the Time of Jean de Berry.* 2 vols. New York: Phaidon, 1967.

Paulson, Ronald. *Hogarth: His Life, Art and Times.* 2 vols. New Haven: Yale University Press, 1971.

Schapiro, Meyer. "Courbet and Popular Imagery: An Essay on Realism and Naivete." *Journal of the Warburg and Courtauld Institutes* 4 (1941):164–91.

Slive, Seymour. "On the Meaning of Frans Hals' 'Malle Babbe.'" *Burlington Magazine* 105 (September 1963): 432–36.

_____. "Realism and Symbolism in Seventeenth-Century Dutch Painting." *Daedalus*, Summer 1962, pp. 469–500.

Sterling, Charles. *Still Life Painting from Antiquity to the Present Time.* Rev. ed. Translated by James Emmons. New York: Universe Books, 1959.

Wildenstein, Georges. *Chardin.* Translated by Stuart Gilbert. Rev. ed. Greenwich, Conn.: New York Graphic Society, 1969.

Chapter 13: Art, Propaganda, and Protest

Of special interest in the literature relating to this chapter is a series of publications on a single work which we know to have been an act of protest, Picasso's *Guernica* of 1937:

Arnheim, Rudolf. *Picasso's "Guernica."* Berkeley: University of California Press, 1946.

Blunt, Sir Anthony. *Picasso's Guernica.* New York and Toronto: Oxford University Press, 1969.

Chipp, Herschel B. "*Guernica:* Love, War, and the Bullfight." *Art Journal* 33, no. 2 (Winter 1973–74), pp. 100–115.

Larrea, Juan. *Guernica.* New York: Valentin, 1947.

An excellent study of the propagandistic function of art is James A. Leith, *The Idea of Art as Propaganda in France, 1750–1799* (Toronto: University of Toronto Press, 1965). Dealing with the same era and focusing on a major figure is D. L. Dowd, *Pageant-Master of the Republic: Jacques-Louis David and the French Revolution* (Freeport, N.Y.: Books for Libraries, 1948).

For the satirical role of caricature and comic art the reader is referred to E. H. Gombrich and Ernst Kris, *Caricature* (Harmondsworth, England: Penguin, 1940); Mary Dorothy George, *English Political Caricature to 1792: A Study of Opinion and Propaganda* (Oxford: Clarendon Press, 1959); F. D. Klingender, ed., *Hogarth and English Caricature* (London and New York: Transatlantic Arts, 1944), a picture book; Richard Fitzgerald, *Art and Politics: Cartoonists for the "Masses" and "Liberator,"* Contributions to American Studies, no. 8 (Westport, Conn., and London: Greenwood Press, 1973); and a fine exhibition catalog, *Caricature and Its Role in Graphic Satire* (Providence: Museum of Art, Rhode Island School of Design, 1971).

For the Mexican muralists, the reader should consult Jean Charlot, *The Mexican Mural Renaissance, 1920–25* (New Haven: Yale University Press, 1963), and Laurence E. Schmeckebeir, *Modern Mexican Art* (Minneapolis: University of Minnesota Press, 1939).

Also of interest are the following works:

Antal, Frederick. "The Moral Purpose of Hogarth's Art." *Journal of the Warburg and Courtauld Institutes* 15 (1952):169–97.

Boime, A. "Thomas Nast and French Art." *American Art Journal*, no. 1 (Spring 1972), pp. 43–65.

Ferrari, Enrique L., ed. *Goya: His Complete Etchings, Aquatints, and Lithographs.* New York: Abrams, 1962.

*Fine, Elsa Honig. *The Afro-American Artist.* New York: Holt, Rinehart and Winston, 1973.

Gutman, Judith M. *Lewis W. Hine and the American Social Conscience.* New York: Walker, 1967.

Keller, Morton. *The Art and Politics of Thomas Nast.* New York: Oxford University Press, 1968.

*Klingender, F. D. *Goya in the Democratic Tradition.* London: Sidgwick and Jackson, 1948. Also in Schocken paperback (1968).

_____. *Marxism and Modern Art.* New York: International Publishers, 1945.

Lehmann-Haupt, L. *Art Under a Dictatorship.* New York: Oxford University Press, 1954.

McLuhan, Marshall. *Understanding Media: The Extension of Man.* London: Routledge and Kegan Paul, 1964.

Paulson, Ronald. *Hogarth's Graphic Works.* 2 vols. New Haven: Yale University Press, 1964.

Richter, Hans. *Dada: Art and Anti-Art,* New York: McGraw-Hill, 1965.

Chapter 14: Images of Fantasy

For further exploration of fantastic art the reader is referred to the following:

Antal, Frederick. *Fuseli Studies.* London: Routledge, 1956.

Barr, Alfred H., ed. *Fantastic Art, Dada, Surrealism,* essays by Georges Hugnet. New York: Museum of Modern Art, 1947.

Berger, Klaus. *Odilon Redon: Fantasy and Colour.* Translated by Michael Bullock. New York: McGraw-Hill, 1965.

Blunt, Sir Anthony. *The Art of William Blake.* New York: Columbia University Press, 1959.

Bridaham, Lester B. *Gargoyles, Chimères, and the Grotesque in French Gothic Sculpture.* 2nd ed., rev. New York: Da Capo Press, 1969.

Fraenger, Wilhelm. *The Millennium of Hieronymus Bosch.* Translated by E. Wilkins and E. Kaiser. Chicago: University of Chicago Press, 1951.

Gombrich, E. H. "Bosch's *Garden of Earthly Delights:* A Progress Report." *Journal of the Warburg and Courtauld Institutes* 32 (1969):162–70.

Graziani, René. "Pieter Bruegel's 'Dulle Griet' and Dante." *Burlington Magazine* 115 (April 1973):209–19.

Janson, H. W. "Fuseli's *Nightmare.*" *Arts and Sciences* 2, no. 1 (Spring 1963), pp. 23–28.

Legrand, Francine, and Sluys, Félix. *Arcimboldo et les Arcimboldesques.* Paris: Editions La Nef, 1955.

Lehner, Ernst, and Lehner, Johanna. *A Fantastic Bestiary: Beasts and Monsters in Myth and Folklore.* New York: Tudor, 1969. A picture glossary of fantastic creatures.

Lindberg, Bo. "The Fire Next Time." *Journal of the Warburg and Courtauld Institutes* 35 (1972):187–99. Further suggestions about the interpretation of Bosch's *Garden of Earthly Delights* (cf. titles by Charles de Tolnay and Gombrich).

Moray, Gerta. "Miró, Bosch and Fantasy Painting." *Burlington Magazine* 113 (July 1971):387–91.

Rowland, Beryl. *Animals with Human Faces.* Knoxville: University of Tennessee Press, 1973. A handy, illustrated catalog of creatures fantastic and otherwise and the ideas associated with them.

Sanchez-Canton, Francisco J. *Goya.* Translated by G. Pillement. New York: Reynal, 1964.

Tolnay, Charles de. *Hieronymus Bosch.* Translated by M. Bullock and H. Minns. New York: Reynal, 1966. The standard work on this artist. Should be consulted in conjunction with the interpretations by Gombrich and Lindberg of *The Garden of Earthly Delights.*

White, T. H., ed. and trans. *The Book of Beasts, Being a Translation from a Latin Bestiary of the Twelfth Century.* London: Cape, 1954.

Chapter 15: Some Aspects of Twentieth-Century Art

Among the statements made by twentieth-century artists some stand out as being particularly important:

Gropius, Walter. *The New Architecture and the Bauhaus.* Cambridge, Mass.: M.I.T. Press, 1955.

*Kandinsky, Wassily. *Concerning the Spiritual in Art, and Painting in Particular.* Translated by M. Sadleir. New York: Wittenborn, 1964.

Klee, Paul. *On Modern Art.* Translated by P. Findlay. London: Faber and Faber, 1948.

_____. *Pedagogical Sketchbook.* Translated by S. Peech. New York: Praeger, 1953.

Mondrian, Piet. *Plastic Art and Pure Plastic Art, 1937; and Other Essays, 1941–1943.* New York: Wittenborn, 1945.

The important work by Jean Metzinger and Albert Gleizes, *Du cubisme,* first published in 1912 and translated into English in 1913, is available in the paperback *Modern Artists on Art,* * edited by Robert L. Herbert (see section 1, "Anthologies"). The reader is also directed to Herschel B. Chipp's *Theories of Modern Art,* cited in the bibliography for chapter 1, for a wide range of theoretical statements. The French poet Guillaume Apollinaire's *Les peintres cubistes* of 1913 is available in English translation as *The Cubist Painters* (New York: Wittenborn, 1949).

Other works are:

Arnason, H. H. *History of Modern Art.* New York: Abrams, 1968.
*Ashton, Dore. *The New York School.* New York: Viking, 1973.
Barr, Alfred H., Jr. *Matisse: His Art and His Public.* New York: Museum of Modern Art, 1951.
————. *Picasso: Fifty Years of His Art.* New York: Museum of Modern Art, 1946.
Battcock, Gregory, ed. *Minimal Art: A Critical Anthology.* New York: Dutton, 1968.
Blanshard, F. B. *Retreat from Likeness in the Theory of Painting.* 2nd ed. New York: Columbia University Press, 1949.
Breton, André. *What Is Surrealism?* Translated by D. Gascoyne. London: Faber and Faber, 1936.
Coke, Van Deren. See bibliography for chapter 5.
D'Harnoncourt, Anne, and McShine, Kynaston, eds. *Marcel Duchamp.* New York and Philadelphia: Museum of Modern Art and Philadelphia Museum of Art, 1973. A superlative exhibition catalog with detailed documentation.
*Duthuit, Georges. *The Fauvist Painters.* New York: Wittenborn, 1950.
*Geldzahler, Henry, ed. *New York Painting and Sculpture, 1940–1970.* New York: Dutton, 1969.
Gernsheim, Helmut, and Gernsheim, Alison. *The History of Photography from Camera Obscura to the Beginning of the Modern Era.* London: Thames and Hudson, 1969.
Golding, John. *Cubism: A History and an Analysis, 1907–1914.* New York: Wittenborn, 1959.
*Greenberg, Clement. *Art and Culture: Critical Essays.* Boston: Beacon Press, 1961. Essays by an important critic of modern art.
*Haftmann, Werner. *Painting in the Twentieth Century.* New ed. 2 vols. New York: Praeger, 1965. A thorough study, profusely illustrated.
Hamilton, George Heard. *Painting and Sculpture in Europe, 1880–1940.* Pelican History of Art. Baltimore: Penguin, 1967.
Hammacher, A. M. *Evolution of Modern Sculpture: Tradition and Innovation.* New York: Abrams, 1969.
Hess, T. B. *Abstract Painting: Background and American Phase.* New York: Viking, 1951.
*Hitchcock, Henry-Russell, and Johann, Philip. *The International Style.* New York: Norton, 1966.
Jaffé, Hans L. C. *De Stijl, 1917–1931: The Dutch Contribution to Modern Art.* Amsterdam: Meulenhoff, 1956.
*Kelly, James J. *The Sculptural Idea.* Minneapolis: Burgess, 1970. A handy introduction to aspects of modern sculpture.
Kepes, Gyorgy, ed. *The Nature and Art of Motion.* New York: Braziller, 1965.
*Lippard, Lucy R. *Pop Art.* New York: Praeger, 1966.
Martin, M. W. *Futurist Art and Theory, 1909–1915.* New York: Oxford University Press, 1968.
Motherwell, Robert. *The Dada Painters and Poets.* New York: Wittenborn, 1951.
Neumann, Erich. *The Archetypal World of Henry Moore.* Translated by R. F. C. Hull. New York: Pantheon, 1959.

*Neumeyer, Alfred. *The Search for Meaning in Modern Art.* Foreword by Sir Herbert Read. Englewood Cliffs, N.J.: Prentice-Hall, Spectrum, 1964.

Newhall, Beaumont. *The History of Photography.* Rev. ed. New York: Museum of Modern Art, 1964.

O'Connor, Francis V. *Jackson Pollock.* New York: Museum of Modern Art, 1967.

Parker, William E. "Uelsmann's Unitary Reality." *Aperture* 13, no. 3 (1967). An analysis of the work of an important contemporary photographer.

Penrose, Sir Roland. *Picasso: His Life and Work.* Rev. ed. New York: Harper & Row, 1973.

Popper, Frank. *Origins and Development of Kinetic Art.* Translated by S. Bann. Greenwich, Conn.: New York Graphic Society, 1968.

*Read, Sir Herbert. *A Concise History of Modern Sculpture.* New York: Praeger, 1964. A handy survey.

*Rose, Barbara. *American Art since 1900: A Critical History.* New York: Praeger, 1967.

Rosenberg, Harold. *The Anxious Object: Art Today and Its Audience.* New York: Horizon, 1964.

Rosenblum, Robert. *Cubism and Twentieth-Century Art.* New York: Abrams, 1961.

Rubin, William S. *Dada and Surrealist Art.* New York: Abrams, 1969.

Scharf, Aaron. *Art and Photography.* Baltimore: Allen Lane, 1969.

Seitz, William C. *The Art of Assemblage.* New York: Museum of Modern Art, 1961. An important exhibition catalog.

_____. *Claude Monet: Seasons and Moments.* New York: Museum of Modern Art, 1960. An important exhibition catalog.

_____. *The Responsive Eye.* New York: Museum of Modern Art, 1965. An important exhibition of Op art.

Selz, Peter. *German Expressionist Painting.* Berkeley: University of California Press, 1957.

_____. *New Images of Man.* New York: Museum of Modern Art, 1959. An exhibition catalog of twentieth-century painting and sculpture.

Soby, James Thrall. *Giorgio di Chirico.* New York: Museum of Modern Art, 1955.

Sweeney, James J. *Alexander Calder.* New York: Museum of Modern Art, 1951.

Ward, John L. *The Criticism of Photography as Art.* Gainesville: University of Florida Press, 1970.

Wingler, H. M. *The Bauhaus: Weimar, Dessau, Berlin, Chicago.* Cambridge, Mass.: M.I.T. Press, 1969.

Chapter 16: From Where We Are Now . . .

For further reading on the material in this chapter, there are, first of all, Jack Burnham's *Beyond Modern Sculpture: The Effects of Science and Technology on the Sculpture of This Century* (New York: Braziller, 1968); Ursula Meyer's *Conceptual Art* (New York: Dutton, 1972); *Idea Art: A Critique,* edited by Gregory Battcock (New York: Dutton, 1973); and Maurice Tuckman, *Art and Technology: A Report on the Art and Technology Program of the Los Angeles County Museum of Art, 1967–71* (New York: Viking, for the Los Angeles County Museum of Art, 1971).

In addition there are the following:

Battcock, Gregory, et al. "Documentation in Conceptual Art." *Arts* 44 (April 1970):42–45.

Borden, Lizzie. "Three Modes of Conceptual Art." *Artforum* 10 (June 1972):68–71.

Burnham, Jack. "Alice's Head: Reflections in Conceptual Art." *Artforum* 8 (February 1970):37–43.

Heizer, Michael. "The Art of Michael Heizer." *Artforum* 8 (December 1969):32–39. On earthworks.

Hill, A., ed. *Data: Directions in Art, Theory, and Aesthetics.* Greenwich, Conn.: New York Graphic Society, 1969.

*Lomax, J. D., ed. *Computers in the Creative Arts: A Study Guide.* Manchester, England: National Computing Centre Publications, 1973.

Smithson, Robert. "A Cinematic Atopia." *Artforum* 10 (September 1971):53–55.

―――. "Robert Smithson's Amarillo Ramp." *Avalanche*, Summer/Fall 1973, pp. 16–21.

Artscanada 30, no. 4 (October 1973). An issue devoted to video art.

"Light from Aten to Laser." *Art News Annual* 35. Edited by T. B. Hess and J. Ashbery. New York: Macmillan, 1969. A survey of light as an element in art from ancient times to the present. Profusely illustrated.

INDEX

Boldface numbers indicate pages on which illustrations appear. Artists' names appear in small capitals.